Photography: Essays & Images

PHOTOGRAPHY: ESSAYS & IMAGES

Illustrated Readings in the History of Photography

Edited by Beaumont Newhall

The Museum of Modern Art, New York

Distributed by New York Graphic Society, Boston

Project Editor Susan Weiley
Designed by Steven Schoenfelder
Production by Tim McDonough
Type set by Dumar Typesetting, Inc., Dayton, Ohio
Printed by Rapoport Printing Corp., New York, New York
Bound by Sendor Bindery, Inc., New York, New York

The Museum of Modern Art
11 West 53 Street
New York, New York 10019

Printed in the United States of America

Table of Contents

Introduction/9

Photography Predicted/13
BY TIPHAIGNE DE LA ROCHE, 1760

*An Account of a Method of Copying Paintings upon Glass, and
of Making Profiles, by the Agency of Light upon Nitrate of Silver*/15
BY THOMAS WEDGWOOD AND SIR HUMPHRY DAVY, 1802

The First News Accounts of the Daguerreotype/17
1839

*Some Account of the Art of Photogenic Drawing,
or, the Process by Which Natural Objects May Be Made to
Delineate Themselves without the Aid of the Artist's Pencil*/23
BY WILLIAM HENRY FOX TALBOT, 1839

The Process of Calotype Photogenic Drawing/33
BY WILLIAM HENRY FOX TALBOT, 1841

The Early History of Photography in the United States/37
BY ALBERT SANDS SOUTHWORTH, 1871

Brady, The Grand Old Man of American Photography/45
AN INTERVIEW BY GEORGE ALFRED TOWNSEND, 1891

The Use of Collodion in Photography/51
BY FREDERICK SCOTT ARCHER, 1851

The Stereoscope and the Stereograph/53
BY OLIVER WENDELL HOLMES, 1859

Doings of the Sunbeam/63
BY OLIVER WENDELL HOLMES, 1863

Upon Photography in an Artistic View, and its Relation to the Arts/79
BY SIR WILLIAM J. NEWTON, 1853

Photography/81
BY LADY ELIZABETH EASTLAKE, 1857

*A Portfolio of Photographs from the
George Frederick Pollock Album*/97
1856

Oscar Gustav Rejlander/105
BY HENRY PEACH ROBINSON, 1890

Nadar's Portraits at the Exhibition of the French Society of Photography/109
BY PHILIPPE BURTY, 1859

Photography/112
BY CHARLES BAUDELAIRE, 1859

The Art of Photography/115
BY FRANCIS FRITH, 1859

Photographs from the High Rockies/121
FROM "HARPER'S NEW MONTHLY MAGAZINE," SEPTEMBER 1869

To My Patrons/129
BY EDWARD L. WILSON, 1871

The Annals of My Glass House/135
BY JULIA MARGARET CAMERON, 1874

Muybridge's Motion Pictures/141
NEWS ACCOUNTS, 1880

An Experiment with Gelatino Bromide/144
BY RICHARD LEACH MADDOX, 1871

The Hand Camera/146
A PORTFOLIO OF CATALOG ILLUSTRATIONS, 1880-1900

The Amateur Photographer/149
BY ALEXANDER BLACK, 1887

Flashes from the Slums: Pictures Taken in Dark Places by the Lightning Process/155
BY JACOB A. RIIS, 1888

Photography, a Pictorial Art/159
BY PETER HENRY EMERSON, 1886

Pictorial Photography/163
BY ALFRED STIEGLITZ, 1899

The Photo-Secession/167
BY ALFRED STIEGLITZ, 1903

Eduard J. Steichen/173
BY ERNST JUHL, 1902

Frederick H. Evans on Pure Photography/177
1900

A Plea for Straight Photography/185
BY SADAKICHI HARTMANN, 1904

The Photo-Secession at Buffalo/189
A PORTFOLIO OF PHOTOGRAPHS
PURCHASED BY THE ALBRIGHT ART GALLERY IN 1910

The Function of the Camera/201
BY DIXON SCOTT, 1906

The Future of Pictorial Photography/205
BY ALVIN LANGDON COBURN, 1916

Stieglitz/209
BY PAUL ROSENFELD, 1921

Photography/219
BY PAUL STRAND, 1917

Random Notes on Photography/223
BY EDWARD WESTON, 1922

The Work of Man Ray/228
BY ROBERT DESNOS, 1929

The New Realism—The Object: Its Plastic and Cinematic Value/231
BY FERNAND LÉGER, 1926

Eugène Atget/235
BY BERENICE ABBOTT, 1929

The Future of the Photographic Process/239
BY LÁSZLÓ MOHOLY-NAGY, 1929

The International Exhibition "Film und Foto," Stuttgart, 1929/243
A PORTFOLIO

Group f.64/251
BY JOHN PAUL EDWARDS, 1935

A Personal Credo/255
BY ANSEL ADAMS, 1943

The Assignment I'll Never Forget/263
BY DOROTHEA LANGE, 1960

The FSA Photographers/267
BY EDWARD STEICHEN, 1938

Photojournalism in the 1920s/271
A CONVERSATION BETWEEN FELIX H. MAN, PHOTOGRAPHER,
AND STEFAN LORANT, PICTURE EDITOR, 1970

Brassaï/277
BY NANCY NEWHALL, 1952

Vision Plus the Camera: Henri Cartier-Bresson/283
BY BEAUMONT NEWHALL, 1946

W. Eugene Smith: A Great Photographer at Work/289
AN INTERVIEW WITH ARTHUR GOLDSMITH, 1956

TIME IN NEW ENGLAND in the Making/297
EXERPTS FROM CORRESPONDENCE BETWEEN
PAUL STRAND AND NANCY NEWHALL, 1945-50

In 1943 and 1944 A Great Change Took Place/305
BY AARON SISKIND, 1963

Found Photographs/307
BY MINOR WHITE, 1957

Walker Evans, Visiting Artist/311
A TRANSCRIPT OF HIS DISCUSSION WITH THE
STUDENTS OF THE UNIVERSITY OF MICHIGAN, 1971

Index/321

Introduction

This book is an autobiography of the art of photography, written by some of the men and women who by their inventive genius, their scientific skill, and their artistic sensibility have forged a technique into a vital visual medium. We have allowed them to speak to us directly, without condensing, excerpting, or otherwise editing their words, and retaining the original spelling and punctuation, so that the volume may be both an authentic source book for students of the history of photography as an art and a narrative for the general reader.

This is not a collection of "recommended readings," but a chronological presentation of points of view. Although they are often contradictory, they all are concerned with picturemaking by photography in relation to picturemaking by such older and more accepted mediums as painting, drawing, etching, lithography, and other basically manual techniques.

Yet, however contradictory these essays may appear, a distinct ground swell can be felt in them: the recognition that this new form of picturemaking has its own being. The writer of the first newspaper account of photography in 1839, after enthusiastically praising the exactitude and wealth of detail in the daguerreotypes he saw, goes on to remark, "Let not the draftsman and painter despair; M. Daguerre's results are something else from their work, and in many cases cannot replace it." Twenty years later Lady Eastlake could not accept photography as an art—but lauded the "something else" as "that new form of communication between man and man —neither letter, message, or picture."

In their quest for recognition as artists, the men and women who called themselves "pictorial photographers" at the turn of the century deliberately forced the medium to conform to effects both natural and functional to painting: They eliminated detail by using a soft focus and they printed their negatives on textured paper. Some went so far as to alter the negative and the print by handwork with pigment, brush, and the retouching knife or the etcher's dry point.

The revolution in the arts that led to Cubism and other forms of abstraction in painting and to the International Style in architecture, also had its effect upon photography. A new academy came into being: purist photography, that emphasized the very qualities that the nineteenth-century critics considered unaesthetic—needle-sharp focus, full tonal scale in negative and print, and the use of glossy-surfaced papers. There was no alternate to this strict doctrine; the limitations of the medium must, they felt, be respected.

To other photographers and critics these "limitations" were not restrictions, but challenges to be explored, and in the 1920s age-old rules of composition were broken and the medium was immeasurably extended.

Because technique is basic to the art of photography, we have included in this anthology descriptions by the inventors of the four basic processes that were universally adopted:

1839–ca. 1855 The paper negative/positive process of W. H. Fox Talbot and the silver plate direct-positive process of Daguerre.

1851–ca. 1880 The wet collodion glass-plate negative process of Frederick Scott Archer.

1871–present The gelatin silver halide emulsion technique of Richard Leach Maddox that although greatly refined in sensitivity over the years, has not yet been replaced.

I am grateful to the following institutions for making available prints from their archives: The Museum of Modern Art, New York; George Eastman House, Rochester, N. Y.; the Library of Congress, Washington, D.C.; the Center for Creative Photography of the University of Arizona, Tucson; the Royal Photographic Society, Bath, England; the Fotomuseum of Agfa-Gevaert, Leverkusen, Germany; the Höhere Bundes- Lehr- und Versuchsanstalt, Vienna. My appreciation goes to Karl Steinorth for reprinting the 1929 Stuttgart portfolio. For permission to reprint copyrighted material I thank the writers, photographers, and publishers named with each essay. I would also like to thank the Department of Publications, particularly Steven Schoenfelder and Patrick Cunningham for their design, Susan Weiley for her editorial assistance, and Tim McDonough for supervising the production of the book. I especially thank John Szarkowski, Director of Photography at The Museum of Modern Art, for his encouragement and ever-willing and enthusiastic help.

Beaumont Newhall
Santa Fe, N.M. 1980

Now a source, as compared with a treatise, has its eternal advantages. First and foremost, it presents the fact pure, so that we *must see what conclusions are to be drawn from it, while the treatise anticipates that labor and presents the fact digested, i.e. placed in an alien, and often erroneous, setting. Sources, however, especially such as come from the hands of great men, are inexhaustible, and everyone must reread the works that have been exploited a thousand times, because they present a peculiar aspect not only to every reader and every century, but also to every time of life.*

But beyond the labor we expend on sources, the prize beckons in those great moments and fateful hours when, from things we have imagined long familiar, a sudden intuition dawns.

JACOB BURCKHARDT

The Miraculous Mirror. Eighteenth-century engraving. George Eastman House, Rochester, N.Y.

Photography Predicted

TIPHAIGNE DE LA ROCHE
1760

In 1760 the French writer Charles François Tiphaigne de la Roche wrote a novel that today would be considered science fiction. Titled Giphantie, *an anagram of his name, it describes his imaginary travels to discover "A view of what has passed, what is now passing, and . . . what will pass in the world." In the African desert he was buffeted by strong winds, which grew to hurricane force. He was lifted into the air and transported, half unconscious, to a beautiful garden in a strange land. There he met a Spirit who said, "I am the Prefect of this island which is called Giphantie." With the Prefect as guide, Tiphaigne explored the wonders of "the island." We reprint from Chapter X of the English translation of 1761 his remarkable prophecy of "fixing" the "transient images" of nature by the action of light.*

THE STORM

Some paces from the noisy globe, the earth is hollowed, and there appears a descent of forty or fifty steps of turf; at the foot of which there is a beaten subterraneous path. We went in; and my guide, after leading me through several dark turnings, brought me at last to the light again.

He conducted me into a hall of a middling size, and not much adorned, where I was struck with a sight that raised my astonishment. I saw, out of a window, a sea which seemed to me to be about a quarter of a mile distant. The air, full of clouds, transmitted only that pale light which forebodes a storm: the raging sea ran mountains high, and the shore was whitened with the foam of the billows which broke on the beach.

By what miracle (said I to myself) has the air, serene a moment ago, been so suddenly obscured? By what miracle do I see the ocean in the center of Africa? Upon

Reprinted from Charles François Tiphaigne de la Roche, *Giphantia: or, A View of What Has Passed, What is Now Passing, and During the Present Century, What Will Pass, in the World* (London: printed for Robert Horsfield, 1761), pp. 93-100.

saying these words, I hastily ran to convince my eyes of so improbable a thing. But in trying to put my head out of the window, I knocked it against something that felt like a wall. Stunned with the blow, and still more with so many mysteries, I drew back a few paces.

Thy hurry (said the Prefect) occasions thy mistake. That window, that vast horizon, those thick clouds, that raging sea, are all but a picture.

From one astonishment I fell into another: I drew near with fresh haste; my eyes were still deceived, and my hand could hardly convince me that a picture should have caused such an illusion.

The elementary spirits (continued the Prefect) are not so able painters as naturalists; thou shalt judge by their ways of working. Thou knowest that the rays of light, reflected from different bodies, make a picture and paint the bodies upon all polished surfaces, on the retina of the eye, for instance, on water, on glass. The elementary spirits have studied to fix these transient images: they have composed a most subtile matter, very viscous, and proper to harden and dry, by the help of which a picture is made in the twinkle of an eye. They do cover with this matter a piece of canvas, and hold it before the objects they have a mind to paint. The first effect of the canvas is that of a mirrour; there are seen upon it all the bodies far and near, whose image the light can transmit. But what the glass cannot do, the canvas, by means of the viscous matter, retains the images. The mirrour shows the objects exactly; but keeps none; our canvases show them with the same exactness, and retains them all. This impression of the images is made the first instant they are received on the canvas, which is immediately carried away into some dark place; an hour after, the subtile matter dries, and you have a picture so much the more valuable, as it cannot be imitated by art nor damaged by time. We take, in their purest source, in the luminous bodies, the colours which painters extract from different materials, and which time never fails to alter. The justness of the design, the truth of the expression, the gradation of the shades,

the stronger or weaker strokes, the rules of perspective, all these we leave to nature, who, with a sure and never-erring hand, draws upon our canvases images which deceive the eye and make reason to doubt, whether, what are called real objects, are not phantoms which impose upon the sight, the hearing, the feeling, and all the senses at once.

The Prefect then entered into some physical discussions, first, on the nature of the glutinous substance which intercepted and retained the rays; secondly, upon the difficulties of preparing and using it; thirdly, upon the struggle between the rays of light and the dried substance; three problems, which I propose to the naturalists of our days, and leave to their sagacity.

Mean while, I could not take off my eyes from the picture. A sensible spectator, who from the shore beholds a tempestuous sea, feels not more lively impressions: such images are equivalent to the things themselves.

The Prefect interrupted my ecstasy. I keep you too long (says he) upon this storm, by which the elementary spirits designed to represent allegorically the troublesome state of this world, and mankind's stormy passage through the same: turn thy eyes, and behold what will feed thy curiosity and increase thy admiration.

THE GALLERY
Or The Fortune of Mankind

SCARCE has the Prefect said these words; when a folding door opened on our right, and let us into an immense Gallery, where my wonder was turned into amazement.

On each side, above two hundred windows let in the light to such a degree, that the eye could hardly bear its splendor. The spaces between them were painted with that art, I have just been describing. Out of each window, was seen some part of the territory of the elementary spirits. In each picture, appeared woods, fields, seas, nations, armies, whole regions; and all these objects were painted with such truth, that I was often forced to recollect myself, that I might not fall again into illusion. I could not tell, every moment, whether what I was viewing out of a window was not a painting, or what I was looking at in a picture was not a reality.

Survey with thy eyes (said the Prefect) survey the most remarkable events that have shaken the earth and decided the fate of men. Alas! What remains of all these powerful springs, of all these great exploits? The most real signs of them are the traces they have left upon our canvases in forming these pictures.

An Account of a Method of Copying Paintings Upon Glass, and of Making Profiles, by the Agency of Light Upon Nitrate of Silver

THOMAS WEDGWOOD AND SIR HUMPHRY DAVY
1802

The first recorded experiments to produce pictures by the action of light upon the salts of silver were made by the physicist Thomas Wedgwood (1771-1805) at the end of the eighteenth century. He was able to record the profiles of objects laid on paper or leather that had been sensitized with a solution of silver nitrate. Although these shadowgraphs were not permanent, since Wedgwood had not discovered how to fix them, and although he found the sensitivity of silver nitrate too low to record a camera image, his experiments indicated techniques that were to be perfected by Joseph Nicéphore Niépce and Louis Jacques Mandé Daguerre in France, and by his fellow countryman William Henry Fox Talbot.

White paper, or white leather, moistened with solution of nitrate of silver, undergoes no change when kept in a dark place; but, on being exposed to the day light, it speedily changes colour, and, after passing through different shades of grey and brown, becomes at length nearly black.

The alterations of colour take place more speedily in proportion as the light is more intense. In the direct beams of the sun, two or three minutes are sufficient to produce the full effect. In the shade, several hours are required, and light transmitted through different coloured glasses, acts upon it with different degrees of intensity. Thus it is found, that red rays, or the common sunbeams passed through red glass, have very little action upon it: yellow and green are more efficacious; but blue and violet light produce the most decided and powerful effects*

The consideration of these facts enables us readily to understand the method by which the outlines and shades of painting on glass may be copied, or profiles of figures procured, by the agency of light. When a white surface, covered with solution of nitrate of silver, is placed behind a painting on glass exposed to the solar light; the rays transmitted through the differently painted surfaces produce distinct tints of brown or black, sensibly differing in intensity according to the shades of the picture, and where the light is unaltered, the colour of the nitrate becomes deepest.

When the shadow of any figure is thrown upon the prepared surface, the part concealed by it remains white, and the other parts speedily become dark.

For copying paintings on glass, the solution should be applied on leather; and, in this case, it is more readily acted upon than when paper is used.

After the colour has been once fixed upon the leather or paper, it cannot be removed by the application of water, or water and soap, and it is in a high degree permanent.

The copy of a painting, or the profile, immediately after being taken, must be kept in an obscure place. It may indeed be examined in the shade, but, in this case,

Reprinted from *Journals of the Royal Institution of Great Britain* 1 (1802), pp. 170-74.

*The facts above mentioned are analogous to those observed long ago by Scheele, and confirmed by Senebier. Scheele found, that in the prismatic spectrum, the effect produced by the red rays upon muriate of silver was very faint, and scarcely to be perceived; whilst it was speedily blackened by the violet rays. Senebier states, that the time required to darken muriate of silver by the red rays, is 20 minutes, by the orange 12, by the yellow 5 minutes and 30 seconds, by the green 37 seconds, by the blue 29 seconds, and by the violet only 15 seconds. (*Senebier sur la Lumière*, vol. III. p. 199.)

Some new experiments have been lately made in relation to this subject, in consequence of the discoveries of Dr. Herschel concerning the invisible heat-making rays existing in the solar beams, by Messrs. Ritter and Böckmann in Germany, and Dr. Wollaston in England.

It has been ascertained, by experiments upon the prismatic spectrum, that no effects are produced upon the muriate of silver by the invisible heat-making rays which exist on the red side, and which are least refrangible, though it is powerfully and distinctly affected in a space beyond the violet rays out of the visible boundary. (See *Annalen der Physik, siebenter Band*, p. 257.) [Note by Wedgwood and Davy]

the exposure should be only for a few minutes; by the light of candles or lamps, as commonly employed, it is not sensibly affected.

No attempts that have been made to prevent the uncoloured parts of the copy or profile, from being acted upon by light have as yet been successful. They have been covered with a thin coating of fine varnish, but this has not destroyed their susceptibility of being coloured; and even after repeated washings, sufficient of the active part of the saline matter will still adhere to the white parts of the leather or paper, to cause them to become dark when exposed to the rays of the sun.

Besides the applications of this method of copying that have been just mentioned, there are many others. And it will be useful for making delineations of all such objects as are possessed of a texture partly opaque and partly transparent. The woody fibres of leaves, and the wings of insects, may be pretty accurately represented by means of it, and in this case, it is only necessary to cause the direct solar light to pass through them, and to receive the shadows upon prepared leather.

When the solar rays are passed through a print and thrown upon prepared paper, the unshaded parts are slowly copied; but the lights transmitted by the shaded parts, are seldom so definite as to form a distinct resemblance of them by producing different intensities of colour.

The images formed by means of a camera obscura, have been found to be too faint to produce, in any moderate time, an effect upon the nitrate of silver. To copy these images, was the first object of Mr. Wedgwood, in his researches on the subject, and for this purpose he first used the nitrate of silver, which was mentioned to him by a friend, as a substance very sensible to the influence of light; but all his numerous experiments as to their primary end proved unsuccessful.

In following these processes, I have found, that the images of small objects, produced by means of the solar microscope, may be copied without difficulty on prepared paper. This will probably be a useful application of the method; that it may be employed successfully however, it is necessary that the paper be placed at but a small distance from the lens.

With regard to the preparation of the solution, I have found the best proportions those of 1 part nitrate to about 10 of water. In this case, the quantity of the salt applied to the leather or paper, will be sufficient to enable it to become tinged, without affecting its composition, or injuring its texture.

In comparing the effects produced by light upon muriate of silver, with those produced upon the nitrate, it seemed evident, that the muriate was the most susceptible, and both were more readily acted upon when moist than when dry, a fact long ago known. Even in the twilight, the colour of moist muriate of silver spread upon paper, slowly changed from white to faint violet; though under similar circumstances no immediate alteration was produced upon the nitrate.

The nitrate, however, from its solubility in water, possesses an advantage over the muriate: though leather or paper may, without much difficulty, be impregnated with this last substance, either by diffusing it through water, and applying it in this form, or by immersing paper moistened with the solution of the nitrate in very diluted muriatic acid.

To those persons not acquainted with the properties of the salts containing oxide of silver, it may be useful to state, that they produce a stain of some permanence, even when momentarily applied to the skin, and in employing them for moistening paper or leather, it is necessary to use a pencil of hair, or a brush.

From the impossibility of removing by washing, the colouring matter of the salts from the parts of the surface of the copy, which have not been exposed to light; it is probable, that both in the case of the nitrate and muriate of silver, a portion of the metallic oxide abandons its acid, to enter into union with the animal or vegetable substance, so as to form with it an insoluble compound. And, supposing that this happens, it is not improbable, but that substances may be found capable of destroying this compound, either by simple or complicated affinities. Some experiments on this subject have been imagined, and an account of the results of them may possibly appear in a future number of the Journals. Nothing but a method of preventing the unshaded parts of the delineation from being coloured by exposure to the day is wanting, to render the process as useful as it is elegant.

The First News Accounts of the Daguerreotype, January 6, 1839

1839

The first to fix the camera's image in permanent form was Joseph Nicéphore Niépce. In 1826, using a pewter plate made light-sensitive with bitumen, he made a picture through a window of farm buildings. The exposure required several hours; during that period the sun moved from east to west, thus destroying the shadows. Discouraged by his failure to promote his invention, Niépce became the partner of Louis Jacques Mandé Daugerre, a Parisian scene painter who, in great secrecy, was working on a somewhat similar process. In 1838, five years after Niépce's death, Daguerre had so perfected his invention— which he called the daguerreotype—that he considered marketing it, and had gone as far as to print a prospectus. Fortunately, the scientist and statesman François Arago, astronomer and a member of the Chamber of Deputies, offered to attempt to secure a government subsidy for Daguerre and Isidore Niépce, who upon the death of his father, had succeeded him in the partnership. The Academy of Sciences formed a committee of Arago, Jean Baptiste Biot, and Alexander von Humboldt; these famous scientists were instructed to make their reports at the Academy's meeting of January 7, 1839.

Somehow the newspaper La Gazette de France *scooped the announcement in its January 6 edition. It is remarkable that the writer of the news story, H. Gaucheraud, recognized many of the basic characteristics of photography: its automatic character, its ability to record the most minute detail, and its effect as the surrogate of reality. Nor did he overlook the faults of the primitive daguerreotype process: its inability to record moving objects due to the excessively long exposure times required, and its lack of sensitivity to all the colors of the spectrum.*

THE FINE ARTS
A New Discovery

We announce an important discovery by our famous diorama painter, M. Daguerre. This discovery par-

Reprinted from *La Gazette de France* (Paris), January 6, 1839. Translated by Beaumont Newhall.

takes of the prodigious. It upsets all scientific theories on light and optics, and it will revolutionize the art of drawing.

M. Daguerre has found the way to fix the images which paint themselves within a camera obscura, so that these images are no longer transient reflections of objects, but their fixed and everlasting impress which, like a painting or engraving, can be taken away from the presence of the objects.

Imagine the faithfulness of nature's image reproduced in the camera and add to it the work of the sun's rays which fix this image, with all its range of high lights, shadows and half-tones, and you will have an idea of the beautiful drawings which M. Daguerre, to our great interest, displayed. M. Daguerre does not work on paper at all; he must have polished metal plates. We have seen on copper several views of boulevards, the Pont Marie and its surroundings and a lot of other places rendered with a truth which nature alone can give to her works. M. Daguerre shows you the piece of bare copper, he puts it in his apparatus before your eyes, and at the end of three minutes—if the summer sun is shining, a few more if autumn or winter weakens the strength of the sun's rays —he takes out the metal and shows it to you covered with an enchanting drawing of the object towards which the apparatus was pointed. It is only a matter of a short washing operation, I believe, and there is the view which has been conquered in so few minutes, everlastingly fixed, so that the strongest sunlight can do nothing to destroy it.

MM. Arago, Biot and Humboldt have verified the authenticity of this discovery, which excited their admiration, and M. Arago will make it known to the Academy of Sciences in a few days.

Do you want other details? Here are some.

Nature in motion cannot reproduce herself, or at least can do so only with great difficulty, by the technique in question. In one of the boulevard views of which I have spoken it happened that all which moved or walked did not appear in the drawing; two coach horses were standing by the curb, one unfortunately moved his head dur-

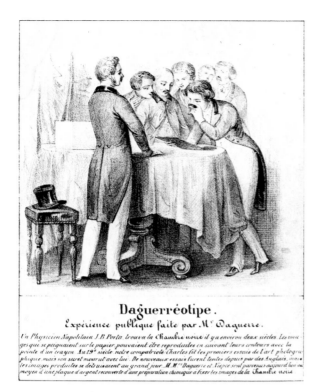

Daguerréotipe.
Expérience publique faite par M.ᵉ Daguerre.

Daguerre showing his daguerreotypes. 1839. Lithograph.
George Eastman House, Rochester, N.Y.

ing the short operation; the animal is headless in the drawing. Trees are rendered very well; but their color, it seems, creates an obstacle in that the sun's rays reproduce them as quickly as the houses and other objects of different color. That makes landscapes difficult to take, because there is one perfect, fixed degree for trees and the color green, another for all the colors which are not green. Indeed, the result is that when the houses are "done," the trees are not, and when the trees are, the houses are "overdone."

Still life, architecture—these are the triumphs of the apparatus which M. Daguerre wants to call after his own name the *Daguerotype*. A dead spider, taken through the solar microscope, has such fine detail in the drawing that you could study its anatomy with or without a magnifying glass, as in nature; not a filament, not a duct, as tenuous as might be, that you cannot follow and examine. Travelers, you will soon be able, perhaps, at the cost of some hundreds of francs, to acquire the apparatus invented by M. Daguerre, and you will be able to bring back to France the most beautiful monuments, the most beautiful scenes of the whole world. You will see how far from the truth of the Daguerotype are your pencils and brushes. Let not the draftsman and painter despair; M. Daguerre's results are something else from their work, and in many cases cannot replace it.

If I wanted to find something resembling the effects rendered by the new process, I would say that they take after copperplate engravings or mezzotints—much more the latter. As to truth, they are above all.

In this short description I have spoken of the discovery only from the artistic point of view. If what I have been told is correct, M. Daguerre's results will hold out nothing short of a challenge to a new theory on an important scientific point. M. Daguerre generously states that the first idea of his process was given to him fifteen years ago by M. Nieps* of Chalons-sur-Saône,† but in such an imperfect state that he had a long and stubborn job to arrive at the goal which he has attained!

H. Gaucheraud

DAGUERRE'S FIRST DAGUERREOTYPES

On July 7, 1839, Daguerre showed a number of his daguerreotypes to the members of the Chamber of Deputies. This appears to be the first public exhibition of his work. The press was enthusiastic. The British Literary Gazette *in its July 13, 1839, edition wrote the following.*

On Sunday last M. Daguerre exhibited several productions of the Daguerreotype in one of the halls of the Chamber of Deputies. There were views of three of the streets of Paris, of the interior of M. Daguerre's studio, and of a group of busts from the Musée des Antiques. The extraordinary minuteness of such multiplied details as was shown in the street views, particularly in that of the Pont Marie, was much admired. The slightest accidental effects of the sun, or boats, the merchandise on the banks of the river, the most delicate objects, the small pebbles under the water, and the different degrees of transparency which they imparted to it,—every thing was reproduced with incredible exactness. The astonishment was, however, greatly increased when, on applying the microscope, an immense quantity of details, of such extreme fineness that the best sight could not seize them with the naked eye, were discovered, and principally among the foliage of the trees. In the view of the studio, all the folds in the draping, and the effects of light and shade produced by them, were rendered with wonderful truth. The head of Homer, which is the principal figure in the picture (representing many ancient subjects), retained a very fine character, and not one of the beauties

*Joseph-Nicéphore Niépce.
†Chalon-sur-Saône, a town 189 miles SSE of Paris.

Reprinted from *The Literary Gazette* (London), July 13, 1839, p. 444.

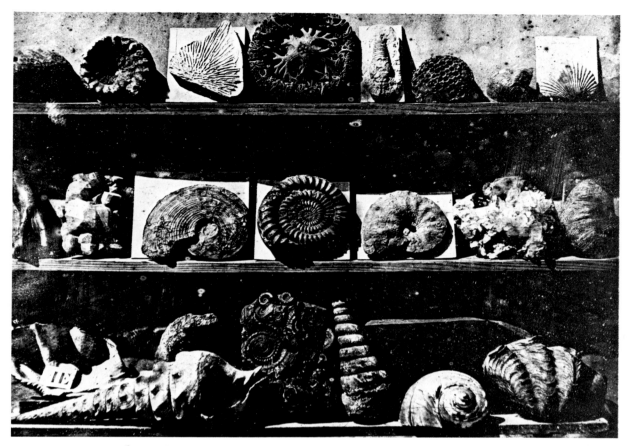

LOUIS JACQUES MANDÉ DAGUERRE. *Shells and Fossils.* 1839. Daguerreotype. Conservatoire National des Arts et Métiers, Paris.

in the sculpture was lost in this reproduction, notwithstanding the difference in the size, which is considerable. The preparation on which the light acts by M. Daguerre's process is spread on a copper plate. All the pictures exhibited in the Chamber were nine or ten inches in height and six or seven in breadth. The value of a copy this size is fixed by M. Daguerre at three francs and a half; and he calculates that the apparatus necessary to produce pictures of these dimensions would cost about four hundred francs in the first instance, but has no doubt that the perfection of the method of fabrication would soon reduce this price in a sensible manner.

Reprinted from NILES' NATIONAL REGISTER (Washington, D.C.), September 28, 1839

THE secret of M. Daguerre's wonderful invention, or discovery, by which he is enabled to transfer an exact transcript of rural scenery, buildings, etc. to paper, and fix the colors permanently, is disclosed in the following article, copied from the *London Globe*. For disclosing the secret, M. Daguerre is said to have received from the French government 6,000 francs, and M. Niépce, who also made discoveries in the same direction, 4,000 francs.

Reprinted from the LONDON GLOBE August 23, 1839

IT having been announced that the process employed by M. Daguerre for fixing images of objects by the camera obscura would be revealed on Monday, at the sitting of the academy of sciences, every part of the space reserved for visitors was filled as early as one o'clock, although it was known that the description of the process would not take place until three. Upwards of two hundred persons who could not obtain admittance remained in the courtyard of the palace of the Institute. The following is an analysis of the description given on this occasion by M. Arago:

The influence of light upon colors was known long ago. It had been observed that substances exposed to its action were affected by it; but beyond this fact nothing was known until 1536, when a peculiar ore of silver was discovered, to which was given the name of argent corné, and which had the property of becoming black when exposed to the light. Photographic science remained at this point until it was discovered that this argent corné (chloruret of silver) did not become black under all the rays of light. It was remarked that the red ray scarcely

19

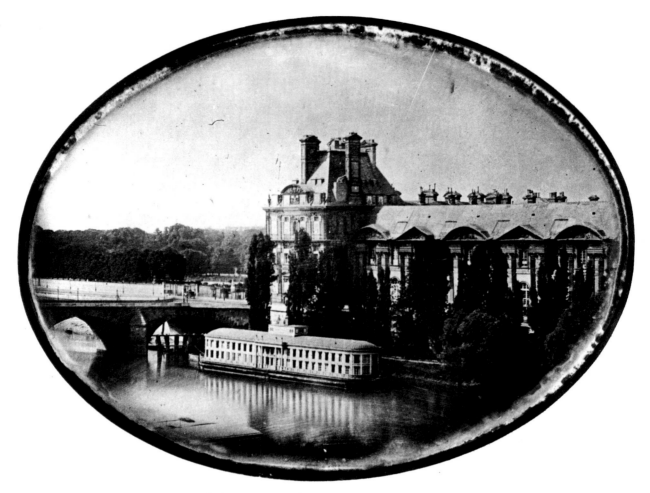

LOUIS JACQUES MANDE DAGUERRE. *The Tuileries and the Seine from the Quai d'Orsay.* 1839. Daguerreotype. Conservatoire National des Arts et Métiers, Paris.

The public found Arago's description of the daguerreotype process quite over their heads, and so the French government ordered Daguerre to give public demonstrations. The first of these took place in a room at the Ministry of the Interior in the Hotel d'Orsay, where Daguerre made this fine picture on September 7, 1839.

effected any change, whilst the violet ray was that which produced the greatest influence—M. J. Baptiste Porta then invented the camera obscura,* and numerous efforts were made to fix the pretty miniature objects which were seen upon the table of it, and the transitory appearance of which was a subject of general regret. All those efforts were fruitless up to the time of the invention of M. Niépce, which preceded that of M. Daguerre, and led to the extraordinary result that the latter gentleman has obtained.

Mr. Niépce, after a host of attempts, employed sheets of silver, which he covered with bitumen *(bitume de Judée)* dissolved in oil of lavender, the whole being cov-

*The first published account of the use of the camera as an aid to the draftsman appeared in Giovanni Battista della Porta's book, *Natural Magic,* of 1558.

ered with varnish. On heating these sheets, the oil disappeared, and there remained a whitish powder adhering to the sheet. Thus prepared, it was placed in the camera obscura; but when withdrawn the objects were hardly visible upon it. M. Niépce then resorted to new means for rendering the objects more distinct. For this purpose, he put his sheets, when removed from the camera obscura, into a mixture of oil of lavender and oil of petroleum. How M. Niépce arrived at this discovery was not explained to us; it is sufficient to state that, after this operation, the objects became as visible as ordinary engravings, and it only remained to wash the sheet with distilled water to make the drawings permanent. But as the bitumen is rather ash-colored than white, M. Niepce had to discover the means of increasing the shadows by more deeply blackening the lines *(hachures).* For this purpose he employed a new mixture of sulphuret of

20

potassium and iodine. But he (M. Niépce) did not succeed as he expected to do, for the iodine spread itself over the whole surface, and renderd the object more confused. The great inconvenience, however, of the process was the little sensitiveness of the coating, *(enduit)* for it sometimes required three days for the light to produce sufficient effect. It will easily be conceived, therefore, that this means was not applicable to the camera obscura, upon which it is essential that the object should be instantaneously fixed, since the relative positions of the sun and the earth being changed, the objects formed by it were destroyed. M. Niépce was therefore without hope of doing more than multiplying engravings, in which the objects, being stationary, are not effective by the different relative positions of the sun. M. Daguerre was devoting himself to the same pursuit as M. Niépce when he associated himself with that gentleman, and brought to the discovery an important improvement. The coating employed by M. Niépce had been laid on by means of a tampon, or dabber, similar to the process used in printing, and consequently the coating was neither of a regular thickness nor perfectly white. M. Daguerre conceived the idea of using the residuum which is obtained from lavender by distilling it; and, to render it liquid and applicable with more regularity, he dissolved it in ether. Thus a more uniform and whiter covering was obtained, but the object, notwithstanding, was not visible at once, it was necessary to place it over a vase containing some kind of essential oil, and then the object stood forth. This was not all that M. Daguerre aimed at. The tints were not deep enough, and this composition was not more sensitive than that of M. Niépce. Three days were still necessary to obtain the designs.

We now come to the great discovery in the process for which M. Daguerre has received a national reward. It is to the following effect: A copper sheet, plated with silver, well cleaned with diluted nitric acid, is exposed to the vapour of iodine, which forms the first coating, which is very thin, as it does not exceed the millionth part of a metre in thickness. There are certain indispensable precautions necessary to render this coating uniform, the chief of which is the using of a rim of metal round the sheet. The sheet thus prepared, is placed in the camera obscura, where it is allowed to remain from eight to ten minutes. It is then taken out, but the most experienced eye can detect no trace of the drawing. The sheet is now exposed to the vapor of mercury, and when it has been heated to a temperature of sixty degrees of Reaumur, or one hundred and sixty-seven Fahrenheit, the drawings come forth as if by enchantment. One singular and hitherto inexplicable fact in this process is, that the sheet, when exposed to the action of the vapor, must be inclined; for if it were placed in a direct position over the vapor, the results would be less satisfactory. The angle used is 48 degrees. The last part of the process is to place the sheet in the hyposulphite of soda, and then to wash it in a large quantity of distilled water. The description of the process appeared to excite great interest in the auditory, amongst whom we observed many distinguished persons connected with science and the fine arts.

Unfortunately the locality was not adjusted suitable for the performance of M. Daguerre's experiments, but we understand that arrangements, will be made for a public exhibition of them. Three highly curious drawings, obtained in this manner, were exhibited—one of the Pont Marie, another of M. Daguerre's atelier, and a third of a room containing some rich carpeting, all the minutest threads of which were represented with the most mathematical accuracy, and with wonderful richness of effect.

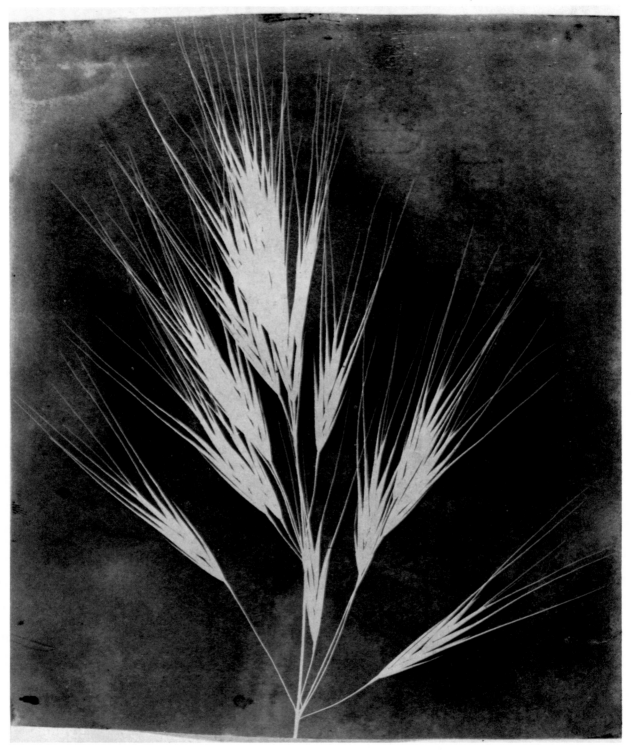

WILLIAM HENRY FOX TALBOT. *Oats.* 1839. Photogenic drawing. Foto Prentenkabinet/Kunsthistorisch Institut, Der Rijks-universiteit, Leiden.

Talbot sent this cameraless photograph to Jean Baptiste Biot, a member of the committee of the French Academy of Sciences investigating Daguerre's process.

Some Account of the Art of Photogenic Drawing, or, The Process by Which Natural Objects May Be Made to Delineate Themselves without the Aid of the Artist's Pencil

WILLIAM HENRY FOX TALBOT
1839

Independently of Niépce and Daguerre, in 1834 William Henry Fox Talbot (1800-1877), English scientist and linguist, conceived of a process that he called "photogenic drawing." Later his friend and colleague Sir John Herschel renamed it "photography." On reading the news account of the interest of the French Academy of Sciences in the similar invention of the heliograph and the daguerreotype, Talbot wrote the following account of his work. It was read for him to the Royal Society of Great Britain on January 31, 1839, and he published it privately in a twelve-page booklet.

§1.

In the spring of 1834 I began to put in practice a method which I had devised some time previously, for employing to purposes of utility the very curious property which has long been known to chemists to be possessed by the nitrate of silver; namely, its discoloration when exposed to the violet rays of light. This property appeared to me to be perhaps capable of useful application in the following manner.

I proposed to spread on a sheet of paper a sufficient quantity of the nitrate of silver, and then to set the paper in the sunshine, having first placed before it some object casting a well-defined shadow. The light, acting on the rest of the paper, would naturally blacken it, while the parts in shadow would retain their whiteness. Thus I expected that a kind of image or picture would be produced, resembling to a certain degree the object from which it was derived. I expected, however, also, that it would be necessary to preserve such images in a portfolio, and to view them only by candlelight; because if by daylight, the same natural process which formed the images would destroy them, by blackening the rest of the paper.

Such was my leading idea before it was enlarged and corrected by experience. It was not until some time after, and when I was in possession of several novel and curious results, that I thought of inquiring whether this process had been ever proposed or attempted before? I found that in fact it had; but apparently not followed up to any extent, or with much perseverance. The few notices that I have been able to meet with are vague and unsatisfactory; merely stating that such a method exists of obtaining the outline of an object, but going into no details respecting the best and most advantageous manner of proceeding.

The only definite account of the matter which I have been able to meet with, is contained in the first volume of the *Journal of the Royal Institution*, page 170, from which it appears that the idea was originally started by Mr. WEDGWOOD, and a numerous series of experiments made both by him and Sir HUMPHRY DAVY, which however ended in failure. I will take the liberty of quoting a few passages from his memoir.

"The copy of a painting, immediately after being taken, must be kept in an obscure place. It may indeed be examined in the shade, but in this case the exposure should be only for a few minutes. No attempts that have been made to prevent the uncoloured parts from being acted upon by light, have as yet been successful. They have been covered with a thin coating of fine varnish; but this has not destroyed their susceptibility of becoming coloured. When the solar rays are passed through a print and thrown upon prepared paper, the unshaded parts are slowly copied; but the lights transmitted by the shaded parts are seldom so definite as to form a distinct resemblance of them by producing different intensities of colour.

"The images formed by means of a *camera obscura* have been found to be too faint to produce, in any moderate time, an effect upon the nitrate of silver. To copy these images was the first object of Mr. WEDGWOOD, but all his numerous experiments proved unsuccessful."

These are the observations of Sir HUMPHRY DAVY. I have been informed by a scientific friend that this unfavourable result of Mr. WEDGWOOD's and Sir HUM-

Reprinted from W. Henry Fox Talbot, *Some Account of the Art of Photogenic Drawing* (London: R. and J. E. Taylor, 1839).

phry Davy's experiments, was the chief cause which discouraged him from following up with perseverance the idea which he had also entertained of fixing the beautiful images of the *camera obscura*. And no doubt, when so distinguished an experimenter as Sir Humphry Davy announced "that all experiments had proved unsuccessful," such a statement was calculated materially to discourage further inquiry. The circumstance also, announced by Davy, that the paper on which these images were depicted was liable to become entirely dark, and that nothing hitherto tried would prevent it, would perhaps have induced me to consider the attempt as hopeless, if I had not (fortunately) before I read it, already discovered a method of overcoming this difficulty, and of *fixing* the image in such a manner that it is no more liable to injury or destruction.

In the course of my experiments directed to that end, I have been astonished at the variety of effects which I have found produced by a very limited number of different processes when combined in various ways; and also at the length of time which sometimes elapses before the full effect of these manifests itself with certainty. For I have found that images formed in this manner, which have appeared in good preservation at the end of twelve months from the time of their formation, have nevertheless somewhat altered during the second year. This circumstance, added to the fact that the first attempts which I made became indistinct in process of time (the paper growing wholly dark), induced me to watch the progress of the change during some considerable time, as I thought that perhaps *all* these images would *ultimately* be found to fade away. I found, however, to my satisfaction, that this was not the case; and having now kept a number of these drawings during nearly five years without their suffering any deterioration, I think myself authorized to draw conclusions from my experiments with more certainty.

§2. EFFECT AND APPEARANCE OF THESE IMAGES

THE IMAGES obtained in this manner are themselves white, but the ground upon which they display themselves is variously and pleasingly coloured.

Such is the variety of which the process is capable, that by merely varying the proportions and some trifling details of manipulation, any of the following colours are readily attainable:

Sky-blue,
Yellow,
Rose-colour,
Brown, of various shades,
Black.

Green alone is absent from the list, with the exception of a dark shade of it, approaching to black. The blue-coloured variety has a very pleasing effect, somewhat like that produced by the Wedgwood-ware, which has white figures on a blue ground. This variety also retains its colours perfectly if preserved in a portfolio, and not being subject to any spontaneous change, requires no preserving process.

These different shades of colour are of course so many different chemical compounds, or mixtures of such, which chemists have not hitherto distinctly noticed.

§3. FIRST APPLICATIONS OF THIS PROCESS

THE FIRST kind of objects which I attempted to copy by this process were flowers and leaves, either fresh or selected from my herbarium. These it renders with the utmost truth and fidelity, exhibiting even the venation of the leaves, the minute hairs that clothe the plant, &c. &c.

It is so natural to associate the idea of *labour* with great complexity and elaborate detail of execution, that one is more struck at seeing the thousand florets of an *Agrostis* depicted with all its capillary branchlets (and so accurately, that none of all this multitude shall want its little bivalve calyx, requiring to be examined through a lens), than one is by the picture of the large and simple leaf of an oak or a chestnut. But in truth the difficulty is in both cases the same. The one of these takes no more time to execute than the other; for the object which would take the most skilful artist days or weeks of labour to trace or to copy, is effected by the boundless powers of natural chemistry in the space of a few seconds.

To give an idea of the degree of accuracy with which some objects can be imitated by this process, I need only mention one instance. Upon one occasion, having made an image of a piece of lace of an elaborate pattern, I showed it to some persons at the distance of a few feet, with the inquiry, whether it was a good representation? when the reply was, "That they were not to be so easily deceived, for that it was evidently no picture, but the piece of lace itself."

At the very commencement of my experiments upon this subject, when I saw how beautiful were the images which were thus produced by the action of light, I regretted the more that they were destined to have such a brief existence, and I resolved to attempt to find out, if possible, some method of preventing this, or retarding it as much as possible. The following considerations led me to conceive the possibility of discovering a preservative process.

The nitrate of silver, which has become black by the

action of light, is no longer the same chemical substance that it was before. Consequently, if a picture produced by solar light is subjected afterwards to any chemical process, the white and dark parts of it will be differently acted upon; and there is no evidence that after this action has taken place, these white and dark parts will any longer be subject to a spontaneous change; or, if they are so, still it does not follow that that change will *now* tend to assimilate them to each other. In case of their remaining *dissimilar,* the picture will remain visible, and therefore our object will be accomplished.

If it should be asserted that exposure to sunshine would *necessarily* reduce the whole to one uniform tint, and destroy the picture, the *onus probandi* evidently lies on those who make the assertion. If we designate by the letter A the exposure to the solar light, and by B some indeterminate chemical process, my argument was this: Since it cannot be shown, *à priori,* that the final result of the series of processes A B A will be the same with that denoted by B A, it will therefore be worth while to put the matter to the test of experiment, viz. by varying the process B until the right one be discovered, or until so many trials have been made as to preclude all reasonable hope of its existence.

My first trials were unsuccessful, as indeed I expected; but after some time I discovered a method which answers perfectly, and shortly afterwards another. On one of these more especially I have made numerous experiments; the other I have comparatively little used, because it appears to require more nicety in the management. It is, however, equal, if not superior, to the first in brilliancy of effect.

This chemical change, which I call the *preserving process,* is far more effectual than could have been anticipated. The paper, which had previously been so sensitive to light, becomes completely insensible to it, insomuch that I am able to show the Society specimens which have been exposed for an hour to the full summer sun, and from which exposure the image has suffered nothing, but retains its perfect whiteness.

§4. ON THE ART OF FIXING A SHADOW

THE PHENOMENON which I have now briefly mentioned appears to me to partake of the character of the *marvellous,* almost as much as any fact which physical investigation has yet brought to our knowledge. The most transitory of things, a shadow, the proverbial emblem of all that is fleeting and momentary, may be fettered by the spells of our *"natural magic,"* and may be fixed for ever in the position which it seemed only destined for a single instant to occupy.

This remarkable phenomenon, of whatever value it may turn out in its application to the arts, will at least be accepted as a new proof of the value of the inductive methods of modern science, which by noticing the occurrence of unusual circumstances (which accident perhaps first manifests in some small degree), and by following them up with experiments, and varying the conditions of these until the true law of nature which they express is apprehended, conducts us at length to consequences altogether unexpected, remote from usual experience, and contrary to almost universal belief. Such is the fact, that we may receive on paper the fleeting shadow, arrest it there and in the space of a single minute fix it there so firmly as to be no more capable of change, even if thrown back into the sunbeam from which it derived its origin.

§5.

BEFORE going further, I may however add, that it is not always necessary to use a preserving process. This I did not discover until after I had acquired considerable practice in this art, having supposed at first that all these pictures would ultimately become indistinct if not preserved in some way from the change. But experience has shown to me that there are at least two or three different ways in which the process may be conducted, so that the images shall possess a character of durability, provided they are kept from the action of direct sunshine. These ways have presented themselves to notice rather accidentally than otherwise; in some instances without any particular memoranda having been made at the time, so that I am not yet prepared to state accurately on what particular thing this sort of semi-durability depends, or what course is best to be followed in order to obtain it. But as I have found that certain of the images which have been subjected to no preserving process remain quite white and perfect after the lapse of a year or two, and indeed show no symptom whatever of changing, while others differently prepared (and left unpreserved) have grown quite dark in one tenth of that time, I think this singularity requires to be pointed out. Whether it will be of much value I do not know; perhaps it will be thought better to incur at first the small additional trouble of employing the preserving process, especially as the drawings thus prepared will stand the sunshine; while the unpreserved ones, however well they last in a portfolio or in common daylight, should not be risked in a very strong light, as they would be liable to change thereby, even years after their original formation. This very quality, however, admits of useful application. For this semi-durable paper, which retains its whiteness for years in the shade, and yet suffers a change whenever exposed to the solar

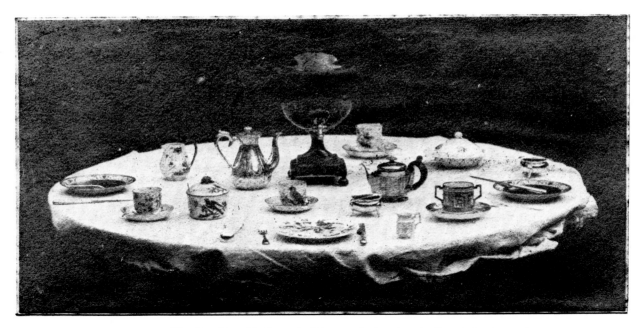

WILLIAM HENRY FOX TALBOT. *The Breakfast Table.* 1840. Photogenic drawing. Talbot Collection, Science Museum, London, Fox Talbot Collection.

An exhibition of Talbot's photographs was held at the Graphic Society in London in 1840. The editor of *The Literary Gazette* commented in the May 16, 1840 issue: "The crystal bottles on the breakfast table are also well worthy of attention: their transparency is marked with singular truth; but, indeed, there is nothing in these pictures which is not at once accurate and picturesque."

light, is evidently well suited to the use of a naturalist travelling in a distant country, who may wish to keep some memorial of the plants he finds, without having the trouble of drying them and carrying them about with him. He would only have to take a sheet of this paper, throw the image upon it, and replace it in his portfolio. The defect of this particular paper is, that in general the *ground* is not even; but this is of no consequence where utility alone, and not beauty of effect is consulted.

§6. *PORTRAITS*

ANOTHER purpose for which I think my method will be found very convenient, is the making of outline portraits, or *silhouettes*. These are now often traced by the hand from shadows projected by a candle. But the hand is liable to err from the true outline, and a very small deviation causes a notable diminution in the resemblance. I believe this manual process cannot be compared with the truth and fidelity with which the portrait is given by means of solar light.

§7. *PAINTINGS ON GLASS*

THE SHADOW-PICTURES which are formed by exposing paintings on glass to solar light are very pleasing. The glass itself, around the painting, should be blackened; such, for instance, as are often employed for the magic lantern. The paintings on the glass should have no

bright yellows or reds, for these stop the violet rays of light, which are the only effective ones. The pictures thus formed resemble the productions of the artist's pencil more, perhaps, than any of the others. Persons to whom I have shown them have generally mistaken them for such, at the same time observing, that the *style* was new to them, and must be one rather difficult to acquire. It is in these pictures only that, as yet, I have observed indications of *colour.* I have not had time to pursue this branch of the inquiry further. It would be a great thing if by any means we could accomplish the delineation of objects in their natural colours. I am not very sanguine respecting the possibility of this; yet, as I have just now remarked, it appears possible to obtain at least *some indication* of variety of tint.

§8. *APPLICATION TO THE MICROSCOPE*

I NOW COME to a branch of the subject which appears to me very important and likely to prove extensively useful, the application of my method of delineating objects to the solar microscope.

The objects which the microscope unfolds to our view, curious and wonderful as they are, are often singularly complicated. The eye, indeed, may comprehend the whole which is presented to it in the field of view; but the powers of the pencil fail to express these minutiae of nature in their innumerable details. What

artist could have skill or patience enough to copy them? or granting that he could do so, must it not be at the expense of much valuable time, which might be more usefully employed?

Contemplating the beautiful picture which the solar microscope produces, the thought struck me, whether it might not be possible to cause that image to impress itself upon the paper, and thus to let Nature substitute her own inimitable pencil, for the imperfect, tedious, and almost hopeless attempt of copying a subject so intricate.

My first attempt had no success. Although I chose a bright day, and formed a good image of my object upon prepared paper, on returning at the expiration of an hour I found that no effect had taken place. I was therefore half inclined to abandon this experiment, when it occurred to me, that there was no reason to suppose that either the nitrate or muriate of silver, as commonly obtained, was the most sensitive substance that exists to the action of the chemical rays;* and though such should eventually prove to be the fact, at any rate it was not to be assumed without proof. I therefore began a course of experiments in order to ascertain the influence of various modes of preparation, and I found these to be signally different in their results. I considered this matter chiefly in a practical point of view; for as to the theory, I confess that I cannot as yet understand the reason why the paper prepared in one way should be so much more sensitive than in another.

The result of these experiments was the discovery of a mode of preparation greatly superior in sensibility to what I had originally employed: and by means of this, all those effects which I had before only anticipated as theoretically possible were found to be capable of realization.

When a sheet of this, which I shall call "Sensitive Paper," is placed in a dark chamber, and the magnified image of some object thrown on it by the solar microscope, after the lapse of perhaps a quarter of an hour, the picture is found to be completed. I have not as yet used high magnifying powers, on account of the consequent enfeeblement of the light. Of course, with a more sensitive paper, greater magnifying power will become desirable.

On examining one of these pictures, which I made about three years and a half ago, I find, by actual measurement of the picture and the object, that the latter is magnified seventeen times in linear diameter, and in

*Sir H. DAVY somewhere says that the iodide is more sensitive, which I have hardly found to be the case in my experiments. [Note by Talbot]

surface consequently 289 ·times. I have others which I believe are considerably more magnified; but I have lost the corresponding objects, so that I cannot here state the exact numbers.

Not only does this process save our time and trouble, but there are many objects, especially microscopic crystallizations, which alter so greatly in the course of three or four days (and it could hardly take any artist less to delineate them in all their details), that they could never be drawn in the usual way.

I will now describe the *degree of sensitiveness* which this paper possesses, premising that I am far from supposing that I have reached the limit of which this quality is capable. On the contrary, considering the few experiments which I have made, (few, that is, in comparison with the number which it would be easy to imagine and propose) I think it most likely, that other methods may be found, by which substances may be prepared, perhaps as much transcending in sensitiveness the one which I have employed, as that does the nitrate of silver which I used in my first experiments.

But to confine myself to what I have actually accomplished, in the preparation of a very sensitive paper. When a sheet of this paper is brought towards a window, not one through which the sun shines, but looking in the opposite direction, it immediately begins to discolour. For this reason, if the paper is prepared by daylight, it must by no means be left uncovered, but as soon as finished be shut up in a drawer or cupboard and there left to dry, or else dried at night by the warmth of a fire. Before using this paper for the delineation of any object, I generally approach it for a little time towards the light, thus intentionally giving it a slight shade of colour, for the purpose of seeing that the *ground* is *even*. If it appears so when thus tried to a small extent, it will generally be found to prove so in the final result. But if there are some places or spots in it which do not require the same tint as the rest, such a sheet should be rejected; for there is a risk that, when employed, instead of presenting a *ground* uniformly dark, which is essential to the beauty of the drawing, it will have large white spots, places altogether insensible to the effect of light. This singular circumstance I shall revert to elsewhere: it is sufficient to mention it here.

The paper then, which is thus readily sensitive to the light of a common window, is of course much more so to the direct sunshine. Indeed, such is the velocity of the effect then produced, that the picture may be said to be ended almost as soon as it is begun.

To give some more definite idea of the rapidity of the process, I will state, that after various trials the nearest evaluation which I could make of the time

necessary for obtaining the picture of an object, so as to have pretty distinct outlines, when I employed the full sunshine, was *half a second*.

§9. *ARCHITECTURE, LANDSCAPE, AND EXTERNAL NATURE*

BUT PERHAPS the most curious application of this art is the one I am now about to relate. At least it is that which has appeared the most surprising to those who have examined my collection of pictures formed by solar light.

Every one is acquainted with the beautiful effects which are produced by a *camera obscura* and has admired the vivid picture of external nature which it displays. It had often occurrred to me, that if it were possible to retain upon the paper the lovely scene which thus illuminates it for a moment, or if we could but fix the outline of it, the lights and shadows, divested of all *colour,* such a result could not fail to be most interesting. And however much I might be disposed at first to treat this notion as a scientific dream, yet when I had succeeded in fixing the images of the solar microscope by means of a peculiarly sensitive paper, there appeared no longer any doubt that an analogous process would succeed in copying the objects of external nature, although indeed they are much less illuminated.

Not having with me in the country a *camera obscura* of any considerable size, I constructed one out of a large box, the image being thrown upon one end of it by a good object glass fixed in the opposite end. This apparatus being armed with a sensitive paper, was taken out in a summer afternoon and placed about one hundred yards from a building favourably illuminated by the sun. An hour or two afterwards I opened the box, and I found depicted upon the paper a very distinct representation of the building, with the exception of those parts of it which lay in the shade. A little experience in this branch of the art showed me that with smaller *camerae obscurae* the effect would be produced in a smaller time. Accordingly I had several small boxes made, in which I fixed lenses of shorter focus, and with these I obtained very perfect but extremely small pictures; such as without great stretch of imagination might be supposed to be the work of some Lilliputian artist. They require indeed examination with a lens to discover all their minutiae.

In the summer of 1835 I made in this way a great number of representations of my house in the country, which is well suited to the purpose, from its ancient and remarkable architecture. And this building I believe to be the first that was ever yet known *to have drawn its own picture*.

The method of proceeding was this: having first adjusted the paper to the proper focus in each of these little *camerae,* I then took a number of them with me out of doors and placed them in different situations around the building. After the lapse of half an hour I gathered them all up, and brought them within doors to open them. When opened, there was found in each a miniature picture of the objects before which it had been placed.

To the traveller in distant lands, who is ignorant, as too many unfortunately are, of the art of drawing, this little invention may prove of real service; and even to the artist himself, however skillful he may be. For although this natural process does not produce an effect much resembling the productions of his pencil, and therefore cannot be considered as capable of replacing them, yet it is to be recollected that he may often be so situated as to be able to devote only a single hour to the delineation of some very interesting locality. Now, since nothing prevents him from simultaneously disposing, in different positions, any number of these little *camerae,* it is evident that their collective results, when examined afterwards, may furnish him with a large body of interesting memorials, and with numerous details which he had not had himself time either to note down or to delineate.

§10. *DELINEATIONS OF SCULPTURE*

ANOTHER use which I propose to make of my invention is for the copying of statues and bas-reliefs. I place these in strong sunshine, and put before them at a proper distance, and in the requisite position, a small *camera obscura* containing the prepared paper. In this way I have obtained images of various statues, &c. I have not pursued this branch of the subject to any extent; but I expect interesting results from it, and that it may be usefully employed under many circumstances.

§11. *COPYING OF ENGRAVINGS*

THE INVENTION may be employed with great facility for obtaining copies of drawings or engravings, or facsimilies of MSS. For this purpose the engraving is pressed upon the prepared paper, with its engraved side in contact with the latter. The pressure must be as uniform as possible, that the contact may be perfect; for the least interval sensibly injures the result, by producing a kind of cloudiness in lieu of the sharp strokes of the original.

When placed in the sun, the solar light gradually traverses the paper, except in those places where it is prevented from doing so by the opake lines of the engraving. It therefore of course makes an exact image or print of the design. This is one of the experiments

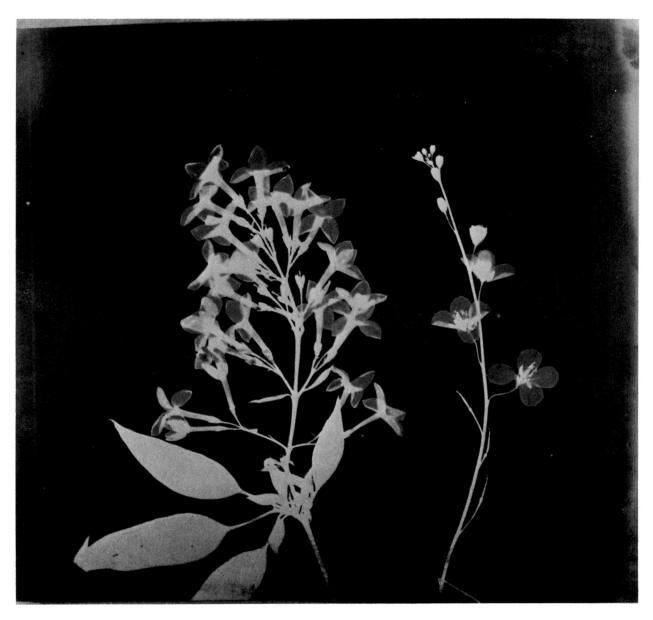

WILLIAM HENRY FOX TALBOT. Botanical specimen. 1839. Photogenic drawing. The Metropolitan Museum of Art, New York.

One of a number of photographs sent by Talbot to the Italian botanist Antonio Bertolini in June 1839.

which DAVY and WEDGWOOD state that they tried, but failed, from want of sufficient sensibility in their paper.

The length of time requisite for effecting the copy depends on the thickness of the paper on which the engraving has been printed. At first I thought that it would not be possible to succeed with thick papers; but I found on trial that the success of the method was by no means so limited. It is enough for the purpose, if the paper allows any of the solar light to pass. When the paper is thick, I allow half an hour for the formation of a good copy. In this way I have copied very minute, complicated, and delicate engravings, crowded with figures of small size, which were rendered with great distinctness.

The effect of the copy, though of course unlike the original (substituting as it does lights for shadows, and *vice versâ*,) yet is often very pleasing, and would, I think, suggest to artists useful ideas respecting light and shade.

It may be supposed that the engraving would be soiled or injured by being thus pressed against the prepared paper. There is not much danger of this, provided both are perfectly dry. It may be well to mention, however, that in case any stain should be perceived on the engraving, it may be readily removed by a chemical application which does no injury whatever to the paper.

In copying engravings, &c. by this method, the lights and shadows are reversed, consequently the effect is wholly altered. But if the picture so obtained is first *preserved* so as to bear sunshine, it may be afterwards itself employed as an object to be copied; and by means of this second process the lights and shadows are brought back to their original disposition. In this way we have indeed to contend with the imperfections arising from two processes instead of one; but I believe this will be found merely a difficulty of manipulation. I propose to employ this for the purpose more particularly of multiplying at small expense copies of such rare or unique engravings as it would not be worth while to re-engrave, from the limited demand for them.

I will now add a few remarks concerning the very singular circumstance, which I have before briefly mentioned, viz. that the paper sometimes, although intended to be prepared of the most sensitive quality, turns out on trial to be wholly insensible to light, and incapable of change. The most singular part of this is the very small difference in the mode of preparation which causes so wide a discrepancy in the result. For instance, a sheet of paper is all prepared at the same time, and with the intention of giving it as much uniformity as possible: and yet, when exposed to sunshine, this paper will exhibit large white spots of very definite outline, where

the preparing process has failed; the rest of the paper, where it has succeeded, turning black as rapidly as possible. Sometimes the spots are of a pale tint of coerulean blue, and are surrounded by exceedingly definite outlines of perfect whiteness, contrasting very much with the blackness of the part immediately succeeding. With regard to the theory of this, I am only prepared to state as my opinion at present, that it is a case of what is called "unstable equilibrium." The process followed is such as to produce one of two definite chemical compounds; and when we happen to come near the limit which separates the two cases, it depends upon exceedingly small and often imperceptible circumstances, which of the two compounds shall be formed. That they are both definite compounds, is of course at present merely my conjecture; that they are signally different, is evident from their dissimilar properties.

I have thus endeavored to give a brief outline of some of the peculiarities attending this new process, which I offer to the lovers of science and nature. That it is susceptible of great improvements, I have no manner of doubt; but even in its present state I believe it will be found capable of many useful and important applications besides those of which I have given a short account in the preceding pages.

PHOTOGENIC DRAWING
(*Further discoveries*)

In compliance with the request of several scientific friends, who have been much interested with the account of the art of Photogenic Drawing, which I had the honour of presenting to the Royal Society on the 31st of last month, I will endeavour to explain, as briefly as I can, but at the same time without omitting anything essential, the methods which I have hitherto employed for the production of these pictures.

If this explanation, on my part, should have the effect of drawing new inquirers into the field, and if any new discoveries of importance should be the result, as I anticipate, and especially if any means should be discovered by which the sensitiveness of the paper can be materially increased, I shall be the first to rejoice at the success; and, in the meanwhile, I shall endeavour, as far as I may be able, to prosecute the inquiry myself.

The subject naturally divides itself into two heads; viz. the preparation of the paper, and the means of *fixing* the design.

(1.) *Preparation of the paper.*—In order to make

Reprinted from *The Literary Gazette* (London), Feb. 23, 1839, pp. 123-24.

what may be called ordinary photogenic paper, I select, in the first place, paper of a good firm quality and smooth surface. I do not know that any answers better than superfine writing paper. I dip it into a weak solution of common salt, and wipe it dry, by which the salt is uniformly distributed throughout its substance. I then spread a solution of nitrate of silver on one surface only, and dry it at the fire. The solution should not be saturated, but six or eight times diluted with water. When dry, the paper is fit to use.

I have found, by experiment, that there is a certain proportion between the quantity of salt and that of the solution of silver, which answers best and gives maximum effect. If the strength of the salt is augmented beyond this point, the effect diminishes, and, in certain cases, becomes exceedingly small.

This paper, if properly made, is very useful for all ordinary photogenic purposes. For example, nothing can be more perfect than the images it gives of leaves and flowers, especially with a summer sun: the light passing through the leaves delineates every ramification of their nerves.

Now, suppose we take a sheet of paper thus prepared, and wash it with a *saturated* solution of salt, and then dry it. We shall find (especially if the paper has been kept some weeks before the trial is made) that its sensibility is greatly diminished, and, in some cases, seems quite extinct. But if it is again washed with a liberal quantity of the solution of silver, it becomes again sensible to light, and even more so than it was at first. In this way, by alternately washing the paper with salt and silver, and drying it between times, I have succeeded in increasing its sensibility to the degree that is requisite for receiving the images of the *camera obscura.*

In conducting this operation it will be found that the results are sometimes more and sometimes less satisfactory in consequence of small and accidental variations in the proportions employed. It happens sometimes that the chloride of silver is disposed to darken of itself, without any exposure to light: this shews that the attempt to give it sensibility has been carried too far. The object is, to *approach* to this condition as near as possible without *reaching* it; so that the substance may be in a state ready to yield to the slightest extraneous force, such as the feeble impact of the violet rays when much attenuated. Having therefore prepared a number of sheets of

paper with chemical proportions slightly different from one another, let a piece be cut from each, and, having been duly marked or numbered, let them be placed side by side in a very weak diffused light for about a quarter of an hour. Then, if any one of them, as frequently happens, exhibits a marked advantage over its competitors, I select the paper which bears the corresponding number to be placed in the *camera obscura.*

(2.) *Method of fixing the images.*—After having tried ammonia, and several other reagents, with very imperfect success, the first thing which gave me a successful result was the *iodide of potassium,* much diluted with water. If a photogenic picture is washed over with this liquid, an *iodide of silver* is formed which is absolutely unalterable by sunshine. This process requires precaution; for if the solution is too strong, it attacks the dark parts of the picture. It is requisite, therefore, to find by trial the proper proportions. The fixation of the pictures in this way, with proper management, is very beautiful and lasting. The specimen of *lace* which I exhibited to the Society, and which was made five years ago, was preserved in this manner.

But my usual method of fixing is different from this, and somewhat simpler, or at least requiring less nicety. It consists in immersing the picture in a *strong* solution of common salt, and then wiping off the superfluous moisture, and drying it. It is sufficiently singular that the same substance which is so useful in *giving* sensibility to the paper, should also be capable, under other circumstances, of *destroying* it; but such is, nevertheless, the fact.

Now, if the picture which has been thus washed and dried is placed in the sun, the white parts colour themselves of a pale lilac tint, after which they become insensible. Numerous experiments have shewn to me that the depth of this lilac tint varies according to the quantity of salt used, relative to the quantity of silver. But, by properly adjusting these, the images may, if desired, be retained of an absolute whiteness. I find I have omitted to mention that those preserved by *iodine* are always of a very pale primrose yellow; which has the extraordinary and very remarkable property of turning to a full gandy yellow whenever it is exposed to the heat of a fire, and recovering its former colour again when it is cold.—I am, &c.

H. Fox Talbot

WILLIAM HENRY FOX TALBOT. *The Library*, ca. 1845. Calotype. Talbot Collection, The Science Museum, London.

The Process of Calotype Photogenic Drawing

WILLIAM HENRY FOX TALBOT
1841

In 1840 Talbot greatly improved his photogenic process. He found that it was not necessary to expose his sensitized paper to light until a visible image appeared. A much shorter exposure—about one second instead of one minute, he estimated—would so alter the silver salts that they could be reduced to metallic silver by chemical treatment. This discovery of the development of the latent image *was basic and epochal: all photographic processes in use today are dependent upon it. Talbot named his new process "calotype" (Greek: beautiful picture). It rivaled the daguerreotype in popularity, and while it lacked the capability of producing images as detailed as that process, it had the advantage that from one negative an unlimited number of copies could be made. It became obsolete, along with the daguerreotype, with the invention of the collodion process by Frederick Scott Archer in 1851. We publish Talbot's own reprint of the paper he presented to the Royal Society of Great Britain on June 10, 1841.*

I had originally intended, in giving an account of my recent experiments in Photography, to have entered into numerous details with respect to the phenomena observed; but finding that to follow out this plan would occupy a considerable time, I have thought that it would be best to put the Society, in the first place, in possession of the principal facts, and by so doing perhaps invite new observers into the field during the present favourable season for making experiments. I have, therefore, confined myself at present to a description of the improved photographic method, to which I have given the name of *Calotype,* and I shall reserve for another occasion all remarks on the theory of the process.

The following is the method of obtaining the Calotype pictures.

Preparation of the Paper.—Take a sheet of the best writing-paper, having a smooth surface, and a close and even texture.

From William Henry Fox Talbot, *The Process of Calotype Photogenic Drawing, Communicated to the Royal Society, June 10, 1841* (London: J. L. Cox & Sons, 1841).

The watermark, if any, should be cut off, lest it should injure the appearance of the picture. Dissolve 100 grains of crystallized nitrate of silver in six ounces of distilled water. Wash the paper with this solution with a soft brush, on one side, and put a mark on that side whereby to know it again. Dry the paper cautiously at a distant fire, or else let it dry spontaneously in a dark room. When dry, or nearly so, dip it into a solution of iodide of potassium containing 500 grains of that salt dissolved in one pint of water, and let it stay two or three minutes in this solution. Then dip it into a vessel of water, dry it lightly with blotting-paper, and finish drying it at a fire, which will not injure it even if held pretty near: or else it may be left to dry spontaneously.

All this is best done in the evening by candlelight. The paper so far prepared I call *iodized paper,* because it has a uniform pale yellow coating of iodide of silver. It is scarcely sensitive to light, but, nevertheless, it ought to be kept in a portfolio or a drawer, until wanted for use. It may be kept for any length of time without spoiling or undergoing any change, if protected from the light. This is the first part of the preparation of Calotype paper, and may be performed at any time. The remaining part is best deferred until shortly before the paper is wanted for use.

When that time is arrived, take a sheet of the *iodized paper* and wash it with a liquid prepared in the following manner:—

Dissolve 100 grains of crystallized nitrate of silver in two ounces of distilled water; add to this solution one-sixth of its volume of strong acetic acid. Let this mixture be called A.

Make a saturated solution of crystallized gallic acid in cold distilled water. The quantity dissolved is very small. Call this solution B.

When a sheet of paper is wanted for use, mix together the liquids A and B in equal volumes, but only mix a small quantity of them at a time, because the mixture does not keep long without spoiling. I shall call this mixture the *gallo-nitrate of silver.*

Then take a sheet of *iodized paper* and wash it over

with this *gallo-nitrate of silver*, with a soft brush, taking care to wash it on the side which has been previously marked. This operation should be performed by candle-light. Let the paper rest half a minute, and then dip it into water. Then dry it lightly with blotting-paper, and finally dry it cautiously at a fire, holding it at a considerable distance therefrom. When dry, the paper is fit for use. I have named the paper thus prepared *Calotype paper*, on account of its great utility in obtaining the pictures of objects with the camera obscura. If this paper be kept in a press it will often retain its qualities in perfection for three months or more, being ready for use at any moment; but this is not uniformly the case, and I therefore recommend that it should be used in a few hours after it has been prepared. If it is used immediately, the last drying may be dispensed with, and the paper may be used moist. Instead of employing a solution of crystallized gallic acid for the liquid B, the *tincture of galls* diluted with water may be used, but I do not think the results are altogether so satisfactory.

Use of the Paper.—The *Calotype paper* is sensitive to light in an extraordinary degree, which transcends a hundred times or more that of any kind of photographic paper hitherto described. This may be made manifest by the following experiment:—Take a piece of this paper, and having covered half of it, expose the other half to daylight for the space of *one second* in dark cloudy weather in winter. This brief moment suffices to produce a strong impression upon the paper. But the impression is latent and invisible, and its existence would not be suspected by any one who was not forewarned of it by previous experiments.

The method of causing the impression to become visible is extremely simple. It consists in washing the paper once more with the *gallo-nitrate of silver*, prepared in the way before described, and then warming it gently before the fire. In a few seconds the part of the paper upon which the light has acted begins to darken, and finally grows entirely black, while the other part of the paper retains its whiteness. Even a weaker impression than this may be *brought out* by repeating the wash of gallo-nitrate of silver, and again warming the paper. On the other hand, a stronger impression does not require the warming of the paper, for a wash of the gallo-nitrate suffices to make it visible, without heat, in the course of a minute or two.

A very remarkable proof of the sensitiveness of the Calotype paper is afforded by the fact, that it will take an impression from simple moonlight, not concentrated by a lens. If a leaf is laid upon a sheet of the paper, an image of it may be obtained in this way in from a quarter to half an hour.

This paper being possessed of so high a degree of sensitiveness, is therefore well suited to receive images in the camera obscura. If the aperture of the object-lens is one inch, and the focal length fifteen inches, I find that *one minute** is amply sufficient in summer to impress a strong image upon the paper of any building upon which the sun is shining. When the aperture amounts to one-third of the focal length, and the object is very white, as a plaster bust, &c., it appears to me that *one second* is sufficient to obtain a pretty good image of it.

The images thus received upon the Calotype paper are for the most part invisible impressions. They may be made visible by the process already related, namely, by washing them with the gallo-nitrate of silver, and then warming the paper. When the paper is quite blank, as is generally the case, it is a highly curious and beautiful phenomenon to see the spontaneous commencement of the picture, first tracing out the stronger outlines, and then gradually filling up all the numerous and complicated details. The artist should watch the picture as it develops itself, and when in his judgment it has attained the greatest degree of strength and clearness, he should stop further progress by washing it with the fixing liquid.

The fixing process.—To fix the picture, it should be first washed with water, then lightly dried with blotting-paper, and then washed with a solution of *bromide of potassium*, containing 100 grains of that salt dissolved in eight or ten ounces of water. After a minute or two it should be again dipped in water and then finally dried. The picture is in this manner very strongly fixed, and with this great advantage, that it remains transparent, and that, therefore, there is no difficulty in obtaining a copy from it. The Calotype picture is a *negative* one, in which the lights of nature are represented by shades; but the copies are *positive*, having the lights conformable to nature. They also represent the objects in their natural position with respect to right and left. The copies may be made upon Calotype paper in a very short time, the invisible impressions being *brought out* in the way already described. But I prefer to make copies upon photographic paper prepared in the way which I originally described in a memoir read to the Royal Society in February, 1839, and which is made by washing the best writing-paper, *first* with a weak solution of common salt, and *next* with a solution of nitrate of silver. Although it takes a much longer time to obtain a copy upon this paper, yet, when obtained, the tints appear

WILLIAM HENRY FOX TALBOT. *Lady at the Harp.*
ca. 1843. Calotype. Talbot Collection, The Science Museum, London.

The harpist is Miss Horatia Feilding, Talbot's half-sister.

more harmonious and pleasing to the eye; it requires in general from three minutes to thirty minutes of sunshine, according to circumstances, to obtain a good copy on this sort of photographic paper. The copy should be washed and dried, and the fixing process (which may be deferred to a subsequent day) is the same as that already mentioned. The copies are made by placing the picture upon the photographic paper, with a board below and a sheet of glass above, and pressing the papers into close contact by means of screws or otherwise.

After a Calotype picture has furnished several copies, it sometimes grows faint, and no more good copies then can be made from it. But these pictures possess the beautiful and extraordinary property of being susceptible of revival. In order to revive them and restore their original appearance, it is only necessary to wash them again by candlelight with gallo-nitrate of silver, and warm them; this causes all the shades of the picture to darken greatly, while the white parts remain unaffected. The shaded parts of the paper thus acquire an opacity which gives a renewed spirit and life to the copies, of which a second series may now be taken, extending often to a very considerable number. In reviving the picture it sometimes happens that various details make their appearance which had not before been seen, having been latent all the time, yet nevertheless not destroyed by their long exposure to sunshine.

I will terminate these observations by stating a few experiments calculated to render the mode of action of the sensitive paper more familiar.

1. Wash a piece of the *iodized paper* with the gallo-nitrate; expose it to daylight for a second or two, and then withdraw it. The paper will soon begin to darken spontaneously, and will grow quite black.

2. The same as before, but let the paper be warmed. The blackening will be more rapid in consequence of the warmth.

3. Put a large drop of the gallo-nitrate on one part of the paper and moisten another part of it more sparingly, then leave it exposed to a very faint daylight; it will be found that the lesser quantity produces the greater effect in darkening the paper; and, in general, it will be seen that the most rapid darkening takes place at the moment when the paper becomes nearly dry; also, if only a portion of the paper is moistened, it will be observed that the edges or boundaries of the moistened part are more acted on by light than any other part of the surface.

4. If the paper, after being moistened with the gallo-nitrate, is washed with water and dried, a slight exposure to daylight no longer suffices to produce so much discoloration; indeed it often produces none at all. But by subsequently washing it again with the gallo-nitrate and warming it, the same degree of discoloration is developed as in the other case (experiments 1 and 2). The dry paper appears, therefore, to be equal, or superior, in sensitiveness to the moist; only with this difference, that it receives a *virtual* instead of an *actual* impression from the light, which it requires a subsequent process to develope.

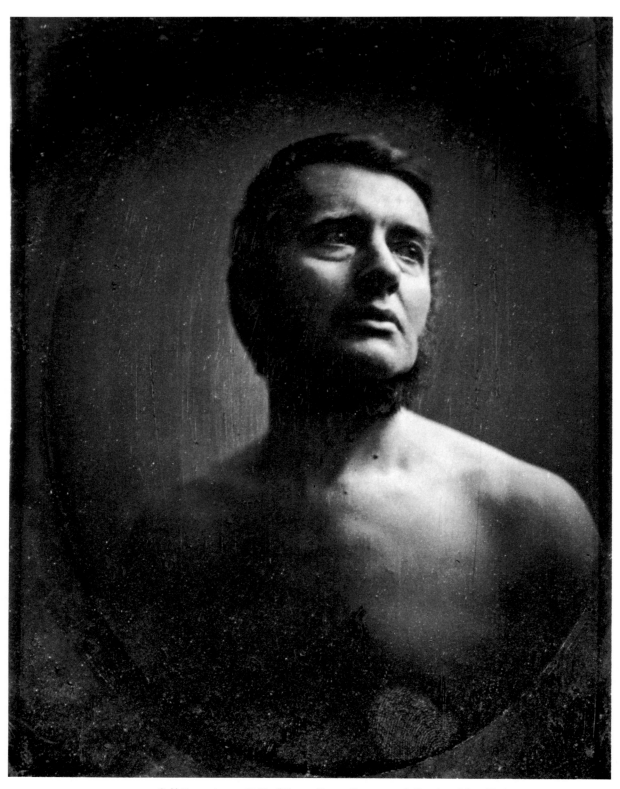

ALBERT SANDS SOUTHWORTH. *Self-Portrait.* ca. 1848. Gilman Paper Company Collection, New York.

The Early History of
Photography in the United States

ALBERT SANDS SOUTHWORTH
1871

Albert Sands Southworth (1811-1894) and his partner Josiah Johnson Hawes (1808-1901) were leading daguerreotypists in Boston. Both learned of the process from the public demonstrations given in the spring of 1840 by François Gouraud, who represented himself as Daguerre's agent, and sold cameras, apparatus, and plates that he had imported. As a whole, the hundreds of daguerreotypes taken by the firm are the finest in the world. In this address to the National Photographic Association meeting in Cleveland, Ohio, in 1870 Southworth looks back to the early days, and closes with insightful remarks on the aesthetics of photography.

My purpose is to hold up before you the importance of the greatest efforts to attain the highest possible perfection in our art and the highest possible standing in our profession. The elementary manipulations and knowledge of first principles of mechanics, and the sciences of optics and chemistry, and the all-important subjects of outline and *chiaroscuro,* in any detail, I can not enter upon within my allotted time, unless to make a single allusion to the immense importance and absolute necessity of acquiring perfect control of each, separately and in combination. To embrace even the important and principal subjects would require much time and many addresses.

It is fit that I express to you my most heartfelt pleasure and thanks for the opportunity of a sincere and earnest effort to benefit and further the interests and usefulness of our beautiful, refined, and wonderful art—that art which we now, as a body, claim as our own by profession, and in the practice of which we are devoting all our best energies and efforts. Not yet has the usual period allotted to a single generation elapsed since Daguerre announced its birth to the world. But a few months after this announcement a French gentleman accompanied Professor Morse, on his return from Europe to New York, for the purpose of introducing and practicing Daguerreotyping in that city, at his special request.* His method was by lectures, experiments, and illustrations by specimen views made at the time, in the presence of the audience.

Professor Gouraud soon lectured in Boston. His illustrative experiment resulted in his producing a dimmed and foggy plate, instead of the architectural details of buildings and the definite lines and forms of street objects. It happened to be a misty day, attended with both snow and rain.

The Professor appeared highly elated, and exhibited his picture with great apparent satisfaction that he had it in his power to copy the very mist and smoke of the atmosphere on a stormy day. Many a photographer has often wished for some natural phenomenon that might serve as a pretext for attributing to some apparent cause the faults of imperfectly-understood chemical combinations or partially-polished plates.

Professor Morse, from the first, took great interest in Daguerre's discovery. Himself an artist, the President of the Academy of Fine Arts in the city of New York, a man of science, of liberal education and refined culture, he had long before unsuccessfully attempted to fix the images as seen in the camera obscura. He entered at once upon the philosophical and practical experiments so nearly allied to his favorite art. This was precisely at the same time he had become absorbed in his experiments with the electric telegraph that he was erecting a glass room and arranging a studio for making Daguerreotype portraits. He encouraged the Messrs. Scovill thus early to enter upon the manufacture of silver plates, at great cost in the preparation: for, said he to them, "there will be such a demand for them soon, that they will be used like paper."

Professor Morse was not less sanguine of the success

Reprinted from *The British Journal of Photography 18 (November 1871), pp. 530-32.*

*S. F. B. Morse was in France in 1839. Daguerre showed him his daguerreotypes, but did not disclose the process. Morse returned to New York in April 1839. François Gouraud, who purported to be the agent of Daguerre, did not arrive in New York from France until November 23, 1839.

ALBERT SANDS SOUTHWORTH & JOSIAH JOHNSON HAWES. *Charles Sumner.* ca. 1855. Daguerreotype. The Metropolitan Museum of Art, New York.

of Daguerreotyping than of that which has attached to his name a world-wide and enduring fame and renown. Thirty years ago last winter I found Mr. Joseph Pennell, of Brunswick, Maine, assisting Professor Morse in the Professor's own building in Nassau-street. Mr. Pennell had a few months previously graduated at Bowdoin College, in his native town. He had gone to New York for the purpose of prosecuting a professional course of study, and had been led to interest himself in Professor Morse's experiments for the purpose of procuring pecuniary assistance by some employment of his leisure hours. He had been my former school and room mate, and had written to me to visit New York and learn respecting the new art. He invited me also to join him as an associate in business for the purpose of making likenesses. He introduced me to Professor Morse, and from him we received all the information and instruction he was able to give upon the subject. Little was then known except that a polished silver surface of plate, coated with the vapour of iodine in the dark, and exposed in the camera obscura for a certain time and then placed over fumes of mercury, would develope a picture in light and shade, the shaded parts being the black-polished surface of the plate, and the lights made out by the mercury chalked upon and adhering to it. I do not remember that Professor Morse had then made any

likenesses. Very clear, distinct views of Brooklyn in the distance and the roofs in the foreground, taken from the top of the buildings in Nassau-street, were upon his table. I do remember the coil of telegraph wire, miles in length, wound upon a cylinder, with which he was experimenting, and which he had prepared to carry over to the New Jersey side and extend for the purpose of testing the practicability of communicating between distant points by electricity, and the use of his alphabet of dots and marks. And here, out of gratitude to him whose kind and genial traits of character are proverbial, permit me to state that with his permission we placed his name for reference upon our first business card in Boston.

Messrs. Wolcott and Johnson were then experimenting with reflectors, and had succeeded in making pictures from life.

Mr. Pennell accompanied me from New York to Cabotville, now Chicopee, and there we commenced our career of experimenting, and began our business of Daguerreotyping, on a capital of less than fifty dollars. We had the sympathy and substantial assistance of Messrs. Ames, Chase, Bemis and other manufacturers and mechanics and business men. We made progress in 1840 in adapting apparatus to views and to miniatures from life. For the purpose of more rapid action by increased light we planned and made a speculum thirteen inches in diameter, thirty-inch focus, and weighing fifty-five pounds. We were at that time aware as now that as much perfection was required for the best lenses for the camera for pictures as for the best telescopes for astronomical purposes, and, consequently, at as great expense. How were we to obtain an instrument which ought to be worth ten thousand dollars? Even at this day, when there are engaged in the photographic art persons of ample means, there is not, nor has there ever been made, any set of lenses for the camera which, if the same in value were arranged for the telescope, would be considered worth using. A large fortune would be required to fit up apparatus and rooms for portrait-making as well as might be done, and benefit the quality and value of the picture. Lenses necessary for everything that is possible have never been sought for, and have never been made. The spring of 1841 found us in Boston deeply in debt, contracted in our experiments during the previous year. We were among strangers, without funds, and often unable to take our letters from the post-office. Postage was not in those days required to be prepaid, and business letters were usually twelve and a-half or eighteen and three-quarter cents each. Our whole expense of living was sometimes as low as seventy-five cents per week. In almost any established business, with the same industry and economy, we should

have accumulated money. We had our discouragements and we had our successes. In the fall of 1841 we sent a case of our Daguerreotypes for exhibition to the fair of the American Institute, and received the first premium for the best Daguerreotypes. The case was sent and returned by express, and we never knew a person connected with the fair. This encouraged us and stimulated us to effort, and led us to hope to be able to keep up with, if not to lead, our competitors. In 1842 our rooms in Boston, on the top of Schollay's building, between Court-street and Tremont-row, opposite Brattle-street, were exchanged for old 5½, now No. 19, Tremont-row, and the name of your humble servant and his worthy partner, Mr. Josiah J. Hawes, is still over the entrance.

Mr. Hawes took Mr. Pennell's place in 1843. Improvements in apparatus and the use of bromine had helped us to use a light comfortable to the eyes, and permit us to work in about one minute in the best light in the day. We now began to electrotype our plates, improving their polish, and thus greatly improving our pictures. We invented, and perfected, and patented our swing polishing plate-holder. For us this was a great acquisition, for it enabled us to finish our plates with great perfection. In the spring of 1846 we made Daguerreotypes of the sun in eclipse in its different stages, with the spots as they appeared through the telescope. We used an object-glass out of a telescope, kindly furnished us by Messrs. Widdefield and Co. This, I doubt not, was the first successful copy of an eclipse. We at this time made several Daguerreotypes of the moon. We had also arranged our triple lenses, by which we were enabled to copy straight lines, and with which we afterwards copied Allston's sketchings upon engravers' plates for Mr. John Cheney, who engraved them upon the lines as Daguerreotyped, we having previously proved, by trials and experiments before the trustees, that we could keep the drawing perfectly on plates sixteen inches square.

In 1846 and 1847 we invented a camera for making several different pictures in the axis of the lens successively at different times, and this apparatus was afterwards patented. In 1850 Mr. Hawes arranged a solar camera with movable mirror or reflector, and a twelve or thirteen inch condensing lens. In 1852 we discovered the principle upon which stereoscopic pictures must be made to be free from distortion and suitable to copy as models, which neither Wheatstone nor Sir David Brewster had accomplished. In 1853 we finished our grand parlour stereoscope. In this instrument pictures appeared, to most observers, the size of nature; and at this day, were it not for the expense, it would be one of the most desirable methods of exhibiting photographs, and by far the grandest and most striking, of any within our knowledge. In

ALBERT SANDS SOUTHWORTH & JOSIAH JOHNSON HAWES. Unidentified lady. ca. 1855. Daguerreotype. George Eastman House, Rochester, N.Y.

1854 we arranged our movable plate-holder, and afterwards took out a patent for it.

In 1855 we practised softening our prints by separating, slightly, the surface of the negative from the silver surface of the positive paper, and by using more than one negative. We acquired perfect facility in controlling at pleasure the harshness and hardness of the prints, and rendering them soft and mellow to any desirable degree. The means used were thin glass, mica gelatine, and transparent paper, and an arrangement for admitting light perpendicularly to the surface of the negative by placing it at the bottom of a box of proper depth, so that the light should not be permitted to act except directly from the front.

The idea of photographing disputed or questioned handwriting as an aid to its identification and authorship was brought up by myself, in 1856 or 1857, in the case of an anonymous communication to the *Ledger* newspaper, shown to me by Mr. J. M. Barnard, the proprietor. Photographs soon came to be used in the courts of Massachusetts, by my introduction, upon questioned signatures and writing, for the purpose of enlarging and making plainer simulated writing of any kind, as well as genuine business papers, and of bringing into convenient juxtaposition the standards and the questioned. The number of different papers presented to me amounts to hundreds in two or

three years, and the sums involved or connected therewith to hundreds of thousands; and in a single case, "The Howland Will," amounted to more than two and a-half millions of dollars. Besides civil questions and suits, very important criminal cases often depend on questioned writings, anonymous letters, &c. The larger part of my time, for some years past, has been taken up in this business. A discourse upon this branch alone might be written, but, for the present, want of time forbids only this reference.

I am not prepared to rehearse, or even to name, all the various applications and uses of photography. It is applied now to illustrations of morbid anatomy advantageously. Astronomical records are made by it with unparalleled rapidity and exactness. Views from the caverns of the earth, and from the depths of the waters, and from the heavens above are placed before us. The wonders of nature, as exhibited in the snow-clad summits of the loftiest mountains; the volcano belching forth its masses of flame and liquid fire, half enveloped in its ascending column of vapour, smoke, and ashes; the majestic and foaming cataract in its icy crystal robes of winter, dazzling to blindness by its more than diamond brilliancy, or softened by the hues of the summer foliage, pouring forth in unceasing tones its grand, sublime, and still harmonious sounds—"the music of the waterfall;" the giant trees of California; the lofty summits of the Sierra Nevada or Mount Diavolo; the rivers and harbours, the plains and mining grounds, with their operations; the cities and villages, and the grand highways in various directions, and the life-imbued car, almost in motion; the engine held with a firm and steady hand, like a warhorse impatient for the blast of the bugle. But it is not worth while to particularise; every conceivable view is presented to our vision with a reality and vividness almost equal to nature itself. The treasures of the artistic world are laid upon our tables; ancient and modern art we can study at our leisure; the fashions and patterns of the manufacturer, of things namable and to be named, are thrust before us and surround us by means of the photographic art.

In thirty years, from a few crude experiments in the laboratory of a private chemist and artist, it has extended its various applications and uses throughout the length and breadth of every quarter of our globe. So manifold are its uses, so necessary to human intelligence have become its historic recordings, that in almost all cities and towns and villages may be found the displays and sample show-cases, with specimens in infinite variety of size and sitting and character, as well as individual personages and stations, from theatrical mimics, clowns, and stage dancers, and in their various costumes and postures (or, without costume), to the presidents and sovereigns of the republics and kingdoms and empires of the world. The pointing index, the projecting sign-camera, or the attracting banner direct the passing public to the rooms and saloons, the parlours and studios of the professional artisans and artists in photography; and few there are who do not possess some sample of this pleasing and attractive art.

On the first announcement of the new discovery of the hitherto unknown properties of light in connection with certain materials and chemicals, learned and scientific and curious minds at once eagerly sought to realize and comprehend and test this new and subtle and wonderful accession to science. The main facts were easily demonstrated—so very easily that experiments were tried, and results produced and exhibited, within the reach of the common and uncultivated mind, and at a very trifling expense. No unusual intellectual education or attainments were required to see that a new and vast field for occupancy and improvement had been opened, and there was soon an almost impetuous rush, either for the pleasure of increasing in knowledge or with the hope of speculative gains. The *savans* and professors of known and familiar sciences sought its uses and aids in their accustomed specialties. By its sister sciences its advent was welcomed by such worthies as Herschel, Brewster, Talbot, and Morse, with other names of merit and renown, attached to astronomy, to chemistry, to optics, to medicine, to natural history, and to the finer and higher arts of painting and sculpture.

In its early development and progress it was seen that the sciences of optics and chemistry must be the principal sharers in aiding its operations and rendering it subservient to mankind in its finished and absolute perfection. Hardly have these sciences reached beyond the age of infancy, and yet most important additions have been made to each in combination with photographic science. New properties of light have been discovered, and new and now indispensable chemicals also. Unsparing efforts have been made by names of merit known and unknown to fame, and not less in amount of ingenuity and perseverance have been the contributions of those unknown to fame or fortune; and now, at this late day, by far the larger majority practising photography as a profession have little knowledge of its chemical or optical combinations or artistic requirements, nor are they disciplined in any principles of the fine arts, or in any mechanical employments whatever. Wisdom and prudence enter upon new and untried paths with cautious steps, eagerly observing every new sign and watchful of new developments; whilst youth, inexperience, and ignorance push impetu-

ously forward, reckless of consequences, accomplishing sometimes accidental success, oftener doomed to inglorious defeat.

Into the practice of no other business or art was there ever such an absurd, blind, and pell-mell rush. From the accustomed labours of agriculture and machine shop, from the factory and counter, from the restaurant, coach-box, and forecastle, representatives have appeared to perform the work for which a life-apprenticeship could hardly be sufficient for a preparation for duties to be performed of a character to deserve honourable mention. It may possibly be considered an extravagant estimate to place the number of persons employed, directly and indirectly, in photographing and manufacturing for the art at 50,000 in our country; but, in my own mind, it is within rather than beyond reasonable limits. Allow one in ten of this number to be in actual use of the camera and pencils or brushes, and we have 5,000 professional artists in picture-making and portraiture. Upon these devolve the responsibility of the design and character and finish of the picture. Mechanical manipulations, not more difficult of acquirement than in many other arts, attend upon this, and must be at the time performed by the artist-photographer. For his apparatus and materials he is dependent upon those who have by lifelong efforts, with genius, ability, and zeal perfected themselves in the sciences and optics and chemistry, and the manufacture of lenses and chemicals. Excellence in these sciences has been attained from the experience and knowledge of former masters and from successive exertions in one progressive line, building, as it were, upon foundations previously properly and securely laid. Such must be placed high in the order of mental culture and knowledge. In certain specialties they are accounted geniuses of distinguished merits, and the enlightened world accords to them deserved and lasting honour. So does it to any who worthily search for and discover the truths of science—for science is truth.

But the artist, even in photography, must go beyond discovery and the knowledge of facts. He must create and invent truths, and produce new developments of facts. I would have him an artist in the highest and truest sense applicable to the production of views or pictures of any and every kind, or to statues and forms in nature universally. I would have him able to wield at pleasure the power of drawing Nature in all her forms, as represented to vision, with lights and shadows, and colours and forms, in all of nature's changes. I would have him as familiar with her as with his alphabet of letters. He should not only be familiar with Nature and her philosophy, but he should be informed as to the principles which govern or influence human actions, and the causes which affect and mark human character. History and poetry should be to him mere *pastime*; observation of nature, cause and effect, should be his employment. Familiar with all that has been done, with a genius to comprehend and estimate excellencies and defects, he will bend his energies to rival this one, while, at the same time, he discards the other. Thus he will save and have time for the application and use of the true principles of art, which otherwise would require to be devoted to laborious and often unsuccessful experiments. This truth is not believed, or, if admitted, is not realised; yet it is truth still that there is no high, easy, unobstructed road to knowledge, but the same long, steep and toilsome path which has ever led, and still is ever to lead, to the treasuries of learning and wisdom. Golden fortunes may be inherited or acquired by chance speculation, a mine of the precious metals may be discovered by diligent search, or accidentally opened by pulling a bush from the mountain side; but no stock of mental culture in any particular or general science was ever acquired but by dropping, hour by hour and day by day, the pence of truth into our own memories and knowledge-boxes, to be cherished and guarded by our own constant and untiring watchfulness and care. And if thus we accumulate principal continually interest will increase in a corresponding ratio, and our savings-bank, yielding four per cent, at first, will in time return its six and ten, and afterwards an hundredfold.

We appreciate the perfection of the lenses with which we make the images of nature or art in our cameras; the perfection in the manufacture of our chemicals, glass, and paper; the variety and beauty in the style of our mountings and frames; but that which is necessary and requisite to fit one for the disposition of light and shade, the arrangement of the sitter, and accessories for the design and composition of the picture, is of a far higher order in the scale of qualifications, demands more observation and comprehensive knowledge, a greater acquaintance with mind in its connection with matter, a more ready and inventive genius, and greater capacity for concentrated thought and effort with prompt accompaniment in action. What is to be done is obliged to be done quickly. The whole character of the sitter is to be read at first sight; the whole likeness, as it shall appear when finished, is to be seen at first in each and all its details and in their unity and combinations. Natural and accidental defects are to be separated from natural and possible perfections —these latter to obliterate or hide the former. Nature is not all to be represented as it is, but as it ought to be, and might possibly have been; and it is required of, and should be the aim of, the artist-photographer to produce

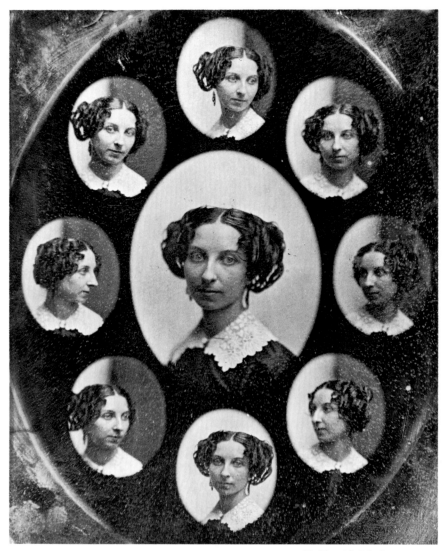

ALBERT SANDS SOUTHWORTH & JOSIAH JOHNSON HAWES. Unidentified lady. ca. 1855. Daguerreotype taken with a camera fitted with a movable plate holder, the invention of Southworth. The Metropolitan Museum of Art, New York.

in the likeness the best possible character and finest expression of which that particular face or figure could ever have been capable. But in the result there is to be no departure from truth in the delineation and representation of beauty, expression, and character.

But it may be asked whether the standard for the qualifications of the artist in photography is to be considered equal to that for painting and sculpture? If the aim and the purpose be the highest point of human perfection in either art, then I repeat that, as great as may be estimated the necessary qualifications and intellectual discipline and natural talents and genius for the painter and sculptor, precisely as much would I require for the artist in photography. The mere manipulations—the handling of brush or chisel—are as mechanical and in no respect beyond adjusting the camera or retouching correctly. The mind

must express the value, and mark and impress resemblances and differences; it must be instructed and directed by impressions at the time emanating from the subject itself.

Photographs possessing all the desirable points are as scarce and valuable as the gems of India or Brazil, and the thousands of multiplied copies of the one are as common and worthless as the counterfeit glass imitations of the other. The demand for this class of photographs increases with the facilities for rapid execution and diminished value and cost. Whilst there exists this demand for a picture of a quality scarcely worthy of the name, we will not find fault with those who stand ready to supply that demand. The taste of the public is to be formed and educated before work of a higher and more meritorious character is required; and permit me to say that, in our

own country, no means will be more likely to accomplish so much towards that desirable end, directly or indirectly, as the exhibitions and meetings of this Association—directly, by raising the standard by which photographers are to estimate their own abilities and productions; indirectly, by the effect of the exhibition in training the public eye to appreciate the differences between inferior and superior pictures.

In addressing you at this time do not understand me as attempting to discourage any who may have entered upon the business of photographing, or of holding up before you any impracticable theory of unattainable perfection. I would impress upon you the necessity of the most constant and unremitting attention to Nature—her changes, her variations, her moods, and her principles and productions. I suppose the picture-maker to be endowed with genius for, and a mind devoted to, art; to such an one no scene can be vacant or uninteresting. He will see in every place something for observation and investigation, from the simplest to the most imposing and sublime. All the actions and the varied expressions of man under all influences—the characteristic forms, lines, and effects of health, age, and condition, of beauty and deformity—he will regard with scrutiny; all varieties of country, all species of animals under all circumstances of repose or excitement, all of the earth below, all of the heavens above. This is his discipline of mind and vision, with fatigue and trouble at first, to be rewarded afterwards with enlarged powers and higher views, until another sense seems to have been added to his faculties unfelt and unknown to the uninitiated. The artist is conscious of something beside the mere physical in every object in nature. He feels its expression, he sympathises with its character, he is impressed with its language; his heart, mind, and soul are stirred in its contemplation. It is the life, the feeling, the mind, the soul of the subject itself. Nature is the creation of infinite knowledge and wisdom, and it is hardly permitted to humanity to even faintly express nature by a copy.

With infinite perfection for our study, observation, and models, let it be our ambition to attain to the highest point of human perfection and knowledge. The temple of knowledge may seem an imposing structure, but it is not too vast or grand for even our limited capacities. Time and opportunity are afforded us for all the exertions requisite for its construction. Upon its pinnacle we may erect our statue of fame if we do no less than is possible. I do not say to anyone connected with the photographic art that you had better change your business and devote your time to another occupation; let it be admitted that you have chosen for yourselves that profession for which your education and genius best fits you—that path which good

judgment and circumstances have opened before you. Having entered upon it remove by industry and energy every obstruction you may encounter; and if, perchance, some formidable barrier present itself, retreat but to choose a new position, and to push on with renewed effort towards the desired goal with the least possible delay and the least possible change of direction.

Observation is the locomotive to be attached to the train of thought and engineered under your own conductorship; the power which turns the revolving wheels must be created by fuel from your own stores. Your freight is to be truth and knowledge and wisdom, in all their purity, from the overflowing treasuries of the infinite Creator of nature. For your harvesting He has sown with a lavishing hand. But not all is gold that glistens; truth lies at the bottom of the well, whilst straws float on the surface. For the truth we are to dig as for hidden treasures—truth, so rare, so often counterfeited or disguised by the glittering tinsel of falsehood, so often mixed with error—truth, always withstanding assaults, defending itself now here, now there; almost overwhelmed by the dust and rubbish of delusion, or the blatant effrontery of impudence, empiricism, and quackery. The question, "What is truth?" began to be asked more than eighteen hundred years ago, and will continue to be asked as long as human nature exists.

I trust that it will not be considered inappropriate that I have chosen to occupy the time allotted to this address in endeavouring to impress upon you the necessity of that general education, which can only be acquired by persevering study, to absolutely fit you for the profession which you have chosen, or in which you find yourself engaged. I would have you respected, and worthy, and honoured occupants of your studios; yourselves a grace and adornment to Nature, in her picturesque and poetical beauty, which, *in your works*, shall be spread over their walls and abound within their domain.

How proper the name given to designate the artist's room—"studio," or study! Had I, at the beginning of my remarks, quoted from Scripture, in connected, though not precisely successive, words found in the eleventh verse of the fourth chapter of the first of Thessalonians—"study" "to do your own business"—it would have comprehended all I have said, and all I can say; and I will close by reversing the order of text and discourse—a text which should be photographed upon every unoccupied blank within the scope of our vision, which should be impressed in plain and prominent characters upon every piece of work upon which we labour, which should ring as a perpetual chorus in our ears, and haunt our sleeping and waking dreams:—*"Study" "to do your own business."*

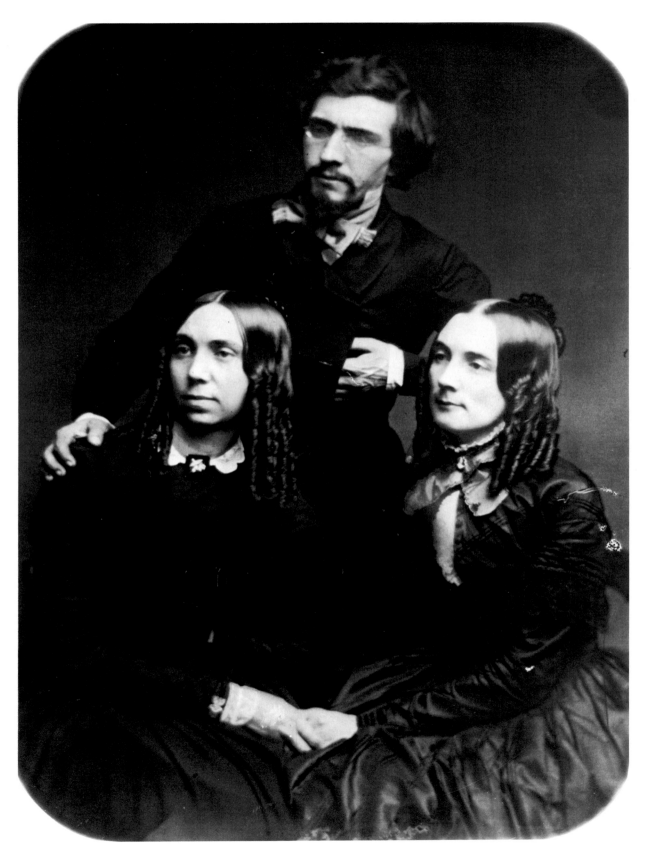

BRADY GALLERY. *Mathew B. Brady with his Wife (left) and Friend.* ca. 1850. Daguerreotype. The Library of Congress, Washington, D.C.

Brady, The Grand Old Man of American Photography

AN INTERVIEW BY GEORGE ALFRED TOWNSEND
1891

The activity of Mathew B. Brady (ca. 1823–1896) as one of the leading portrait photographers of the mid-nineteenth century has been eclipsed by his extraordinary documentation of the Civil War. Yet in this interview, made when he was sixty-seven, he proudly boasts: "My gallery has been the magazine to illustrate all the publications in the land." He was referring to his vast collection of daguerreotypes and prints from collodion negatives of America's leaders and celebrities that were used as models by engravers, lithographers, and painters. Like most proprietors of portrait studios, he employed many operators, and it is obvious that he also acquired portraits for his collection made outside his studio by other gallery owners. He recollects that for his now-famous documentation of the Civil War, "I had men in all parts of the army, like a rich newspaper." The credit lines "Daguerreotype by Brady" and "Photograph by Brady" thus became trademarks more than personal attributions. He was a pictorial historian, the dynamic director of an enterprise to preserve in pictures America's leaders and public events.

STILL TAKING PICTURES

Brady, the Grand Old Man of American Photography

HARD AT WORK AT SIXTY-SEVEN

A Man Who Has Photographed More Prominent Men Than Any Other Artist in the Country—Interesting Experiences with Well-Known Men of Other Days—Looking "Pleasant."

WASHINGTON, April 10.—"Brady the photographer alive? The man who daguerreotyped Mrs. Alexander Hamilton and Mrs. Madison, Gen. Jackson, and Edgar A. Poe, Taylor's Cabinet, and old Booth? Thought he was dead many a year."

Reprinted from *The World* (New York), April 12, 1891, p. 26.

No, like a ray of light still travelling toward the vision from some past world or star, Matthew B. Brady* is at the camera still and if he lives eight years longer will reach the twentieth century and the age of seventy-five. I felt as he turned my head a few weeks ago between his fingers and thumb, still intent upon that which gave him his greatest credit—finding the expression of the inner spirit of a man—that those same digits had lifted the chins and smoothed the hairs of virgin sitters, now grandmothers, the elite of the beauty of their time, and set the heads up or down like another Warwick of the rulers of parties, sects, agitations and the stage. As truly as Audubon, Wagner or Charles Wilson Peale, Mr. Brady has been an idealist, a devotee of the talent and biography of his fifty years of career. He sincerely admired the successful, the interesting men and women coming and going, and because he had a higher passion than money, we possess many a face in the pencil of the sun and the tint of the soul thereof which otherwise would have been imbecile in description or fictitious by the perversion of some portrait painter. For the same reason, perhaps, Brady is not rich. He allowed the glory of the civil war to take away the savings and investments of the most successful career in American photography; his Central Park lots fed his operators in Virginia, Tennessee and Louisiana, who were getting the battle-scenes. It is for this reason, perhaps, that he is at work now over the Pennsylvania Railroad ticket office, near the Treasury Department, and only yesterday he took the whole Pauncefote family, to their emphatic satisfaction—minister, wife and daughters—as he took the Pan-American Commission officially. His gallery is set around with photographs he has made from his own daguerreotypes of public people from Polk's administration down, for

*He seldom used his first name, but when he did he spelled it with one "t," as in this certified signature on bankruptcy proceedings in 1873:

45

he was very active in the Mexican War, taking Taylor, Scott, Santa Anna, Houston and Walker, Quitman and Lopez. I thought as I looked at the white cross of his moustache and goatee and blue spectacles and felt the spirit in him still of the former exquisite and good-liver which had brought so many fastidious people to his studio, that I was like Leigh Hunt taking the hand of old Poet-Banker Rogers, who had once shaken hands with Sam Johnson, who had been touched for the king's evil by Queen Anne, and I had almost asked Mr. Brady about Nelly Custis and Lord Cornbury and Capt. John Smith.

"How old are you, Mr. Brady?"

"Never ask that of a lady or a photographer; they are sensitive. I will tell you, for fear you might find it out, that I go back to near 1823-'24; that my birthplace was Warren County, N.Y., in the woods about Lake George, and that my father was an Irishman."

"Not just the zenith-place to drop into art from?"

"Ah! but there was Saratoga, where I met William Page, the artist, who painted Page's Venus. He took an interest in me and gave me a bundle of his crayons to copy. This was at Albany. Now Page became a pupil of Prof. Morse in New York city, who was then painting portraits at starvation prices in the University rookery on Washington square. I was introduced to Morse; he had just come home from Paris and had invented upon the ship his telegraphic alphabet, of which his mind was so full that he could give but little attention to a remarkable discovery one Daguerre, a friend of his, had made in France."

"Was Daguerre Morse's friend?"

"He was. Daguerre had traveled in this country exhibiting dissolving views and Morse had known him.* While Morse was abroad Daguerre and Nipes [i.e. Niépce] had after many experiments fixed the picture in sensitive chemicals, but they applied it chiefly or only to copying scenes. Morse, as a portrait painter, thought of it as something to reduce the labor of his portraits. He had a loft in his brother's structure at Nassau and Beekman streets, with a telegraph stretched and an embryo camera also at work. He ordered one of Daguerre's cameras from a Mr. Wolf,† and felt an interest in the new science. Prof. John W. Draper and Prof. Doremus counselled me, both eminent chemists. It was

Draper who invented the enameling of a daguerreotype and I entered at last into business, say about 1842-'43. My studio was at the corner of Broadway and Fulton streets, where I remained fifteen years, or till the verge of the civil war. I then moved up Broadway to between White and Franklin, and latterly to Tenth street, maintaining also a gallery in Washington City. From the first I regarded myself as under obligation to my country to preserve the faces of its historic men and mothers. Better for me, perhaps, if I had left out the ornamental and been an ideal craftsman!"

"What was the price of daguerreotypes forty-five years ago?"

"Three to five dollars apiece. Improvements not very material were made from time to time, such as the Talbotype and the ambrotype. I think it was not till 1855 that the treatment of glass with collodion brought the photograph to supersede the daguerreotype. I sent to the Hermitage and had Andrew Jackson taken barely in time to save his aged lineaments to posterity. At Fulton street, bearing the name of the great inventor before Morse, I took many a great man and fine lady—Father Matthew, Kossuth, Paez, Cass, Webster, Benton and Edgar A. Poe. I had great admiration for Poe, and had William Ross Wallace bring him to my studio. Poe rather shrank from coming, as if he thought it was going to cost him something. Many a poet has had that daguerreotype copied by me. I loved the men of achievement, and went to Boston with a party of my own once to take the Athenian dignitaries, such as Longfellow, whom I missed. In 1850 I had engraved on stone twelve great pictures of mine, all Presidential personages like Scott, Calhoun, Clay, Webster and Taylor; they cost me $100 for the stones, and the book sold for $30. John Howard Payne, the author of "Home, Sweet Home," was to have written the letter-press, but Lester did it. In 1851 I exhibited at the great Exhibition of London, the first exhibition of its kind, and took the first prize away from all the world.‡ I also issued the first sheet of photographic engravings of a President and his Cabinet, namely Gen. Taylor in 1849. I sent this to old James Gordon Bennett and he said: 'Why, man, do Washington and his Cabinet look like that?' Alas! They were dead before my time. I went to Europe in 1851 upon the same ship with Mr. Bennett, wife and son. His wife I often took, but the old man was shy of the camera. He did, however, come in at last, and I took him with all his staff once— son, Dr. Wallace, Fred Hudson, Ned Hudson, Ned

*There is no record that Daguerre personally visited the United States, but his Diorama paintings were exhibited in New York, Philadelphia, Washington, and other cities from 1840 to 1847. Morse met Daguerre in Paris in 1839 and wrote a glowing account of the daguerreotypes he saw for the New York *Observer*, April 20, 1839.

†Morse relates that his first camera was built for him by G. W. Prosch, who also made his telegraphic apparatus.

‡Six prize medals were awarded to photographers at the Great Exhibition of the Works of All Nations; two of these went to Americans: Brady and John A. Whipple of Boston.

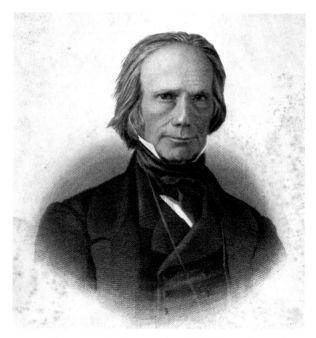

Henry Clay. 1851. Steel engraving by W. G. Jackman from a daguerreotype by Brady. The Museum of Modern Art, New York.

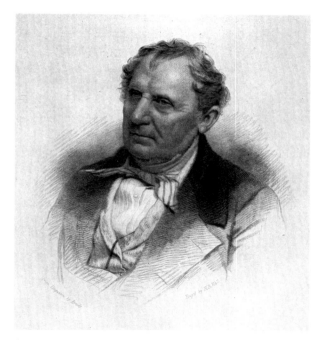

James Fenimore Cooper. 1851. Steel engraving by H. B. Hall from a daguerreotype by Brady. Frontispiece to the *International Magazine.*

Williams, Capt. Lyons, as I took Horace Greeley and all his staff, Dana, Kipley, Stone, H ldreth [*sic*], Fry."

"Was the London Exhibition of benefit to you?"

"Indeed, it was. That year I went through the galleries of Europe and found my pictures everywhere as far as Rome and Naples. When in 1860 the Prince of Wales came to America I was surprised, amidst much competition, that they came to my gallery and repeatedly sat. So I said to the Duke of Newcastle: 'Your Grace, might I ask to what I owe your favor to my studio? I am at a loss to understand your kindness.' 'Are you not the Mr. Brady,' he said, 'who earned the prize nine years ago in London? You owe it to yourself. We had your place of business down in our notebooks before we started.' "

"Did you take pictures in England in 1851?"

"Yes. I took Cardinal Wiseman, the Earl of Carlisle and others. I took in Paris Lamartine, Cavaignac and others, and Mr. Thompson with me took Louis Napoleon, then freshly Emperor."*

I could still see the deferential, sincere way Brady had in procuring these men. His manner was much in his conscientious appreciation of their usefulness. Men who disdain authority and cultivate rebellion know not the

victories achieved by the conquering sign of *Ich Dien*— "I serve."

Mr. Brady is a person of trim, wiry, square-shouldered figure, with the light of an Irish shower-sun in his smile. Said I:

"Did anybody ever rebuff you?"

"No, not that I can think of. Some did not keep their engagements. But great men are seldom severe. I recollect being much perplexed to know how to get Fenimore Cooper. That, of course, was in the day of daguerreotyping. I never had an excess of confidence, and perhaps my diffidence helped me out with genuine men. Mr. Cooper had quarrelled with his publishers, and a celebrated daguerreotyper, Chilton,† I think, one of my contemporaries, made the mistake of speaking about the subject of irritation. It was reported that Cooper had jumped from the chair and refused to sit. After that daguerreotypers were afraid of him. I ventured in at Biggsby's, his hotel, corner of Park place. He came out in his morning gown and asked me to excuse him till he had dismissed a caller. I told him what I had come for. Said he: 'How far from here is your gallery?' 'Only two blocks.' He went right along, stayed two hours, had half a dozen sittings, and Charles Elliott painted from it the portrait of Cooper for his publishers, Stringer & Townsend. I have had Willis, Bryant, Halleck, Giulian C. Verplank in my chair."

*"Brady brought back a daguerreotype of Louis Napoleon —by Warren Thompson of Paris—but it lacks the brilliancy which so characterize our pictures."—*Humphrey's Journal of Photography,* May 15, 1852, p. 47.

†James R. Chilton (1810-1863).

"And Albert Gallatin?"

"Yes, I took a picture of him who knew Washington Irving and fought him and ended by adopting most of his views. Washington Irving was a delicate person to handle for his picture, but I had him sit and years afterwards I went to Baltimore to try to get one of those pictures of Irving from John P. Kennedy, who had it."

"Jenny Lind?"

"Yes, Mr. Barnum had her in charge and was not exact with me about having her sit. I found, however, an old schoolmate of hers in Sweden who lived in Chicago, and he got me the sitting.* In those days a photographer ran his career upon the celebrities who came to him, and many, I might say most, of the pictures I see floating about this country are from my ill-protected portraits. My gallery has been the magazine to illustrate all the publications in the land. The illustrated papers got nearly all their portraits and war scenes from my camera. Sontag, Alboni, La Grange, the historian Prescott—what images of bygone times flit through my mind."

"Fanny Ellsler?"

"She was brought to me by Chevalier Wykoff for a daguerreotype."

"Not in her Herodias raiment?"

"No, it was a bust picture. The warm life I can see as she was, though dead many a year ago."

"Did you daguerreotype Cole, the landscape artist?"

"I did, with Henry Furman. I think Cole's picture is lost from my collection."

"Aggassiz?"

"I never took him up, through the peculiarity of his tenure in New York; he would come over from Boston in the day, lecture the same night and return to Boston by night. One day I said sadly to him: 'I suppose you never mean to come?' 'Ah!' said he, 'I went to your gallery and spent two hours studying public men's physiognomies, but you were in Washington City.' So I never got him."

"I suppose you remember many ladies you grasped the shadows of?"

"Mrs. Lincoln often took her husband's picture when he came to New York after the Douglas debates and spoke at the Cooper Institute. When he became President Marshal Lamon said: 'I have not introduced Mr. Brady.' Mr. Lincoln answered in his ready way, 'Brady and the Cooper Institute made me President.' I have taken Edwin Forrest's wife when she was a beautiful woman; Mrs. Sickles and her mother; Harriet Lane; Mrs. Polk. Yes, old Booth, the father of Edwin, I have

*Humphrey's Journal of Photography, January 1, 1853, p. 287, notes that Polycarpus Von Schneidau of Chicago "takes Jenny Lind in Brady's rooms."

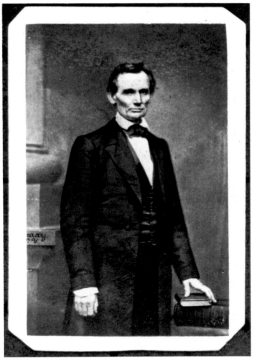

BRADY GALLERY. *Abraham Lincoln.* February 27, 1860. Carte-de-visite. George Eastman House, Rochester, N.Y.

posed, and his son, John Wilkes, who killed the President. I remember when I took Mr. Lincoln, in 1859, he had no beard. I had to pull up his shirt and coat collar; that was at the Tenth street gallery. Mr. Seward got the gallery for the Treasury to do the bank-note plates by conference with me. I took Stanton during the Sickles trial and Philip Barton Key while alive. I had John Quincy Adams to sit for his daguerreotype and the full line of Presidents after that. I took Jefferson Davis when he was a Senator and Gen. Taylor's son-in-law. Mrs. Alexander Hamilton was ninety-three when she sat for me."

"All men were to you as pictures?"

"Pictures because events. It is my pleasant remembrance that Grant and Lee helped me out and honored me on remarkable occasions. I took Gen. Grant almost at once when he appeared in Washington city from the West, and Lee the day but one after he arrived in Richmond."

"Who helped you there?"

"Robert Ould and Mrs. Lee. It was supposed that after his defeat it would be preposterous to ask him to sit, but I thought that to be the time for the historical picture. He allowed me to come to his house and photograph him on his back porch in several situations. Of course I had known him since the Mexican war when he was upon Gen. Scott's staff, and my request was not as from an intruder."

"Did you have trouble getting to the war to take views?"

"A good deal. I had long known Gen. Scott, and in the days before the war it was the considerate thing to buy wild ducks at the steamboat crossing of the Susquehanna and take them to your choice friends, and I often took Scott, in New York, his favorite ducks. I made to him my suggestion in 1861. He told me, to my astonishment, that he was not to remain in command. Said he to me: 'Mr. Brady, no person but my aide, Schuyler Hamilton, knows what I am to say to you. Gen. McDowell will succeed me to-morrow. You will have difficulty, but he and Col. Whipple are the persons for you to see.' I did have trouble; many objections were raised. However, I went to the first battle of Bull Run with two wagons from Washington. My personal companions were Dick McCormick, then a newspaper writer, Ned House, and Al Waud, the sketch artist. We stayed all night at Centreville; we got as far as Blackburne's Ford; we made pictures and expected to be in Richmond next day, but it was not so, and our apparatus was a good deal damaged on the way back to Washington; yet we reached the city. My wife and my most conservative friends had looked unfavorably upon the departure from commercial business to pictorial war correspondence, and I can only describe the destiny that overruled me by saying that, like Euphorion, I felt that I had to go. A spirit in my feet said, 'Go,' and I went. After that I had men in all parts of the army, like a rich newspaper. They are nearly all dead, I think. One only lives in Connecticut. I spent over $100,000 in my war enterprises. In 1873 my New York property was forced from me by the panic of that year. The Government later bought my plates and the first fruits of my labors, but the relief was not sufficient and I have had to return to business. Ah! I have a great deal of property here. Mark Twain was here the other day."

"What said he?"

"He looked over everything visible, but of course not the unframed copies of my works, and he said: 'Brady, if I was not so tied up in my enterprises I would join you upon this material in which there is a fortune. A glorious gallery to follow that engraved by Sartain and cover the expiring mighty period of American men can be had out of these large, expressive photographs; it would make the noblest subscription book of the age.'"

"I suppose you sold many photographs according to the notoriety of the time."

"Of such men as Grant and Lee, at their greatest periods of rise or ruin, thousands of copies; yet all that sort of work takes rigid, yes, minute worldly method. My energies were expended in getting the subjects to come in, in posing them well and in completing the likeness. Now that I think of it, the year must have been 1839, when Morse returned from Europe, and soon after that Wolf made my camera. I had a large German instrument here a few weeks ago, and some one unknown stole the tube out of it, which cost me $150."

I reflected that this man had been taking likenesses since before the birth of persons now half a century old.

Brady lived strongest in that day when it was a luxury to obtain one's likeness, and he had some living people who began with the American institution. John Quincy Adams, for instance, was a school boy at the Declaration of Independence, or soon after, but, living to 1849, Brady seized his image in the focus of the sun. Had he been thirteen years earlier he could have got John Adams and Jefferson, too; and he missed the living Madison and Monroe and Aaron Burr by only four or five years. For want of such an art as his we worship the Jesus of the painters, knowing not the face of our Redeemer, and see a Shakespeare we know not to have been the true Will or a false testament. Our Washington city photographer probably beheld a greater race of heroes in the second half of the nineteenth century than the first, but in the growth of the mighty nation has come a refined passion to see them who were the Magi at the birth of this new star. Before Mr. Brady was Sully the painter, before Sully was Charles Wilson Peale, working to let no great American visage escape, and in their disposition and devotion these three men were worthy of Vandyke's preserving pencil. The determined work of M. B. Brady resembles the literary antiquarianism of Peter Force,* who lived in the city of Washington also, and the great body of collections of both have been acquired by the Government.

GEORGE ALFRED TOWNSEND ("Gath")

*Peter Force (1790-1868), American historian, editor and publisher of *American Archives,* 9 vols. 1837-53. His library was purchased in 1867 by the Library of Congress, where is now also preserved a large part of Brady's collection.

FREDERICK SCOTT ARCHER. *Leicester Buildings.* From an album of albumen prints from Archer's first collodion negatives, presented by him to the photographer Jabez Hogg in 1851. The Royal Photographic Society, Bath, England.

The Use of Collodion in Photography

FREDERICK SCOTT ARCHER
1851

Many attempts had been made to combine the exquisite detail of the daguerreotype, which had the disadvantage that each exposure produced a unique picture on expensive silverplates, and the calotype, which had the advantage that each exposure produced a master negative from which any number of positives could be made on inexpensive paper. Finally successful was the British sculptor Frederick Scott Archer (1813-1857), who coated glass plates with collodion sensitized with silver iodide. His process became universal for a quarter of a century. Here is his first account of his invention.

The imperfections in paper photography, arising from the uneven texture of the material, however much care may be taken in the manufacture of it, and which from its nature, being a fibrous substance, cannot, I believe, be overcome, has induced me to lay it aside and endeavor to find some other substance more applicable, and meeting the necessary conditions required of it, such as fineness of surface, transparency, and ease of manipulation.

A layer of albumen on glass answers many of these conditions, producing a fine transparent film, but it is difficult to obtain an even coating on the glass plate; it requires careful drying, and is so extremely delicate when damp that it will not bear the slightest handling; besides these objections, the necessity of having a large stock of glass when a number of pictures are to be taken, is much against its general use. My endeavor, therefore, has been to overcome these difficulties, and I find from numerous trials that *Collodion,* when well prepared, is admirably adapted for photographic purposes as a substitute for paper. It presents a perfectly transparent and even surface when poured on glass, and being in some measure tough and elastic, will, when damp, bear handling in several stages of the process.

I will now give a short outline of my mode of using

Reprinted from *The Chemist,* No. 2 (March 1851), pp. 257-58.

it. The first step in the process is to prepare the solution of collodion. There are several ways of doing this, but I will briefly allude to two.

Pour a quantity (say 1 oz.) of collodion into a bottle containing dry iodide of silver. Shake them well together, and then allow the excess of iodide of silver to settle. The collodion will in this way take up a certain quantity of the silver salt, and become opaque; it should then be transferred to another bottle containing iodide of potassium, to be again well shaken up until the iodide of silver is entirely dissolved, and the solution becomes perfectly transparent.

Or this:—To a solution of iodide of potassium in spirits of wine add a small quantity of iodide of silver sufficient to saturate the iodide of potassium; yet, however, the latter salt be in excess. Add a small quantity of this solution to the collodion, between 5 and 10 grs. by measure to 1 oz. of collodion will be sufficient, and if any of the iodide of silver should precipitate, a small quantity of iodide of potassium must be added to dissolve it. In this way, or by the former mode, the collodion may be prepared.

The next step is to spread this solution evenly on a plate of glass. This can be done by pouring a sufficient quantity on the glass to run in a body freely. When it has entirely covered the glass plate, let the superabundance be drained off at one corner into the bottle again; this operation cannot be done too quickly, for the ether rapidly evaporating would prevent the collodion running evenly over the surface of the plate, from becoming too thick.

The plate is now plunged into a bath of nitrate of silver, allowed to remain there for a few seconds, and then washed in water. (This washing is intended to remove all the ether from the surface of the collodion, which, if allowed to remain, would cause an unevenness in the sensitiveness of the surface, producing streaks or spots.) Immediately after washing, it may be exposed to the action of light for the time necessary to obtain a picture. This picture can be developed either by gallic or pyrogallic acid. If the latter acid be used, a few precau-

tions are necessary, to which I will allude presently. The former acid may be used as a bath, in the ordinary way. After the picture is developed, the film of collodion should be loosened from the edges of the glass plate with a flat glass rod. By doing this, it will easily separate from the plate and can be allowed to float freely in the water bath, previous to being placed in the bath of hyposulphite of soda, and then again thoroughly washed.

The drawing can now be mounted on a plate of glass, and when dry can be varnished, to protect it from injury.

If thought more convenient (and, in fact, this mode is the best when pyrogallic acid is used), the film of collodion, after being exposed to light and the image developed, can be removed from the glass plate (leaving the fixing and final washing to be done at leisure) by rolling it up on a glass rod, thus:—Take a sheet of ordinary white wrapping or thick blotting paper (if glazed it will be better), about the same breadth and about one-third longer than the drawing to be removed, soak it in water, and place it with the glazed side in contact with the surface of collodion. Turn the end of the collodion picture over the edge of the paper lying upon it, then place the glass rod just within the edge, and commence rolling it upon the rod; with a little dexterity, this can be accomplished without injuring the drawing. The cylinder thus formed, is easily removed from the glass rod, and can be preserved for any length of time in this state by being kept damp and away from the light, to be finally fixed at some more convenient time. Thus one plate of glass will be sufficient to make any number of drawings upon, the above operations being repeated for each picture.

The plate of glass should be rather larger than the drawings intended to be made upon it, to allow for rough edges, &c. The back of the glass may be ground to get the focus upon, and one side should be formed into a kind of handle to prevent the hand of the operator being near the solution when the glass is in use.

30 grs. of nitrate of silver to 1 oz. of water will be sufficient for the nitrate of silver bath.

3 grs. of pyrogallic acid to 1 oz. of water, to which must be added about 1 drachm of acetic acid.

Between 5 and 10 grs. of nitrate of silver to 1 oz. of water.

The two latter solutions are to be mixed in equal proportions when a picture is to be developed. A wide-mouthed glass measure will be necessary to hold this mixture.

I have found it convenient to have a trough made of gutta percha, the two sides and bottom of which are about $\frac{1}{8}$ inch high and just large enough to hold the glass plate. With this trough the mixed solution can be poured over the plate, without fear of any being thrown over the edges.

18th February, 1851

The Stereoscope and the Stereograph

OLIVER WENDELL HOLMES
1859

Oliver Wendell Holmes (1809–1894), famed Boston physician, essayist, and humorist, and father of the noted jurist, was an ardent amateur photographer in the days of the wet plate. He was especially attracted to the three-dimensional photographs produced by a twin-lens camera and viewed by an optical device named by its inventor. Charles Wheatstone, the "stereoscope." Holmes altered this somewhat clumsy instrument into a handheld lightweight frame that held the twin photographs at a reading distance from a pair of magnifying lenses. The effect of this reconstruction of human binocular vision was to him, as to thousands of others, simply miraculous.

Democritus of Abdera, commonly known as the Laughing Philosopher, probably because he did not consider the study of truth inconsistent with a cheerful countenance, believed and taught that all bodies were continually throwing off certain images like themselves, which subtle emanations, striking on our bodily organs, gave rise to our sensations. Epicurus borrowed the idea from him, and incorporated it into the famous system, of which Lucretius has given us the most popular version. Those who are curious on the matter will find the poet's description at the beginning of his fourth book. Forms, effigies, membranes, or *films,* are the nearest representatives of the terms applied to these effluences. They are perpetually shed from the surfaces of solids, as bark is shed by trees. *Cortex* is, indeed, one of the names applied to them by Lucretius.

These evanescent films may be seen in one of their aspects in any clear, calm sheet of water, in a mirror, in the eye of an animal by one who looks at it in front, but better still by the consciousness behind the eye in the ordinary act of vision. They must be packed like the leaves of a closed book; for suppose a mirror to give an image of an object a mile off, it will give one at every point less than a mile, though this were subdivided into a million parts. Yet the images will not be the same;

Reprinted from *The Atlantic Monthly* 3 (June 1859), pp. 738-48.

for the one taken a mile off will be very small, at half a mile as large again, at a hundred feet fifty times as large, and so on, as long as the mirror can contain the image.

Under the action of light, then, a body makes its superficial aspect potentially present at a distance, becoming appreciable as a shadow or as a picture. But remove the cause,—the body itself,—and the effect is removed. The man beholdeth himself in the glass and goeth his way, and straightway both the mirror and the mirrored forget what manner of man he was. These visible films or membranous *exuviae* of objects, which the old philosophers talked about, have no real existence, separable from their illuminated source, and perish instantly when it is withdrawn.

If a man had handed a metallic speculum to Democritus of Abdera, and told him to look at his face in it while his heart was beating thirty or forty times, promising that one of the films his face was shedding should stick there, so that neither he, nor it, nor anybody should forget what manner of man he was, the Laughing Philosopher would probably have vindicated his claim to his title by an explosion that would have astonished the speaker.

This is just what the Daguerreotype has done. It has fixed the most fleeting of our illusions, that which the apostle and the philosopher and the poet have alike used as the type of instability and unreality. The photograph has completed the triumph, by making a sheet of paper reflect images like a mirror and hold them as a picture.

This triumph of human ingenuity is the most audacious, remote, improbable, incredible,—the one that would seem least likely to be regained, if all traces of it were lost, of all the discoveries man has made. It has become such an everyday matter with us, that we forget its miraculous nature, as we forget that of the sun itself, to which we owe the creations of our new art. Yet in all the prophecies of dreaming enthusiasts, in all the random guesses of the future conquests over matter, we do not remember any prediction of such an incon-

53

ceivable wonder, as our neighbor round the corner, or the proprietor of the small house on wheels, standing on the village common, will furnish any of us for the most painfully slender remuneration. No Century of Inventions includes this among its possibilities. Nothing but the vision of a Laputan, who passed his days in extracting sunbeams out of cucumbers, could have reached such a height of delirium as to rave about the time when a man should paint his miniature by looking at a blank tablet, and a multitudinous wilderness of forest foliage or an endless Babel of roofs and spires stamp itself, in a moment, so faithfully and so minutely, that one may creep over the surface of the picture with his microscope and find every leaf perfect, or read the letters of distant signs, and see what was the play at the "Variétés" or the "Victoria," on the evening of the day when it was taken, just as he would sweep the real view with a spy-glass to explore all that it contains.

Some years ago, we sent a page or two to one of the magazines,—the "Knickerbocker," if we remember aright,—in which the story was told from the "Arabian Nights," of the three kings' sons, who each wished to obtain the hand of a lovely princess, and received for answer, that he who brought home the most wonderful object should obtain the lady's hand as his reward. Our readers, doubtless, remember the original tale, with the flying carpet, the tube which showed what a distant friend was doing by looking into it, and the apple which gave relief to the most desperate sufferings only by inhalation of its fragrance. The railroad-car, the telegraph, and the apple-flavored chloroform could and do realize, every day,—as was stated in the passage referred to, with a certain rhetorical amplitude not doubtfully suggestive of the lecture-room,—all that was fabled to have been done by the carpet, the tube, and the fruit of the Arabian story.

All these inventions force themselves upon us to the full extent of their significance. It is therefore hardly necessary to waste any considerable amount of rhetoric upon wonders that are so thoroughly appreciated. When human art says to each one of us, I will give you ears that can hear a whisper in New Orleans, and legs that can walk six hundred miles in a day, and if, in consequence of any defect of rail or carriage, you should be so injured that your own very insignificant walking members must be taken off, I can make the surgeon's visit a pleasant dream for you, on awakening from which you will ask when he is coming to do that which he has done already,—what is the use of poetical or rhetorical amplification? But this other invention of *the mirror with a memory,* and especially that application of it which has given us the wonders of the stereoscope, is

not so easily, completely, universally recognized in all the immensity of its applications and suggestions. The stereoscope, and the pictures it gives, are, however, common enough to be in the hands of many of our readers; and as many of those who are not acquainted with it must before long become as familiar with it as they are now with friction-matches, we feel sure that a few pages relating to it will not be unacceptable.

Our readers may like to know the outlines of the process of making daguerreotypes and photographs, as just furnished us by Mr. Whipple, one of the most successful operators in this country. We omit many of those details which are everything to the practical artist, but nothing to the general reader. We must premise, that certain substances undergo chemical alterations, when exposed to the light, which produce a change of color. Some of the compounds of silver possess this faculty to a remarkable degree,— as the common indelible marking-ink, (a solution of nitrate of silver,) which soon darkens in the light, shows us every day. This is only one of the innumerable illustrations of the varied effects of light on color. A living plant owes its brilliant hues to the sunshine; but a dead one, or the tints extracted from it, will fade in the same rays which clothe the tulip in crimson and gold,—as our lady-readers who have rich curtains in their drawing-rooms know full well. The sun, then, is a master of *chiaroscuro,* and, if he has a living petal for his pallet, is the first of colorists.— Let us walk into his studio, and examine some of his painting machinery.

1. THE DAGUERREOTYPE.—A silver-plated sheet of copper is resilvered by electro-plating, and perfectly polished. It is then exposed in a glass box to the vapor of iodine until its surface turns to a golden yellow. Then it is exposed in another box to the fumes of the bromide of lime until it becomes of a blood-red tint. Then it is exposed once more, for a few seconds, to the vapor of iodine. The plate is now sensitive to light, and is of course kept from it, until, having been placed in the darkened camera, the screen is withdrawn and the camera-picture falls upon it. In strong light, and with the best instruments, *three seconds'* exposure is enough,— but the time varies with circumstances. The plate is now withdrawn and exposed to the vapor of mercury at 212°. Where the daylight was strongest, the sensitive coating of the plate has undergone such a chemical change, that the mercury penetrates readily to the silver, producing a minute white granular deposit upon it, like a very thin fall of snow, drifted by the wind. The strong lights are little heaps of these granules, the middle lights thinner sheets of them; the shades are formed by the

dark silver itself, thinly sprinkled only, as the earth shows with a few scattered snow-flakes on its surface. The precise chemical nature of these granules we care less for than their palpable presence, which may be perfectly made out by a microscope magnifying fifty diameters or even less.

The picture thus formed would soon fade under the action of light, in consequence of further changes in the chemical elements of the film of which it consists. Some of these elements are therefore removed by washing it with a solution of hyposulphite of soda, after which it is rinsed with pure water. It is now permanent in the light, but a touch wipes off the picture as it does the bloom from a plum. To fix it, a solution of hyposulphite of soda containing chloride of gold is poured on the plate while this is held over a spirit-lamp. It is then again rinsed with pure water, and is ready for its frame.

2. The Photograph.—Just as we must have a mould before we can make a cast, we must get a *negative* or reversed picture on glass before we can get our positive or natural picture. The first thing, then, is to lay a sensitive coating on a piece of glass,—crown-glass, which has a natural surface, being preferable to plate-glass. *Collodion,* which is a solution of gun-cotton in alcohol and ether, mingled with a solution of iodide and bromide of potassium, is used to form a thin coating over the glass. Before the plate is dry, it is dipped into a solution of nitrate of silver, where it remains from one to three or four minutes. Here, then, we have essentially the same chemical elements that we have seen employed in the daguerreotype,—namely, iodine, bromine, and silver; and by their mutual reactions in the last process we have formed the sensitive iodide and bromide of silver. The glass is now placed, still wet, in the camera, and there remains from three seconds to one or two minutes, according to circumstances. It is then washed with a solution of sulphate of iron. Every light spot in the camera-picture becomes dark on the sensitive coating of the glass-plate. But where the shadows or dark parts of the camera-picture fall, the sensitive coating is less darkened, or not at all, if the shadows are very deep, and so these shadows of the camera-picture become the lights of the glass picture, as the lights become the shadows. Again, the picture is reversed, just as in every camera-obscura where the image is received on a screen direct from the lens. Thus the glass plate has the right part of the object on the left side of its picture, and the left part on its right side; its light is darkness, and its darkness is light. Everything is just as wrong as it can be, except that the relations of each wrong to the other wrongs are like the relations of the corresponding rights to each other in the original natural image. This is a *negative* picture.

Extremes meet. Every given point of the picture is as far from the truth as a lie can be. But in travelling away from the pattern it has gone round a complete circle, and is at once as remote from Nature and as near it as possible.—"How far is it to Taunton?" said a countryman, who was walking the wrong way to reach that commercial and piscatory centre.—"'Bäout twenty-five thäousan' mild,"—said the boy he asked,—"'f y' go 'z y' 'r' goin' näow, 'n' bäout häaf a mild 'f y' right räoun' 'n' go t'other way."

The negative picture being formed, it is washed with a solution of hyposulphite of soda, to remove the soluble principles which are liable to decomposition, and then coated with shellac varnish to protect it.

This *negative* is now to give birth to a *positive*,—this mass of contradictions to assert its hidden truth in a perfect harmonious affirmation of the realities of Nature. Behold the process!

A sheet of the best linen paper is dipped in salt water and suffered to dry. Then a solution of nitrate of silver is poured over it and it is dried in a dark place. This paper is now sensitive; it has a conscience, and is afraid of daylight. Press it against the glass negative and lay them in the sun, the glass uppermost, leaving them so for from three to ten minutes. The paper, having the picture formed on it, is then washed with the solution of hyposulphite of soda, rinsed in pure water, soaked again in a solution of hyposulphite of soda, to which, however, the chloride of gold has been added, and again rinsed. It is then sized and varnished.

Out of the perverse and totally depraved negative,—where it might almost seem as if some magic and diabolic power had wrenched all things from their properties, where the light of the eye was darkness, and the deepest blackness was gilded with the brightest glare,— is to come the true end of all this series of operations, a copy of Nature in all her sweet graduations and harmonies and contrasts.

We owe the suggestions to a great wit, who overflowed our small intellectual home-lot with a rushing freshet of fertilizing talk the other day,—one of our friends, who quarries thought on his own premises, but does not care to build his blocks into books and essays,—that perhaps this world is only the *negative* of that better one in which lights will be turned to shadows and shadows into light, but all harmonized, so that we shall see why these ugly patches, these misplaced gleams and blots, were wrought into the temporary arrangements of our planetary life.

For, lo! when the sensitive paper is laid in the sun under the negative glass, every dark spot on the glass

arrests a sunbeam, and so the spot of the paper lying beneath remains unchanged; but every light space of the negative lets the sunlight through, and the sensitive paper beneath confesses its weakness, and betrays it by growing dark just in proportion to the glare that strikes upon it. So, too, we have only to turn the glass before laying it on the paper, and we bring all the natural relations of the object delineated back again,—its right to the right of the picture, its left to the picture's left.

On examining the glass negative by transmitting light with a power of a hundred diameters, we observe minute granules, whether crystalline or not we cannot say, very similar to those described in the account of the daguerreotype. But now their effect is reversed. Being opaque, they darken the glass wherever they are accumulated, just as the snow darkens our skylights. Where these particles are drifted, therefore, we have our shadows, and where they are thinly scattered, our lights. On examining the paper photographs, we have found no distinct granules, but diffused stains of deeper or lighter shades.

Such is the sun-picture, in the form in which we now most commonly meet it,—for the daguerreotype, perfect and cheap as it is, and admirably adapted for miniatures, has almost disappeared from the field of landscape, still life, architecture, and *genre* painting, to make room for the photograph. Mr. Whipple tells us that even now he takes a much greater number of miniature portraits on metal than on paper; and yet, except occasionally a statue, it is rare to see anything besides a portrait shown in a daguerreotype. But the greatest number of sun-pictures we see are the photographs which are intended to be looked at with the aid of the instrument we are next to describe, and to the stimulus of which the recent vast extension of photographic copies of Nature and Art is mainly owing.

3. THE STEREOSCOPE.—This instrument was invented by Professor Wheatstone, and first described by him in 1838. It was only a year after this that M. Daguerre made known his discovery in Paris; and almost at the same time Mr. Fox Talbot sent his communication to the Royal Society, giving an account of his method of obtaining pictures on paper by the action of light. Iodine was discovered in 1811, bromine in 1826, chloroform in 1831, gun-cotton, from which collodion is made, in 1846, the electro-plating process about the same time with photography; "all things, great and small, working together to produce what seemed at first as delightful, but as fabulous, as Aladdin's ring, which is now as little suggestive of surprise as our daily bread."

A stereoscope is an instrument which makes surfaces look solid. All pictures in which perspective and light and shade are properly managed, have more or less of the effect of solidity; but by this instrument that effect is so heightened as to produce an appearance of reality which cheats the senses with its seeming truth.

There is good reason to believe that the appreciation of solidity by the eye is purely a matter of education. The famous case of a young man who underwent the operation of couching for cataract, related by Cheselden, and a similar one reported in the Appendix to Müller's Physioiogy, go to prove that everything is seen only as a superficial extension, until the other senses have taught the eye to recognize *depth,* or the third dimension, which gives solidity, by converging outlines, distribution of light and shade, change of size, and of the texture of surfaces. Cheselden's patient thought "all objects whatever touched his eyes, as what he felt did his skin." The patient whose case is reported by Müller could not tell the form of a cube held obliquely before his eye from that of a flat piece of pasteboard presenting the same outline. Each of these patients saw only with one eye,—the other being destroyed, in one case, and not restored to sight until long after the first, in the other case. In two months' time Cheselden's patient had learned to know solids; in fact, he argued so logically from light and shade and perspective that he felt of pictures, expecting to find reliefs and depressions, and was surprised to discover that they were flat surfaces. If these patients had suddenly recovered the sight of *both* eyes, they would probably have learned to recognize solids more easily and speedily.

We can commonly tell whether an object is solid, readily enough with one eye, but still better with two eyes, and sometimes *only* by using both. If we look at a square piece of ivory with one eye alone, we cannot tell whether it is a scale of veneer, or the side of a cube, or the base of a pyramid, or the end of a prism. But if we now open the other eye, we shall see one or more of its sides, if it have any, and then know it to be a solid, and what kind of solid.

We see something with the second eye which we did not see with the first; in other words, the two eyes see different pictures of the same thing, for the obvious reason that they look from points two or three inches apart. By means of these two different views of an object, the mind, as it were, *feels round it* and gets an idea of its solidity. We clasp an object with our eyes, as with our arms, or with our hands, or with our thumb and finger, and then we know it to be something more than a surface. This, of course, is an illustration of the fact, rather than an explanation of its mechanism.

Though, as we have seen, the two eyes look on two different pictures, we perceive but one picture. The two

have run together and become blended into a third, which shows us everything we see in each. But, in order that they should so run together, both the eye and the brain must be in a natural state. Push one eye a little inward with the forefinger, and the image is doubled, or at least confused. Only certain parts of the two retinae work harmoniously together, and you have disturbed their natural relations. Again, take two or three glasses more than temperance permits, and you see double; the eyes are right enough, probably, but the brain is in trouble, and does not report their telegraphic messages correctly. These exceptions illustrate the every-day truth, that, when we are in right condition, our two eyes see two somewhat different pictures, which our perception combines to form one picture, representing objects in all their dimensions, and not merely as surfaces.

Now, if we can get two artificial pictures of any given object, one as we should see it with the right eye, the other as we should see it with the left eye, and then, looking at the right picture, and that only, with the right eye, and at the left picture, and that only, with the left eye, contrive some way of making these pictures run together as we have seen our two views of a natural object do, we shall get the sense of solidity that natural objects give us. The arrangement which effects it will be a *stereoscope,* according to our definition of that instrument. How shall we attain these two ends?

1. An artist can draw an object as he sees it, looking at it only with his right eye. Then he can draw a second view of the same object as he sees it with his left eye. It will not be hard to draw a cube or an octahedron in this way; indeed, the first stereoscopic figures were pairs of outlines, right and left, of solid bodies, thus drawn. But the minute details of a portrait, a group, or a landscape, all so nearly alike to the two eyes, yet not identical in each picture of our natural double view, would defy any human skill to reproduce them exactly. And just here comes in the photograph to meet the difficulty. A first picture of an object is taken,—then the instrument is moved a couple of inches or a little more, the distance between the human eyes, and a second pictur is taken. Better than this, two pictures are taken at once in a double camera.

We were just now stereographed, ourselves, at a moment's warning, as if we were fugitives from justice. A skeleton shape, of about a man's height, its head covered with a black veil, glided across the floor, faced us, lifted its veil, and took a preliminary look. When we had grown sufficiently rigid in our attitude of studied ease, and got our umbrella into a position of thoughtful carelessness, and put our features with much effort into an unconstrained aspect of cheerfulness tempered with

dignity, of manly firmness blended with womanly sensibility, of courtesy, as much as to imply,—"You honor me, Sir," toned or sized, as one may say, with something of the self-assertion of a human soul which reflects proudly, "I am superior to all this,"—when, I say, we were all right, the spectral Mokanna dropped his long veil, and his waiting-slave put a sensitive tablet under its folds. The veil was then again lifted, and the two great glassy eyes stared at us once more for some thirty seconds. The veil then dropped again; but in the mean time, the shrouded sorcerer had stolen our double image; we were immortal. Posterity might thenceforth inspect us, (if not otherwise engaged,) not as a surface only, but in all our dimensions as an undisputed *solid* man of Boston.

2. We have now obtained the double-eyed or twin pictures, or STEREOGRAPH, if we may coin a name. But the pictures are two, and we want to slide them into each other, so to speak, as in natural vision, that we may see them as one. How shall we make one picture out of two, the corresponding parts of which are separated by a distance of two or three inches?

We can do this in two ways. First, by *squinting* as we look at them. But this is tedious, painful, and to some impossible, or at least very difficult. We shall find it much easier to look through a couple of glasses that *squint for us.* If at the same time they *magnify* the two pictures, we gain just so much in the distinctness of the picture, which, if the figures on the slide are small, is a great advantage. One of the easiest ways of accomplishing this double purpose is to cut a convex lens through the middle, grind the curves of the two halves down to straight lines, and join them by their thin edges. This is a *squinting magnifier,* and if arranged so that with its right half we see the right picture on the slide, and with its left half the left picture, it squints them both inward so that they run together and form a single picture.

Such are the stereoscope and the photograph, by the aid of which *form* is henceforth to make itself seen through the world of intelligence, as thought has long made itself heard by means of the art of printing. The *morphotype,* or form-print, must hereafter take its place by the side of the *logotype* or word-print. The *stereograph,* as we have called the double picture designed for the stereoscope, is to be the card of introduction to make all mankind acquaintances.

The first effect of looking at a good photograph through the stereoscope is a surprise such as no painting ever produced. The mind feels its way into the very depths of the picture. The scraggy branches of a tree in

the foreground run out at us as if they would scratch our eyes out. The elbow of a figure stands forth so as to make us almost uncomfortable. Then there is such a frightful amount of detail, that we have the same sense of infinite complexity which Nature gives us. A painter shows us masses; the stereoscopic figure spares us nothing,—all must be there, every stick, straw, scratch, as faithfully as the dome of St. Peter's, or the summit of Mont Blanc, or the ever-moving stillness of Niagara. The sun is no respecter of persons or of things.

This is one infinite charm of the photographic delineation. Theoretically, a perfect photograph is absolutely inexhaustible. In a picture you can find nothing the artist has not seen before you; but in a perfect photograph there will be as many beauties lurking, unobserved, as there are flowers that blush unseen in forests and meadows. It is a mistake to suppose one knows a stereoscopic picture when he has studied it a hundred times by the aid of the best of our common instruments. Do we know all that there is in a landscape by looking out at it from our parlor-windows? In one of the glass stereoscopic views of Table Rock, two figures, so minute as to be mere objects of comparison with the surrounding vastness, may be seen standing side by side. Look at the two faces with a strong magnifier, and you could identify their owners, if you met them in a court of law.

Many persons suppose that they are looking on *miniatures* of the objects represented, when they see them in the stereoscope. They will be surprised to be told that they see most objects as large as they appear in Nature. A few simple experiments will show how what we see in ordinary vision is modified in our perceptions by what we think we see. We made a sham stereoscope, the other day, with no glasses, and an opening in the place where the pictures belong, about the size of one of the common stereoscopic pictures. Through this we got a very ample view of the town of Cambridge, including Mount Auburn and the Colleges, in a single field of vision. We do not recognize how minute distant objects really look to us, without something to bring the fact home to our conceptions. A man does not deceive us as to his real size when we see him at the distance of the length of Cambridge Bridge. But hold a common black pin before the eyes at the distance of distinct vision, and one-twentieth of its length, nearest the point, is enough to cover him so that he cannot be seen. The head of the same pin will cover one of the Cambridge horse-cars at the same distance, and conceal the tower of Mount Auburn, as seen from Boston.

We are near enough to an edifice to see it well, when we can easily read an inscription upon it. The stereoscopic views of the arches of Constantine and of Titus give not only every letter of the old inscriptions, but render the grain of the stone itself. On the pediment of the Pantheon may be read, not only the words traced by Agrippa, but a rough inscription above it, scratched or hacked into the stone by some wanton hand during an insurrectionary tumult.

This distinctness of the lesser details of a building or a landscape often gives us incidental truths which interest us more than the central object of the picture. Here is Alloway Kirk, in the churchyard of which you may read a real story by the side of the ruin that tells of more romantic fiction. There stands the stone "Erected by James Russell, seedsman, Ayr, in memory of his children,"—three little boys, James, and Thomas, and John, all snatched away from him in the space of three successive summer-days, and lying under the matted grass in the shadow of the old witch-haunted walls. It was Burns's Alloway Kirk we paid for, and we find we have bought a share in the griefs of James Russell, seedsman; for is not the stone that tells this blinding sorrow of real life the true centre of the picture, and not the roofless pile which reminds us of an idle legend?

We have often found these incidental glimpses of life and death running away with us from the main object the picture was meant to delineate. The more evidently accidental their introduction, the more trivial they are in themselves, the more they take hold of the imagination. It is common to find an object in one of the twin pictures which we miss in the other; the person or the vehicle having moved in the interval of taking the two photographs. There is before us a view of the Pool of David at Hebron, in which a shadowy figure appears at the water's edge, in the right-hand farther corner of the right-hand picture only. This muffled shape stealing silently into the solemn scene has already written a hundred biographies in our imagination. In the lovely glass stereograph of the Lake of Brienz, on the left-hand side, a vaguely hinted female figure stands by the margin of the fair water; on the other side of the picture she is not seen. This is life; we seem to see her come and go. All the longings, passions, experiences, possibilities of womanhood animate that gliding shadow which has flitted through our consciousness, nameless, dateless, featureless, yet more profoundly real than the sharpest of portraits traced by a human hand. Here is the Fountain of the Ogre, at Berne. In the right picture two women are chatting, with arms akimbo, over its basin; before the plate for the left picture is got ready, "one shall be taken and the other left"; look! on the left side there is but one woman, and you may see the blur where the other is melting into thin air as she fades forever from your eyes.

Oh, infinite volumes of poems that I treasure in this small library of glass and pasteboard! I creep over the vast features of Rameses, on the face of his rockhewn Nubian temple; I scale the huge mountain-crystal that calls itself the Pyramid of Cheops. I pace the length of the three Titanic stones of the wall of Baalbec,—mightiest masses of quarried rock that man has lifted into the air; and then I dive into some mass of foliage with my microscope, and trace the veinings of a leaf so delicately wrought in the painting not made with hands, that I can almost see its down and the green aphis that sucks its juices. I look into the eyes of the caged tiger, and on the scaly train of the crocodile, stretched on the sands of the river that has mirrored a hundred dynasties. I stroll through Rhenish vineyards, I sit under Roman arches, I walk the streets of once buried cities, I look into the chasms of Alpine glaciers, and on the rush of wasteful cataracts. I pass, in a moment, from the banks of the Charles to the ford of the Jordan, and leave my outward frame in the arm-chair at my table, while in spirit I am looking down upon Jerusalem from the Mount of Olives.

"Give me the full tide of life at Charing Cross," said Dr. Johnson. Here is Charing Cross, but without the full tide of life. A perpetual stream of figures leaves no definite shapes upon the picture. But on one side of this stereoscopic doublet a little London "gent" is leaning pensively against a post; on the other side he is seen sitting at the foot of the next post;—what is the matter with the little "gent?"

The very things which an artist would leave out, or render imperfectly, the photograph takes infinite care with, and so makes its illusions perfect. What is the picture of a drum without the marks on its head where the beating of the sticks has darkened the parchment? In three pictures of the Ann Hathaway Cottage, before us,—the most perfect, perhaps, of all the paper stereographs we have seen,—the door at the farther end of the cottage is open, and we see the marks left by the rubbing of hands and shoulders as the good people came through the entry, or leaned against it, or felt for the latch. It is not impossible that scales from the epidermis of the trembling hand of Ann Hathaway's young suitor, Will Shakespeare, are still adherent about the old latch and door, and that they contribute to the stains we see in our picture.

Among the accidents of life, as delineated in the stereograph, there is one that rarely fails in any extended view which shows us the details of streets and buildings. There may be neither man nor beast nor vehicle to be seen. You may be looking down on a place in such a way that none of the ordinary marks of its being actually inhabited show themselves. But in the rawest Western settlement and the oldest Eastern city, in the midst of the shanties at Pike's Peak and stretching across the court-yards as you look into them from above the clay-plastered roofs of Damascus, wherever man lives with any of the decencies of civilization, you will find the *clothes-line*. It may be a fence, (in Ireland,)—it may be a tree, (if the Irish license is still allowed us,)—but clothes-drying, or a place to dry clothes on, the stereoscopic photograph insists on finding, wherever it gives us a group of houses. This is the city of Berne. How it brings the people who sleep under that roof before us to see their sheets drying on that fence! And how real it makes the men in that house to look at their shirts hanging, arms down, from yonder line!

The reader will, perhaps, thank us for a few hints as to the choice of stereoscopes and stereoscopic pictures. The only way to be sure of getting a good instrument is to try a number of them, but it may be well to know which are worth trying. Those made with achromatic glasses may be as much better as they are dearer, but we have not been able to satisfy ourselves of the fact. We do not commonly find any trouble from chromatic aberration (or false color in the image). It is an excellent thing to have the glasses adjust by pulling out and pushing in, either by hand, or, more conveniently, by a screw. The large instruments, holding twenty-five slides, are best adapted to the use of those who wish to show their views often to friends; the owner is a little apt to get tired of the unvarying round in which they present themselves. Perhaps we relish them more for having a little trouble in placing them, as we do nuts that we crack better than those we buy cracked. In optical effect, there is not much difference between them and the best ordinary instruments. We employ one stereoscope with adjusting glasses for the hand, and another common one upon a broad rosewood stand. The stand may be added to any instrument, and is a great convenience.

Some will have none but glass stereoscopic pictures; paper ones are not good enough for them. Wisdom dwells not with such. It is true that there is a brilliancy in a glass picture, with a flood of light pouring through it, which no paper one, with the light necessarily falling *on* it, can approach. But this brilliancy fatigues the eye much more than the quiet reflected light of the paper stereograph. Twenty-five glass slides, well inspected in a strong light, are *good* for one headache, if a person is disposed to that trouble.

Again, a good paper photograph is infinitely better than a bad glass one. We have a glass stereograph of Bethlehem, which looks as if the ground were covered with snow,—and paper ones of Jerusalem, colored and uncolored, much superior to it both in effect and detail. The

Oriental pictures, we think, are apt to have this white, patchy look; possibly we do not get the best in this country.

A good view on glass or paper is, as a rule, best uncolored. But some of the American views of Niagara on glass are greatly improved by being colored; the water being rendered vastly more suggestive of the reality by the deep green tinge. *Per contra,* we have seen some American views so carelessly colored that they were all the worse for having been meddled with. The views of the Hathaway Cottage, before referred to, are not only admirable in themselves, but some of them are admirably colored also. Few glass stereographs compare with them as real representatives of Nature.

In choosing stereoscopic pictures, beware of investing largely in *groups*. The owner soon gets tired to death of them. Two or three of the most striking among them are worth having, but mostly they are detestable,—vulgar repetitions of vulgar models, shamming grace, gentility, and emotion, by the aid of costumes, attitudes, expressions, and accessories worthy only of a Thespian society of candle-snuffers. In buying brides under veils, and such figures, look at the lady's *hands*. You will very probably find the young countess is a maid-of-all-work. The presence of a human figure adds greatly to the interest of all architectural views, by giving us a standard of size, and should often decide our choice out of a variety of such pictures. No view pleases the eye which has glaring patches in it,—a perfectly white-looking river, for instance,—or trees and shrubs in full leaf, but looking as if they were covered with snow,—or glaring roads, or frosted-looking stones and pebbles. As for composition in landscape, each person must consult his own taste. All have agreed in admiring many of the Irish views, as those about the Lakes of Killarney, for instance, which are beautiful alike in general effect and in nicety of detail. The glass views on the Rhine, and of the Pyrenees in Spain, are of consummate beauty. As a specimen of the most perfect, in its truth and union of harmony and contrast, the view of the Circus of Gavarni, with the female figure on horseback in the front ground, is not surpassed by any we remember to have seen.

What is to come of the stereoscope and the photograph we are almost afraid to guess, lest we should seem extravagant. But, premising that we are to give a *colored* stereoscopic mental view of their prospects, we will venture on a few glimpses at a conceivable, if not a possible future.

Form is henceforth divorced from matter. In fact, matter as a visible object is of no great use any longer, except as the mould on which form is shaped. Give us a few negatives of a thing worth seeing, taken from different points of view, and that is all we want of it. Pull it down or burn it up, if you please. We must, perhaps, sacrifice some luxury in the loss of color; but form and light and shade are the great things, and even color can be added, and perhaps by and by may be got direct from Nature.

There is only one Coliseum or Pantheon; but how many millions of potential negatives have they shed,—representatives of billions of pictures,—since they were erected! Matter in large masses must always be fixed and dear; form is cheap and transportable. We have got the fruit of creation now, and need not trouble ourselves with the core. Every conceivable object of Nature and Art will soon scale off its surface for us. Men will hunt all curious, beautiful, grand objects, as they hunt the cattle in South America, for their *skins,* and leave the carcasses as of little worth.

The consequence of this will soon be such an enormous collection of forms that they will have to be classified and arranged in vast libraries, as books are now. The time will come when a man who wishes to see any object, natural or artificial, will go to the Imperial, National, or City Stereographic Library and call for its skin or form, as he would for a book at any common library. We do now distinctly propose the creation of a comprehensive and systematic stereographic library, where all men can find the special forms they particularly desire to see as artists, or as scholars, or as mechanics, or in any other capacity. Already a workman has been travelling about the country with stereographic views of furniture, showing his employer's patterns in this way, and taking orders for them. This is a mere hint of what is coming before long.

Again, we must have special stereographic collections, just as we have professional and other special libraries. And as a means of facilitating the formation of public and private stereographic collections, there must be arranged a comprehensive system of exchanges, so that there may grow up somthing like a universal currency of these bank-notes, or promises to pay in solid substance, which the sun has engraved for the great Bank of Nature.

To render comparison of similar objects, or of any that we may wish to see side by side, easy, there should be a stereographic *metre* or fixed standard of focal length for the camera lens, to furnish by its multiples or fractions, if necessary, the scale of distances, and the standard of power in the stereoscope-lens. In this way the eye can make the most rapid and exact comparisons. If the "great elm" and the Cowthorpe oak, if the State-House and St. Peter's, were taken on the same scale, and looked at with the same magnifying power, we should compare them without the possibility of being misled by those partialities which might tend to make us overrate the indigenous

vegetable and the dome of our native Michel Angelo.

The next European war will send us stereographs of battles. It is asserted that a bursting shell can be photographed. The time is perhaps at hand when a flash of light, as sudden and brief as that of the lightning which shows a whirling wheel standing stock still, shall preserve the very instant of the shock of contact of the mighty armies that are even now gathering. The lightning from heaven does actually photograph natural objects on the bodies of those it has just blasted,—so we are told by many witnesses. The lightning of clashing sabres and bayonets may be forced to stereotype itself in a stillness as complete as that of the tumbling tide of Niagara as we see it self-pictured.

We should be led on too far, if we developed our belief as to the transformations to be wrought by this greatest of human triumphs over earthly conditions, the divorce of form and substance. Let our readers fill out a blank check on the future as they like,—we give our endorsement to their imaginations beforehand. We are looking into stereoscopes as pretty toys, and wondering over the photograph as a charming novelty; but before another generation has passed away, it will be recognized that a new epoch in the history of human progress dates from the time when He who

> —never but in uncreated light
> Dwelt from eternity—

took a pencil of fire from the hand of the "angel standing in the sun," and placed it in the hands of a mortal.

OLIVER WENDELL HOLMES. *Barn.* n.d. The Museum of Fine Arts, Boston.

Doings of the Sunbeam

OLIVER WENDELL HOLMES
1863

As noted in the previous article, Oliver Wendell Holmes was an ardent amateur photographer. He was especially attracted to stereoscopic photography, and designed a lightweight viewer to replace the cumbersome stereoscopes in use in the 1850s. In the following article, the third of his three contributions on photography to the magazine The Atlantic Monthly, *he takes the reader into a typical wet-plate darkroom and describes in his delightful style the processing of glass negatives and printing them on albumen paper. We reproduce with the article, which was not illustrated, a few of the photographs he describes.*

Few of those who seek a photographer's establishment to have their portraits taken know at all into what a vast branch of commerce this business of sun-picturing has grown. We took occasion lately to visit one of the principal establishments in the country, that of Messrs. E. and H. T. Anthony, in Broadway, New York. We had made the acquaintance of these gentlemen through the remarkable instantaneous stereoscopic views published by them, and of which we spoke in a former article in terms which some might think extravagant. Our unsolicited commendation of these marvellous pictures insured us a more than polite reception. Every detail of the branches of the photographic business to which they are more especially devoted was freely shown us, and "No Admittance" over the doors of their inmost sanctuaries came to mean for us, "Walk in; you are heartily welcome."

We should be glad to tell our readers of all that we saw in the two establishments of theirs which we visited, but this would take the whole space which we must distribute among several subdivisions of a subject that offers many points of interest. We must confine ourselves to a few glimpses and sketches.

The guests of the neighboring hotels, as they dally with their morning's omelet, little imagine what varied uses come out of the shells which furnished them their anticipatory repast of disappointed chickens. If they had visited Mr. Anthony's upper rooms, they would have seen a row of young women before certain broad, shallow pans filled with the glairy albumen which once enveloped those potential fowls.

The one next us takes a large sheet of photographic paper, (a paper made in Europe for this special purpose, very thin, smooth, and compact,) and floats it evenly on the surface of the albumen. Presently she lifts it very carefully by the turned-up corners and hangs it *bias,* as a seamstress might say, that is, cornerwise, on a string, to dry. This "albumenized" paper is sold most extensively to photographers, who find it cheaper to buy than to prepare it. It keeps for a long time uninjured, and is "sensitized" when wanted, as we shall see by-and-by.

The amount of photographic paper which is annually imported from France and Germany has been estimated at fifteen thousand reams. Ten thousand native partlets—

"Sic vos non vobis nidificatis, aves"—*

cackle over the promise of their inchoate offspring, doomed to perish unfeathered, before fate has decided whether they shall cluck or crow, for the sole use of the minions of the sun and the feeders of the caravanseras.

In another portion of the same establishment are great collections of the chemical substances used in photography. To give an idea of the scale on which these are required, we may state that the estimate of the annual consumption of the precious metals for photographic purposes, in this country, is set down at ten tons for silver and half a ton for gold. Vast quantities of the hyposulphite of soda, which, we shall see, plays an important part in the process of preparing the negative plate and finishing the positive print, are also demanded.

In another building, provided with steam-power, which performs much of the labor, is carried on the great work of manufacturing photographic albums, cases for portraits, parts of cameras, and of printing pictures from negatives. Many of these branches of work are very inter-

Reprinted from *The Atlantic Monthly* 12 (July 1863), pp. 1-15.

*"O birds, you do not build nests for yourselves!"

esting. The luxurious album, embossed, clasped, gilded, resplendent as a tropical butterfly, goes through as many transformations as a "purple emperor." It begins a pasteboard larva, is swatched and pressed and glued into the condition of a chrysalis, and at last alights on the centretable gorgeous in gold and velvet, the perfect *imago*. The cases for portraits are made in lengths, and cut up, somewhat as they say ships are built in Maine, a mile at a time, to be afterwards sawed across so as to become sloops, schooners, or such other sized craft as may happen to be wanted.

Each single process in the manufacture of elaborate products of skill oftentimes seems and is very simple. The workmen in large establishments, where labor is greatly subdivided, become wonderfully adroit in doing a fraction of something. They always remind us of the Chinese or the old Egyptians. A young person who mounts photographs on cards all day long confessed to having never, or almost never, seen a negative developed, though standing at the time within a few feet of the dark closet where the process was going on all day long. One forlorn individual will perhaps pass his days in the single work of cleaning the glass plates for negatives. Almost at his elbow is a toning bath, but he would think it a good joke, if you asked him whether a picture had lain long enough in the solution of gold or hypo-sulphite.

We always take a glance at the literature which is certain to adorn the walls in the neighborhood of each operative's bench or place for work. Our friends in the manufactory we are speaking of were not wanting in this respect. One of the girls had pasted on the wall before her,

"Kind words can never die"

It would not have been easy to give her a harsh one after reading her chosen maxim. "The Moment of Parting" was twice noticed. "The Haunted Spring." "Dearest May," "The *Bony* Boat," "Yankee Girls," "Yankee Ship and Yankee Crew," "My Country 't is of thee," and—was there ever anybody that ever broke up prose into lengths who would not look to see if there were not a copy of some performance of his own on the wall he was examining, if he were exploring the inner chamber of a freshly opened pyramid?

We left the great manufacturing establishment of the Messrs. Anthony, more than ever impressed with the vast accession of happiness which has come to mankind through this art, which has spread itself as widely as civilization. The photographer can procure every article needed for his work at moderate cost and in quantities suited to his wants. His prices have consequently come down to such a point that pauperism itself need hardly shrink from the outlay required for a family portrait-gallery. The "tin-types," as the small miniatures are called,

—stannotypes would be the proper name,—are furnished at the rate of *two cents* each! A portrait such as Isabey* could not paint for a Marshal of France,—a likeness such as Malbone† could not make of a President's Lady, to be had for two coppers,—a dozen *chefs d'oeuvre* for a quarter of a dollar!

We had been for a long time meditating a devotion of a part of what is left of our more or less youthful energies to acquiring practical knowledge of the photographic art. The auspicious moment came at last, and we entered ourselves as the temporary apprentice of Mr. J. W. Black‡ of this city, well known as a most skilful photographer and a friendly assistant of beginners in the art.

We consider ourselves at this present time competent to set up a photographic ambulance or to hang out a sign in any modest country town. We should, no doubt, overtime and under-tone, and otherwise wrong the countenances of some of our sitters; but we should get the knack in a week or two, and if Baron Wenzel owned to having spoiled a hat-full of eyes before he had fairly learned how to operate for cataract, we need not think too much of libelling a few village physiognomies before considering ourselves fit to take the minister and his deacons. After years of practice there is always something to learn, but every one is surprised to find how little time is required for the acquisition of skill enough to make a passable negative and print a tolerable picture. We could not help learning, with the aid that was afforded us by Mr. Black and his assistants, who were all so very courteous and pleasant, that, as a token of gratitude, we offered to take photographs of any of them who would sit to us for that purpose. Every stage of the process, from preparing a plate to mounting a finished sun-print, we have taught our hands to perform, and can therefore speak with a certain authority to those who wish to learn the way of working with the sunbeam.

Notwithstanding the fact that the process of making a photographic picture is detailed in a great many books,—nay, although we have given a brief account of the principal stages of it in one of our former articles, we are going to take the reader into the sanctuary of the art with us, and ask him to assist, in the French sense of the word, while we make a photograph,—say, rather, while the mysterious forces which we place in condition to act work that miracle for us.

*Jean Baptiste Isabey (1767-1855), French miniature painter.
†Edward Greene Malbone (1777-1807), American miniature painter.
‡James Wallace Black (1825-1896), Boston photographer.

A typical wet-plate darkroom. The window is covered with orange paper. The photographer is developing a plate by pouring developer over it until a satisfactory image is seen. From Gaston Tissandier, *A History and Handbook of Photography,* London, 1878.

We are in a room lighted through a roof of ground glass, its walls covered with blue paper to avoid reflection. A camera mounted on an adjustable stand is before us. We will fasten this picture, which we are going to copy, against the wall. Now we will place the camera opposite to it, and bring it into focus so as to give a clear image on the square of ground glass in the interior of the instrument. If the image is too large, we push the camera back; if too small, push it up towards the picture and focus again. The image is wrong side up, as we see; but if we take the trouble to reverse the picture we are copying, it will appear in its proper position in the camera. Having got an image of the right size, and perfectly sharp, we will prepare a sensitive plate, which shall be placed exactly where the ground glass now is, so that this same image shall be printed on it.

For this purpose we must quit the warm precincts of the cheerful day, and go into the narrow den where the deeds of darkness are done. Its dimensions are of the smallest, and its aspect of the rudest. A feeble yellow flame from a gas-light is all that illuminates it. All around us are troughs and bottles and water-pipes, and ill-conditioned utensils of various kinds. Everything is blackened with nitrate of silver; every form of spot, of streak, of splash, of spatter, of stain, is to be seen upon the floor, the walls, the shelves, the vessels. Leave all linen behind you, ye who enter here, or at least protect it at every exposed point. Cover your hands in gauntlets of India-rubber, if you would not utter Lady Macbeth's soliloquy over them when they come to the light of day. Defend the nether garments with overalls, such as plain artisans are wont to wear. Button the ancient coat over the candid shirt-front, and hold up the retracted wristbands by elastic bands around the shirt-sleeve above the elbow. Conscience and nitrate of silver are telltales that never forget any tampering with them, and the broader the light the darker their record. Now to our work.

Here is a square of crown glass three-fourths as large as a page of the "Atlantic Monthly," if you happen to know that periodical. Let us brush it carefully, that its surface may be free from dust. Now we take hold of it by the upper left-hand corner and pour some of this thin syrup-like fluid upon it, inclining the plate gently from side to side, so that it may spread evenly over the surface, and let the superfluous fluid drain back from the right hand upper corner into the bottle. We keep the plate rocking from side to side, so as to prevent the fluid running in lines, as it has a tendency to do. The neglect of this precaution is evident in some otherwise excellent photographs; we notice it, for instance, in Frith's* Abou Simbel, No. 1, the magnificent rock-temple façade. In less than a minute the syrupy fluid has dried, and appears like a film of transparent varnish on the glass plate. We now place it on a flat double hook of gutta percha and lower it gently into the nitrate-of-silver bath. As it must remain there three or four minutes, we will pass away the time in explaining what has been already done.

The syrupy fluid was *iodized collodion.* This is made by dissolving gun-cotton in ether with alcohol, and adding some iodide of ammonium. When a thin layer of this fluid is poured on the glass plate, the ether and alcohol evaporate very speedily, and leave a closely adherent film of organic matter derived from the cotton, and containing the iodide of ammonium. We have plunged this into the bath, which contains chiefly nitrate of silver, but also some iodide of silver,—knowing that a decomposition

*Francis Frith (1822-1898), English photographer, famous for his photographs of Egyptian temples. See p. 114.

will take place, in consequence of which the iodide of ammonium will become changed to the iodide of silver, which will now fill the pores of the collodion film. The iodide of silver is eminently sensitive to light. The use of the collodion is to furnish a delicate, homogeneous, adhesive, colorless layer in which the iodide may be deposited. Its organic nature may favor the action of light upon the iodide of silver.

While we have been talking and waiting, the process just described has been going on, and we are now ready to take the glass plate out of the nitrate-of-silver bath. It is wholly changed in aspect. The film has become in appearance like a boiled white of egg, so that the glass produces rather the effect of porcelain, as we look at it. Open no door now! Let in no glimpse of day, or the charm is broken in an instant! No Sultana was ever veiled from the light of heaven as this milky tablet we hold must be. But we must carry it to the camera which stands waiting for it in the blaze of high noon. To do this we first carefully place it in this narrow case, called a *shield*, where it lies safe in utter darkness. We now carry it to the camera, and, having removed the ground glass on which the camera-picture had been brought to an exact focus, we drop the shield containing the sensitive plate into the groove the glass occupied. Then we pull out a slide, as the blanket is taken from a horse before he starts. There is nothing now but to remove the brass cap from the lens. That is giving the word Go! It is a tremulous moment for the beginner.

As we lift the brass cap, we begin to count seconds,—by a watch, if we are naturally unrhythmical,—by the pulsations in our souls, if we have an intellectual pendulum and escapement. Most persons can keep tolerably even time with a second-hand while it is traversing its circle. The light is pretty good at this time, and we count only as far as thirty, when we cover the lens again with the cap. Then we replace the slide in the shield, draw this out of the camera, and carry it back into the shadowy realm where Cocytus flows in black nitrate of silver and Acheron stagnates in the pool of hyposulphite, and invisible ghosts, trooping down from the world of day, cross a Styx of dissolved sulphate of iron, and appear before the Rhadamanthus of that lurid Hades.*

Such a ghost we hold imprisoned in the shield we have just brought from the camera. We open it and find our milky-surfaced glass plate looking exactly as it did when we placed it in the shield. No eye, no microscope, can detect a trace of change in the white film that is spread over it. And yet there is a potential image in it,—a latent soul, which will presently appear before its judge. This is the Stygian stream,—this solution of proto-sulphate of iron, with which we will presently flood the white surface.

We pour on the solution. There is no change at first; the fluid flows over the whole surface as harmless and as useless as if it were water. What if there were no pictures there? Stop! what is that change of color beginning at this edge, and spreading as a blush spreads over a girl's cheek? It is a border, like that round the picture, and then dawns the outline of a head, and now the eyes come out from the blank as stars from the empty sky, and the lineaments define themselves, plainly enough, yet in a strange aspect,—for where there was light in the picture we have shadow, and where there was shadow we have light. But while we look it seems to fade again, as if it would disappear. Have no fear of that; it is only deepening its shadows. Now we place it under the running water which we have always at hand. We hold it up before the dull-red gas-light, and then we see that every line of the original and the artist's name are reproduced as sharply as if the fairies had engraved them for us. The picture is perfect of its kind, only it seems to want a little more force. That we can easily get by the simple process called "intensifying" or "redeveloping." We mix a solution of nitrate of silver and of pyrogallic acid in about equal quantities, and pour it upon the pictured film and back again into the vessel, repeating this with the same portion of fluid several times. Presently the fluid grows brownish, and at the same time the whole picture gains the depth of shadow in its darker parts which we desire. Again we place it under the running water. When it is well washed, we plunge it into this bath of hyposulphite of soda, which removes all the iodide of silver, leaving only the dark metal impregnating the film. After it has remained there a few minutes, we take it out and wash it again as before under the running stream of water. Then we dry it, and when it is dry, pour varnish over it, dry that, and it is done. This is a *negative,*—not a true picture, but a reversed picture, which puts darkness for light and light for darkness. From this we can take true pictures, or *positives.*

Let us now proceed to take one of these pictures. In a small room, lighted by a few rays which filter through a yellow curtain, a youth has been employed all the morning in developing the sensitive conscience of certain sheets of paper, which came to him from the manufacturer already glazed by having been floated upon the white of eggs and carefully dried, as previously described.

*In classical mythology, Hades, the underworld, is bordered by the rivers Cocytus, Acheron, and the Styx, across which the bodies of the dead are transported; Rhadamanthus was one of the three judges who separated the blessed from the damned.

This "albumenized" paper the youth lays gently and skill-fully upon the surface of a solution of nitrate of silver. When it has floated there a few minutes, he lifts it, lets it drain, and hangs it by one corner to dry. This "sensitized" paper is served fresh every morning, as it loses its delicacy by keeping.

We take a piece of this paper of the proper size, and lay it on the varnished or pictured side of the negative, which is itself laid in a wooden frame, like a picture-frame. Then we place a thick piece of cloth on the paper. Then we lay a hinged wooden back on the cloth, and by means of two brass springs press all close together,—the wooden back against the cloth, the cloth against the paper, the paper against the negative. We turn the frame over and see that the plain side of the glass negative is clean. And now we step out upon the roof of the house into the bright sunshine, and lay the frame, with the glass uppermost, in the full blaze of light. For a very little while we can see the paper darkening through the nega-tive, but presently it clouds so much that its further changes cannot be recognized. When we think it has darkened nearly enough, we turn it over, open a part of the hinged back, turn down first a portion of the thick cloth, and then enough of the paper to see something of the forming picture. If not printed dark enough as yet, we turn back to their places successively the picture, the cloth, the opened part of the frame, and lay it again in the sun. It is just like cooking: the sun is the fire, and the pic-ture is the cake; when it is browned exactly to the right point, we take it off the fire. A photograph-printer will have fifty or more pictures printing at once, and he keeps going up and down the line, opening the frames to look and see how they are getting on. As fast as they are done, he turns them over, back to the sun, and the cooking process stops at once.

The pictures which have just been printed in the sun-shine are of a peculiar purple tint, and still sensitive to the light, which will first "flatten them out," and finally darken the whole paper, if they are exposed to it before the series of processes which "fixes" and "tones" them. They are kept shady, therefore, until a batch is ready to go down to the toning room.

When they reach that part of the establishment, the first thing that is done with them is to throw them face down upon the surface of a salt bath. Their purple changes at once to a dull red. They are then washed in clean water for a few minutes, and after that laid, face up, in a solution of chloride of gold with a salt of soda. Here they must lie for some minutes at least; for the change, which we can watch by the scanty daylight ad-mitted, goes on slowly. Gradually they turn to a darker shade; the reddish tint becomes lilac, purple, brown, of

somewhat different tints in different cases. When the process seems to have gone far enough, the picture is thrown into a bath containing hyposulphite of soda, which dissolves the superfluous, unstable compounds, and rapidly clears up the lighter portions of the picture. On being removed from this, it is thoroughly washed, dried, and mounted, by pasting it with starch or dex-trine to a card of the proper size.

The reader who has followed the details of the process may like to know what are the common difficulties the beginner meets with.

The first is in coating the glass with collodion. It takes some practice to learn to do this neatly and uniformly.

The second is in timing the immersion in the nitrate-of-silver bath. This is easily overcome; the glass may be examined by the feeble lamp-light at the end of two or three minutes, and if the surface looks streaky, replunged in the bath for a minute or two more, or until the surface looks smooth.

The third is in getting an exact focus in the camera, which wants good eyes, or strong glasses for poor ones.

The fourth is in timing the exposure. This is the most delicate of all the processes. Experience alone can teach the time required with different objects in different lights. Here are four card-portraits from a negative taken from one of Barry's crayon-pictures, illustrating an experiment which will prove very useful to the beginner. The nega-tive of No. 1 was exposed only two seconds. The young lady's face is very dusky on a very dusky ground. The lights have hardly come out at all. No. 2 was exposed five seconds. Undertimed, but much cleared up. No. 3 was exposed fifteen seconds, about the proper time. It is the best of the series, but the negative ought to have been intensified. It looks as if Miss E. V. had washed her face since the five-seconds picture was taken. No. 4 was ex-posed sixty seconds, that is to say, three or four times too long. It has a curious resemblance to No. 1, but is less dusky. The contrasts of light and shade which gave life to No. 3 have disappeared, and the face looks as if a sec-ond application of soap would improve it. A few trials of this kind will teach the eye to recognize the appear-ances of under- and over-exposure, so that, if the first negative proves to have been too long or too short a time in the camera, the proper period of exposure for the next may be pretty easily determined.

The printing from the negative is less difficult, because we can examine the picture as often as we choose; but it may be well to undertime and overtime some pictures, for the sake of a lesson like that taught by the series of pictures from the four negatives.

The only other point likely to prove difficult is the toning in the gold bath. As the picture can be watched,

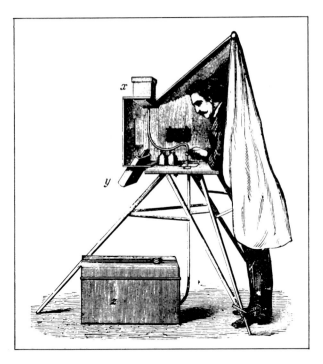

A portable darktent for processing wet-plate negatives. From H. W. Vogel, *The Chemistry of Light and Photography,* New York, 1875.

however, a very little practice will enable us to recognize the shade which indicates that this part of the process is finished.

We have copied a picture, but we can take a portrait from Nature just as easily, except for a little more trouble in adjusting the position and managing the light. So easy is it to reproduce the faces that we love to look upon; so simple is that marvellous work by which we preserve the first smile of infancy and the last look of age: the most precious gift Art ever bestowed upon love and friendship!

It will be observed that the glass plate, covered with its film of collodion, was removed directly from the nitrate-of-silver bath to the camera, so as to be exposed to its image while still wet. It is obvious that this process is one that can hardly be performed conveniently at a distance from the artist's place of work. Solutions of nitrate of silver are not carried about and decanted into baths and back again into bottles without tracking their path on persons and things. The *photophobia* of the "sensitized" plate, of course, requires a dark apartment of some kind: commonly a folding tent is made to answer the purpose in photographic excursions. It becomes, therefore, a serious matter to transport all that is required to make a negative according to the method described. It has consequently been a great desideratum to find some way of preparing a sensitive plate which could be dried

68

and laid away, retaining its sensitive quality for days or weeks until wanted. The artist would then have to take with him nothing but his camera and his dry sensitive plates. After exposing these in the camera, they would be kept in dark boxes until he was ready to develop them at leisure on returning to his *atelier.*

Many "dry methods" have been contrived, of which the *tannin process* is in most favor. The plate, after being "sensitized" and washed, is plunged in a bath containing ten grains of tannin to an ounce of water. It is then dried, and may be kept for a long time without losing its sensitive quality. It is placed dry in the camera, and developed by wetting it and then pouring over it a mixture of pyrogallic acid and the solution of nitrate of silver. Amateurs find this the best way for taking scenery, and produce admirable pictures by it, as we shall mention by-and-by.

In our former articles we have spoken principally of stereoscopic pictures. These are still our chief favorites for scenery, for architectural objects, for almost everything but portraits,—and even these last acquire a reality in the stereoscope which they can get in no other way. In this third photographic excursion we must only touch briefly upon the stereograph. Yet we have something to add to what we said before on this topic.

One of the most interesting accessions to our collection is a series of twelve views, on glass, of scenes and objects in California, sent us with unprovoked liberality by the artist, Mr. Watkins.* As specimens of art they are admirable, and some of the subjects are among the most interesting to be found in the whole realm of Nature. Thus, the great tree, the "Grizzly Giant," of Mariposa, is shown in two admirable views; the mighty precipice of El Capitan, more than three thousand feet in precipitous height,—the three conical hill-tops of Yo Semite, taken, not as they soar into the atmosphere, but as they are reflected in the calm waters below,—these and others are shown, clear, yet soft, vigorous in the foreground, delicately distinct in the distance, in a perfection of art which compares with the finest European work.

The "London Stereoscopic Company" has produced some very beautiful paper stereographs, very dear, but worth their cost, of the Great Exhibition. There is one view, which we are fortunate enough to possess, that is a marvel of living detail,—one of the series showing the opening ceremonies. The picture gives principally the musicians. By careful counting, we find there are *six hundred faces to the square inch* in the more crowded portion of the scene which the view embraces,—a part occupied

*Carleton Emmons Watkins (1829-1916), American photographer, best known for his West Coast landscapes.

CARLETON E. WATKINS. *Inverted in the Tide Stand the Grey Rocks.* 1861. Stereograph. Yosemite Collection, National Park Service (Baird Collection).

by the female singers. These singers are all clad in white, and packed with great compression of crinoline,—if that, indeed, were worn on the occasion. Mere points as their faces seem to the naked eye, the stereoscope, and still more a strong magnifier, shows them with their mouths all open as they join in the chorus, and with such distinctness that some of them might readily be recognized by those familiar with their aspect. This, it is to be remembered, is not a reduced stereograph for the microscope, but a common one, taken as we see them taken constantly.

We find in the same series several very good views of Gibson's* famous colored "Venus," a lady with a pleasant face and a very pretty pair of shoulders. But the grand "Cleopatra" of our countryman, Mr. Story,† of which we have heard so much, was not to be had,—why not we cannot say, for a stereograph of it would have had an immense success in America, and doubtless everywhere.

The London Stereoscopic Company has also furnished us with views of Paris, many of them instantaneous, far in advance of the earlier ones of Parisian origin. Our darling little church of St. Etienne du Mont, for instance, with its staircase and screen of stone embroidery, its carved oaken pulpit borne on the back of a carved oaken Samson, its old monuments, its stained windows, is brought back to us in all its minute detail as we remember it in many a visit made on our way back from the

morning's work at La Pitié‡ to the late breakfast at the Café Procope. Some of the instantaneous views are of great perfection, and carry us fairly upon the Boulevards as Mr. Anthony transports us to Broadway. With the exception of this series, we have found very few new stereoscopic pictures in the market for the last year or two. This is not so much owing to the increased expense of importing foreign views as to the greater popularity of *card-portraits,* which, as everybody knows, have become the social currency, the sentimental "green-backs" of civilization, within a very recent period.

We, who have exhausted our terms of admiration in describing the stereoscopic picture, will not quarrel with the common taste which prefers the card-portrait. The last is the cheapest, the most portable, requires no machine to look at it with, can be seen by several persons at the same time,—in short, has all the popular elements. Many care little for the wonders of the world brought before their eyes by the stereoscope; all love to see the faces of their friends. Jonathan does not think a great deal of the Venus of Milo, but falls into raptures over a card-portrait of his Jerusha. So far from finding fault with him, we rejoice rather that his affections and those of average mortality are better developed than their taste; and lost as we sometimes are in contemplation of the shadowy masks of ugliness which hang in the frames of the photographers, as the skins of beasts are stretched upon tanners' fences, we still feel grateful, when we remember the days of itinerant portrait-painters, that the indignities of Nature are no longer intensified by the outrages of Art.

The sitters who throng the photographer's establish-

*John Gibson (1790-1866), British sculptor.
†William Wetmore Story (1819-1895), American sculptor; his "Cleopatra" is in the Metropolitan Museum of Art, New York.
‡The Hôpital de la Pitié, where Holmes was a medical student.

ment are a curious study. They are of all ages, from the babe in arms to the old wrinkled patriarchs and dames whose smiles have as many furrows as an ancient elm has rings that count its summers. The sun is a Rembrandt in his way, and loves to track all the lines in these old splintered faces. A photograph of one of them is like one of those fossilized sea-beaches where the raindrops have left their marks, and the shellfish the grooves in which they crawled, and the wading birds the divergent lines of their foot-prints,—tears, cares, griefs, once vanishing as impressions from the sand, now fixed as the vestiges in the sand-stone.

Attitudes, dresses, features, hands, feet, betray the social grade of the candidates for portraiture. The picture tells no lie about them. There is no use in their putting on airs; the make-believe gentleman and lady cannot look like the genuine article. Mediocrity shows itself for what it is worth, no matter what temporary name it may have acquired. Ill-temper cannot hide itself under the simper of assumed amiability. The querulousness of incompetent complaining natures confesses itself almost as much as in the tones of the voice. The anxiety which strives to smooth its forehead cannot get rid of the telltale furrow. The weakness which belongs to the infirm of purpose and vacuous of thought is hardly to be disguised, even though the moustache is allowed to hide *the centre of expression.*

All parts of a face doubtless have their fixed relations to each other and to the character of the person to whom the face belongs. But there is one feature, and especially one part of that feature, which more than any other facial sign reveals the nature of the individual. The feature is *the mouth,* and the portion of it referred to is *the corner.* A circle of half an inch radius, havings its centre at the junction of the two lips will include the chief focus of expression.

This will be easily understood, if we reflect that here is the point where more muscles of expression converge than at any other. From above comes the elevator of the angle of the mouth; from the region of the cheekbone slant downwards the two *zygomatics,* which carry the angle outwards and upwards; from behind comes the *buccinator,* or trumpeter's muscle, which simply widens the mouth by drawing the corners straight outward; from below, the depressor of the angle; not to add a seventh, sometimes well marked,—the "laughing muscle" of Santorini.* Within the narrow circle where these muscles meet the ring of muscular fibres surrounding the mouth the battles of the soul record their varying fortunes and

results. This is the *"noeud vital,"*—to borrow Flourens's† expression with reference to a nervous centre,—the *vital knot* of expression. Here we may read the victories and defeats, the force, the weakness, the hardness, the sweetness of a character. Here is the nest of that feeble fowl, self-consciousness, whose brood strays at large over all the features.

If you wish to see the very look your friend wore when his portrait was taken, let not the finishing artist's pencil intrude within the circle of the vital knot of expression.

We have learned many curious facts from photographic portraits which we were slow to learn from faces. One is the great number of aspects belonging to each countenance with which we are familiar. Sometimes, in looking at a portrait, it seems to us that this is just the face we know, and that it is always thus. But again another view shows us a wholly different aspect, and yet as absolutely characteristic as the first; and a third and a fourth convince us that our friend was not one, but many, in outward appearance, as in the mental and emotional shapes by which his inner nature made itself known to us.

Another point which must have struck everybody who has studied photographic portraits is the family likeness that shows itself throughout a whole wide connection. We notice it more readily than in life, from the fact that we bring many of these family-portraits together and study them more at our ease. There is something in the face that corresponds to *tone* in the voice,—recognizable, not capable of description; and this kind of resemblance in the faces of kindred we may observe, though the features are unlike. But the features themselves are wonderfully tenacious of their old patterns. The Prince of Wales is getting to look like George III. We noticed it when he was in this country; we see it more plainly in his recent photographs. Governor Endicott's features have come straight down to some of his descendants in the present day. There is a dimpled chin which runs through one family connection we have studied, and a certain form of lip which belongs to another. As our *cheval de bataille* stands ready saddled and bridled for us just now, we must indulge ourselves in mounting him for a brief excursion. This is a story we have told so often that we should begin to doubt it but for the fact that we have before us the written statement of the person who was its subject. His professor, who did not know his name or anything about him, stopped him one day after lecture and asked him if he was not a relation of Mr.———— , a person of some note in Essex County.—Not that he had ever heard of.—The professor

* Giovanni Domenica Santorini (1681–ca. 1737), Italian anatomist.

†Pierre Jean Marie Flourens (1794–1867), French physiologist.

thought he must be,—would he inquire?—Two or three days afterwards, having made inquiries at his home in Middlesex County, he reported that an elder member of the family informed him that Mr. ——————'s great-grandfather on his mother's side and his own great-grandfather on his father's side were own cousins. The whole class of facts, of which this seems to us too singular an instance to be lost, is forcing itself into notice, with new strength of evidence, through the galleries of photographic family-portraits which are making everywhere.

In the course of a certain number of years there will have been developed some new physiognomical results, which will prove of extreme interest to the physiologist and the moralist. They will take time; for, to bring some of them out fully, a generation must be followed from its cradle to its grave.

The first is a precise study of the effects of age upon the features. Many series of portraits taken at short intervals through life, studied carefully side by side, will probably show to some acute observer that Nature is very exact in the tallies that mark the years of human life.

The second is to result from a course of investigations which we would rather indicate than follow out; for, if the student of it did not fear the fate of Phalaris,—that he should find himself condemned as unlifeworthy upon the basis of his own observations,—he would very certainly become the object of eternal hatred to the proprietors of all the semi-organizations which he felt obliged to condemn. It consists in the study of the laws of physical degeneration,—the stages and manifestations of the process by which Nature dismantles the complete and typical human organism, until it becomes too bad for her own sufferance, and she kills it off before the advent of the reproductive period, that it may not permanently depress her average of vital force by taking part in the life of the race. There are many signs that fall far short of the marks of cretinism,—yet just as plain as that is to the *visus eruditus,*—which one meets every hour of the day in every circle of society. Many of these are partial arrests of development. We do not care to mention all which we think may be recognized, but there is one which we need not hesitate to speak of from the fact that it is so exceedingly common.

The vertical part of the lower jaw is short, and the angle of the jaw is obtuse, in infancy. When the physical development is complete, the lower jaw, which, as the active partner in the business of mastication, must be developed in proportion to the vigor of the nutritive apparatus, comes down by a rapid growth which gives the straight-cut posterior line and the bold right angle so familiar to us in the portraits of pugilists, exaggerated by the caricaturists in their portraits of fighting men, and no-

ticeable in well-developed persons of all classes. But in imperfectly grown adults the jaw retains the infantile character,—the short vertical portion necessarily implying the obtuse angle. The upper jaw at the same time fails to expand laterally: in vigorous organisms it spreads out boldly, and the teeth stand square and with space enough; whereas in subvitalized persons it remains narrow, as in the child, so that the large front teeth are crowded, or slanted forward, or thrown out of line. This want of lateral expansion is frequently seen in the jaws, upper and lower, of the American, and has been considered a common cause of caries of the teeth.

A third series of results will relate to the effect of character in moulding the features. Go through a "rogues' gallery" and observe what the faces of the most hardened villains have in common. All these villainous looks have been shaped out of the unmeaning lineaments of infancy. The police-officers know well enough the expression of habitual crime. Now, if all this series of faces had been carefully studied in photographs from the days of innocence to those of confirmed guilt, there is no doubt that a keen eye might recognize, we will not say the first evil volition in the change it wrought upon the face, nor each successive stage in the downward process of the falling nature, but epochs and eras, with differential marks, as palpable perhaps as those which separate the aspects of the successive decades of life. And what is far pleasanter, when the character of a neglected and vitiated child is raised by wise culture, the converse change will be found —nay, has been found—to record itself unmistakably upon the faithful page of the countenance; so that charitable institutions have learned that their strongest appeal lies in the request, "Look on this picture, and on that,"— the lawless boy at his entrance, and the decent youth at his dismissal.

The field of photography is extending itself to embrace subjects of strange and sometimes of fearful interest. We have referred in a former article to a stereograph in a friend's collection showing the bodies of the slain heaped up for burial after the Battle of Malignano. We have now before us a series of photographs showing the field of Antietam and the surrounding country, as they appeared after the great battle of the 17th of September. These terrible mementos of one of the most sanguinary conflicts of the war we owe to the enterprise of Mr. Brady of New York. We ourselves were on the field upon the Sunday following the Wednesday when the battle took place. It is not, however, for us to bear witness to the fidelity of views which the truthful sunbeam has delineated in all their dread reality. The photographs bear witness to the accuracy of some of our own sketches in a paper published in the December number of this maga-

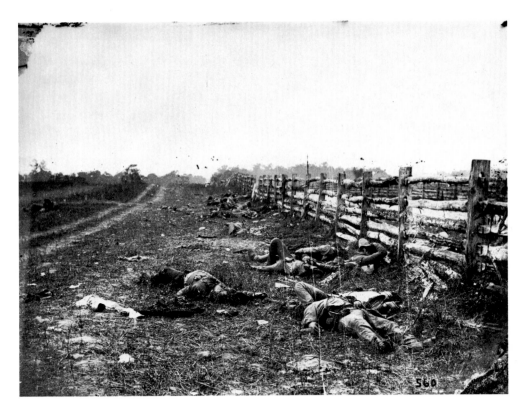

ALEXANDER GARDNER. *Confederate Dead by a Fence on the Hagerston Road, Antietam, September 17, 1862.* The Library of Congress, Washington, D.C.

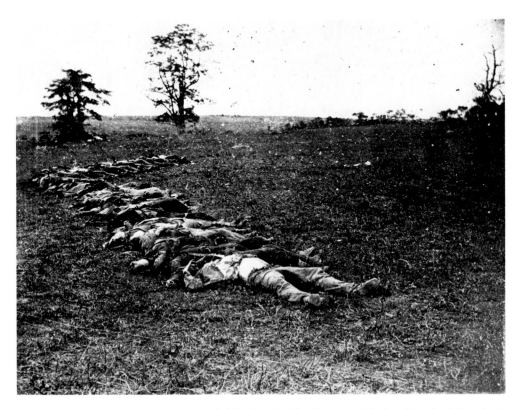

Brady's caption for this photograph, probably taken by Gardner, was *Gathered for Burial at Antietam after the Battle of September 17, 1862.* The Library of Congress, Washington, D.C.

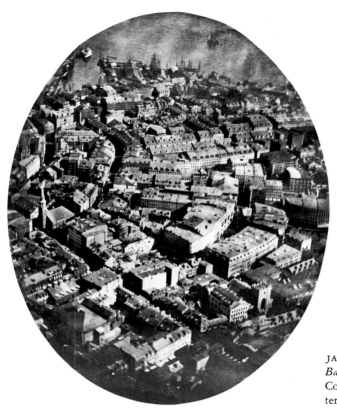

JAMES WALLACE BLACK. *Boston, from the Balloon "Queen of the Air," 1860.* Sipley Collection, George Eastman House, Rochester, N.Y.

zine. The "ditch" is figured, still encumbered with the dead, and strewed, as we saw it and the neighboring fields, with fragments and tatters. The "colonel's gray horse" is given in another picture just as we saw him lying.

Let him who wishes to know what the war is look at this series of illustrations. These wrecks of manhood thrown together in careless heaps or ranged in ghastly rows for burial were alive but yesterday. How dear to their little circles far away most of them!—how little cared for here by the tired party whose office it is to consign them to the earth! An officer may here and there be recognized; but for the rest—if enemies, they will be counted, and that is all. "80 Rebels are buried in this hole" was one of the epitaphs we read and recorded. Many people would not look through this series. Many, having seen it and dreamed of its horrors, would lock it up in some secret drawer, that it might not thrill or revolt those whose soul sickens at such sights. It was so nearly like visiting the battlefield to look over these views, that all the emotions excited by the actual sight of the stained and sordid scene, strewed with rags and wrecks, came back to us, and we buried them in the recesses of our cabinet as we would have buried the mutilated remains of the dead they too vividly represented. Yet war and battles should have truth for their delineator. It is well enough for some Baron Gros or Horace Vernet to please an im-

perial master with fanciful portraits of what they are supposed to be. The honest sunshine

"Is Nature's sternest painter, yet the best";

and that gives us, even without the crimson coloring which flows over the recent picture, some conception of what a repulsive, brutal, sickening, hideous thing it is, this dashing together of two frantic mobs to which we give the name of armies. The end to be attained justifies the means, we are willing to believe; but the sight of these pictures is a commentary on civilization such as a savage might well triumph to show its missionaries. Yet through such martyrdom must come our redemption. War is the surgery of crime. Bad as it is in itself, it always implies that something worse has gone before. Where is the American, worthy of his privileges, who does not now recognize the fact, if never until now, that the disease of our nation was organic, not functional, calling for the knife, and not for washes and anodynes?

It is a relief to soar away from the contemplation of these sad scenes and fly in the balloon which carried Messrs. King* and Black in their aërial photographic excursion. Our townsman, Dr. John Jeffries, as is well recollected, was one of the first to tempt the perilous heights of the atmosphere, and the first who ever performed a

*Samuel Archer King, American balloonist and, from 1864 to 1866 active as photographer in Boston.

journey through the air of any considerable extent. We believe this attempt of our younger townsmen to be the earliest in which the aëronaut has sought to work the two miracles at once, of rising against the force of gravity, and picturing the face of the earth beneath him without brush or pencil.

One of their photographs is lying before us. Boston, as the eagle and the wild goose see it, is a very different object from the same place as the solid citizen looks up at its eaves and chimneys. The Old South and Trinity Church are two landmarks not to be mistaken. Washington Street slants across the picture as a narrow cleft. Milk Street winds as if the cowpath which gave it a name had been followed by the builders of its commercial palaces. Windows, chimneys, and skylights attract the eye in the central parts of the view, exquisitely defined, bewildering in numbers. Towards the circumference it grows darker, becoming clouded and confused, and at one end a black expanse of waveless water is whitened by the nebulous outline of flitting sails. As a first attempt it is on the whole a remarkable success; but its greatest interest is in showing what we may hope to see accomplished in the same direction.

While the aëronaut is looking at our planet from the vault of heaven where he hangs suspended, and seizing the image of the scene beneath him as he flies, the astronomer is causing the heavenly bodies to print their images on the sensitive sheet he spreads under the rays concentrated by his telescope. We have formerly taken occasion to speak of the wonderful stereoscopic figures of the moon taken by Mr. De la Rue* in England, by Mr. Rutherford† and by Mr. Whipple‡ in this country. To these most successful experiments must be added that of Dr. Henry Draper,§ who has constructed a reflecting telescope, with the largest silver reflector in the world, except that of the Imperial Observatory at Paris, for the special purpose of celestial photography. The reflectors made by Dr. Draper "will show Debilissima quadruple, and easily bring out the companion of Sirius or the sixth star in the trapezium of Orion." In taking photographs from these mirrors, a movement of the sensitive plate of only one-hundredth of an inch will render the image perceptibly less sharp. It was this accuracy of convergence of the light which led Dr. Draper to prefer the mirror to the achromatic lens. He has taken almost all the daily phases

of the moon, from the sixth to the twenty-seventh day, using mostly some of Mr. Anthony's quick collodion, and has repeatedly obtained the full moon by means of it in *one-third of a second.*

In the last "Annual of Scientific Discovery" are interesting notices of photographs of the sun, showing the spots on his disk, of Jupiter with his belts, and Saturn with his ring.

While the astronomer has been reducing the heavenly bodies to the dimensions of his stereoscopic slide, the anatomist has been lifting the invisible by the aid of his microscope into palpable dimensions, to remain permanently recorded in the handwriting of the sun himself. Eighteen years ago, M. Donné‡ published in Paris a series of plates executed after figures obtained by the process of Daguerre. These, which we have long employed in teaching, give some pretty good views of various organic elements, but do not attempt to reproduce any of the tissues. Professor O. N. Rood,** of Troy, has sent us some most interesting photographs, showing the markings of infusoria enormously magnified and perfectly defined. In a stereograph sent us by the same gentleman the epithelium scales from mucous membrane are shown floating or half-submerged in fluid,—a very curious effect, requiring the double image to produce it. Of all the microphotographs we have seen, those made by Dr. John Dean, of Boston, from his own sections of the spinal cord, are the most remarkable for the light they throw on the minute structure of the body. The sections made by Dr. Dean are in themselves very beautiful specimens, and have formed the basis of a communication to the American Academy of Arts and Sciences, in which many new observations have been added to our knowledge of this most complicated structure. But figures drawn from images seen in the field of the microscope have too often been known to borrow a good deal from the imagination of the beholder. Some objects are so complex that they defy the most cunning hand to render them with all their features. When the enlarged image is suffered to delineate itself, as in Dr. Dean's views of the *medulla oblongata,* there is no room to question the exactness of the portraiture, and the distant student is able to form his own opinion as well as the original observer. These later achievements of Dr. Dean have excited much attention here and in Europe, and point to a new epoch of anatomical and physiological delineation.

*Warren De la Rue (1815-1899), English astronomer.

†Lewis Morris Rutherford (1816-1892), American astronomer.

‡John Adams Whipple (1822-1891), American photographer active in Boston.

§Henry Draper (1837-1882), American astronomer famed for his telescopic photographs of heavenly bodies.

‡ Alfred Donné (1801-1873), French physician, director of the clinic in the Hôpital de la Charité in Paris, published an *Atlas exécuté d'après nature au micro-daguerreotype* (Paris, 1845), with nineteen engravings from daguerreotypes of biological specimens.

**Ogden Nicholas Rood (1831-1902), American physicist.

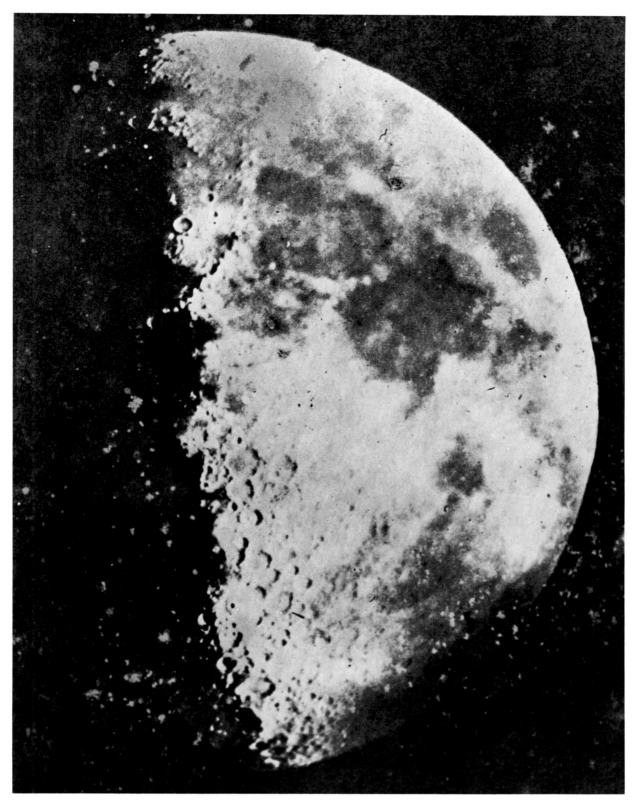

JOHN ADAMS WHIPPLE. *The Moon.* Daguerreotype taken through the 23-foot telescope of Harvard College Observatory. 1851. Reproduced from a paper copy print by Whipple in *The Photographic Art Journal,* July 1853.

The reversed method of microscopic photography is that which gives portraits and documents in little. The best specimen of this kind we have obtained is another of those miracles which recall the wonders of Arabian fiction. On a slip of glass, three inches long by one broad, is a circle of thinner glass, as large as a ten-cent piece. In the centre of this is a speck, as if a fly had stepped there without scraping his foot before setting it down. On putting this under a microscope magnifying fifty diameters there comes into view the Declaration of Independence in full, in a clear, bold type, every name signed in fac-simile; the arms of all the States, easily made out, and well finished; with good portraits of all the Presidents, down to a recent date. Any person familiar with the faces of the Presidents would recognize any one of these portraits in a moment.

Still another application of photography, becoming every day more and more familiar to the public, is that which produced enlarged portraits, even life-size ones, from the old daguerreotype or more recent photographic miniature. As we have seen this process, a closet is arranged as a camera-obscura, and the enlarged image is thrown down through a lens above on a sheet of sensitive paper placed on a table capable of being easily elevated or depressed. The image, weakened by diffusion over so large a space, prints itself slowly, but at last comes out with a clearness which is surprising,—a fact which is parallel to what is observed in the stereoscopticon, where a picture of a few square inches in size is "extended" or diluted so as to cover some hundreds of square feet, and yet preserves its sharpness to a degree which seems incredible.

The copying of documents to be used as evidence is another most important application of photography. No scribe, however skilful, could reproduce such a paper as we saw submitted to our fellow-workman in Mr. Black's establishment the other day. It contained perhaps a hundred names and marks, but smeared, spotted, soiled, rubbed, and showing every awkward shape of penmanship that a miscellaneous collection of half-educated persons could furnish. No one, on looking at the photographic copy, could doubt that it was a genuine reproduction of a real list of signatures; and when half a dozen such copies, all just alike, were shown, the conviction became a certainty that all had a common origin. This copy was made with a *Harrison's globe lens* of sixteen inches' focal length, and was a very sharp and accurate duplicate of the original. It is claimed for this new American invention that it is "quite ahead of anything European;" and the certificates from the United States Coast-Survey Office go far towards sustaining its pretensions.

Some of our readers are aware that photographic operations are not confined to the delineation of material objects. There are certain establishments in which, for an extra consideration, (on account of the *difficilis ascensus,* or other long journey they have to take,) the spirits of the departed appear in the same picture which gives the surviving friends. The actinic influence of a ghost on a sensitive plate is not so strong as might be desired; but considering that spirits are so nearly immaterial, that the stars, as Ossian tells us, can be seen through their vaporous outlines, the effect is perhaps as good as ought to be expected.

Mrs. Brown, for instance, has lost her infant, and wishes to have its spirit-portrait taken with her own. A special sitting is granted, and a special fee is paid. In due time the photograph is ready, and, sure enough, there is the misty image of an infant in the background, or, it may be, across the mother's lap. Whether the original of the image was a month or a year old, whether it belonged to Mrs. Brown or Mrs. Jones or Mrs. Robinson, King Solomon, who could point out so sagaciously the parentage of unauthenticated babies, would be puzzled to guess. But it is enough for the poor mother, whose eyes are blinded with tears, that she sees a print of drapery like an infant's dress, and a rounded something, like a foggy dumpling, which will stand for a face: she accepts the spirit-portrait as a revelation from the world of shadows. Those who have seen shapes in the clouds, or remember Hamlet and Polonius, or who have noticed how readily untaught eyes see a portrait of parent, spouse, or child in almost any daub intended for the same, will understand how easily the weak people who resort to these places are deluded.

There are various ways of producing the spirit-photographs. One of the easiest is this. First procure a bereaved subject with a mind "sensitized" by long immersion in credulity. Find out the age, sex, and whatever else you can, about his or her departed relative. Select from your numerous negatives one that corresponds to the late lamented as nearly as may be. Prepare a sensitive plate. Now place the negative against it and hold it up close to your gas-lamp, which may be turned up pretty high. In this way you get a foggy copy of the negative in one part of the sensitive plate, which you can then place in the camera and take your flesh-and-blood sitter's portrait upon it in the usual way. An appropriate background for these pictures is a view of the asylum for feeble-minded persons, the group of buildings at Somerville, and possibly, if the penitentiary could be introduced, the hint would be salutary.

The number of amateur artists in photography is continually increasing. The interest we ourselves have taken in some results of photographic art has brought us under

a weight of obligation to many of them which we can hardly expect to discharge. Some of the friends in our immediate neighborhood have sent us photographs of their own making which for clearness and purity of tone compare favorably with the best professional work. Among our more distant correspondents there are two so widely known to photographers that we need not hesitate to name them: Mr. Coleman Sellers* of Philadelphia and Mr. S. Wager Hull of New York. Many beautiful specimens of photographic art have been sent us by these gentlemen,—among others, some exquisite views of Sunnyside and of the scene of Ichabod Crane's adventures. Mr. Hull has also furnished us with a full account of the dry process, as followed by him, and from which he brings out results hardly surpassed by any method.

A photographic intimacy between two persons who never saw each other's faces (that is, in Nature's original positive, the principal use of which, after all, is to furnish negatives from which portraits may be taken) is a new form of friendship. After an introduction by means of a few views of scenery or other impersonal objects, with a letter or two of explanation, the artist sends his own presentment, not in the stiff shape of a purchased *carte de visite,* but as seen in his own study or parlor, surrounded by the domestic accidents which so add to the

*Coleman Sellers (1827-1907), American mechanical engineer, locomotive builder, and amateur photographer.

individuality of the student or the artist. You see him at his desk or table with his books and stereoscopes round him; you notice the lamp by which he reads,—the objects lying about; you guess his condition, whether married or single; you divine his tastes, apart from that which he has in common with yourself. By-and-by, as he warms towards you, he sends you the picture of what lies next to his heart,—a lovely boy, for instance, such as laughs upon us in the delicious portrait on which we are now looking, or an old homestead, fragrant with all the roses of his dead summers, caught in one of Nature's loving moments, with the sunshine gilding it like the light of his own memory. And so these shadows have made him with his outer and his inner life a reality for you: and but for his voice, which you have never heard, you know him better than hundreds who call him by name, as they meet him year after year, and reckon him among their familiar acquaintances.

To all these friends of ours, those whom we have named, and not less those whom we have silently remembered, we send our grateful acknowledgements. They have never allowed the interest we have long taken in the miraculous art of photography to slacken. Though not one of them may learn anything from this simple account we have given, they will perhaps allow that it has a certain value for less instructed readers, in consequence of its numerous and rich omissions of much which, however valuable, is not at first indispensable.

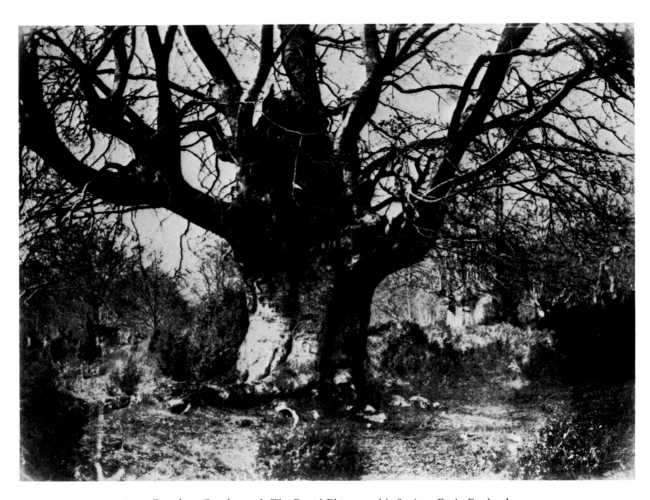

SIR WILLIAM J. NEWTON. *Burnham Beeches.* n.d. The Royal Photographic Society, Bath, England.

Upon Photography in an Artistic View, and its Relation to the Arts

SIR WILLIAM J. NEWTON
1853

In 1853 a group of photographers, both amateurs and professionals, formed The Photographic Society of London, which quickly became a center for the exchange of knowledge about the technique, the scientific principles, and the aesthetic possibilities of photography. At the first meeting the painter Sir William John Newton (1785–1869) read a paper on the value of the camera to artists. His advice to put the subject "a little out of focus thereby giving a greater breadth of effect" led to much discussion and controversy.

The present advanced state of Photography, and its applicability to the Fine Arts, as well as to many branches of science, suggested the idea of forming a Photographic Society, and I am happy to state that it is now established under most favourable circumstances, and if carried out with zeal and energy, must produce results of the greatest importance to art and science.

It is not however my intention to dilate upon the science of Photography. I shall endeavour to direct attention principally to its *artistic* character, and to embrace what, after all appears to me to be almost of first importance, viz. the mode of proceeding which a Photographer ought to adopt, and how his labours and productions should bear upon it.

Let us consider what these productions are. The subjects vary with the taste of the operator; and the collection, which but lately decorated these walls, showed how numerous were the selections, in which solar action had been applied. Every variety of subject, from the most solid and substantial to the most light and airy, were displayed with that exactitude of delineation which completely sets at nought the exertions of *manual* ingenuity; still the general tone of nature has yet to be accomplished by means of Photography.

Who has *not* studied nature so much as to observe how beautifully she throws her atmospheric veil, detaching each object, while producing that harmony and union of parts which the most splendid specimen of chemical Photography fails to realize! Consequently, *at present*, it is in vain to look for that true representation of light and shade in Photography, which is to be found in a fine work of art.

What course therefore ought a Photographer to pursue?—Let him in the laboratory devise and discover the means by which he can produce his pictures still more minute and perfect in detail, as that must always be a great stride in what is, strictly speaking, Photography and science; but, he must ever remember, that his subjects are principally natural objects, powerfully acted upon by atmospheric influence.

Therefore, in the illustrations which are sent forth to the world to be placed in similar positions as pictures and engravings, their appearance ought not to be so *chemically*, as *artistically* beautiful. The nearest approach in this respect, which I have yet seen, were the excellent Photographs exhibited by Mr. Stewart.

It must always be borne in mind, that essentially speaking, the Camera is by no means calculated to *teach* the *principles* of art; but, to those who are already well informed in this respect, and have had practical experience, it may be made the means of considerable advancement. At the same time I do not conceive it to be necessary or *desirable* for an *artist* to represent or aim at the attainment of every minute detail, but to endeavour at producing a broad and general effect, by which means the *suggestions* which nature offers, as represented by the Camera, will assist his studies materially: and indeed, for this purpose, I do not consider it necessary that the whole of the subject should be what is called *in focus*; on the contrary, I have found in many instances that the object is better obtained by the whole subject being a little *out of focus*, thereby giving a greater breadth of effect, and consequently more *suggestive* of the true character of nature. I wish, however, to be understood as applying these observations to artists only, such productions being considered as private *studies* to assist him in his compositions; and for groups of figures, or any subject requiring to be obtained as quickly as possible, the Collodion

Reprinted from *Journal of the Photographic Society* 1 (1853), pp. 6-7.

process is, of course, the best we are yet acquainted with.

I will now take this opportunity of adverting to another mode which an *artist* may fairly adopt, with respect to his negatives, in order to render them more like works of art; and I am particularly desirous of directing attention to this subject, because it has been recently stated in this room, that a Photograph should always remain as represented in the Camera, without any attempt to improve it by art. In this, however, I by no means agree, and therefore I am desirous of removing such false and limited views as applying to the practice of artists, or indeed, to any person having the skill and judgment requisite for the above object.

Wonderful as the powers of the Camera are, we have not yet attained that degree of perfection so as to represent faithfully the effect of *colours,* and consequently of *light and shade*; for instance, a bright red or yellow which would act as a *light* in nature, is always represented as a *dark* in the Camera; and the same with green; blue, on the contrary, is always lighter; hence the impossibility of representing the true effect of nature, or a picture, by means of Photography. Consequently, I conceive that when a tolerably faithful and picturesque effect can be obtained by a chemical or other process, applied to the negative, the operator is at full liberty to use his own discretion.

When Photography is applied to buildings for *architectural* purposes, then every effort should be exerted to get all the detail as sharp and clean as possible, regardless of any other consideration. But, as I have before observed, a different treatment is required to produce a picturesque effect; for instance, the light of the sky generally acts so powerfully upon the excited surface while in the Camera, as to produce an opake black, whereby, in taking the positive, the chemical rays cannot penetrate;—the consequence is, a perfectly white surface, which, when contrasted with dark objects, such as trees and buildings, &c., is always rather hard and disagreeable. Now in such case I consider it to be right to proceed in any manner by which this may be obviated; for instance, in the foregoing observations respecting the sky, iodide or cyanide of potassium may be employed to give the form of clouds, which, in this respect, would be darker than the general tone of the paper; or, if the negative should be of a transparent character, then Indian ink, or other dark material, may be used so as to produce the effect of light clouds.

I will now advert to the mode I have adopted, in taking positives by the *negative* process. I am, however, well aware that I lose something by this means in sharpness, and perhaps in softness, but, on the whole, it appears to me that a more artistic character is produced, that it is more under control, and that there is a greater certainty as respects, not only the effect, but the colour you may desire; for portraits perhaps the usual mode is the best. I own that I prefer the colour which most resembles that of a print; this, however, is a matter of taste; but, if a *warmer* tone is preferred, this can be obtained by using a stronger iodized paper. I generally use from seven to ten grains of iodide of silver to one ounce of water: however, I will not enter further into this subject, as I have, at the request of several friends, sent a rather minute statement of the Calotype process (which I have adopted for about three years) to the paper called "Notes and Queries," and I believe it will appear this week. I wish, however, to state that my object has been to assist the *beginner* rather than anything else.

In conclusion, I consider it to be a sort of duty, as an artist, to recommend the student in art *not* to take up the Camera as a means of advancement in his profession until he has made himself well acquainted with the true principles of his art, as well as acquired considerable power of hand, with a view to draw with ease and correctness the *outline* of any object he may wish to represent. If, however, any student should imagine that the Camera will help him to this desirable attainment without the requisite study on his part, he will find himself much mistaken when, perhaps, it may be too late to repair the injury. I am the more desirous of directing the attention of the student in Art to the foregoing observations, because I am well aware of the seductive nature of the practice of Photography, and how it is calculated to divert him from his principal object in the earlier part of his studies.

I beg to state that I have thrown out these observations merely as hints; every photographer will of course judge for himself the best mode of proceeding, according to his requirements; but as an artist and a photographer of some experience, I have considered that I was more particularly called upon to state my views respecting the mode of applying Photography as an assistant to the Fine Arts.

Photography

LADY ELIZABETH EASTLAKE
1857

The following article was first published as a review of some of the early writings on photography. Originally unsigned, it was revealed by the British periodical Photographic Notes *to have been written by Lady Elizabeth Eastlake (1809–1893), the wife of Sir Charles Eastlake, the Director of the National Gallery of Art in London and, for the first two years of its existence, president of the Photographic Society of London (now the Royal Photographic Society of Great Britain). It is not only one of the first histories of photography, but also is a most penetrating analysis of the position of photography as an art. After painstakingly cataloging the deficiencies of picture-making by photography as compared to picture-making by painting, Lady Eastlake arrives at the surprisingly modern conclusion that photography is "a new medium of communication" and has its independent and indispensable place.*

1. *History and Practice of Photogenic Drawing, or the true principles of the Daguerreotype, with the New Method of Dioramic Painting. Secrets purchased by the French Government, and by their command published for the benefit of the Arts and Manufactures.* By the Inventor, L. J. M. Daguerre, Officer of the Legion of Honour, and Member of various Academies. Translated from the original by J. S. Memes, LL.D., London, 1839.
2. *A Practical Manual of Photography, containing a concise History of the Science and its connection with Optics, together with simple and practical details for the Production of Pictures by the Action of Light upon prepared Surfaces of Paper, Glass, and Silvered Plates, by the Processes known as the Daguerreotype, Calotype, Collodion, Albumen, &c.* By a Practical Photographer.
3. *On the Practice of the Calotype Process of Photography.* By George S. Cundell, Esq. Philosophical Magazine, vol. xxiv., No. 160. May, 1844.
4. *Researches on the Theory of the Principal Phenomena of Photography in the Daguerreotype Process.* By A. Claudet. Read before the British Association at Birmingham, Sept. 14, 1849.
5. *Researches on Light, an Examination of all the Phenomena connected with the Chemical and Molecular Changes produced by the influence of the Solar Rays, embracing all the known Photographic Processes and new Discoveries in the Art.*
6. *Progress of Photography—Collodion—the Stereoscope. A Lecture by Joseph Ellis.* Read at the Literary and Scientific Institution of Brighton, Nov. 13, 1855.
7. *The Journal of the Photographic Society.* Edited by the Rev. J. R. Major, M.A., F.S.A., King's College, London.

It is now more than fifteen years ago that specimens of a new and mysterious art were first exhibited to our wondering gaze. They consisted of a few heads of elderly gentlemen executed in a bistre-like colour upon paper. The heads were not above an inch long, they were little more than patches of broad light and shade, they showed no attempt to idealise or soften the harshnesses and accidents of a rather rugged style of physiognomy—on the contrary, the eyes were decidedly contracted, the mouths expanded, and the lines and wrinkles intensified. Nevertheless we examined them with the keenest admiration, and felt that the spirit of Rembrandt had revived. Before that time little was the existence of a power, availing itself of the eye of the sun both to discern and to execute, suspected by the world—still less that it had long lain the unclaimed and unnamed legacy of our own Sir Humphry Davy. Since then photography has become a household word and a household want; is used alike by art and science, by love, business, and justice; is found in the most sumptuous saloon, and in the dingiest attic—in the solitude of the Highland cottage, and in the glare of the London gin-palace—in the pocket of the detective, in the cell of the convict, in the folio of the painter and architect, among the papers and patterns of the mill-owner and manufacturer, and on the cold brave breast on the battle-field.

The annals of photography, as gathered from the London Directory, though so recent, are curious. As early as

Reprinted from *Quarterly Review* (London) 101 (April 1857), pp. 442-68.

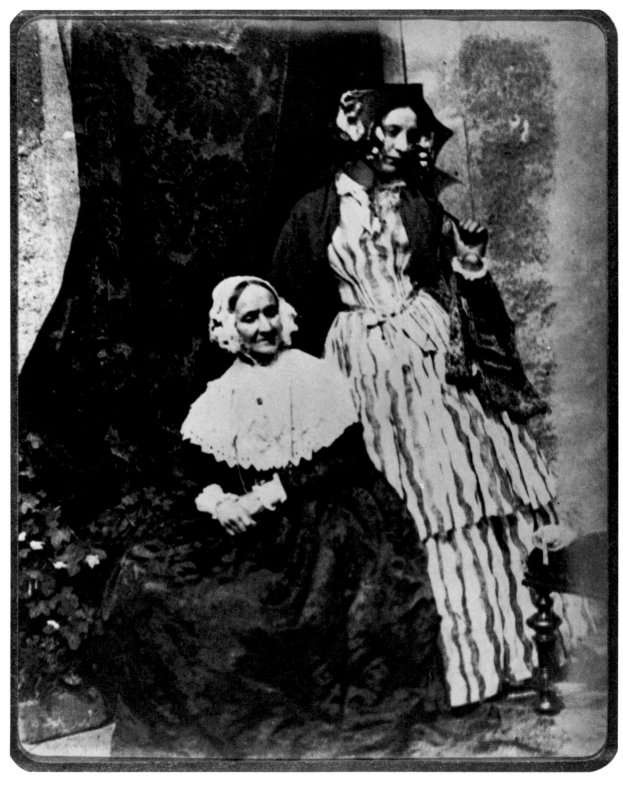

DAVID OCTAVIUS HILL & ROBERT ADAMSON. *Mrs. Anne Rigby and her daughter Elizabeth* [later Lady Eastlake]. ca. 1844. Calotype. George Eastman House, Rochester, N.Y.

1842 one individual, of the name of Beard, assumed the calling of a daguerreotype artist. In 1843 he set up establishments in four different quarters of London, reaching even to Wharf Road, City Road, and thus alone supplied the metropolis until 1847. In 1848 Claudet* and a few more appear on the scene, but, owing to then existing impediments, their numbers even in 1852 did not amount to more than seven. In 1855 the expiration of the patent and the influence of the Photographic Society swelled them to sixty-six—in 1857 photographers have a heading to themselves and stand at 147.

These are the higher representatives of art. But who can number the legion of petty dabblers, who display their trays of specimens along every great thoroughfare in London, executing for our lowest servants, for one shilling, that which no money could have commanded for the Rothschild bride of twenty years ago? Not that photographers flock especially to the metropolis; they are wanted everywhere and found everywhere. The large provincial cities abound with the sun's votaries, the smallest town is not without them; and if there be a village so poor and remote as not to maintain a regular establishment, a visit from a photographic travelling van gives it the advantages which the rest of the world are enjoying. Thus, where not half a generation ago the existence of such a vocation was not dreamt of, tens of thousands (especially if we reckon the purveyors of photographic materials) are now following a new business, practising a new pleasure, speaking a new language, and bound together by a new sympathy.

For it is one of the pleasant characteristics of this pursuit that it unites men of the most diverse lives, habits, and stations, so that whoever enters its ranks finds himself in a kind of republic, where it needs apparently but to be a photographer to be a brother. The world was believed to have grown sober and matter-of-fact, but the light of photography has revealed an unsuspected source of enthusiasm. An instinct of our nature, scarcely so worthily employed before, seems to have been kindled, which finds something of the gambler's excitement in the frequent disappointments and possible prizes of the photographer's luck. When before did any motive short of the stimulus of chance or the greed of gain unite in one uncertain and laborious quest the nobleman, the tradesman, the prince of blood royal, the innkeeper, the artist, the manservant, the general officer, the private soldier, the hard-worked member of every learned profession, the gentleman of leisure, the Cambridge wrangler, the man who bears some of the weightiest responsibili-

ties of this country on his shoulder, and, though last, not least, the fair woman whom nothing but her own choice obliges to be more than the fine lady? The records of the Photographic Society, established in 1853, are curiously illustrative of these incongruities. Its first chairman, in order to give the newly instituted body the support and recognition which art was supposed to owe it, was chosen expressly from the realms of art. Sir Charles Eastlake therefore occupied the chair for two years; at the end of which the society selected a successor quite as interested and efficient from a sphere of life only so far connected with art and science as being their very antipodes, namely, Sir Frederick Pollock, the Chief Baron of England. The next chairman may be a General fresh from the happy land where they photograph the year round; the fourth, for aught that can be urged to the contrary, the Archbishop of Canterbury. A clergyman of the Established Church has already been the editor to the journal of the society. The very talk of these photographic members is unlike that of any other men, either of business or pleasure. Their style is made of the driest facts, the longest words, and the most high-flown rhapsodies. Slight improvements in processes, and slight varieties in conclusions, are discussed as if they involved the welfare of mankind. They seek each other's sympathy, and they resent each other's interference, with an ardour of expression at variance with all the sobrieties of business, and the habits of reserve; and old-fashioned English *mauvaise honte* is extinguished in the excitement, not so much of a new occupation as of a new state. In one respect, however, we can hardly accuse them of the language of exaggeration. The photographic body can no longer be considered only a society, it is becoming 'one of the institutions of the country.' Branches from the parent tree are flourishing all over the United Kingdom. Liverpool assists Norwich, Norwich congratulates Dublin, Dublin fraternises with the Birmingham and Midland Institute, London sympathises with each, and all are looking with impatience to Manchester. Each of these societies elect their officers, open their exhibitions, and display the same encouraging medley of followers. The necessity too for regular instruction in the art is being extensively recognised. The Council of King's College have instituted a lectureship of photography. Photographic establishments are attached to the Royal Arsenal at Woolwich; a photographic class is opened for the officers of the Royal Artillery and Engineers; lectures are given at the Royal Institution, and popular discourses at Mechanics' Institutes. Meanwhile British India has kept pace with the mother country. The Photographic Society at Bombay is only second in period of formation to that of London. Calcutta, Madras,

*Antoine François Jean Claudet (1797-1867), French daguerreotypist in England.

Bengal, and minor places all correspond by means of societies. The Elphinstone Institution has opened a class for instruction. Nor is the feeling of fellowship confined to our own race. The photographic and political alliance with France and this country was concluded at about the same period, and we can wish nothing more than that they may be maintained with equal cordiality. The Duke de Luynes, a French nobleman of high scientific repute, has placed the sum of 10,000 francs at the disposal of the Paris Photographic Society, to be divided into two prizes for objects connected with the advance of the art,—the prizes open to the whole world. The best landscape photographs at the *Exposition des Beaux Art* were English, the best architectural specimens in the London Exhibition are French. The Exhibition at Brussels last October was more cosmopolitan than Belgian. The Emperors of Russia and Austria, adopting the old way for paying new debts, are bestowing snuff-boxes on photographic merit. These are but a few of the proofs that could be brought forward of the wide dissemination of the new agent, and of the various modes of its reception, concluding with a juxtaposition of facts which almost ludicrously recall paragraphs from the last speech from the throne; for while our Queen has sent out a complete photographic apparatus for the use of the King of Siam, the King of Naples alone, of the whole civilised world, has forbidden the practice of the works of light in his dominions!

Our chief object at present is to investigate the connexion of photography with art—to decide how far the sun may be considered an artist, and to what branch of imitation his powers are best adapted. But we must first give a brief history of those discoveries which have led to the present efficiency of the solar pencil. It appears that the three leading nations—the French, the English, and the Germans—all share in the merit of having first suggested, then applied, and finally developed the existence of the photographic element. It may not be superfluous to all our readers to state that the whole art in all its varieties rests upon the fact of the blackening effects of light upon certain substances, and chiefly upon silver, on which it acts with a decomposing power. The silver being dissolved in a strong acid, surfaces steeped in the solution became encrusted with minute particles of the metal, which in this state darkened with increased rapidity. These facts were first ascertained and recorded, as regards chloride of silver, or silver combined with chlorine, in 1777, by Scheele, a native of Pomerania, and in 1801, in connexion with nitrate of silver, by Ritter of Jena. Here therefore were the raw materials for the unknown art; the next step was to employ them. And now we are at once met by that illustrious name to which we

have alluded. Sir Humphry Davy was the first to make the practical application of these materials, and to foresee their uses. In conjunction with Mr. Thomas Wedgwood, only less eminent than his brother Josiah,* Sir Humphry succeeded, by means of a camera obscura,† in obtaining images upon paper, or white leather prepared with nitrate of silver—of which proceeding he has left the most interesting record in the *Journal of the Royal Society* for June, 1802.‡ Their aim, as the title shows, was not ambitious; but the importance lay in the first stain designedly traced upon the prepared substance, not in the thing it portrayed. In one sense, however, it was very aspiring, if colour as well as form were sought to be transferred, as would appear from their attempt to copy coloured glass; otherwise it is difficult to account for their selecting this particular material.*

Besides showing the possibility of imprinting the forms of objects thus reflected in the camera, the paper in question proceeds to describe the process since known as 'Photographic Drawing,' by which leaves, or lace, or the wings of insects, or any flat and semi-transparent substances, laid upon prepared paper, and exposed to the direct action of the sun, will leave the perfect tracery of their forms. But having thus conjured up the etherial spirit of photography, they failed in all attempts to retain it in their keeping. The charm once set agoing refused to stop—the slightest exposure to light, even for the necessary purposes of inspection, continued the action, and the image was lost to view in the darkening of the whole paper. In short, they wanted the next secret, that of rendering permanent, or, in photographic language, of *fixing* the image. Here, therefore, the experiment was left to be taken up by others, though not without a memento of the prophetic light cast on the mind's eye of the great elucidator; for Sir Humphry observes, 'Nothing but a method of preventing the unshaded parts of the delineation from being coloured by the exposure to the day is wanted to render this process as useful as it is elegant.'

Meanwhile, in 1803, some remarkable experiments were made by Dr. Wollaston, proving the action of light upon a resinous substance known in commerce as "gum

*Thomas Wedgwood (1771-1805) and Josiah Wedgwood (1769-1843) were sons of the illustrious potter of Etruria, Josiah Wedgwood (1730-1795).

†As Wedgwood and Davy recount (pp. 15-16), they were unsuccessful in recording a camera image.

‡Reprinted, pp. 15-16.

*An account of a method of copying paintings upon glass and making *profiles* by the agency of light upon nitrate of silver, with observations by Humphry Davy. [Note by Lady Eastlake]

guaiacum;" and in due time another workman entered the field who availed himself of this class of materials. The name of Joseph Nicéphore de Niépce is little known to the world as one of the founders of the now popular art, his contributions being exactly of that laborious and rudimental nature which later inventions serve to conceal. He was a French gentleman of private fortune, who lived at Châlon-sur-Saone, and pursued chemistry for his pleasure. Except also in the sense of time, he cannot be called a successor to Davy and Wedgwood; for it is probable that the path they had traced was unknown to him. Like them, however, he made use of the camera to cast his images; but the substance on which he received them was a polished plate of pewter, coated with a thin bituminous surface. His process is now rather one of the curiosities of photographic history; but, such as it was, it gained the one important step of rendering his creations permanent. The labours of the sun in his hands remained spell-bound, and remain so still. He began his researches in 1814, and was ten years before he attained this end. To M. Niépce also belongs the credit of having at once educed the high philosophic principle, since then universally adopted in photographic practice, which put faith before sight—the conviction of what must be before the appearance of what is. His pictures, on issuing from the camera, were invisible to the eye, and only disengaged by the application of a solvent which removed those shaded parts unhardened by the action of the light. Nor do they present the usual reversal of the position of light and shade, known in photographic language as a *negative* appearance; but whether taken from nature or from an engraving, are identical in effect, or what is called *positives*. But though, considering all these advantages, the art of Heliography, as it was called by its author, was at that early period as great a wonder as any that have followed it, yet it was deficient in those qualities which recommend a discovery to an impatient world. The process was difficult, capricious, and tedious. It does not appear that M. Niépce ever obtained an image from nature in less than between seven to twelve hours, so that the change in lights and shadows necessarily rendered it imperfect; and in a specimen we have seen, the sun is shining on opposite walls. Deterred probably by this difficulty from any aspirations after natural scenes, M. Niépce devoted his discovery chiefly to the copying of engravings. To this he sought to give a practical use by converting his plate, by means of the application of an acid, into a surface capable of being printed by the ordinary methods. Here again he was successful, as specimens of printed impressions still show, though under circumstances too uncertain and laborious to encourage their adoption. Thus the comparative obscurity in which

his merits have remained is not difficult to comprehend; for while he conquered many of the greater difficulties of the art, he left too many lesser ones for the world to follow in his steps. To these reasons may be partially attributed the little sensation which the efforts of this truly modest and ingenious gentleman created in this country, which he visited in 1827, for the purpose, he states, of exhibiting his results to the Royal Society, and of rendering homage of his discovery to his Britannic Majesty. A short memorial, drawn up by himself, was therefore forwarded, with specimens, to the hands of George IV.; but a rule on the part of the Royal Society to give no attention to a discovery which involves a secret proved a barrier to the introduction of M. Niépce's results to that body. Dr. Wollaston was the only person of scientific eminence to whom they appear to have been exhibited; and, considering their intrinsic interest, as well as the fact of his being in some sort their progenitor, it is difficult to account for the little attention he appears to have paid them. M. Niépce therefore returned to his own country, profoundly convinced of the English inaptitude for photographic knowledge.

In the mean time the indiscretion of an optician revealed to the philosopher of Châlon the fact that M. Daguerre, a dioramic artist by profession, was pursuing researches analogous to his own in Paris. This led to an acquaintance between the two, and finally to a legal partnership in the present pains and possible profits of the new art. M. Niépce died in 1833 without, it seems, contributing any further improvement to the now common stock; and M. Daguerre, continuing his labours, introduced certain alterations which finally led to a complete change in the process. Suffice it to say that, discarding the use of the bituminous varnish, and substituting a highly polished tablet of silver, he now first availed himself of that great agent in photographic science, the action of iodine, by means of which the sensitiveness of his plate was so increased as to render the production of the image an affair of fewer minutes than it had previously been of hours. At the same time the picture, still invisible, was brought to light by the application of the fumes of mercury, after which a strong solution of common salt removed those portions of the surface which would otherwise have continued to darken, and thus rendered the impression permanent.

Here, therefore, was a representation obtained in a few minutes by a definite and certain process, which was exquisitely minute and clear in detail, capable of copying nature in all her stationary forms, and also true to the natural conditions of light and shade. For the fumes of mercury formed minute molecules of a white colour upon those parts of the iodised tablet darkened by the

light, thus producing the lights to which the silver ground supplied the shades.

In 1839 the results of M. Daguerre's years of labour, called after himself the Daguerreotype, came forth fully furnished for use; and in the June of that year gave rise to a remarkable scene in the French Chambers. The question before the deputies was this: MM. Daguerre and Niépce jun. (for the partnership gave all the advantages of M. Daguerre's discovery to the son of his late colleague) were possessed of a secret of the utmost utility, interest, and novelty to the civilised world—a secret for which immense sacrifices of time, labour, and money had been made, but which, if restricted by patent for their protection, would be comparatively lost to society. A commission had therefore been appointed by the French Government to inquire into its merits, and the secret itself intrusted to M. Arago, who succeeded at once in executing a beautiful specimen of the art. Thus practically convinced, he addressed the Chamber in a speech which is a masterpiece of scientific summary and philosophic conclusion. He pointed out the immense advantages which might have been derived, "for example, during the expedition to Egypt, by a means of reproduction so exact and so rapid." He observed that "to copy the millions and millions of hieroglyphics which entirely cover the great monuments at Thebes, Memphis and Carnac, &c., would require scores of years and legions of artists; whereas with the daguerreotype a single man would suffice to bring this vast labour to a happy conclusion." He quoted the celebrated painter De la Roche in testimony of "the advantage to art by designs perfect as possible, and yet broad and energetic—where a finish of inconceivable minuteness in no respect disturbs the repose of the masses, nor impairs in any manner the general effect." The scene was French in the highest sense— at once scientific, patriotic, and withal dramatic,—France herself treating for the creations of genius on the one hand, and on the other dispensing them, "a gift to the whole world." It was repeated in the Chamber of Peers, who, in addition to other arguments addressed to them by M. Gay-Lussac, were reminded, with a true French touch, that 'even a field of battle in all its phases may be thus delineated with a precision unattainable by any other means!" The result was that a pension of 10,000 francs was awarded for the discovery—6000 to M. Daguerre, 4000 to M. Niépce. The seals which retained the secret were broken, and the daguerreotype became the property of the world.

We unwillingly recall a fact which rather mars the moral beauty of this interesting proceeding, viz. that by some chicanery a patent for the daguerreotype was actually taken out in England, which for a time rendered this the only country which did not profit by the liberality of the French Government. The early history of photography is not so generous in character as that of its maturity.

It may be added that all that has been since done for the daguerreotype are improvements in the same direction. It has that mark of a great invention—not to require or admit of any essential deviation from its process. Those who have contributed to perfect it are also of the same race as the inventor. The names of M. Fizeau and M. Claudet are associated with its present state. The first, by using a solution of chloride of gold, has preserved the daguerreotype from abrasion, and given it a higher tone and finish; while M. Claudet, who has variously contributed to the advance of the art, by the application of chloride of bromine with iodine, has accelerated a hundred-fold the action of the plate; at the same time, by a prolongation of a part of the process, he has, without the aid of mercury, at once converted the image into a positive, the silver ground now giving the lights instead, as before, of the shades of the picture.

We may now turn to England, and to those discoveries which, though less brilliant in immediate result, yet may be said to have led to those practical uses which now characterise the new agent. The undivided honour of having first successfully worked out the secret of photography in England belongs to Mr. Fox Talbot. He also is a private gentleman, living in the country, and pursuing chemical researches for his own pleasure. In his case it may be strictly said that he took up the ground to which Davy and Wedgwood had made their way. Paper was the medium he adhered to from the beginning, and on which he finally gained the victory. We have no account of the repeated essays and disappointments by which this gentleman advanced step by step to the end in view. All we know is that the French success on metal and the English success on paper were, strange to say, perfectly coincident in date. Daguerre's discovery was made known in Paris in January, 1839; and in the same month Mr. Fox Talbot sent a paper to the Royal Society,* giving an account of a method by which he obtained pictures on paper, rendered them unalterable by light, and by a second and simple process, which admitted of repetition to any extent, restored the lights and shadows to their right conditions.

This announcement fell, like the pictures of light themselves, upon ground highly excited in every way to receive and carry it forward. It was immediately taken up by Sir John Herschel, who commenced a series of experiments of the utmost practical importance to pho-

* See pp. 23-30.

tography and science in general, one of the first results of which was the discovery of the hyposulphate of soda as the best agent for dissolving the superfluous salts, or, in other words, of fixing the picture. This was one of those steps which has met with general adoption. Another immediate impulse was given by a lecture read at the London Institution in April, 1839, and communicated by the Rev. J. B. Reade, recommending the use of gallic acid in addition to iodide or chloride of silver as a means of greatly increasing the sensitiveness of the preparation. Again, Mr. Robert Hunt, since known as the author of the work that heads this article, published at the British Association at Plymouth, in 1841, another sensitive process, in which the ferrocyanate of potash was employed; and in 1844 the important use of the proto-sulphate of iron in bringing out, or, as it is termed, *developing* the latent picture. Other fellow-labourers might be mentioned, too, all zealous to offer some suggestion of practical use to the new-born art. Meanwhile Mr. Fox Talbot, continuing to improve on his original discovery, thought fit in 1842 to make it the subject for a patent, under the name of the calotype process. In this he is accused of having incorporated the improvements of others as well as his own, a question on which we have nothing to say, except that at this stage of the invention the tracks of the numerous exploring parties run too close to each other to be clearly identified. As to the propriety of the patent itself, no one can doubt Mr. Fox Talbot's right to avail himself of it, though the results show that the policy may be questioned. For this gentleman reaped a most inadequate return, and the development of the art was materially retarded. In the execution of a process so delicate and at the best so capricious as that of photography, the experience of numbers, such as only free-trade can secure, is required to define the more or less practical methods. Mr. F. Talbot's directions, though sufficient for his own pre-instructed hand, were too vague for the tyro; and an enlistment into the ranks of the "Pilgrims of the Sun" seldom led to any result but that of disappointment. Thus, with impediments of this serious nature, photography made but slow way in England; and the first knowledge to many even of her existence came back to us from across the Border. It was in Edinburgh where the first earnest, professional practice of the art began, and the calotypes of Messrs. Hill and Adamson remain to this day the most picturesque specimens of the new discovery.

It was at this crisis that a paper published in the "Philosophical Transactions" of May, 1844, by Mr. George Cundell, gave in great measure the fresh stimulus that was needed. The world was full of the praise of the daguerreotype, but Mr. Cundell stood forth as the advo-cate of the calotype or paper process, pointed out its greater simplicity and inexpensiveness of apparatus, its infinite superiority in the power of multiplying its productions, and then proceeded to give those careful directions for the practice, which, though containing no absolutely new element, yet suggested many a minute correction where every minutia is important. With the increasing band of experimentalists who arose—for all photographers are such—now ensued the demand for some material on which to receive their pictures less expensive than the silver plate, and less capricious than paper. However convenient as a medium, this latter, from the miscellaneous nature of its antecedents, was the prolific parent of disappointment. Numerous expedients were resorted to render it more available—it was rubbed, polished, and waxed, but, nevertheless, blotches and discolorations would perpetually appear, and that at the very moment of success, which sorely tried the photographic heart. The Journal of the Society sends up at this time one vast cry of distress on this subject, one member calling unto another for help against the common enemy. Under these circumstances many a longing eye was fixed upon glass as a substitute; and numerous experiments, among which those by Sir John Herschel were the earliest and most successful, were tried to render this material available. But glass itself was found to be an intractable material; it has no powers of absorption, and scarcely any affinities. The one thing evidently needed was to attach some transparent neutral coating of extreme tenuity to its surface, and in due time the name of Niépce again appears supplying the intermediate step between failure and success. M. Niépce de St. Victor, nephew to the inventor of heliography, is known as the author of the albumen process, which transparent and adhesive substance being applied to glass, and excited with the same chemical agents as in the calotype process, is found to produce pictures of great beauty and finish. But, ingenious as is the process, and often as it is still used, it fails of that unsurpassable fitness which alone commands universal adoption. The amalgamation of the substances is tedious and complicated, and the action of the light much slower. The albumen process was a great step, and moreover a step in the right direction; for it pointed onward to that discovery which has reduced the difficulties of the art to the lowest sum, and raised its powers, in one respect at all events, to the highest possibility, viz. to the use of collodion. The Daguerre to this Niépce was a countryman of our own—Mr. Scott Archer —who is entitled to fame not only for this marvellous improvement, but for the generosity with which he threw it open to the public. The character of the agent, too, adds interest to the invention. The birth and paren-

tage of collodion are both among the recent wonders of the age. Gun-cotton—partly a French, partly a German discovery—is but a child in the annals of chemical science; and collodion, which is a solution of this compound in ether and alcohol, is its offspring. Its first great use was, as is well known, in the service of surgery; its second in that of photography. Not only did the adoption of this vehicle at once realise the desires of the most ardent photographer—not only, thus applied, did it provide a film of perfect transparency, tenuity, and intense adhesiveness—not only was it found easy of manipulation, portable and preservable—but it supplied that element of rapidity which more than anything else has given the miraculous character to the art. Under the magician who first attempted to enlist the powers of light in his service, the sun seems at best to have been but a sluggard; under the sorcery of Niépce he became a drudge in a twelve-hours' factory. On the prepared plate of Daguerre and on the sensitive paper of Fox Talbot the great luminary concentrates his gaze for a few earnest minutes; with the albumen-sheathed glass he takes his time more leisurely still; but at the delicate film of collodion—which hangs before him finer than any fairy's robe, and potent only with invisible spells—he literally does no more than wink his eye, tracing in that moment, with a detail and precision beyond all human power, the glory of the heavens, the wonders of the deep, the fall, not of the avalanche, but of the apple, the most fleeting smile of the babe, and the most vehement action of the man.

Further than this the powers of photography can never go; they are already more nimble than we need. Light is made to portray with a celerity only second to that with which it travels; it has been difficult to contrive the machinery of the camera to keep pace with it, and collodion has to be weakened in order to clog its wheels.

While these practical results occupied the world, more fundamental researchers had been carried on. By the indefatigable exertions of Sir John Herschel and Mr. Hunt the whole scale of mineral and other simple substances were tested in conjunction with tried and untried chemical processes, showing how largely nature abounds with materials for photographic action. Preparations of gold, platinum, mercury, iron, copper, tin, nickel, manganese, lead, potash &c. were found more or less sensitive and capable of producing pictures of beauty and distinctive character. The juices of beautiful flowers were also put into requisition, and papers prepared with the colours of the Corchorus japonica, the common ten-weeks' stock, the marigold, the wallflower, the poppy, the rose, Senecio splendens, &c., have been made to re-ceive delicate though in most cases fugitive images. By these experiments, though tending little to purposes of utility, the wide relations and sympathies of the new art have been in some measure ascertained, and its dignity in the harmonious scale of natural phenomena proportionably raised.

When once the availability of one great primitive agent is thoroughly worked out, it is easy to foresee how extensively it will assist in unravelling other secrets in natural science. The simple principle of the stereoscope, for instance, might have been discovered a century ago, for the reasoning which led to it was independent of all the properties of light, but it could never have been illustrated, far less multiplied as it now is, without photography. A few diagrams, of sufficient identity and difference to prove the truth of the principle, might have been constructed by hand for the gratification of a few sages, but no artist, it is to be hoped, could have been found possessing the requisite ability and stupidity to execute the two portraits, or two groups, or two interiors, or two landscapes, identical in every minutia of the most elaborate detail, and yet differing in point of view by the inch between the two human eyes, by which the principle is brought to the level of any capacity. Here, therefore, the accuracy and insensibility of a machine could alone avail; and if in the order of things the cheap popular toy which the stereoscope now represents was necessary for the use of man, the photograph was first necessary for the service of the stereoscope.

And while photography is thus found ready to give its aid to other agencies, other agencies are in turn ready to co-operate with that. The invention now becoming familiar to the public by the name of photo-galvanic engraving is a most interesting instance of this reciprocity of action. That which was the chief aim of Niépce in the humblest dawn of the art, viz. to transform the photographic plate into a surface capable of being printed, which had been *bona fide* realised by Mr. Fox Talbot, M. Niépce de St. Victor, and others, but by methods too complicated for practical use, is now by the co-operation of electricity with photography done with the simplicity and perfection which fulfil all conditions. This invention is the work of M. Pretsch of Vienna, and deserves a few explanatory words. It differs from all other attempts for the same purpose in not operating upon the photographic tablet itself, and by discarding the usual means of varnishes and bitings in. The process is simply this. A glass tablet is coated with a gelatine diluted till it forms a jelly, and containing bichromate of potash, nitrate of silver and iodide of potassium. Upon this when dry is placed, face downwards, a paper positive, through which the light, being allowed to fall, leaves upon the gelatine

a representation of the print. It is then soaked in water, and while the parts acted upon by the light are comparatively unaffected by the fluid, the remainder of the jelly swells, and rising above the general surface gives a picture in relief, resembling an ordinary engraving upon wood. Of this intaglio a cast is now taken in gutta-percha, to which the electro process in copper being applied, a plate or matrix is produced bearing on it an exact repetition of the original positive picture. All that now remains to be done is to repeat the electro process, and the result is a copper plate, in the necessary relievo, of which, as the company who have undertaken to utilise the invention triumphantly set forth, nature furnishes the materials, and science the artist, the inferior workman being only needed to roll it through the press.

And here, for the present, terminate the more important steps of photographic development, each in its turn a wonder, and each in its turn obtained and supported by wonders only a little older than itself. It was not until 1811 that the chemical substance called iodine, on which the foundations of all popular photography rest, was discovered at all; bromine, the only other substance equally sensitive, not till 1826. The invention of the electro process was about simultaneous with that of photography itself. Gutta-percha only just preceded the substance of which collodion is made; the ether and chloroform, which are used in some methods, that of collodion. We say nothing of the optical improvements purposely contrived or adapted for the service of the photograph—the achromatic lenses, which correct the discrepancy between the visual and chemical foci; the double lenses, which increase the force of the action; the binocular lenses, which do the work of the stereoscope; nor of the innumerable other mechanical aids which have sprung-up for its use; all things, great and small, working together to produce what seemed at first as delightful, but as fabulous, as Aladdin's ring, which is now as little suggestive of surprise as our daily bread. It is difficult now to believe that the foundations of all this were laid within the memory of a middle-aged gentleman, by a few lonely philosophers, incognizant of each other, each following a glimmer of light through years of toil, and looking upward to that Land of Promise to which beaten tracks and legible handposts now conduct an army of devotees. Nevertheless, there is no royal road thrown open yet. Photography is, after all, too profoundly interwoven with the deep things of Nature to be entirely unlocked by any given method. Every individual who launches his happiness on this stream finds currents and rocks not laid down in the chart. Every sanguine little couple who set up a glass-house at the commencement of summer, call their friends about them,

and toil alternately in broiling light and stifling gloom, have said before long, in their hearts, "Photography, thy name is disappointment!" But the photographic back is fitted to the burden. Although all things may be accused in turn—their chemicals, their friends, and even Nature herself—yet with the next fine day there they are at work again, successively in hope, excitement, and despair, for, as Schiller says,—

"Etwas fürchten, und hoffen, und sorgen

Muss der Mensch für den kommenden Morgen."*

At present no observation or experience has sufficed to determine the state of atmosphere in which the photographic spirits are most propitious; no rule or order seems to guide their proceedings. You go out on a beautifully clear day, not a breath stirring, chemicals in order, and lights and shadows in perfection; but something in the air is absent, or present, or indolent, or restless, and you return in the evening only to develop a set of blanks. The next day is cloudy and breezy, your chemicals are neglected, yourself disheartened, hope is gone, and with it the needful care; but here again something in the air is favourable, and in the silence and darkness of your chamber pictures are summoned from the vasty deep which at once obliterate all thought of failure. Happy the photographer who knows what is his enemy, or what is his friend; but in either case it is too often 'something,' he can't tell what; and all the certainty that the best of experience attains is, that you are dealing with one of those subtle agencies which, though Ariel-like it will serve you bravely, will never be taught implicitly to obey.

As respects the time of the day, however, one law seems to be thoroughly established. It has been observed by Daguerre and subsequent photographers that the sun is far more active, in a photographic sense, for the two hours before, than for the two hours after it has passed the meridian. As a general rule, too, however numerous the exceptions, the cloudy day is better than the sunny one. Contrary, indeed, to all preconceived ideas, experience proves that the brighter the sky that shines above the camera the more tardy the action within it. Italy and Malta do their work slower than Paris. Under the brilliant light of a Mexican sun, half an hour is required to produce effects which in England would occupy but a minute. In the burning atmosphere of India, though photographical the year round, the process is comparatively slow and difficult to manage; while in the clear, beautiful, and, moreover, cool light of the higher Alps

*These lines, from Schiller's *The Bride of Messina*, may be freely translated as

Something to fear, hope for and hold dear
Man must have for the morrow that is near.

of Europe, it has been proved that the production of a picture requires many more minutes, even with the most sensitive preparations, than in the murky atmosphere of London. Upon the whole, the temperate skies of this country may be pronounced most favourable to photographic action, a fact for which the prevailing characteristic of our climate may partially account, humidity being an indispensable condition for the working state both of paper and chemicals.

But these are at most but superficial influences—deeper causes than any relative dryness or damp are concerned in these phenomena. The investigation of the solar attributes, by the aid of photographic machinery, for which we are chiefly indebted to the researches of Mr. Hunt and M. Claudet, are, scientifically speaking, the most interesting results of the discovery. By these means it is proved that besides the functions of light and heat the solar ray has a third, and what may be called photographic function, the cause of all the disturbances, decompositions, and chemical changes which affect vegetable, animal, and organic life. It had long been known that this power, whatever it may be termed—energia—actinism—resided more strongly, or was perhaps less obstructed, in some of the coloured rays of the spectrum than in others—that solutions of silver and other sensitive surfaces were sooner darkened in the violet and the blue than in the yellow and red portions of the prismatic spectrum. Mr. Hunt's experiments further prove that mere light, or the luminous ray, is little needed where the photographic or "chemical ray" is active, and that sensitive paper placed beneath the comparative darkness of a glass containing a dense purple fluid, or under that deep blue glass commonly used as a finger-glass, is photographically affected almost as soon as if not shaded from the light at all. Whereas, if the same experiment be tried under a yellow glass or fluid, the sensitive paper, though robbed neither of light nor heat, will remain a considerable time without undergoing any change.*

We refer our readers to this work for results of the utmost interest—our only purpose is to point out that

*We may add, though foreign to our subject, that the same experiment applied by Mr. Hunt to plants has been attended with analagous results. Bulbs of tulips and ranunculuses have germinated beneath yellow and red glasses, but the plant has been weakly and has perished without forming buds. Under a green glass (blue being a component part of the colour) the plants have been less feeble, and have advancd as far as flower-buds; while beneath the blue medium perfectly healthy plants have grown up, developing their buds, and flowering in perfection. [Note by Lady Eastlake]

†Possibly Christoph Friedrich Nicolai (1733-1811), German critic and writer.

the defects or irregularities of photography are as inherent in the laws of Nature as its existence—being coincident with the first created of all things. The prepared paper or plate which we put into the camera may be compared to a chaos, without form and void, on which the merest glance of the sun's rays calls up image after image till the fair creation stands revealed: yet not revealed in the order in which it met the solar eye, for while some colours have hastened to greet his coming, others have been found slumbering at their posts, and have been left with darkness in their lamps. So impatient have been the blues and violets to perform their task upon the recipient plate, that the very substance of the colour has been lost and dissolved in the solar presence; while so laggard have been the reds and yellows and all tints partaking of them, that they have hardly kindled into activity before the light has been withdrawn. Thus it is that the relation of one colour to another is found changed and often reversed, the deepest blue being altered from a dark mass into a light one, and the most golden-yellow from a light body into a dark.

It is obvious, therefore, that however successful photography may be in the closest imitation of light and shadow, it fails, and must fail, in the rendering of true chiaroscuro, or the true imitation of light and dark. And even if the world we inhabit, instead of being spread out with every variety of the palette, were constituted but of two colours—black and white and all their intermediate grades—if every figure were seen in monochrome like those that visited the perturbed vision of the Berlin Nicolai†—photography could still not copy them correctly. Nature, we must remember, is not made up only of actual lights and shadows; besides these more elementary masses, she possesses innumerable reflected lights and half-tones, which play around every object, rounding the hardest edges, and illuminating the blackest breadths, and making that sunshine in a shady place, which it is the delight of the practised painter to render. But of all these photography gives comparatively no account. The beau ideal of a Turner and the delight of a Rubens are caviar to her. Her strong shadows swallow up all timid lights within them, as her blazing lights obliterate all intrusive half-tones across them; and thus strong contrasts are produced, which, so far from being true to Nature, it seems one of Nature's most beautiful provisions to prevent.

Nor is this disturbance in the due degree of chiaroscuro attributable only to the different affinities for light residing in different colours, or to the absence of true gradation in light and shade. The quality and texture of a surface has much to do with it. Things that are very smooth, such as glass and polished steel, or certain com-

plexions and parts of the human face, or highly-glazed satin-ribbon—or smooth leaves, or brass-buttons—everything on which the light *shines*, as well as everything that is perfectly white, will photograph much faster than other objects, and thus disarrange the order of relation. Where light meets light the same instantaneous command seems to go forth as that by which it was at first created, so that, by the time the rest of the picture has fallen into position, what are called the high lights have so rioted in action as to be found far too prominent both in size and intensity.

And this bring us to the artistic part of our subject, and to those questions which sometimes puzzle the spectator, as to how far photography is really a picturesque agent, what are the causes of its successes and its failures, and what in the sense of art are its successes and failures? And these questions may be fairly asked now when the scientific processes on which the practice depends are brought to such perfection that, short of the coveted attainment of colour, no great improvement can be further expected. If we look round a photographic exhibition we are met by results which are indeed honourable to the perseverance, knowledge, and in some cases to the taste of man. The small, broadly-treated, Rembrandt-like studies representing the sturdy physiognomies of Free Church Ministers and their adherents,* which first cast the glamour of photography upon us, are replaced by portraits of the most elaborate detail, and of every size not excepting that of life itself. The little bit of landscape effect, all blurred and uncertain in forms, and those lost in a confused and discoloured ground, which was nothing and might be anything, is superseded by large pictures with minute foregrounds, regular planes of distance, and perfectly clear skies. The small attempts at architecture have swelled into monumental representations of a magnitude, truth, and beauty which no art can surpass—animals, flowers, pictures, engravings, all come within the grasp of the photographer; and last, and finest, and most interesting of all, the sky with its shifting clouds, and the sea with its heaving waves, are overtaken in their course by a power more rapid than themselves.

But while ingenuity and industry—the efforts of hundreds working as one—have thus enlarged the scope of the new agent, and rendered it available for the most active, as well as for the merest still life, has it gained in an artistic sense in like proportion? Our answer is not in the affirmative, nor is it possible that it should be so. Far from holding up the mirror to nature, which is an assertion usually as triumphant as it is erroneous, it holds up that which, however beautiful, ingenious, and valuable in powers of reflection, is yet subject to certain distortions and deficiencies for which there is no remedy. The sci-

ence therefore which has developed the resources of photography, has but more glaringly betrayed its defects. For the more perfect you render an imperfect machine the more must its imperfections come to light: it is superfluous therefore to ask whether Art has been benefited, where Nature, its only source and model, has been but more accurately falsified. If the photograph in its early and imperfect scientific state was more consonant to our feelings for art, it is because, as far as it went, it was more true to our experience of Nature. Mere broad light and shade, with the correctness of general forms and absence of all convention, which are the beautiful conditions of photography, will, when nothing further is attempted, give artistic pleasure of a very high kind; it is only when greater precision and detail are superadded that the eye misses the further truths which should accompany the further finish.

For these reasons it is almost needless to say that we sympathise cordially with Sir William Newton,† who at one time created no little scandal in the Photographic Society by propounding the heresy that pictures taken slightly out of focus, that is, with slightly uncertain and undefined forms, "though less *chemically*, would be found more *artistically* beautiful." Much as photography is supposed to inspire its votaries with aesthetic instincts, this excellent artist could hardly have chosen an audience less fitted to endure such a proposition. As soon as could an accountant admit the morality of a false balance, or a seamstress the neatness of a puckered seam, as your merely scientific photographer be made to comprehend the possible beauty of "a slight *burr*." His mind proud science never taught to doubt the closest connexion between cause and effect, and the suggestion that the worse photography could be the better art was not only strange to him, but discordant. It was hard too to disturb his faith in his newly acquired powers. Holding, as he believed, the keys of imitation in his camera, he had tasted for once something of the intoxicating dreams of the artist; gloating over the pictures as they developed beneath his gaze, he had said in his heart "anch' io son pittore."‡ Indeed there is no lack of evidence in the Photographic Journal of his believing that art had hitherto been but a blundering groper after that truth which the cleanest and precisest photography in his hands was now destined to reveal. Sir William Newton, therefore, was fain to allay the storm by qualifying his meaning to the level of photographic toleration, knowing that, of all the delusions

* Lady Eastlake here refers to the calotype portraits of David Octavius Hill and Robert Adamson, taken in Edinburgh between 1843 and 1848.
† For his lecture to the Photographic Society, see pp. 79-80.
‡ "I, too, am a painter."

which possess the human breast, few are so intractable as those about art.

But let us examine a little more closely those advances which photography owes to science—we mean in an artistic sense. We turn to the portraits, our *premiers amours,* now taken under every appliance of facility both for sitter and operator. Far greater detail and precision accordingly appear. Every button is seen—piles of stratified flounces in most accurate drawing are there,—what was at first only suggestion is now all careful making out,—but the likeness to Rembrandt and Reynolds is gone! There is no mystery in this. The first principle in art is that the most important part of a picture should be best done. Here, on the contrary, while the dress has been rendered worthy of a fashion-book, the face has remained, if not so unfinished as before, yet more unfinished in proportion to the rest. Without referring to M. Claudet's well-known experiment of a falsely coloured female face, it may be averred that, of all the surfaces of a few inches square the sun looks upon, none offers more difficulty, artistically speaking, to the photographer, than a smooth, blooming, clean washed, and carefully combed human head. The high lights which gleam on this delicate epidermis so spread and magnify themselves, that all sharpness and nicety of modelling is obliterated—the fineness of skin peculiar to the under lip reflects so much light, that in spite of its deep colour it presents a light projection, instead of a dark one—the spectrum or intense point of light on the eye is magnified to a thing like a cataract. If the cheek be very brilliant in colour, it is as often as not represented by a dark stain. If the eye be blue, it turns out as colourless as water; if the hair be golden or red, it looks as if it had been dyed, if very glossy it is cut up into lines of light as big as ropes. This is what a fair young girl has to expect from the tender mercies of photography—the male and the older head, having less to lose, has less to fear. Strong light and shade will portray character, though they mar beauty. Rougher skin, less glossy hair, Crimean moustaches and beard overshadowing the white under lip, and deeper lines, are all so much in favour of a picturesque result. Great grandeur of feature too, or beauty of *pose* and sentiment, will tell as elevated elements of the picturesque in spite of photographic mismanagement. Here and there also a head of fierce and violent contrasts, though taken perhaps from the meekest of mortals, will remind us of the Neapolitan or Spanish school, but, generally speaking, the inspection of a set of faces, subject to the usual conditions of humanity and the camera, leaves us with the impression that a photographic portrait, however valuable to relative or friend, has ceased to remind us of a work of art at all.

And, if further proof were wanted of the artistic inaptitude of this agent for the delineation of the human countenance, we should find it in those magnified portraits which ambitious operators occasionally exhibit to our ungrateful gaze. Rightly considered, a human head, the size of life, of average intelligence, and in perfect drawing, may be expected, however roughly finished, to recall an old Florentine fresco of four centuries ago. But, "ex nihilo, nihil fit:"* the best magnifying lenses can in this case only impoverish in proportion as they enlarge, till the flat and empty Magog which is born of this process is an insult, even in remotest comparison with the pencil of a Masaccio.

The falling off of artistic effect is even more strikingly seen if we consider the department of landscape. Here the success with which all accidental blurs and blotches have been overcome, and the sharp perfection of the object which stands out against the irreproachably speckless sky, is exactly as detrimental to art as it is complimentary to science. The first impression suggested by these buildings of rich tone and elaborate detail, upon a glaring white background without the slightest form or tint, is that of a Chinese landscape upon looking-glass. We shall be asked why the beautiful skies we see in the marine pieces cannot be also represented with landscapes; but here the conditions of photography again interpose. The impatience of light to meet light is, as we have stated, so great, that the moment required to trace the forms of the sky (it can never be traced in its cloudless gradation of tint) is too short for the landscape, and the moment more required for the landscape too long for the sky. If the sky be given, therefore, the landscape remains black and underdone; if the landscape be rendered, the impatient action of the light has burnt out all cloud-form in one blaze of white. But it is different with the sea, which, from the liquid nature of its surface, receives so much light as to admit of simultaneous representation with the sky above it. Thus the marine painter has both hemispheres at his command, but the landscape votary but one; and it is but natural that he should prefer Rydal Mount and Tintern Abbey to all the baseless fabric of tower and hill which the firmament occasionally spreads forth. But the old moral holds true even here. Having renounced heaven, earth makes him, of course, only an inadequate compensation. The colour green, both in grass and foliage, is now his great difficulty. The finest lawn turns out but a gloomy funeral-pall in his hands; his trees, if done with the slower paper process, are black, and from the movement, uncertain webs against the white sky,—if by collodion, they look as if worked in dark cambric, or

*"From nothing, nothing comes."

stippled with innumerable black and white specks; in either case missing all the breadth and gradations of nature. For it must be remembered that every leaf reflects a light on its smooth edge or surface, which, with the tendency of all light to over-action, is seen of a size and prominence disproportioned to things around it; so that what with the dark spot produced by the green colour, and the white spot produced by the high light, all intermediate grades and shades are lost. This is especially the case with hollies, laurels, ivy, and other smooth-leaved evergreens, which form so conspicuous a feature in English landscape gardening—also with foreground weeds and herbage, which, under these conditions, instead of presenting a sunny effect, look rather as if strewn with shining bits of tin, or studded with patches of snow.

For these reasons, if there be a tree distinguished above the rest of the forest for the harshnss and blueness of its foliage, we may expect to find it suffer less, or not at all, under this process. Accordingly, the characteristic exception will be found in the Scotch fir, which, however dark and sombre in mass, is rendered by the photograph with a delicacy of tone and gradation very grateful to the eye. With this exception it is seldom that we find any studies of trees, in the present improved state of photography, which inspire us with the sense of pictorial truth. Now and then a bank of tangled bushwood, with a deep, dark pool beneath, but with no distance and no sky, and therefore no condition of relation, will challenge admiration. Winter landscapes also are beautiful, and the leafless Burnham beeches a real boon to the artist; but otherwise such materials as Hobbema, Ruysdael, and Cuyp converted into pictures unsurpassable in picturesque effect are presented in vain to the improved science of the photographic artist. What strikes us most frequently is the general *emptiness* of the scene he gives. A house stands there, sharp and defined like a card-box, with black blots of trees on each side, all rooted in a substance far more like burnt stubble than juicy, delicate grass. Through this winds a white spectral path, while staring palings or linen hung out to dry (oh! how unlike the luminous spots on Ruysdael's bleaching-grounds!), like bits of the white sky dropped upon the earth, make up the poverty and patchiness of the scene. We are aware that there are many partial exceptions to this; indeed, we hardly ever saw a photograph in which there was not something or other of the most exquisite kind. But this brings us no nearer the standard we are seeking. Art cares not for the right finish unless it be in the right place. Her great aim is to produce a whole; the more photography advances in the execution of parts, the less does it give the idea of completeness.

There is nothing gained either by the selection of more ambitious scenery. The photograph seems embarrassed with the treatment of several gradations of distance. The finish of background and middle distance seems not to be commensurate with that of the foreground; the details of the simplest light and shadow are absent; all is misty and bare, and distant hills look like flat, grey moors washed in with one gloomy tint. This emptiness is connected with the rapidity of collodion, the action of which upon distance and middle ground does not keep pace with the hurry of the foreground. So much for the ambition of taking a picture. On the other hand, we have been struck with mere studies of Alpine masses done with the paper process, which allows the photograph to take its time, and where, from the absence of all foreground or intermediate objects, the camera has been able to concentrate its efforts upon one thing only—the result being records of simple truth and precision which must be invaluable to the landscape-painter.

There is no doubt that the forte of the camera lies in the imitation of one surface only, and that of a rough and broken kind. Minute light and shade, cognisant to the eye, but unattainable by hand, is its greatest and easiest triumph—the mere texture of stone, whether rough in the quarry or hewn on the wall, its especial delight. Thus a face of rugged rock, and the front of a carved and fretted building, are alike treated with a perfection which no human skill can approach; and if asked to say what photography has hitherto best succeeded in rendering, we should point to everything near and rough—from the texture of the sea-worn shell, of the rusted armour, and the fustian jacket, to those glorious architectural pictures of French, English, and Italian subjects, which, whether in quality, tone, detail, or drawing, leave nothing to be desired.

Here, therefore, the debt of Science for additional clearness, precision, and size may be gratefully acknowledged. What photography can do is now, with her help, better done than before; what she can but partially achieve is best not brought too elaborately to light. Thus the whole question of success and failure resolves itself into an investigation of the capacities of the machine, and well may we be satisfied with the rich gifts it bestows, without straining it into a competition with art. For everything for which Art, so-called, has hitherto been the means but not the end, photography is the allotted agent—for all that requires mere manual correctness, and mere manual slavery, without any employment of the artistic feeling, she is the proper and therefore the perfect medium. She is made for the present age, in which the desire for art resides in a small minority, but the craving, or rather necessity for cheap, prompt, and correct facts in the public at large. Photography is the

93

purveyor of such knowledge to the world. She is the sworn witness of everything presented to her view. What are her unerring records in the service of mechanics, engineering, geology, and natural history, but facts of the most sterling and stubborn kind? What are her studies of the various stages of insanity—pictures of life unsurpassable in pathetic truth—but facts as well as lessons of the deepest physiological interest? What are her representations of the bed of the ocean, and the surface of the moon—of the launch of the Marlborough, and of the contents of the Great Exhibition—of Charles Kean's now destroyed scenery of the "Winter's Tale," and of Prince Albert's now slaughtered prize ox—but the facts which are neither the province of art nor of description, but of that new form of communication between man and man—neither letter, message, nor picture—which now happily fills up the space between them? What indeed are nine-tenths of those facial maps called photographic portraits, but accurate landmarks and measurements for loving eyes and memories to deck with beauty and animate with expression, in perfect certainty, that the ground-plan is founded upon fact?

In this sense no photographic picture that ever was taken, in heaven, or earth, or in the waters underneath the earth, of any thing, or scene, however defective when measured by an artistic scale, is destitute of a special, and what we may call an historic interest. Every form which is traced by light is the impress of one moment, or one hour, or one age in the great passage of time. Though the faces of our children may not be modelled and rounded with that truth and beauty which art attains, yet *minor* things—the very shoes of the one, the inseparable toy of the other—are given with a strength of identity which art does not even seek. Though the view of a city be deficient in those niceties of reflected lights and harmonious gradations which belong to the facts of which Art takes account, yet the facts of the age and of the hour are there, for we count the lines in that keen perspective of telegraphic wire, and read the characters on the playbill or manifesto, destined to be torn down on the morrow.

Here, therefore, the much-lauded and much-abused agent called Photography takes her legitimate stand. Her business is to give evidence of facts, as minutely and as impartially as, to our shame, only an unreasoning machine can give. In this vocation we can as little overwork her as tamper with her. The millions and millions of hieroglyphics mentioned by M. Arago may be multiplied by millions and millions more,—she will render all as easily and as accurately as one. When people, therefore, talk of photography, as being intended to supersede art, they utter what, if true, is not so in the sense they mean. Photography *is* intended to supersede much that art has

hitherto done, but only that which it was both a misappropriation and a deterioration of Art to do. The field of delineation, having two distinct spheres, requires two distinct labourers; but though hitherto the freewoman has done the work of the bondwoman, there is no fear that the position should be in the future reversed. Correctness of drawing, truth of detail, and absence of convention, the best artistic characteristics of photography, are qualities of no common kind, but the student who issues from the academy with these in his grasp stands, nevertheless, but on the threshold of art. The power of selection and rejection, the living application of that language which lies dead in his paint-box, the marriage of his own mind with the object before him, and the offspring, half stamped with his own features, half with those of Nature, which is born of the union—whatever appertains to the free-will of the intelligent being, as opposed to the obedience of the machine,—this, and much more than this, constitutes that mystery called Art, in the elucidation of which photography can give valuable help, simply by showing what it is not. There is, in truth, nothing in that power of literal, unreasoning imitation, which she claims as her own, in which, rightly viewed, she does not relieve the artist of a burden rather than supplant him in an office. We do not even except her most pictorial feats—those splendid architectural representations— from this rule. Exquisite as they are, and fitted to teach the young, and assist the experienced in art, yet the hand of the artist is but ignobly employed in closely imitating the texture of stone, or in servilely following the intricacies of the zigzag ornament. And it is not only in what she can do to relieve the sphere of art, but in what she can sweep away from it altogether, that we have reason to congratulate ourselves. Henceforth it may be hoped that we shall hear nothing further of that miserable contradiction in terms "bad art"—and see nothing more of that still more miserable mistake in life "a bad artist." Photography at once does away with anomalies with which the good sense of society has always been more or less at variance. As what she does best is beneath the doing of a real artist at all, so even in what she does worst she is a better machine than the man who is nothing but a machine.

Let us, therefore, dismiss all mistaken ideas about the harm which photography does to art. As in all great and sudden improvements in the material comforts and pleasures of the public, numbers, it is true, have found their occupation gone, simply because it is done cheaper and better in another way. But such improvements always give more than they take. Where ten self-styled artists eked out a precarious living by painting inferior miniatures, ten times that number now earn their bread by sup-

plying photographic portraits. Nor is even such manual skill as they possessed thrown out of the market. There is no photographic establishment of any note that does not employ artists at high salaries—we understand not less than 1*l* a day—in touching, and colouring, and finishing from nature those portraits for which the camera may be said to have laid the foundation. And it must be remembered that those who complain of the encroachments of photography in this department could not even supply the demand. Portraits, as is evident to any thinking mind, and as photography now proves, belong to that class of facts wanted by numbers who know and care nothing about their value as works of art. For this want, art, even of the most abject kind, was, whether as regards correctness, promptitude, or price, utterly inadequate. These ends are not only now attained, but, even in an artistic sense, attained far better than before. The coloured portraits to which we have alluded are a most satisfactory coalition between the artist and the machine. Many an inferior miniature-painter who understood the mixing and applying of pleasing tints was wholly unskilled in the true drawing of the human head. With this deficiency

supplied, their present productions, therefore, are far superior to anything they accomplished, single-handed, before. Photographs taken on ivory, or on substances invented in imitation of ivory, and coloured by hand from nature, such as are seen at the rooms of Messrs. Dickinson, Claudet, Mayall, Kilburn, &c., are all that can be needed to satisfy the mere portrait want, and in some instances may be called artistic productions of no common kind besides. If, as we understand, the higher professors of miniature-painting—and the art never attained greater excellence in England than now—have found their studios less thronged of late, we believe that the desertion can be but temporary. At all events, those who in future desire their exquisite productions will be more worthy of them. The broader the ground which the machine may occupy, the higher will that of the intelligent agent be found to stand. If, therefore, the time should ever come when art is sought, as it ought to be, mainly for its own sake, our artists and our patrons will be of a far more elevated order than now: and if anything can bring about so desirable a climax, it will be the introduction of Photography.

HENRY POLLOCK. *A Viaduct on the South Eastern Railway.* Collodion.

A Portfolio of Photographs from the George Frederick Pollock Album

1856

The preceding essay by Lady Elizabeth Eastlake was not illustrated. Happily, a collection of British photographs of the period exists in an album owned in 1856 by George Frederick Pollock (1821–1915), senior master of the Supreme Court of Great Britain. He succeeded Lady Elizabeth's husband, Sir Charles Eastlake, as president of the Photographic Society of London (now the Royal Photographic Society of Great Britain) in 1855. In addition to well-known photographers, Pollock's brothers Henry and A. I. are represented. The album is now in the collection of Arnold Crane.

HUGH W. DIAMOND. *Still Life.* Collodion.

JOHN PERCY. *An Old Oak.* Calotype.

F. W. CWEREY. *Lismore Castle, Ireland.* Collodion.

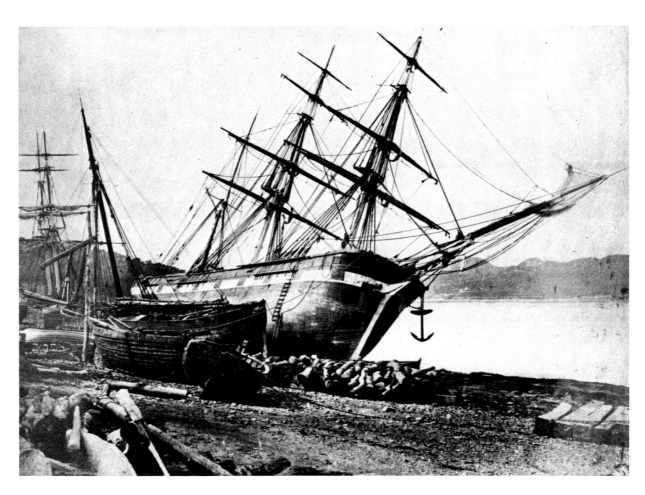

DAVID JOHNSON. *The "Jane Tudor."* Collodion.

HENRY POLLOCK. *"The Dark Blue Sea." Breakers on the Coast, North Devon.* Collodion.

"... the sky with its shifting clouds, and the sea with its heaving waves, are overtaken in their course by a power more rapid than themselves ..."—Lady Eastlake.

FRANCIS BEDFORD. *Rivaulx Abbey, Yorkshire.* Collodion.

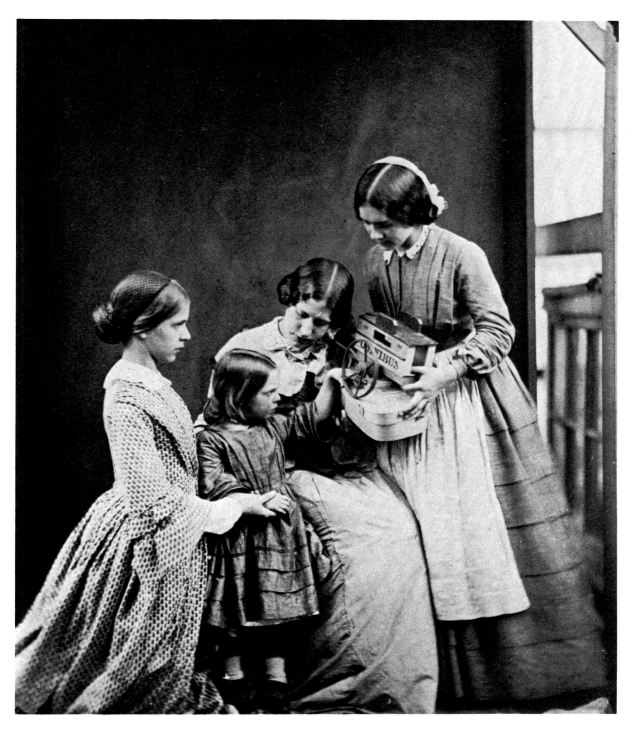

A. I. POLLOCK. *Grandmother's Present.* Collodion.

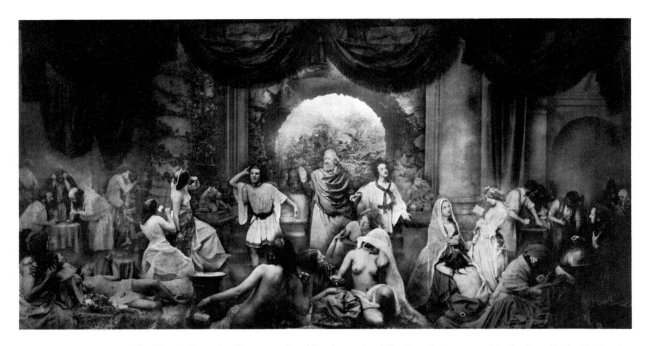

OSCAR G. REJLANDER. *The Two Ways of Life*. 1857. Combination print. The Royal Photographic Society, Bath, England.

Oscar Gustav Rejlander

HENRY PEACH ROBINSON
1890

In 1857 Oscar Gustav Rejlander (1813-1875), a Swede residing in England, produced an allegorical photograph entitled The Two Ways of Life, *which was exhibited at the Manchester Art Treasures Exhibition. To produce it he posed models in groups, making separate negatives that he then combined on one print. The photograph, a frank resemblance to contemporary painting, was highly controversial, as his friend Henry Peach Robinson (1830-1901) points out. Robinson himself, using a similar style, produced quantities of this type of photograph and popularized "combination printing" by his extensive writings.*

The idea of an exhibition of all that could be gathered together of the works of O. G. Rejlander at the Camera Club was a happy one, and will serve to recall to the memory of many photographers the great artist and genial friend who honored our art with his genius; and he was the greatest genius who ever gave up to photography talents which would have enabled their possessor to shine in any form of art.

Rejlander was one of the earliest friends I made through photography and it gives me great pleasure to respond to the request of the editor of the *Photographic News* to say a few words on the man and his works. I first met him at a meeting of the Birmingham Photographic Society in 1858. He was then living in Wolverhampton, and shortly after our meeting he came to visit me at Leamington, from which time until his death in January, 1875, in the closest friendship, and for many years in photographic criticism, our names—perhaps because we had the same aims, and partly also, probably, for the sake of alliteration—were coupled together, a conjunction of which I have always been proud; and it is a curious coincidence that our works have again come together or rather followed each other in the "One Man" exhibitions of the Camera Club.

At the time I have mentioned, Rejlander had made himself famous by many pictures which were far and away, in all essential art qualities, beyond anything that had ever been before shown, and especially by his wonderful composition which represented allegorically "The Two Ways of Life." This was first shown at the Art Treasures Exhibition at Manchester, in 1857, to which exhibition, by the way, I had sent my first poor efforts at pictorial photography. This famous picture, as was also much of his best work, was executed at Wolverhampton, in a small studio in which many a photographer would scarcely have found room to photograph a single head. Here this astonishing group, consisting of about thirty figures, and attempting the highest poetry in art with so much success as to gain respect, if not approval, from all, was put together. Any one but an enthusiast would have seen the impossibility of success with such a subject in such materials, but amid difficulties that would have scared most men, Rejlander saw only the end, and if he did not succeed in reaching it, his failure was almost as honorable as complete success.

Apart from the subject, which is allegorical, and partly carried out by the use of the nude—now ruled, and rightly, to be outside the natural limitations of the art—the picture is a marvel of skill and excellence. In composition and in clearness of story telling it has never been surpassed in any art, and the apparent impossibilities he overcame have always been a wonder to those who know most of the means by which it was produced. No photograph has ever met with so much criticism, for and against. It was rejected at an Edinburgh exhibition, not, however, on its artistic merits; a picture intended to convey the highest moral was rejected because of its supposed immorality. It would take too much space here to trace the courses of the two youths, who are represented as going the two ways of life, the one to the good and the other to the bad. In 1858 Rejlander was persuaded to read a paper before the Photographic Society of London—the only one he ever read—in which he explained the meaning of every figure. At the same time, with the generous intention of being of use to photographers, and to further the cause of art, he, unfortunately, described the method by which the pic-

Reprinted from *Anthony's Photographic Bulletin* 21 (February 22, 1890), pp. 107-10.

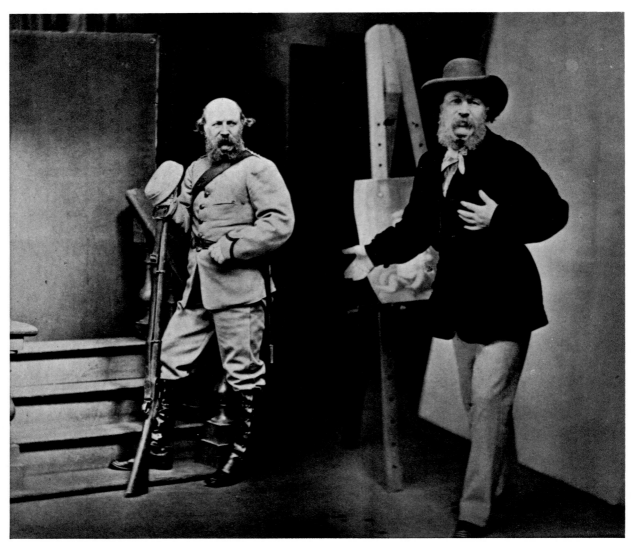

OSCAR G. REJLANDER. *Rejlander the Artist Introducing Rejlander the Volunteer*, ca. 1871. The Royal Photographic Society, Bath.

ture had been done; the little tricks and dodges to which he had to resort; how, for want of classic architecture for his background, he had to be content with a small portico in a friend's garden; how bits of drapery had to do duty for voluminous curtains: a simplicity into which others also have fallen, and thereby gave the clever critics the clew they wanted, and enabled the little souls to declare that the picture was only a thing of shreds and patches. It is so much easier to call a picture a patchwork combination than to understand the inner meaning of so superb a work as this masterpiece of Rejlander's! He had a sense of the unjustice of judging a work by the method of its production. He says in his paper: "I have a lively presentiment that the time will come when a work will be judged by its merits, and not by the method of its production; and then, with some fostering care, things can and will be done that

scarcely believers, and never unbelievers, yet dream of in their philosophy."

This picture was Rejlander's greatest effort, and I much regret that the committee of the club was not able to secure a full-sized copy for exhibition; the small reduction gives a very inadequate idea of the large picture. In his paper the artist promised other and greater efforts in succeeding years; the promise was never destined to be fulfilled. He often regretted that he never afterwards found time, and, indeed, the means—for such pictures are expensive to produce—to carry out his intention. He felt that such ambitious work was not properly appreciated, but he never lost faith in the method of combination printing, of which he was the originator, and occasionally employed it for smaller pictures up to the last. One of these, now in the Camera Club Exhibition, I greatly value. He was always brim-

ming over with happy ideas, and would at any time prefer to express himself in a picture than writing. I was once in the middle of a now long-forgotten controversy, endeavoring to defend our art from those who could only see in it a mechanical trade, when I received the little picture I have mentioned from him. He was a volunteer as well as an artist. The photograph represents Rejlander the artist jumping up from before his easel to introduce Rejlander the volunteer. The contrast between the artist in velvet coat and broad-brimmed felt hat, and the same man in the same picture in his regimentals, was startling. Under it was written "O. G. R. introduces himself as a volunteer to H. P. R.," thus delicately and pleasantly conveying that his help was at my service.

In ordinary manipulation Rejlander could not be called a perfect photographer; so that he conveyed his thoughts clearly, he did not care for delicacies of development or clean plates. To him art was a vehicle for conveying a thought. It was the thing to be said, not the manner of saying it, that demanded all his powers. He could never see the beauty in the indefinite. Being without affectation, a sound artist and real poet, nothing short of real art and true poetry would satisfy him. Though most original, he abhorred the eccentric.

Perhaps, after all, it was in fertility of ideas and imagination, and the readiness with which he used them, that he was at his greatest. As an example of his readiness, here is an illustration. He once sent home a portrait of a bright little boy dressed in velvet coat and knickerbockers. The boy had one hand in his pocket, and the action bent the figure a little aside. The picture was rejected because the figure was not upright. Rejlander immediately wrote underneath it, "I've got a pocket too!" and the picture was at once a tremendous success. Yet, I remember an occasion when it happened that a title he strongly objected to turned one of his pictures into the most popular photograph of the day. It happened this way. He sent to an exhibition a picture of a very little boy yelling furiously. He was then making experiments in expressions to illustrate Darwin's "Expression of the Emotions in Man and Animals," and entitled this photograph "Mental Distress." In his notice of the exhibition, a former editor of the *Photographic*

News, the late ever-regretted H. Baden Pritchard, called the howling youngster "Gink's Baby." This hit the humor of the hour, which was then much interested in a book of that name, and it became the photograph of the day and sold by thousands; but Rejlander was never reconciled to the loss of his scientific title. Many examples may be quoted of his happy thoughts, both pathetic and humorous, but it would be difficult to describe them so as to do them justice, unaccompanied by the pictures. "Grief," "Night in London"—a most moving picture of a ragged and desolate boy seated on a door step, and " 'Tis Light Within—Dark Without!"—a blind woman singing, are examples of the pathetic that occur at the moment; while the humorous are represented by "Did She"? one man (Rejlander himself) telling an amusing secret to another, whose face expresses a full appreciation of what he hears; and "She is looking at me, the dear creature!" an ugly and vain old man smirking and looking out of the corners of his eyes.

In the very interesting book of Darwin's I have mentioned are several figures in which Rejlander has tried to express in his own person the expressions intended to be conveyed. The contrasted figures of Anger and Humility are perfect, and show what possibilities as an actor were in him had he followed that branch or art.

Personally, Rejlander was beloved by all who knew him. His winning ways, his friendly genial charm, his ever fresh and humorous anecdotes, his quaint thoughts and original expressions, his enthusiasm for all art, and especially for the art of his adoption, his simplicity and sincerity, endeared him to his many friends. He was never known to use a word that would hurt the feelings of others; he preferred to be silent rather than condemn the work of another, and always took great delight in praising the attempts of a brother photographer when he honestly could. His was not one of those envious natures that cannot brook any success not his own; he rejoiced in the progress of the art, even when it was accomplished by other hands. He was absolutely free from petty jealousy. It was not necessary, nor his way, as it unfortunately is the way with some photographic aspirants, to denounce all art and artists so that he may stand in the foreground on his own little molehill. He was a rare man, a great artist, and a loving friend.

NADAR. *Honoré Daumier.* 1855. Modern print from original negative. Collection of Beaumont Newhall.

Nadar's Portraits at the Exhibition of the French Society of Photography

PHILIPPE BURTY
1859

Gaspard Félix Tournachon (1820–1910), who preferred to be known as Nadar, a pseudonym he adopted while a caricaturist, took up photography in 1853 and soon became the most celebrated portraitist in Paris. This review of Nadar's photographs in an 1859 exhibition of the French Society of Photography appeared in the influential art periodical La Gazette des Beaux-Arts.

It is indisputable that M. Nadar has made his portraits works of art in every accepted sense of the word, by the way he lights his sitters, by the freedom he gives in pose and stance, by his search for the typical expression of the features. All the artistic, dramatic, political galaxy—in a word the intelligentsia—of our time has passed through his studio; the sun is but the agent, M. Nadar is the artist who puts him to work. The series of portraits that he exhibits is the *Panthéon**—this time serious—of our generation. Daumier† meditates on his epic Robert Macaire,‡ Paul de Saint-Victor§ sculpts in his mind the Venus de Milo, M. Guizot# stands, his hand in his waistcoat, as severe and cold as though he was waiting for silence in the court before launching into a thundering rebuttal; Corot‖ smiles as someone asks him why he doesn't *finish* his landscapes; Dumas** holds his powerful, yes soulful head; Jean Journet,†† with his wild beard, is sermonizing, and Madame Laurent‡‡ reappears under four costumes of Les Chevaliers du Brouillard. We especially call attention to the bust of Madame Laurent seen from behind. The casual locks of hair, a firm neck supporting the elegant head and over the shoulders, a shawl draped in bold folds; it is not much, yet it lives, it is a likeness, that goes into your memory like the drawing of a great master. All these photographs are broad in effect and rendering. Each one is a positive and definite likeness whether of people you have never seen, or compared with those that are around us, they demonstrate that an intelligent man uses his brain as well as his camera, and that if photography is by no means a complete art, the photographer always has the right to be an artist.

NADAR. *Eugenè Delacroix.* 1855. Modern print from original negative. Collection of Beaumont Newhall.

Reprinted from *La Gazette des Beaux-Arts* 2 (May 15, 1859), pp. 215-16. Translated by Beaumont Newhall.

Panthéon was the title of a large lithograph by Nadar containing caricatures of 249 contemporaries.
†Honoré Daumier (1808-1879), caricaturist, painter, and sculptor.
‡"Robert Macaire" was a fictional character in Daumier's satirical lithographs.
§Paul de Saint-Victor (1827-1881), literary critic.
#François Guizot (1789-1874), statesman and historian.
‖Camille Corot (1796-1875), landscape painter.
**Alexandre Dumas (1802-1870), novelist and playwright.
††Jean Journet (1799-1861), evangelist.
‡‡Laurent, probably Marie Laurent (1826-1876), singer.

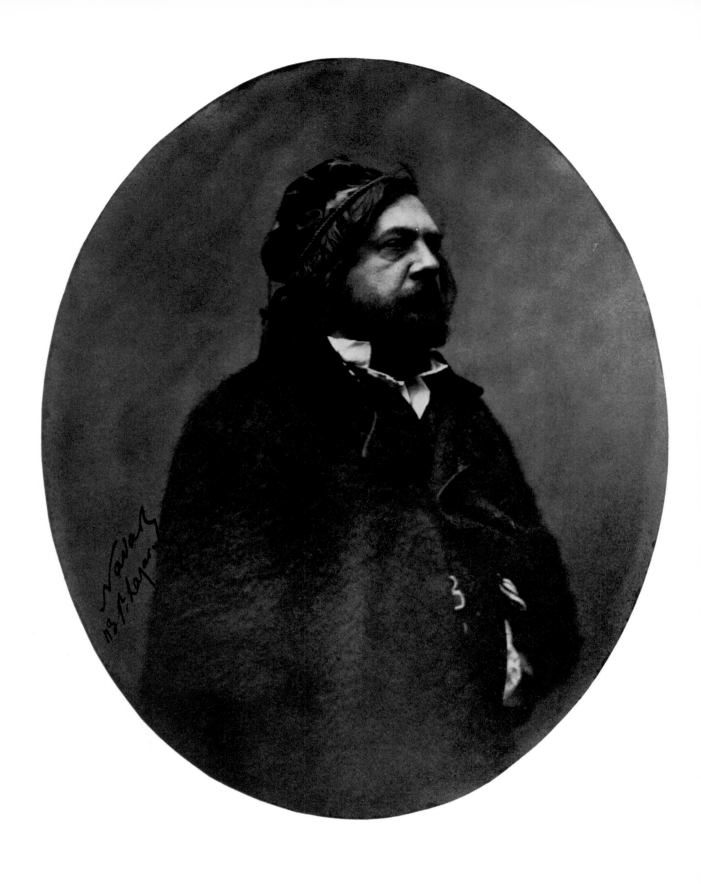

NADAR. *Théophile Gautier.* ca. 1856. University of New Mexico, Albuquerque.

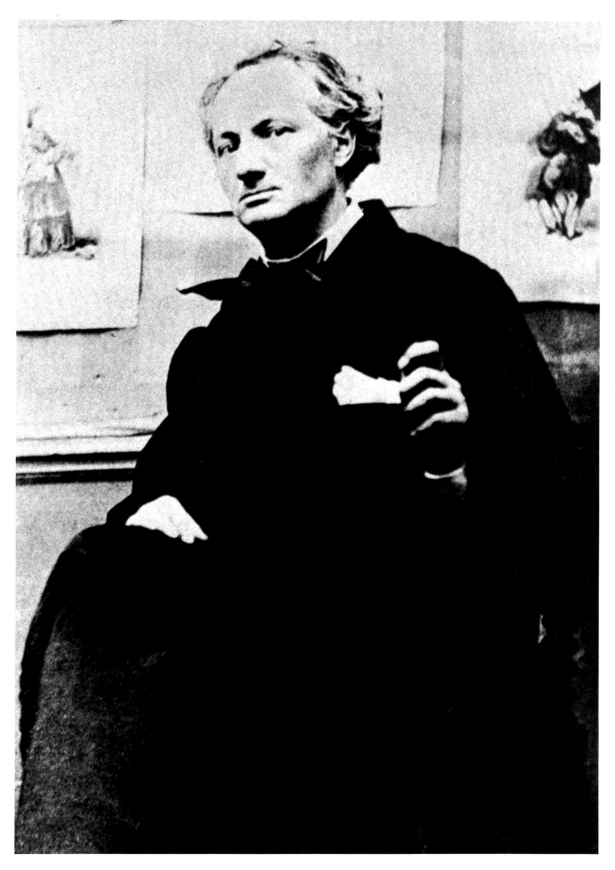

NADAR. *Charles Baudelaire.* ca. 1855. Bibliothèque Nationale, Paris.

Photography

CHARLES BAUDELAIRE
1859

The French poet Charles Baudelaire (1821–1867) was also one of the most brilliant and perceptive art critics of his time. Even though Baudelaire was a good friend of Nadar's, he feared that art would be corrupted by photography. His concern, in retrospect, was not so much with the medium itself as with the commercialization that accompanied its popularity and led to financial success by many would-be artists.

During this lamentable period, a new industry arose which contributed not a little to confirm stupidity in its faith and to ruin whatever might remain of the divine in the French mind. The idolatrous mob demanded an ideal worthy of itself and appropriate to its nature—that is perfectly understood. In matters of painting and sculpture, the present-day *Credo* of the sophisticated, above all in France (and I do not think that anyone at all would dare to state the contrary), is this: "I believe in Nature, and I believe only in Nature (there are good reasons for that). I believe that Art is, and cannot be other than, the exact reproduction of Nature (a timid and dissident sect would wish to exclude the more repellent objects of nature, such as skeletons or chamber-pots). Thus an industry that could give us a result identical to Nature would be the absolute of Art." A revengeful God has given ear to the prayers of this multitude. Daguerre was his Messiah. And now the faithful says to himself: "Since photography gives us every guarantee of exactitude that we could desire (they really believe that, the mad fools!), then photography and Art are the same thing." From that moment our squalid society rushed, Narcissus to a man, to gaze at its trivial image on a scrap of metal. A madness, an extraordinary fanaticism took possession of all these new sun-worshippers. Strange abominations took form. By bringing together a group of male and female

Reprinted from Charles Baudelaire, The Mirror of Art (London: Phaidon Press Limited, 1955), pp. 228-31. Translated by Jonathan Mayne. Quoted with permission of the publisher.

clowns, got up like butchers and laundry-maids in a carnival, and by begging these *heroes* to be so kind as to hold their chance grimaces for the time necessary for the performance, the operator flattered himself that he was reproducing tragic or elegant scenes from ancient history. Some democratic writer ought to have seen here a cheap method of disseminating a loathing for history and for painting among the people, thus committing a double sacrilege and insulting at one and the same time the divine art of painting and the noble art of the actor. A little later a thousand hungry eyes were bending over the peep-holes of the stereoscope, as though they were the attic-windows of the infinite. The love of pornography, which is no less deep-rooted in the natural heart of man than the love of himself, was not to let slip so fine an opportunity of self-satisfaction. And do not imagine that it was only children on their way back from school who took pleasure in these follies; the world was infatuated with them. I was once present when some friends were discretely concealing some such pictures from a beautiful woman, a woman of high society, not of mine—they were taking upon themselves some feeling of delicacy in her presence; but "No," she replied. "Give them to me! Nothing is too strong for me." I swear that I heard that; but who will believe me? "You can see that they are great ladies," said Alexandre Dumas. "There are some still greater!" said Cazotte.

As the photographic industry was the refuge of every would-be painter, every painter too ill-endowed or too lazy to complete his studies, this universal infatuation bore not only the mark of a blindness, an imbecility, but had also the air of a vengeance. I do not believe, or at least I do not wish to believe, in the absolute success of such a brutish conspiracy, in which, as in all others, one finds both fools and knaves; but I am convinced that the ill-applied developments of photography, like all other purely material developments of progress, have contributed much to the impoverishment of the French artistic genius, which is already so scarce. In vain may our modern Fatuity roar, belch forth all the rumbling wind of its rotund stomach, spew out all the undigested sophisms

with which recent philosophy has stuffed it from top to bottom; it is nonetheless obvious that this industry, by invading the territories of art, has become art's most mortal enemy, and that the confusion of their several functions prevents any of them from being properly fulfilled. Poetry and progress are like two ambitious men who hate one another with an instinctive hatred, and when they meet upon the same road, one of them has to give place. If photography is allowed to supplement art in some of its functions, it will soon have supplanted or corrupted it altogether, thanks to the stupidity of the multitude which is its natural ally. It is time, then, for it to return to its true duty, which is to be the servant of the sciences and arts— but the very humble servant, like printing or shorthand, which have neither created nor supplemented literature. Let it hasten to enrich the tourist's album and restore to his eye the precision which his memory may lack; let it adorn the naturalist's library, and enlarge microscopic animals; let it even provide information to corroborate the astronomer's hypotheses; in short, let it be the secretary and clerk of whoever needs an absolute factual exactitude in his profession—up to that point nothing could be better. Let it rescue from oblivion those tumbling ruins, those books, prints and manuscripts which time is devouring, precious things whose form is dissolving and which demand a place in the archives of our memory— it will be thanked and applauded. But if it be allowed to encroach upon the domain of the impalpable and the imaginary, upon anything whose value depends solely upon the addition of something of a man's soul, then it will be so much the worse for us!

I know very well that some people will retort, "The disease which you have just been diagnosing is a disease of imbeciles. What man worthy of the name of artist, and what true connoisseur, has ever confused art with industry?" I know it; and yet I will ask them in my turn if they believe in the contagion of good and evil, in the action of the mass on individuals, and in the involuntary, forced obedience of the individual to the mass. It is an incontestable, an irresistible law that the artist should act upon the public, and that the public should react upon the artist; and besides, those terrible witnesses, the facts, are easy to study; the disaster is verifiable. Each day art further diminishes its self-respect by bowing down before external reality; each day the painter becomes more and more given to painting not what he dreams but what he sees. Nevertheless *it is a happiness to dream,* and it used to be a glory to express what one dreamt. But I ask you! does the painter still know this happiness?

Could you find an honest observer to declare that the invasion of photography and the great industrial madness of our times have no part at all in this deplorable result? Are we to suppose that a people whose eyes are growing used to considering the results of a material science as though they were the products of the beautiful, will not in the course of time have singularly diminished its faculties of judging and of feeling what are among the most ethereal and immaterial aspects of creation?

FRANCIS FRITH. *Convent of Mar-Saba, near Jerusalem.* ca. 1862. The Museum of Modern Art, New York.

FRANCIS FRITH. *Entrance to the Great Temple, Luxor.* 1857. The Museum of Modern Art, New York.

The Art of Photography

FRANCIS FRITH
1859

Francis Frith (1822–1898), one of the most prolific of British photographers, specialized in recording architectural monuments of the past and in landscapes of the type called in their day "topographical." A superb craftsman, he first became internationally known for the photographs he made in Egypt, Nubia, and Palestine during three expeditions he made between 1856 and 1860. He opened a bulk printing works in Reigate, England, in 1858, from which issued thousands of photographs to satisfy the demand for travel views.

To some of his contemporaries the truth of photography—its ability to record seemingly infinite detail—was a barrier to its acceptance as "high art." C. Jabez Hughes in 1860 told the members of the South London Photographic Society:*

Permit me, before proceeding further, to make a few distinctions to assist us in discussing our subject. I propose to divide general photography into three classes—Mechanical photography, Art-photography, and, for want of a better term, High-Art photography.

MECHANICAL PHOTOGRAPHY will include all kinds of pictures which aim at a simple representation of the objects to which the camera is pointed, and will include not only all reproductions but the great majority of portraits and landscapes. Let it be understood that I do not mean the term *mechanical* to be understood depreciatingly. On the contrary, I mean that everything that is to be depicted exactly as it is, and where all the parts are to be equally sharp and perfect is to be included under this head. I might have used the term *literal* photography, but think the former better. This branch, for obvious reasons, will always be the most practised: and where literal, unchallengeable truth is required, is the only one allowable.

ART-PHOTOGRAPHY will embrace all pictures where the artist, not content with taking things as they may naturally occur, determines to infuse his mind into them by arranging, modifying, or otherwise disposing them, so that they may appear in a more appropriate or beautiful

manner than they would have been without such interference. This class may easily embrace almost all subjects. In landscapes the artist may select the period of the year, the condition of the weather, time of the day, point of sight, length of exposure, &c., as material agencies in beautifying his picture; the same in portraiture, by arrangement of light, *pose*, expression, presence or absence of accessories, &c., also in the composition of pictures by the due attention to all the necessary parts, so as to form one harmonious whole.

HIGH-ART PHOTOGRAPHY—This distinction may appear presumptuous; but I feel a necessity for it to include certain pictures which aim at higher purposes than the majority of art-photographs, and whose aim is not merely to amuse, but to instruct, purify, and ennoble.

Hughes's definition of the mechanical parallels that of Frith: "Every stone, every little perfection or dilapidation, the most minute detail which, in an ordinary drawing, would merit no special attention, becomes; in a photograph, worthy of careful study." Frith strongly advises the photographer to follow "the principles of Art," but to avoid pretension: "Photography does not even now profess to be 'high Art,' or in any way a substitute for it."

Unfortunately the planned sequel to this article, to which Frith alludes, did not appear in The Art-Journal.

From the time when, pegged into a high little chair, we first jerked off, upon the back of a letter, a representation of the skein of silk which our mother was unravelling by our side, we have taken a lively interest in all the pictorial processes which have so abundantly variegated the surfaces of paper and of canvas. By almost all these, results have been produced more or less gratifying. Perhaps the only effort which has provoked our indignation, is the ever-present, unmeaning vulgarity which crawls, like a plaque of loathsome insects in Egypt, over the walls of our houses. We reserve, however, our wrath for a

Reprinted from *The Art Journal* 5 (1859), pp. 71-72.

*C. Jabez Hughes, "On Art Photography," *American Journal of Photography* 3 (1861) pp. 260-63.

special outpouring upon "paper-hangings." The efforts which have affected us with the deepest melancholy, are a few of Turner's later pictures, and innumerable bad photographs. To the Art upon which the production of these last is chargeable, we now confine our observations.

We recollect to have had our notice called to certain objects in the Exhibition of 1851, in Class A. Class A embraces all that mine of speculative and delusive subjects termed "promising." Those to which we now refer purported to be mechanically constructed landscapes, we believe, by Mr. Fox Talbot. They were, undoubtedly, "interesting" and curious, but we regarded them as we do the results of a calculating or talking machine, with astonishment and pity. They suggested, too, an uncomfortable idea that the "artist" had spilled a cup of *café noir* over sundry sheets of paper, and pinned them up to dry. It is not our intention in the present article, or in subsequent articles, upon photography, to adopt any theories of partizanship, or to be enslaved by any prejudices whatever. We shall endeavour to write purely in the interests of *Art*. The character of this Journal, as a friend of the easel and palette, is sufficiently known to screen us from the jealousy of painters; and, on the other hand, we profess so ample an acquaintance with the practice and results of photography in its various branches, that its lovers need not fear our doing it full and impartial justice. The history of the art, the steps by which it progressed, and the formulae of these operations, are not so much our province as is its present state, and the comparative success of its various processes. Of these, we must be permitted to judge *with reference to pictorial and illustrative Art in general*. We think that we are now entitled to decline to take up a photograph, and pronounce upon it simply as "a most curious and wonderful production, made in a few seconds, sir,—in a few seconds! *Everything* is there, you see!" We must allow to the art the credit of having established for itself a title to be regarded in comparison with its neighbours. Photographers do not now want to be patted on the back, and told that they are good little boys, and that their performances are very creditable, considering their age; but they boldly hire the Suffolk Street Gallery, and challenge the *abstract* admiration of the men who have been used there to exhibit their own beautiful works.

It is a critical and timid time of life, this, when the quondam schoolboy feels that he must renounce the privileges of his class, and be judged as a man by the stern world of men. *Such an ordeal, we do not hesitate to say, the art of photography is now passing through*; and this is *our* starting point. Almost up to the present time, it has been, very properly, in the hands of chemists and opticians, and the men who had a steady hand and a correct eye for the "definition" in a brick-wall. Not that we would deny to exceptional productions of years ago, to daguerreotype portraits, and to a few "talbo-type" landscapes, a high degree of delicacy and artistic beauty; but we may safely say that anything approaching to a satisfactory uniformity of successful and pleasing result has only been established within a very recent period. Thus, to close the first or introductory branch of our subject, we remark, that although we are inclined to admit that photography has passed the bounds of mere scientific interest, and now take rank amongst the great pictorial arts of the day,—with lithographic or steel-plate printing, and even, with certain broad distinctions, with painting itself,—we do not thus necessarily place it on a par with any of these arts; it is still, as compared with them, "in its infancy;" and it has its own distinctive defects, which are, as yet, more obvious and objectionable than any which can ordinarily be charged upon the sister Arts. To counterbalance these, however, it has its own peculiar charms and beauties, and it possesses certain qualities, to be discussed hereafter, both in its practice and results, which are *altogether* its own. Whether some of these are to be regarded as advantages, or otherwise, will continue to be a matter of opinion, but they will afford us subject for interesting discussion and remark.

Having defined, to some extent, the position to which photography has attained, we now turn our attention to some of its chief peculiarities as a pictorial art.

Of these, the most obvious, and that which undoubtedly lies at the root of its popularity, is its *essential* truthfulness of outline, and, to a considerable extent, of perspective, and light and shade. We are aware that ladies, of uncertain age, have discovered and pronounced that "those photographic machines are as false and deceitful as *the rest of mankind;* that the portraits which Mr. So-and-so took of them were no more like them than nothing at all—their own sisters would not have known them!" We are aware that gentlemen with uncomfortably large noses (not over well "defined" by nature with "tips"), with immense tuberous feet, and double-jointed knees, covered with worn-out patterns, have taken pains to spread abroad in the public mind an alarming theory about spherical *aberration*. It is true that combinations of lenses, arranged so as to shorten the focus, and quicken the chemical action of the light, large ones especially— such lenses are commonly used for portraiture—are liable to this objection, to a serious extent. Such lenses have also other heavy faults. Their manufacture we believe to be, at present, very imperfectly understood. But the distortion, or disproportionate enlargement of near objects, produced by a landscape lens of good construction, is so very small as not to amount to a defect, whilst the "defi-

nition" which they give is so wonderfully minute and perfect, as to lead us to believe that the construction and manufacture of these instruments has approached very nearly to perfection, and certainly leaves little or nothing to be desired.

We are, then, not only inclined to leave the art in quiet possession of its "corner-stone," but we find it difficult to express how fully, and for how many different reasons, we appreciate this attribute of photography. We can scarcely avoid moralizing in connection with this subject; since truth is a divine quality, at the very foundation of everything that is lovely in earth and heaven; and it is, we argue, quite impossible that this quality can so obviously and largely pervade a popular art, *without exercising the happiest and most important influence, both upon the tastes and the morals of the people.* It is an attribute, to which, we believe, there is, in the whole range of Art, no parallel; to whose uses and delights we can assign no limits, and shall, of course, not attempt to enumerate them. We will merely suggest to our readers an offer, by auction, of a collection of genuine photographic portraits of all the great and holy men of antiquity, and of our Newton, and Milton, and Shakespeare! The concourse of people! The bids! The reserved price! We protest there *is,* in this new spiritual quality of Art, a charm of wonderful freshness and power, which is quite independent of general or artistic effect, and which appeals instinctively to our readiest sympathies. Every stone, every little perfection, or dilapidation, the most minute detail, which, in an ordinary drawing, would merit no special attention, becomes, on a photograph, worthy of careful study. Very commonly, indeed, we have observed that these faithful pictures have conveyed to ourselves more copious and correct ideas of detail than the inspection of the subjects themselves had supplied; for there appears to be a greater aptitude in the mind for careful and minute study *from paper, and at intervals of leisure,* than when the mind is occupied with the general impressions suggested by a view of the objects themselves, accompanied, as these inspections usually are, by some degree of unsettlement, or of excitement, if the object be one of great or unwonted interest. The probable effects of the truthfulness of photography upon Art in general, will be considered at a future time.

We now come to the disadvantages of this attribute: for it happens, by a singular fatality, that upon it hangs the chief reproach to photographic productions as works of Art. The fact is, that it is *too truthful.* It insists upon giving us "the truth, the whole truth, and nothing but the truth." Now, we want, in Art, the first and last of these conditions, but we can dispense very well with the middle term. Doubtless, it is as truly the province of Art

to improve upon nature, by control and arrangement, as it is to copy her closely in all that we *do* imitate; and, therefore, we say boldly, that by the non-possession of these privileges, photography pays a heavy compensation to Art, and must for ever remain under an immense disadvantage in this respect. We are sure that no one will be more ready to subscribe to the accuracy of this remark, than the accomplished photographer himself. No man knows so well as he, that very rarely indeed does a landscape arrange itself upon his focussing-glass, as well, as effectively, as he could arrange it, *if he could.* No man is so painfully conscious as he is, that nature's lights and shades are generally woefully patchy and ineffective, *compared with Turner's*; and, in short, that although his chemical knowledge be perfectly adequate, and his manipulation faultless, it is a marvel, an accident, a chance of a thousand, when a picture "turns out" as *artistic,* in every respect, as his cultivated taste could wish.

Next to the truthfulness of photography, its most striking peculiarities are its somewhat mechanical character, and the rapidity with which its results are produced. These characteristics constitute the chief elements of the extent and popularity of the practice of photography, just as its truthfulness is the greatest charm of its results. It was perfectly natural and inevitable that when this art began to excite universal attention, the whole body of skilled draughtsmen looked upon it with jealousy and distrust. It is inevitable that many artists must continue to dislike or to despise it. We can even imagine that some who hailed it as a beautiful thing, and who even made a partial and timid use of it, have harboured it as they would a tame snake; giving it a good switching now and then, lest it should grow rampant, and bite. It is evident that some classes of artists had substantial cause to dread it. It has already almost entirely superseded the craft of the miniature painter, and is upon the point of touching, with an irresistible hand, several other branches of skilled Art.

But, quite apart from "interested motives," there was, and there continues to be, a reasonable jealousy, not so much of the Art itself, or of its capabilities, as of its pretensions, and the *spirit of its practice.* We do not participate in these fears, because we are convinced of two things with reference to this subject. Firstly, that to practice the Art *with distinction,* which will very shortly be, if it be not now, the only kind of practice which will command notice, requires a much greater acquaintance with the principles of Art than would seem to be applicable to "a merely mechanical science." And, secondly, we are convinced that no extravagant "pretensions" can long be maintained in the public mind. Photography does not even now profess to be either "high

117

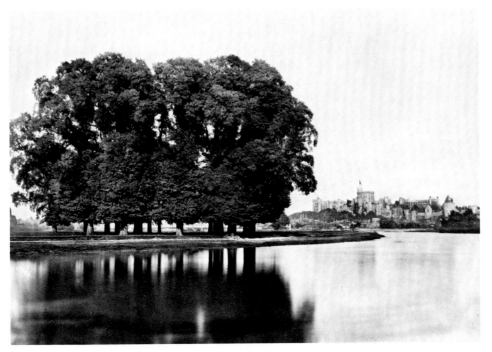

FRANCIS FRITH. *Windsor from the Railway.* n.d. The Museum of Modern Art, New York.

Art," or in any way a substitute for it. We shall endeavor to define clearly, at a future time, both what in our opinion it *has* done, and what it may yet hope to accomplish; and we shall not hesitate also to exhibit what we consider it has *not* done, and what, in our humble opinion, it can never, in the nature of things, hope to do.

The class of persons, now a very large one, who practice photography, is undoubtedly a very different class from the old regime of "artists." It certainly includes a vast number who know nothing, and, if we judge by their *crimes,* care less for the principles, we will not say of Art, but of common sense and decency. But even these, its practice, how degrading soever to an "artist," may insensibly benefit. Whatever Art may, in the opinion of some, suffer from photography, that large class of the public, who are sunk so far *below Art,* will unquestionably reap from it a more than compensating advantage. We do not believe in its power to deter any youth, to whom nature has given an artist's eye and heart, from a proper cultivation of those tastes and talents from which he is gifted. Your most accomplished artist, if he will stoop to the task, will ever be your best photographer, and your skillful "manipulator," if he be possessed likewise of a grain of sense or perception, will never rest until he has acquainted himself with the rules which are applied to Art in its higher walks; and he will then make it his constant and most anxious study how he can apply these rules to his own pursuit. And this—although no easy matter, and a thing

not to be perfected in a day—he will find to be a study which will admit of the most varied and satisfactory application.

The rapidity of production of which the merely mechanical process of photographic picture-making is capable, may easily become a source of great mischief. The student should bear in mind that what he is to aim at is not the production of a large number of "good" pictures, but, if possible, of ONE which shall satisfy all the requirements of his judgment and taste. That one, when produced, will be, we need not say, of infinitely greater value to his feelings and reputation than a "lanefull" of merely "good" pictures. Think of the careful thought and labour which are expended over every successful piece of canvas, and the months of patient work which are requisite to perfect a first-class steel plate! And then turn to the gentleman who describes a machine which he has contrived for taking six dozen pictures a day! Every one of them—this is the distressing part of the business—every one of them capable of throwing off as many impressions as the steel plate! We shudder to think of the thousands of vile "negatives" boxed up at this moment in holes and corners, any one of which may, on a sunny day, hatch a brood of hateful "positives."

We feel it to be a solemn duty to remind photographers of the responsibilities which they incur by harbouring these dangerous reproductive productions; and we beg of them—for their own sakes, and for that of society—

118

to lose no time in washing off, or otherwise destroying, by far the greater part of their "negative" possessions.

When Daguerre and his contemporaries, some twenty years ago, succeeded in fixing the most delicate lights and shades, reflected from an object through an optical lens *upon polished silver surfaces,* the world was charmed with the invention. It was, indeed, exquisitely beautiful in its results. To the present day we believe that, in point of delicacy and detail, there is no pictorial process in the whole range of Art that can be said to surpass the daguerreotype. But the costly metallic medium, with its unpleasantly brilliant reflecting surface, was a manifest difficulty in the way of its adaptations; whilst the fact of its being a *non-reproductive* process excluded the idea of its application to the various commercial and valuable purposes for which the great principle of photographic representation was seen to be so strikingly available. Thus we take leave of "daguerreotypes." They are very wonderful and very beautiful; but they are no more available for the popular uses of Art than are the costly illuminated manuscripts in the British Museum. The only purposes to which this process is now applied are to an exceedingly limited and rapidly narrowing extent in portraiture, and for the stereoscope, to which latter use the smoothness of its surface and its delicacy have been the attractions.

We have now to beg the patient attention of our readers, whilst we point out some most wonderful adaptations of the photographic art.

To Mr. Fox Talbot is due, we believe, the production of the first matrix, or "negative," by means of the camera, which by a second process, still purely photographic, and capable of indefinite repetition, gave a "positive" result —that is, a picture with objects in their correct relative positions, and with the proper relations of light and shade. Now, it is obvious that, in order to accomplish these objects, the matrix, or "negative," must be produced in the camera *with all these conditions reversed.* The right hand of the picture must be brought to the left; blacks must be white, and whites black; shadows must be clear, and high lights opaque. We wish also to call attention to another most striking apparent difficulty. The foreground of a picture requires, of course, that its shadows should be deep and broad, and its whole treatment bold and decisive, as compared with the distant portions of the landscape. Now, since the depth and boldness of a photographic result depend upon the chemical action of the light *not being too strong* (for the effect of an over-exposed picture is a general feebleness, all the shadow being by degrees obliterated), it results that the chemical power of the rays of light

reflected from the objects in the view is required to be greatest from the most distant ones, and lessening in exact proportion as they approach the foreground of the picture; and this, contrary to all apparent reason, *is found to be precisely the case;* and all the other above-named required conditions—by a sort of providential arrangement so remarkable that it looks exceedingly like a *special* one, rather than by any complicated devices of Mr. Fox Talbot's—hasten to crowd themselves upon the wonderful "negative" picture. The lens, of its own accord, reverses the relative position of the objects,— throws right to the left, and left to the right,—the chemical action of the light *blackening* (instead of *whitening*) the prepared surface in the most inconceivably delicate proportion to its intensity. We have, altogether, such an indivisible, unalterable, and appropriate combination of natural laws, bearing upon the subject with such perfect *benevolence* towards the desired result, that it has frequently struck us that a photographic picture is not so much a contrivance of man as a design of nature, with which we have become happily acquainted, and which to neglect in cultivation would approach nearly to a sin.

The process originally employed by Mr. Fox Talbot is the one which is termed the Talbotype, or "Calotype." The medium used is paper, carefully freed from metallic specks, and of an even texture; it is saturated with an iodide of silver. The exposure in the camera varies from four to twenty minutes. The image, when removed from the camera, is a *latent* one, or very feebly visible. It is "developed" (that is, the action of the light in blackening the salt of silver is carried on to the required extent) by means of gallic acid. This venerable and respectable process is still employed, to a very limited extent, chiefly by artists and amateur travelers, who are not so much anxious to produce fine pictures as to carry away suggestions and remembrances, its portability and cheapness being great recommendations; yet as we have before stated, we have seen very beautiful results by this process —very far more to our liking than, for instance, any good-sized *landscape* by the albumen process. For example, amongst many which have been before the public, the views in the Pyrenees (12 in. by 14 in.) by the Viscount Vigier, are admirable for their texture, perspective, and lighting. Mr. Buckle, of Leamington, and Mr. Rosling, of Reigate, were each neat and beautiful calotype manipulators in the early days of the art.

We shall thus for the present take our leave of the second great division of the photographic processes, but shall probably have occasion to refer to it collaterally in comparison with the results of processes to be discussed hereafter.

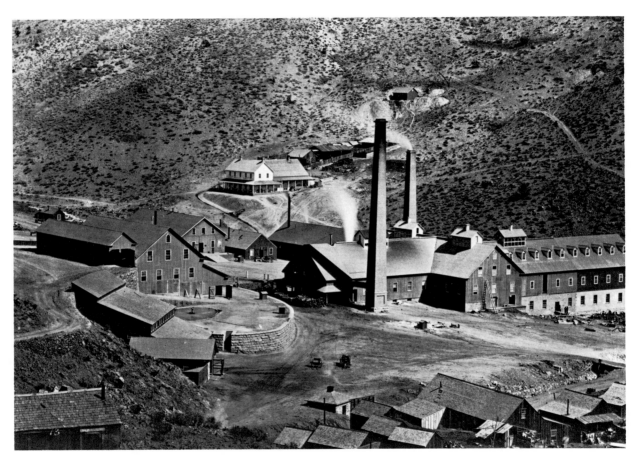

TIMOTHY H. O'SULLIVAN. *The Gould and Curry Mill, Virginia City, Nevada.* 1867. George Eastman House, Rochester, N.Y.

Photographs from the High Rockies
From HARPER'S NEW MONTHLY MAGAZINE

1869

Among the major achievements of nineteenth-century photographers was the recording of the landscape of the American West, particularly those as yet unexplored areas through which the transcontinental railroad would be built. Of the many photographers who accompanied government survey expeditions, Timothy H. O'Sullivan (1840–1882) produced outstanding work. It ranks in its expressive quality with his photographs of the Civil War. Why the anonymous author of this account of the United States Geological Exploration of the 40th Parallel, directed by Clarence King, does not name or identify O'Sullivan is a puzzle. Accompanying the lively narrative are crude wood-engravings from O'Sullivan's photographs. In reprinting this article, we have substituted reproductions from original prints in the collection of the George Eastman House, Rochester, New York.

Places and people are made familiar to us by means of the camera in the hands of skillful operators, who, vying with each other in the artistic excellence of their productions, avail themselves of every opportunity to visit interesting points, and take care to lose no good chance to scour the country in search of new fields for photographic labor.

During our late war we had photographic representations of battle-fields, which are now valuable as historical material, both for present and for future use.

The battle of Bull Run would have been photographed "close up" but for the fact that a shell from one of the rebel field-pieces took away the photographer's camera. In 1863, while photographing Fort Sumter and the Confederate batteries in the vicinity of Charleston, a courageous operator saw his camera twice knocked over by fragments of shell, his camera-cloth torn, and the loose white sand of Morris Island scattered over plates and chemicals. The veteran artillerists who manned the battery from which the views were made wisely sought refuge in the bomb-proofs to secure themselves from the heavy shell fire which was opened upon their fortification; but the photographer stuck to his work, and the pictures made on that memorable occasion are among the most interesting of the war. Many of the best photographs of events that occurred during the war were made by the adventurous artist who now furnishes pictures of scenes among the High Rockies, and narrates the adventures incident of the long journey during which the photographs were made.

Early in the summer of 1867 a surveying party of about forty persons left California to proceed eastward directly across the different ranges of the Rocky Mountains as far as the Great Salt Lake, and traveled most of the distance in the vicinity of the proposed route of the Central Pacific Railroad. The company comprised scientific gentlemen and other civilians, such as cooks and packers, to the number of seventeen. An escort of twenty men from the Eighth United States Cavalry, under the command of a sergeant, was considered a force quite adequate to guard against any danger from the Piutes and other tribes of mountain Indians who might be attracted by the stock, rations, or *hair* of the party. Two mules and an experienced packer were assigned to the photographing artist, and were by him duly accepted as a satisfactory outfit for the proposed expedition.

Traveling for some days in California, through fair mountain country, the mules became used to their packs, and the party sufficiently familiar with each other to realize the fact that to know a man well you must campaign with him.

A tarry at Nevada City,* long enough to rest the stock, gave the Artist time to explore the mines along the great Comstock Lode, situated in Gold Hill and Silver City. This locality was a few months since visited by one of the direst calamities that ever befell the inhabitants of the mining regions of our country. I refer to the fires on the different levels of the Crown Point, Kentuck, and Yellow Jacket mines.

*In fact, the survey party tarried at Virginia City, Nevada, not Nevada City, which is seventy-five miles west of the Comstock Lode, in California.

Reprinted from *Harper's New Monthly Magazine* 39 (September 1869), pp. 465-75.

By means of magnesium light interesting views were taken of places located several hundred feet below daylight; but as this is not an article relating to gold mining, we will come up out of that profitable hole in the ground from which something like ninety million dollars in gold have been taken, and proceed northward to the banks of the Truckee, a swiftly flowing stream which empties its alkaline waters into the southern portion of Pyramid Lake.

The Truckee has its source in the Wabash Mountains, from the cañon and gorges of which flow brooks that may be traced to living springs of almost any mineral property that one may desire. These brooks combining form the Truckee. On this river the *Nettie,* a boat at which a single glance was all that was necessary to convince a man reared on the rugged coast of New England that the craft was the handiwork of an artisan who had built boats for New London fishermen. She was a perfect model of her class.

The pack animals were left in charge of the men who were not desirous to visit Pyramid Lake, while into the *Nettie* were stowed provisions and articles of actual necessity, among which may be mentioned the instruments and chemicals necessary for our photographer to "work up his views."

To sail or float down the rapids of the Truckee in a boat of the *Nettie's* build was an undertaking that, prior to this time, had not been accomplished. Between the rapids of the stream lay stretches of deep still water, through which the boat glided, impelled either by sail or sweeps. Presently the great rapids are reached; the stream is wider and shallower. Danger is near. The location of the rock, that is hidden beneath the rushing water, is discovered by the whirling eddy. In some places the foaming torrent dashes against a projecting spur of rock that breaks the current in showers of spray, of which the larger drops fall in the form of tiny crystal spheres that dance and sparkle for an instant ere they disappear below in the swift stream that has, in places, worn its course through, and exposed to view singular rock formations that tell of volcanic action.

The trunk of a tree comes floating swiftly down the tide, and is plunged into the whirling rapids. The stout stem that has stood for years, a landmark for the Piutes, is in a moment splintered by the rushing water as if riven by lightning. It is through these rapids that the *Nettie* must be navigated, if she can be released from the strong hold which the current has of her, as she lies jammed by the mad velocity of the stream against two projecting rocks. The strong oars are swept away and caught by the rocks below. In a twinkling the tough ash is bent into a shape more like the bow of an ox yoke than that of the tried oar.

Our photographic friend, being a swimmer of no ordinary power, succeeded in reaching the shore, not opposite the *Nettie,* though it was but forty yards from the shore, for he was carried a hundred yards down the rapids. A rope was thrown to him from the boat, and thus he rescued the little craft with her crew from their perilous situation. The sharp rocks had torn the little clothing of which he had not divested himself, and had so cut and bruised his body that he was glad to crawl into the brier tangle that fringed the river's brink. When at last he gained the point nearest to the boat his excited friends threw shoreward his pocket-book, freighted with three hundred dollars in twenty-dollar gold pieces. "That was rough," said he; "for I never found that 'dust' again, though I prospected a long time, barefooted, for it." The line which had been thrown was quickly made fast to a convenient spur of rock, and the *Nettie,* half filled with water, was soon hauled to the shore, where the exploring party, wet and famished, pitched their camp among the briers for the night. On the following morning the *Nettie* was finally passed through the rapids by the aid of ropes, and not long after the party arrived at the outlet of Pyramid Lake, an irregular and stormy sheet of water, some 30 miles long and 12 wide.

The peculiar rock formations, from which this lake derives its name, are remarkable even among the "Rockies." The principal pyramid towers above the lake to a height of more than 500 feet, presenting in its general outline a remarkably perfect pyramidal form. Close scrutiny shows portions of its sides to consist of volcanic tufa, which greatly resembles a vegetable growth of vast size.

In color the pyramidal mounds vary with the varying light. At some moments they convey the impression of a rich, warm, brown tint; at others the hue is a cool gray that more nearly resembles the color which a close examination will prove to be the true one.

A visit to the largest pyramid developed the fact that it was occupied by tenants entirely capable of holding inviolate their prior right of possession against all human visitors. From every crevice there seemed to come a hiss. The rattling, too, was sharp and long continued. The whole rock was evidently alive with rattlesnakes. In every party that ever ventured into a country infested by rattlesnakes are some men who derive great pleasure in killing every snake that may show its head or sound its rattle. A loud shout of "Snakes! rattlers!" brought out the band of exterminators; but such a number of snakes came upon the field that it was clearly beyond the power of our snake-haters to carry on the combat with any hope of final victory. They gave up, and abandoned the locality to the serpentine tribe, which will probably

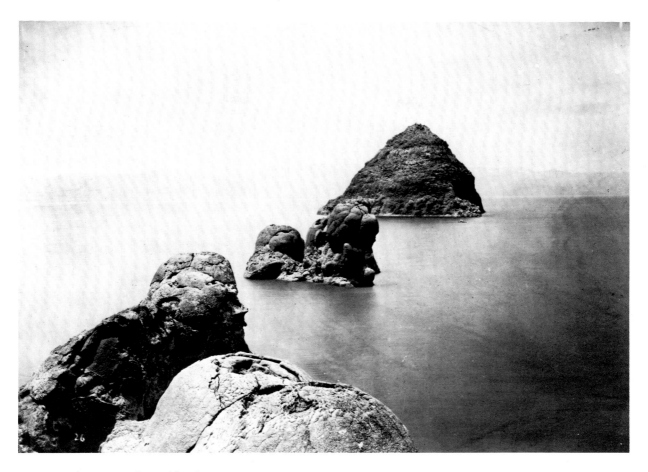

TIMOTHY O'SULLIVAN. *Pyramid Lake.* 1867. George Eastman House, Rochester, N.Y.

retain the ownership for a period of time indefinite and unlimited.

The water of Pyramid Lake is clear, sparkling, and very salt. It abounds in fish, among which are the *couier,* a sprightly fish, having flesh the color of salmon, and quite as game. In weight this fish ranges from three to twenty pounds, and an occasional specimen rises to the fly that will scale quite twenty-five pounds. Besides the *couier* there is an abundance of trout, not precisely the speckled beauties of the Lake Superior region; neither do they bear a very close resemblance to the sluggish, black, spotted trout of our more Southern States. It is a trout, nevertheless, which rises readily to the artificial fly, and is a pleasing morsel for the epicurean palate. Cooked in the various styles known to the campers, this fish will compare favorably with its eastern brethren. Other varieties of the finny tribe abound in Pyramid Lake; but these are the ones which will be most sought after by any courageous disciple of Izaak Walton, who leaves the cars of the Central Pacific Railroad where it strikes the Truckee, and who ventures down to its outlet in this curious lake.

From Pyramid Lake the exploring party journeyed back by land to a point on the overland stage route, where the animals and extra camp equipage were in waiting for them. The Central Pacific Railroad has now its iron bands beside this road, and, in this vicinity, passes through a valley picturesque, and, for this section, tolerably fertile.

The next point of interest was the Humboldt Valley and Sink, on the way to which the party passed through a country where, besides the Indians, were occasionally found white inhabitants who had come from the Eastern States and traveled thus far on their long journey to California, and here they had squatted. These people seem to be peculiar to this portion of the Union. They have, ordinarily, left the States many years before, and migrating toward the famed Eldorado of the Pacific coast, have, from some reasons best known to themselves, here shortened their trail and come to a full stop. Possibly, and even quite probably, the Indians have "cleaned them out," to use the Plains' phraseology; that is, have stampeded their stock, and appropriated whatever was of any value in the "outfit" to their own use and behoof, leaving the emigrant to settle down, squat, where he was,

and obtain such subsistence as he might be able to secure by cutting and preparing wild hay for the use of the great mining companies which dot those sections of the Rocky Mountains as do red barns the rugged hill-sides of the old Granite State.

In this way the wayfarer will get a little "dust" ahead to help him to a new start for the promised land, and this will only result in another tarry at the first locale that pleases his fancy, and there he will again settle down, an inviting bait to any party of *bad* Indians that may wander like himself, but with a more definite pur-pose, into the little valley that satisfies the "hay rancher."

It takes a long time to reach California by adopting such a trail as this; and if the pilgrim does at last arrive there, the chances will be as nine to ten that this per-ambulating life-waster will take the back track, declaring his purpose to be "to clar the settlements 'cause thar ain't no ground that's worth any thing but what's taken up."

The Humboldt Sink is one of those peculiarities that nature presents as picturesque evidence of great volcanic convulsions that have occurred in years long since passed away. In the Humboldt and Carson "sinks"—a term indigenous to this locality—as well as in many other parts of the High Rockies, where traces of volcanic eruptions are found, the horizontal system of rock is not commonly seen. The rocks present a broken outline which may be pleasing enough to the eye, but to journey over with pack-mules is found laborious and difficult in the extreme. The foothold is very insecure, and danger from fragments of rock that are frequently dislodged by those who are in advance is continually experienced by the climbers in the rear. The accompanying illustra-tion will convey some idea of a mountain crest, one of the curiosities of the Great Humboldt Sink.

To persons engaged in mountain climbing, the rarity of the atmosphere is one of the first among the many discomforts that will be likely to be experienced. Animals suffer from this thin, depreciated atmosphere quite as much as men, and it was not difficult to learn that the mule which made an easy burden of a pack at the altitude of 2000 feet above the Pacific could not bear the same load over any long trail at the height of 10,000 or 11,000. It will be noticed, too, that birds seldom make long flights when in the rarer atmosphere of the higher peaks of the Rockies.

In speaking of the Humboldt and Carson sinks our photographer remarks: "It was a pretty location to work in, and *viewing* there was as pleasant work as could be desired; the only drawback was an unlimited number of the most voracious and particularly poisonous mos-quitoes that we met with during our entire trip. Add to this the entire impossibility to save one's precious body

from frequent attacks of that most enervating of all fevers, known as the 'mountain ail,' and you will see why we did not work up more of that country. We were, in fact, driven out by the mosquitoes and fever. Which of the two should be considered as the more unbearable it is impossible to state."

Some portions of the trail next followed were over a traveled route; but the greater portion of the distance was through or over a country absolutely wild and unexplored, except what the Indians and fur-trappers who frequent the mountains may have accomplished in the way of exploitation.

In moving from the Pacific coast toward the foot-hills, which form the eastern limit of the great mountain range of our continent, the traveler will find it necessary to cross range after range, all having a general direction from north to south. Many of these ranges are only separated by little valleys. The usual distance from range to range is not more than 25 or 30 miles, and frequently the distance is not even so great.

In crossing these ranges or "divides," as these irregu-larities are designated in the language of the country, our exploring party found it necessary to travel during the midnight hours. The reason for this being the condition of the snow-crust, which in the summer season is not sufficiently thick, even on the highest ranges, during the day, to sustain the weight of either man or beast. In crossing some of these snow-covered crests the party endured indescribable hardships, for the crust was in some cases too thin, even at two or three o'clock in the morning, to bear up the sharp hoofed mules, burdened with their heavy packs. In one instance not less than thirteen hours were consumed in crossing divide, and the whole distance traveled did not exceed 2½ miles. On this occasion snow-drifts from 30 to 40 feet in depth were crossed. The men and animals were frequently lost from sight.

When, during the day, they arrived at the snow-line, they camped until midnight, or even later, to wait till the surface snow which had thawed during the day should become frozen or crusted by the frosty air of night—this crust, as a general rule, being sufficiently strong to bear up men and animals, and make it possible to take a trail which would otherwise be quite im-practicable.

The explorers frequently found in the valleys little basins of snow-water that were of an extent to be digni-fied by the name of lake; indeed such they were, though some of them were found at an altitude of nearly 9000 feet above the surf that rolls upon the shores of the grand Pacific coast.

In the Ruby Range, one of the finest of the Rocky

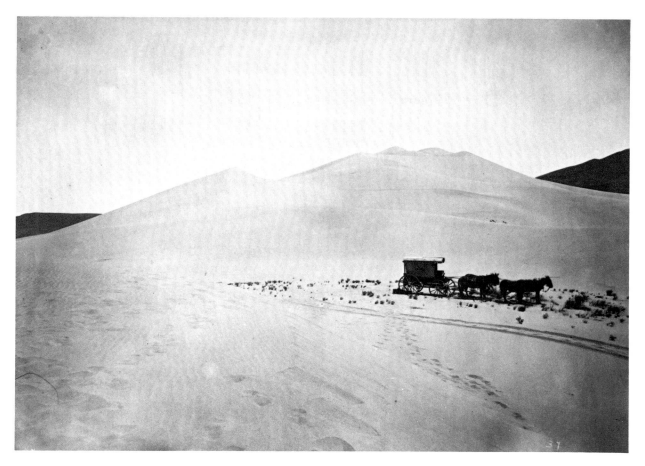

TIMOTHY O'SULLIVAN. *Shifting Sand Dunes.* 1867. George Eastman House, Rochester, N.Y.

cordon, are some of the most beautiful of these lakelets. Near the lake, too, there are quite a number of trees. Some of them, notwithstanding the altitude of their situations, have attained considerable size.

This particular locality has been for years a favorite resort for some few Indians of the Piute tribe, attracted, maybe, by the excellence of the pine-nut which grows in the vicinity, and by springs of which the waters are said to possess great curative properties in certain cases of physical malady. The pine-nut is one of the principal articles used as food by these Piutes and other mountain tribes. The general appearance of the tree is not unlike our pine of the Eastern States; the branches are more gnarled and the leaf somewhat longer; the cone or bur is much larger, and affords the little wedge-shaped nut, which the Indians secure late in the fall by throwing the burs into a fire, from which they are taken when charred and the nuts shaken out. From some of these burs the number of nuts obtained would quite fill an ordinary tea-cup. This nut, when dried, is sometimes pounded into a coarse meal, which is made into cakes and baked in the ashes, in much the same manner as the hoe-cake is

by the negroes of the South. In taste the nut is resinous, and to the palate unaccustomed to the food not extremely agreeable.

The cañons in the Ruby Range were among the most interesting places met with during the entire trip. Standing just within the entrance of the one here shown it was possible to realize the immense power which could force this vast passage through a rock that would seem quite too hard to suffer greatly from the pigmy strength of man. The strata of the rocks are quite regular, and no marked appearance that the great trap has been occasioned by volcanic action can be noted; indeed, there is evidently great dislodgment of rock, and the stratification is invariably horizontal, or with only a slight dip.

Our photographer, becoming tired of *too* much High Rocky, took advantage of an opportunity that offered to visit the great mounds of shifting sand which are located in an arid waste nearly a hundred miles to the south of the Carson Sink. For this trip an ambulance drawn by a team of four mules was used instead of the pack mule; a change in the means of locomotion that enhanced the comfort of the artist, and enabled him to

125

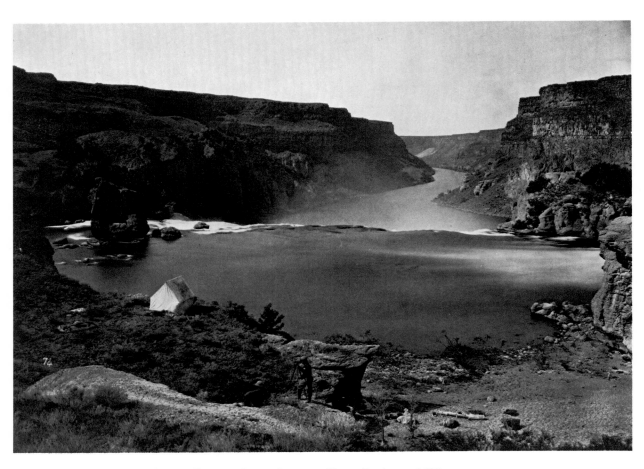

TIMOTHY O'SULLIVAN. *Shoshone Falls.* 1867. George Eastman House, Rochester, N.Y.

transport a sufficient quantity of water to make the variety of views that he purposed to add to his already magnificent and valuable collection.

Arriving in the vicinity of the sand-mounds, the first impression conveyed by them was that of immense snow-drifts, for in the sunlight the white sand sparkled like a hard frozen crust of snow. The contour of the mounds was undulating and very graceful, it being continually broken into the sharp edges left by the falling away of some portions of the mound, which had been undermined by the keen winds that spring up during the last hours of daylight and continue throughout the night.

Frequently, while traversing this waste, a light breeze would catch the sand, loosened by a footstep, and carry the sparkling crystals up the mound in the form of a whirlwind. This circling cloud of sand appeared each moment to increase in size and strength until the crest of the mound was attained, when, as if ambitious of continuing its flight, the dancing sand took one whirl more, then broke, and its dismembered fragments were added to the other side of the mound. It is by the whirlwinds that these great mounds of sand—some of them reaching to the height of 500 feet—are shifted from place to place.

The photographer returned from the shifting sand-mounds and joined the party, which had already advanced some distance along the trail to the eastward, taking for their route the overland stage road. Then leaving this they moved northward toward the falls of the Snake River, designated, in the vicinity of Salt Lake, as the Great Shoshone Falls. The volume of water pouring over the Shoshone Falls is small compared with the great flood which gives grandeur to Niagara. Neither is the width of the river greater than that portion of Niagara known as the American Fall. In the Shoshone

we have fall after fall to view as a preliminary exhibition. Each cascade is a splendid fall of itself, and the vast walls of rock are worn into weird forms by the constant action of rushing water.

The surroundings of the main fall are such that any number of views may be had of the scene. Standing upon the craggy rocks that jut out from and form the walls of the table-land below the falls, one may obtain a bird's eye view of one of the most sublime of Rocky Mountain scenes. Even in this location, which is many feet above the falls, the air is heavy with moisture, which is attributable to the mist into which the river's great leap shivers the water. From the position on the crags you have also a grand sight of the different falls of which the main one seems but the culmination. Each small fall is in itself a perfect gem with a setting of grandeur in the glorious masses of rock. On one great wall can be traced a tolerably perfect outline of a vast figure of a man. The whole form is not less than 100 feet in height.

There is in the entire region of the falls such wildness of beauty that a feeling pervades the mind almost unconsciously that you are, if not the *first* white man who has ever trod that trail, certainly one of the very few who have ventured so far. From the island above the falls you may not see the great leap that the water takes, but you will certainly feel sensible of the fact that you are in the presence of one of Nature's greatest spectacles as you listen to the roar of the falling water and gaze down the stream over the fall at the wild scene beyond.

Our photographic glimpses of Rocky Mountain scenery end with the picturesque little natural bridge which serves for a crossing over a deep gorge in the neighborhood of the falls.

HENRY W. BRADLEY & WILLIAM HERMAN RULOFSON. *The Gold Medal Prize Picture*. Albumen print issued as the frontispiece to *The Philadelphia Photographer*, July 1874.

Henry W. Bradley (1814-1891) and William Herman Rulofson (1826-1878) both began to take daguerre-otypes in California in the days of the Gold Rush. In 1863 they formed a partnership and bought the photo-graphic gallery of Robert H. Vance, which they rapidly outgrew and expanded. In 1874 they wrote Wilson: "there are in all twenty-nine rooms . . . we are now giving employment to thirty-four hands all told."

To My Patrons

EDWARD L. WILSON
1871

Edward L. Wilson (1838–1903) founder, editor, and publisher of the professional periodical The Philadelphia Photographer *and permanent secretary of the National Photographic Association, was an enterprising man. In 1871 he conceived the idea of writing an eight-page pamphlet giving advice to the public on* when *to come to a photographic gallery for a portrait,* what *to wear and* how *to pose, which studio proprietors could use to promote their business. For each order he printed a cover, with the name of the studio and its address. The little leaflet—which measures only 3½ by 4 inches —rapidly became a best seller. By July 1871, 25,000 copies were sold. By October, 100,000. In the September 1880 issue of* The Philadelphia Photographer *Wilson boasted that over 1,100,000 copies had been sold, including translations into German and Spanish, and that he had reduced the price per 1000 copies, with imprint, to $15.00.*

The booklet gives a vivid insight into the enormous popularity of photographic portraiture in the 1870s and the seriousness of both the photographer and the sitter. Of particular interest is advice on what color clothes to wear—for at that period glass plates were sensitive only to the blue rays: black stripes on a red dress became invisible; blue photographed as white. Like most advertising ephemera, To My Patrons *is extremely rare. The "prize portraits" that follow are photographic prints selected by Wilson as frontispieces to* The Philadelphia Photographer. *He offered them as models and exemplars to budding professionals.*

TO MY PATRONS

The intention of this little book is to say a few words in a kindly way to those who have photographs taken, in order that the intercourse between them and their photographer may be pleasant, and result in the most successful pictures. People who desire pictures, generally seem unwilling to give the necessary time to secure good ones. As time is precious, therefore, we publish this that you may be informed beforehand on certain points, a knowledge of which will *save time.* Please peruse what follows carefully.

PHOTOGRAPHY

Is NOT a branch of mechanics, whereby a quantity of material is thrown into a hopper, and with the grinding of grim, greasy machinery, beautiful portraits may be turned out. The day when a daub of black and a patch of white pass for a photograph, you are well aware is ended; for you will not receive such abominations yourself as likenesses of those near and dear to you, and especially of the one dearer to you than any one else, namely your own dear self.

To produce pictures different from these requires skill, good taste, culture, much study and practice, to say nothing of an expensive outfit and a properly arranged studio. With all these the photographer must know how to manage a most obstreperous class of chemicals, fickle as the wind, and, therefore, he needs all the assistance *from you* that you are able to give him in the sundry ways explained further on. He is entitled to the same respect and consideration from you as your minister, your physician, or your lawyer, and it is just as essential that he should have *rules* for the best government of his establishment as it is for any one else whom you patronize, consequently you should be quite as unwilling to trespass upon such reasonable regulations as he may make as you would to apply a fly-blister when your physician orders you to *take* soothing syrup. Remember, then, that it is *he* who takes the picture and not you; that it is *he* whom you hold responsible for the result and not yourself; that it is *he* who knows best (or ought to) *how* to take it, and not you, and that *his* reputation suffers if he fails, and not yours. For the sake of a good result, then, try to submit to the suggestions of your photographer. *We* guarantee satisfaction.

WHEN TO COME

A BRIGHT DAY is not necessary. In fact, the light is best when the heavens are clouded and the sun shines through

JEREMIAH GURNEY & SON. Portrait of a child. Albumen print, issued as frontispiece to *The Philadelphia Photographer,* July 1868.

Jeremiah Gurney, established as a portrait photographer in New York City in 1840, took his son Benjamin into partnership. They wrote Wilson that they found *To My Patrons* to be an advertising medium of immense value.

the clouds. Light-haired and light-eyed subjects should avoid a very bright day if convenient.

A "light-cloudy" day is not objectionable if it is not actually dark. The only difference between the two is that on a dark day the sitting is prolonged a few seconds.

Arrangements for the babies should be made so as not to interfere with their daily sleep, as they look and feel so much better and sweeter after a nap. The morning is also best for them, and a clear day, because the light works more quickly. Avoid coming late in the day.

Never expect to enter a photographic studio and to be taken at once—on the jump. It is worse than running after a railway train as it steams away from you. In both cases you generally have to wait. We wait on you in turn.

HOW TO COME

NEVER COME in a hurry or a flurry. *Red* takes *black,* and red faces take black. Moreover, if you are pushed for time, your pictures will present a worn and wearied expression, which you will not like, and which will *compel* you to take the time for another sitting. Arrange matters at the office, or the shop, or at home, or with your creditors, so that you can take it P-E-R-F-E-C-T-L-Y E-A-S-I-L-Y during the operations of awaiting your turn and the making of your picture. If you do, the likeness will be calm, peaceful, and true to you, and you will feel repaid for your tranquillity. Ladies who have shopping and an engagement with the photographer on the same day, will please be careful to attend to the latter first.

HOW TO DRESS

DRESS IS a matter which should have your careful attention. The photographer is very much tried by his patrons sometimes, who place upon their persons, when about to sit for a picture, all sorts of gew-gaws and haberdasheries which they never wear when at home, or when mingling among their friends. The consequence, is some miserable distortions and caricatures, which chagrin all concerned. Dress naturally, and *think* a little while you are about it. Fancy shapes and styles soon change, and sometimes the *dress* in a picture will sicken one of it when the *face* is all that could be desired.

The question is often asked why actors and actresses take the most pleasing pictures. The reason is, because they study the principles of art and good taste in the pursuit of their profession, and they understand how to dress. Moreover, they generally bring with them not only just what *they* think may "look pretty," but also a selection of articles, such as veils, flowers, curls, braids, and laces, which give the photographer a choice, and often *make* the picture, by adding to the graceful folds and lines in it. They also give us permission to use these to

heighten an effect or cover a fault.

The best materials to wear, for ladies, are such as will fold or drape nicely; for example, reps, winceys, poplins, satins and silks. Materials with too much gloss are objectionable, though we can generally overcome that, and many other things, by managing our light.

The various colors known in the dry goods market take about as follows:

Lavender, Lilac, Sky Blue, Blue Purple, and French Blue take very light, and are worse photographically, than pure White. Corn color and Salmon are better.

China Pink, Rose Pink, Magenta, Crimson, Pea Green, Buff, Plum color, Dark Purple, pure Yellow, Mazarine Blue, Navy Blue, Fawn color, Quaker color, Dove color, Ashes of Roses, and Stone color, show a very pretty light gray in the photograph.

Scarlet, Claret, Garnet, Sea Green, Light Orange, Leather color, Light Bismarck, and Slate color, take still darker, and are all excellent colors to photograph.

Cherry, Wine color, Light Apple Green, Metternich Green, Dark Apple Green, Bottle Green, Dark Orange, Golden and Red Brown, show nearly the same agreeable color in the picture, which is dark but not black.

Dark Bismarck and Snuff Brown generally take blacker than a black silk or satin, and are not very agreeable to drape. A black silk looks nice on almost anybody, and if not bedecked with red ribbons or lace that will take white, generally pleases.

The list of colors above apply as well to silks as to woollen goods, though a silk will generally take lighter than a woollen dress, because it has more gloss, and reflects more light. Striped goods, or goods having bold patterns in them, should never be worn for a picture. Avoid anything that will look streaky or spotty. White drapery, with deep folds, the bodies trimmed with laces, puffs, &c., are fine for shadow pictures.

By a careful study of the above you can readily see how to dress. A great patch of white does not look well on a dark dress, therefore avoid pink or blue ribbons and trimmings on such dresses, and *vice versa.*

Ladies with *dark* or *brown* hair especially, should avoid such contrasts. Open, lace work collars and embroideries are prettier than solid ones, which latter are apt to take white.

Ladies and children with *light* hair should dress in something lighter than those whose hair is dark or brown. We will give you a photographic reason for this. Light substances photograph more quickly than dark. Hence if a fair person wears dark dresses, either the person or the dress will be overdone and *vice versa* with a dark person.

In the matter of head-dress, exercise good taste. Few

WILLIAM NOTMAN. Seated woman. Albumen print, issued as frontispiece to *The Philadelphia Photographer*, October 1869.

William Notman (1826-1891) was the leading photographer in Canada. He was a frequent contributor to *The Philadelphia Photographer*.

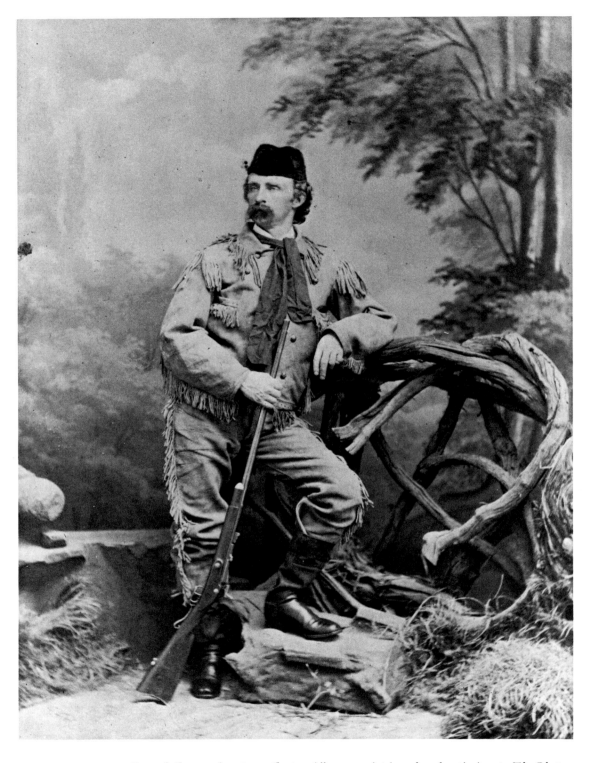

JOHN A. SCHOLTEN. *General George Armstrong Custer.* Albumen print issued as frontispiece to *The Photographic World,* September 1872.

John Scholten opened a photographic studio in St. Louis in 1857. He lost 30,000 negatives when fire destroyed his studio in 1878. *The Photographic World* was another journalistic enterprise of Wilson's. Scholten ordered 5,000 copies of *To My Patrons* in English and 2,000 in German.

ladies seem to understand how to arrange their hair so as to harmonize with the form of the head, and blindly follow the fashion, be the neck long or short, or the face narrow or broad.

A broad face will appear still more so if the hair is arranged low over the forehead, or parted at one side.

A long neck becomes dreadfully stork-like when the hair is built up high, while a few drooping curls would change the whole effect most agreeably. A high forehead in a lady is improved by being hid with the hair or curls also. In a profile picture do not press the hair too closely to the head, or display too little of it.

Powder should be allowed on freckles where the artist thinks best. Powdered hair gives good effects.

Gentlemen will do well to give attention to the matter of color of dress, as directed in the remarks to the ladies.

HOW TO "BEHAVE"

THIS SUBJECT we broach reluctantly, but we often meet the opposition from our patrons which is certain to spoil the results, and which absorbs too much time. For our mutual good, permit us to be frank.

The head-rest must be used, not to *give* the position but that you may *keep* it. The natural pulsations of the body cause it to move (in spite of the strongest will) sufficient to make your negative useless. Time will be saved, then, by its use.

Wink as much as you please, but don't turn your eyes. While sitting for your picture, forget all dolefulness, and also forget where you are. Whistle Yankee-doodle mentally, or think of some pleasant thing that will enliven your spirits, and impress a pleasant look upon your face. Merely think enough of what you are really about to keep still, and not a whit more. Let your photographer pose and arrange you. He is responsible, and will do his best. On this point see foregoing remarks.

Better leave your friends outside the screen while you are having your picture taken. You do not want to be stared out of countenance, nor your photographer does not want to be interefered with.

Sitting pictures are preferable to standing ones, generally, for the most graceful attitudes can be secured in them. This point the photographer can best decide for you. Trust him. In groups, also submit to his taste.

You cannot judge of your picture from the negative, so please save our time by not asking to see it. We will show you a printed proof, and sit you again if it is unsatisfactory. Please give us time to print your pictures

carefully and well. Hurry in finishing makes bad work.

THE CHILDREN

WE ARE always glad to take a reasonable amount of pains with children. They are subjects that make lovely pictures, but they are often difficult to secure. We can always get *something* of them, and if it is not satisfactory the first or second time it is not apt to be so at all *that* day, and it is best to bring them again.

Never *threaten* a child if it won't sit, and never *coax* it with sweet-meats. Permit the operator to manage it from the beginning. Dress the little ones with care and good taste. Avoid startling plaids, and gaudy colors, or a *variety* of colors. Dark dresses should not be put on them. Let the photographer choose the position.

A sitting or kneeling attitude is best, for few little ones stand quietly long enough to have a picture taken.

BUSINESS

WE ARE prepared to make all classes of photographs in the best styles, of all sizes, examples of which will be found at our establishment.

All the popular styles and sizes are regularly made as they become known.

FRAMES

NEARLY every photograph, larger than a carte, should be, and is framed. A careful inspection of our stock before you purchase is, therefore, politely requested. We like to see our pictures hung in tasteful frames, &c., and are, therefore, willing to sell them at a small advance, in order to have our work present a creditable appearance in your drawing-room or parlor.

COPYING

CAREFUL attention is given to making copies of other pictures. Enlarged pictures may be made as large as life from the tiniest locket picture, and made in every way satisfactory by careful and judicious

COLORING

PHOTOGRAPHS from nature or from other pictures, we color in the best styles in Oil, Water colors, Crayon, Pastel, or Ink at rates to suit all circumstances.

PRICES

OUR PRICES are kept at reasonable rates. There may be work done for less, but we ask that QUALITY be given the preference.

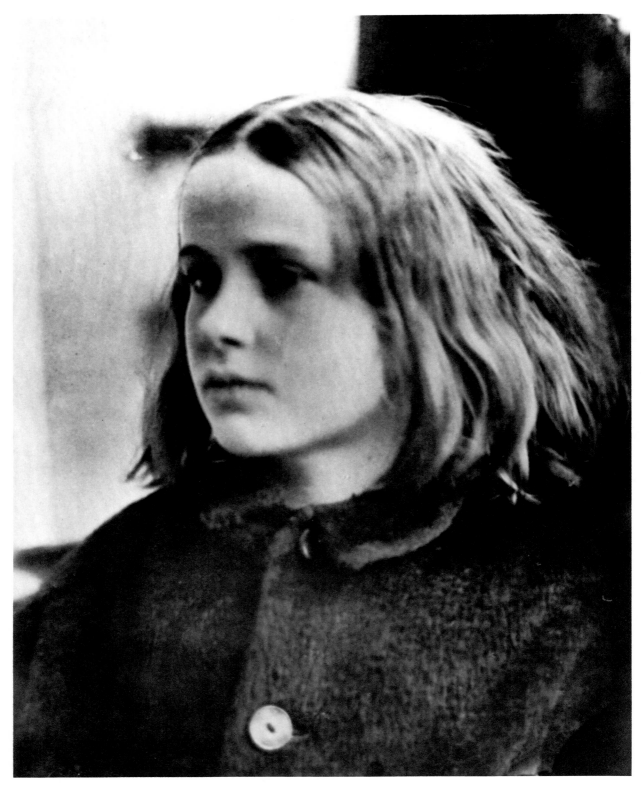

JULIA MARGARET CAMERON. *Annie, My First Success, January 1864*. Gernsheim Collection, University of Texas at Austin.

The Annals of My Glass House

JULIA MARGARET CAMERON
1874

Few photographers have ever equaled in spiritual intensity the master portraits of Julia Margaret Cameron (1811–1879), an Englishwoman who took up photography as an amateur in 1864. At Freshwater Bay on the Isle of Wight she photographed her illustrious friends, including Sir John Herschel, Thomas Carlyle, and Alfred Lord Tennyson. The power of the photographs has not been forgotten since she first exhibited them in 1865, even though critics almost unanimously have faulted her technique. Her struggle with, and triumph over, the mechanics of photography, and the measure of her emotion during the act of photography, are movingly described in this autobiographical fragment.

Mrs. Cameron's Photography," now ten years old, has passed the age of lisping and stammering and may speak for itself, having travelled over Europe, America, and Australia, and met with a welcome which has given it confidence and power. Therefore, I think that the "Annals of My Glass House" will be welcome to the public, and, endeavouring to clothe my little history with light, as with a garment, I feel confident that the truthful account of indefatigable work, with the anecdote of human interest attached to that work, will add in some measure to its value.

That details strictly personal and touching the affections should be avoided, is a truth one's own instinct would suggest, and noble are the teachings of one whose word has become a text to the nations—

"Be wise: not easily forgiven
Are those, who setting wide the doors that bar
The secret bridal chamber of the heart
Let in the day."

Therefore it is with effort that I restrain the overflow of my heart and simply state that my first lens was given to me by my cherished departed daughter and her husband with the words, "It may amuse you, Mother, to try

to photograph during your solitude at Freshwater."

The gift from those I loved so tenderly added more and more impulse to my deeply seated love of the beautiful, and from the first moment I handled my lens with a tender ardour, and it has become to me as a living thing, with voice and memory and creative vigour. Many and many a week in the year '64 I worked fruitlessly, but not hopelessly—

"A crowd of hopes
That sought to sow themselves like winged lies
Born out of everything I heard and saw
Fluttered about my senses and my soul."

I longed to arrest all beauty that came before me, and at length the longing has been satisfied. Its difficulty enhanced the value of the pursuit. I began with no knowledge of the art. I did not know where to place my dark box, how to focus my sitter, and my first picture I effaced to my consternation by rubbing my hand over the filmy side of the glass. It was a portrait of a farmer of Freshwater, who, to my fancy, resembled Bollingbroke. The peasantry of our island is very handsome. From the men, the women, the maidens and the children I have had lovely subjects, as all the patrons of my photography know.

This farmer I paid half-a-crown an hour, and, after many half-crowns and many hours spent in experiments, I got my first picture, and this was the one I effaced when holding it triumphantly to dry.

I turned my coal-house into my dark room, and a glazed fowl-house I had given to my children became my glass house! The hens were liberated, I hope and believe not eaten. The profit of my boys upon new laid eggs was stopped, and all hands and hearts sympathised in my new labour, since the society of hens and chickens was soon changed for that of poets, prophets, painters and lovely maidens, who all in turn have immortalized the humble little farm erection.

Having succeeded with one farmer, I next tried two children; my son, Hardinge, being on his Oxford vacation, helped me in the difficulty of focussing. I was half-way through a beautiful picture when a splutter of laugh-

First published in *Photo Beacon* (Chicago) 2 (1890), pp. 157-60. Reprinted, by permission, from the original manuscript in the collection of The Royal Photographic Society of Great Britain, London.

ter from one of the children lost me that picture, and less ambitious now, I took one child alone, appealing to her feelings and telling her of the waste of poor Mrs. Cameron's chemicals and strength if she moved. The appeal had its effect, and I now produced a picture which I called "My First Success."

I was in a transport of delight. I ran all over the house to search for gifts for the child. I felt as if she entirely had made the picture. I printed, toned, fixed and framed it, and presented it to her father that same day: size, 11 by 9 inches.

Sweet, sunny haired little Annie! No later prize has effaced the memory of this joy, and now that this same Annie is 18, how much I long to meet her and try my master hand upon her.

Having thus made my start, I will not detain my readers with other details of small interest; I only had to work on and to reap rich reward.

I believe that what my youngest boy, Henry Herschel, who is now himself a very remarkable photographer, told me is quite true—that my first successes in my out-of-focus pictures were a fluke. That is to say, that when focussing and coming to something which, to my eye, was very beautiful, I stopped there instead of screwing on the lens to the more definite focus which all other photographers insist upon.

I exhibited as early as May '65. I sent some photographs to Scotland—a head of Henry Taylor, with the light illuminating the countenance in a way that cannot be described; a Raphaelesque Madonna, called "La Madonna Aspettante." These photographs still exist, and I think they cannot be surpassed. They did not receive the prize. The picture that did receive the prize, called "Brenda," clearly proved to me that detail of table-cover, chair and crinoline skirt were essential to the judges of the art, which was then in its infancy. Since that miserable specimen, the author of "Brenda" has so greatly improved that I am content to compete with him and content that those who value fidelity and manipulation should find me still behind him. Artists, however, immediately crowned me with laurels, and though "Fame" is pronounced "The last infirmity of noble minds," I must confess that when those whose judgment I revered have valued and praised my works, "my heart has leapt up like a rainbow in the sky," and I have renewed all my zeal.

The Photographic Society of London in their *Journal* would have dispirited me very much had I not valued that criticism at its worth. It was unsparing and too manifestly unjust for me to attend to it. The more lenient and discerning judges gave me large space upon their walls which seemed to invite the irony and spleen of the printed notice.

136

To Germany I next sent my photographs. Berlin, the very home of photographic art, gave me the first year a bronze medal, the succeeding year a gold medal, and one English institution—the Hartly Institution—awarded me a silver medal, taking, I hope, a home interest in the success of one whose home was so near to Southampton.

Personal sympathy has helped me on very much. My husband from first to last has watched every picture with delight, and it is my daily habit to run to him with every glass upon which a fresh glory is newly stamped, and to listen to his enthusiastic applause. This habit of running into the dining-room with my wet pictures has stained such an immense quantity of table linen with nitrate of silver, indelible stains, that I should have been banished from any less indulgent household.

Our chief friend, Sir Henry Taylor, lent himself greatly to my early efforts. Regardless of the possible dread that sitting to my fancy might be making a fool of himself, he, with greatness which belongs to unselfish affection, consented to be in turn Friar Laurence with Juliet, Prospero with Miranda, Ahasuerus with Queen Esther, to hold my poker as his sceptre, and do whatever I desired of him. With this great good friend was it true that so utterly

"The chord of self with trembling
Passed like music out of sight,"

and not only were my pictures secured for me, but entirely out of the Prospero and Miranda picture sprung a marriage which has, I hope, cemented the welfare and well-being of a real King Cophetua who, in the Miranda, saw the prize which has proved a jewel in that monarch's crown. The sight of the picture caused the resolve to be uttered which, after 18 months of constancy, was matured by personal knowledge, then fulfilled, producing one of the prettiest idylls of real life that can be conceived, and, what is of far more importance, a marriage of bliss with children worthy of being photographed, as their mother had been, for their beauty; but it must also be observed that the father was eminently handsome, with a head of the Greek type and fair ruddy Saxon complexion.

Another little maid of my own from early girlhood has been one of the most beautiful and constant of my models, and in every manner of form has her face been reproduced, yet never has it been felt that the grace of the fashion of it has perished. This last autumn her head illustrating the exquisite Maud—

"There has fallen a splendid tear
From the passion flower at the gate,"

is as pure and perfect in outline as were my Madonna Studies ten years ago, with ten times added pathos in the

expression. The very unusual attributes of her character and complexion of her mind, if I may so call it, deserve mention in due time, and are the wonder of those whose life is blended with ours as intimate friends of the house.

I have been cheered by some very precious letters on my photography, and having the permission of the writers, I will reproduce some of those which will have an interest for all.

An exceedingly kind man from Berlin displayed great zeal, for which I have ever felt grateful to him. Writing in a foreign language, he evidently consulted the dictionary which gives two or three meanings for each word, and in the choice between these two or three the result is very comical. I only wish that I was able to deal with all foreign tongues as felicitously:—

"Mr. ———— announces to Mrs. Cameron that he received the first half, a Pound Note, and took the Photographies as Mrs. Cameron wishes. He will take the utmost sorrow* to place the pictures were good.

"Mr. ———— and the Comitie regret heavily† that it is now impossible to take the Portfolio the rooms are filled till the least winkle.‡

"The English Ambassude takes the greatest interest of the placement the Photographies of Mrs. Cameron and M ———— sent his extra ordinarest respects to the celebrated and famous female photographs.—Yours most obedient, etc."

The kindness and delicacy of this letter is self-evident and the mistakes are easily explained:—

*Care—which was the word needed—is expressed by "Sorgen" as well as "Sorrow." We invert the sentence and we read—To have the pictures well placed where the light is good.

†Regret—Heavily, severely, seriously.

‡Winkle—is corner in German. [Notes by J. M. Cameron]

The exceeding civility with which the letter closes is the courtesy of a German to a lady artist, and from first to last, Germany has done me honour and kindness until, to crown all my happy associations with that country, it has just fallen to my lot to have the privilege of photographing the Crown Prince and Crown Princess of Germany and Prussia.

This German letter had a refinement which permits one to smile *with* the writer, not *at* the writer. Less sympathetic, however, is the laughter which some English letters elicit, of which I give one example:—

"Miss Lydia Louisa Summerhouse Donkins informs Mrs. Cameron that she wishes to sit to her for her photograph. Miss Lydia Louisa Summerhouse Donkins is a carriage person, and, therefore, could assure Mrs. Cameron that she would arrive with her dress uncrumpled.

"Should Miss Lydia Louisa Summerhouse Donkins be satisfied with her picture, Miss Lydia Louisa Summerhouse Donkins has a friend who is *also* a Carriage person who would *also* wish to have her likeness taken."

I answered Miss Lydia Louisa Summerhouse Donkins that Mrs. Cameron, not being a professional photographer, regretted she was not able to "take her likeness," but that had Mrs. Cameron been able to do so she would have very much preferred having her dress crumpled.

A little art teaching seemed a kindness, but I have more than once regretted that I could not produce the likeness of this individual with her letter affixed thereto.

This was when I was at L.H.H.,* to which place I had moved my camera for the sake of taking the great Carlyle.

When I have had such men before my camera my whole soul has endeavoured to do its duty towards them in recording faithfully the greatness of the inner as well as the features of the outer man.

The photograph thus taken has been almost the embodiment of a prayer. Most devoutly was this feeling present to men when I photographed my illustrious and revered as well as beloved friend, Sir John Herschel. He was to me as a Teacher and High Priest. From my earliest girlhood I had loved and honoured him, and it was after a friendship of 31 years' duration that the high task of giving his portrait to the nation was allotted to me. He had corresponded with me when the art was in its first infancy in the days of Talbot-type and autotype. I was then residing in Calcutta, and scientific discoveries sent to that then benighted land were water to the parched lips of the starved, to say nothing of the blessing of friendship so faithfully evinced.

When I returned to England the friendship was naturally renewed. I had already been made godmother to one of his daughters, and he consented to become godfather to my youngest son. A memorable day it was when my infant's three sponsors stood before the font, not acting by proxy, but all moved by real affection to me and to my husband to come in person, and surely Poetry, Philosophy and Beauty were never more fitly represented than when Sir John Herschel, Henry Taylor and my own sister, Virginia Summers, were encircled round the little font of the Mortlake Church.

When I began to photograph I sent my first triumphs

*Little Holland House, the London residence of Mrs. Cameron's sister, Sarah Primseps.

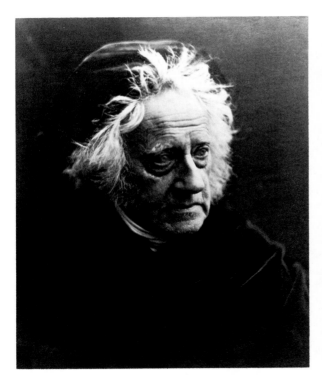

JULIA MARGARET CAMERON. *Sir John F. W. Herschel.* 1867. The Museum of Modern Art, New York.

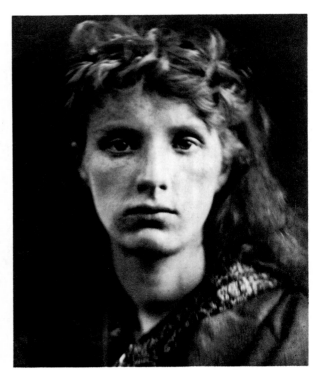

JULIA MARGARET CAMERON. *The Mountain Nymph, Sweet Liberty.* 1866. Gernsheim Collection, University of Texas at Austin.

The model is Cyllene Margaret Wilson, an orphan adopted by Mrs. Cameron. The title is from Milton's *Allegro:* "Come, and trip it as ye go/On the light fantastic toe/And in thy right hand lead with Thee/The Mountain Nymph, Sweet Liberty."

to this revered friend, and his hurrahs for my success I here give. The date is September 25th, 1866:—

"MY DEAR MRS. CAMERON,—

"This last batch of your photographs is indeed wonderful, and wonderful in two distinct lines of perfection. That head of the 'Mountain Nymph, Sweet Liberty' (a little farouche and egarée, by the way, as if first let loose and half afraid that it was too good), is really a most astonishing piece of high relief. She is absolutely alive and thrusting out her head from the paper into the air. This is your own special style. The other of 'Summer Days' is in the other manner—quite different, but very beautiful, and the grouping perfect. Prosperpine is awful. If ever she was 'herself the fairest flower' her 'cropping' by 'Gloomy Dis' has thrown the deep shadows of Hades into not only the colour, but the whole cast and expression of her features. Christabel is a little too indistinct to my mind, but a fine head. The large profile is admirable, and

altogether you seem resolved to out-do yourself on every fresh effort."

This was encouragement eno' for me to feel myself held worthy to take this noble head of my great Master myself, but three years I had to wait patiently and longingly before the opportunity could offer.

Meanwhile I took another immortal head, that of Alfred Tennyson, and the result was that profile portrait which he himself designates as the "Dirty Monk." It is a fit representation of Isaiah or of Jeremiah, and Henry Taylor said the picture was as fine as Alfred Tennyson's finest poem. The Laureate has since said of it that he likes it better than any photograph that has been taken of him *except* one by Mayall; that *"except"* speaks for itself. The comparison seems too comical. It is rather like comparing one of Madame Tussaud's waxwork heads to one of Woolner's ideal heroic busts. At this same time Mr. Watts gave me such encouragement that I felt as if I had wings to fly with.

138

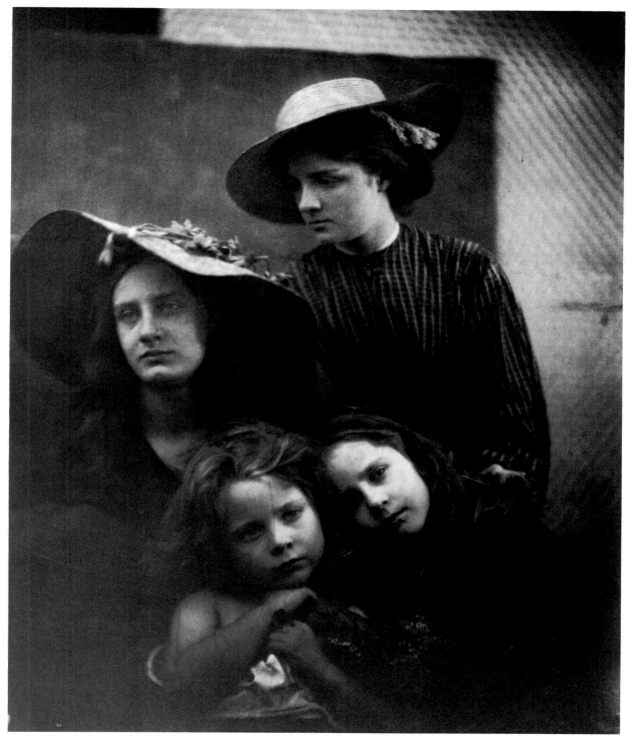

JULIA MARGARET CAMERON. *Summer Days.* ca. 1865. Gernsheim Collection, University of Texas at Austin.

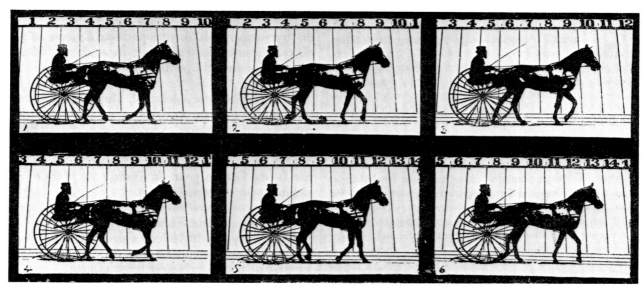

1. Walking. 348 feet per minute.

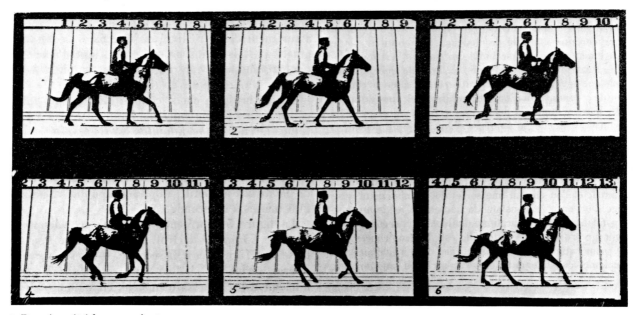

2. Running. 656 feet per minute.

EADWEARD MUYBRIDGE. *The Horse in Motion.* 1878. The photographs, taken in Palo Alto, California, appear as published in *La Nature,* Paris, December 14, 1878.

Muybridge's Motion Pictures: News Accounts

1880

Eadweard J. Muybridge (1830–1904), English-born photographer active in California, became famous in 1877 for his photographs of the horse in motion. Using a battery of twelve cameras, the shutters of which were released mechanically as the horse swept past the axis of each lens, Muybridge secured sequences of photographs, which he published internationally. They were sensational, for they revealed attitudes never before seen of the gallop, the trot, the pace, and the walk. In 1880 he projected these images intermittently on a screen with a projection apparatus of his own design: the motion picture was born.

THE ZOOGYROSCOPE

Photographs Illustrating Animals in Motion.

INTERESTING EXHIBITION BY MUYBRIDGE— HORSES TROTTING, DOGS RUNNING, BIRDS FLYING—ATHLETIC ANTICS.

A private exhibition of the zoogyroscope was given by E. J. Muybridge, the photographer, at the gallery of the San Francisco Art Association, last evening. As is known to the readers of THE CALL, Mr. Muybridge has been engaged during the past two years in making photographic representations of animals in motion, under the patronage of Governor Leland Stanford, at the residence of the latter at Menlo Park. Governor Stanford became greatly interested in the subject, and, gratified by the maiden efforts of Muybridge in photographing the movements of his favorite trotting horse, Occident, he gave him *carte blanche* to pursue his experiments. A number of instruments were constructed especially for the purpose, in Europe and this country, and at the Governor's place, Palo Alta, every facility was afforded for carrying on his investigations, until finally, by the combination of the magic lantern and the zoogyroscope, he has arrived very nearly to perfection. It is estimated that Governor Stanford has expended between $40,000 and

Reprinted from the *San Francisco Call*, May 5, 1880.

$50,000 in this "hobby," as some of his friends term it. At

THE EXHIBITION LAST EVENING

A large number of views were given of the different gaits of horses—the walk, the canter, the pace, the trot, the run, etc. The camera used in taking these views caught the object and transferred it to the glass in the first thousandth part of a second—a degree of time that is difficult for the mind to comprehend. Stonehenge and other writers on the horse have asserted that the quadruped in trotting, as in walking, always has two of its feet upon the ground at a time. The experiments of Muybridge show that in motion the horse frequently has three and at times all four feet from the ground. It has generally, too, been held that the toe strikes the ground first. Muybridge shows that it is in all cases the heel. The strides of different horses were represented; that of Elaine, which covered 16 feet, Abe Edgerton 18 feet, and Clay 17 feet. The latter horse Muybridge said had a very peculiar stride. When at the top of his speed and clearing 17 feet, he was for nine feet entirely clear of the ground, all four feet being in the air for that distance. Several interesting views were given, showing the change in the position of a horse's limbs as he began to break, during a break, and as he was gradually settled by his driver. In the representation of running horses, a fact was shown that explained what had long been a mystery to horsemen: why running horses broke down sooner than trotting horses. It was found that the former throw the weight of their body upon the fore feet—in fact, the whole weight is, for a time, thrown upon one fore foot. In leaping, it was shown that one fore foot strikes the ground first, followed by the other placed slightly in advance, and then the hind feet are brought down together closely behind. What attracted the most attention, in fact aroused a pronounced flutter of enthusiasm from the audience, was the representation by aid of

THE ZOOGYROSCOPE

Of horses in motion. While the previous views had shown their positions at different stages of motion, these

placed upon the screen apparently the living, moving horse. Nothing was wanting but the clatter of the hoofs upon the turf and an occasional breath of steam from the nostrils, to make the spectator believe that he had before him genuine flesh-and-blood steeds. In the views of hurdle-leaping the simulation was still more admirable, even to the motion of the tail as the animal gathered for the jump, the raising of his head, all were there. Views of an ox trotting, a wild bull on the charge, greyhounds and deer running, and birds flying in mid-air, were shown. The zoogyroscope is a circular glass, having a miniature picture of the animal to be represented in motion at regular intervals upon its surface, and equi-distant with these pictures are small slats which admit the light from the oxyhydrogen lanterns, and as the plate is turned the effect is similar to that produced by the well-known toy—the zootrope—and shows the animals in apparent actual motion. The exhibition concluded with a number of fine, instantaneous photographic views of athletes, in various positions.

A series of public exhibitions will be given this and every evening during the week.

———————

DEPRECIATION
Effects of Instantaneous Photography.

ALL OF THE sprawling cuts, the elaborate work of artists, the engravings, in fact all of the former representations of horses in motion are reduced to worthless frauds by the latest scientific achievement in instantaneous photography. In one sense it is a pity that the labors of so many artists should have been so worthlessly consigned to the limbo of ignorance and error, but in the constant progression, such has been the fate of many theories and pet conceptions.

Farewell to the representation of the flying steeds stretched into postures which were received as the truly correct method the ground was covered in the gallop, and the classical counterfeits are now worthless. The pic-

———————

Reprinted from *California Spirit of the Times,* May 8, 1880.

———————

*John Frederick Herring (1795-1865), English artist who specialized in painting race horses.

ture of Euclid and Charles the XII, in their memorable dead heat for the St. Leger—so *vividly* put on the canvass by Herring*—is relegated into the division of proven errors, and with that hundreds of others are consigned to the "curiosity shop" which contains so many evidences of the fallibility of the judgment of men.

A queer feature is that in the endeavor to correct what was known to a few to be wrong, just as untenable a position was taken, and the closest observers, in avoiding the beaten path of common ignorance, fell into others which were equally as far from the truth. These errors arose from the impossibility of the unaided eye to convey correct impressions to the brain. The movements are so quick that there is a failure to comprehend them, for the brain to receive or the memory retain the instantaneous impressions. Before the discovery of the telescope mankind labored under the same disadvantage, and whatever was beyond the range of human vision was a hidden world. The grand discovery of an eye which would catch, and a plate which would register the most evanescent of movements, has enabled us to comprehend what was concealed before, and if we fail to avail ourselves of the teachings of this superhuman professor, it will be a confession of wilful perversity and an avowal of stupid, mulish ignorance. We do not anticipate acquiescence in those who have not seen the photographs or the exhibitions which give them still more emphatically, and when people at first refuse to believe in the truth of the representation we are not surprised. But when it is put within the reach of everyone, and that a few hours attendance and an expenditure of half a dollar will enable any one to convince himself of the truth of the delineations, further ignorance of the subject is not to be endured.

Mr. Muybridge offers positive proofs of the truth of the representations. The pictures which are doubted are put on a simple, though ingenious contrivance, viz: a rotating transparent disk, and by the aid of the magic lantern these are thrown upon a screen, the animals moving the same as in life. There is no miracle in this, everything being explained so as to be within the scope of the meanest understanding, and the hyper-sceptical must acknowledge the truth, or be contented to be placed in Foster's catalogue of "senseless, stupid blockheads."

Instantaneous photography, plain as it is, is beyond the comprehension of this class.

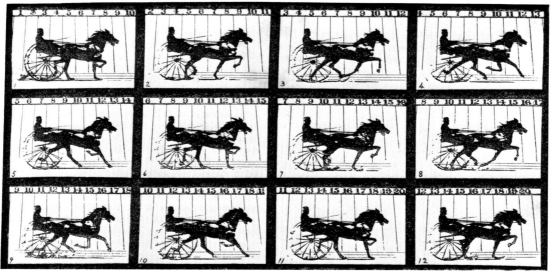

3. Trotting. 2345 feet per minute.

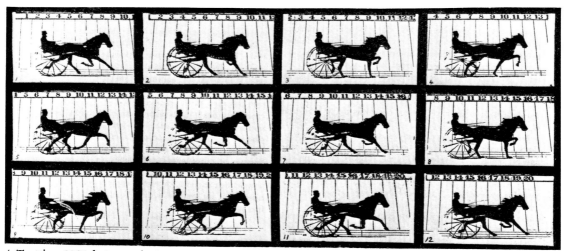

4. Trotting. 2385 feet per minute.

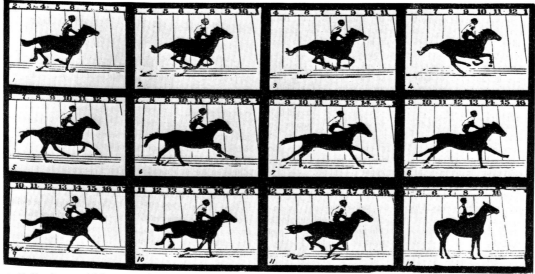

5. Galloping. 3746 feet per minute.

An Experiment with Gelatino Bromide

RICHARD LEACH MADDOX
1871

Photography as practiced today is based on the invention of the gelatin bromide dry plate by Richard Leach Maddox (1816–1902), a British physician and photomicrographer who was dissatisfied with the collodion process for this specialized work. Too busy to perfect his discovery, he generously published his laboratory notes so that others might bring to perfection what he had begun. Maddox's discovery meant that photographers no longer needed to prepare their negative material immediately before exposure. They could purchase ready-sensitized dry plates that they could process long after exposure. Furthermore, these plates were far more sensitive than the collodion plates, which became practically obsolete by 1880. Exposures could now be made in fractions of a second, and cameras could be handhheld.

The collodio-bromide processes have for some time held a considerable place in the pages of THE BRITISH JOURNAL OF PHOTOGRAPHY, and obtained such a prominent chance of being eventually the process of the day in the dry way, that a few remarks upon the application of another medium may perhaps not be un-interesting to the readers of the Journal, though little more can be stated than the result of somewhat careless experiments tried at first on an exceedingly dull afternoon. It is not for a moment supposed to be new, for the chances of novelty in photography are small, seeing the legion of ardent workers and the ground already trodden by its devotees, so that for outsiders little remains except to take the result of labours so industriously and largely circulated through these pages and be thankful.

Gelatine, which forms the medium of so many printing processes, and which doubtless is yet to form the base of more, was tried in the place of collodion in this manner:—Thirty grains of Nelson's gelatine were washed in cold water, then left to swell for several hours, when all the water was poured off and the gelatine set in a wide-mouthed bottle, with the addition of four drachms of pure water and two small drops of *aqua regia,* and then placed in a basin of hot water for solution. Eight grains of bromide of cadmium dissolved in half-a-drachm of pure water were now added, and the solution stirred gently. Fifteen grains of nitrate of silver were next dissolved in half-a-drachm of water in a test tube and the whole taken into the dark room, when the latter was added to the former slowly, stirring the mixture the whole time. This gave a fine milky emulsion, and was left for a little while to settle. A few plates of glass well cleaned were next levelled on a metal plate put over a small lamp; they were, when fully warmed, coated by the emulsion spread to the edges by a glass rod, then returned to their places and left to dry. When dry, the plates had a thin, opalescent appearance, and the deposit of bromide seemed to be very evenly spread in the substance of the substratum.

These plates were printed from in succession from different negatives, one of which had been taken years since on albumen with ox-gall and diluted phosphoric acid, sensitized in an acid nitrate bath, and developed with pyrogallic acid, furnishing a beautiful warm brown tint.

The exposure varied from the first plate thirty seconds to a minute and a-half, as the light was very poor. No vestige of an outline appeared on removal from the printing-frame. The plates were dipped in water to wet the surface, and over them was poured a plain solution of pyrogallic acid, four grains to the ounce of water. Soon a faint but clean image was seen, which gradually intensified up to a certain point, then browned all over; hence the development in the others was stopped at an early stage, the plate washed and the development continued with fresh pyro., with one drop of a ten-grain solution of nitrate of silver, then re-washed and cleared by a solution of hyposulphite of soda.

The resulting prints were very delicate in detail, of a colour varying between a bistre and olive tint, and after washing dried with a brilliant surface. The colour of the print varied greatly, according to the exposure. From the colour and delicacy it struck me that with care to strain the gelatine or use only the clearest portion, such

Reprinted from *The British Journal of Photography* 18 (September 8, 1871), pp. 422-23.

a process might be utilised for transparencies for the lantern and the sensitive plates be readily prepared.

Some plates were fumed with ammonia; these fogged under the pyro. solution. The proportions set down were only taken at random, and are certainly not as sensitive as might be procured under trials. The remaining emulsion was left shut up in a box in the dark room and tried on the third day after preparation: but the sensibility had, it seems, greatly diminished, though the emulsion, when rendered fluid by gently warming, appeared creamy and the bromide thoroughly suspended. Some of this was now applied to some pieces of paper by means of a glass rod, and hung up to surface dry, then dried fully on the warmed level plate, and treated as sensitized paper.

One kind of paper that evidently was largely adulterated by some earthy base dried without any brilliancy, but gave, under exposure of a negative for thirty seconds, very nicely-toned prints when developed with a weak solution of pyro., having very much the look of a neutral-toned carbon print without any glaze, and I think might be rendered useful on plain paper. Some old albumenised paper of Marion's was tried, the emulsion being poured both on the albumen side and, in other pieces, on the plain side, but the salting evidently greatly interfered, the resulting prints being dirty-looking and greyed all over.

These papers fumed with ammonia turned grey under development. They printed very slowly, even in strong sunlight, and were none of them left long enough to develope into a full print. After washing they were cleared by weak hypo. solution. It is very possible the iron developer may be employed for the glass prints, provided the usual acidification does not render the gelatine soft under development.

The slowness may depend in part on the proportions of bromide and nitrate not being correctly balanced, especially as the ordinary, not the anhydrous, bromide was used, and on the quantities being too small for the proportion of gelatine. Whether the plates would be more sensitive if used when only surface dry is a question of experiment; also, whether other bromides than the one tried may not prove more advantageous in the presence of the neutral salt resulting from the decomposition, or the omission or decrease of the quantity of *aqua regia*. Very probably also the development by gallic acid and acetate of lead developer may furnish better results than the plain pyro.

As there will be no chance of my being able to continue these experiments, they are placed in their crude state before the readers of the Journal, and may eventually receive correction and improvement under abler hands. So far as can be judged, the process seems quite worth more carefully-conducted experiments, and, if found advantageous, adds another handle to the photographer's wheel.

The Hand Camera,
A Portfolio of Catalog Illustrations
1880-1900

The invention of the gelatin dry plate and film brought about a new type of camera design for the ever-increasing amateur market. The camera could be handheld, and exposures could be made not only at snapshot speeds, but also in rapid succession. This led to a new kind of photography and, within a few years, to motion pictures. For the cinematographic camera is, basically, a still camera capable of taking sixteen or more photographs per second. A bewildering variety of cameras was offered to the photographer in the advertising pages of magazines. We reproduce illustrations of a few of them.

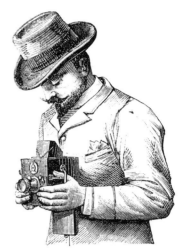

The Kinegraphe, for single exposure on 8 by 9 cm plates. Manufactured by E. Français, Paris. Introduced in 1887.

The "Block Notes" camera, for single exposures on 4.5 by 6 cm (1¾ by 2⅜ inch) plates. Manufactured by L. Gaumont et Cie, Paris. Introduced in 1902.

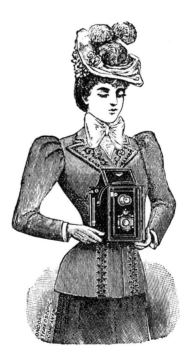

Double Camera. The upper camera served to view the image while the lower camera made the exposure. Manufactured by Marion, Paris, 1889.

The Twin-Lens "Artist" Camera, for twelve exposures on 3¼ by 4¼-inch plates. Manufactured by the London Stereoscopic and Photographic Company, Ltd., London. Introduced in 1899.

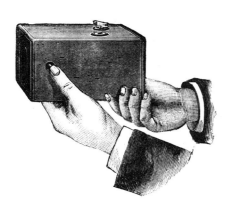

The Kodak, for 100 exposures on roll film masked to a 2½-inch circle. Manufactured by the Eastman Dry Plate and Film Company, Rochester, N.Y. Introduced in 1888.

The Parcel Detective Camera, for 3¼ by 4¼-inch plates. Manufactured by Marion & Company, London. Introduced about 1887.

The Concealed Vest Camera, for six exposures, each 1⅝ inches in diameter, on a single glass plate 5½ inches in diameter. To be worn under the coat, as a vest. Manufactured by Stirn & Lyon, New York. Introduced in 1896.

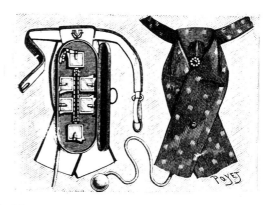

The Photo Cravatte, worn as a necktie, with the lens disguised as a stick pin. For six exposures on separate 2.5 by 2.5 cm. plates. Invented by Edmond Bloch, Paris.

The Photo Jumelle, or Binocular Camera. One lens took the picture while the other lens cast an image for viewing on a ground glass. It held twelve plates 4.5 by 6 cm. Manufactured by Jules Carpentier, Paris. Introduced in 1892.

J. WELLS CHAMPNEY. *A Street Band.* ca. 1887. Reproduced from *The Century Magazine,* vol. 34 (September 1887).

The Amateur Photographer

ALEXANDER BLACK
1887

Alexander Black (1859–1940) was a popular American writer and enthusiastic amateur at the very time that photographic technique was simplified and greatly expanded in scope by the invention of gelatin dry plates and the introduction of lightweight, handheld cameras. With his "Picture Plays"—slide projections of actors playing out his scripts in pantomime—he predicted the motion picture. In this lively article he describes the fascination of the new photography, or, to use his own words, "the contagion of the camera," before sophistication and specialization had set in.

The subtle alchemy of the hobby has never worked more interesting results than in the case of the amateur photographer. That gentle madness which has given a triteness to the phrase "enthusiastic amateur," is especially engaging in the person of one who has succumbed to the curious contagion of the camera. And there is something so communicable in this enthusiasm, that it behooves no one to regard the phenomenon with disrespectful flippancy. Who is to know that his best friend has not been taken down over night? In the street a man feels a hand upon his shoulder, and is served by Banks or Temple with a moral subpoena for a sitting.

Once acquired, the photographic passion is easily gratified. The inventive genius of the century seems to have conspired for its encouragement. The daintiest devices in wood and brass, the coyest lenses, the airiest tripods, the snuggest carrying-cases,—all seem especially endowed with that peculiar quality which tempts one who has straddled a new hobby to plant the spurs impetuously. A few years ago matters were very different. The keynote of amateur photography, the "dry-plate," has been supplied within eight or ten years, since the dry-plate process, though in use for more than a decade, was not brought to trustworthy perfection until it had undergone several seasons' trial. There were, indeed, "wet-plate amateurs," and there are to-day some who

Reprinted from *The Century Magazine* 34 (September 1887), pp. 722-29.

follow the example of many professionals in adhering to the older method. But amateur photography now practically means dry-plate photography. It was the amateur who welcomed the dry-plate at a time when the professional was yielding it only a cautious tolerance. Why he welcomed it may scarcely require explanation.

The principle of the wet-plate process is suggested by its name. The glass negative-plate is coated with collodion, exposed in the camera while wet, and developed at once. This implies the presence of appliances within a short distance of the place where the exposure is made. In order to make views out-of-doors the photographer was obliged to carry an outfit which in these times would look lugubriously elaborate. I have seen a "home-made" amateur wet-plate apparatus, made very ingeniously of telescoping boxes, with an eye-hole at the top, an arm-hole at each side, an orange-light window in the front (for all the tinkering with the moist plate had to be done without white, actinic light), and the whole, with its trays, baths, solutions in bottles, etc., could be reduced to a relatively small bundle.

When the dry-plate arrived it became possible to do away with all this ponderous machinery. The dry-plates, bought ready prepared, can be kept for months before use, and for months again after exposure before they are developed—a phenomenon of which the wonder is always new. Thus one may carry a camera with him through Europe, pack up the exposed plates, and, unless some custom-house official, to the amateur's unspeakable despair, insists upon opening a few of the packages to discern the meaning of their ominous weight, develop them all on his return home.

This element of portability is not the only feature of the dry-plate process which had an immediate influence upon the development of amateur photography. A capacity for rapid work was from the outset an important characteristic of the process. By continued experiment the sensitiveness of the gelatine film with which the plates are coated was from time to time increased, until now an exposure for the two-hundredth part of a second is sufficient to secure an adequate negative. The value

149

WILLIAM SCHMID. *On the Way from School.* ca. 1887. Reproduced from *The Century Magazine*, vol. 34 (September 1887).

of this achievement is wider than the field of the amateur. Within the few years during which instantaneous work has been possible, both science and art have increased their obligations to the camera. Every one remembers the burst of merriment and wonder that greeted Mr. Muybridge's pictures of the horse in motion. The motion of a sound-jarred lamp-flame, the flight of a cannon-shot, the forkings of lightning, and a thousand other phenomena have been dexterously photographed. Through this medium both the naturalist and the surgeon have gained a better knowledge of muscular action. One anatomist uses the rapid plate to settle the long-standing dispute as to whether, in the twirling of the fist, the *ulna* or the *radius* moves the more; another fastens with bee's-wax upon the line of a model's spine a row of glistening Christmas-tree balls, and then takes a dozen impressions within a second while the model is walking away from the operator. It is in this manner that instantaneous photography has made itself invaluable to students in many departments of knowledge, students who, while they are in a sense amateur photographers, make professional use of the product.

A novel result of the instantaneous process is seen in the camera without legs. "There is only one way to get along without a tripod," said a well-known New York photographer. "You must focus, and for this purpose a stick, inserted in the bottom of the camera and resting in the ground, might be used." After being assured by excellent authorities that the idea was absurd, Mr. William Schmid, of Brooklyn, N.Y., made the first of the "detective" cameras. Mr. Schmid is neither a professional photographer nor a mechanic, but a musician. Let me say behind a respectful parenthesis that most of the improvements in modern photography have

been discovered or instituted by amateurs. Working only for pleasure and attainment, the amateur thinks nothing of a risk. He indulges in most unorthodox measures, violating recognized rules of procedure, and with bewildering impunity. Then, the amateur blunders. To blunder is to discover, though it is infinitely more pleasurable to have the other fellow do the discovering. With his client waiting without to learn the result of the sitting, the professional cannot afford to discover at this price.

The "detective" solved several problems. Focusing, which is a simple matter of arithmetic, was accomplished with a lever. In order to discover the field of the lens and the situation of the image on the plate, a small camera obscura was fitted in the front of the box; and a perforated disk of black rubber made the exposure in a space of time ranging between the thirty-fifth and the one-hundred-and-thirtieth part of a second. Nothing connected with photography has proved so fascinating as this "detective" camera. Disguised in a small, inconspicuous box, which might readily be taken for a professional hand-satchel, it is indeed a "witch-machine," as it was named last summer by an astonished resident of the Tyrol, when, under its inventor's arm, it was winking its way through some of the quaintest towns of Europe. In the open air nothing is closed against the "detective." In the rigging of a tossing ocean steamer, or in a crowd on the Bowery, it is always prepared, with one eye open and the other shut. Fragments of street scenery, little *genre* bits in out-of-the-way corners, tableaux in rustic or town life, requiring instant capture, all impossible to the ordinary camera, are caught by the "detective" in their very effervescence.

In the hands of police officials the "detective" has justified its name. It has already several times figured in court proceedings, and may well be regarded with uneasiness by those whose face is not their fortune. An English detective is described as having disguised himself as a bootblack and hidden a camera in a foot-box, with results very gratifying to the Police Department and very bewildering to the rogues.

Several varieties of the "detective," or portable, camera are in the market. Then there is the "vest camera," consisting of a false vest in which one of the false buttons forms the neck of the lens. For stealing portraits the arrangement is very ingenious, and ought to prove a valuable assistant to the caricaturist. The pictures, though small, are sometimes surprisingly good. Again, a German has secreted a camera in the hat. An ostensible ventilating aperture in the front is the eye-hole of the lens.

For larger and more serious work the portable camera

is, of course, inadequate. Probably the favorite size of camera with experienced amateurs is the camera fitted for 5 x 8 inch plates. The size has, after all, little to do with the value of the result. Wisdom dictates the utility of a modestly small camera at the outset. In sizes larger than 5 x 8 inches, or 6½ x 8½ inches,—another useful size,—plates become somewhat expensive playthings. The discovery that negatives can be made with gelatine-coated paper, which is placed on rollers and reeled, panorama-like, at the back of the camera, has opened up interesting possibilities to the photographer.

Vastly more important than the precise size of the box is the character of the lens, upon which the quality of the photograph is wholly dependent. In his selection of a lens every shrewd amateur is careful; but as every shrewd amateur is not shrewd when he buys his first lens, it is not inadvisable to emphasize at all times the prudence, whatever the cost of the outfit, of spending at least half of the sum on the lens; to say two-thirds of the sum would be stating a better rule.

But out-of-door apparatus is no bugbear to the amateur. So far as the camera and its immediate appliances go, no difficulty is commonly found in getting just what is needed, provided the buyer does not stake his happiness on the first camera that is shown him, without looking over the series of later inventions.

Photography indoors and the processes of the dark-room have not so many ready-made features as picture-making in the open air. The dark-room problem must be solved at the very beginning. The photographer must find some place in the house from which all light can be excluded, and where there is, if possible, running water. "I would like photography a good deal better," said a Boston lawyer the other day, "if my attic ceiling didn't slope so suddenly." It is not so much that attics are apt to have a forty-five degree emphasis, as that the absorbed operator, working with a dim light, forgets all about the slope. A permanent dark-room is probably the exception among amateurs, who are generally able to find a room or the corner of a room which may be pressed into service during the time developing is going on. If the development of the plates is deferred until the evening (a common practice), the precautions for excluding light will be to a great extent unnecessary.

Whether simply or elaborately treated, the dark-room is certain to remain a "matter in difference" between the photographer and the head of the domestic bureau. Whether he has an apartment dedicated to his uses, or an impromptu den evolved from the bath-room and an assortment of blankets and shawls, the amateur incurs a liability to feminine displeasure, and must find his own way of offering propitiation. In case the photographer

is of the other sex (a possibility of which the chances daily become interestingly greater), woman's superiority over the domestic forces upon which it is necessary to rely will come into play to her benefit.

In making pictures indoors, the illumination, instead of being managed by nature, as out-of-doors, must be managed by the photographer. In the house, unless the amateur has a roof-opening of some sort, securing the "top light" of the professional, portraits and groups must be made with only the side light of windows. This unfavorable angle of light must be overcome by the use of reflectors, which may consist of an adjustable white screen, or have the unpremeditated picturesqueness of a sheet thrown over a clothes-horse. One of the first enterprises an amateur essays is the photographing of an interior. In this way he characteristically begins at the most difficult end of the art. Nothing is more precarious than photographing an interior. The windows, which supply the light, are the source of the greatest anxiety, since they themselves generally require only the short exposure given a landscape, while the dim interior demands an exposure perhaps fifty times as long. To overcome this difficulty, windows coming within the range of the lens must be covered carefully until a sufficient exposure has been given to the rest of the room. The cap is then replaced, the window coverings removed, and a short exposure given the whole.

An interior may often be photographed to advantage by gas-light. The chief obstacle in the way of success by this method is that of keeping the source of light out of the range of the lens. Several hours may be required to make a satisfactory negative, but the result will be an ample reward. A New York publisher, who can show a handsome series of negatives, once undertook to photograph his library by gas-light. So that there might be

JOHN L. STETTINUS. *The Diver.* ca. 1887. Reproduced from *The Century Magazine,* vol. 34 (September 1887).

no possibility of intrusion, he did not set his camera until ten o'clock in the evening, and concluded to leave the cap off for two hours. On that night his daughter was going to an evening party. He asked her when she would be home. "At twelve o'clock, sir," she replied with readiness. There was obviously no reason why the publisher should sit up; his daughter understood the cap arrangement thoroughly. "Maggie," he said, "when you come home you will find my camera set in the library. Go in and put on the cap and turn off the gas." The next day the publisher developed the plate. It was a complete failure, horribly over-exposed; scarcely an object was discernible. "Maggie!" called the publisher from the door of his den, in tones that forbade equivocation, *what time did you get home?*" "At—three o'clock, sir," said Maggie.

Portraits and all amateur indoor pictures are liable to have this characteristic of deep shadows, so repugnant to the business photographer. Yet these are the strong lights and shades the artist loves. The effect is warmer, more individual, than in the so-called "well-lighted" portrait or interior. I have seen portraits that left a little too much to the imagination; there is a happy mean.

In many other respects amateur work has its own special charm. Freed from the commercial necessities which fetter the professional, the amateur need have nothing but the principles of art for guidance. In this delicious liberty he well may be, and is, envied by those who must yield something to the whim of the buyer, and who have a hard fight with the Philistines in every effort to elevate the standard of their art.

The amateur has an opportunity to infuse individuality into his products,—one is expert at portraiture; another at landscape; a third is noted for his city types and localities; a fourth takes up with natural-history subjects; a fifth with yachts and water views; the bicyclist screws a jaunty, elfin camera upon the cross-bar of his wheel; the canoeist stows one in his locker.

Transparencies and lantern slides are readily made from negatives, and are a special hobby with many amateurs. Chicago has formed a Lantern Slide Club, evidently with a view to coöperation in this particular field. We shall doubtless soon hear of Composite Clubs, since composite portraiture has completely subjugated the amateur. A thrill of excitement is occasionally caused by the announcement that some one has photographed in color; the truth being that some one has a new scheme for the photographing *of* color. Isochromatic, orthochromatic, or axioscotic photography, as we may agree to term it, has drawn a great deal of attention of late from all who for any reason are interested in photography. The Germans have made great progress in the *farben-empfindliche*

("color-sensitive") methods. In the United States science and art have been placed under obligations to Mr. Ives, of Philadelphia, who has completely mastered the hitherto insurmountable difficulty of gaining in a photograph the relative color values of the objects photographed.

A New York physician, the windows of whose house overlook the East River from the bluff on the east side of the city, is too busy to go after subjects, but lets his subjects, like his patients, come to him. At the window of an upper room in his house he has a camera set with a drop-shutter,—used for instantaneous work,—carefully adjusted. From his easy-chair in the consulting-room on the lower floor he can look out on the river, can see the plebeian river craft crawling and smoking upon the water, and every afternoon may watch the self-important Sound steamers churning their way past the indifferent small fry of the stream. When one of these autocrats of the Sound or some other floating object of importance looms within the range of the lens, the doctor may touch an electric button near his inkstand, and upstairs at the window that little shutter-guillotine bites off a square inch of light, which carries the image to the sensitive plate at the back of the camera. After office hours the doctor goes up and takes out the plate.

The curiously diverse *personnel* of amateur photography* includes a large number of active physicians. It is worthy of note that the profession of medicine seems to foster the cultivation of hobbies. How great a debt art owes to the fact that Dr. Haden began playing with the etching needle! Some of our prominent Eastern merchants have gone into photography in a characteristically sumptuous way, fitting up luxurious sky-light rooms, and adding to the dark-room equipment every mechanical comfort money may buy. A Massachusetts parson, who loves to drive a decorously fast team, has a cluster of prints illustrating the charming region through which he makes his Monday tours. A Brooklyn Court stenographer can reveal the vagaries of the police station and the Black Maria. It is, perhaps, not essential to the unity of this sketch that I should mention, as illustrating a phase of the subject, a hospital steward at the Sandwich Islands who took up with photography for the purpose of practicing on the leprosy patients; or the Canadian sheriff who added the tortures of an unwilling pose to the misery of a batch of prisoners who were about to be hanged!

*The Tzar is said to be one of the growing company of Russian amateurs; the Prince of Wales, President of the Amateur Photographic Association of Great Britain, has acquired much expertness with the camera, and royal sanction has elsewhere, it seems, been very heartily given. [Note by A. Black.]

Watermelon Party. n.d. Snapshot taken with an early model Kodak camera. George Eastman House, Rochester, N.Y.

Street Scene, Rochester, N.Y. ca. 1888. Snapshot taken with an early model Kodak camera. George Eastman House, Rochester, N.Y.

The rapid growth of amateur photography is forcibly indicated by the number and size of the amateur photographic societies. All the large and many of the smaller cities have now one or more associations of this sort.

Many New York amateurs are associated with the Photographic Section of the American Institute. The Columbia College Amateur Photographic Society finds a leading spirit in Professor Chandler. The Society of Amateur Photographers, of New York, organized four years ago, is now a large and prosperous organization, holding annual exhibitions and awarding diplomas for the best examples of work in different fields. The Society's influence has had the effect of elevating the artistic standard not only of amateur photography, but of photographic art in general. At the semi-monthly meetings the members discuss with frankness the experiments they have made, relate their mild vicissitudes, describe their blunders and the resultant discoveries. No one is ashamed that he should have made mistakes. An amateur who had no failures would be regarded as a sort of artistic snob. As an off-set to this variety, where it exists, there is generally the humorous fellow whose plates always either "fog" or "frill," whose prints freckle, and who,

when he insists on "silvering" his own paper, gets a little nitrate of silver on the end of his nose, where it promptly blushes brown on meeting the sun, and can only be removed, if it must be removed at once, with pumice-stone or sand-paper.

The "Field Day" has become an institution with the amateur societies, and woe to the sensitive who get in the path of one of these armed bodies! On these excursions the member with the "detective" usually has his best sport in practicing on the other members, who, at the moment of a photographic crisis, are not always so impressive as they themselves could wish.

What a flow of "developer" after one of these country tours! Far into the night, perhaps, the trays are rocking, and the lanterns dimly flickering; and in quarters, mayhap, that were hard to secure and duly transform. Country-side and sea-shore know the amateur photographer, his practices, and his needs. We cannot believe that the country boarding-house, certainly not the well-regulated hotel of the future, will neglect to incorporate in its table of attractions, "Improved Dark-room for Amateur Photographers."

JACOB A. RIIS. *Baxter Street Alley in Mulberry Bend, New York.* 1888. The Museum of the City of New York.

Flashes from the Slums: Pictures Taken in Dark Places by the Lightning Process.

Some of the Results of a Journey through the City with an Instantaneous Camera—the Poor, the Idle, and the Vicious

JACOB A. RIIS
1888

Jacob A. Riis (1849–1914) took up photography in the 1880s for one purpose: to provide believable, indeed deliberately shocking pictures of the slums of the Lower East Side of New York and of their poverty-stricken inhabitants. An immigrant from Denmark himself, he knew at first hand the miserable living conditions of the ghetto that the area had become. A score of years later, as a newspaper reporter, he wrote muckraking stories, hoping to arouse the public conscience. Finding that words alone were inadequate, he turned to the camera to secure lantern slides for the lectures he gave in churches and schools. The following unsigned article vividly describes the forays that Riis and his friends made into the slums with camera and primitive flashlight.

Much of the effectiveness of the photographs was lost in this presentation, because the half-tone facsimile reproduction of photographs on newsprint was not yet perfected; only crude line blocks from drawings of them could be printed. Yet this illustrated article led to the book How the Other Half Lives, *in 1890, which in turn led Theodore Roosevelt, while president of the New York City Board of Police Commissioners, to take action. The infamous Mulberry Bend was demolished, and a park took its place; tenements were gradually replaced with improved housing. Riis continued his campaign: six more books appeared, often in several editions. As far as we know, Riis photographed only for the purposes of his humanitarian crusade, and apparently did not use his camera after 1898. Happily, his negatives are preserved. From them Alexander Alland, Sr., made prints that were exhibited at the Museum of the City of New York in 1947. They revealed Riis—whose work was previously known only through poor reproductions—to be a major photographer.*

With their way illuminated by spasmodic flashes, as bright and sharp and brief as those of the lightning itself, a mysterious party has lately been startling

Reprinted from *The Sun* (New York), February 12, 1888.

the town o' nights. Somnolent policemen on the street, denizens of the dives in their dens, tramps and bummers in their so-called lodgings, and all the people of the wild and wonderful variety of New York night life have in their turn marvelled at and been frightened by the phenomenon. What they saw was three or four figures in the gloom, a ghostly tripod, some weird and uncanny movements, the blinding flash, and then they heard the patter of retreating footsteps, and the mysterious visitors were gone before they could collect their scattered thoughts and try to find out what it was all about. Of course all this fuss speedily became known to THE SUN reporters, and equally as a matter of course they speedily found out the meaning of the seeming mystery. But at the request of the parties interested the publication of the facts was delayed until the purpose of the expedition was accomplished. That has now been done, and its history may now be written.

The party consisted of members of the Society of Amateur Photographers of New York experimenting with the process of taking instantaneous pictures by an artificial flash light, and their guide and conductor, an energetic gentleman, who combines in his person, though not in practice, the two dignities of deacon in a Long Island church and a police reporter in New York. His object in the matter, besides the interest in the taking of the pictures, was the collection of a series of views for magic lantern slides, showing, as no mere description could, the misery and vice that he had noticed in his ten years of experience. Aside from its strong human interest, he thought that this treatment of the topic would call attention to the needs of the situation, and suggest the direction in which much good might be done. The nature of this feature of the deacon-reporter's idea is indicated by the way he has succeeded in interesting the children in his Sunday school on Long Island in the work of helping the destitute children of the metropolis. The ground about the little church edifice is turned into a garden, in which the Sunday school children work at spading, hoeing, planting, and weeding, and the potatoes and other vegetables thus raised are

contributed to a children's home in this city. In further-ance of just such aims the deacon-reporter threw him-self with tireless energy into the pursuit of pictures of Gotham's crime and misery by night and day to make a foundation for a lecture called "The Other Half; How it Lives and Dies in New York," to give at church and Sunday school exhibitions, and the like.

The entire composition of the night rousing party was: Dr. Henry G. Piffard and Richard Hoe Lawrence, two accomplished and progressive amateur photographers; Dr. John T. Nagle of the Health Board, who is strongly interested in the same direction, and Jacob A. Riis, the deacon-reporter.

The first picture in this report gives a view of life among the white slaves, as the needle-women of New York are truthfully and pathetically designated since THE SUN has disclosed so much of the misery and oppression they suffer. The women are mother and daughter, both widows. As they are both able to work, and have no children or any one depending on them, they are exceptionally well off among the class to which they belong. But it is only by unremitting work, early and late, that they are able to keep over themselves the poor shelter of a tenement house roof and provide the actual necessaries of life.

The adventures of the picture-taking party in other di-rections were interesting and sometimes amusing. Their night pictures were faithful and characteristic, being mostly snap shots and surprises. In the daytime they could not altogether avoid having their object known, and, struggle as they might against it, they could not altogether prevent the natural instinct of fixing up for a picture from being followed. When a view was of in-terest and value as they found it, they were sometimes unable to stop the preparation and posing from almost destroying the interest in it. Mr. Riis has kindly fur-nished a number of his photographs to THE SUN's artist, and they are given here. An example of the flash-light pictures is this from the lodging room of the Thirtieth street police station. The three women caught in the flash are three different types of the station house lodger. One is shown in sodden or brazen indifference, one in retiring modesty and averted face, and the third in angry defiance of camera and visitors.

Another flash-light picture, though showing only still life, is eloquent of the misery and destitution of those with whom imagination can people it, as each recurring night does people it, with the wrecks of humanity that form its clientage. It is a Pell street seven-cent lodging house, whose cots or beds or bunks or hammocks, par-taking as they do of the characteristics of all three, are simply strips of canvas stretched between beams, six

feet apart. Mr. Riis has other views of this place at night which are a revelation to those who were never there.

The pictures secured of some of the notorious courts and alleys of the lowest tenement districts of the Fourth and Sixth wards are very interesting, and are especially relied upon by Mr. Riis to make his points in favor of the Children's Aid Society and other children helpers, because they are always swarming with children. The court at 22 Baxter street, long of an unsavory reputation, and with a still more unsavory name, is now almost wholly given up to Italian occupancy. It is still dirty and distressed, and its picture, as given here, is not without interest. It is a typical tenement house yard, the clothes lines, the hydrant, the push cart, and the chil-dren being always to be found.

At 59 Baxter street is a similar place, an alley leading in from the sidewalk, with tenements on either side crowding so close as to almost shut out the light of day. On one side they are brick and on the other wood, but there is little difference in their ricketiness and squalor. This is also an Italian colony, and the bags of rags and bones and paper shown are gathered by these people, despite the laws and ordinances and the 8,000 police.

At 59 Mulberry street, in the famous Bend, is another alley of this sort, except it is as much worse in character as its name, "Bandits' Roost," is worse than the designa-tions of most of these alleys. It has borne this name these many years, and though there have been many entire changes in the occupants in that time, each suc-ceeding batch seems to be calculated in appearance and character to keep up the appropriateness of the name. There are no bags of rags to indicate even that low form of industry here. Many Italians live here, but they are devoted to the stale beer industry. On each side of the alley are stale beer dives in room after room, where the stuff is sold for two or three cents a quart. After buying a round the customer is entitled to a seat on the floor, otherwise known as a "lodging," for the night.

Another outcropping of the benevolent purpose of Mr. Riis in behalf of the boys is his showing of a touch-ing picture of street Arabs in sleeping quarters, which it must have taken a hunt to discover. These youngsters have evidently spent their lodging money for gallery seats at the show, and have found shelter on the back stoop of an old tenement house.

The researches into the manner of life of the "other half" continually brought the investigators face to face with "the growler," which is the highly suggestive name of the can or pitcher in which beer is brought by the pint or quart from the corner saloon. The bright young-ster here pictured as the Growler Ganymede has thou-sands of prototypes in this city. He serves both the

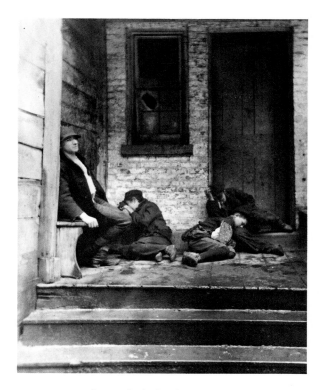

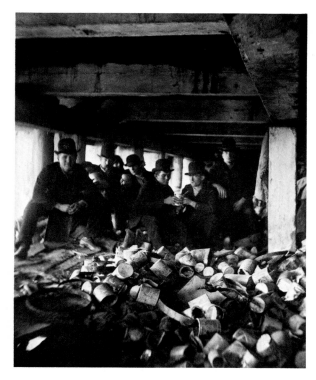

JACOB A. RIIS. *Street Arabs in Sleeping Quarters at Night.* 1888. The Museum of the City of New York.

JACOB A. RIIS. *The Short Tail Gang, under Pier at Foot of Jackson Street, Later Corlears Hook Park.* 1888. The Museum of the City of New York.

families in the tenements and the gangs that congregate on the corners or in stables or some other shelter to work the growler. In many cases yet younger children are pressed into this service, and girls, as well as boys, of tender years are sent into saloons of bad character for this purpose.

A "growler gang" that is the exemplification of all that is degrading and disreputable in the whole range of the practice is the one whose headquarters is under the Jackson street dump. The surroundings of these drinkers are dirt, flying ashes, and refuse of all kinds, the tin-can carpeted floor, and the stench-laden air, and there are no attractions except the one of beer guzzling. Decent people are not expected here, and interruptions are not to be feared. So these fellows, who, though young and sturdy, never work, can assemble here and "rush the growler" until the last eight cents is gone.

A similar gang on the west side in the greater freedom they enjoy around the stables and slaughter houses up town, indulge in all the beer they can get while assembled in the open air. They have, nevertheless, means of getting under cover when, as is frequently the case, that becomes necessary.

A feature of growler gang life is the proceeding known as "wrestling for the price." That means getting money with which to buy beer. And when these young toughs talk about getting money, it simply means getting it, and there is no restriction expressed or implied regarding the means to be employed. At these times the advent of a drunken man into the district patrolled by the gang is a piece of good luck for the boys—not for him. The interesting process of robbing a "lush" as here shown is deftly and quickly gone through with.

The degradation pictured in this view of a Thompson street dive is, perhaps, as low as any that the picture takers came across. The dive is one of the places known as "Black and Tans," because its frequenters are colored men and white women of the most degraded sort. The man who is lounging on the barrel is an ignorant, worthless black of a capacity equal to work as a day laborer were it not that the energy for such occupation can only be supplied by the pressure of the most dire necessity. The woman shown is white as to complexion, but a dissolute life and the effects of drink have dragged her down to the level of the man, if, indeed, she is not beneath it.

157

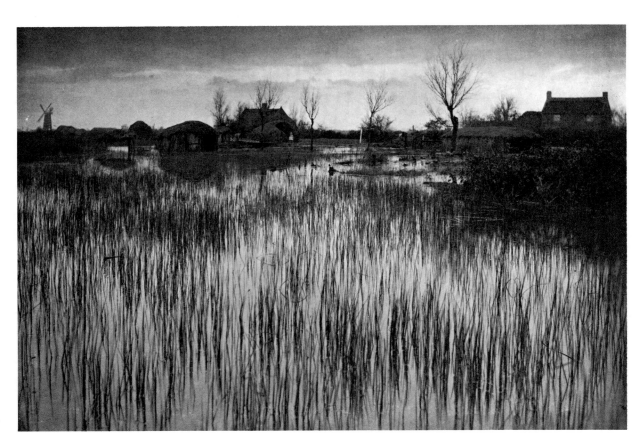

PETER HENRY EMERSON. *A Rushy Shore.* Platinotype. Plate 36 of *Life and Landscape on the Norfolk Broads,* London, 1886. The Museum of Modern Art, New York.

Photography, A Pictorial Art

PETER HENRY EMERSON
1886

Peter Henry Emerson (1856–1936) first exhibited his photographs as an amateur in London in 1882. Highly intellectual and a brilliant medical student, he abandoned a promising career as a physician to devote all his energies to practicing photography as an art and writing about the medium. Greatly influenced by the physiological writings on the mechanics of human vision by Hermann von Helmholtz, and by the plein-air paintings of Jean François Millet and the Barbizon group, he established an aesthetic approach to photography that was revolutionary. He advised photographers to focus sharply only on the principle subject, thus allowing the distance to become increasingly vague. He told them to take their cameras outdoors and photograph real people in their native environment, rather than posing costumed models against studio backgrounds.

He announced his conviction that this approach was the only road to the achievement of art by photography in this lecture, given in London at The Camera Club on March 11, 1886. The pioneer pictorialists, who rendered everything seen on the ground glass as sharply as possible, were bewildered. They were dismayed that their carefully contrived "composition pictures" should be so harshly criticized. When Emerson's book, Naturalistic Photography for Students of the Art, *appeared in 1889, sharp controversy broke out in the photographic press. Although Emerson renounced his beliefs that photography was an art in 1891—after he was told by scientists that control of tones by development was impossible—his impassioned arguments and beautiful prints brought a fresh spirit to photography.*

In approaching the subject of Art, one is appalled by its difficulty and complexity, for Art is indefinable, although it is possible to say what is not Art. The misconceptions and confusion in Art matters are due to the literature of the subject. From early times nearly all

Reprinted from *The Amateur Photographer* 3 (March 19, 1886), pp. 138-39.

writers on Art have been lay-men. These men have discussed Art and Art matters from the literary view, whilst the artists have kept silence and only expressed their opinions by their works. Hence, the unthinking public have had their own opinions formed for them, and as these opinions were evolved from the inner consciousness of the writers, and not based on any logical first principles, it necessarily followed that opinion on Art matters shifted like a weathercock. Now, one school was held up as the pink of perfection, only to be ostracised from the realms of good taste a few decades later. And until quite recently the matter was quite hopeless. People said "Art is a matter of taste, my taste is as good as yours, I say this picture is better than that and now what have you to say?" To such argument there was then no answer. Anyone who has read the history of Art, and a very interesting history it is, will be surprised at, and will look with pity on the unthinking millions who have been swayed by opinions based on no reason. The days of metaphysics are over, and with them, we hope, has died all that class of pernicious illogical literature, evolved from the inner consciousness of man.

In our own day, the powerful effects of fine writing have had a most hurtful influence on the great British public in the artistic sense. One of these spasmodic elegants of Art literature has made it a point to scoff at any connexion between science and Art, and has flooded the world, in beautiful writing in which his power lies, with dogmatic assertions and illogical statements. He has treated botany, photography, political economy, and I know not what other subjects, in a style which, had it been the work of a sixth form boy at a good school, would have secured a well merited punishment. Yet these false stones, in their beautiful setting of fine writing, have procured him as many worshippers as his hero himself. A lesser light than he, a poor creature, who has essayed to stride in his master's footsteps, has, with a little more truth, but with much less beauty and originality, devoted whole pages to attack and denounce photography. It is a question whether this

159

writer is worthy of a happy despatch; if so, I purpose killing him on a more public stage than this; and lastly, in our own branch of Art, one writer has served up a senseless jargon of quotations from literary writers on Art matters, a confused bundle of lines which take all sorts of ridiculous directions, and which this worthy impresses are necessary to make a picture. The bulk of the work contains the quintessence of a blend of literary fallacies and Art anachronisms, and yet, in spite of all these wiseacres, many a beautiful picture has been produced which had defied their every law. Let us briefly run through the different periods of Art, and see how it was hampered and enslaved by external influences.

The earliest Art was the scratchings of the men of the stone age upon their rocks, reproductions of which I pass around. Next we come to the fascinating period of Egyptian history: Egyptian pictorial Art as handed down to us on the mural paintings of the tombs are, as you will see by the specimens, crude and common place. Akin to these are the remains we have of the monarchies of Western Asia. We then come to the cultivated and wonderful Greeks. Their plastic Art is well known to most of us, and notwithstanding its age, is as beautiful to-day, and as much admired by artists, as it was then. Why is this? Is it to be explained why the Venus of Milo is more beautiful than the later production of Michael Angelo, the hypertropic Moses? This will be seen later on. I pass round a few photographs from the antique, and a few from the works of Michael Angelo. Comparisons are unfortunate for Michael Angelo. Woltmann and Woermann* tell us that no single specimen of the works of the great Greek masters has come down to us, but judging from the enthusiastic tone of the classical authors, we may surmise that that artistic people attained as great proficiency in some branches of pictorial Art as we know they did in the plastic Art. I pass round a photograph of one of the mural paintings at Pompeii, but these were only the work of journeymen.

When Rome began to subjugate Greece, Art went into slavery. The early Christians employed it as a means to propagate their doctrines. The oriental idea of teaching by parables spread in their community, and we find the art of the catacombs enslaved to the new mysticism which arose on the Pagan ruins. The gorgeous monstrosities of Byzantium were also made a serf to religion. At last, in the twelfth century, we find the Art of Italy developed into a national art, but still a slave to the church. Beautiful things were done, but alas, the great men of that period had to paint to order, to paint what are called works of the imagination, in other words untruths; and what was the consequence? A surfeit of madonnas, annunciations, presentations, massacres, and other subjects, which are diametrically opposed to true Art. With the great Leonardo da Vinci a new departure was made, portraits and lay subjects became more frequent. The portrait I now pass round is the famous Mona Lisa, Da Vinci's great work. Works of all kinds were now produced, but still Art was in slavery. Pictures were judged by pre-existing standards—a most fatal error.

In a brief paper like the present it is perfectly impossible to finish even a rough sketch of the subject. Art went from one slavery to another, religion, morals, courts, kings, the literati, all in turn ruled it, until there was born in Suffolk one John Constable, the son of a miller. With a clear head, and the freshness and originality of genius, he sought to find beauty in nature, and not in picture galleries. A few of his pictures went to Paris, and the cultured few saw that he was right, that his was truth. Rousseau, the father of the French modern school, boldly struck aside and followed Constable. Corot, the tender, followed, but not to his full bent; then came Jean François Millet, honoured name, and later still the young Le Page, who died, alas! too young. These were the pioneers who established that naturalistic school which is now in the van of this sixth century.

I have found the greatest difficulty in making my remarks brief; it is as difficult to write a little about a great subject as it is to write about nothing. We must now leave this fascinating development of Art, and show how and why photography is a fine Art. Pictorial Art is man's expression by means of pictures of that which he considers beautiful in nature. Now any Art is a fine Art which can, by pictures, express these beauties, and that Art is best which best expresses them. Let us begin with painting, the master pictorial Art, for until we can reproduce the colours of nature, we can never equal painting; but all other branches of pictorial Art we are able to surpass. Painting alone is our master. Now let us see how far painting can reproduce nature. Professor Helmholtz† has worked this question out for us, and to him I am indebted for the following notes. In reproducing nature, as he says, one of the principal things is the quantitative relation between luminous intensities. "If the artist is to imitate exactly the impression which the object produces on our eye, he ought to be able to dispose of lightness and darkness equal to that which nature offers." But of this there can be no idea. Let me give a case in point. Let there be, in a picture gallery, a desert scene, in which a procession of Bedouins shrouded in white, and of dark negroes, marches under

*German authors of a popular art history.

†Hermann Ludwig Ferdinand von Helmholtz (1821-1894), German physiologist.

160

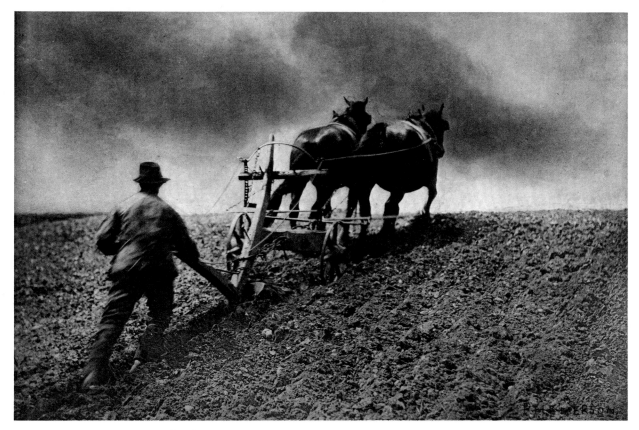

PETER HENRY EMERSON. *A Stiff Pull.* Photogravure. Plate 4 of *Pictures of East Anglian Life,* London, 1888. The Museum of Modern Art, New York.

This picture was criticized in *The American Amateur Photographer,* January 1890, by D. Habord of London: "An awful abortion representing a man plowing up-hill with a pair of horses. The man's foot was as long as the horse's head and the whole picture was gloriously so 'naturalistic,' i.e., 'fuzzy' or 'focused with judgment' that it was denounced as an imposture." In the March issue Emerson replied to this charge by stating that the platinotype had received a silver medal at the Amateur Photo Exhibition in London in 1886, judged by the photographic scientist W. de W. Abney and artists Sir James Linton and Thomas Ford. He quoted favorable press reviews and concluded, "I may add that the picture has been most highly spoken of since, for it is one of the best plates in my work 'Pictures of East Anglian Life.' "

the burning sunshine; close to it a bluish moonlight scene, where the moon is reflected in the water, and groups of trees, and human forms, are seen to be faintly indicated in the darkness. You know from experience that both pictures, if they are well done, can produce with surprising vividness the representation of their objects; and yet, in both pictures, the brightest parts are produced with the same white lead, which is but slightly altered by admixtures; while the darkest parts are produced with the same black, both being hung on the same wall, share the same light, and the brightest as well as the darkest parts of the two scarcely differ as concerns the degree of their brightness. How is it, however, with the actual degrees of brightness represented? Now, although the pictures scarcely differ as regards the degrees of their brightness, yet in nature the sun is 800,000 times brighter than the moon; but as pictures are lighted by reflected light, the brightest white in a picture has about 1/20th the brightness of white directly

lighted by the sun. Hence it will be seen that white surfaces in pictures in sunlight are much less bright than in reality, and the moonlight whites of pictures are much brighter than they are in reality. How, then, is it that there is any similarity between the picture and the reality? This is explained by the physiological process of fatigue. Any sense, as we know, is dulled by fatigue; to wit, the effect of loud noises and bright lights on hearing and seeing. The eye of the man in the desert is dulled by the dazzling sunlight, whilst the eye of the wanderer by moonlight has been raised to an extreme degree of sensitiveness. What, then, must the painter do? He must endeavor to produce by his colours in the moderately sensitive eye of the spectator in a picture gallery the same effect as seen in the sunlight or moonlight. To accomplish this, he gives a translation of his impression into another scale. We know, regarding all sensations, that any particular sense is so coarse that it cannot distinguish differences between certain wide limits. The

161

finer the distinctions of light cannot therefore be appreciated by the eye. The painter, therefore, must, as nearly as he can, give the same *ratio* of brightness to his colours as that which actually exists. Hermholtz says that "perfect artistic painting is only reached when we have succeeded in imitating the action of light upon the eye, and not merely the pigments."

Now let me give you an example of the fallacy of the pre-Raphaelites. They imitated the pigments, not the light. I will illustrate my meaning with this cigar-box. We thus see that much is impossible in Art, and that one of the greatest points is rendering correctly the relative values or ratio of luminous intensities. Now we know that the effect of binocular vision is to force a scene on our perceptions as a plane surface; hence the painter has in this point no pull over the photographic lens, but rather the reverse. Of the greatest importance to a picture also is aerial perspective, that is, the scattering of light by atmospheric turbidity, more generally moisture. This turbidity is most important, and the lack of it dwarfs distant objects; hence from the lack of it in the higher Alps, we get these caricatures which yearly adorn our galleries. These dwarfed maps of mountain peaks seem rather in fashion just now—heaven only knows why. No painter can do them justice, and no good one ever attempts them, and yet photographers, who are not so able to represent them, are constantly doing so, and, to show the prevalent ignorance, these photographs are often honoured with the highest awards because of their sharpness and clearness. Letters have been written suggesting that English and foreign views should not be classed together, and much other nonsense of this description, all simply showing ignorance.

A work of Art is, as we have said, an expression by means of pictures of what is beautiful, and the points to gauge in a picture are to notice what a man wishes to express, and how well he has expressed it. I know Switzerland, and love it well; but I would no more attempt to make a picture of a peak than I would of a donkey engine. A peak, shrouded and accentuated by aerial turbidity, and just peeping into an Alpine subject, might from its mystery and sentiment add to the artistic value of a foreground subject. But the usual photographs of peaks could be of interest only in a Baedeker.* This turbidity can be well rendered in a photograph. Painters, as we do, use optical instruments, such as Claude glasses,†

*One of the then popular travel guide books published by the firm of Karl Baedeker (1801-1859) and his successors.
†A concave mirror of dark glass used by painters for observing landscapes. The effect it gave was similar to that given by a painting by Claude Lorrain.

prisms, and the camera itself. The whole point, then, that the painter strives to do is to render, by any means in his power, as true an impression of any picture which he wishes to express as possible. A photographic artist strives for the same end, and in two points only does he fall short of the painter—in colour, and in ability to render so accurately the relative values, although this is, to a great extent, compensated for by the tone of the picture. I here use the word in its artistic sense, and not in its misused photographic sense. How, then, is photography superior to etching, wood-cutting, charcoal drawing? The drawing of the lens is not to be equalled by any man; the tones of a correctly and suitably printed picture far surpass those of any other black and white process. An etching, in fact, has no tones, except those supplied by the printer. As I have said before, if it falls short anywhere, it is in the rendering of the relative values, but the perfection of the tone corrects this in a great measure. There is ample room for selection, judgment, and posing, and, in a word, in capable hands, a finished photograph is a work of Art. Again, it is evident that the translation of pictures by photogravure, for the same reasons given above, will be superior to that of any engraving. But we must not forget that nine-tenths of photographs are no more works of Art than the chromos, lithos, and bad paintings which adorn the numerous shops and galleries.

Thus we see that Art has at last found a scientific basis, and can be rationally discussed, and that the modern school is the school which has adopted this rational view; and I think I am right in saying that I was the first to base the claims of photography as a fine Art on these grounds, and I venture to predict that the day will come when photographs will be admitted to hang on the walls of the Royal Academy.

Reference was made in the earlier part of this paper to Greek statues, and it is now easy to understand why they have endured so long, and are the beau ideals of the artists to-day, as they were of the artists of Ancient Greece. The secret all lies in the fact that they were done from nature, from actual living models—Phidias and Praxiteles tried their utmost to express in an artistic way, in living marble, the human being before them. They succeeded, and these statues to-day are of more value than the monstrosities of the middle ages, and are unequalled by the moderns. In closing I would say, the modern school of painting and photography are at one; their aims are similar, their principles are rational, and they link one into the other; and will in time, I feel confident, walk hand in hand, the two survivals of the fittest.

Pictorial Photography

ALFRED STIEGLITZ
1899

One of the best essays Alfred Stieglitz (1864–1946) wrote on photography appeared in the November 1899 issue of Scribner's Magazine—*a periodical of general readership—and was illustrated with photographs from his one-man exhibition at the Camera Club of New York. The essay expresses his photographic philosophy at the time he was experimenting with the printing techniques so favored by the pictorialists—the gum-bichromate process and local development and metallic toning of platinotypes—processes he was soon to repudiate.*

About ten years ago the movement toward pictorial photography evolved itself out of the confusion in which photography had been born, and took a definite shape in which it could be pursued as such by those who loved art and sought some medium other than brush and pencil through which to give expression to their ideas. Before that time pictorial photography, as the term was then understood, was looked upon as the bastard of science and art, hampered and held back by the one, denied and ridiculed by the other. It must not be thought from this statement that no really artistic photographic work had been done, for that would be a misconception; but the point is that though some excellent pictures had been produced previously, there was no organized movement recognized as such.

Let me here call attention to one of the most universally popular mistakes that have to do with photography—that of classing supposedly excellent work as professional, and using the term amateur to convey the idea of immature productions and to excuse atrociously poor photographs. As a matter of fact nearly all the greatest work is being, and has always been done, by those who are following photography for the love of it, and not merely for financial reasons. As the name implies, an amateur is one who works for love; and viewed in this light the incorrectness of the popular classification is readily apparent.

Reprinted from *Scribner's Magazine* 26 (November 1899), pp. 528-37.

Pictures, even extremely poor ones, have invariably some measure of attraction. The savage knows no other way to perpetuate the history of his race; the most highly civilized has selected this method as being the most quickly and generally comprehensible. Owing, therefore, to the universal interest in pictures and the almost universal desire to produce them, the placing in the hands of the general public a means of making pictures with but little labor and requiring less knowledge has of necessity been followed by the production of millions of photographs. It is due to this fatal facility that photography as a picture-making medium has fallen into disrepute in so many quarters; and because there are few people who are not familiar with scores of inferior photographs the popular verdict finds all photographers professionals or "fiends."

Nothing could be farther from the truth than this, and in the photographic world to-day there are recognized but three classes of photographers—the ignorant, the purely technical, and the artistic. To the pursuit, the first bring nothing but what is not desirable; the second, a purely technical education obtained after years of study; and the third bring the feeling and inspiration of the artist, to which is added afterward the purely technical knowledge. This class devote the best part of their lives to the work, and it is only after an intimate acquaintance with them and their productions that the casual observer comes to realize the fact that the ability to make a truly artistic photograph is not acquired offhand, but is the result of an artistic instinct coupled with years of labor. It will help to a better understanding of this point to quote the language of a great authority on pictorial photography, one to whom it owes more than to any other man, Dr. P. H. Emerson. In his work, "Naturalistic Photography," he says: "Photography has been called an irresponsive medium. This is much the same as calling it a mechanical process. A great paradox which has been combated is the assumption that because photography is not 'hand-work,' as the public say—though we find there is very much 'hand-work' *and* head-work in it—therefore it is not an art language. This is

a fallacy born of thoughtlessness. The painter learns his technique in order to speak, and he considers painting a mental process. So with photography, speaking artistically of it, it is a very severe mental process, and taxes all the artist's energies even after he has mastered technique. The point is, *what you have to say and how to say it*. The originality of a work of art refers to the originality of the thing expressed and the way it is expressed, whether it be in poetry, photography, or painting. That one technique is more difficult than another to learn no one will deny; but the greatest thoughts have been expressed by means of the simplest technique, writing."

In the infancy of photography, as applied to the making of pictures, it was generally supposed that after the selection of the subjects, the posing, lighting, exposure, and development, every succeeding step was purely mechanical, requiring little or no thought. The result of this was the inevitable one of stamping on every picture thus produced the brand of mechanism, the crude stiffness and vulgarity of chromos, and other like productions.

Within the last few years, or since the more serious of the photographic workers began to realize the great possibilities of the medium in which they worked on the one hand, and its demands on the other, and brought to their labors a knowledge of art and its great principles, there has been a marked change in all this. Lens, camera, plate, developing-baths, printing process, and the like are used by them simply as tools for the elaboration of their ideas, and not as tyrants to enslave and dwarf them, as had been the case.

The statement that the photographic apparatus, lens, camera, plate, etc., are pliant tools and not mechanical tyrants, will even to-day come as a shock to many who have tacitly accepted the popular verdict to the contrary. It must be admitted that this verdict was based upon a great mass of the evidence—mechanical professional work. This evidence, however, was not of the best kind to support such a verdict. It unquestionably established that nine-tenths of the photographic work put before the public was purely mechanical; but to argue therefrom that all photographic work *must* therefore be mechanical was to argue from the premise to an inconsequent conclusion, a fact that a brief examination of some of the photographic processes will demonstrate beyond contradiction. Consider, for example, the question of the development of a plate. The accepted idea is that it is simply immersed in a developing solution, allowed to develop to a certain point, and fixed; and that, beyond a care that it be not overdeveloped or fogged, nothing further is required. This, however, is far from the truth. The photographer has his developing solutions, his restrainers, his forcing baths, and the like, and in order to turn out a plate whose tonal values will be relatively true he must resort to local development. This, of course, requires a knowledge of and feeling for the comprehensive and beautiful tonality of nature. As it has never been possible to establish a scientifically correct scale of values between the high lights and the deep shadows, the photographer, like the painter, has to depend upon his observation of and feeling for nature in the production of a picture. Therefore he develops one part of his negative, restrains another, forces a third, and so on; keeping all the while a proper relation between the different parts, in order that the whole may be harmonious in tone. This will illustrate the plastic nature of plate development. It will also show that the photographer must be familiar not only with the positive, but also with the negative value of tones. The turning out of prints likewise is a plastic and not a mechanical process. It is true that it can be made mechanical by the craftsman, just as the brush becomes a mechanical agent in the hands of the mere copyist who turns out hundreds of paint-covered canvases without being entitled to be ranked as an artist; but in proper hands print-making is essentially plastic in its nature.

An examination of either the platinum or the gum process, the two great printing media of the day, will at once demonstrate that what has already been asserted of the plate is even more true of these. Most of the really great work of the day is done in one or the other of these processes, because of the great facility they afford in this direction, a facility which students of the subject are beginning to realize is almost unlimited. In the former process, after the print has been made, it is developed locally, as was the plate. With the actual beauties of the original scene, and its tonal values ever before the mind's eye during the development, the print is so developed as to render all these as they impressed the maker of the print; and as no two people are ever impressed in quite the same way, no two interpretations will ever be alike. To this is due the fact that from their pictures it is as easy a matter to recognize the style of the leading workers in the photographic world as it is to recognize that of Rembrandt or Reynolds. In engraving, art stops when the engraver finishes his work, and from that time on the process becomes a mechanical one; and to change the results the plate must be altered. With the skilled photographer, on the contrary, a variety of interpretations may be given of a plate or negative without any alterations whatever in the negative, which may at any time be used for striking off a quantity of purely mechanical prints. The latest experiments with

the platinum process* have opened up an entirely new field—that of local brush development with different solutions, so as to produce colors and impart to the finished picture all the characteristics of a tinted wash-drawing. This process, which has not yet been perfected, has excited much interest, and bids fair to result in some very beautiful work. By the method of local treatment above referred to almost absolute control of tonality, atmosphere, and the like is given to the photographer, on whose knowledge and taste depends the picture's final artistic charm or inartistic offensiveness.

In the "gum-process," long ago discarded by old-time photographers as worthless, because not facile from the mechanical point of view, but revived of recent years, the artist has a medium that permits the production of any effect desired. These effects are invariably so "un-photographic" in the popular sense of that word as to be decried as illegitimate by those ignorant of the method of producing them. In this process the photographer prepares his own paper, using any kind of surface most suited to the result wanted, from the even-surfaced plate paper to rough drawing parchment; he is also at liberty to select the color in which he wishes to finish his picture, and can produce at will an india-ink, red-chalk, or any other color desired. The print having been made he moistens it, and with a spray of water or brush can thin-out, shade, or remove any portion of its surface. Besides this, by a system of recoating, printing-over, etc., he can combine almost any tone or color-effect. Two of the accompanying illustrations are from bichromate-of-gum prints, one in india-ink on buff paper, the other on rough drawing paper, also in india.

"Retouching," says Dr. Emerson, "is the process by which a good, bad, or indifferent photograph is converted into a bad drawing or painting." It was invariably inartistic, generally destructive of values, and always unphotographic, and has to-day almost disappeared.

With the appreciation of the plastic nature of the photographic processes came the improvement in the methods above described and the introduction of many others. With them the art-movement, as such, took a more definite shape, and, though yet in its infancy, gives promise of a robust maturity. The men who were responsible for all this were masters and at the same time innovators, and while they realized that, like the painter and the engraver their art had its limitations, they also appreciated what up to their time was not generally supposed to be the fact, that the accessories necessary for the production of a photograph admitted of the giving expression to individual and original ideas in an original and distinct manner, and that photographs could be realistic and impressionistic just as their maker was moved by one or the other influence.

A cursory review of the magazines and papers the world over that devote their energies and columns to art and its progress will convince the reader that to-day pictorial photography is established on a firm and artistic basis. In nearly every art-centre exhibitions of photographs are shown that have been judged by juries composed of artists and those familiar with the technique of photography, and passed upon as to their purely artistic merit; while in Munich, the art-centre of Germany, the "Secessionists," a body of artists comprising the most advanced and gifted men of their times, who (as the name indicates they have broken away from the narrow rules of custom and tradition) have admitted the claims of the pictorial photograph to be judged on its merits as a work of art independently, and without considering the fact that it has been produced through the medium of the camera. And that the art-loving public is rapidly coming to appreciate this is evidenced by the fact that there are many private art collections to-day that number among their pictures original photographs that have been purchased because of their real artistic merit. The significance of this will be the more marked when the prices paid for some of these pictures are considered, it being not an unusual thing to hear of a single photograph having been sold to some collector for upward of one hundred dollars. Of the permanent merit of these pictures posterity must be the judge, as is the case with every production in any branch of art designed to endure beyond the period of a generation.

The field open to pictorial photography is to-day practically unlimited. To the general public that acquires its knowledge of the scope and limitations of modern photography from professional show windows and photo-supply cases, the statement that the photographer of to-day enters practically nearly every field that the painter treads, barring that of color, will come as something of a revelation. Yet such is the case: portrait work, genre-studies, landscapes, and marine, these and a thousand other subjects occupy his attention. Every phase of light and atmosphere is studied from its artistic point of view, and as a result we have the beautiful night pictures, actually taken at the time depicted, storm scenes, approaching storms, marvellous sunset-skies, all of which are already familiar to magazine readers. And it is not sufficient that these pictures be true in their rendering of tonal-values of the place and hour they portray, but

*Platinum paper is made by sensitizing paper with platinum salts and iron salts. On exposure the ferric salts become ferrous salts; and in their presence platinum salts are reduced to metallic platinum upon development.

they must also be so as to the correctness of their composition. In order to produce them their maker must be quite as familiar with the laws of composition as is the landscape or portrait painter; a fact not generally understood. Metropolitan scenes, homely in themselves, have been presented in such a way as to impart to them a permanent value because of the poetic conception of the subject displayed in their rendering. In portraiture, retouching and the vulgar "shine" have been entirely done away with, and instead we have portraits that are strong with the characteristic traits of the sitter. In this department head-rests, artificial backgrounds, carved chairs, and the like are now to be found only in the workshops of the inartistic craftsman, that class of so-called portrait photographers whose sole claim to the artistic is the glaring sign hung without their shops bearing the legend, *"Artistic Photographs Made Within."* The attitude of the general public toward modern photography was never better illustrated than by the remark of an art student at a recent exhibition. The speaker had gone from "gum-print" to "platinum," and from landscape to genre-study, with evident and ever-increasing surprise; had noted that instead of being purely mechanical, the printing processes were distinctly individual, and that the negative never twice yielded the same sort of print; had seen how wonderfully true the tonal renderings, how strong the portraits, how free from the stiff, characterless countenance of the average professional work, and in a word how full of feeling and thought was every picture shown. Then came the words, *"But this is not photography!"* Was this true? No! For years the photographer has moved onward first by steps, and finally by strides and leaps, and, though the world knew but little of his work, advanced and improved till he has brought his art to its present state of perfection. This is the real photography, the photography of to-day; and that which the world is accustomed to regard as pictorial photography is not the real photography, but an ignorant imposition.

The Photo-Secession

ALFRED STIEGLITZ
1903

In 1903 Alfred Stieglitz, wearied by years of unsuccessful attempts to cajole the camera clubs of the United States to organize exhibitions of such high aesthetic standards that photography would be recognized as an art in America, took the fight upon his own shoulders. With the enthusiastic cooperation of friends, including Gertrude Käsebier, Clarence H. White, and Eduard J. Steichen, he founded an informal society that he named the Photo-Secession in remembrance of his years in Germany and Austria, where groups of artists breaking away from the academic establishment called themselves the "Sezession." Stieglitz contributed many articles about the aims and goals of the group to photographic magazines; however, the most succinct definition of the purpose of the Photo-Secession—and a clarion call to photographers everywhere—appeared in The Bausch & Lomb Lens Souvenir, *a brochure reproducing the prize-winning photographs of a 1903 competition held by the Bausch & Lomb Optical Company of Rochester, New York, for the best pictures taken with lenses of their manufacture. Stieglitz won the grand prize for* The Street—Winter, *which was reproduced in the brochure together with the accompanying statement.*

The progress of the ages has been rhythmic and not continuous, although always forward. In all phases of human activity the tendency of the masses has been invariably towards ultra conservatism. Progress has been accomplished only by reason of the fanatical enthusiasm of the revolutionist, whose extreme teaching has saved the mass from utter inertia. What is to-day accepted as conservative was yesterday denounced as revolutionary. It follows, then, that it is to the extremist that mankind largely owes its progression. In this country photography also has followed this law, and whatever have been the achievements which have won it exceptional distinction, they have been attained by the efforts of the enthusiastic so-called extremists. True, however, to this general law of development, these results have been achieved only through bitter strife, until those most deeply interested in the advancement of photography along the lines of art have been compelled to register their protest against the reactionary spirit of the masses. This protest, this secession from the spirit of the doctrinaire, of the compromiser, at length found its expression in the foundation of the Photo-Secession. Its aim is loosely to hold together those Americans devoted to pictorial photography in their endeavor to compel its recognition, not as the handmaiden of art, but as a distinctive medium of individual expression. The attitude of its members is one of rebellion against the insincere attitude of the unbeliever, of the Philistine, and largely of exhibition authorities. The Secessionist lays no claim to infallibility, nor does he pin his faith to any creed, but he demands the right to work out his own photographic salvation.

Reprinted from *The Bausch & Lomb Lens Souvenir* (Rochester, New York: Bausch & Lomb Optical Company, 1903).

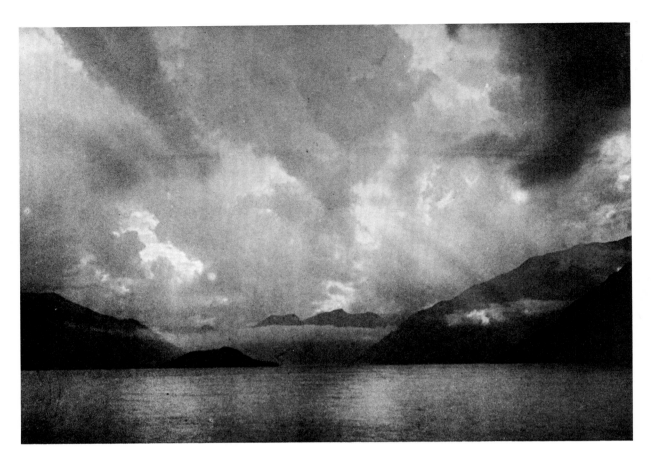

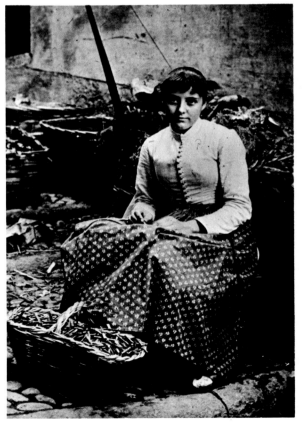

Above: ALFRED STIEGLITZ. *The Approaching Storm.* 1887.
Collotype.

This collotype appeared as the frontispiece to the magazine
Die Photographische Rundschau, vol. 3, no. 7 (1888). The
editor commented: "The author of this very interesting
photograph is well known as an excellent amateur. He has
informed us that for some time he intended to capture by
photography a gathering storm—a sight at once over-
powering and of great potential beauty. One afternoon in
August, 1887, he was sitting on the veranda of the place
where he was staying in Bellagio and admiring in a half-
doze the majesty of the beautiful lake. He did not notice
that the sky was darkening and black clouds were gather-
ing all around. A sudden clap of thunder woke him up. He
was astonished by the change in scenery, and at once de-
cided not to let the opportunity go by. He jumped up, got
his camera, and quickly made an exposure. He used an
azalin plate with an Aurantia yellow filter and exposed for
a minute and a half. The plate was developed in pyrogallol
and to his delight Mr. Stieglitz obtained exactly what he
wanted. Unfortunately the accompanying illustration does
not faithfully reproduce the splendor of the moment. All
the atmospheric effect is lost; the picture is neither as bril-
liant, nor as rich, as the original platinum print made
directly from the negative."

ALFRED STIEGLITZ. *Marina, Bellagio, 1887.* From the orig-
inal lantern slide. George Eastman House, Rochester, N.Y.

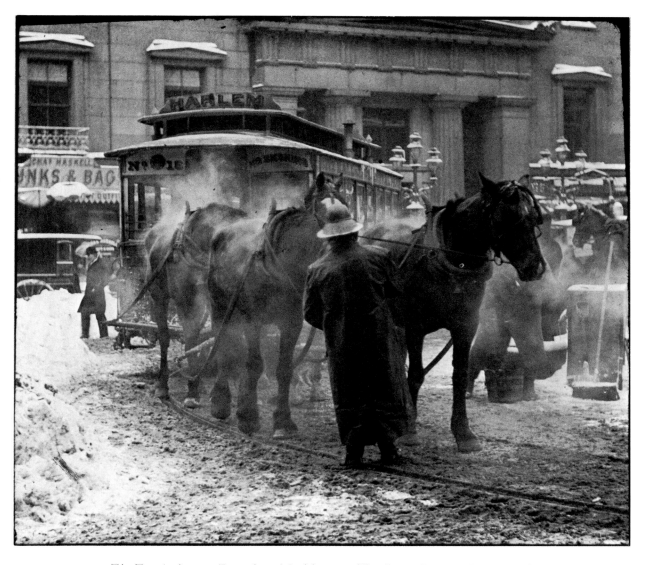

ALFRED STIEGLITZ. *The Terminal.* 1892. From the original lantern slide. George Eastman House, Rochester, N.Y.

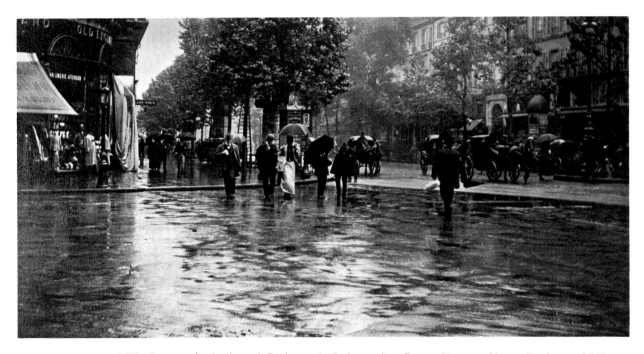

ALFRED STIEGLITZ. *A Wet Day on the Boulevard, Paris.* 1894. Carbon print. George Eastman House, Rochester, N.Y.

ALFRED STEIGLITZ. *Portrait of a Baby.* n.d. Platinotype, locally developed. Reproduced from *Camera Notes.*

EDWARD STEICHEN. *Self-Portrait with Brush and Palette.* 1901. Gum-bichromate print. Alfred Stieglitz Collection, The Art Institute of Chicago.

Eduard J. Steichen

ERNST JUHL
1902

The meteoric rise of Eduard J. Steichen (1879–1973), following the first European showing of his photographs in London and in Paris in 1900 is well documented by this article. Written by the German critic Ernst Juhl to accompany a portfolio of eleven high-quality reproductions, it was published in the periodical* Die Photographische Rundschau *(The Photographic Review), of which he was art editor.*

Juhl chose some of the most extreme examples of Steichen's gum-bichromate prints—a nonsilver photographic process that allowed such manual control in developing with a brush that the results were often confused with drawings or watercolors. To many these prints were not considered photographs.

The magazine in which Steichen's prints were reproduced was founded in 1887 as the official organ of the Club of Amateur Photographers of Vienna. Subsequently the periodical was published in Halle, Germany, and expanded to include news about, and the monthly minutes of, eleven photographic societies in Germany and Austria. The Rundschau *depended on their support for its very existence.*

Steichen's photographs and Juhl's article drew so much criticism from readers that the publisher was forced to take drastic action. In the September issue he explained: "Contrary to expectations, these photographs brought forth a storm of indignation from a number of societies. They threatened to leave the Rundschau *if in the future there was not a change in artistic direction. In order not to endanger the continuation of the* Rundschau *after it has flourished for so many years, Herr Juhl has resigned his position as of August 1."*

In "The Photographic Art Journal" there is an anonymous article about Steichen that will interest our readers. We present this introduction in a free translation.†

"In the development of any art there comes a time when the creative mind reasserts itself and attempts to

shake free from the fetters of the past. This dissent, this demand for artistic freedom, is always made by youth, and generally meets with the scornful and bitter opposition of age. At times there rises a great innovator and dissenter, who holds a following in his control, apparently by his personal force and expression.

"We in this country are aware of the events following the exhibition of an entirely new series of pictures by Mr. A. Horsley Hinton, and how a new word—Hintonesque—was coined and applied to photographic pictures, which had apparently been produced while under the influence of that 'school.' Mr. Robert Demachy points out in an article on 'Artistic Photography in France' (Photograms of the Year 1901) 'how a new and beneficial impulsion has been given to pictorial photography in France during the last year, from the exhibition of work by the "American School" of photographic art.'

"It is difficult to account for these schools. Admiration for the master's work may be a dominant feature, but the fact appears to be that the master produces in his pictures a new method of aesthetic pleasure which appeals personally, and finding a delight in them, his followers essay to produce the like, generally, however, they do not reach his standard, for the reason they have not that rare creative power possessed by the master. We have in these factors an intellectual evolutionary progress, produced by a new and external environment. The existence of these 'schools' is probably due to another source—our susceptibility to motive—or in other words, the development and organization of impulse. Individual genius of some kind has always been present, and is always essential in progress. So that no advance is possible without some individual leader, who may assert himself; and genius being the sole law-giver in art, to men of this class belong the distinction of being the leaders.

"Progress in one direction of photographic art at the

*Steichen later changed the spelling of his first name to Edward and dropped the middle initial.
† This quotation appeared in *The Photographic Art Journal* (London), April 15, 1903, pp. 25-29. We have transcribed from the original article rather than retranslating it.

Translated by Beaumont Newhall from *Die Photographische Rundschau* 16 (July 1902), pp. 127-29.

EDWARD STEICHEN. *The Black Vase*. 1901. The Metropolitan Museum of Art, New York.

"'The Black Vase' is one of those queer things that are nothing and mean nothing, but to which it is, nevertheless, impossible to deny a large measure of artistic feeling. It may even lay some claim to poetry if the beholder is sufficiently impressionable. But why it should be called 'The Black Vase' rather than, more obviously, the white window or the stretched neck, does not appear."—*Photography* (London), October 3, 1901.

present time is generally agreed to be due to the leaders of the 'American School.'

"That this should be so seems repellent to the conservative mind, but to the dissenter it is in conformity with the great law of evolution. There are always two vast fundamental forces at work; one forever presses forward new forms and new ideas, and the other forever moulds, conserves, adapts, reproduces. We have also in

another sense epochs of conservation and epochs of expansion, progress being the resultant of all these active forces.

"It has been pointed out that genius is mainly an affair of energy, and art being a form of energy, a nation whose spirit is characterised by energy, may well be eminent in some form of art. This may partly explain the rise of the 'American School' in one domain of artistic photog-

EDWARD STEICHEN. *Portrait of Frits Thaulow*. ca. 1901. Gum-bichromate print. Reproduced from *Die Photographische Rundschau,* July 1902.

"We now come to the works of E. J. Steichen, the first of which is a 'Portrait of Frits Thaulow,' the deservedly celebrated Norwegian landscape painter. What a thousand pities that it is not a portrait in the ordinary sense of the word, instead of this irritating trifle that reminds one of Tenniel's illustration of the smile of the Cheshire cat. Mr. Steichen has a perfect right to play about with his prints as he likes, but we doubt whether it is not something of an impertinence to his public to put forward such kill-time trivialities as portraits of important men in whom much eager interest is felt."—*Photography,* October 3, 1901.

raphy. While there can be no doubt of the position of England as regards landscape photography, the new epoch of expansion in photographic portraiture and figure studies comes from the great Western Hemisphere, and what that exercise of energy, which is the life of genius, demands and insists upon, is a sense of freedom and independence of all authority and routine, and the fullest room for expansion at will.

"All this is well exemplified in the portrait pictures of eminent French personages by Eduard J. Steichen. In these we have an effort to realise new ideals, and as an experiment with new methods of portrayal. That they are a painter-artist's expressions of ideals adapted to photography is at once apparent, and, like their portraits in other mediums, they are full of personal character."

Robert Demachy says, in the May number of the Bulletin du Photo-Club de Paris:

"Steichen, who resembles nobody else, continues to embitter part of the public. I heard it said, in front of one of his 'Studies,' that if it had been a charcoal drawing, then it would have been a good picture, but since it was a photograph it was detestable. This critic summarized for me the methods of attack and argument of the opponents of photography as an art. In other words: what is artistic in painting is not in photography. I will try not to quarrel with that. My whole and sincere admiration of Steichen's work does not depend upon the type of photographic process. It may be that his portrait of Rodin resembles an albumen print that has been reduced by chemical means, in which

case I am amazed at the artistic expression given by such an over-fixed print. That may seem unusual to the apprentice of a small town photographer, but to me the painstaking examination of a piece of paper is not the right way to measure art."

When modern pictorial photography was introduced to Germany six years ago by the three well-known friends, Kühn, Henneberg and Watzek, hardly anybody would have thought that yet another wholly new style of photography would arise. Some three years ago we were prepared for the surprise from America in the work of Mrs. Käsebier, Clarence White and others who forced the photographic print to hitherto unknown expression. They were prints which—except for the large gum prints made expressly for the wall—were created for the collector's portfolio, to be held in the hand while looking at them.

Part of Steichen's work has the complete charm of mezzotint engravings. The most extraordinary examples are to be found in his self-portrait and in the "Rodin." Steichen, who at the moment is hanging an exhibition of his work in the Maison de Artistes in Paris, calls these prints that owe so much to skill of hand, "Light Pictures." The portraits of Thaulow, Chase and "The Sketch" are further examples of this manner, while the portraits of Lenbach, Mucha, the Black Vase, Narcissus, Solitude and "The Rose" are examples of pure photography.

The beauty of Steichen's work will not be recognized by everybody, as is often the lot of the beautiful. I must admit that I can only make an attempt at explaining his art. To those who do not feel the magic of this unique work, words are of little use, and he who bars the way to the perception of it by all kinds of negative criticism will miss great enjoyment.

Steichen is only 23 years old, and he began his career as draftsman for a lithographic firm when he was only 15 years old in Milwaukee, where his parents emigrated from Luxembourg in their youth. At first he took up photography as a pastime, but soon began to apply to it his artistic urge. Until settling in Paris, beginning in 1900, Steichen did not have the opportunity to see art or any pictorial photography. He had no academic schooling in painting, but worked at it alone for two years. That was probably just as well, for he might have been turned aside from his own path if he had followed the example of others.

I have before me a few photographic reproductions of some of the forty oil paintings that are currently in his Paris exhibition along with his pictorial photographs. Unfortunately they are not suitable for reproduction.

If a better print can be made of the photograph of Steichen's portrait of Beethoven, which Steichen has just finished, we will print a reproduction of it in one of the next issues of this magazine.

His oil paintings are very similar to the photographs here reproduced. I believe in Steichen's future as a painter, even though I naturally can form no judgment about his color sense until I have seen his pictures in the original.

As a pictorial photographer he already stands at the summit. He is a pathfinder.

Frederick H. Evans on Pure Photography

1900

Frederick H. Evans (1853–1943) specialized in photographing architecture, particularly the medieval cathedrals of England and France. In this address, given at the opening of his exhibition at the Royal Photographic Society in London on April 25, 1900, Evans describes his aesthetic goals and his working methods. In an age when many photographers were printing by the gum-bichromate process, Evans held firmly to the belief that such manipulation was a denial of photographic quality and insisted on printing his negatives on platinum paper without the intervention of retouching or other handwork.

MR. FREDERICK H. EVANS
House Exhibitions

On Wednesday, April 25th, 1900, Mr. Chapman Jones, F.I.C., F.C.S., Vice-President, in the Chair, an exhibition of photographs, mainly architectural, the work of Mr. Frederick H. Evans, and numbering some 150 examples, was opened by him in the Society's rooms. Mr. Evans delivered the following

OPENING ADDRESS

MR. PRESIDENT, Ladies, and Gentlemen,—I feel very sensible of the honour your Society does me in thus opening up an opportunity of showing you what my best work has been, and I can only hope that your inspection of the walls will justify you in your flattering invitation.

It has been extremely interesting to myself, getting these prints together, and has proved very helpful and encouraging, as I have "bulked" up better than I expected; it is a severe test to any worker thus to see so many of his productions together; to be put to the experience of having an average of his work collected and exposed to the critical gaze of such a Society as this. But it is a healthy experience, as it reveals so fully what man-

Reprinted from *The Photographic Journal* 59 (April 30, 1900), pp. 236-41.

nerisms one may have succumbed to, and shows in what directions one's best work has been done, and thus suggests new ways of working for the future.

As regards my architectural work, which forms the larger part of this collection, I ought to say that the historical or merely architectural value of my subjects has always been of secondary interest to me; it is the beautiful rather than the antiquarian aspect that attracts me; and though, of course, all such attempts fall infinitely short of the beauty of the originals, yet I often wonder at the great truth and beauty which can form a photographic record of a fine piece of architecture, and that too from the point of view of "a work of art," much as a photograph's right to be so considered has been disputed.

Photography, in its art expression, may, I think, have almost its greatest value and success in architectural subjects. The restrictions and limitations seem less stringent, and the conditions more lenient, than in landscape or figure work; colour also is not so impossible an element, and it is altogether a more easily truthful field than most for the employment of photography to art ends, considering how severe are the limitations photography is conditioned by. In an artist's hands, photography is capable of quite satisfactorily dealing with the good drawing, good composition, proper management of light and shade that architecture demands; and at the same time is able to place on record far finer and more abundant detail than is possible to the draughtsman, and that without sacrificing any of the breadth of statement which must ever characterise the true artist's work; all subjects are not possible of course, walls will come in the way of one's tripod, but all subjects that *are* possible can be as adequately dealt with as by any other means of recording them.

The so-called mechanical exactitude of the camera should also make its work valuable in an historical sense, as for instance the rendering of stone surfaces when recording detail for detail's sake; soft rich detail suggesting the actual surface is easily possible without any undue shouting of hard minute detail; it is *not* a mechanical

177

FREDERICK H. EVANS. *Lincoln Cathedral: A Turret Stairway.* 1895. Photogravure. The Museum of Modern Art, New York.

matter of course, as any error in lighting, or exposure, or after treatment, would mean a false rendering; cast shadows from bright sunlight may, for instance, quite easily convey a perfectly wrong and misleading impression in detail or drawing. But with true work, how instructive for posterity would be a record both "before and after" the restoration fiend has done his destructive work! Think, if we only had good photographs of our wonderful cathedrals and churches when they were newly built, or before the marvellous ornamentation we can now only guess at, was destroyed?

If we valued our great architecture as we ought, we should not only have photographic records to scale, of all the important details, etc., but we should also have every aspect of our great buildings, in general and in particular, from the point of view of beauty; so that the present appearance, in the best conditions of lighting, might be on record for both our current delight, and the inestimable joy of our descendants, when these architectural treasures are gone for ever. Without such records, it will be impossible for succeeding generations to form any proper idea of the wonders they find our literature so full of references to. Of course, the art record by draughtsman and painter and etcher is very rich and full, but I would plead for photography in addition to these, for the greater truth and the greater amount of truth it can convey, when properly handled.

A fond and foolish dream of mine for many years has been, that such an enterprise might some day be put on an official basis; no amateur, at the mercy of red tape restrictions in cathedrals, etc., can attempt the work in any hope of all-round success; but a Government official, with an adequate staff, and with the right to enter any public building for the careful and respectful photographing of anything in it, could make such a series of pictures as would be a priceless boon to posterity. Of course, the present reply would be that of Sir Boyle Roche, "Why should we trouble about posterity; what has posterity done for us?"

Moreover, if such a Government department ever became possible, it would supply every building photographed with its own set of copies, so that visitors could inspect them on the spot and study inaccessible detail, and compare parts, etc., in a way now quite impossible. All such photographs would have a registered number and be obtainable at a nominal cost from the Government department, so that students would be enormously aided in every direction of study. The National Photographic Record Association would still have an almost impossibly large field of work, in gathering up photographs of current events, local history being thus made in an absolutely invaluable way for the future historian.

Though I have done but little on the antiquarian side, my own special sort of work may I think have its own value, its own little niche; for it is not everyone who has the time to see a building in all its phases of beauty and effect, or has the power of isolating those beauties, and so realising the more subtle and recondite charms a great building has, but gives up only to patient study and trained observation; and I am hoping, in my vanity, that there are some things on these walls, inadequate as they are, that will be fresh to many observers, and be of some use as suggestions in effects of light and shade, unwanted points of view and efforts at composition, and perhaps somewhat uncommon care in exposure and printing.

All the prints here are in platinotype, and though they vary greatly in colour and quality of tone, they have all been made by the ordinary methods of development, with no abnormal additions to the baths. The varying quality of tone and colour is of course due to varying qualities of negatives, but some is certainly due to the varying conditions of the paper, in age, etc. The differences in the negatives are from the nature of the subjects and the exposures they have demanded, not from differing methods of development, all being by the ordinary pyro-ammonia. I like to think that the varying quality arises from my endeavour to be truthful and respectful to my originals, and so far as my memory will bear me out, they certainly do recall to me, with a fair share of truth, the character of the subject at the time I took it.

My chief aim has always been to try for such effects of light and shade as will give the irresistible feeling that one *is* in an interior, and that it is full of light and space. Realism in the sense of true atmosphere, a feeling of space, truth of lighting, solidity and perfection of perspective (in the eye's habit of seeing it), has been my ambitious aim; and to say that I have not achieved it, but only hinted at it, would be praise enough, considering the really great difficulties in the way of a full achievement, and how few examples of such even the great "art world" can point to.

I have not been courageous enough as yet to try anything (if there is anything) beyond platinotype, for which printing process I am sure my own gratitude must ever remain quite inexpressible; apart from it, photography as *my* art expression would never have satisfied me. I have not worked carbon, and the new gum print is, I am afraid, beyond me. I am more interested in this stage of my experiments, in making plain, simple, straightforward photography, render, at its best and easiest, the effects of light and shade that so fascinate me. I deprecate indeed any but the trained artist playing about with these new and wonderful printing methods; I think that anyone who, like myself, is unable to draw, sketch, or

FREDERICK H. EVANS. *Kelmscott Manor: Attics.* 1896. Platinotype. The Museum of Modern Art, New York.

"Mr. Fredk. H. Evans' Attic, *Kelmscott Manor* is typical of work of uncommon delicacy and range of subject. The technical difficulties to be overcome in giving a satisfactory realisation of an apparently simple theme such as the one chosen here will be appreciated by the expert. The result shows the measure of success attained, and it is characteristic of a series of great interest to those who admire the home which William Morris endowed with the fruits of his incomparable taste."—*Photograms of the Year 1900.*

paint, is more likely to go wrong than right in the enormously free printing-development powers the gum process gives; without the proper and special training of hand and eye the artist has to go through so laboriously, one is all but certain to perpetuate things by this gum print process that will only make the "art world" laugh us to scorn over. Moreover, I do not enjoy such direct imitations of other methods as most gum work degenerates into. Personally I detest conundrums, and it does not seem worth while to have to wonder if an exhibit is a bad photograph or a worse chalk drawing. I am, it is true, often told that my own things are more like pencil or chalk or wash drawings, that they are not like photographs; but that, I take it, simply means that the mechanical character, the sense of the camera having done it, not the man behind it, is absent; that the art suggestion, the beauty of the origi-

nal, is the main impression, and that I think is the best compliment a photographer need aspire to.

My prints are all from untouched, undodged negatives, with no treatment of the print except ordinary spotting out of technical defects, or the occasional lowering of an obtrusive high light. Whenever I work on the back of a negative, to make up for errors or deficiencies in exposure or development, I find it very difficult, all but impossible, to avoid upsetting the natural gradations of the subject; false lighting gets introduced too easily. I am sure too much time is spent in trying to make bad negatives yield good prints, and they will not. Plain prints from plain negatives is, I take it, pure photography, and as I am not an artist in the sense of being able to use pencils or brushes, however badly, I have to be content with this; and the little successes I have occa-

180

sionally been cheered by, encourage me to think that it is not such a bad road to travel by towards the great goal of art.

The negative is the all-important element; for by it we seek to record some effect of nature, and according to our success in the light-action we get on our plate, so is our print from it valuable or the reverse. Photography is one of the finest of methods for rendering atmosphere and light and shade in all the subtleties of nature's gradations, and for this we need an approximately perfect negative and that perfectly printed from. But in the gum process the negative, at least in some hands, seems the least important element, as such so-called control can be exercised in the printing development. But this is surely a fatal step from any reliance on pure photography as a medium for the expression of artistic natural truth.

This apologia for pure photography (which I advocate, I suppose, because I find it easiest) need not be taken as implying any contemptuous feeling for any really fine or true work done by the gum process; there have been many prints exhibited of work by it that could only be reckoned as the finest possible rendering, though it would be interesting to have compared perfect platinotype prints side by side with them. Art is art however produced, and the means are always secondary to the end. It is the bad imitation of bad chalk or pencil drawings that arouses my ire and opposition; but this, as usual, merely comes to saying that bad work is hateful, and should not get a chance of being shown on exhibition walls, even though it be called a "gum print."

It is of course easy to argue also on the side of this elaborate dodging in printing and development, that all means are legitimate when successful, and that nothing succeeds like success—as, for instance: an exposure is made on a subject that has elements that an artist painting it would suppress as superfluous or antagonistic to the main subject or impression; the painter or draughtsman suppresses them by simply omitting them; the photographer suppresses them, more or less successfully, by adopting a printing process that will enable him to develop up only the portions he desires, a process giving him a control more akin to that of the etching printer; but this means that the work has so largely depended on art instincts seconded by skilled trained fingers, that the finished work seems less a photograph in the accepted sense than a definite art production.

This, in turn may seem to make my plain pure photograph of less art value and of a more mechanical character, seeing that it is but a plain print from a plain negative, which anyone could make who had mastered the easy details of platinum printing. But it is hardly so, for the whole success of this as art, whatever printing proc-

FREDERICK H. EVANS. *Height and Light in Bourges Cathedral.* ca. 1901. Platinum print. Reproduced from *Camera Work,* no. 4 (October 1903).

Taken with a hand camera for plates 3¼ inches square, printed by contact and cropped. Evans was pleased that he could retain quality in such a small picture. He wrote Alfred Stieglitz on June 25, 1903: "I sent the tiny Bourges one to Henry James and he said of it, when acknowledging it, 'It is indeed a splendid thing, as fine yet as condensed, as if it were a kind of philosophic sonnet on the subject.'"

ess be adopted, depends on the quality of the negative, on the conditions under which the subject was taken, and that is where the artist reigns supreme; *his* work is there, behind the camera; any radical error there can never be atoned for, no after treatment will make it "come out right," and no printing control will make it appear to have been the right instead of the wrong thing to have done. And if the conditions under which the exposure is made be correct and at their best, and the exposure itself be adequate, the platinotype print or the carbon print or the gum-bichromate print will be equally good, though varied in colour perhaps.

Certainly in architecture I should deprecate, and most strongly, this freedom in control and dodging and altering; it leads one away from the essential value of pure photography, its convincing power and suggestion of actuality; one feels in looking at drawings and engravings and etchings of architectural subjects, that the original was too often but a text to the artist to discourse from, that vital truth to the original is not a first characteristic; one would like a fine photograph to be hung beside such a

drawing (as fine in its way as the drawing or painting is in its way), for the sake of the actual truth it would suggest and convey. Our cathedrals are rich enough in broad and subtle effects of light and shade, atmosphere, grandeur of line and mass, to be content with pure photography at its best; nothing need be added from the artist's inner consciousness to make it more impressive or beautiful.

Recognizing my ignorance of and I am afraid my inability to work the gum process, I was much comforted lately by this sentence in an editorial of a prominent photographic paper:—"Some of those whose gum prints compare favourably with platinotype, even in the matters of detail and gradation, might, etc., etc." This confirmed me in my perhaps lazy resolution to remain constant to the proved charms of Mdlle. Platinotype, rather than to flee to the "uncertain, coy, and hard to please" and most villainously named, Miss Gum Print.

To myself, the greatest charm of photography is the happy way in which it will render the feeling of light, the sense of space, and of atmosphere, the beauties of opposing lights and darks. Photographs that seem taken by "the light that never was on land or sea," do not interest me: they do not, as they first should, suggest nature and the natural light of day; and surely this latter is easy enough of rendering without concocting a light (or its absence) that can only claim the paternity of that much abused word, artistic.

My special study and enjoyment of black and white, had, I am sometimes told, blunted my full appreciation of landscape colour in paintings, i.e., it affects me less pleasurably than pure, good black and white; unless (and here perhaps is the good the study of black and white does one) the colour-scheme is rich in the same values and contrasts and gradations it would have were it attempted in black and white. The work and study of photography helps one by compelling one to analyse and criticise a colour-scheme as one would a black and white. It is for these reasons that I would urge young photographers to the more intimate study of black and white art. Though monochrome is, at present, our only medium of expression, it is surprising how little actual, instinctive feeling for, or sense of, values and qualities in black and white the average photographer has. No opportunity should be lost of studying the great masters in this direction, analysing each drawing that gives enjoyment and satisfaction, till one knows *why* one enjoys it; an instinctive training is thus gained that is of incalculable value in one's work. Only such study will help to the acquiring of that "instantaneous process" of seeing when a subject is at its best lighting, or is capable of adequate translation into monochrome. Without such study failures and dis-

appointments are certain; and what is worse, the worker has no sense of why they come about; he only wonders why his exposure went wrong, and either blames his exposure meter, or the plate maker, or the last new developer he has tried.

I have ventured to include a few landscape attempts, albeit of the most modest dimensions, but as I do not feel mere size to be an art criterion I am not much abashed at the small size of these things. I have to confess that so far my attempts at enlargements have not proved equal to the effects I get from the original negative; and I do not think that mere increase in size is a proportionate gain, if one cannot at least keep the effect and quality of the original small print.

Those prints that possess clouds are also plain prints from undodged negatives, the clouds being on the same negative (mostly obtained by the Burchett colour-screen) * and done in one printing. If there were no clouds at the time I have accepted nature's verdict, for I cannot bring myself to believe in the possible success or legitimacy of using cloud-forms taken at some other time or in some other place; it is a wrong principle, surely, and can only be successful by the luckiest of accidents. When clouds are printed from the same negative and properly printed for balance of tone, they give one I think the feeling of being an integral part of the picture; one feels convinced by it as a whole as well as in its parts; and this is, I think, never present in the case of printed-in clouds of a different origin. It seems to me that the only form of double-printing that can be successful artistically, is that from a second negative taken in as quick succession as possible after (or before) the landcape portion, on a second plate, each being developed in the same manner. But I am hoping great things from the new quick screens introduced by Mr. Cadett, the entire range of tonal values seems much more likely to be successfully registered than by any other method.

It is, I think, from the use of alien cloud forms and bad working on backs of negatives, that one finds so many exhibited photographs so uninteresting: they are so incoherent, so contradictory, and instead of at once charming and convincing the beholder, they puzzle and worry one, and finally leave the critic uninterested and dissatisfied, and of course blaming photography for its shortcomings and lack of art value.

I do not want to venture among those quicksands, the endless discussions as to whether photography can be

*Colour-screens: in American parlance color filters placed in front of the lens to modify the light rays forming the image. A yellow filter absorbs blue rays: the resulting black-and-white print shows a dark sky.

FREDERICK H. EVANS. *Sunlight and Shadow, Mont St. Michel.* 1906. Platinotype, Royal Photographic Society, Bath, England.

considered in any degree art or fine art; but I would like just to hint that perhaps a more useful and a humbler way of looking at it would be as to why it should not be considered worthy a place among the crafts. A clever artistic photographer has a full claim I think to the cognomen, craftsman. The great difficulty I have is in getting handworkers in any art to allow that I have any right to say or think that photography can be a means of expression. It is of course a very complete means of recording or copying, but of a personal art *expression* (which at times amounts to creative effort) they will hear nothing. They say that even though it may not always be done,

yet it would be possible for six men to be sent to the same spot and to bring back the same camera record. This I deny. I contend there is as much individuality exercised in photographic as in any other work; those who oppose this could of course easily prove it for themselves by experimenting with a camera and half-a-dozen lenses, but this they will not do, and so the discussion gets limited to intelligent assertion on my part and ignorant assertion on theirs, and there is nothing so impossible or hopeless to combat as wilful ignorance. I have often tried to repeat certain negatives, but have invariably failed, most so of course in out-of-door work: but even in interiors I think I might challenge any one to go to any of my subjects on these walls and bring away an exact replica, in print as well as negative of course: he may easily do better (or worse), but to repeat it with the so-called mechanical accuracy of the box with a glass in it is, I say, impossible, and if this does not mean individuality it means nothing, and individuality is the basis of all art.

It is a subject one must not enlarge upon here and now, but in defence of it I may perhaps quote a line—if you will allow me to have the courage of my egotism— from the most appreciative notice I have yet had, when three years ago I sent 120 architectural things to Boston, U.S.A., to an architectural club, by invitation of my friends there:—"This photographer seems to apply not only the rules of the artist but those of the writer to his compositions, for each is a distinct character study. It is unusual to find this clearly defined individuality in photographs, and especially in those which have any value as truthful representations of architectural subjects. Some effects are almost creative: they approach that forbidden altitude as nearly as anything the lens has yet brought forth."

I quote this merely because it was refreshing to find a stranger enter so wholly into what one had tried to do: it is the aim that is worthy the praise, the performance, of course, hardly ever comes up to what it might, could, would, or should be. I only wish some of our critics on this side would exercise the same patient thought and vision, instead of being content with such short-sighted generalisations as this which recently graced the pages of the *Daily Chronicle*: "Landscapes, by men who looked at nature with the eyes of the poet and not of the photographer." They would then help photography and earnest photographic workers to enter into, and aid in the spread of a more general art-appreciation sense: painters and all artists indeed, have much to learn and grow up to, equally with the contemned photographer. I think the annual spring exhibition at Burlington House can show quite as many dreadful things as any autumn exhibition of the Royal Photographic Society. For one, I sometimes rejoice that I cannot paint, for fear the magic of handling colour should ever have made me be content with and accept some of the things one sees so cheerfully hung there.

A word as to the portraits I have ventured to hang here: all are by the Dallmeyer-Bergheim lens, except four of the smaller ones, which were done by a single landscape lens of large aperture. The quality of the image given by the Dallmeyer-Bergheim lens,* when at its best focus, pleases my eye extremely, for its beautiful sense of modelling. There are no sharp lines anywhere and yet no sense of fuzziness: at close vision the image is of course distinctly unsatisfactory as regards pure definition: but at a proper distance there comes a delightfully real, living sense of modelling that is quite surprising, and most grateful and acceptable to the eye. It has a painty effect (if I may be allowed the expression), a modelled line, that is not approached by the work of any other lens within my acquaintance. Of course the proper standard for a portrait study, especially from whole-plate size upwards, is, will it hang up well, as a painting should; and this is just where the work of the D.-B. lens excels, I think. Its difficulty in use and its slowness of speed will, of course, always prohibit it for general commercial use, but for the artistic worker it is an all but indispensable instrument.

But now, to conclude this essay in the obvious, permit me to say, that even were I an artist in the accepted sense of the word, and making "art" my profession, I would rather be the producer of a good photograph than of a poor or indifferent painting or drawing; and I hope I shall never come to say, in parody of the proverb, "I cannot draw or paint, and to photograph I am ashamed."

As an interesting comparison I have hung four of my things reproduced by the Swan Electric Engraving Company, in their finest photogravure: if the Council feel that these are worthy of a place in the general collection of this Society, I shall have much pleasure in leaving these four frames for their acceptance.

A vote of thanks to Mr. Evans was carried unanimously.

*A "soft-focus" lens, consisting of two elements, uncorrected for both spherical and chromatic aberration, thus producing a slightly diffused image. Manufactured by T. R. Dallmeyer of London in 1895 at the suggestion of John S. Bergheim, a pictorial photographer.

A Plea for Straight Photography

SADAKICHI HARTMANN
1904

To the Japanese-born, German-educated American art critic Sadakichi Hartmann (1867–1944), the marriage of photography and painting was incompatible. What to Stieglitz seemed the very proof of photography's position as an art—that such a gifted artist as Steichen showed proficiency in both mediums—to Hartmann was confusion. He expressed his concern in a parody of Hamlet's soliloquy, which opens:

> *To paint or to photograph—*
> *That is the question:*
> *Whether 'tis more to my advantage*
> *to color*
> *Photographic accidents and call*
> *them paintings,*
> *Or squeeze the bulb against*
> *a sea of critics*
> *And by exposure kill them?**

In a more serious vein, Hartmann also addressed photographers directly, urging them to respect the physical characteristics of the medium. This article heralds a reaction to the manipulated photograph that was to grow in strength over the next decade. He objects to any handwork upon negative or print that interferes with the photographic image to such an extent that the result no longer resembles a photograph. His concern echoes the functional aesthetic that was emerging in many other artistic media.

The exhibition of the Photo-Secession, which opened on Saturday, February 6, at the Art Galleries of the Carnegie Institute, Pittsburgh, affords a most unique opportunity of comparing the styles and methods of applying photography to artistic ends. It consists of about three hundred prints, contributed by fifty-four exhibitors.

The average merit of this collection is distinctly in advance of all its predecessors. It has eclipsed the Chicago

and Philadelphia Salons of 1898-1901, the exhibition at the National Arts Club, New York, in 1902, and the recent Photo-Secession show at the Corcoran Art Gallery, Washington, not only in number but also in excellence of workmanship, and may be safely described as the most interesting and most representative exhibition of pictorial photography which has ever been held. The jury consisted of Messrs. Alfred Stieglitz, Joseph T. Keiley and Eduard J. Steichen, who also supervised the hanging.

As was to be expected of an exhibition, selected and arranged by three pictorial extremists, who lay more stress on "individual expression" than on any other quality, the majority of pictures showed a certain sameness in quality and idea, as well as in the character of the mounting and framing. And yet, at least three-fourths of the exhibits gave evidence of personal artistic intention, and clearly and unmistakably reflected the taste, the preferences, and the imagination of the individual maker.

It is only a general tendency towards the mysterious and bizarre which these workers have in common; they like to suppress all outlines and details and lose them in delicate shadows, so that their meaning and intention become hard to discover. They not only make use of every appliance and process known to the photographer's art, but without the slightest hesitation, as Steichen in his "Moonrise" and "The Portrait of a Young Man," and Frank Eugene in his "Song of the Lily," overstep all legitimate boundaries and deliberately mix up photography with the technical devices of painting and the graphic arts. Both men are guilty of having painted, more than once, entire backgrounds into their pictures. Steichen's highlights are nearly all put in artificially, and Eugene invariably daubs paint and etches on his negatives to realize artistic shadows. There is hardly an exhibitor, photo-secessionist or not, who does not practice the trickeries of elimination, generalization, accentuation or augmentation, and many of them, who have not the faintest idea of drawing or painting, do it in a very awkward and amateurish way. But the striving after picture-like qualities and effects is the order of the day, and throughout the pictures hung—although practically noth-

Reprinted from *American Amateur Photographer* 16 (March 1904), pp. 101-109.

**Camera Work* 6 (April 1904), p. 25.

ing wantonly eccentric or repellent in its artificiality had been admitted—there was hardly one which was not influenced by the prevailing clamor for high art. Even in their titles they try to carry out this idea. Why, for instance, did Yarnall Abbott call his nude with a background of trees (almost commonplace in treatment) "Waldweben?" What has a meaningless pictorial fragment to do with Wagner's realistic tone-picture? Are such proceedings not slightly misleading and somewhat pretentious?

And yet nobody can deny that their work, as a whole, is the outcome or intelligent and consistent effort. Grace and subtlety and a fair share of imagination it possesses without doubt, and its exponents put so much enthusiasm into their work that its very earnestness compels respect, even if it does not always command admiration. But the question (or rather the problem) is whether such pictorial work still belongs to the domain of photography. Are those people not doing injustice to a beautiful method of graphic expression, and at times debasing its powers, which sixty years of photographic research and progress have established?

This is very difficult to answer. It depends entirely on circumstances and on the spirit in which one approaches such as a picture. Should I for instance visit a rich man's art gallery and somewhere on the walls run across Steichen's "Lenbach" in which a number of lines have been etched, several high lights accentuated and half tones painted in by brush, or "A Charcoal Effect" by Mary Devens, it would probably affect me with a special and unique expression of pleasure, and I would care little and very likely not even notice whether it were a monotype, a charcoal drawing, an etching or a photographic print. But when I go into an exhibition of photographs and encounter the very same prints, the situation is changed. I at once ask myself: What sort of photography is it? How is it made? Why does this part look like a hand painted monotype, and that one like an etching or a charcoal drawing? Is it still photography, or is it merely an imitation of something else? And if it is the latter, what is its aesthetic value?

Surely every medium of artistic expression has its limitations. We expect an etching to look like an etching, and a lithograph to look like a lithograph, why then should not a photographic print look like a photographic print? Etching, true enough, is capable of imitating other arts, and a clever etcher might produce an etching which is like an engraving, and another which is like a mezzotint, and a third which is almost like a black and white wash drawing. But if we saw nothing else but the imitations—and we rarely see them and never by master etchers like Jacque, Appian, Veyresset, Meryon and Whistler

186

—we might be inclined to say, "Well, this is really very wonderful, but now suppose the etcher would imitate an etching!" As the etching needle is the great expressional instrument for sketchy line work, so legitimate photographic methods are the great expressional instrument for a straightforward depiction of the pictorial beauties of life and nature, and to abandon its superiorities in order to aim at the technical qualities of other arts is unwise, because the loss is surely greater than the gain.

By "a straightforward depiction of the pictorial beauties of life and nature" I mean work like Stieglitz's "Scurrying Homewards," "Winter on Fifth Avenue," "The Net Mender," etc., or his recent "The Hand of Man." "They also have been manipulated," the Photo-Secessionists will argue. Yes, I know he has eliminated several logs of wood that were lying near the sidewalk when he took the snapshot of his "Winter on Fifth Avenue," took out a rope that disturbed the foreground in his "Scurrying Homewards," lightened the sky in "The Net Mender," and darkened the rails in "The Hand of Man." Why not? Surely that is permissible, as it is really nothing but the old-fashioned retouching. If "dodging" is wrong, then also Eickemeyer, and nearly all pictorial photographers, have to be condemned. "But if you allow elimination, why do you object to accentuation, do not all retouchers accentuate their highlights?" Sure enough, but only where it is indicated on the negative and not wilfully, wherever it happens to look well. The whole pictorial effect of a photographic print should be gained by photographic technique, pure and simple, and not merely a part of it. It is surely not legitimate to let the camera do the most difficult part, for instance the reproduction of a figure, and then after embellishing it with a few brush strokes or engraved lines (a comparatively easy task for a man used to painting) claim that it is all done by photography. Surely a figure can be placed and surrounded so artistically—just as nature at times composes itself so beautifully—that the result would be a picture which would even satisfy a secession jury, and necessitate no faking devices.

The strictly straight prints of these pictorial extremists, like the "Theobald Chartran" and "Solitude" of Steichen, the "Portrait of Miss Jones" of Eugene prove it. They are just as beautiful as their other work, why then not make all in the same manner? It would be more difficult. But these men are all in other respects so painstaking and conscientious, why not also in their attitude towards photography itself, whose interests they wish to further. I fear they will never "compel the recognition of pictorial photography, not as a handmaiden of art, but as a distinctive medium of individual expression" so long as they borrow as freely from other arts as they do

at present. Photography must be absolutely independent and rely on its own strength in order to acquire that high position which the Secessionists claim for her.

But all preaching is in vain, and judging from the present condition of things, it will take years before this latest phase of pictorial photography will be replaced by a more normal one, as it will render necessary a total readjustment of the ideas as to what art photography really is.

It may be interesting to investigate how this change in photographic taste evolved. At the start it was merely the outcome of a revolt from the conventional photographic rendering of sharp detail and harsh contrasts. This was refreshing, as the old-fashioned work had but little claim to beauty and none whatever to art. Stieglitz, Eickemeyer, Dumont, at that time did some remarkable work. Then some new technical methods were introduced which completely revolutionized photographic work. The first was the gum process introduced by Demachy and carried to its utmost possible limit by Steichen, the second was the glycerine process, as practised by Keiley, and the third the manipulation of the plate, the so-called process of photo-etching invented by Eugene. It is difficult to state which of the three processes has done the most mischief. In the meanwhile Alfred Stieglitz, who had become the champion of artistic photography in America, continually clamored for more "individual expression." And as "individual expression" in straight photography is extremely difficult to attain, the artistic photographer began to imitate the artist. "Individual expression" became synonymous with "painter-like expression," and as the three processes mentioned facilitated their efforts in that direction, they were adopted by all the camera workers of the new movement. Alfred Stieglitz suddenly saw himself surrounded by a lot of men and women who professed to be artists in their life as well as in their work. The final results were the foundation of the Photo-Secession Society in 1902, and the exhibition at the Carnegie Institute, Pittsburgh.

In the various groups exhibited one could clearly trace the evolution of the movement. It began with Eickemeyer; then followed in rapid succession Gertrude Käsebier (an expert in dodging processes), F. Holland Day, Clarence H. White, Eugene, Keiley, and finally Steichen and Alvin Langdon Coburn. Although Stieglitz reflects all the different phases, strange to say he remained a straight photographer in all his work.

All the other artistic photographers could not resist the temptation of trying themselves in gum and glycerine or applying the Eugene-Steichen method of augmentation. It became the fashion to blur objects, and the so-called "cult of the spoilt print" set in. The results were often far from being satisfactory, largely because the majority

of the workers could boast of no art training, and had no skill in the handling of brush and etching tools. The fun that was everywhere poked at the "fuzzy print" was not quite unjustified.

Of course no critic has the right to be absolutely positive that the work which he fancies is absolutely the only work that is in the right vein, and that everything else and everyone else is only working and studying in order to make him laugh and have fun. He must be able to think independently of any tradition, of any set idea of what is right and wrong, and be ready to try and understand what the photographic workers have to say.

The glycerine development, especially when employed with mercury, is full of possibilities. It has qualities entirely its own and need not borrow by imitation, but why need it be invariably utilized for fuzzy effects. Why do they obstinately insist on carrying mediums farther than they go?

Yet I cannot deny that I have also seen very beautiful, convincing as well as self-explanatory specimens in this line of work. The Pittsburgh Exhibition was in many respects a revelation to me, and I would be the last to discredit the merits of enthusiastic workers as John G. Bullock, Rose Clark, Mary Devens, Wm. B. Dyer, Herbert S. French, Mary M. Russel, Eva Watson, H. Schutze, Edmund Stirling, S. L. Willard, etc., but I claim and am absolutely convinced that still greater triumphs can be achieved in straight photography, and that they have been achieved by these workers whenever they applied the simple methods of straight or almost straight photography. It hurts me to see gifted persons like Gertrude Käsebier and Coburn, for instance, waste their talents on methods that have no justification to exist, and that have—mark my word—no permanent value and no future. The more so as they all can work straight, and are at their best when they work straight.

"And what do I call straight photography," they may ask, "can you define it?" Well, that's easy enough. Rely on your camera, on your eye, on your good taste and your knowledge of composition, consider every fluctuation of color, light and shade, study lines and values and space division, patiently wait until the scene or object of your pictured vision reveals itself in its supremest moment of beauty, in short, compose the picture which you intend to take so well that the negative will be absolutely perfect and in need of no or but slight manipulation. I do not object to retouching, dodging or accentuation as long as they do not interfere with the natural qualities of photographic technique. Brush marks and lines, on the other hand, are not natural to photography, and I object and always will object to the use of the brush, to finger daubs, to scrawling, scratching

and scribbling on the plate, and to the gum and glycerine process, if they are used for nothing else but producing blurred effects.

Do not mistake my words. I do not want the photographic worker to cling to prescribed methods and academic standards. I do not want him to be less artistic than he is to-day, on the contrary I want him to be *more artistic*, but only in legitimate ways.

The present movement has done an infinite amount of good, as it has awakened an interest in the artistic possibilities of photography, and proven beyond doubt that it is capable of distinct individual expression. But that it cannot continue in the present way, even Mr. Stieglitz realizes. The total suppression of almost every quality which we customarily associate with photography must cease. The photographer is not justified, as Mr. Steichen claims, in the striving to obtain results of the painter, the etcher, and the lithographer. And I am convinced a reaction will set in which will refuse all (at the very best only feeble) imitations of the material technique employed by any of these arts.

To me the Photo-Secession movement is merely the extreme swing of the pendulum which is necessary ere a reaction in photographic work will bring it back to a normal but at the same time much higher artistic plane than it has ever occupied before.

I myself have been connected with this movement from the very start; I have stood by it through thick and thin because I realized that my ideal of straight photography could only be reached by making concession and by roundabout ways. But now as the time for a reaction has come, I sincerely hope that my words will have so much weight with some of the workers that they will read this plea for straight photography and give it serious consideration, for it is my innermost conviction that there must come a change if we do not want to sacrifice all we have gained. I want pictorial photography to be recognized as a fine art. It is an ideal that I cherish as much as any of them, and I have fought for it for years, but I am equally convinced that it can only be accomplished by straight photography.

The Photo-Secession at Buffalo:
A Portfolio of Photographs Purchased by the Albright Art Gallery in 1910

To the Photo-Secessionists and particularly to Stieglitz, the "Buffalo Show" was a triumph. He wrote to Ernst Juhl (I translate):

The day before yesterday I sent you the catalog of the Buffalo exhibition, that has just closed. The exhibition was without doubt the most important that has been held up to now. Only the most select, the best things that exist, and only *originals* except for about 20 gravures, which were also originals in their way. The Albright Art Gallery is the most beautiful gallery in America. The exhibition made such a deep artistic impression that the institute bought 12 pictures at a good price and has put aside a gallery for them. This gallery will be maintained permanently. So at last the dream that I had in Berlin in 1885 has become a reality—the complete acknowledgment of photography by an important institution.*

The exhibition was a summation of the international movement of pictorial photography. The 600 photographs that were shown were in large part a series of one-person retrospective exhibitions.

Sadakichi Hartmann described the exhibition as:
a conquest, the realization of an ideal. Its triumph will rarely be repeated, and even if repeated, will assume a different aspect. . . . I have seen numerous exhibitions, photographic and otherwise, but I do not remember any which excelled this one in clarity and precision of presentation. . . . I sit at my desk and I wonder how such a refined sensation of visional joy mingled with an appreciation of the mind so deep and true, as I experienced walking through these large peaceful galleries, could have ever been conjured up in this diffident commerce-sodden community. It can only be the result, I mused, of the natural exaltation of a mind free from prejudices (except if it were directed against insincerity), solely as the pursuit of some lofty ideal. And I must confess that I have never met a group of men who have taken their vocation more seriously and disinterestedly than these pictorialists. . . . These workers realize that their art instincts must blossom forth into wholesome consciousness as natural expansion before their medium of expression can take its proper and its fullest meaning. And it was this spirit which made the Albright Exhibit of November, 1910, memorable in the annals of photography and art.†

We reproduce a selection of photographs purchased by the Albright Gallery, with notes on the artists from the catalog.

*Alfred Stieglitz, autograph letter in German to Ernst Juhl, January 6, 1911; translated by Beaumont Newhall. Alfred Stieglitz Archives, Beinecke Library, Yale University. By permission of Yale University and the Estate of Alfred Stieglitz.

†Sadakichi Hartmann, "What Remains," *Camera Work* 33 (January 1911), pp. 30-32.

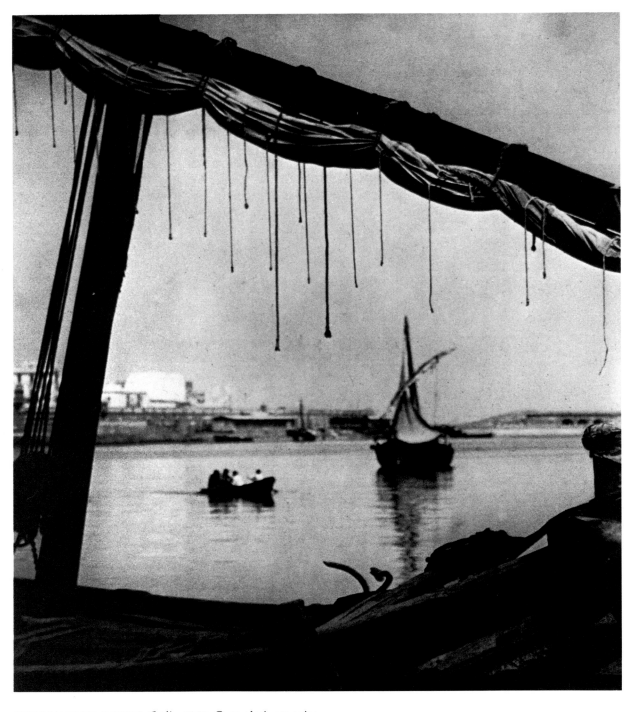

ALVIN LANGDON COBURN. *Cadiz.* 1908. Gum-platinum print.

"Mr. Coburn popularized the platinum-gum process. He has a number of followers among the younger British photographers and also some in America." Albright-Knox Art Gallery, Buffalo, N.Y.

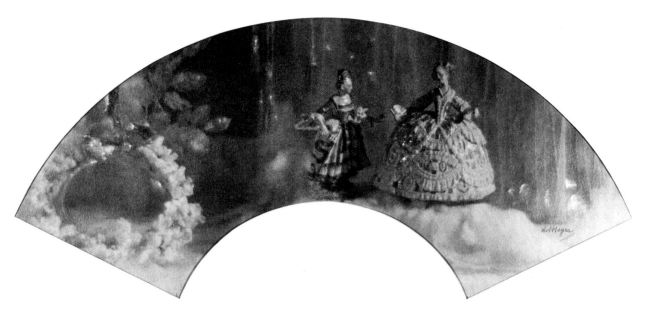

BARON A. DE MEYER. *The Dresden China Fan.* n.d. Platinotype. Albright-Knox Art Gallery, Buffalo, N.Y.

"Baron de Meyer's affiliations place him in the Austrian-German section, although his sympathies are with the American workers."

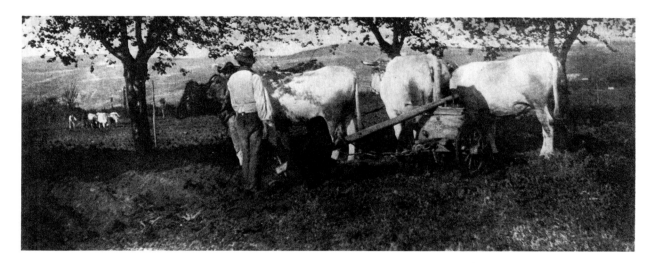

J. CRAIG ANNAN. *Lombardy Ploughing Team.* 1894. Carbon print. Albright-Knox Art Gallery, Buffalo, N.Y.

"Since the early nineties Mr. Annan has been one of the chief forces in the development of pictorial photography. This collection of prints is thoroughly representative of his achievements, and shows him to be a master of photogravure."

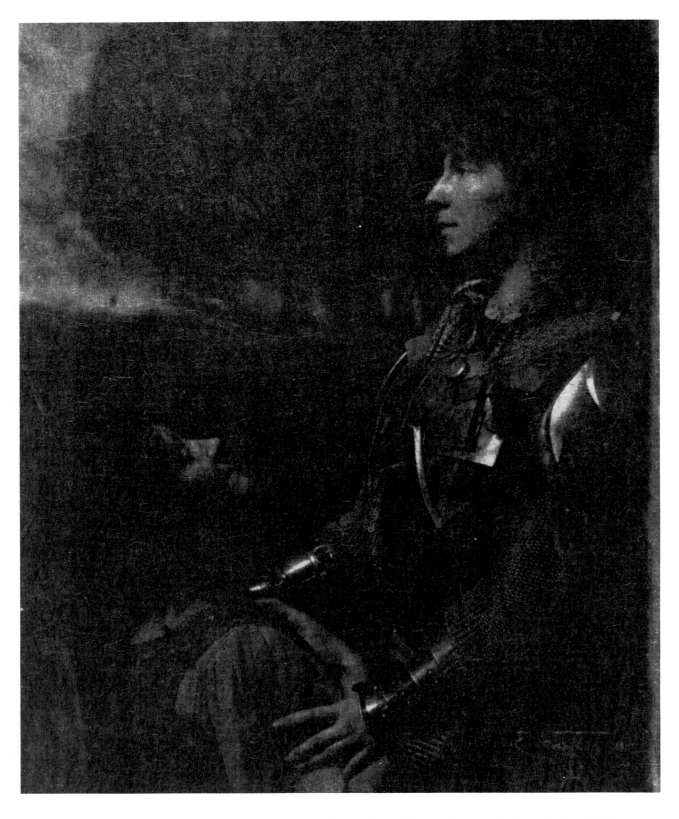

FRANK EUGENE. *Arthur and Guinevere.* 1900. Platinotype on Japan tissue. Albright-Knox Art Gallery, Buffalo, N.Y.

"Mr. Eugene began photographing in the eighties. He introduced the practice of etching on the negative, and was the first to make successful platinum prints on Japan tissue. All the examples of the latter in this exhibition are the original Japan tissue prints, and are unique, and have never been surpassed."

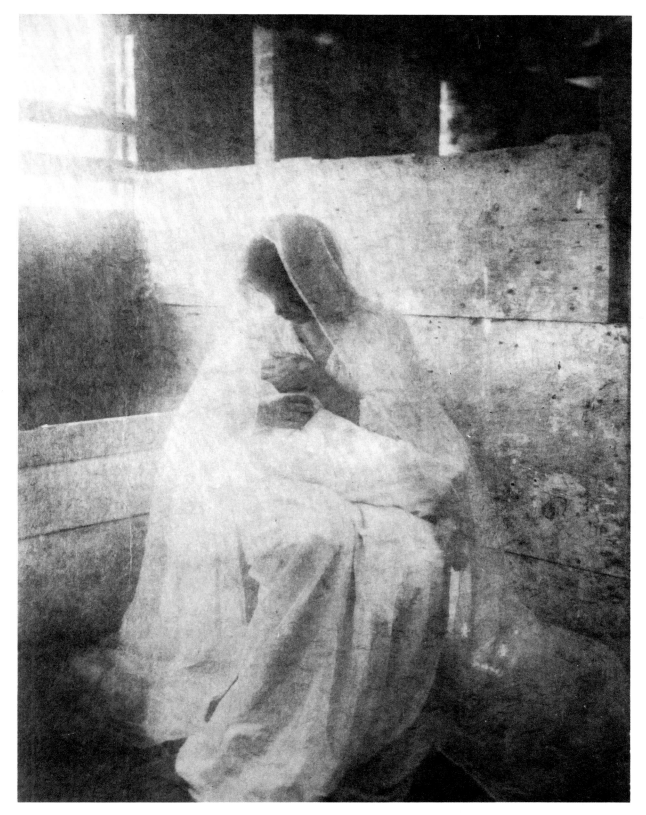

GERTRUDE KÄSEBIER. *The Manger.* Negative, 1899; platinotype on Japan tissue, 1910. Albright-Knox Art Gallery, Buffalo, N.Y.

"Mrs. Käsebier's photographic career began in the nineties. She is the most distinguished woman photographer living, and possibly the foremost since Mrs. Cameron (England in the sixties). Her work has had a strong influence in raising the standard of 'professional' photography, and this influence has been exerted as much in Germany as in America."

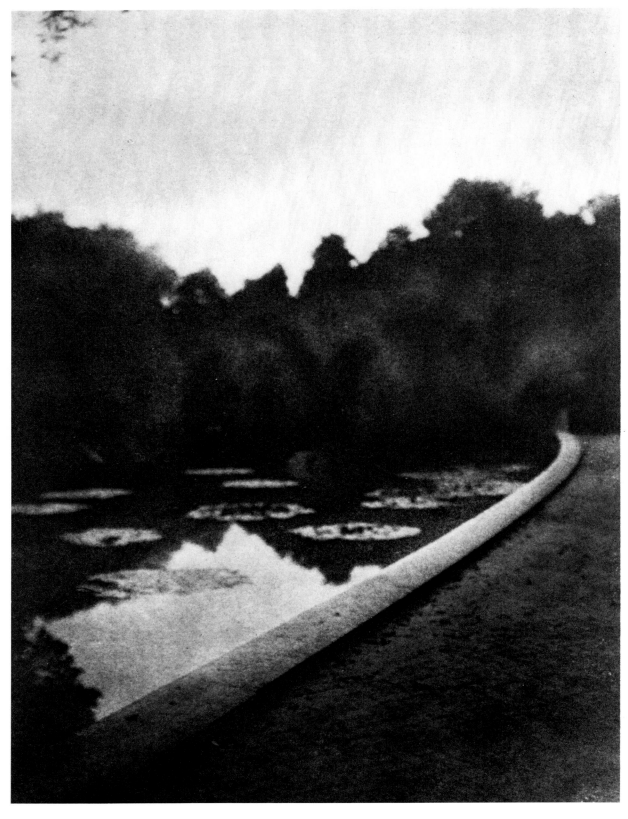

JOSEPH T. KEILEY. *Garden of Dreams*. 1899. Platinotype, glycerine developed. Albright-Knox Art Gallery, Buffalo, N.Y.

"Mr. Keiley developed and adapted to pictorial photography the glycerine process as it is universally used today. Many of the prints in this collection are unique and are the ones that popularized this printing method."

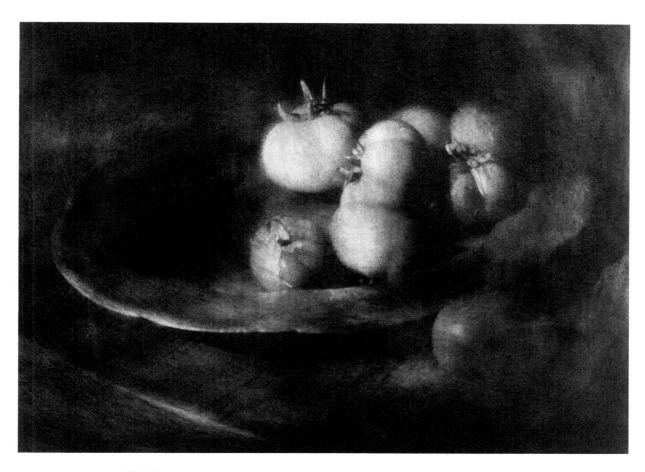

HEINRICH KUEHN. *Still Life.* 1908. Gum-bichromate print. Albright-Knox Art Gallery, Buffalo, N.Y.

"Hugo Hennenberg of Vienna, Heinrich Kuehn of Innsbruck, and Hans Watzek of Vienna (deceased, 1902), known as the 'Trifolium,' evolved the multiple-gum printing method as is now used so extensively by the Austrian and German pictorial photographers. They are the founders of the so-called 'German-Austrian' school in photography. All three began their careers in the eighties, and through their efforts have been vital forces in the evolution of pictorial photography."

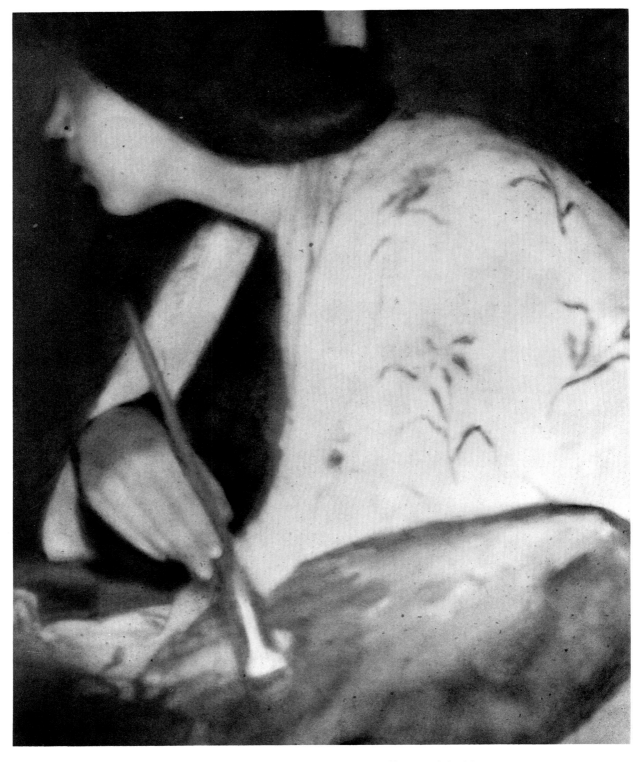

GEORGE H. SEELEY. *The Painter.* 1907. Platinotype. Albright-Knox Art Gallery, Buffalo, N.Y.

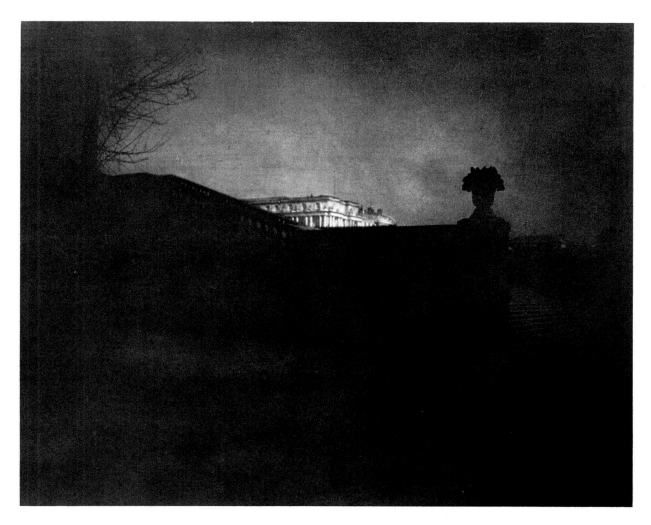

EDWARD STEICHEN. *Moonlight Impression from the Orangerie, Versailles Series.* 1908. Gum-bichromate print. Albright-Knox Art Gallery, Buffalo, N.Y.

"In the struggle for the recognition of photography, Mr. Steichen's work has been one of the most powerful factors, and his influence on some workers, both in America and Europe, has been marked. His use of the 'gum-bichromate' process is peculiarly his own."

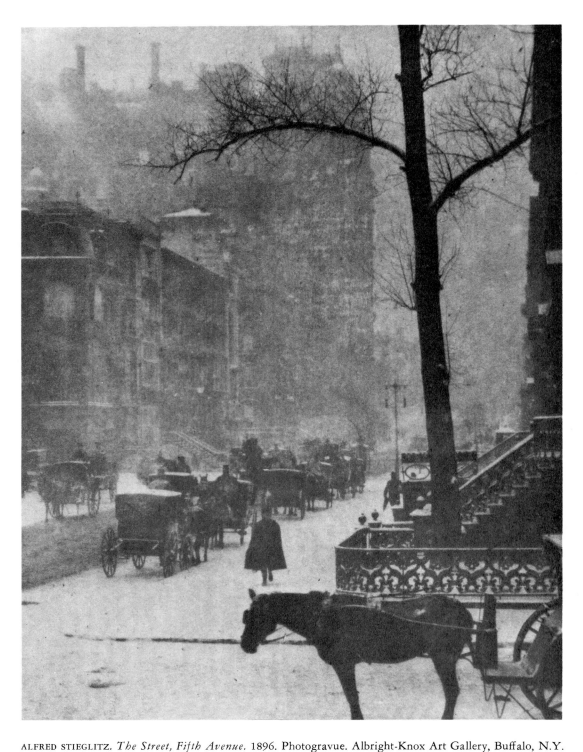

ALFRED STIEGLITZ. *The Street, Fifth Avenue.* 1896. Photogravue. Albright-Knox Art Gallery, Buffalo, N.Y.

"Mr. Stieglitz began his career in Berlin, Germany, in 1883, and his fight for photography was begun three years later. Returning to America, in 1890, he continued the struggle in the form of his own photography, exhibitions, and literature on the subject—these efforts verging toward the realization of Secession principles. He popularized platinum printing in America, as well as photogravure, in which medium only many of his prints exist. He was the first to choose his subjects in city streets under various aspects, such as those of rain and snow—considered at the time impossible to render successfully photographically. Simultaneously with Mr. Paul Martin, in London, he was the first to successfully experiment with night scenes. Many of the original examples of these pioneer efforts are included in the collection."

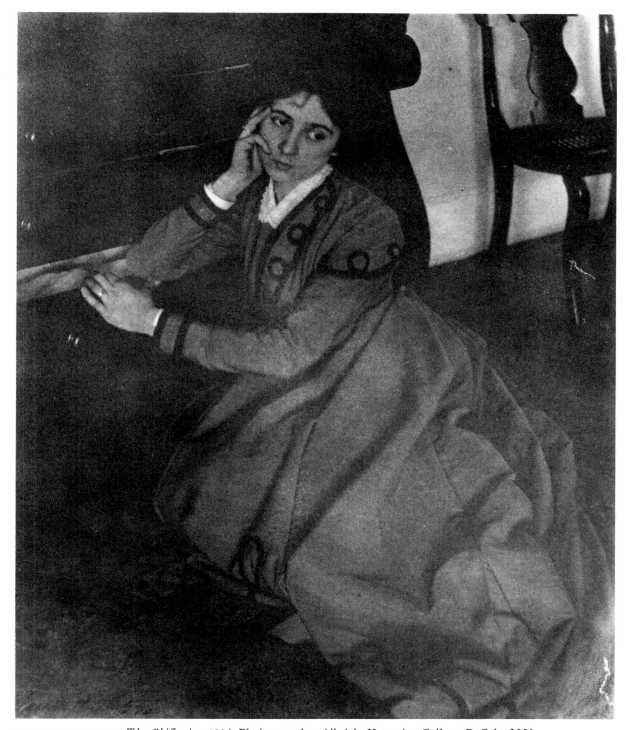

CLARENCE H. WHITE. *The Chiffonier*. 1904. Platinum print. Albright-Knox Art Gallery, Buffalo, N.Y.

"Both as photographer and teacher Mr. White has exercised a wide influence for some twelve years in America, and more recently in Europe. He has virtually confined his work to the platinum process, and has shown a marked preference for the technical problems of light."

ALVIN LANGDON COBURN. *Portrait of Gilbert K. Chesterton.* 1904. George Eastman House, Rochester, N.Y.

ALVIN LANGDON COBURN. *London Bridge.* 1905. George Eastman House, Rochester, N.Y.

"It is Mr. Coburn's vision and susceptibility that make him interesting, and make his fingers clever. Look at his portrait of Mr. Gilbert Chesterton, for example! 'Call that technique? Why the head is not even on the plate. The delineation is so blunt that the lens must have been knocked out of a tumbler; and the exposure was too long for a vigorous image.' All this is quite true; but just look at Mr. Chesterton himself! He is our Quinbus Flestrin, the young Man Mountain, a large, abounding, gigantically cherubic person who is not only large in body and mind beyond all decency, but seems to be growing larger as you look at him—'swellin' wisibly' as Tony Weller puts it. Mr. Coburn has represented him as swelling off the plate in the very act of being photographed, and blurring his own outlines in the process. Also, he has caught the Chestertonian resemblance to Balzac, and unconsciously handled his subject as Rodin handled Balzac. You may call the placing of the head on the plate wrong, the focussing wrong, the exposure wrong, if you like; but Chesterton is right; and a right impression of Chesterton is what Mr. Coburn was driving at."—George Bernard Shaw, Preface to Catalogue of an Exhibition of the work of Alvin Langdon Coburn at the Liverpool Amateur Photographic Association, 1906.

The Function of the Camera

DIXON SCOTT
1906

Alvin Landon Coburn, a member of the Photo-Secession, was given an exhibition by the Liverpool Amateur Photographic Association in 1906. George Bernard Shaw, then at midcareer as a highly popular playwright, was also an avid amateur photographer and wrote an introduction to the catalog that became famous, if only for the sentence: "Technically good negatives are more often the result of the survival of the fittest than of special creation: the photographer is like the cod which produces a million eggs in order that one may reach maturity."

John Dixon Scott, who was art critic for the Liverpool Courier, *used the exhibition to make a remarkable prophecy of the photography of the future.*

In a certain room in one of those black-browed buildings in Eberle-street, there was hanging the other day a cluster of extraordinarily beautiful little pieces of art, done in a medium whose special possibilities have hitherto, I fancy, been rather ingenuously neglected. Photography has been with us quite a number of days now, and it is really more than time that we relinquished our ingenuity, that we showed some comprehension of her qualifications, her instincts, her unique abilities. It is really more than time for some young artist to uprise and demonstrate that he at last has discovered the fine unprecedented genius which photography alone possesses, that he at last has discovered her curious and quite inimitable duties.

I am not quite sure that Mr. Alvin Langdon Coburn is just that artist—there are a few failures among the pieces of his work which the Liverpool Amateur Photographic Association exhibited at Eberle-street, a few confessions of doubt and hesitation—but Mr. Coburn, at any rate, is among that artist's very immediate precursors. For he has made the great, simple discovery that Photography is not merely an Art, but is also an Art entirely individual and independent. He has seen that

Reprinted from *The Liverpool Courier*, May 16, 1906.

the real Photography, the Photograph of the Future, is neither the clear, sharp, fiercely accurate record beloved by the honest gentleman of the old anti-sentimental school, nor the 'pictorial' affair, the affair that reminds you of a Whistler, or a Constable, or a Corot, evolved by the aid of all manner of cabalistic and (in the eyes of the purists) more or less questionable devices, by the later 'artistic' school. Mr. Coburn has had the coolness (need I say that he is an American?) to detach himself from the dusty quarrel of these two hostile factions; and, standing a little apart in his delightfully discreet way, he has been shrewd enough to discern the futility of their arguments. The honest, realistic photograph, filled with ever-increasing completeness, as time goes on and appliances grow more perfect, with severely truthful detail, will, of course, always retain an honourable place amongst the world's records and scientific data. But the 'pictorial' photograph, the photograph whose chief ambition and unconceded delight it is to capture as many as possible of those effects which peculiarly belong to the work of the painters and the draughtsmen—this mimetic creature has all but had her day.

IDEALS AND LIMITATIONS

IF YOU ARE ever ill-advised enough to offer the Photographer of the Future the little compliment wherewith you have gratified so many of his predecessors, if you are uncritical enough to say that his little achievement reminds you of a Rembrandt or a Whistler, he will very properly regard your remark as a piece of the most disgusting impertinence. For he will thoroughly and explicitly comprehend what Mr. Coburn has recognised, partially and instinctively, that the achievements of the Photographer must differ, in subject and intention, as profoundly as they already do in technique, from the achievements of the workers with brush and pencil. They must possess other ideals and observe other limitations. They must appeal to a range of emotions hitherto almost entirely undisturbed. They must fill a field thus far unoccupied; they must define, and they must at all times religiously defend the sacred singularity of their appeal.

"Photography seems to me already to have reached its due perfection," said a certain Liverpool artist the other day—an artist whom Mr. Coburn (the point is worth remarking) places in the first rank of contemporary English painters. I am convinced that he is wrong, that the Art of Photography is but now beginning to emerge from its curiously protracted slumbers.

And I speak with this conviction on the subject because it is one of which I am technically entirely ignorant. One is often tempted to speculate whether a complete and carefully-cherished ignorance of technique should not be the first qualification of the critic of any of the arts; for the proof of the picture, the poem, the statue, the piece of music, is in the enjoyment; and a knowledge of technique tends not infrequently to substitute for that enjoyment the very different, more intellectual, and somewhat artificial pleasures of the specialist. But in this matter of Photography, where the enchanting foibles of the human hand—chiefest of elements in the peculiar effectiveness of your poem or your picture—play a part so infinitesimal where the processes move with so scientific a rectitude—here, at any rate, one need surely doubt no longer. "After all," says Mr. Bernard Shaw, "the decisive quality in a photographer is the faculty of seeing certain things and being tempted by them." And to this quality, to the philosophy of subject and the ethics of effect, the layman, happily unshadowed by the mysteries of the dark-room, can turn his attention with a freedom undreamed of by the worker. That I don't know a lens from a negative, that the only "diaphragms" I have acquaintance with are physiological, and the only "emulsions" medicinal—let these facts be the sufficient justification of my assurance.

THE CAMERA AS A TOOL

AMPLY PROVIDED, then, with this great gift of ignorance, it becomes a matter of no huge difficulty to discern the nature of those "certain things" towards which Mr. Coburn and his followers and his superseders will find themselves more and more definitely "being tempted." To do so, it is only necessary to ask oneself what those specific qualities are which mark off the camera as a tool from the tools of the ordinary picturemaker, his brushes, and chalks, and tubes. Of these qualities there are obviously three: in the first place an ability to grasp instantaneously the minutest lineaments, the finest reticulations of any given arrangement of lines and masses; in the second place an inability to do anything without the collaboration of contemporary actuality; in the third place an inability to handle, an inability, indeed, to do anything but curiously distort, the nuances of colour which every said arrangement of actual lines and masses

inevitably includes. Now, with these facts in front of one, does it not immediately become almost ludicrously apparent that the native concern of the camera must be with the passages of contemporary actuality which are, in the first place, transient and irrecoverable, which are, in the second place, too full of vital complexities ever to be rightly recalled by the memory, or reconstructed by the imagination, and which depend, in the third place, for both transience and complexity, upon elements of bulk and contour, rather than upon elements of colour and evanescent bloom?

Or perhaps, so stated, these main principles seem a trifle elaborate and theoretical? Let me make my meaning clearer by the aid of a definite example.

A CITY SCENE

IT IS ONE of the uproarious ways of our city—an eager tumult of traffic, a fluent interweaving of cabs, carriages, lorries, electric cars, tentatory policemen, sporadic pedestrians—lampposts uplift here and there a crystalline poignancy, there is an acute entanglement of overhead wires, massed buildings, patterned with swift incidents of light and shade, stand in monotoned cliffs on this hand and on that. In one word—Lord street at noon. Well, that, in spite of its multiplex detail, in spite of the ceaseless instability of its incidents, presents an effect fairly stable and protracted. Its atoms spin, and lurch, and disappear, but the general attitude of the thing is fairly constant. A painter could render it: painters have rendered it. But in another instant something happens which thrusts the painter utterly out of court, and provides the Photographer with a motive full of the most exquisite possibilities, and a motive that no art but his own has any power to utilise. North John-street spits out a sudden motor-car. Its driver, flurried by the vortex, jerks and blunders. There is a scream of interlocking wheels, the rhythm of the road crackles out into a piercing discordancy, a dramatic nucleus snatches and compels the whole whirling assemblage. For a fraction of the time the effect hangs thus,—intimate, unanimous, organic,—every item within vision contributing to the fierce momentary tension. And then the strain slackens, the equability returns, the unique conspiracy of subtle notes vanishes irrecoverably, and the Photographer's opportunity has come and gone.

IN THE COUNTRY

IT IS FROM the town that I have taken this example, and urban, almost without exception, are the other typical motives which I have in mind. For it is to the town, I think, to the town's prodigality of incident and unsurpassable fluidity, that the Photographer of the Future will

turn most frequently. The constant flux of her protean roadways, the intricacies of her disordered buildings, her passion for surprises—these are all characteristics which commend her to the camera. The subtlety of the countryside and its changefulness are of course constantly being celebrated, and it might seem as though these were among those primal qualities for which the Photographer must look. But if you will consider the make for a moment, you will see, I think, that this subtlety and this changefulness depend almost entirely upon the great fact which the camera is compelled to ignore: the great fact of colour. Before me, as I write, stretches a little fruit tree, sustaining an exquisite poise, accented here and there with blossoms of fugitive rose, co-ordinating a sweep of intimate landscape and a blaze of exultant sky. And during the half-hour or so I have been writing, a thousand changes have swept over the little tree, and it has become, in turn, a perfect motive for a thousand very different pictures. But the moods that have visited it have been the moods that belong to colour, the delicate modulations that ebb and flow with the subtle veiling and unveiling of the sun—changes which the camera is quite powerless to seize; and the pictures are the pictures of a painter. It is so almost always with the outside world. Its evanescence is a thing of tint and tone. Its lines and masses change only with the slow procession of the seasons. And since in the town these things are precisely reversed, it is, as I say, to the town that the Photographer will chiefly turn.

In but one element of external nature does one find this urban quality repeated. The movements of the waters of the world, from the torsion of upland streams to the unpredictable passions of the sea,—these grant much in the way of a volatile significance that may be divorced from here. They will be largely used. As to the clouds— those high-poised Pacifics, those rivers and oceans made

aerial and independent,—I cannot think that they provide a perfect field. Their changes, on all but the wildest of wind-winnowed days, are too gradual and dignified to give the camera but the slightest of especial privileges; whilst for these, as must be obvious, the brush has resources which amply atone.

I have left until the end, hoping to speak of them with especial amplitude, the singular opportunities which surround that epitome of changefulness in contour, of comparative changelessness in line,—the human figure. But I have already overrun my space, and if I am to speak of them at any length it must be on another occasion. Meanwhile, observe, if you please, that the principles we have been tracing point very clearly to an abandonment of those ineluctable poses which a man might continue for a month, and an adoption instead of attitudes and gestures quite momentary,—the dramatic outlines which the body takes in moments of high passion or deep emotion, effects brimming with character because the heat of some flying mood has burned away the lying lineaments of convention. Difficult, you think? Why, of course it will be difficult. I am talking about an Art.

Coburn tells me that he is busy with experiments in colour-photography, and his optimism on the subject is very beautiful to behold. Of course, when that day dawns we will have to recast our judgment very considerably. But it has not dawned yet. And when it does, you must give me leave to write another article.*

*In 1907 color photography did become practical with the invention of the Autochrome process, which could be used in any plate camera. The article Dixon Scott asked leave to write appeared in *Colour Photography and Other Recent Developments of the Art of the Camera,* edited by Charles Holme and published by The Studio, London, 1908. Three-color photographs by Coburn were reproduced in the book.

ALVIN LANGDON COBURN. *Vortograph.* 1917. George Eastman House, Rochester, N.Y.

In 1917 Coburn exhibited his paintings and abstract photographs which his friend the poet Ezra Pound named "Vortographs." Pound was a member of the Vorticist group of English painters who established a school of Cubist painting. In a letter to Beaumont Newhall, dated April 11, 1947, Coburn explained:

"The Vortographs were made with three mirrors clamped together in a triangle, into which the lens of the camera was projected, and through which various objects (bits of crystal and wood on a table with a glass top) were photographed. The principle was similar to the old kaleidoscope . . .

"I greatly enjoyed making these Vortographs, for the patterns amazed and fascinated me!

"There was, at that time (1917) a notion that the camera could not be 'abstract' and I was out to disprove this. I think I successfully did so!"

The Future of Pictorial Photography

ALVIN LANGDON COBURN
1916

Alvin Langdon Coburn (1882–1966), the youngest of the Photo-Secessionists and at twenty-one a member of The Linked Ring, the leading British society of pictorial photographers, was the first of the pictorialists to be captivated by the new abstract movement in painting. In 1912 he made a series of "New York from Its Pinnacles"—views looking down from high skyscrapers—that in their perspective he compared to Cubism. Two years later, encouraged by the Vorticist group of progressive British abstract artists who gathered around writer Ezra Pound and painter Wyndham Lewis, he began working out the kaleidoscopic, multimirror device he named the Vortoscope, which distorted the optics of the camera so that the images become unrecognizable. Though short-lived, these "Vortographs" were the first experiments in the field he urged fellow photographers to investigate. This short essay appeared in Photograms of the Year 1916, *an annual that published photographs made in the style that had already become traditional pictorialism.*

An artist is a man who tries to express the inexpressible. He struggles and suffers knowing that he can never realise his most perfect ideal. Occasional moments of ecstasy lure him on, but nothing is final in art, it is always progressing and advancing, as man's intelligence expands in the light of more perfect knowledge of himself and the universe.

It is this progress of the arts that has interested me. Where is it leading us? There are the "moderns" in Painting, in Music, and in Literature. What would our grandfathers have said of the work of Matisse, Stravinsky and Gertrude Stein? What *do* our grandfathers say? They hold up their hand in horror, they show their bad manners by scoffing and jeering at something they are too antiquated to understand. It is the revolutionary of to-day, however, who is the "classic" of to-morrow; there is no escaping the ruthless forward march of time.

Yes, if we are alive to the spirit of our time it is these

Reprinted from *Photograms of the Year 1916*, pp. 23-34.

moderns who interest us. They are striving, reaching out towards the future, analysing the mossy structure of the past, and building afresh, in colour and sound and grammatical construction, the scintillating vision of their minds; and being interested particularly in photography, it has occurred to me, why should not the camera also throw off the shackles of conventional representation and attempt something fresh and untried? Why should not its subtle rapidity be utilised to study movement? Why not repeated successive exposures of an object in motion on the same plate? Why should not perspective be studied from angles hitherto neglected or unobserved? Why, I ask you earnestly, need we go on making commonplace little exposures of subjects that may be sorted into groups of landscapes, portraits, and figure studies? Think of the joy of doing something which it would be impossible to classify, or to tell which was the top and which the bottom!

In last year's exhibition of the Royal Photographic Society there was a little group of prints by American workers, mostly entitled "Design"—many of my readers will remember them. They were groups of various objects photographed because of their shape and colour value, and with no thought of their sentimental associations. There were, I believe, tables, golf clubs, portfolios, etc., etc. The idea was to be as abstract as it is possible to be with the camera. Max Weber, the Cubist painter-poet, was responsible for the idea of these designs, and Weber is one of the most sincere artists that it has ever been my good fortune to meet; but of course these experiments in a new direction only met with sneers and laughter—it is always the same with an innovation in any direction. In his new book, "Essays on Art," Weber says: "To express moods that stir the emotion from within, as does music, the plastic artist, when he conceives of energetic rhythmic interlaced forms or units, should be much more moved than even by music. It is like cementing a thought, or arresting a perfect moment of time, or like giving body to space, or solidity to air, or coloured light to darkness."

How many of us are moved like this in photography?

ALVIN LANGDON COBURN. *Ezra Pound.* 1917. George Eastman House, Rochester, N.Y.

We think of the camera as a rather material means of self-expression—if we think about it at all; but is it really so? Pause for a moment and consider the mysterious quality of light registering itself in sensitized gelatine—all the scientific poetry in the words "latent image." In the days when men were burned at the stake for practising "black magic" the photographer would have been an undoubted victim if it had been invented in those dark times; but now every "nipper" has a "Brownie," and a photograph is as common as a box of matches—perhaps even more so, this being war time! Photography is too easy in a superficial way, and in consequence is treated slightingly by people who ought to know better. One does not consider Music an inferior art simply because little Mary can play a scale. What we need in photography is more sincerity, more respect for our medium and less respect for its decayed conventions.

All the summer I have been painting, and so I can come back to photography with a more or less fresh viewpoint, and it makes me want to shout, "Wake up!" to many of my photographic colleagues. "Do something outrageously bad if you like, but let it be freshly seen." If we go on fishing out our old negatives and making a few feeble prints of them, just as we have been doing for the past ten years, photography will stagnate. I have the very greatest respect for photography as a means of personal expression, and I want to see it alive to the spirit of progress; if it is not possible to be "modern" with the newest of all the arts, we had better bury our black boxes, and go back to scratching with a sharp bone in the manner of our remote Darwinian ancestors. I do not think that we have begun to even realise the possibilities of the camera. The beauty of design displayed by the microscope seems to me a wonderful field to explore from the purely pictorial point of view, the use of prisms for the splitting of images into segments has been very slightly experimented with, and multiple exposures on the same plate—outside of the childish fakes of the so-called "spirit photographs"—have been neglected almost entirely.

As a start I suggest that an exhibition be organised of "Abstract Photography"; that in the entry form it be distinctly stated that no work will be admitted in which the interest of the subject-matter is greater than the appreciation of the extraordinary. A sense of design is, of course all important, and an opportunity for the expression of suppressed or unsuspected originality would prove very beneficial.

You may think what you like about the modern movement in the arts, but the world will never be the same place again. We may disapprove of modernity in art, but we can never go back to Academicism with the smug complacency of yore. The hollowness, the unthinkable dullness of it all, is now only too clearly apparent. And it is my hope that photography may fall in line with all the other arts, and with her infinite possibilities, do things stranger and more fascinating than the most fantastic dreams.

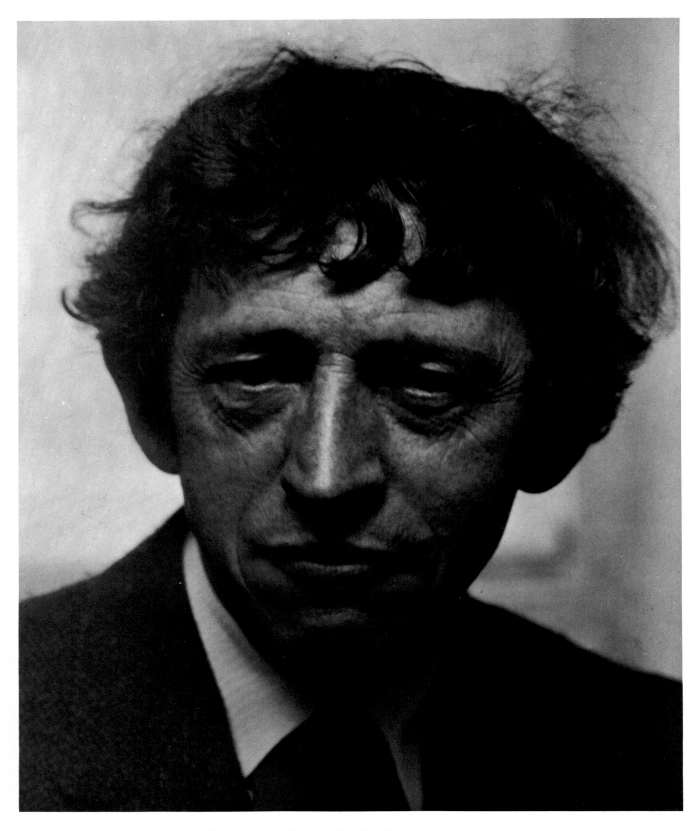

ALFRED STIEGLITZ. *John Marin*. 1920. The Museum of Modern Art, New York.

Stieglitz

PAUL ROSENFELD
1921

In 1921 Alfred Stieglitz held the first exhibition of his photographs since the closing of the Little Galleries of the Photo-Secession—commonly called "291"—and the demise of Camera Work *in 1917. One hundred and forty-five prints, ranging in date from 1886 to 1920, were hung in the Anderson Galleries in New York. The show was both a summation and the beginning of a new stylistic period, for it included "A Demonstration of Portraiture," made between 1918 and 1920. Stieglitz now believed that a personality cannot be expressed by a single photograph, and the face alone is not sufficient: the whole body, he felt was equally revealing. Thus twenty-six different prints were catalogued as "A Woman [One Portrait]." The woman was Georgia O'Keeffe.*

We reproduce a selection of photographs from the period that may well have been included in the exhibition; unfortunately there is no record of specific prints shown beyond the catalog titles. We also reprint, in facsimile, the statement by the artist.

Of the many reviews of the exhibition, we have chosen to reprint the one by Paul Rosenfeld (1890–1936), novelist and music critic for The Dial. *He writes with sympathy and understanding based on a long acquaintance with Stieglitz dating back to the days when he was a collaborator in the publication of the short-lived periodical* 291.

Alfred Stieglitz is of the company of the great affirmers of life. His photographs bear witness to the presence in him of a sense of the significance of animate and inanimate things as catholic as any which man has every possessed. He is not only one who, like the illuminated sage of the Hindus, "regards with equal mind an illuminated, selfless Brahmin, a cow, an elephant, a dog, and even an outcast who eats the flesh of dogs." For the man who out of the black box and the bath of chemicals produced these cool dynamic prints, there seems to be scarcely anything, any object, in all the world without

Reprinted from *The Dial* 70 (April 1921), pp. 397-409.

high import, scarcely anything that is not in some fashion related to himself. The humblest objects appear to be, for him, instinct with marvellous life. The dirt of an unwashed window pane, a brick wall, a piece of tattered matting, the worn shawls of immigrant women, horses steaming in the smudged snow of a New York thoroughfare, feet bruised and deformed by long encasement in bad modern shoes, seem, for this man who has shoved the nozzle of his camera so close to them, as wonderful, as germane to his spirit, as the visage of a glorious woman, the regard of ineffable love out of lucent unfathomable eyes, the gesture of chaste and impassioned surrender. A foolish Victorian parlour with a cast of the Venus de Milo in the corner contains the universe as fully in his sight as do a pair of hands of warmest ivory; a back yard hung with clothes-lines and cut by fire-escapes as fully as the breast and torso of a woman. Indeed, Stieglitz' rich shadowed prints, his surfaces of pearl and milk and bronze, his black and platinum planes and segments of planes, are built up by means of the forms of objects most often humdrum, banal, common. He has found universal, found forming a related design, the wheelrims and the sides of carts, sign-painted walls, the storm-light of a feverish August afternoon in New York, rippling lake-water and raindrops, typewriters and paper packages and pipes stuffed with burning tobacco, all sorts of common materials, all sorts of rough clothing. He has felt the life of every portion of the body of women, based pictures not alone on faces and hands and backs of heads, on feet naked and feet stockinged and shod, on breasts and torsos, thighs and buttocks. He has based them on the navel, the *mons veneris,* the armpits, the bones underneath the skin of the neck and collar. He has brought the lens close to the epidermis in order to photograph, and shown us the life of the pores, of the hairs along the shin-bone, of the veining of the pulse and the liquid moisture on the upper lip.

How clearly all these things sing for him, how chock-full of life they are for him, how naturally they compose themselves for him into a rounded work of art, that the

quality of his prints attests. There have never before been such photographs. Never before have such completely organized surfaces, such robustly living and functioning bodies, been born of the photographic processes. Out of the forms and textures of the myriad humdrum objects, the myriad confused objects attacked by the lens, there has been made an expression ideal as is music; an order as pure, as complete, as that of Cézanne or of any of the great masters of the aesthetic pictural organization. Some of the prints, no doubt, deserve to rank with the work of the great masters of polyphonic music. Clothes-lines and hands, white shirts and leafing trees, gutter and gallery of 291 set daintily with Brancusi sculptures, have all been taken into the photographer and issued again, suffused utterly with his own law and revelatory of it. There is no vagueness, no indecision in them. Every particle of them is active. The entire chaos and pellmell that rolls all time before our eyes, is issued out of Stieglitz defined, related, firm; and expressive of the high significance of which he has caught sight through them. A man is coiled, ineluctably, within the white borders of these spotted, machine-made objects. The impalpable thing that is an individuality, speaks out of each of them sonorously, simply, directly. Indeed, the prints of Stieglitz are among the very sensitive records of human existence. So vivid and delicate are they that one wants to touch them. So highly sensitized is the medium, so drenched with a personality, that one feels present in the work the very natural forces which have created man, and which he, in turn, is striving fitfully to make part of his body. The prints are like the Chinese concerted pieces in which one hears sing not only the human being, but the animal kingdom and the mineral kingdom as well. Workers in other media, it is possible, have produced objects greater in amount, in volume, in passion. But it remains doubtful whether any one has approached the dark wet quick of man more nearly than Stieglitz. Neither the pigment of the Chinese nor the water-colour of Cézanne, neither the orchestra of Debussy nor the dialogue of Schnitzler, records more subtly, more delicately, the quality of the life in a man, the movement always in progress within him. Before Stieglitz' work we are made to think perforce of the writing of a needle sensitive to the spiritual gravity of a man, to the temperature of his passion, the pressure of his blood, as the seismograph is sensitive to the minute vibrations of the crust of the earth. These forms recall not so much the picture-making of other times, as they do highly complex mathematical and chemical formulae.

But the photographs of Stieglitz affirm life not only because they declare the wonder and significance of myriad objects never before felt to be lovely. They affirm it because they declare each of them the majesty of the moment, the augustness of the here, the now. They attest in clearest tones that life is present fully in every instant of time; that the present contains both past and future; that there is no instant of time not fully bound and related to every other. For they themselves are but the record of moments. The camera can record nothing else. It is able to "take" nothing but the objects before it. For it, nothing exists save what is before the lens, no moment save the moment when its shutter is opened to the light. But each of the instants fixed by Stieglitz and his machine have the weight of a sum of life. Stieglitz has caught many moments, some apparently the most fugitive, some apparently the most trivial. He has caught fleeting facial expressions, sudden twitching smiles, momentary flashes of anger and pain. He has arrested apparently insignificant motions of the hands, motions of hands sewing, gestures of hands poised fitfully on the breast, motions of hands peeling apples. And in each of them, he has found a symbol of himself. For he himself, so his works attest, has always been willing to live every moment as though it were the last of his life, the last left him to expend his precious vitality. He himself has always been willing, in order to fix the instant, the object before him, and to record all that lay between him and it, to pour out his energy with gusto, with abandon. His life appears always to be present at the surface of his body. All is squeezed out, nothing left; the aesthetic form of his pieces, their convexity, their grand double movement, that of penetration into the background and that of receding and hollowing and opening, their steady progress from the lower edge of the print up toward the higher, demonstrate the completeness of the release. So, out of the brief sudden smile or fixation of the gaze, out of the restless play of the hands, Stieglitz has made something that looks out over the ages, questioningly, wistfully, pityingly. Out of a regard of weariness and kindness and gentle chiding laughter, he has made a sort of epilogue to the relations of women and men. Sphinxes look out over the world again. Indeed, perhaps these arrested movements are nothing but every woman speaking to every man.

Never, indeed, has there been such another affirmation of the majesty of the moment. No doubt, such witness to the wonder of the here, the now, was what the impressionist painters were striving to bear. But their instrument was not sufficiently swift, sufficiently pliable; the momentary effects of light they wished to record escaped them while they were busy analysing it. Their "impression" is usually a series of superimposed im-

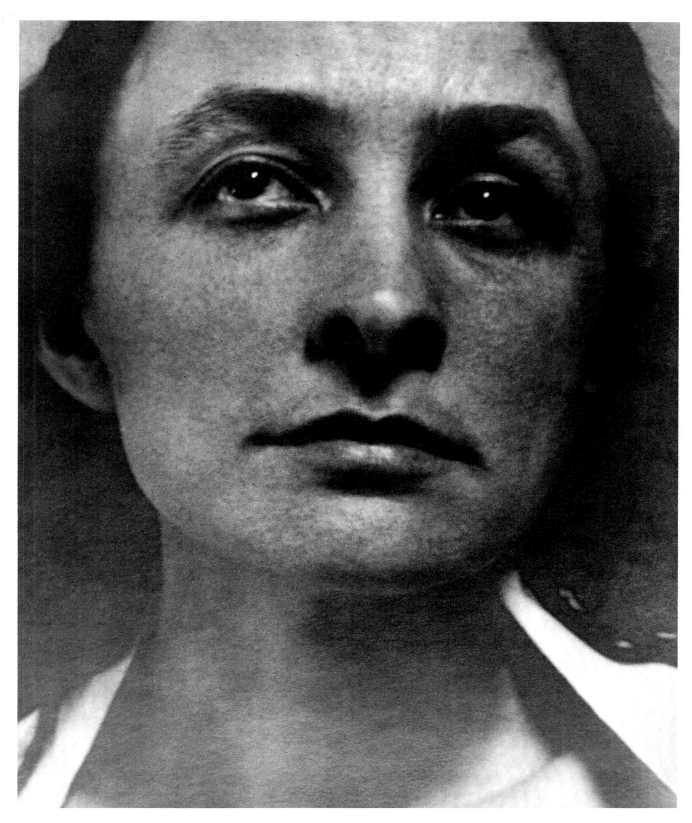

ALFRED STIEGLITZ. *Georgia O'Keeffe.* 1919. The Museum of Modern Art, New York.

pressions. For such immediate response, a machine of the nature of the camera was required. And yet, with the exception of Stieglitz, not a one of the photographers has used the camera to do what alone the photographer can do, fix the visual moments, register what lies between himself and the object before his lens at a given moment of time. All have been concerned not so much with the object, with the moment, as they have with the making of an "artistic photograph," and so failed to use their instrument properly. They have not been thinking so much of what it is they feel, as what it is Whistler or Degas or Boecklin would have felt at such a moment, had Whistler or Degas or Boecklin photographed in place of painting and etching. They have been "looking before and after," and pining for what is not. They have been striving away from the moment to the moments in the past in which the individuals who made certain works of art, lived. What it is that has kept them from expressing the here, the now, is perhaps nothing other than the unwillingness to accept fully the pain of existence, to embrace voluntarily the suffering of life. For unless one consent in suffering, there can be no complete living of the present. There can be no complete draining of the cup of the now by him who is unwilling to empty it if perchance it contain hemlock in place of wine. There can only be a vague floating to some other-wheres which perhaps never existed, or will never exist. There can be no facing of what is directly before one by him who is unwilling at every instant of his life to look his fate fully in the eye, to dare to summon his entire man, perhaps in vain, to solve the problem immediately before him. Perhaps, indeed, the acceptance of the present is nothing else than a resolution to be solitary, if need be, always; to suffer, if need be, always; to accept a grim fate, if that be hidden in one's bowels. We here in America have long since forgotten this simple and holy truth, and it is well that this photographer, who knows it well, comes with his platinum prints to remind us of it.

Had Stieglitz expressed himself through any of the accepted media of art, instead of through photography, his affirmation could not have been anything but a great one. But the fact that he has used a machine, a complex modern mechanism, to record himself, makes it one doubly so. For, in using the camera, he has demonstrated the power of man. He has made the very machine demonstrate the unmechanicalness of the human spirit. For a century, the machines have been enslaving the race. For a century, they have been impoverishing the experience of humanity. Like great Frankenstein monsters, invented by the brain of human beings to serve them, these vast creatures have suddenly turned on their mas-

ters, and made them their prey. It is not so much the fact that men have used these great implements in manufacturing that has manacled them, as the fact that the mass production permitted by the use of arms of steel has succeeded in mechanizing human life. The lazy human being, always on the *qui vive* for some method of saving himself the fatigue of brain work, discovered that whereas it was even more difficult to make sensitive the hand of steel than the hand of flesh, it was possible, without applying much brain-power, to produce vast quantities of necessary and unnecessary articles with the machine. The vast quantities of necessities, the quickness of production, increased the population; the increase of the population in turn increased the need of the establishment of the criterion of quantity in place of that of quality. Then, however, the machine turned on its masters. It forced them to forgo experience for the sake of repeating incessantly a few gestures; it forced them to repeat their old experiences over and over; to numb their desire for improving themselves through improving their crafts; to think principally of greater and cheaper production, rather than of finer and more durable work. It caused them to seek to root out of themselves all interest in experience, because of the pain of relinquishing desire, were desire once to establish itself; it caused them to seek to regard objects only with the eyes of commerce and industry, and not with those of the earth-loving, nature-loving, green-and-growth-loving spirit. The machine should have rendered more subtle, more conscious and powerful the human brain; it succeeded, during the nineteenth century, in rendering it more inert than ever. Instead of making [it] free, it had reduced the greater part of the community to doing work fit for morons.

Particularly in America had life become mechanized. The pioneers had of bitter necessity surrendered all interest in experience, all desire for self-culture, all thinking that was not narrow or utilitarian. The triumph of industrialism had further narrowed life. The human being was repressed in America as he had not been repressed in Europe for many centuries. The whole of society was in conspiracy against itself, eager to separate body and soul, to give the body completely over to the affairs of business while leaving the soul straying aimlessly in the clouds. A sort of fury of disdain for nature took hold of the whole of the community; forests were ruthlessly devastated, waterfalls were drained of their water, palisades blasted away. The will to be machines seemed to fill all folk. The Book of Genesis was rewritten, and made to declare, "In the beginning, God created the heavens, the earth, and industrial competition." In New York Harbour, on an island, there was

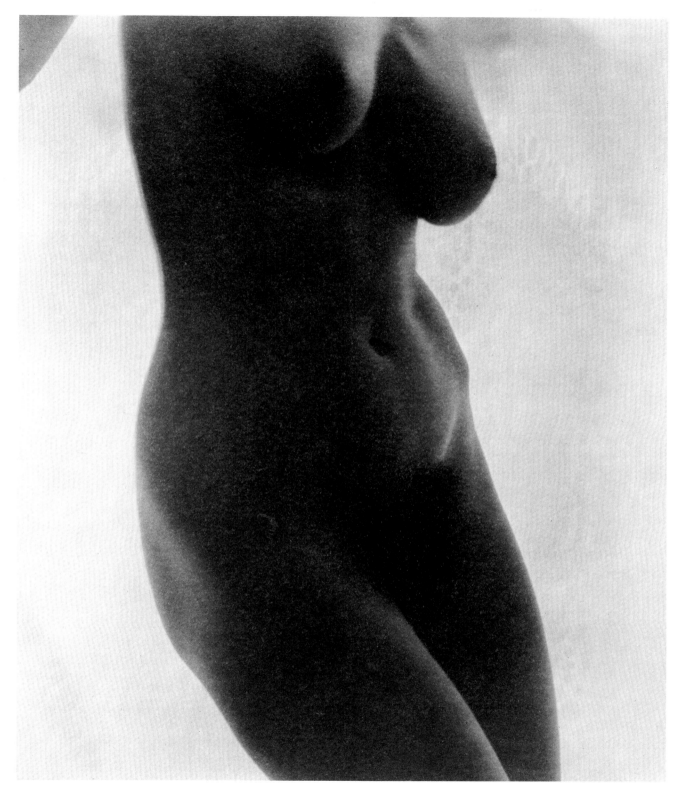

ALFRED STIEGLITZ. *Torso.* 1919. The Metropolitan Museum of Art, New York.

erected a statue intended originally to represent Commerce and Industry at the entrance to de Lesseps' Panama Canal. With justice it was called the Statue of Liberty. For, in America, the right of humanity to its life, to its experience, to liberty to develop, to free play, was become its right to be born and to engage, during the natural term of its existence, in commerce and in industry. So completely had the machine succeeded in producing here a sort of man as little individual as any which Western civilization had seen for long, that America seemed in truth the greatest of the many great disappointments of humanity.

And yet, it had been a future of another sort that the old world had wished the new. It was a high dream, that the old lands had called America. It had nursed a hope, the old world, of a fresh sort of life for all men in the new. A race of individuals was to appear on the other side of the Atlantic. For the first time, loosed from the hierarchies and the concepts of the old world, the human being was to become the freed man. Fair play to man and all his faculties, right to his life and to his selfhood, right to experiment, perfect freedom of soul—that, in the marvellous dream of Europe, the new world was to secure each individual. Beings were to be permitted to expand their natures in "numberless and even conflicting directions." Out of herds, out of political states, out of races, out of all the categories of the past, there were to develop, not Englishmen nor Germans, not Catholics nor Protestants, but democratic men, each one an entity, a state, a race, each one polarized, each one the possessed of his own religion, each one as jealous of the individuality of his neighbour as of his own. Whitman, announcing "the great individual, fluid as Nature, chaste, affectionate, compassionate, fully armed," announcing "a life that shall be copious, vehement, spiritual, bold," announcing "myriads of youths beautiful, gigantic, sweet-blooded," and "race of splendid and savage old men," was merely uttering again the music that had swelled the hearts of Europeans a century before him, as their eyes gazed out over the Atlantic.

It is not at all strange, therefore, that the subjugation of the complex modern mechanism should first have been accomplished in the name of the human spirit by one who, like Stieglitz, was born in the land most ravished by mechanical civilization. Here, in America, the machine most boldly challenged to combat those who believed in life, those fledged ready to welcome with open arms experience. In America, it most tyrannously threatened to rob them of their birthright. And there was always the promise of the States made their young, made the men of every land, and repeated loudly and glibly in every one of their official proclamations, to

make all who were fully co-ordinated and ready to feel to the utmost the hot life in them, savagely resentful of the state of affairs. Especially was this true of one who, like Stieglitz, was sprung of folk not long out of Europe. For the dream of a new world on the west coast of the Atlantic was dreamed most passionately just in revolutionary Europe, and the children of the visionaries were most predisposed to accept in earnest the words so glibly and loudly uttered by official America. To be sure, the directest fashion of forcing America to make good its lightly proffered promises would have been capturing the new manufacturing implements of humanity, and using them to free instead of further to enslave the brain. There can be no doubt that, had any sort of success in utilizing industrial machinery in order to set free society lain open to the single solitary individual, it would have been in the world of manufacture that a man of the sort of Stieglitz, little mechanical in his body, would have found himself. He had an undoubted flair for machinery; before discovering the camera, he went to Berlin and inscribed himself at the Polytechnik as a student of mechanical engineering. Indeed, for a while, he did venture into the market-place of New York as head of a business concern which used photo-mechanical processes. But he found it impossible to make headway against "down-town" morals.

But in the camera, Stieglitz found his instrument. In the camera, he found the means to the solution of his conflict. Up to the moment he had discovered it as a student in the Polytechnik in Berlin, he had been unoriented. Supposed to be studying mechanical engineering, he had, in fact, spent most of his time playing billiards, practising piano, and standing through performances at the opera. But once acquainted with that mechanism, his will quickly formed. Why it did so, that he was far from guessing at the time. But there can be no doubt that he had half-consciously realized that, by using the camera to express himself, he could meet his environment on its terms, and at the same time, on his own. Here was one of the complex modern mechanisms into the making of the like of which so much Yankee shrewdness had been poured. But here, at the same time, was an instrument, still resistant of man, for neither Hill nor Mrs Cameron had begun to explore the photographic medium, which could be made to do by a single solitary individual what industrial machinery could not. The camera could affirm the human values which America had so gravely promised to foster. The camera, so the young polytechnician with the American flag in his pocket must dimly have surmised, could give him what the legend of America had promised him and what the industrialism of America had denied him. Perhaps a

predilection for black helped attract him to photography. But chief of all incentives to use it, must assuredly have been the knowledge that the camera would permit him to rejoice with the world in its new arms and hands and feet and eyes, and yet permit him to experience life, to develop his own latent strength and vision.

What Stieglitz began doing with the camera immediately he became interested in it, was precisely what the folk of the industrial world of America were failing to do with their implements. He began attempting to make it a part of his living, changing, growing body. They were seeking, whether or not they were aware of the fact, to make themselves like the dead mechanism. He began making the act of photography an experience. He had no theories of his art; he did not even know whether it was art that he was setting about creating. He had only a curious intuition of what the black box and solarization and developers and printing paper might be made to do; above all, a savage desire to make the rebellious machine record what he felt, to make the resistant dead eye of the camera register that which his animal eye perceived. The machine people were content to repeat *ad infinitum* the achievement of the machine; Stieglitz began boldly attacking the problems of plastic representation, convinced that he could in some way learn to make his instrument obey his wishes. Every one of his photographs, one can say with assurance, is an experiment. There is no repetition of past experience in them. They contain, of course, restatements of much that had already been stated by men. But they each of them are the result of a complete summoning of all the strength and science gained through past experience, for the sake of solving the problem immediately before the photographer. They are the results of complete re-considerations of what exposure, developing, paper can do to solve a problem. The prints themselves are sometimes the results of fifty, of one or even two hundred attempts at printing satisfactorily. Each of them is a daring cast into the future; a daring attempt to discover new land for the human soul. Each one, is the attempt to further sensitize the medium; to make it include more and more of life in its scope.

And in liberating the medium, Stieglitz managed to liberate himself. The earliest of his photographs, it is true, have aesthetic form; it is surprising to what an extent the photographer, entirely unconscious, at the time, of the laws of plastic representation, managed to make his prints three-dimensional, to interweave foreground and background. But as time passed, Stieglitz managed to press more and more power into his work without sacrificing its purity, to get greater and greater amounts out of line and form. More and more massive become the shadowed squares and oblongs. More and more weight he pressed into the forms, till in some of them we seem to feel the pressure of the whole weight of a man. Menhirs and monoliths design themselves clearly within the white mats; great coils of life lie brazen and terrible upon the walls. Some of the prints are like sculpture. Some recall flesh-polished ivory; others satin; others copper and silversmith work. Breasts and arms become like pieces of primitive sculpture, simple and gigantic. A head is heavy as a cannon-ball. Lines are elegant and sinuous as Ingres'; dramatic and vehement as Ingres' never are. Great simple rhythms co-ordinate the parts of the picture. In some of the later examples of his work, Stieglitz has achieved a sort of plastic polyphony; a counterpoint of great masses. A human force plays at ease within these limits; a man has been fully registered by a new art.

Not only what the industrial machinery was deemed incapable of doing, but what had hitherto, because it was thought only the human hand could move so finely, been given only the old rudimentary instruments, pencil and chisel and brush, to do that, so the mastery of Stieglitz definitely proves, can be done quite as well by the instruments that require only at intervals the application of the hand. The objects that, thanks to the liberality of Mr Mitchell Kennerly, hung before one at the Anderson Galleries, during the two weeks in February last, when some hundred and forty-five of his prints were exhibited, machine-made though they were, were an expression of life the like of which has scarcely before been made in America. Save for Whitman, there has been amongst us no native-born artist equal to this photographer. Indeed, it was a sort of Yankee Comédie Humaine that was crowded against the walls of the two rooms. Here, as scarcely ever before, one saw the quality of life in America as it has been lived during the last forty years. It is a record full of tragedy, full of suffering and defeat, and yet, marvellously and beautifully free of resentment, of bitterness, of egotism. An individual life has been used in making it, and yet has been used in the most selfless fashion. Only the human spirit speaks in this utterance; it lays before the eyes of all men facts arrived at with almost scientific objectivity, speaks as though it were all men speaking to all men, And through it we see—not Stieglitz, but America, New York, ourselves. After a short prelude, a European prelude with happy gentle children standing by the sides of old houses, sturdy peasants labouring in harvest fields amid golden grain, the pure snow-crags of the Swiss mountains, the curtain rises upon New York. There are people aplenty in the photographs taken by Stieglitz during his joyous *Wanderjahre* abroad. But the photo-

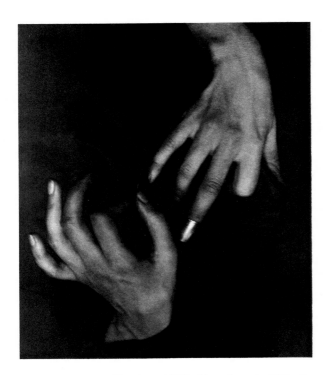

ALFRED STIEGLITZ. *Hands and Thimble—Georgia O'Keeffe.* 1920. Palladiotype. The Museum of Modern Art, New York.

Autograph note by Alfred Stieglitz on back of the mount of his photograph *Hands and Thimble—Georgia O'Keeffe.*

graphs of New York are well-nigh empty of human beings. If people appear in them at all, they are separated terribly from the photographer. A glittering hard white bridge thrusts back the nose-picking men and ape-mothers of The Steerage; the folk crowded in the yawning mouth of the ferry-boat are separated from the foreground by an abyss of water. Once in a while some simple workman, a street-cleaner, a horse-car driver, a teamster, is included. But generally, it is an inhuman world that is shown us. Stone-work vaults ambitiously 'gainst heaven, steam shoots forth white and shrill; far across a waste of water, a line of fairy towers design themselves against the sky; a lonely night stretches away blue and cold through the trees of snowy Central Park; a sapling tree stands tenuous and feeble in the drizzly light of April on Fifth Avenue. Where man should have been, there are only locomotives belching columns of filthy smoke, steel rails cutting sharply through the murk and smoky air, the heavy piles of giant office-buildings, the hard glitter of lit uncurtained office windows in the cold night. All life is ambitious, vaulting, hard.

People come into the photographs. The series of portraits begins; for during the years of the little gallery at 291 Fifth Avenue, something of what was human in New York began to take definite form. There were a few individuals, a few individuals fighting desperately for their lives. But what the photographs of the city

piles and railway yards revealed, is repeated, as in another key, in the portraits of the group of workers that centered in 291. Men these are, but men strangely tied, strangely contorted. They seem a new sort of fish peering through aquarium walls of glass. One, his neck wrapped in a muffler that is like a vice, gazes out of his shell in fright and in hopeless straining to be loosed. Another, a ghastly Greco whiteness on his shirt, sits in a chair as if that chair were the electric executor in the death-house at Sing-Sing. Another, a sort of young Albrecht Dürer, slumps dejectedly; still another peeps timidly and elfishly out of a silvery murk. Others seem pressed in upon themselves by black weights, sit folded up in themselves, hold up their heads into a white aureole of mad conceit, stand minuscule amid a debris of pictures, shoulder their ways ruthlessly and uncouthly, appear on the point of coming to pieces and drifting away into nowhere. Only one, a negro, gazes out in warm, unselfish devotion.

Once again, in still another way, perhaps in its most essential form, the same motif is repeated. The third great group of Stieglitz's photographs is chiefly the portrait of a woman, for what goes on in the outer world is active in its most naked form in the relation of the sexes, and what lies between men and women from moment to moment eventually comes to pass in mundane affairs. Here, symbolized by the head and body of a

216

A STATEMENT

THIS exhibition is the sharp focussing of an idea. The one hundred and forty-five prints constituting it represent my photographic development covering nearly forty years. They are the quintessence of that development. One hundred and twenty-eight of the prints have never before been seen in public. Of these seventy-eight are the work since July, 1918. Some important prints of this period are not being shown, as I feel that the general public is not quite ready to receive them. The fifty other prints never shown before were produced between the years 1908-1919. Of the earlier work I show but a few significant examples. With more the exhibition would become needlessly large.

The Exhibition is photographic throughout. My teachers have been life—work—continuous experiment. Incidentally a great deal of hard thinking. Any one can build on this experience with means available to all.

Many of my prints exist in one example only. Negatives of the early work have nearly all been lost or destroyed. There are but few of my early prints still in existence. Every print I make, even from one negative, is a new experience, a new problem. For, unless I am able to vary—add—I am not interested. There is no mechanicalization, but always photography.

My ideal is to achieve the ability to produce numberless prints from each negative, prints all significantly alive, yet indistinguishably alike, and to be able to circulate them at a price not higher than that of a popular magazine, or even a daily paper. To gain that ability there has been no choice but to follow the road I have chosen.

I was born in Hoboken. I am an American. Photography is my passion. The search for Truth my obsession.

ALFRED STIEGLITZ

PLEASE NOTE: In the above STATEMENT the following, fast becoming "obsolete", terms do not appear: ART, SCIENCE, BEAUTY, RELIGION, every ISM, ABSTRACTION, FORM, PLASTICITY, OBJECTIVITY, SUBJECTIVITY, OLD MASTERS, MODERN ART, PSYCHOANALYSIS, AESTHETICS, PICTORIAL PHOTOGRAPHY, DEMOCRACY, CEZANNE, "291", PROHIBITION.

The term TRUTH did creep in but may be kicked out by any one.

From the catalog of the exhibition of photographs by Alfred Stieglitz held at the Anderson Galleries, New York, 1921.

woman, herself a pure and high expression of the human spirit, there is registered something of what human life was, not only in America, but all over the globe, during the last few years; perhaps, also, something of what human life always is. Sometimes, it is a tree, a noble, dying chestnut, or a little apple tree standing pearled with raindrops in autumn wind-stillness and not a head or pair of hands or torso, that is used in these infinitely poignant, infinitely tragic, expressions. But whatever it is, woman or tree, it makes surge in us the same flood of wonderful and sorrowful emotion, the same tragic recognition. Feet are worn and crucified; hands stretch suffocatingly to the light falling through a window as aquatic plants waver to the surface of the water; a woman, pitiful resignation in her face, holds up her two hands in the effort to sustain life pure and intact, holds them as though she would forego all the world, give up all joy, all reward, if only it be granted her to keep ever fresh in her the sense of the wonder and of the tragedy of existence. A torso, the hip-bone a point of suffering, stretches itself in a parched and arid land; itself in Arizona, a waterless, verdureless, clime. A palm lies open, candid and generous, there is no concealment. A magnificent chestnut, a great powerful trunk of life, seared and gnarled, holds aloft its dying branches. Pain coils a human being in its brazen hell, as an arm coils about a recumbent form. Sorrowful and knowing eyes gaze out; the navel is a centre of anguish, the point of an anguish that eats away the life within; a human being at bay flares up like a lioness threatened; breasts hang tired and sensitive, sore from too much pain. A tiny phallic statuette weeps; is bowed over itself in weeping; while behind, like watered silk, there waves the sunlight of creation. A naked body, white cloths draping the arms, stands ecstatic in the window-light, greeting the light no man can see. Is it the call to death the releaser? Is it the piercing cry of the human being for the life of its soul? We cannot tell.

And in ourselves, too, confronted by these noble monuments, there surges a great yea-saying to life. We, too, before the works of this man who has included things great and small in his sympathy, who has accepted so freely his own moment, his own life, the pain as well as the beauty, of the world; we, too, find the will to accept to the utmost the present, even though it be the present of a turmoiled world, a raw America, to see what there is directly in front of us, to express ourselves in terms of our own time, to live in our own careers. It is not alone the fact that he has expressed us, and so communicated the impulse to create, that moves us so. The deep sense of inevitable inferiority that is entrenched so strongly in us all cannot remain where these things are. The conviction that the world is old, that man will remain always the slave of the machine, that America is foredoomed a blasted heath, a barren soil out of which no straight and robust and lofty form of life can grow; the conviction which appears to have been born in us all and which helps hold all of us back from building ourselves out, is seen, through these photographs, a stratagem of the sluggish human blood. Were there no other proof, these cool prints unaided would bear witness that the world is young; that the world is ever able to permit life to cease being mediocre, and to erect itself upon its surface in grand and high and tragic form. Were there no other, here would be proof abounding that America, or, for that matter, Kamchatka or Patagonia, can nourish the high and sober and serene arts of life richly, if only there are men present with a will to develop them. These photographs are the justification of today. It appears indeed as though Alfred Stieglitz, in setting himself free from the restless flux of mediocrity and chaos, and lifting himself to tragic heights, had provided a perennial means by which all others of his time, who so desire, can help free themselves for the life of the spirit, the life of art.

Photography

PAUL STRAND
1917

The last photographs published by Stieglitz in Camera Work *in 1916 and 1917 were by a newcomer, Paul Strand. They were views of New York that captured the "uproarious ways of the city" that Dixon Scott, the Liverpool critic of the preceding essay, found to be a chief function of the camera. Some were large heads of street people taken unawares. Some were bold semi-abstractions.*

*Stieglitz wrote of them: "The eleven photogravures in this number represent the real Strand. The photographer who has added something to what has gone before. The work is brutally direct. Devoid of all flim-flam; devoid of trickery and of any 'ism'; devoid of any attempt to mystify an ignorant public, including the photographers themselves. These photographs are the direct expression of today."**

Along with the photographs Stieglitz printed the following essay, which Strand had written for the periodical Seven Arts. *In it he describes the aesthetic based upon "the limitations and at the same time the potentials" of the photographic medium that he was to follow for the rest of his life.*

Photography, which is the first and only important contribution thus far, of science to the arts, finds its raison d'être like all media, in a complete uniqueness of means. This is an absolute unqualified objectivity. Unlike the other arts which are really anti-photographic, this objectivity is of the very essence of photography, its contribution and at the same time its limitation. And just as the majority of workers in other media have completely misunderstood the inherent qualities of their respective means, so photographers, with the possible exception of two or three, have had no conception of the photographic means. The full potential power of every medium is dependent upon the purity of its use, and all attempts at mixture end in such dead things as the color-etching, the photographic painting and in photography, the gum-print, oil-print, etc., in which the introduction of handwork and manipulation is merely the expression of an impotent desire to paint. It is this very lack of understanding and respect for their material, on the part of the photographers themselves which directly accounts for the consequent lack of respect on the part of the intelligent public and the notion that photography is but a poor excuse for an inability to do anything else.

The photographer's problem therefore, is to see clearly the limitations and at the same time the potential qualities of his medium, for it is precisely here that honesty no less than intensity of vision, is the prerequisite of a living expression. This means a real respect for the thing in front of him, expressed in terms of chiaroscuro (color and photography having nothing in common) through a range of almost infinite tonal values which lie beyond the skill of human hand. The fullest realization of this is accomplished without tricks of process or manipulation, through the use of straight photographic methods. It is in the organization of this objectivity that the photographer's point of view toward Life enters in, and where a formal conception born of the emotions, the intellect, or of both, is as inevitably necessary for him, before an exposure is made, as for the painter, before he puts brush to canvas. The objects may be organized to express the causes of which they are the effects, or they may be used as abstract forms, to create an emotion unrelated to the objectivity as such. This organization is evolved either by movement of the camera in relation to the objects themselves or through their actual arrangement, but here, as in everything, the expression is simply the measure of a vision, shallow or profound as the case may be. Photography is only a new road from a different direction but moving toward the common goal, which is Life.

Notwithstanding the fact that the whole development of photography has been given to the world through *Camera Work* in a form uniquely beautiful as well as perfect in conception and presentation, there is no real consciousness, even among photographers, of what has

Reprinted from *Seven Arts* 2 (August 1917), pp. 524-25.

**Camera Work*, no. 49/50 (June 1917), p. 36.

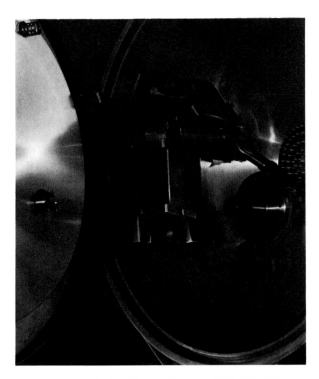

PAUL STRAND. *Motion Picture Camera.* 1923. The Museum of Modern Art, New York.

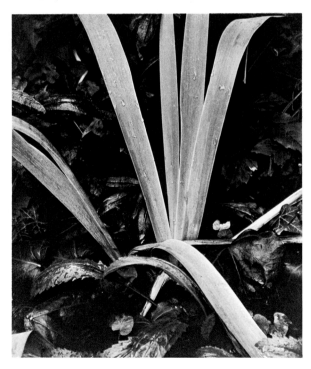

PAUL STRAND. *Iris Facing the Winter, Orgeval.* 1973. The Museum of Modern Art, New York.

actually happened: namely, that America has really been expressed in terms of America without the outside influence of Paris art schools or their dilute offspring here. This development extends over the comparatively

220

short period of sixty years, and there was no real movement until the years between 1895 and 1910, at which time an intense rebirth of enthusiasm and energy manifested itself all over the world. Moreover, this renaissance found its highest esthetic achievement in America, where a small group of men and women worked with honest and sincere purpose, some instinctively and a few consciously, but without any background of photographic or graphic formulae much less any cut and dried ideas of what is Art and what isn't; this innocence was their real strength. Everything they wanted to say, had to be worked out by their own experiments: it was born of actual living. In the same way the creators of our skyscrapers had to face the similar circumstances of no precedent, and it was through that very necessity of evolving a new form, both in architecture and photography that the resulting expression was vitalized. Where in any medium has the tremendous energy and potential power of New York been more fully realized than in the purely direct photographs of Stieglitz? Where a more subtle feeling which is the reverse of all this, the quiet simplicity of life in the American small town, so sensitively suggested in the early work of Clarence White? Where in painting, more originality and penetration of vision than in the portraits of Steichen, Käsebier and Frank Eugene? Others, too, have given beauty to the world but those workers, together with the great Scotchman, David Octavius Hill, whose portraits made in 1860* have never been surpassed, are the important creators of a living photographic tradition. They will be the masters no less for Europe than for America because by an intense interest in the life of which they were really a part, they reached through a national, to a universal expression. In spite of indifference, contempt and the assurance of little or no remuneration they went on, as others will do, even though their work seems doomed to a temporary obscurity. The things they do remain the same; it is a witness to the motive force that drives.

The existence of a medium, after all, is its absolute justification, if as so many seem to think, it needs one at all, comparison of potentialities is useless and irrelevant. Whether a watercolor is inferior to an oil, or whether a drawing, an etching, or a photograph is not as important as either, is inconsequent. To have to despise something in order to respect something else is a sign of impotence. Let us accept joyously and with gratitude everything through which the spirit of man seeks to an even fuller and more intense self-realization.

*The calotypes of David Octavius Hill and his collaborator, Robert Adamson, were all made between 1843 and 1848, the year Adamson died.

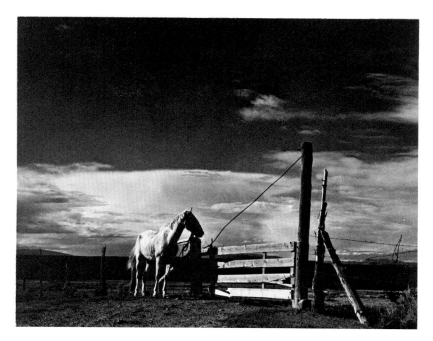

PAUL STRAND. *White Horse, Ranchos de Taos, New Mexico.* 1932. The Museum of Modern Art, New York.

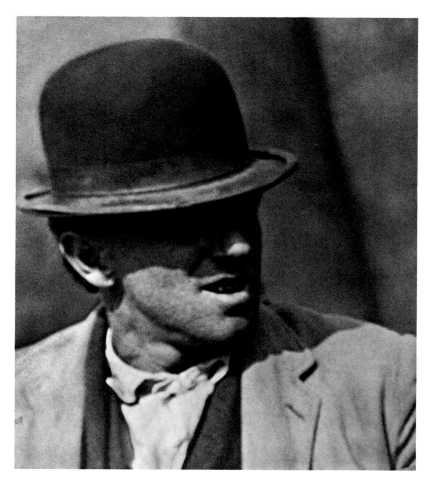

PAUL STRAND. Untitled. ca. 1915. The Museum of Modern Art, New York.

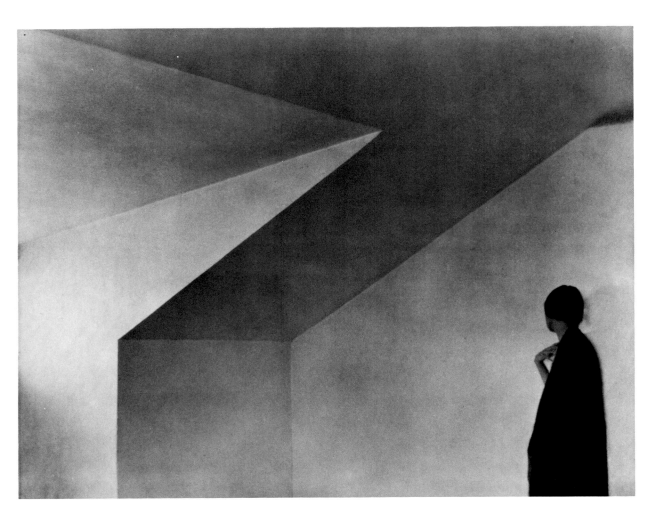

EDWARD WESTON. *Attic.* 1921. Platinotype. George Eastman House, Rochester, N.Y.

Random Notes on Photography

EDWARD WESTON
1922

The year 1922 was a formative one for Edward Weston (1886–1958). That fall he made the pilgrimage to New York to meet Alfred Stieglitz that he so movingly records in his Daybook.* *And en route he photographed the smokestacks of the Armco steel mills in Ohio with a new, strident vision. In June of that year he gave a lecture to the Southern California Camera Club. He sent a transcript of his manuscript to his friend Johan Hagemeyer, which we publish here exactly as typed. At the end of the typescript Weston penned the note:*

"—this is part of a 'lecture' I gave before the 'So. Cal. Camera Club.' I lack time to go over this so you will overlook mistakes—As you know my own habit is to use the dash—in preference to comma—but the 'stenog' could not get it through her head!"

Edward—6'22

Already Weston had formulated his philosophy of what he later called previsualization: "I see my finished platinum print on the ground glass in all its desired qualities, before my exposure...."

Art is an end in itself, Technique a means to that end: one can be taught, the other cannot, for it is that quality which we bring into the world with us, and lacking it as an integral part, no amount of study will enable one to acquire it. One may achieve a certain understanding and appreciation through study and schools, but no creative ability. But technique, one cannot emphasize too greatly the importance of technique, for no matter how great the desire, no matter how fine the innate sensitiveness, without technique, that "means to an end," one must continually falter and stumble and

Reprinted from the original typescript in the Edward Weston/Johan Hagemeyer Collection, Center for Creative Photography, University of Arizona. By permission of the University of Arizona and the Estate of Edward Weston.

*Nancy Newhall, ed., *The Daybooks of Edward Weston, Vol. I, Mexico.* (Millerton, N.Y.: Aperture, 1973), pp. 4-8.

perhaps collapse in a mire of unrealized aspirations, so turning to the camera as the first step toward realizing our desires in Photography, the camera, that "wonderful extension of our own vision," the vision of each one of us, whether it be with filmy eyes or intense penetration, we must absolutely understand the importance of mechanical efficiency in its operation. Of course, I am speaking primarily of the camera as used in portraiture, for one may blunder around in land-scape work, trying the swings this way and the lens that way, but not in portraiture, and here I will suggest that a few of the many thousand "Pictorialists" who are making pretty landscapes, done a thousand times before, and better by the etcher or painter, might turn their energies and talents to experimenting in portraiture to great advantage, for it is in portraiture and figure studies that photography's opportunity lives. Nature, pure and unaided by man, is usually chaotic. The painter can eliminate or combine to suit his fancy. The photographer can too, by messing around with a lot of Gum Arabic and paint and brushes, while destroying at the same time photography's chiefest charm, its subtle rendering of textures and the elusive qualities in shifting lights and shadows.

But returning to portraiture. Only the photographer can register what lies between himself and the object before his lens at a given moment in time, catch fleeting facial expressions, sudden twitching smiles, momentary flashes of anger and pain, or arrest apparently insignificant motions of the hands sewing, gestures of the hands posed fitfully on the breast, motions of hands peeling apples, and all the many vital instants of life which "affirm the majesty of the moment."

And now this brings us back to technique and our present consideration. Mechanical efficiency in the use of the camera is of very great importance, for how is one to record this vast kaleidoscope of human emotions with the slightest mechanical hesitancy in focusing, or in judgment as to lens, aperture, or in the correct use of the swings. Indeed, all these, besides accurate exposure, must be so well known that they are as automatic as breathing.

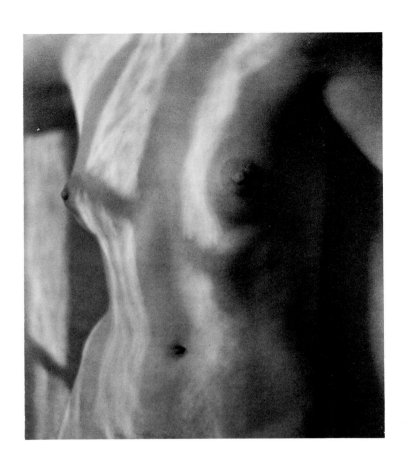

EDWARD WESTON. *Reflected Sunlight on Torso.* 1922. Platinotype. The Museum of Modern Art, New York.

Douglas Donaldson suggested to me that modern workers are too anxious for novelty—making something different from the other fellow—rather than doing over and over some theme of their ancestors to ultimate perfection as do the Chinese or Japanese. Yes and also no. We do strive too hard for novelty, but let us have fresh vision. The themes and life of this day require their own technique and presentation, and here steps in the new and vital medium of expression, typical of the day, and as Laurvik* said to me. "The most valuable medium through which our present age can be portrayed—Photography—that wonderful extension of our own vision." But it takes a big man to admit photography's value. Laurvik, Bernard Shaw, Stieglitz, Maeterlink, Whistler, Albert Sterner have all contributed their word of approval, while most of the half-baked photographers stand gaping in awe at the shrine of the painter or sculptor—apologetic and imitative, not big enough to grasp Photography, not understanding its limitations or own peculiar beauties.

Surely never have words more pregnant with understanding, stating so clearly the inherent qualities, the

essential values of photography—been used as by Paul Rosenfeld in his article "Stieglitz" in "The Dial," April 1921—and he reaches his climax of comprehension when he speaks of photography as "An affirmation of the majesty of the moment." The whole paragraph which I shall quote,† is a poetically rendered, deeply felt summing up of Photography's place in the realm of creative mediums—and what the Photographer must be and feel and understand if he be worthy of his medium. I know in which pictures I have felt this "Majesty of the Moment" most keenly—those pictures in which, when the fleeting instant was before me and recognized, I was breathless with anxiety and excitement lest I fail to seize and record it for all time. Oh, well do I know whether my exposure has brought to me a living, quivering picture, tremendously vital in its acknowledgement of life, or whether my camera has merely recorded my own uninterested or uninspired outlook. Yes, I know this at the very instant of exposure. Here I will quote from the article on "Stieglitz." . . .†

Perhaps more than in any other creative work, the

*J. Nilsen Laurvik, director of the San Francisco Museum of Art.

†The passage Weston read to the audience is not included in the typescript. However the paragraph referred to can be found on page 210.

greatest photographers must be "intuitives." How fatal it is in photography to be uncertain, to have to stop and study over an arrangement or lighting. Success in photography, portraitures especially, is dependent on being able to grasp those supreme instants which pass with the ticking of a clock, never to be duplicated—so light, balance—expression must be seen—felt as it were—in a flash, the mechanics and technique being so perfected in one as to be absolutely automatic. For instance the length of exposure to give should be another sense, never a calculation. I see my finished platinum print on the ground glass in all its desired qualities, before my exposure—and the only excuse I make for after manipulation, shading, dodging, retouching is the possibility of loosing a different position of expression by the delay in correcting some minor fault. I have thought for long I must give the boys a training in photography—no matter what their life work is to be. What amazingly fine education this continued search for the very quintessence of life—the poetry of being—to have to seize unhesitatingly and make final at once in the silver emulsion—not to be changed as a painter can—one's recognition of the climax.

Schools for technique are what we need—schools where discipline and application are taught—schools where the mind acquires the habit of thinking, and where the hands are taught to obey and carry out one's desires. Art—that either comes or does not come. It cannot be taught. It is what we bring with us when we come into this world—and we carry it along to a definite conclusion only if we are willing to sweat—sweat blood and die hard.

An artist's work is influenced by his surroundings—his material at hand. But perchance my walls are bare and Whistlerlike—my work therefore possessing sometimes a suggestion of his qualities—the critics, "Those cut-throat bandits on the road to fame," will say, "Oh—he is influenced by Whistler or Japanese prints or whatnot." Now I do not protest against any intimated influence, but I do say that mostly the artist takes the customs and types of the day—ugly or fine—and recreates them in his fancy. The architecture of the age, good or bad—showing it in new and fascinating aspects. It would seem as though the greatest work from those who paint, etch or photograph—must come from ugly or sordid surroundings—or at least from surroundings not too near a completion of grandeur—for one feels the artist's greater achievement when a New York slum—in all its sordidness—is raised to a glorification of reality—while the most serious interpretation of, for instance the "Taj Mahal" would not be likely to stir one intellectually nor emotionally—for one has the realization that the build-ing is already an end in itself—not to be used as a basis for further interpretations.

XYZ, author of several books on photography—also once much heralded Pictorial photographer—now scarcely heard of—states that Photography must have the "Vitalizing influence of the hand." This is the remark of a "dub"—Devitalizing—texture destroying—prostituting, I would say—in re the hand. Photography is a medium destroyed in value through manual interference—a medium so subtle that providing one is equally keen—the most profound instants—the finest nuances of light and shade may be captured in the magic silver, and at the very instant desired—not when memory has to rebuild—perhaps crudely—the past. XYZ's remark is that of a visionless person—unequal to grasp or understand the real possibilities of his craft—let him paint! Photography is too difficult to become master of except by a most sophisticated mind.

It is only through the ability to recognize an important attitude—gesture or expression—in one's sitter that any worthwhile result is achieved in portraiture. To wait—to be keenly sensitive to changing light and shadow—flow of line—characteristic posture—these are the important things. When I hear of a Photographer planning his sitting in advance, where this will go—where that will be placed—even to the extent of drawing a diagram—I know the results will be stillborn—lifeless—expressing nothing. To wait patiently—suggesting changes if necessary—without the subject's guessing why—to be exceedingly receptive to each important moment—with eyes open intelligently—comprehensively—these are all significant hints towards a successful portrait or rendering of a mood. Of course these suggestions are worthless to one without real penetration of vision—no picture will be conceived greater than one's mentality—so you Iowa farmers—back to the plow for a few more generations!

Last summer Mr. G. called on me, purchasing two prints to start a collection of my work. I afterward had repeated to me his conversation with Mr. B., of a Los Angeles book shop, in which he called me a "photographer's photographer," "a superb technician." So I have been termed before—and my technique is fine and sufficient to carry out my present desires—but the technique seen in my work is not the result of a profound knowledge of chemistry or optics—it is rather from an intimate understanding of light, and the ability to reproduce that understanding in my negative, through an instinctive feeling for correct exposure, a sense not given to all photographers—an intuitive sense. Again what is known as my "fine technique" is simply an intelligent awareness of values and textures, and the power of

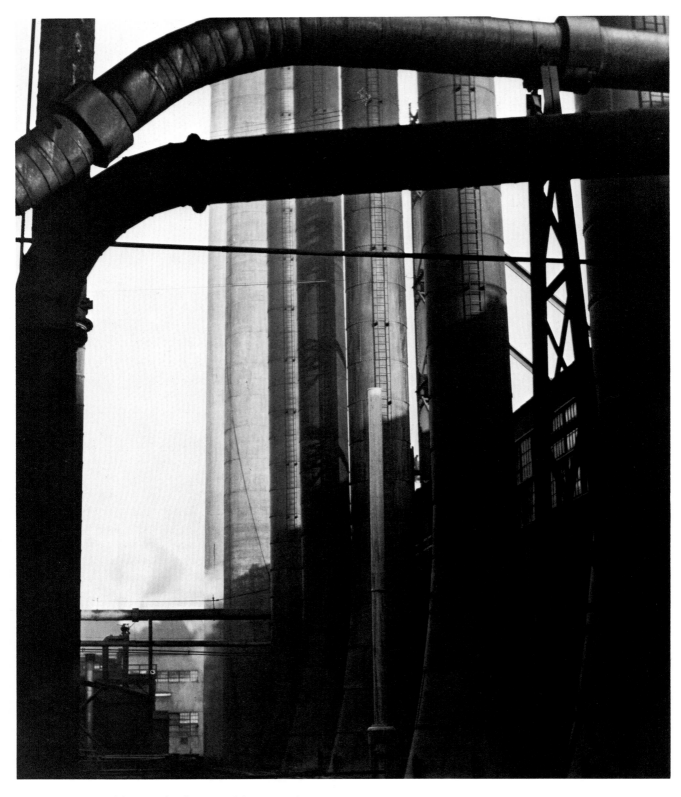

EDWARD WESTON. *Armco Steel, Ohio.* 1922. Platinotype. The Museum of Modern Art, New York.

translating the image on my ground glass through comprehensive focusing and instinctive exposure—into my silver emulsion—thence on into the development of the latent image and the final printing in platinum. No secret developers are mine, nor lenses nor printing papers. Only a fine feeling for the subtleties of light and shade and their relativity, the separation of planes relevant to the desired result and the excellent rendering of textures in a suitable medium. These are what others note as my "technique."

And here seems to be an opportune place to record some personal observations to me from J. Nilson Laurvik, director of the San Francisco Museum of Art—and one of the finest critics in America today, with a reputation for being fearless and outspoken in his opinions. I met Laurvik first at the convening of the jury for the first Oakland Salon of Photography, later at an exhibit—at which time I asked him if I might show him a few of my prints. He did not know my work but was at once agreeable—and invited me to tea in the Palace of Fine Arts. Before meeting Laurvik, I spent a couple of hours at the Roerich* Exhibit—and I felt almost apologetic over my own work—being so overwhelmed with the wonder of Roerich—and so I expressed myself to Laurvik—who rather berated my lack of faith in photography—exclaiming "Do not feel that way. Photographs may be very refreshing for a change." In looking over my prints—Laurvik was most sensitive as to whether any real feeling, intellectual or emotional, had been sensed at the time of exposure. He unerringly picked out those which had real intent or those which were forced—lacking in spontaneity—or reminiscent of another medium or the past. His final scrutiny was invariably the *print quality*—which delighted me. "Fine thing." "Great feeling," he would exclaim, "And now let us see the print quality." He liked my attic series very much. . . .

I recall a few remarks from Laurvik on photography: "Photography is the most valuable medium we have to express our own time." "Your photographs (this as he looked them over) are more stimulating, more imaginative, more refreshing, than most of the work in that show in the other room of the San Francisco Art Association." "Some day photographs by the masters of the craft will be prized and valued as a Rembrandt or Whistler etching is now." "I would rather be photographed than painted, and some of the best men have painted me." "Photography is simply a marvelous extension of our own vision." "If I had my way, photographers should never be allowed to see paintings."

"Never read your press notices."

A few quotations from that amazingly fine book on "Cubists and Post Impressionism," by Eddy:† "It is the 'ist' who is always blazing a trail somewhere. He may lose himself in the dense undergrowth of his theories, but he at least marks a path others have not trodden." "Art thrives on controversy—like every human endeavor. The fiercer the controversy, the surer—the sounder—the saner the outcome." "It is characteristic of the little man to ridicule everything he does not understand—it is characteristic of the great man to be silent in the presence of what he does not understand." The whole book is stimulating and one might quote page after page.

I must conclude—after all—that my ideals of pure photography—unaided by the hand—are much more difficult to live up to in the case of landscape workers—for the obvious reason that nature unadulterated and unimproved by man—is simply chaos. In fact, the camera proves that nature is crude and lacking in arrangement, and only possible when man isolates and selects from her. The etcher or painter have all the best of it in this, with their power of selection and culmination—while the photographer—in trying to eliminate objectionable items from his negatives—is usually destructive to the finest qualities in his medium. One has only to scan exhibition walls to conclude that most photographic landscapes, unless they be mere fragments, could have been better done using some other medium. This being so, they should never have been made at all. The conclusion from all this must be that photography is much better suited to subjects amenable to arrangement or subjects already co-ordinated by man. Pictures of the tremendous industries of our day—pictures drawn from out the whirl of our seething maelstrom of commercialism—and of course—portraiture. I am convinced that no other means of expression has, or will, approach photography in grasping the very essence of man. At least the opportunity is in Photography and awaits the genius behind the camera. There have been keen analysts of humanity who have recorded quite brilliant characterizations with the camera—but lacking in pictorial rendering—and there have been those whose work showed fine perception of rhythm and balance and values —but considered as portraits, as likenesses—were sterile. So to combine pictorial qualities and likeness is the real achievement. Few, only a handful, even less than that, are doing this. (I am one of them!) ‡

*Nikolay Roerich (1874-1947), Russian landscape painter and stage designer.

†Arthur Jerome Eddy, *Cubists and Post-impressionism* (Chicago: A. C. McClurg, 1914).

‡This phrase is crossed out on the typescript.

The Work of Man Ray

ROBERT DESNOS
1929

The Surrealist poet Robert Desnos (1900–1945) was a friend of the American painter and photographer Man Ray (1890–1976). Both were active members of that group of artists and writers in Paris who founded the Surrealist movement in the 1920s. Man Ray was a pioneer in making photographs without a camera by placing small objects on sensitized paper then exposing it to light, thus securing shadowgraphs. He named these semi-abstractions "Rayographs." He also experimented with partially reversing the tones in photographs by exposing the prints to light during development. This phenomenon, known to scientists as the Sabattier effect, is usually called "solarization."

Our only exploration of the Universe has been with the aid of senses corrupted by prejudice. Our vision of the world when reduced to its minimum is the same as that of the most primitive missing link: doubtless the blind fish in the depths of the ocean constructs his mythology among the aromatic sea-weed in spite of the entire collection of gods which man strives to force from matter. With the awakening of our senses, we decreed that chaos had been dispersed. But there are other forms of chaos surrounding us and we have no way of dividing these into water, air, earth or fire. There is an infinity of senses which we lack. The conquest of just one of them would revolutionize the world more than the invention of a religion or the sudden arrival of a new geological era.

As a matter of fact, we have not complete mastery of our five delicate receptors, despite the experience of many thousands of years. Dreams, for instance, which depend essentially on sight and what we call optical illusions, because the camera does not capture them, are entirely outside that control which man pretends to exercise over all that surrounds him.

A famous captain ordered his soldiers to strike the enemy on the navel: another on the hair and another

the left wrist. But the poet knows well that there are no premature corpses (all deaths are anonymous).

It would be, in my opinion, renaturing the significance of the Universe that Man Ray suggests to me, were I to dwell on the figuration of dazzling elements in his work; for he reveals a land that is as tangible and, for the same reasons, as indisputably material as light, heat or electricity.

A painter, Man Ray gives greater thought to the chess game of the spirit than to that of painting. He speculates on the slightest move of the obelisk or on Marcel Duchamp's throat. The spirals twine in and out like supple brains, but not a single point obeys the attempt to straighten out their straight-line curves in order to designate an illusory winner in the lottery or, more illusory still, an hour. He arrives between two shocks of an earth-quake, stops creation on the peak of a plunge, immediately before the return to the normal position. He catches faces at that fugitive moment between two expressions. Life is not present in his pictures and still there is nothing dead about them. There is a pause, a stop, only: Man Ray is the painter of the syncope.

A sculptor, he demands that the most iron bound laws take a direction outside the realm of chisels. He abandons marble and granite to grave-stones and clay to shoe-soles; for him other plastic materials are necessary in order to realize, in space, constructions that are independent of their resistance to human forces. The mysterious physical knows little difference between the fragility of paper and the solidity of porphyry. If it were pleased to do so, it would endow the former with vigor and the latter with a mobility that fears liquids. Weight, at its solicitation, would transform a lampshade into a sort of spiral more sensitive than a seismograph or a weather vane condemned by some whimsical meteorologist to confinement in space under a muted crystal bell.

A photographer, Man Ray derives neither from artistic deformation, nor from the servile reproduction of "nature." Your planes and humps will reveal to you a person you do not know, and whom you have never dared

Reprinted from *Transition* 15 (February 1929), pp. 264-66. Translated by Maria Mc D. Jolas.

"A Comb Entering the Gyroscope"—
a delicate and finely patterned ab-
stract study in white, gray and black

"Imitation of the Gyroscope by the
Magnifying Glass, Assisted by a Pin."
Note the contrasts of light and shade

*M*AN *Ray—the well-known American painter now
living in Paris and closely allied with the modern
school of French art—has recently been experimenting
along new lines with the artistic possibilities of photo-
graphy. These "rayographs", as he calls them, are
made, without the aid of a camera lens, by interposing
the objects photographed between the light, which is
made to fall upon them in a certain way, and a sheet
of sensitive paper. Jean Cocteau, the French critic,
has written of these prints that they are "meaningless
masterpieces,in which are realized the most voluptuous
velvets of the aquafortist. There has never been any-
one else who has been able to produce anything like
this scale of blacks sinking into each other, of shadows
and half shadows? He has come to set painting free
again. His mysterious groups are infinitely better than
any of the ordinary still-lifes which attempt to conquer
the flat canvas and the elusive mud of the colors."*

A Torn Letter, a Spool of Wire and
a Watch Fob—a full and curiously
satisfying photographic composition

"Composition of Objects Selected with
Both Eyes Closed." This suggests the
modern artistic passion for machinery

A New Method of Realizing the Artistic Possibilities of Photography

Experiments in Abstract Form, Made without a Camera Lens, by Man Ray, the American Painter

MAN RAY. Page from *Vanity Fair*, November 1922. Courtesy of *Vanity Fair*, The Condé Nast Publications Inc.

glimpse in your dreams. A new "you" will spring from the delicate hands of the chemist in the red glow of the laboratory. It will bat its eyes out in the open air, the way night birds do.

There does not yet exist a word for the designation of Man Ray's invention, these abstract photographs in which he makes the solar spectre participate in adventurous constructions. As children we used to cut out our hands imprinted on citrate paper* exposed to the sun. Proceeding from this naïf process, he thus succeeded in creating landscapes which are foreign to our planet, revealing a chaos that is more stupefying than that foreseen by any Bible: here the miracle allows itself to be captured without resistance and something else, besides, leaves its anguishing thumbprint on the revelatory paper.

That sentimentality, which dishonors nearly everything man touches, is barred. An attentive chloroform will communicate to you the metaphysical anguish without which there is no dignity on earth. If you are able to abandon terrestial conceptions, you will penetrate into a world having neither longitude nor latitude, into a bit of that infinite which, open to a few, is the most moving excuse that the modern epoch could give for its productive aptitude.

Like the famous monk who, far from the Eucharistic boons, established the presence of thunder in a mixture of sulphur and saltpetre, Man Ray does not calculate, or predict the result of his manipulations. In his wake we will go down these toboggans of flesh and light, these vertiginous slopes and we will hunt the keys of

*A type of photographic paper that darkens on exposure to light, without the need for development.

partly glimpsed cellars. A clown in his paper veinstone heavier than lead, makes far-off signals. But we hold the miraculous between the sides of this sheet of paper, just as we hold it everywhere we want it to be; great imaginary maelstrom that hollows itself and offers us its bouquet of vertigo.

But we dare not lose ourselves bag and baggage therein despite the reiterated calls of our likeness in the depths of the water. Tomorrow you will read in the newspapers a fully detailed account of the crime, with proofs to back it up: finger prints and anthropometric photographs. You may nevertheless be sure that we will not agree as to the significance of this black or colored type: these letters and these pictures.

It is of little importance to me whether the conception of Man Ray is superior or inferior to his realization. Beginning with the moment when I agree to consider it, I have the same rights over his work that he has. Except when my door is tightly closed, those I am fond of know how to get it open. The exegesis has yet to irritate many creators. Seeing their work get away from them, they can't restrain a sentiment of property, that master of mediocre souls. If the reasons given by a spectator for the justification of a work are superior to those of the author, the spectator becomes the legitimate possessor of the work he is discussing. But the attitude of Man Ray lets us understand no such conflict. It guarantees for him supremacy in his own province. Behind his persistent silence it pleases me to see the partial beatitude of those who have received a revelation. Whatever his initiation may have been, Man Ray derives from poetry and it is in this capacity that I have lived today on his domain, which is as wide open as Eternity.

A New Realism—The Object:
Its Plastic and Cinematic Value

FERNAND LÉGER
1926

Like so many other painters of the 1920s, Fernand Léger (1881–1955) was greatly attracted to film; his Ballet mécanique *is a classic. Unlike most commercial film-makers, however, he recognized that the power of the camera fairly overwhelms the performance of the actor. Here he suggests using photography to isolate an object or a fragment of an object and to present it enlarged and in closeup.*

Every effort in the line of spectacle or moving picture, should be concentrated on bringing out the values of the object—even at the expense of the subject and of every other so called photographic element of interpretation, whatever it may be.

All current cinema is romantic, literary, historical expressionist, etc.

Let us forget all this and consider, if you please:

A pipe—a chair—a hand—an eye—a typewriter—a hat—a foot, etc., etc.

Let us consider these things for what they can contribute to the screen just as they are—in isolation—their value enhanced by every known means.

In this enumeration I have purposely included parts of the human body in order to emphasize the fact that in the new realism the human being, the personality, is very interesting only in these fragments and that these fragments should not be considered of any more importance than any of the other objects, listed.

The technique emphasized is to isolate the object or the fragment of an object and to present it on the screen in close-ups of the largest possible scale. Enormous enlargement of an object or a fragment gives it a personality it never had before and in this way it can become a vehicle of entirely new lyric and plastic power.

I maintain that before the invention of the moving picture no one knew the possibilities latent in a foot—a hand—a hat.

These objects were, of course, known to be useful—they were seen, but never looked at. On the screen they can be looked at—they can be discovered—and they are found to possess plastic and dramatic beauty when properly presented. We are in an epoch of specialization—of specialties. If manufactured objects are on the whole well realized, remarkably well finished—it is because they have been made and checked by specialists.

I propose to apply this formula to the screen and to study the plastic possibilities latent in the enlarged fragment, projected (as a close-up) on the screen, specialized, seen and studied from every point of view both in movement and immobile.

Here is a whole new world of cinematographic methods.

These objects, these fragments, these methods are innumerable—limitless. Life is full of them. Let us see them on the screen.

The point is to know how to "exploit" them—the point is to find out the right way of using them. It is more difficult than it seems.

To get the right plastic effect, the usual cinematographic methods must be entirely forgotten. The question of light and shade becomes of prime importance. The different degrees of mobility must be regulated by the rhythms controlling the different speeds of projection—*la minuterie*—the timing of projections must be calculated mathematically.

New men are needed—men who have acquired a new sensitiveness toward the object and its image. An object for instance if projected 20 seconds is given its full value—projected 30 seconds it becomes negative.

A transparent object can remain immobile, and light will give it movement. An opaque object can then be moved in rhythm with the tempo of the transparent object. In this way an enormous variety of effects can be achieved by the use of totally different objects having in themselves absolutely no expression, but handled with understanding and knowledge. Light is everything. It transforms an object completely. It becomes an independent personality.

Take an aluminum saucepan. Let shafts of light play upon it from all angles—penetrating and transforming

Translation reprinted from *The Little Review,* Winter 1926, pp. 7-8.

BRETT WESTON. *Hand and Ear.* 1928. The Museum of Modern Art, New York.

AUGUST SANDER. *The Right Eye of My Daughter Sigrid.* 1926. The Museum of Modern Art, New York.

232

RALPH STEINER. *Typewriter*. 1921-22. Courtesy of the artist.

it. Present it on the screen in a closeup—it will interest the public for a time, yet to be determined. The public need never even know that this fairy-like effect of light in many forms, that so delights it, is nothing but an aluminum saucepan.

I repeat—for the whole point of this article is in this: the powerful—the spectacular effect of the object is entirely ignored at present.

Light animates the most inanimate object and gives it cinematographic value.

This new point of view is the exact opposite of everything that has been done in the cinema up to the present. The possibilities of the fragment or element have always been neglected in order to present vague moving masses in the active rhythm of daily life. Everything has been sacrificed for an effect which bears no relation to the true reality. The realism of the cinema is still to be created— It will be the work of the future.

EUGÈNE ATGET. *Balcon, 17 rue du Petit Pont.* 1912-13. The Museum of Modern Art, New York.

Eugène Atget

BERENICE ABBOTT
1929

*It is to the distinguished documentary photographer
Berenice Abbott (born 1898) that we owe our first
appreciation of Eugène Atget (1857–1927) as a great
photographer whose vision went far beyond his specialty:
pictures of Old Paris. While an apprentice at the studio
of Man Ray in Paris, she met Atget, was entranced by
his photographs, and made portraits of him. Unfortu-
nately he never saw them, for when she brought them to
his apartment to show him she found that he had died.
With determination she purchased, with the help of
Julien Levy, all the negatives and prints left in his
apartment/workshop after his death. She learned the
little that we know of his life, she was the first to write
of him as an important photographer, and she preserved
the collection until its acquisition by The Museum of
Modern Art. We have chosen less well-known images of
Atget from the Abbott-Levy Collection to accompany
this early appreciation.*

It is not profitable to discuss whether or not photog-
raphy may be an art. Results will speak in due time.
Indeed the expression that this medium affords is so
utterly new that some time must elapse before we con-
quer our surprise. In looking at the work of Eugène
Atget, a new world is opened up in the realm of creative
expression as surely as the cotton gin awoke a sleepy
world to the vista of industrialism, or the once forbidden
tomato brought new delights to our palate.

Nadar is probably the only early photographer of
significance—but the work of Atget has been of far
greater importance in revolutionising photography. He
is the modern forerunner in the sense that hitherto that
medium had been used as a small trade for very limited
purposes. Photographers were petty tradespeople ekeing
out an existence from the daily, sordid tasks of making
all men look important and all women look beautiful—
and press photography. A few pathetic souls engaged
their spare time in making "artistic pictures."

Reprinted from *Creative Art* 5 (September 1929), pp.
651-56.

Atget was not "aesthetic." His was a dominating pas-
sion that drove him to fix Life. With the marvellous lens
of dream and surprise, he "saw" (that is to say, photo-
raphed) practically everything about him, in and outside
Paris, with the vision of a poet. As an artist he saw ab-
stractly, and I believe he succeeded in making us feel
what he saw. Photographing, recording life, dominating
his subjects, was as essential to him as writing to James
Joyce or flying to Lindberg.

We know very little about his life except that he was
from Bordeaux. An orphan, he was raised by an uncle
and when a young boy shipped at sea as a cabin boy.
Approximately from the age of 20 to 35 he was an
actor, playing in small theatres of the provinces. He
was not considered handsome enough to play the hero,
but was contented playing for the most part rôles of the
villain or "troisième rôles." However, the monotony and
lack of monetary remuneration caused him to look for
new fields. He had also now a wife to support, a woman
ten years older than himself, who had played with him
in the theatre and who became his sole companion.

With meagre economies they went to Paris. Atget had
many friends who were painters and with his innate
pictorial sense he undoubtedly considered becoming one
of them. He had already the desire to create a collection
of everything in and near Paris which was beautiful,
curious, historical. Immense subject! How can anybody
but a photographer hope to-day to fix for posterity the
image of the modern city? Fortunately for him and for
us his instincts were very sure. He decided to photograph.

His apparatus was rudimentary, large, heavy. A simple
rectilinear lens, the cheapest he could buy, became the
"eye" of this prodigious photographer. It was slow but
penetrating. His plates were large and heavy, and each
time a picture was taken a tripod was erected. His scheme
was laboriously and slowly carried out. This man of
violent temper and of absolute ideas had all the patience
of a saint with his photographing. No time was too long
to spend over a print, no material too good. Vain to
add that this métier paid only with misery. The last
twenty years of his life he ate nothing but bread, milk,

EUGÈNE ATGET. *St. Cloud.* 1921. The Museum of Modern Art, New York.

and pieces of sugar. He was as absolute in his art.

He arose at daybreak and having studied his light departed—everywhere, it would seem. His instincts led him into very strange places where apparently nothing commanded interest. He was rebuffed, suspected, "he was a spy" or "he was a lunatic." His early hours helped to avoid antagonistic and stupid people and the moving objects encountered later in the day. His instruments were little adapted to any scenes of action except in the brightest light.

When the question of selling his pictures arose, difficulties began. But one day Luc-Olivier-Merson, designer of the French hundred franc note, bought a print for fifteen francs. Atget, encouraged, was saved. Vic-

torien Sardou* indicated to him houses, sites, chateaux, hovels that were about to disappear. The miseries and treasures of Paris were equally photographed by Atget, her monuments, her old churches, Parisian types, little occupations, the rag pickers' quarters, the fairs, shop windows, boulevard scenes, the farthest streets, the humblest homes, interiors of all types of houses, the most astonishing of which are of the "petty bourgeois" type. There is an astonishing series of the vehicles of Paris including the market gardener's cart, the barrow of the laundryman, funeral coaches, milk wagons, prison wagons, omnibuses of the 1890's drawn by horses. There

*Victorien Sardou (1831-1908), French playwright.

EUGÈNE ATGET. *Avenue des Gobelins.* ca. 1925. The Museum of Modern Art, New York.

EUGÈNE ATGET. *Porteuse de Pain.* 1899-1900. The Museum of Modern Art, New York.

are also the wagons of the coal dealer, the plasterer, the brewer, cabs, hansoms, etc. Almost more than any other subject he photographed trees—hundreds of trees and flowers and plants—carefully detailed, in "close-ups." He knew all their names and wrote on each print the name of the tree.

Architectural subjects also drew his eye. There are few types of doorways of interest that his lens has not registered, nor did he miss the court-yards, so much a part of Paris. Of equal interest are his grilles, balconies and stairways. Among the other series are to be found decorative motives, religious art, fountains, and finally there are the street scenes, the river views, old and new Paris! The boutiques make up the most astonishing and

original series. Anybody who knows Paris knows how bizarre, naïve delightful, relentlessly individualistic these shop fronts can be. All the traces of the French race and spirit seem to be imbued in these curiously human mani-festations.

His important work is the result of his mature years, after the age of thirty-five until his death. He became more and more stooped from the dreadful weight of his camera which he took out with him up to his last year. His face became more and more that of a tired actor, which I had the honour of photographing, shortly before his death. He did not live to see the result. He died August 1927. And I think with his purpose fulfilled.

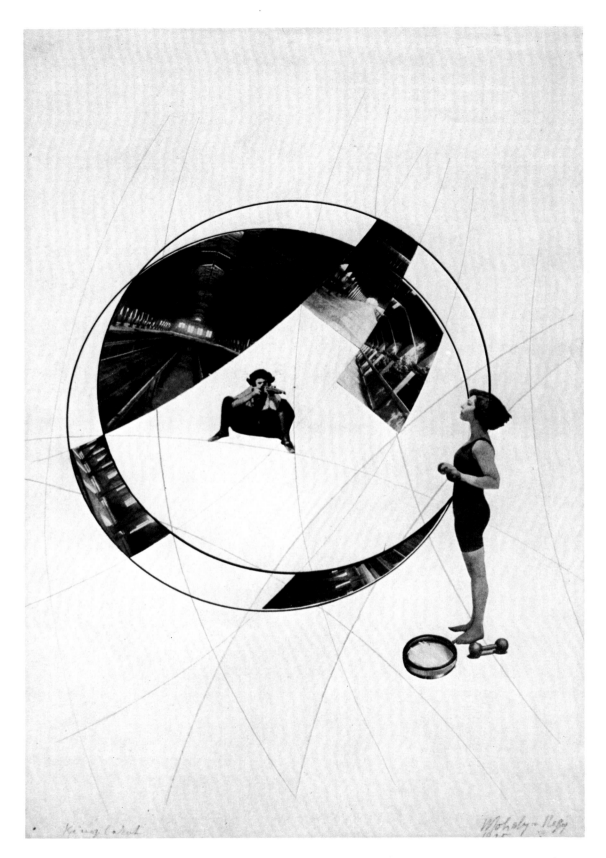

LÁSZLÓ MOHOLY-NAGY. *Love Thy Neighbor.* 1925. Photomontage. The Museum of Modern Art, New York.

The Future of the Photographic Process

LÁSZLÓ MOHOLY-NAGY
1929

László Moholy-Nagy (1895-1946), Hungarian-born Constructivist abstract painter, became interested in the aesthetic potenials of photography in Berlin around 1920. He soon found that the camera could be used as a tool for the visual discovery of forms, and that rich abstract designs could be made without a camera by placing objects both opaque and translucent in contact with photographic paper and exposing the arrangement to light. He began making these "photograms," as he named them, at the same time that Man Ray was producing his somewhat similar "Rayographs." From 1923 to 1928 Moholy-Nagy was a master at the Bauhaus in Weimer and Dessau, the most progressive art school in Germany. It was there that he wrote his classic book, Painting, Photography, Film *(1925). This essay is an excellent summary of his theories.*

The creative utilization of new perceptions and principles will eleminate the idea that photography is not an "art." The human spirit always produces for itself fields of activity, wherever it can become creatively expressive. Thus we shall soon see a big impetus in the domain of photography.

Photography as a presentational art is not merely a copy of nature. This is proven by the fact that a "good" photograph is a rare thing. Among millions of photos which appear in illustrated newspapers and books you will find only occasionally a really "good photograph." The strange thing in this, proving our case, is the fact that after a long cultivation of the optic sense, we infallibly and instinctively, choose the "good" photos independent of the novelty or the unknown quality of the "thematic" idea. A new feeling is developing for the light-dark, the luminous white, the dark-grey transitions filled with liquid light, the exact charm of the finest textures: in the ribs of a steel construction as well as in the foam of the sea—and all this registered in the hundredth or thousandth part of a second.

Reprinted from *Transition* 15 (February 1929), pp. 289-93. Translated from the German by Eugène Jolas.

Since light phenomena generally produce higher possibilities for differentiation in motion than in a static state, all photographic processes attain their climax in the film (motion-relation of light-projections).

Film activity up till now has been mainly limited to the reproduction of dramatic actions, without exploiting the possibilities of the photographic apparatus in a creative-compositional sense. The apparatus as a technical instrument and as the most important productive factor of film composition, copied "in naturam" the objects of the world. That must be considered; but up till now that has been considered too much, with the result that other essential elements of film composition have not been sufficiently refined. The perfection of *form,* of *interpentration,* of *light-dark relations,* of *movement,* of *tempo!* By neglecting these we lost the possibility of developing a brilliant usage, in film conceptions, of the objective elements, and remained, in general, glued to the reproduction of nature and stage presentations.

Most men to-day have a view of the world dating from the period of the most primitive steam-engine. The modern illustrated newspapers are still reactionary when measured by their immense possibilities! And what educational and cultural work we could and must perform! Communicate the marvels of technology, of science, of the spirit! In big things and little things, far and near! There are doubtless in the fields of photography a whole series of important works which mediate the inexhaustible wonders of life. Up till now this has been the task of the painters of all ages. A number of them, however, are already recognizing the inadequacy of the old presentational means. Thus it is that many an effort in painting to show the things of the world objectively, has become an important advance for the mutual relations between photography and the composition of painting. The reproduction of to-day's standard forms in such pictures, however, will appear as crude attempts at representation when the right utilization of photographic material begins, in the most delicate tones of grey and brown, in the faint enamel effect of the luminousness of photographic glazed paper. When photography comes

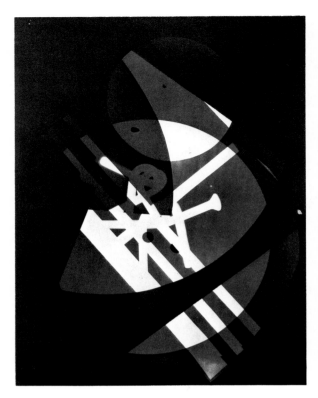

LÁSZLÓ MOHOLY-NAGY. Photogram. 1926. George Eastman House, Rochester, N.Y.

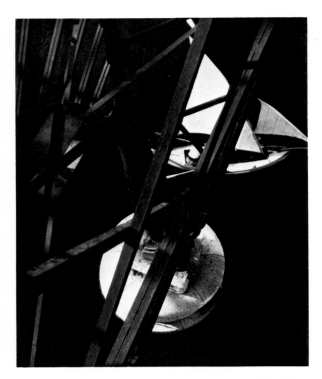

LÁSZLÓ MOHOLY-NAGY. *From the Transporter Bridge, Marseilles.* 1929. George Eastman House, Rochester, N.Y.

into the full knowldege of its real laws, the composition of representation will be brought to a height and perfection which can never be attained by manual means.

It is still revolutionary to proclaim a basic enrichment of our optic organ with the aid of changed compositional principles in painting and the film. Most men still cling too much to an evolutionary continuity of the manual-imitative *ad analogiam* classical pictures, so that they are unable to conceive this complete change.

But he who is not afraid to take the inevitable path of tomorrow will find for himself the basis of a really creative work. The clear recognition of the means will allow him to follow mutual suggestions in the composition of photography, or the film, as well as in compositional-painting, (also objective). I myself, through my photographic work, have learned a great deal for my painting, and reversely, problematic positions of my pictures have very often given me suggestions for photographic experiments. It is true in general that imitative painting, rooted in the historic, will, through colored (and tonal) composition in the film, liberate itself with increasing certainty from the presentation of objective elements in favor of pure color relations; and the role of the real or super-real or utopian presentation and reproduction of the object—which was the task of painting until recently—will be taken over by photography (or

the film) which, in its methods, is organized with precision.

It would be a fatal error now to weld a totality from this beginning phase—for photography as well as for the abstract picture; this would also be underrating the future possibilities for synthesis, which will surely look different from what we might predict now. An intuitive and logical examination of the problem makes also possible the recognition that the mechanical-optical color-composition—color photography, or film, will lead to entirely different results than today's light and other kinds of exposures. There will then be no trace of the trashy color sentimentality of this subjection to nature. Color photography as well as sound-pictures and opto-phonetic composition will be placed on a perfectly new and healthy basis, even if the experiments are to spread over a century.

The possibilities of utilizing photography are already innumerable, since through it the crudest and the finest effects of light values—later on also of color values—can be obtained. Such as:

Registration of situations, of reality;

Combining and projecting upon another and next to each other; Interpenetration; Organizable scenic intensifications; superreality, utopia and jest (this will be the new joke!)

Objective, but also expressive, portraits;

Advertising methods; bill posters, political propaganda;

Compositional methods for photo-pictures, i.e. photographs instead of the text;

Typophotos;

Compositional methods for absolute abstract light projections in planes or space;

Simultaneous Movies, etc. etc.

The reproduction of various movements in their dynamism also belongs with the possibilities of the film; scientific and other observations of a functional chemical kind; reduced and magnified time exposures; the film newspaper projected by wireless; and, in consequence of the utilization of these possibilities, the development of pedagogy, criminal lore, the entire news service, etc. What a surprise, for example, if we were to film a man every day, beginning with his birth, until his death in old age! It would surely be something of a shock if we could witness, in the space of five minutes, on his face alone, the slowly changing expression of a long life, his growing beard, etc.; or else the active statesman making a speech, the musician, the poet, animals etc. in their life functions; the deepest inter-relations are thus revealed through microscopic visions. *Even with a right understanding for the material, speed and distance of thinking are not adequate for foreseeing all the possibilities of development.*

To illustrate the idea of photoplasticism: these photo-plastic studies—composed of various photographs—are an experimental method of simultaneous presentation; compressed interpenetration of the visual and the verbal jest; a weird linking with the imaginary of the most real, imitative means. But at the same time they may tell a story, and be of solid quality; more true "than life itself." This work which today is still done by hand, we will soon be able to produce mechanically with the aid of projections and new methods of copying.

This is already the case, at least partially, in the development of the film to-day: irradiation, transmission of one scene into another, copying of various scenes one on top of the other. The variable placing of the iris and other dark lanterns can be used to connect parts of events, which in themselves are not connected, through a common rhythm. You simply put a fragment in the movement with an iris-lantern and open the new one with the same means. We can establish a unity of impression with productions which are divided in horizontal or vertical stripes or are lifted half-way upward; and many other things besides. Of course, we shall be able to do more with new methods and instruments.

The present method of cutting out, arrangement side by side, the fatiguing organization of photographic proofs, shows a superior form in contrast to the early pasting work of the Dadaists. But only through mechanical construction and development along big lines will photography and the film realize the marvelous possibilities for effect which are inherent in them.

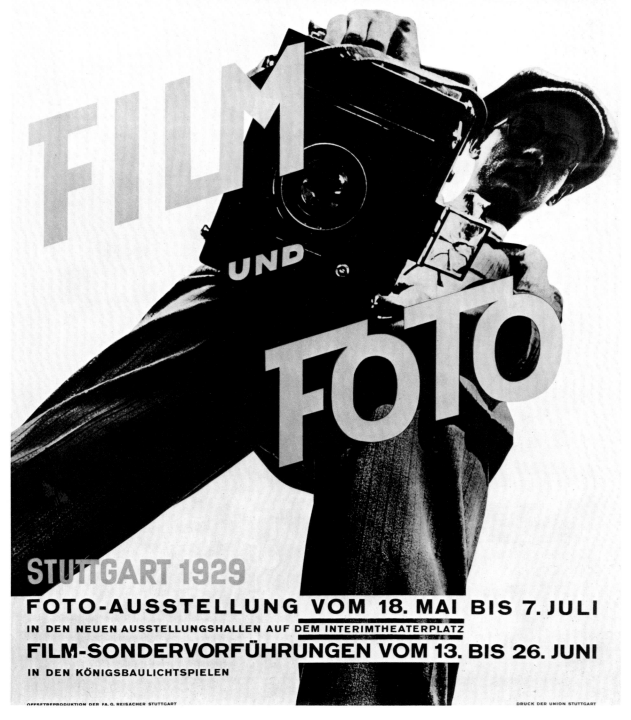

Poster for the international exhibition "Film und Foto," organized by the Deutsche Werkbund in Stuttgart. 1929. Der Staats-galerie, Stuttgart. The man with the Debrie Parvo motion picture camera is Mikhail Kaufmann, brother of Dziga Vertov, who directed the 1926 film *Man with a Movie Camera*.

The International Exhibition "Film und Foto," Stuttgart 1929: A Portfolio

In 1929 the prestigious German guild of progressive artists and architects who called themselves the Deutsche Werkbund turned their attention to photography and held in the municipal exposition building of Stuttgart a mammoth international exhibition. The catalog lists 977 titles, but since many of the entries refer to unitemized groups of photographs, the total far exceeded that figure. The vast exhibition was circulated to other European cities and created a sensation wherever it was shown. Like the 1910 Photo-Secession exhibition in Buffalo, New York, FIFO—as it came to be called—summed up a period that, because of the political upheaval and the oncoming war, was soon to come to an end in Europe. On the following pages we reproduce eight of the photographs that were selected for catalog illustrations and the poster of the exhibition.

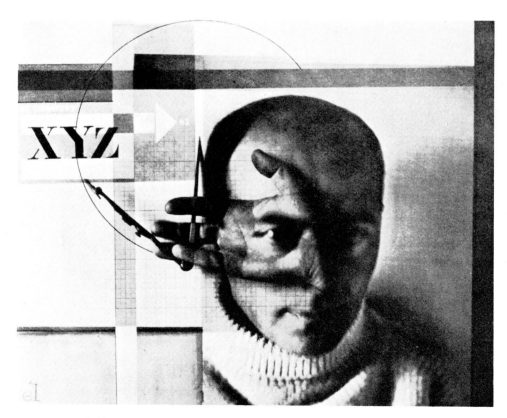

EL LISSITZKY. *Self-Portrait.*

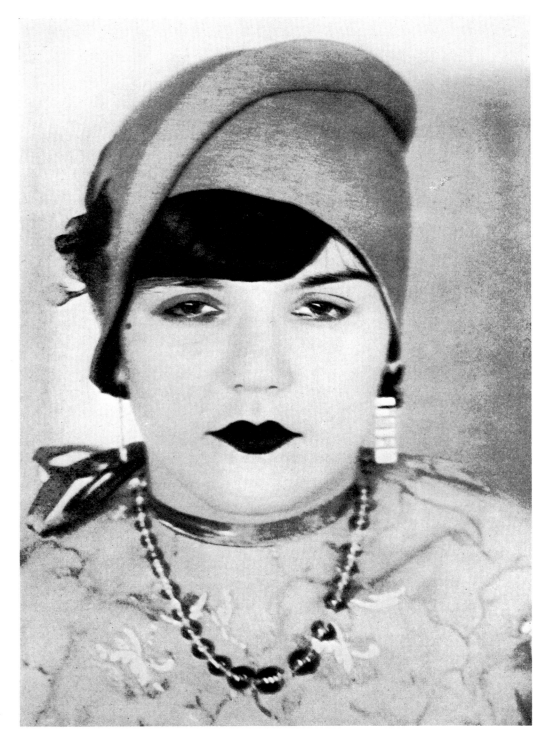

WALTER PETERHANS. Portrait.

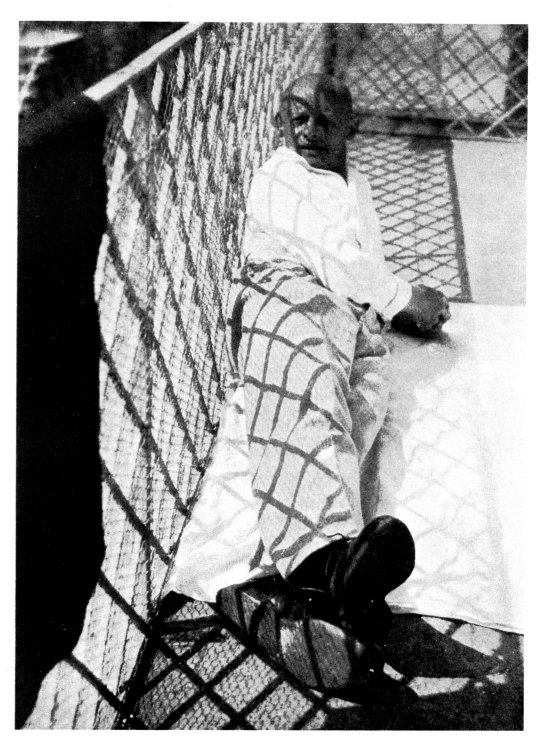

LÁSZLÓ MOHOLY-NAGY. *Oskar Schlemmer.*

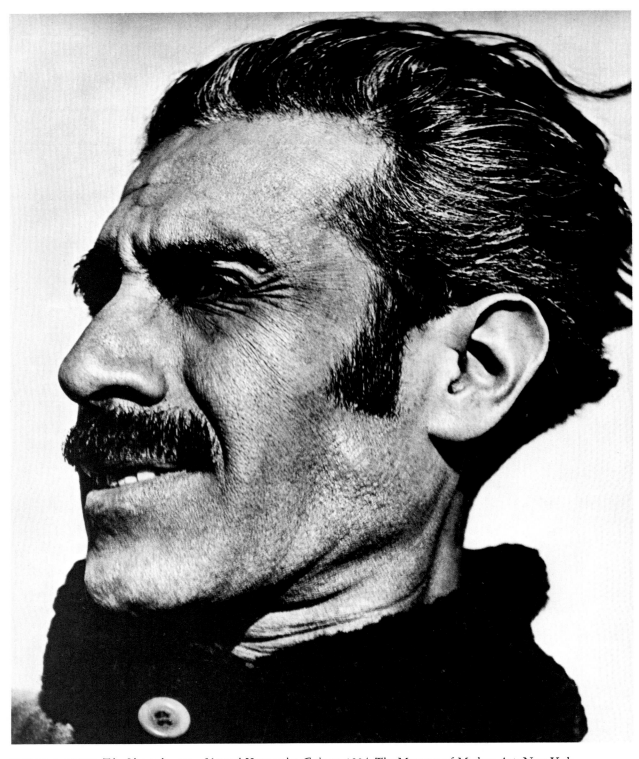

EDWARD WESTON. *The Sharpshooter—Manuel Hernandez Galvan.* 1924. The Museum of Modern Art, New York.

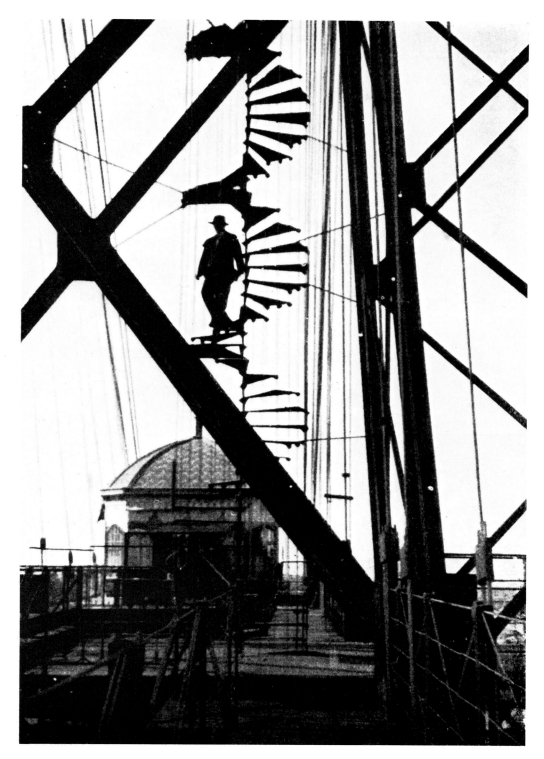

HERBERT BAYER. *Spiral Staircase, Marseille.* ca. 1928.

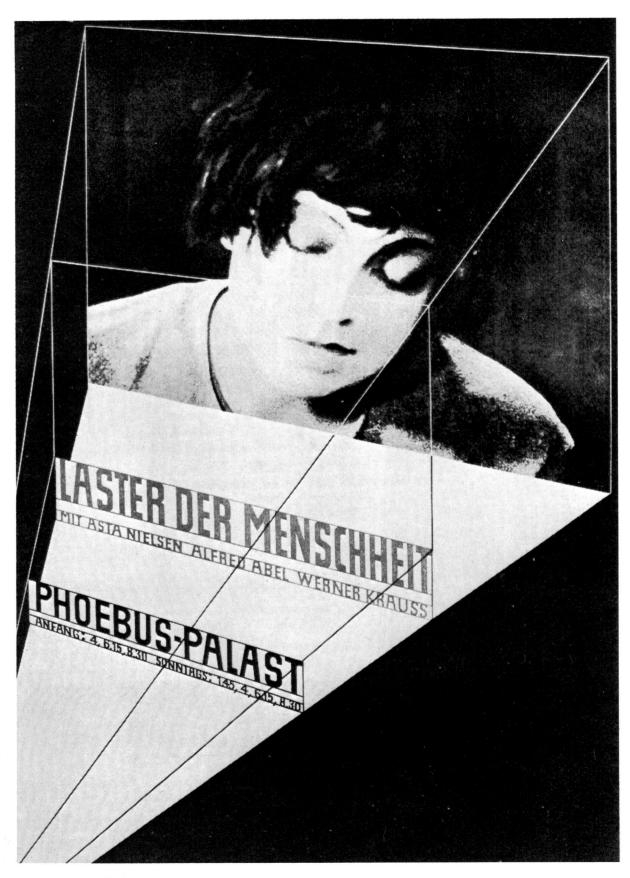

JAN TSCHICHOLD. Film poster.

248

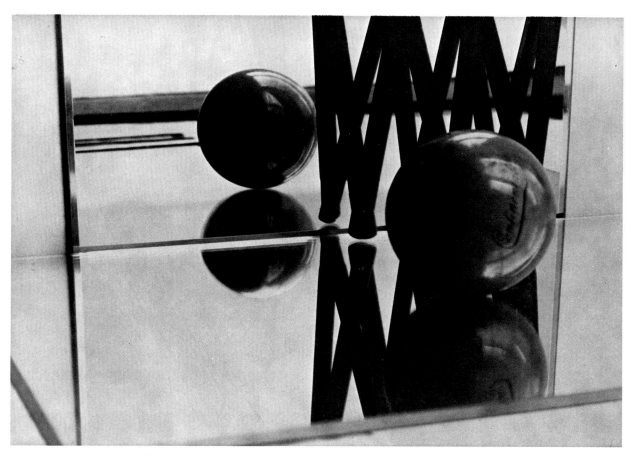

FLORENCE HENRI. *Composition no. 76.* 1929. The Museum of Modern Art, New York.

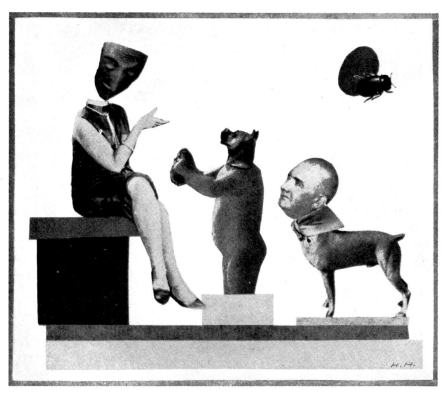

HANNAH HÖCH. *The Cocotte.*

GROUP ƒ.64

FROM TIME TO TIME VARIOUS
OTHER PHOTOGRAPHERS WILL
BE ASKED TO DISPLAY THEIR
WORK WITH GROUP ƒ.64

THOSE INVITED FOR THE FIRST
SHOWING ARE:

PRESTON HOLDER
CONSUELLA KANAGA
ALMA LAVENSON
BRETT WESTON

GROUP

(ANSEL EASTON ADAMS
IMOGEN CUNNINGHAM
JOHN PAUL EDWARDS
SONYA NOSKOWIAK
HENRY SWIFT
WILLARD VAN DYKE
EDWARD WESTON)

ANNOUNCES AN EXHIBITION
OF PHOTOGRAPHS AT THE
M. H. DeYOUNG MEMORIAL MUSEUM
FROM NOVEMBER FIFTEENTH
THROUGH DECEMBER THIRTY-
FIRST, NINETEEN THIRTY-TWO

Announcement for the group ƒ. 64.

Group f.64

JOHN PAUL EDWARDS
1935

The term "f.64" is a technical one: it is the measure of the effective diameter, or aperture, of a photographic lens in terms of its focal length. Thus when the variable diaphragm of a lens of, say, ten inches focal length is reduced to the marking of f.64, the working diameter is 1/64 of 8 inches or 1/8 inch. It is an axiom that the smaller the effective diameter of a lens, the greater its depth of field: objects both near and far can be brought to sharp focus. The technical term f.64 was chosen by a group of photographers in California as the name for an informal society dedicated to what they often called "pure photography," since their most basic tenet was that every part of a photograph must be in sharp focus. Other rules: use the largest possible camera; print invariably on smooth, glossy paper; trimming, retouching, or other handwork is not admissable; and mount the print on a white card. "Pure photography" was a reaction to the latter-day pictorialism that followed the demise of the Photographic Salon of London and the Photo-Secession in America; it was a time when the weakest of soft-focus pictures of the most banal subject matter and obvious composition were being widely exhibited and published. John Paul Edwards (1883–1958), a founding member of Group f.64, describes its formation, and four other founders—Edward Weston, Ansel Adams (born 1902), Willard Van Dyke (born 1906) and Imogen Cunningham (1883–1976), make statements of their attitude toward "photographic purism."

In August 1932 a group of photographic purists met informally at a fellow worker's studio for a discussion of the modern movement in photography.

All present had sympathetic ideas and ideals regarding the importance of the pure photography movement. It was felt that these kindred interests could be fostered to mutual advantage by the formation of a small active working group. Such a group was formed and given the significant, albeit provocative title, Group f.64. A group this, without formal organization or by-laws, officers, or titles, but strongly bound by appreciation of pure photography as a medium of personal expression.

The original membership of Group f.64 consisted of Edward Weston, Ansel Adams, Imogen Cunningham, Willard Van Dyke, Sonya Noskowiak, Henry Swift, and John Paul Edwards. Recently, Dorothea Lange, William Simpson, and Peter Stackpole have been added to the group.

The purpose of Group f.64 is not militant. It has no controversy with the photographic pictorialist. It does feel however, that the greatest aesthetic beauty, the fullest power of expression, the real worth of the medium lies in its pure form rather than in its superficial modifications. Photography per se has inherent fine qualities which are never lost, though sometimes momentarily forgotten. The modern purist movement in photography, emphasized by the work of Group f.64 presents nothing essentially new, but is a definite renaissance.

Periodically, the history of photography has been colored by new phases of a nature so fleeting that they must be classified as momentary fads. Most of them have left, in material degree, no influence upon photography. Witness the vogues which have in turn intrigued the worker: the soft focus lens, carbon, carbro, gum, bromoil, bromoil transfer, faint grey monotone printing, or its counterpart, stygian blackness, and what not. The superficial character of these phases is proved by the fact that they seemed so important at the time, and now are almost forgotten.

A brief word as to the methods and working equipment of the group:

Generally speaking, a view camera on a study tripod is favored for landscape and still life subjects. The camera should have a full range of adjusting movements. Any lens of suitable focal length anastigmat or even a good rapid rectilinear may serve well. A great investment in fine optical equipment is quite unnecessary unless one so desires. For portrait photography, the camera used in most cases is the Graflex.

For negative use, the super speed panchromatic film,

Reprinted from *Camera Craft* 42 (March 1935), pp. 107-108, 110, 112-13.

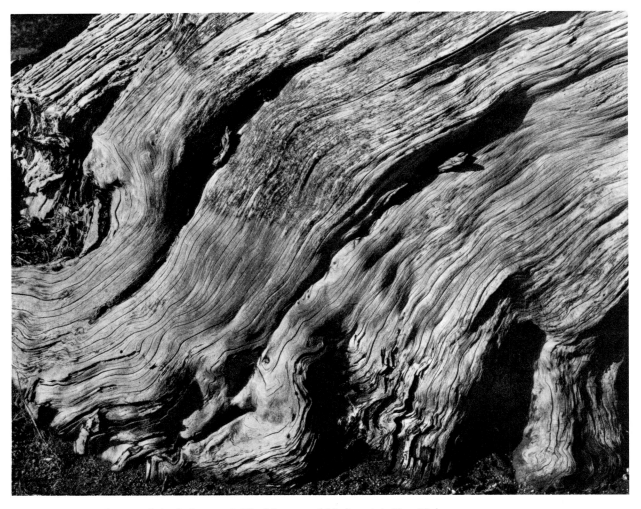

EDWARD WESTON. *Cypress, Point Lobos.* 1929. The Museum of Modern Art, New York.

and the film more recently offered, Panatomic. The Pyro-Soda developer indicated by the manufacturer is the most generally accepted. K1 and K2 color filters provide an ample range of color correction for nearly all subjects.

As a printing medium, glossy papers more correctly present the value of the negative, and give a depth and richness of tone utterly lost on matt surface papers. An unobtrusive plain white mount is more desirable for these prints, and a dry mounting press is quite necessary for satisfactory mounting. Group f.64 feels as a basic principle, the ever present importance of striving to achieve the most perfect technique possible within the limitations of the respective instrument used.

That we might view this subject from varied personal angles, I have requested and here present statements from four of the original members of the group regarding their individual approaches to photography:

EDWARD WESTON

To QUOTE Edward Weston: (From "Photography," by

Edward Weston, copyright 1934, Esto Publishing Co.)

"Both the limitations and the potentialities of a given medium condition the artist's approach and the presentation of his subject matter. But limitations need not interfere with full creative expression; they may, in fact, by affording a certain resistance, stimulate the artist to fuller expression. The rigid form of the sonnet has never circumscribed the poet. In the so-called limitations of its means may be discovered one of photography's most important and distinguishing features. The mechanical camera and indiscriminate lens-eye, by restricting too *personal interpretation,* directs the worker's course toward an *impersonal revealment* of the objective world. "Self-expression" is an objectification of one's deficiencies and inhibitions. In the discipline of camera-technique, the artist can become identified with the whole of life and so realize a more complete expression.

"An excellent conception can be quite obscured by faulty technical execution, or clarified by faultless tech-

252

nique. Look then with a discriminating eye at the photograph exposed to view on the Museum wall. It should be sharply focused, clearly defined from edge to edge, from nearest object to most distant. It should have a smooth or glossy surface to better reveal the amazing textures and details to be found only in a photograph. Its value should be clear cut, subtle or brilliant, never veiled. This in brief is a pattern to work to."

WILLARD VAN DYKE

"I BELIEVE that art must be identified with contemporary life. I believe that photography can be a powerful instrument for the dissemination of ideas, social or personal. I believe that the photo-document is the most logical use of the medium."

ANSEL ADAMS

"I CONSIDER the production of Group f.64 as definitely transitional in character. I define *transitional* in regard to point-of-view—aesthetic and social. I believe we have obtained a fairly final expression of mechanical technique (in reference to the present development of the medium), and I think our next step should be the relation of this technique to a more thorough and inclusive aesthetic expression.

"Our work has been basically experimental. In our desire to attain a pure expression in our medium we have made powerful attacks in various directions, stressing objective, abstract, and socially significant tendencies. These phases of our work should now be taken from the laboratory (along with our technical attainments) and functionally applied. I have always disagreed with an *obvious* approach to the above phases: I have argued that a basic aesthetic motivation was sufficient in all forms of art, and that this motivation, when applied to a definite functional problem, became in itself socially significant.

"I feel we have taken upon ourselves an obligation to photography and to art in general, which we must always accept as a basis of our production. We have done truly important work in the re-establishment of the pure photographic medium as a form of Art; how important our contribution is only the future can reveal.

"With this conviction in mind, I maintain that we can never lose sight of the transitional character of our present work. The comment I receive most often on Group f.64 is one of positive opinion that we have established a school—a technical ritual—and that we are active in maintaining the *status quo*. We have become an *institution* in the mind of the photographic public; a rather disturbing and radical institution,—and our chief task at present will be to keep the prestige we have

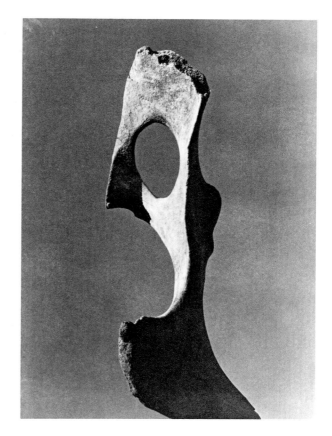

WILLARD VAN DYKE. *Whalebone and Sky.* ca. 1932. The Museum of Modern Art, New York.

ANSEL ADAMS. *Boards and Thistles.* 1932. The Museum of Modern Art, New York.

253

IMOGEN CUNNINGHAM. *Two Callas.* ca. 1929. The Museum of Modern Art, New York.

developed and at the same time expand in fresh and stimulating directions.

"We have built up a host of imitators who, in the main, have merely extracted surface aspects—detail, glossy papers, white mount-boards, forced view-points, etc.—and are confident that they have achieved the quality of a Weston in so doing. Sad but true, most of this work is little better than average from any standards, and the most unfortunate element therein is the sense of false values established in the photographer himself. He seldom realizes that photography is not the result of any one, or of several, formulae or taboos; the ultimate aspect of the truly fine photograph is derived only from the comprehension of detailed elements in relation to basic conception. What photography seriously requires is adequate criticism on its own terms.

"One of our major achievements is the exposition of the fact that diverse personal tendencies can be expressed through a similar approach to the medium (technically and intellectually). We have interpreted our respective points of view in a consistent purity of technique and aesthetic conception. Our ultimate objectives of expression are not identical by any means. The variety of approach, emotional and intellectual,—of subject material, or tonal values, of style—which we evidence in our respective fields is proof sufficient that pure photography is not a *metier* of rigid and restricted rule. It can interpret with beauty and power the wide spectrum of emotional experience."

IMOGEN CUNNINGHAM

"PHOTOGRAPHY began for me with people and no matter what interest I have given plant life, I have never totally deserted the bigger significance in human life. As document or record of personality I feel that photography isn't surpassed by any other graphic medium. The big discussion as to whether it is an art or not was settled for me as well twenty years ago by many writers in Stieglitz' publication "Camera Work" as it is to-day. Lewis Mumford says there are fewer good photographers than painters. There is a reason. The machine does not do the whole thing."

A Personal Credo

ANSEL ADAMS
1943

This article was written by Ansel Adams in June 1943. It was an important year for him. In April he had resigned as instructor at the Art Center School in Los Angeles, where he had developed the zone system of exposure control, because he was unhappy with the school's emphasis upon commercialism. He was looking forward to a period of reconsideration, consolidation, and creative activity. World War II was raging; the atmosphere was unsettling and baffling. Ansel Adams was greatly affected. He wrote from his residence in Yosemite National Park to his friend David H. McAlpin, "I want to be of some creative use, to do something which will help get this war over with. I do not need to wear a uniform, hold a title, strut, or wield authority. I just want to photograph the things I can photograph best, and turn them to maximum use." The Navy had taken over the Ahwanee Hotel; trainees were marching 105 miles through the Valley, and Ansel photographed them at set points, providing prints for the National Park Service, for the War Department and—at 15 cents each —for the men, which he turned out by the thousand in his Yosemite darkroom. He then worked for the Office of War Information with Dorothea Lange, documenting the Italian colony in San Francisco for a publication in Italy. But these assignments did not fill the need he felt to affirm through photography "the enormous beauty of the world," thus "achieving an ultimate happiness and faith." Just as "A Personal Credo" appeared in print, he was given an opportunity to photograph the Japanese-American community set up by the War Relocation Authority in the California desert at Manzanar. The result was the book Born Free and Equal, *containing splendid photographs of the natural environment and sensitive portraits of the Japanese-Americans, young and old, who although citizens of the United States, were forced to abandon their homes and their occupations for the duration of World War II.*

Reprinted from *The American Annual of Photography for 1944* 58 (Boston: American Photographic Publishing Co., 1943), pp. 7-16.

It is difficult to evaluate the status of contemporary photography apart from the fields of war activity. The war, of course, utilizes practically all available materials, leaving little for the amateur or professional—to say nothing of the most important ingredients, time and inclination. Yet, within the war effort, apart from the enormous amount of purely technical application, there exists a vast opportunity for important documentation, and for propaganda, reportage, and the purely expressive aspects of the art. The sheer practical urgency of the times will probably inhibit much of the personal forms of photography, but it will be a matter of lasting regret if the greatest moments of the tremendous human upheaval are not recorded as only the camera is capable of doing. As an organized approach to this inclusive documentation is probably impossible now, it will be necessary to rely on high editorial ability to selectively collate the myriads of photographs which will be produced by the armed forces, by industry, and by the social service organizations.

The world of commercial photography must carry on as best it can. In the advertising fields there seems to be less emphasis on immediate selling and more on institutional good-will, the latter bearing a sharp eye on the post-war world. I feel there will be, however, a decided difference between the pre-war and the post-war world, and those who are patiently awaiting a resumption of the old ways will be rudely disillusioned. I know that professional photography will survive and tremendously expand but many of its present aspects will change. The salons will carry on, too. In this, and other fields as well, the restrictions will probably be healthy, as reduced output seems complementary to intense expression. As for "the independents"—their situation is unpredictable, but I am confident that any man having something to say will find a way to say it.

Documentation—in the present social interpretation of the term—will burst into full flower at the moment of peace. Herein lies the magnificent opportunity of all photographic history. Here is where the camera can be related to a vast constructive function: the revelation

ANSEL ADAMS. *Leaves, Glacier National Park, Montana.* 1942. Courtesy of the artist.

of a new world as it is born and grows into maturity. I believe that the highest function of post-war photography will be to relate the world of nature to the world of man, and man to men.

It is easy to rest upon the vague security of words; the terms "beauty," "dignity," "spirituality" and "function" are but symbols of qualities, and are vulnerable to connotations. Let us hope that categories will be less rigid in the future; there has been too much of placing photography in little niches—commercial, pictorial, documentary, and creative (a dismal term). Definitions of this kind are inessential and stupid; good photography remains good photography no matter what we name it. I would like to think of just "photography"; of each and every photograph containing the best qualities in proper degree to achieve its purpose. We have been slaves to categories, and each has served as a kind of concentration camp for the spirit. The function of a photograph may be of the simplest practical nature, or it may relate to a most personal and abstract emotion; the sincerity of intention and the honesty of spirit of the photographer can make any expression, no matter how "practical," valid and beautiful. What is required is an underlying *ethic* and sensitivity to the important and true qualities of the world in which we live. No man has the right to dictate what other men should perceive, create or produce, but all should be encouraged to reveal themselves, their perceptions and emotions, and to build confidence in the creative spirit.

The frantic concentration on volume and on the spectacular in the modern commercial world has most certainly inhibited simple and direct personal expression. The forces of demand are powerful, and it is seldom that the creative person has the opportunity to contribute his own qualities of perception and emotion in the face of accepted patterns of thought and interpretation. The advertising photographer "adjusts" himself to his client; the competitive salon photographer often thinks more of acceptances and awards than of his own inner creative convictions; people are given what they want (which may mean that they continue to get only what they already have). I believe the people want, and can appreciate, far more than they have been given. The style of the popular publications is apparently profitable—hence it must be "right." I dispute this—not in fact, but in principle. I have faith in people and believe it is our fault if we have not touched them with the best we have to give. The agents who *presume*, and the readers who *accept* will be influenced to the greatest extent by consistently superior work on our part. If all photographers could but realize the ultimate importance of a high *ethic*

ANSEL ADAMS. *Dead Poplar in the Owens Valley, California.* ca. 1940. Courtesy of the artist.

and would join in a collective determination to maintain clean standards, a vast change for the better would obtain. Unfortunately some who have achieved leadership in the profession often dictate from a confused throne of success—a success which may be more financial than otherwise.

With a few exceptions, publications of the photographic world are founded on the desire to stimulate the photographic trade; materials, equipment, gadgets have been in high flood of production and sales and the advertising of these countless items have been the backbone of this publishing. The dangerous suggestion that you can hire someone to do the drudgery, plus the encouragement of superficial thought and methods, has robbed photography of much dignity, clarity and effectiveness. If photography were to become a difficult mechanical medium, and if it were possible to explain the actual lack of need for most materials and gadgets, many publications would have no reason to exist, and I believe pictures, on the whole, would be better. Photographers have been led to make a fetish of equipment, and are falsely encouraged in superficial concepts and methods, resulting in unfortunate misconceptions of the basic potentialities of photography. I believe the ideal photo-

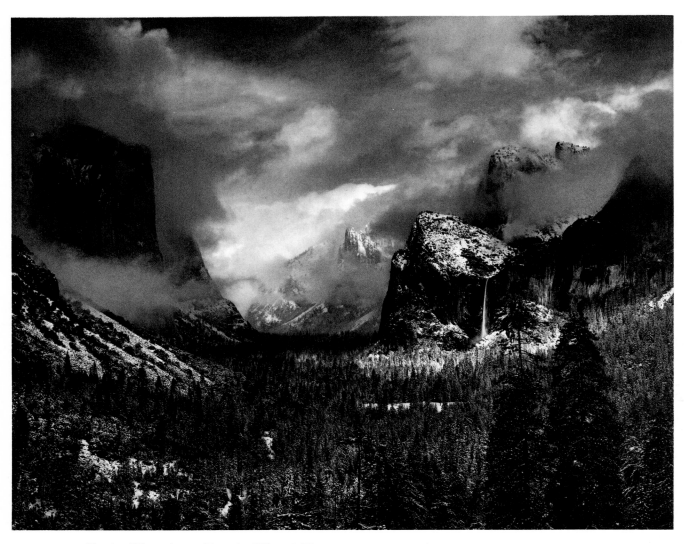

ANSEL ADAMS. *Clearing Winter Storm, Yosemite Valley, California.* ca. 1936. Courtesy of the artist.

graphic journal should be simple and rather dignified—but not austere—and contain good reproductions of good photographs of every description, and accurate, definitive texts. It should also contain legitimate advertising of *proven equipment and materials*. Unfortunately, most of the photographic magazines are conspicuous for their lack of policy, being mere trade-journals in the expanded meaning of the term.

There is an unfortunate blind spot in the manufacturer-consumer relationship. The former is obligated to *exact* procedures of research and manufacture, and consistent standards of production. The latter, except in a few specialist fields, is limited to a *precise* method of use of equipment and materials; there is no reason why he should be versed in the complexities of research and manufacture any more than an architect would need to know the complexities of steel manufacture—knowledge of *what steel will do* and confidence that it will do it, is all he requires. It is my observation that the manufacturers lean towards defining photography in terms of equipment and materials, when they should really define their products in terms of *photography*. The manufacturer should not dictate the progress of applied photography; he should anticipate and follow it. On the other hand, the photographers should be in close contact with the manufacturers in other than commercial dealings; they should mutually work towards continued improvement of the craft, and the perfection of equipment and materials. I do not know of a creative photographer who would not welcome such an association and gladly co-operate in every possible way. Through practical knowledge and experience, empirical as it may be, the photographers know more about the art and craft of their medium than do the manufacturers. It is ridiculous for them to presume adequate knowledge of the advanced chemical and physical methods of the research technician, or the involved and exquisite controls of production, but they are rightfully the planners and arbiters of their own craft.

Underlying the whole fabric of art and creative work is the contemporary world-ethic. The conflict of a few who are intent upon pursuit of the ideal, and the many who exploit brains and imagination, is age-old; but in our time a sinister development of this condition is all too apparent. The momentum derived from mechanical facility carries truly unworthy work far beyond its natural height. In many phases of the professional photographic fields there is a marked inadequacy of taste and technique, and, above all, a lack of respect and understanding in regard to the possibilities and limitations of the medium. There are men working for big money in the profession who are but charlatans of the most flagrant

type; they possess an adequate mechanical ability which only serves to accent their presumptuous lack of taste and sensitivity. Yet even these deserve tolerant appraisal; they are encouraged in their approach by the vast commercial clientele, which is but partially aware of its destructive influence. People are being trained in thoroughly superficial ways for what should be serious and profound professions. Our civilization protects our health, our safety, and our pocketbooks, by controlled professional standards and legal supervision. But nothing much is done for our spirit, which is of much greater importance. We are defenseless against gross impositions on our emotions, our esthetic sense, and our ethics. Hence, I believe in the absolute necessity of a strong and severe licensing control of professional photography, and of a firm guild organization among the creative artists and professionals. Medicine, the law, architecture, engineering, and other professions, are strengthened by such procedures of control, and I see no reason why photography should not be among them. Assuming that it requires five to eight years of serious training to be proficient in the major professions, why should photographers be turned loose on the world with only a superficial knowledge of their craft, and little or no experience in application?

However, the picture is not entirely dark; there are many unknowns who are working daily miracles in routine photography. And there are increasing numbers of men and women in many fields who are advancing photography through the sheer quality and sincerity of their work and of their belief in what the medium can accomplish. Many of these are amateurs in the best sense of the term. In the future our age will be remembered (as all other ages are remembered) by the productions of our creative people; photography is secure in such names as Stieglitz, Weston, Lange, and many others—not in the names of successful opportunists who may happen to hold contemporary popularity. Millions of men have lived to fight, build palaces and boundaries, shape destinies and societies; but the compelling force of all times has been the force of originality and creation profoundly affecting the roots of the human spirit.

I have often thought that if photography were *difficult* in the true sense of the term—meaning that the creation of a simple photograph would entail as much time and effort as the production of a good watercolor or etching —there would be a vast improvement in total output. The sheer ease with which we can produce a superficial image often leads to creative disaster. We must remember that a photograph can hold just as much as we put into it, and no one has ever approached the full possibilities of the medium. Without desire for self-flagellation, I often wish we were limited to processes as diffi-

cult as the old wet-plate and sun-print methods. We would then be efficient, and would not have time or energy to make photographs of casual quality or content. The requirements of care and precision would result inevitably in a superior and more intense expression. I have seen many of the old photographs of Hill, Cameron, Brady, O'Sullivan, Emerson, Atget, and others of earlier days, and I always marvel at their intensity, economy, and basic emotional quality. I am aware of the fact that most of these early photographs were made for *factual* purposes; there is little evidence of self-conscious art intention. I believe a great statement in any medium remains a great statement for all time; and, while I do not favor the imitation of other men or of other times, I feel we should recognize the spirit of the earlier photographers, through the best examples of their work, and strengthen our own thereby. For more than one hundred years photography, through the work of relatively few men, has maintained a magnificent spiritual resonance, as moving and profound as great music. Of course, great photographs are being made today, and it is our hope that the creative work of the future will achieve heights undreamed of heretofore. It is up to us—the photographers of today—to make this hope a reality.

I have been asked many times, "What is a great photograph?" I can answer best by showing a great photograph, not by talking about one. However, as word definitions are required more often than not, I would say this: "A great photograph is a full expression of what one feels about what is being photographed in the deepest sense, and is, thereby, a true expression of what one feels about life in its entirety. And the expression of what one feels should be set forth in terms of simple devotion to the medium—a statement of the utmost clarity and perfection possible under the conditions of creation and production." That will explain why I have no patience with unnecessary complications of technique or presentation. I prefer a fine lens because it gives me the best possible optical image, a fine camera because it complements the function of the lens, fine materials because they convey the qualities of the image to the highest degree. I use smooth papers because I know they reveal the utmost of image clarity and brilliance, and I mount my prints on simple cards because I believe any "fussiness" only distracts from and weakens the print. I do not retouch or manipulate my prints because I believe in the importance of the direct optical and chemical image. I use the legitimate controls of the medium only to augment the *photographic* effect. Purism, in the sense of rigid abstention from any control, is ridiculous; the logical controls of exposure, development and printing are essential in the revelation of photographic qualities.

The correction of tonal deficiencies by dodging, and the elimination of obvious defects by spotting, are perfectly legitimate elements of the craft. As long as the final result of the procedure is *photographic,* it is entirely justified. But when a photograph has the "feel" of an etching or a lithograph, or any other graphic medium, it is questionable—just as questionable as a painting that is photographic in character. The incredibly beautiful revelation of the lens is worthy of the most sympathetic treatment in every respect.

Simplicity is a prime requisite. The equipment of Alfred Stieglitz or Edward Weston represents less in cost and variety than many an amateur "can barely get along with." Their magnificent photographs were made with intelligence and sympathy—not with merely the machines. Many fields of photography demand specific equipment of a higher order of complexity and precision; yet economy and simplicity are relative, and the more complex a man's work becomes, the more efficient his equipment and methods must be.

Precision and patience, and devotion to the capacities of the craft, are of supreme importance. The sheer perfection of the lens-image implies an attitude of perfefection in every phase of the process and every aspect of the result. The relative importance of the craft and its expressive aspects must be clarified; we would not go to a concert to hear scales performed—even with consummate skill—nor would we enjoy the sloppy rendition of great music. In photography, technique is frequently exalted for its own sake; the unfortunate complement of this is when a serious and potentially important statement is rendered impotent by inferior mechanics of production.

Of course, "seeing," or visualization, is the fundamentally important element. A photograph is not an accident—it is a concept. It exists at, or before, the moment of exposure of the negative. From that moment on to the final print, the process is chiefly one of *craft;* the pre-visualized photograph is rendered in terms of the final print by a series of processes peculiar to the medium. True, changes and augmentations can be effected during these processes, but the fundamental thing which was "seen" is not altered in basic concept.

The "machine-gun" approach to photography—by which many negatives are made with the hope that one will be good—is fatal to serious results. However, it should be realized that the element of "seeing" is not limited to the classic stand-camera technique. The phases of photography which are concerned with immediate and rapid perception of the world—news, reportage, forms of documentary work (which may not admit contemplation of *each* picture made) are, nevertheless, dependent upon a basic attitude and experience. The instant aware-

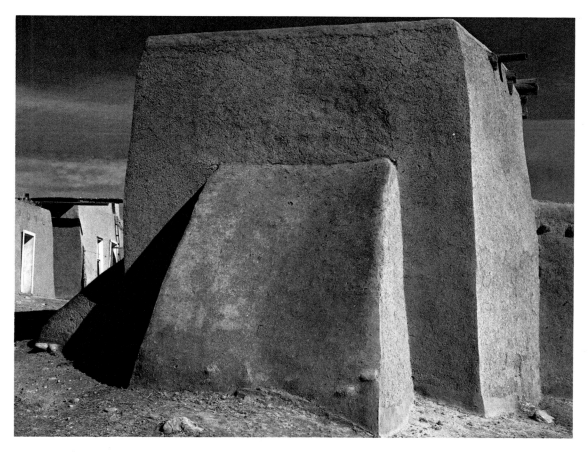

ANSEL ADAMS. *Rear of Church, Cordova, New Mexico.* 1938. Courtesy of the artist.

ness of what is significant in a rapidly changing elusive subject presupposes an adequate visualization more general in type than that required for carefully considered static subjects such as landscape and architecture. The accidental contact with the subject and the required immediacy of exposure in no way refutes the principles of the basic photographic concept. Truly "accidental" photography is practically non-existent; with preconditioned attitudes we *recognize* and are arrested by the significant moment. The awareness of the *right moment* is as vital as the perception of values, form, and other qualities. There is no fundamental difference in the great landscapes and quiet portraits of Edward Weston and the profoundly revealing pictures of children by Helen Levitt. Both are photographic perceptions of the highest order, expressed through different, but entirely appropriate, techniques.

Not only does the making of a photograph imply an acute perception of detail in the subject, but a fine print deserves far more than superficial scrutiny. A photograph is usually looked *at*—seldom looked *into*. The experience of a truly fine print may be related to the experience of a symphony—appreciation of the broad melodic line, while important, is by no means all. The wealth of detail, forms, values—the minute but vital significances re-

vealed so exquisitely by the lens—deserve exploration and appreciation. It takes *time* to really see a fine print, to feel the almost endless revelation of poignant reality which, in our preoccupied haste, we have sadly neglected. Hence, the "look-through-a-stack-of-prints-while-you're waiting" attitude has some painful connotations.

Sympathetic interpretation seldom evolves from a predatory attitude; the common term *"taking* a picture" is more than just an idiom; it is a symbol of exploitation. *"Making* a picture" implies a creative resonance which is essential to profound expression.

My approach to photography is based on my belief in the vigor and values of the world of nature—in the aspects of grandeur and of the minutiae all about us. I believe in growing things, and in the things which have grown and died magnificently. I believe in people and in the simple aspects of human life, and in the relation of man to nature. I believe man must be free, both in spirit and society, that he must build strength into himself, affirming the "enormous beauty of the world" and acquiring the confidence to see and to express his vision. And I believe in photography as one means of expressing this affirmation, and of achieving an ultimate happiness and faith.

261

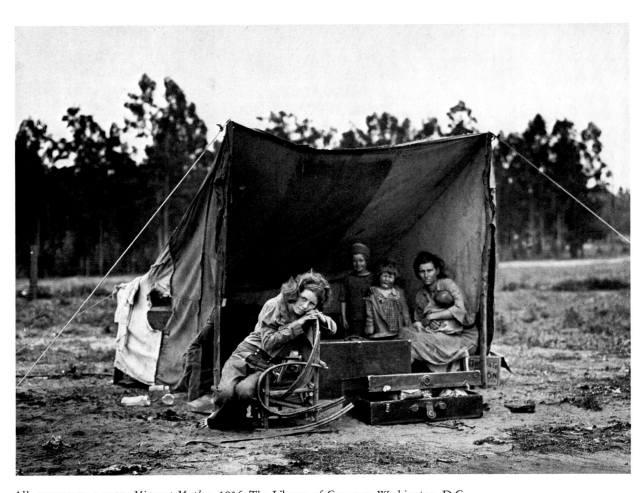

All: DOROTHEA LANGE. *Migrant Mother.* 1936. The Library of Congress, Washington, D.C.

The Assignment I'll Never Forget

DOROTHEA LANGE
1960

Dorothea Lange (1895–1965) was an outstanding member of the team of photographers enlisted by Roy E. Stryker to document for the Farm Security Administration the plight of agricultural workers who in the late thirties faced a double problem: the loss of crops by the improper cultivation of the land—which caused middle America to be called the "Dust Bowl," because the fertile earth was blown away—and the drop in the food market during the Great Depression. Dorothea Lange understood Stryker's program better than any of the FSA photographers, for she had worked for—and married—an agricultural economist, Professor Paul Taylor of the University of California. No more trenchant observation was made of the desperation of those farm people who were displaced from their land and forced to seek seasonal employment than her famous photograph Migrant Mother. *Here Dorothea Lange, in a rare personal analysis of what can only be called "the picturemaking drive," recounts her experiences in taking this photograph. We reprint her contribution to the series "The Assignment I'll Never Forget," which appeared in the February 1960 issue of the magazine* Popular Photography.

When I began thinking of my most memorable assignments, instantly there flashed to mind the experience surrounding "Migrant Mother," an experience so vivid and well remembered that I will attempt to pass it on to you.

As you look at the photograph of the migrant mother, you may well say to yourself, "How many times have I seen this one?" It is used and published over and over, all around the world, year after year, somewhat to my embarrassment, for I am not a "one-picture photographer."

Once when I was complaining of the continual use and reuse of this photograph to the neglect of others I have produced in the course of a long career, an astute

Reprinted from *Popular Photography* 46 (February 1960), pp. 42, 126, with permission of Paul Taylor, representative of the Estate of Dorothea Lange.

friend reproved me. "Time is the greatest of editors," he said, "and the most reliable. When a photograph stands this test, recognize and celebrate it."

"Migrant Mother" was made twenty-three years ago, in March, 1936, when I was on the team of Farm Security Administration photographers (called "Resettlement Administration" in the early days). . . . It was the end of a cold, miserable winter. I had been traveling in the field alone for a month, photographing the migratory farm labor of California—the ways of life and the conditions of these people who serve and produce our great crops. My work was done, time was up, and I was worked out.

It was raining, the camera bags were packed, and I had on the seat beside me in the car the results of my long trip, the box containing all those rolls and packs of exposed film ready to mail back to Washington. It was a time of relief. Sixty-five miles an hour for seven hours would get me home to my family that night, and my eyes were glued to the wet and gleaming highway that stretched out ahead. I felt freed, for I could lift my mind off my job and think of home.

I was on my way and barely saw a crude sign with pointing arrow which flashed by me at the side of the road, saying PEA-PICKERS CAMP. But out of the corner of my eye I *did* see it.

I didn't want to stop, and didn't. I didn't want to remember that I had seen it, so I drove on and ignored the summons. Then, accompanied by the rhythmic hum of the windshield wipers, arose an inner argument:

Dorothea, how about that camp back there?
What is the situation back there?
Are you going back?
Nobody could ask this of you, now could they?

To turn back certainly is not necessary, Haven't you plenty of negatives already on the subject? Isn't this just one more of the same? Besides, if you take a camera out in this rain, you're just asking for trouble. Now be reasonable, etc., etc.

Having well convinced myself for twenty miles that I could continue on, I did the opposite. Almost without

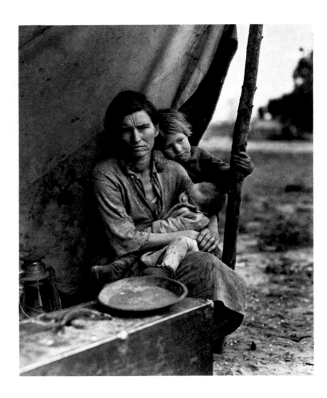

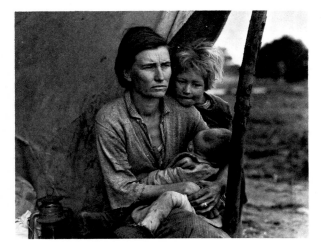

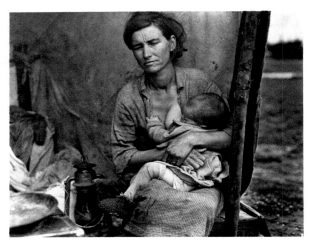

realizing what I was doing, I made a U-turn on the empty highway. I went back those twenty miles and turned off the highway at that sign, PEA-PICKERS CAMP.

I was following instinct, not reason; I drove into that wet and soggy camp and parked my car like a homing pigeon.

I saw and approached the hungry and desperate mother, as if drawn by a magnet. I do not remember how I explained by presence or my camera to her, but I do remember she asked me no questions. I made five exposures, working closer and closer from the same direction. I did not ask her name or her history. She told me her age, that she was thirty-two. She said that they had been living on frozen vegetables from the surrounding fields, and birds that the children killed. She had just sold the tires from her car to buy food. There she sat in that lean-to tent with her children huddled around her, and seemed to know that my pictures might help her, and so she helped me. There was a sort of equality about it.

The pea crop at Nipomo had frozen and there was no work for anybody. But I did not approach the tents and shelters of other stranded pea-pickers. It was not neces-sary; I knew I had recorded the essence of my assignment.

This, then, is the "Migrant Mother" photograph with which you are so familiar. It has, in a sense, lived a life of its own through these years; it goes on and on. The negative now belongs to the Library of Congress, which controls its use and prints it. Whenever I see this photograph reproduced, I give it a salute as to an old friend. I did not create it, but I was behind that big, old Graflex, using it as an instrument for recording something of importance. The woman in this picture has become a symbol to many people; until now it is her picture, not mine.

What I am trying to tell other photographers is that had I not been deeply involved in my undertaking on that field trip, I would not have had to turn back. What I am trying to say is that I believe this inner compulsion to be the vital ingredient in our work; that if our work is to carry force and meaning to our view we must be willing to go all-out.

"Migrant Mother" always reminds me of this, although I was in that camp for only ten minutes. Then I closed my camera and *did* go straight home.

264

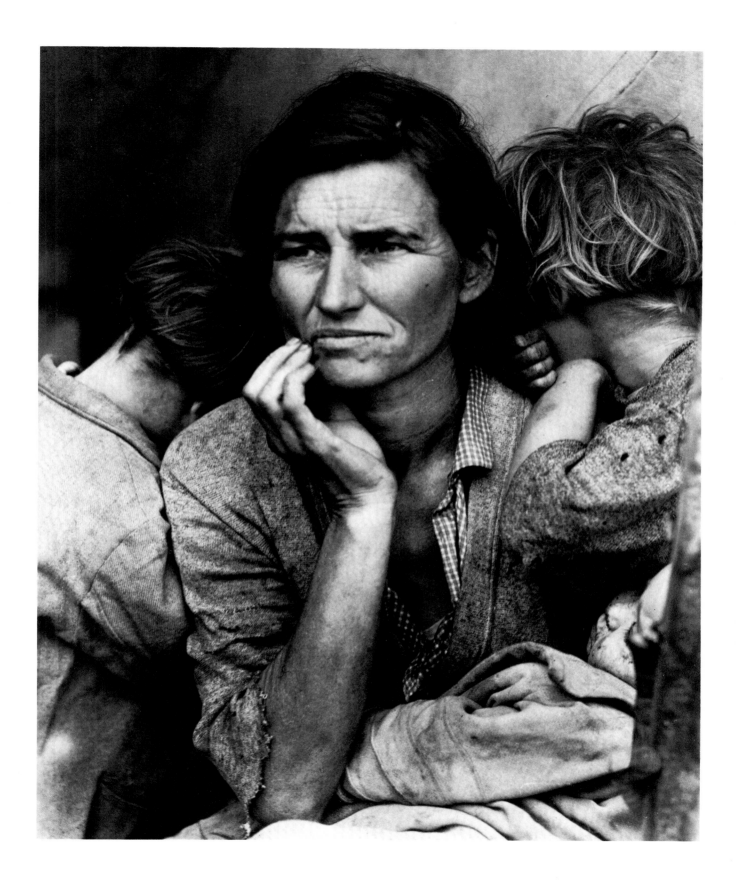

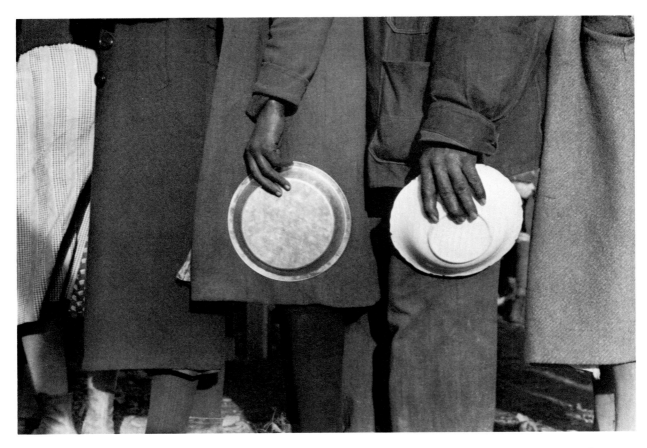

WALKER EVANS. *Flood Refugees. Forrest City, Arkansas, February 1937.* The Library of Congress, Washington, D.C.

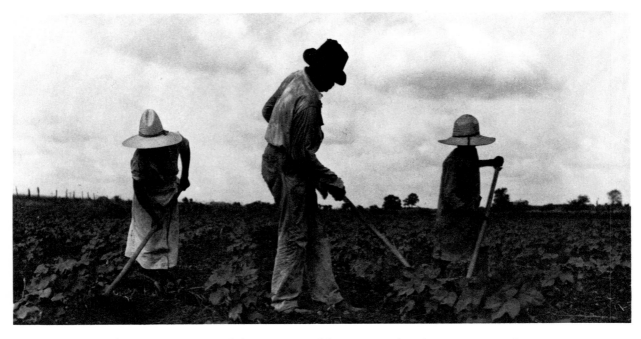

DOROTHEA LANGE. *Sharecroppers, Eutaw, Alabama.* ca. 1936. The Museum of Modern Art, New York.

The FSA Photographers

EDWARD STEICHEN
1938

*On his ninetieth birthday, March 27, 1969, Edward Steichen commented: "When I first became interested in photography . . . my idea was to have it recognized as one of the fine arts. Today I don't give a hoot in hell about that. The mission of photography is to explain man to man and each to himself. And that is the most complicated thing on earth and almost as naive as a tender plant."**

This deep belief in photography's importance in understanding human relationships drove him to create in 1955 the momentous and monumental exhibition "The Family of Man" and the book of the same title while he was Director of Photography at The Museum of Modern Art. In a real sense, his comments on the first major exhibition of the Farm Security Administration, held in the Grand Central Building, New York, in 1938 as part of a trade show, is an outline of "The Family of Man." We reproduce some of the photographs to which Steichen refers, from the FSA files in The Library of Congress, Washington, D.C.

One of the favored words in the photographic literature of today is "documentary." It is used with particular glibness by writers who are in the process of patting themselves on the back that they have suddenly, and without any help from Papa or Mamma, discovered photography. They proceed to dissect and analyze the various phases and branches of photography, wrap up and tie them into neat little packages that they file away into convenient pigeonholes, and the one marked "documentary" usually contains the conclusion that the beginning of photography and the end of photography is documentation, and that's that. In choosing examples to illustrate their reasoning, frequent reference has been made to pictures of vegetable fragments, egg beaters, telephone wire insulators, power line poles, etc. So as

not to interfere with the logic of their arguments, they conveniently overlooked such other documents as passport photography, the "mugging" of criminals, the photographs of nuts and bolts for hardware catalogues, etc. etc. Gibes and fancy passes were made at such photographs as were said to "tell a story," and indignant condemnation ran high as the idea of propaganda came into consideration.

About this time Uncle Sam seems to have listened in on the conversation. He became interested in the words "documentary," "story telling," and "propaganda" and then someone may have said to Uncle Sam, "You know, Sam, times are hard and, among others, there are some cracking good photographers hanging around having quite a struggle to get along; you ought to give them jobs." And according to the record, a man by the name of Roy Stryker, who was then connected with one of the so-called alphabet departments of the U.S.A., began lining up some of these photographers and putting them to work for Uncle Sam, who thus found himself in still another branch of the photographic business. We can't be sure, of course, but probably some of these photographers were put to work chiefly on the job of photographing some of the "big shots" all over the country, in the act of pressing buttons, cutting ribbons at grand openings, or perhaps photographing piles of this, stacks of that, yards of this, miles of that, boxes, bales, and timber, pictures of Politician A congratulating Politician B, etc.

But we do know that if they were busily engaged in producing this kind of "tweedle dum" and "tweedle dee" document, they also found time to produce a series of the most remarkable human documents that were ever rendered in pictures. But the "Art for art's sake" boys in the trade were upset, for these documents told stories and told them with such simple and blunt directness that they made many a citizen wince, and the question of what stop was used, what lens was used, what film was used, what exposure was made, became so completely overshadowed by the story, that even photographers forgot to ask. Not all citizens winced. Some got indignant, some got mad, and some of them just made remarks. You will

Reprinted from *U.S. Camera 1939* (New York: William Morrow & Co., 1938), pp. 43-45.

*Quoted in *The New York Times*, March 28, 1969, p. 49.

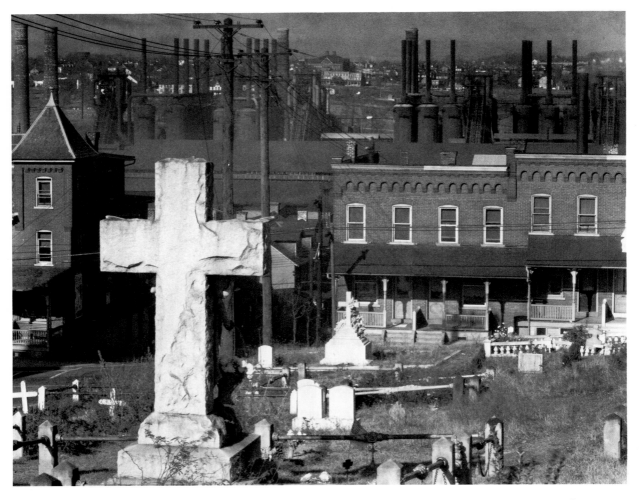

WALKER EVANS. *Graveyard, Houses, and Steel Mill, Bethlehem, Pennsylvania, November 1935.* The Library of Congress, Washington, D.C.

find verbatim examples of all these expressions the citizens of New York rendered during the International Photographic Exhibition accompanying the various pictures in the following FSA pages.

We don't know if the photographers made these pictures with the purpose of telling a story. If they did not, then their cameras certainly put one over on them.

For sheer story-telling impact, the picture of the hands with the plates on page 46, or the double page spread on pages 64 and 65 picturing in parallel planes the cemetery, the steel plant and the home, would be hard to beat. And then have a look at the three figures with hoes at the beginning of this note. Three figures, three human beings, three share croppers, three scare crows, three automatons, or just three results of "the highest standard of living of any country in the world." One can't help thinking of Millet's world-famed picture of the two

French peasants called The Angelus. One is reminded of this picture largely because the scenes are so different. Then look at the picture of the nervous looking parlor organ out in the stubble of what was once a corn field. This photograph makes any cockeyed Dada picture seem like a blooming Christmas card in comparison to this grinning gargoyle.

"Now step up folks, and look this way!" Have a look into the faces of the men and the women in these pages. Listen to the story they tell and they will leave with you a feeling of living experience you won't forget; and the babies here, and the children; weird, hungry, dirty, lovable, heart-breaking images; and then there are the fierce stories of strong, gaunt men and women in time of flood and drought. If you are the kind of rugged individualist who likes to say "Am I my brother's keeper?", don't look at these pictures—they may change your mind.

268

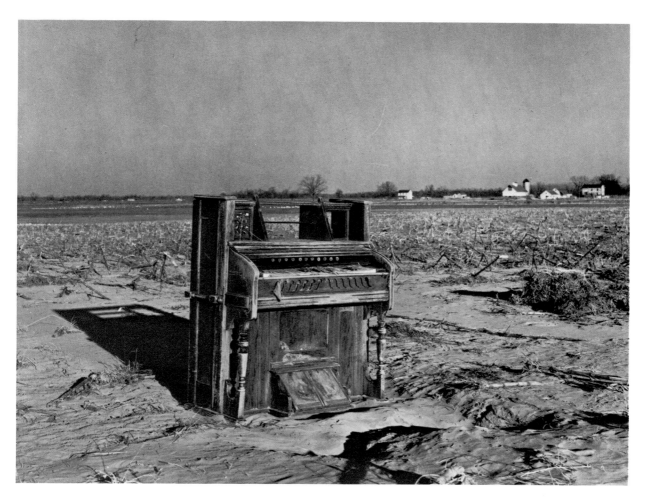

RUSSELL LEE. *Aftermath of Flood, Mount Vernon, Indiana.* 1937. The Museum of Modern Art, New York.

The selection of these F.S.A. pictures shown on the following pages does no more than present a fragmentary cross-cut section of the total work accomplished. It would take several books the size of U.S. CAMERA to do the whole job justice.

It is not the individual pictures nor the work of individual photographers that make these pictures so important, but it is the job as a whole as it has been produced by the photographers as a group that makes it such a unique and outstanding achievement. I do not look upon these pictures as propaganda. Pictures in themselves are very rarely propaganda. It is the use that is made of pictures that makes them propaganda. These prints are obviously charged with human dynamite and the dynamite must be set off to become propaganda; they are not propaganda—not yet.

One of the virtues that is most often ascribed to the documentary photograph as related to human beings, is the "impersonal." The excellent photographs produced in Soviet Russia impress us at once with the difference between the Russian Official Photographs and the F.S.A. Official Photographs. The Soviet is represented as the home of fine, healthy, vigorous boys and girls marching in Moscow, working in factories, in fields, or in clubs; well fed, plump, gay children in government nurseries; lineups of tractors or automobiles giving the impression of miraculously synchronized high-speed production. As a matter of fact, the whole tenor of these Soviet photographic documents would seem to strive to get in under a caption such as is presented on the "World's highest wage" poster on page 48 which proclaims "There is no way like the American way." Then cast your eyes on the F.S.A. picture above this poster—a picture of a share cropper's residence and children.

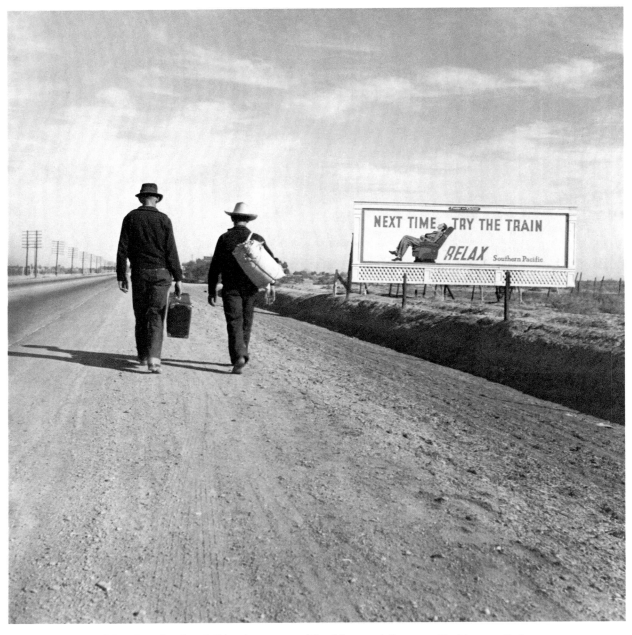

DOROTHEA LANGE. *Near Los Angeles, California.* ca. 1938. The Library of Congress, Washington, D.C.

The U.S.S.R. pictures and the F.S.A. pictures are documents. Pictures of electric insulators and passport photographs are documents, but it looks as if the word "impersonal" could safely be dropped now that we are seriously getting settled down to the business of good story-telling pictures.

A Chinese philosopher is supposed to have said that a pictures is worth 1,000 words. If this thought was really spoken, and if he was really a philosopher, and if he could have seen these F.S.A. photographs, he would surely want to amend his statement to the point of adding a few ciphers to his original estimate.

Photojournalism in the 1920s:
A Conversation between Felix H. Man, Photographer, and Stefan Lorant, Picture Editor

1970

In this colloquy Felix H. Man (b. 1893) and Stefan Lorant (b. 1901) discuss the early days of photojournalism in Germany, from about 1929 to 1933, when the Hitler regime forced them both to leave the country. They eventually worked together in England. Lorant was editor of the Munich Illustrated Press. *Man was working for the publishing house of Ullstein in Berlin when he took up photography professionally, and first showed his work to Lorant. The relation between photographer and editor is clearly presented in this remarkable conversation.*

B.N. First of all, how did you two meet?

LORANT: We were talking about this in the car, driving up here from my home in Lenox, Massachusetts, where Hans was visiting me. Oh, I should first tell how he changed his name from Hans Baumann, his real name, to Felix Man. When he began taking photographs and selling them to me, he was still employed by Ullstein, so he had to use a pseudonym, and chose that of Man. The first picture essay that I printed in the Müncher was about the swimming pool with bathing beauties in Berlin's Luna Park. As I liked his work, I bought many more picture stories from him.

At that time editing was quite different than it is now. Editors were individualists; they were prima donnas. An editor had the function of a good conductor. As the good conductor knows what kind of sounds he wants to produce, so the editor of a picture magazine must have in his imagination the issue he wants to create. To do that effectively he needs good players, good photographers. A conductor must have rapport with his concertmaster and with members of his orchestra. They must have similar tastes, similar feelings. Likewise the editor and his photographer.

Edited from a transcript of a tape recording made at a seminar meeting in the history of photography, conducted by Beaumont Newhall at the Visual Studies Workshop, Rochester, New York, in collaboration with the State University of New York at Buffalo, May 13, 1971.

In the early days of modern photojournalism—in the 1920s—the editor never had a shooting script. He didn't say to the photographer, "Go out and take Winston Churchill in his bathtub, snap him kissing his wife, take him putting on his hat." He simply said, "Look, I want to have a photo-reportage on Churchill's day. How he gets up in the morning, what he does during the day, how he works, how he relaxes—enough pictures to fill three or four pages."

As the photographer and editor were basically thinking alike, there was hardly ever a disagreement between us. We talked little about photography. We talked rather about art, music and of course, and mostly, about girls. We understood each other perfectly as our minds were on the same wavelength. I understood what Bauman did, and he knew what I tried to do. We had a harmonious relationship. He constantly surprised me with his stories by putting *more* into the subject than I thought there at the outset. In other words, we made beautiful music together. We did not look upon our kind of photojournalism as experimentation. It came to us naturally.

What interested me, and I think Bauman too, was humanity—how people look, how they behave, how they listen to each other, how they laugh and cry; we searched for the reaction in their faces.

A parent sees a photograph. "My God, that's *my* child!" Or, "Oh, that's my mother." So we have tried—or Bauman tried—to capture that moment. And I attempted to present it and convey his thoughts through the layout.

B.N.: Let's ask Mr. Man about going to work in this field—your problems, your attitude, and how you developed.

MAN: Well, there was the purely technical problem. It was extremely difficult with the existing cameras and negative material to take photographs of the kind I took in 1929.

At this point Felix Man turned to the Ermanox camera, taken from the George Eastman House collection, and fastened it upon a tripod.

This is the camera we worked with—Erich Salomon and

myself—and we always had to use it on a tripod. Imagine walking around with a camera on a tripod. I'll set it up here. Of course you're going to watch me, but I'm looking somewhere else. After a while you'll get tired, and will act natural. Then, at just the right moment, I just press and I'll have the picture I want. A natural picture. We wanted natural pictures. We had to judge the distance. We couldn't focus on the ground glass; it would have been too obvious.

B.N.: Let's tell the folks that, despite its small size, the Ermanox is a plate camera.

MAN: Yes. It used glass plates 4½ by 6 centimeters in size—that's only about 1¾ by 2⅜ inches. Each plate was in a separate holder. Now you can imagine if you go on a story you cannot carry a hundred or fifty plates with you. You have a limited number of plates—usually twenty-five or thirty. You have to make up your mind beforehand how many pictures you can take. Today somebody goes on a story and shoots 50 Leica films— that's almost two thousand pictures! That was impossible in our day. We didn't take lot of pictures so that afterwards you could pick out the best.

What we took *had* to be a picture, a real picture, and

we worked with all our heart, with our soul—we absolutely were into it.

Here's a picture taken in 1929.* The first time that such a picture was taken in a theater, without any additional light, without flash. I had to watch, and wait and wait and wait until nobody really moved.

B.N.: Your editor didn't just send you out to take specific subjects, just . . .

MAN: He just told me to do the first night in a theater. The audience, the stage, and in the intermission I took some more.

B.N.: Did you work together on the layout?

LORANT: No, never.

MAN: No.

LORANT: The editor was the sole arbiter. I usually locked myself into my room with the pictures Bauman gave me, put them on the floor, and worked out a layout. Sometimes it came out well. At other times it didn't turn out

*The photograph was of the dimly lit boxes and dress circle of the Deutsche Theater (Max Reinhardt) in Berlin, taken during the intermission of a gala first-night.

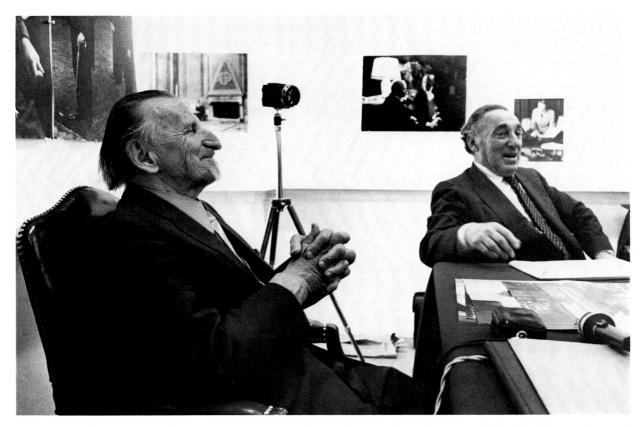

FELIX H. MAN, left, and Stefan Lorant during a seminar at George Eastman House, Rochester, N.Y. 1971. Edward Hausner/ New York Times Pictures.

FELIX H. MAN. *Benito Mussolini in His Office in the Palazzo Venezia, Rome.* 1931. Courtesy of the artist.

as well as I would have liked. We both made our mistakes, but I could always understand his mistakes and I think he could understand mine. Such cooperation is not possible today. Today editing is mostly by consensus of a group. In the twenties nobody came to me telling me what I should do—not the publisher, not the man who financed the paper, nobody—I had absolute power regarding what went into the magazine. I could follow my imagination. The magazines of those days were so much more personal than the magazines of today. If one looked at the pages of an illustrated weekly in the twenties, one instantly recognized the style of the editor; one immediately knew that the story was from the *Berliner Illustrierte*, or the *Münchner* or the *Kölner*—one recognized the editor's hand. Now you never know if you're looking at this week's Life or one six years old—they seem virtually the same in content and layout.

MAN: When I photographed "A Day in the Life of Mussolini" it was agreed that I would take photographs wherever I like while with him—but no posed photographs. It was rather difficult to get into his office in the Palazzo Venezia, an enormous big hall. The floor was burnished marble, highly polished. Mussolini was sitting at his desk some 25 yards away, just pretending he didn't see us but secretly watching how we managed those 25 yards—did we walk firmly, or carefully, or slowly? The man with me was the translator.

When you're photographing a conductor in action you have to watch him very carefully, because the exposure, even with the $f/1.8$ Ermanox lens, is about a quarter of a second. There's always, in every movement, a dead point. And this dead point you have to shoot. There's just a moment, and then he goes on. I made a series of Stravinsky conducting in Berlin.

Sometimes you use strategy. I photographed Max Liebermann, the leading German impressionist painter, when he was about eighty years old and didn't hear very well. I was keen on getting a picture of him saying "What? What?" He was always saying that. So I set up my camera. He was standing behind his desk and he talked, of course, and suddenly I said something deliberately in a low voice. And at once he said "What?" and at the same moment I pressed my camera and I had the picture I wanted.

Then there was Arturo Toscanini. He was absolutely set against having any photographs taken in 1931. But one day he was rehearsing with Laurenz Melchior, sit-

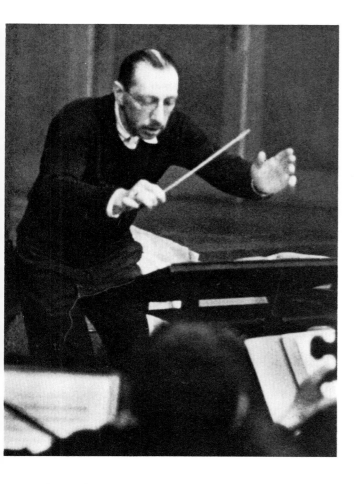

Felix H. Man. *Igor Stravinsky conducting a rehearsal.* 1929. Taken with an Ermanox 4.5 by 6 cm glass plate camera. Courtesy of the artist.

ting at the piano, singing. I was in a neighboring room that had a sliding door. A friend went through—he left a little gap open so that just the lens pointed through and so when Toscanini was singing I quickly took the photograph and disappeared!

STUDENT: I wonder if there's any difference between pictures taken at the time when it was not common to take them the way you describe and today, when everybody accepts photographers. Do you find people become actors because the press is such a common thing?

MAN: The problem today is that the mechanism is too simple. The more gadgets you use, the worse the picture —that's my opinion. And another point—to take fifty pictures and then pick out the three best is not the way to take good pictures. You must concentrate and watch and have the feeling of what you have to take, and then take it. And that's very often lacking today.

LORANT: I think that if the photographer feels strongly and honestly about the subject—whether he's Man or Cartier-Bresson or Gene Smith—and is able to translate his feelings about the subject into his pictures, then the photographer is an artist and the work will have lasting value.

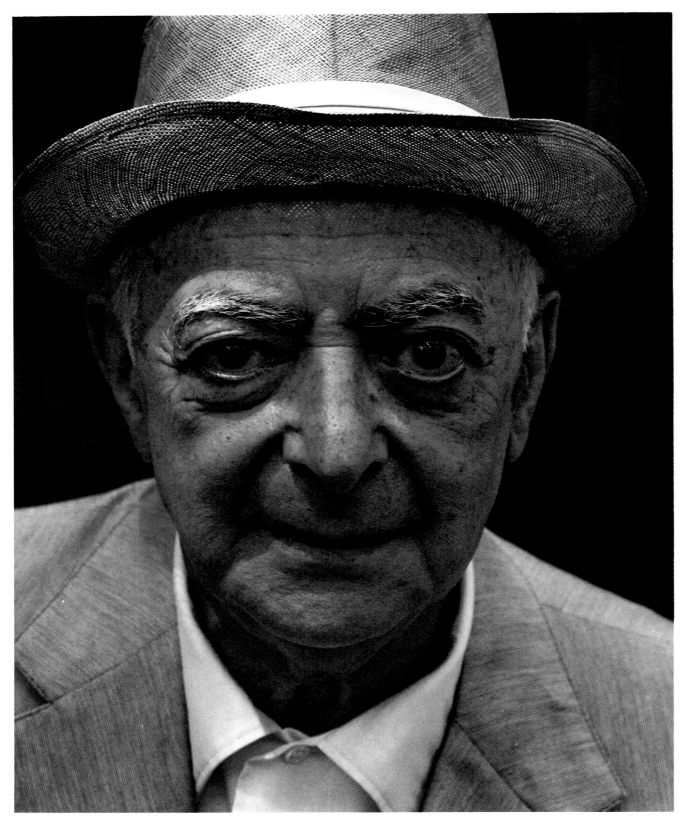

ANSEL ADAMS. *Brassaï, Yosemite National Park, California.* 1974. Courtesy of the artist.

Brassaï: "I Invent Nothing. I Imagine Everything."

NANCY NEWHALL
1952

In 1952 Nancy Newhall and I spent a day with Brassaï in Paris—at his home and in one of the cafés he so loves. It was a memorable visit, a renewal of an acquaintance begun in 1936. Nancy caught the very essence of his omnivorous, seemingly insatiable quest for expressing human understanding in many mediums. The portrait of Brassaï by Ansel Adams, and the portrait of Adams by Brassaï, were made during a visit to Yosemite National Park.

8 1 Rue du Faubourg St.-Jacques, Paris—a tall apartment house on a corner. In the square below, a street fair stood melancholy in the late afternoon light. The flying carousel, with a huge metal dove among its boats, the immense, undulating serpent on which to rush round and round, the alley lined with shooting galleries, the little automobiles on trolleys, bright as Christmas balls— all were deserted. The carnival people were going back under the autumn trees to their painted carts drawn up on the cobbles; there were voices and a tinkle of crockery, a door slammed, a washtub was hung out to dry. The dribble of daytime customers was over; the fair awaited the night.

As in the entries of most Paris apartment houses, there was only the gray light from the street and a dim glimmer within the lodge of the concierge. "M. Brassaï . . .? Au fond, à gauche, prenez l'ascenseur, cinquième étage!" By groping, the little elevator was found and the frantic little doors pushed back; under the weight of a foot the floor sank—and a light went on. Slowly, creakingly, the little cage rose beside the circling stairs and came shakingly to a stop. I can never escape soon enough from French elevators, nor from the feeling that somehow one ought to pat them for their labors, like aged but faithful donkeys.

Years ago, fleetingly, we had met Brassaï, like a ball of

energy, and kind. He had given us the photograph, of climbers on an icy mountain slope, with which we had begun our personal collection. The door opened. A dark vivid girl—Gilberte, Mme. Brassaï, or, dropping the pseudonym, Mme. Gyula Halász. And Brassaï himself— the same ball of energy, with the same extraordinary eyes. The eyes of great photographers are often extraordinary; Stieglitz's deep and dark, as though you were looking through a lens into the darkness beyond; Weston's, hot, slow, absorbing; Adams's, brilliant under the wild flying brows that see everything at once like a 180 degree lens. Brassaï's eyes are black, sparkling, enormous; he seems able to throw them at anything that interests him. Henry Miller once called him "The Eye of Paris"—

Brassaï has that rare gift which so many artists despise—*normal vision*. He has no need to lie or to preach. He would not alter the living arrangement or the world by one iota; he sees the world precisely as it is. . . . For Brassaï is an eye, a living eye . . . the still, all-inclusive eye of the Buddha which never closes. *The insatiable eye . . .* the cosmologic eye, persisting through wrack and doom, impervious, inchoate, *seeing only what is.**

Brassaï's little room for thinking and talking is a magpie's nest, a room formed by a boundless curiosity and amusement. During its mutations through the years, probably anything could have been found here, even the dull and the conventional suddenly transformed by association. Jumping jacks and playing cards and posters and a calendar on which he has pasted his photograph of a cat's eyes gleaming in the dark; a cluster of masks hung on the corner of a bookcase; a statue of St. Sebastian with holes for arrows into which he has stuck cigarettes; a row of primitive paintings under the ceiling, and under them a row of daguerreotypes; then a jungle of pharmacists' vases with electric lights shining behind them and past the silhouettes of strange buds and branches; small sculptures from Mexico and Africa; tiny skulls; shells of

This essay was first published in its entirety in *Untitled 10* (1976), pp. 11-16, the journal of The Friends of Photography, Carmel, California. A condensed version appeared in *Camera* (Lucerne), May 1956, pp. 185-215.

*Henry Miller, "The Eye of Paris," *The Wisdom of the Heart* (Norfolk, Conn.: New Directions), pp. 173-75.

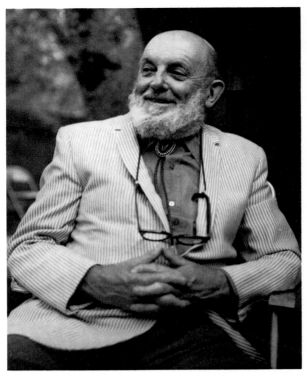

BRASSAÏ. *Ansel Adams.* 1974. Courtesy of the artist.

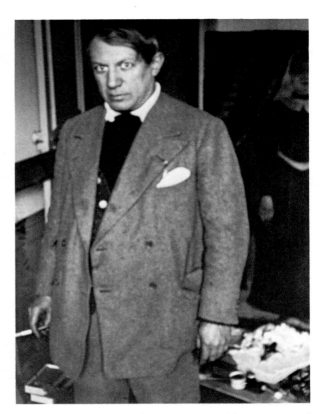

BRASSAÏ. *Picasso, rue de la Boétie.* 1932. The Museum of Modern Art, New York.

mother-of-pearl; a horrifying fiesta figure from Seville, dead white, faceless, with a tall peaked hood reminiscent of the Inquisition; soap made with the water from the holy spring at Lourdes. Boxes of negatives; a glass case full of Brassaï's own sculptures on pebbles, meant to be held and seen in the hand. The back wall, topped by large earthen pots, crammed with dummies of incipient books with boxes of prints marked *Picasso I, Picasso II, Paris de Jour, Nus, Portraits,* etc. From the balcony, over pots mantled with ivy, you look across the square and the chimneypots of Paris.

Brassaï brought out a flood of photographs, all 11x14-inch glossies. We spread them on the couch, on the floor, we stacked them against the chair and the table legs. Paris by day and by night—the Paris that has obsessed untold numbers of men like a dream, like a passion, the imperceptible men and the famous ones, the frugal, the acquisitive, the spendthrift; the humble little gatherer of information for the city directory, Victor Barthélemy, who began his great collection of photographs by asking everywhere he went if they had old photographs of Paris; Atget, drinking his tea and going forth under his 8x10 down the dark alleys and misty boulevards of a Paris still asleep; Daumier, with his savage insight and rending pity; Toulouse-Lautrec, mordantly observing the death-in-life night world; Balzac—whom Brassaï

vaguely resembles—preoccupied with his Comédie Humaine.

Brassaï is not Paris-born; he is not French. "I was born in Transylvania on September 9, 1899, at nine at night. Nothing but nines or multiples of nines in my birthdate. This figure has pursued me all my life. I live always at no. 81. . . ." Brasso, the medieval town on the edge of the Orient, where he was born and whence he takes his pseudonym, he first left when he was four; his father, a professor of French literature, came back to his beloved Paris to refresh himself for a year at the Sorbonne. For that year little Gyula (Jules) Halász and his brother lived the enchanted life of little Parisians. In 1924 he came back again, after studying art in Budapest and Berlin. And Paris, the huge, the manifold, began to call him, especially down its vistas through the night.

"For a very long time I had an aversion to photography," wrote Brassaï in his 1952 album. "Up to my thirtieth year I did not know what a camera was." One dark night, standing on the Pont Neuf with his old friend and fellow countryman, the photographer André Kertész, he found out. Kertész's camera was up on its tripod, and it seemed to Brassaï that they had been talking near it or over it for a very long time. "Well, take your picture and let's go." "It's being taken," Kertész said with a smile. "Wait another fifteen minutes and we'll

have it." Brassaï was fascinated. "Open a little box in the middle of the night and half an hour later you have a photo?" Brassaï went to see that negative developed. And the next day he bought the camera Kertész advised, a little Voigtländer, 6½ x 9 cm., with Heliar 4.5 lens. "I had a whole profusion of images to bring to light, which during the long years I lived walking through the night never ceased to lure me, pursue me, even to haunt me, and since I saw no method of seizing them other than photography, I made a few tries." These obsessive images, about to be made into Brassaï's first book, *Paris de Nuit,* 1933, seemed to Henry Miller "the illustrations to my books. . . . I beheld to my astonishment a thousand replicas of all the scenes, all the streets, all the walls, all the fragments of that Paris wherein I died and was born again. There on his bed, in myriad pieces and arrangements, lay the cross to which I had been nailed. . . ." The walls of Paris, eroded by rain, age and man, and scratched by him with his own weird obsessive symbols of death and sex; its roofs, windows, cobbles, incised by daylight or illumined against the night and the mist. The immense and endless panorama of its people: the concierges and their cats, the cafés, the brothels, the curious oldsters with their pitiful trades, the shadowy parks and the glittering Metro, the lighted fountains and the powerful confusion of the dim market.

And beyond Paris: the medieval hospital at Beaune, with nuns in white coifs; the Rabelaisian feasts of Burgundy, with whole hogs in jelly, decorated, miles of banquet tables hemmed with wineglasses, chefs and gourmets in academic robes. Midnight mass on Christmas in a remote village, with a young shepherd holding a lamb in his arms. The strange rock-borne town of Baux-en-Provence, where the sheep emerging from crags and grottoes in the pumice seemed to Brassaï like souls summoned up from Purgatory. Holy Week in Seville—the medieval hoods among baroque splendor and the dancing skirts. The Côte d'Azur, and a white boat like a dream on the sand.

But always and forever Paris again. And his friends, Picasso, Rouault, Braque, Matisse, Eluard, Breton, Prévert.

Brassaï is not, like Henri Cartier-Bresson, an invisible man. People look at him and his camera naturally and comfortably. He can go along any street into any life from top to underside of society and become, by osmosis, accepted into it. What Cartier-Bresson sees with a shock or a tingle to heart or intellect, Brassaï sees as part of the Human Comedy; where Cartier-Bresson watches for the all but invisible instant, the almost incredible accident that turns the world inside out, Brassaï watches for the moment devoid of *transience,* the moment when char-

acter is totally visible, with its roots down into time and place. Brassaï has a huge gusto and an unshakeable objectivity; he can see without revulsion or exaggeration the whole horror and wonder of humanity. Towards the flow of reality around him, he has the humility that marks the great photographer. ". . . The object is absolutely inimitable; the question is always to find that sole translation that will be valid in another language. And now, immediately, there is the *difficulty of being faithful to the object,* the fear of betraying it (for all literal translation is treason), which obliges us to recreate it or reinvent it. The compelling pursuit of *resemblance,* of representation (whatever may be said about it today) *leads us far, much farther than "free" imagination or invention. It is what excites in art those pictorial, verbal, or other discoveries that constantly renew expression.* The sources are always exciting, but they flow formless. . . . How to capture them, how to retain them without *form?* Not being a stenographer, nor a recording machine, my course seems clear: to cast the living thing into an immutable form. . . . In a word, *I invent nothing, I imagine everything."*

In this humility transfixed by reality as perceived, Henry Miller found a saving grace, a losing the soul to find it, much needed in these days. "I realize in looking at his photos that by looking at things aesthetically, just

BRASSAÏ. *Graffiti.* n.d. The Museum of Modern Art.

BRASSAÏ. *Avenue de l'Observatoire.* 1934. The Museum of Modern Art, New York.

as much as by looking at things moralistically, or pragmatically, we are destroying their value, their significance. . . . The object and the vision are one. . . . Every man today who is really an artist is trying to kill the artist in himself—and he must, if there is to be an art in the future. We are suffering from a plethora of art. We are art-ridden. Which is to say that instead of a truly personal, truly creative vision of things, we have merely an *aesthetic view*." And he realized also, what is true of all genuine photographers, that Brassaï "by depersonalizing himself . . . was enabled to discover his personality in everything."

In Brassaï's reporting, you do not find the dominant image that contains the whole, nor the image that exists as a lyric for its own sake. The reality is within; it is felt through his photographs. Nor does Brassaï make photographs beautiful in American eyes; these are routine glossies, blowups from his Rolleiflex or 6 x 9 cm plate negatives, roughhewn, and crudely dodged. "Art-ridden" by the past, few photographers on the Continent today regard a print as anything more than a transition from the seeing to the publication in newspaper, magazine or book. A Brassaï is all here at first look. But what a look! You will never forget that macabre witness for Toulouse and Baudelaire, Bijou, the super-annuated prostitute wreathed in tulle and fake pearls, nor can you wash out of your memory such graffiti as the hanged man gouged into the stone. These are the blink of a Goya or Balzac-like eye.

Brassaï's realities are seen with such mass and volume that with ease he was able to have his photographs of cafés, street corners, Metro corridors enlarged back to

the size of the originals to serve as decors for the ballet, *Le Rendez-Vous,* written by Jacques Prévert, with music by Kosma, and for the play, *En Passant.* These decors, he insists, must always be lighted as the originals were lighted; the scenes he made for Jean Cocteau's Phèdre were ruined by the use of alien light. Photography being light, it offers, as transparency or flat, extraordinary potentials for theatrical illusion, and Brassaï must here be a pioneer in a new field.

The strangeness of the commonplace continues to haunt Brassaï. Into a series of colored folders he keeps putting photographs that are weird or witty metamorphoses of each other; he is assembling a kind of encyclopedia of life "as a stranger from another world might see it." And he goes further; by writing—"the eye ceding its place to the ear, I seek to *sharpen* my thought." Subjects such as Sleep, around which he groups images for his Encyclopedia; *The Story of Marie,* 1949, a char-woman heard through her talk and her thoughts; sketches of the people he has photographed—the concierge of Notre Dame de Paris, whom he bribed to let him go up onto the roof of the cathedral at night; the man-aquarium, who swallows live frogs and fish and then spews them up again still flapping; the old artificial-flower maker and her jealous dove; the ancient news vendor, as much a part of the corner as the lamppost.

Nothing Brassaï might do would surprise his friends; he has too much energy, too wide a horizon to be confined to one or two outlets, even the endlessly multiform mediums of photography and writing. He had been keeping his drawing to himself and a few very close friends. "One day when Picasso came to see me, a little before the war, I brought these drawings out of my boxes. He was seized by them: 'Why have you abandoned drawing, Brassaï? You have a mine of gold and you exploit a mine of salt!' Since then he has never ceased to exhort me to take up drawing again."

During the Nazi occupation, Brassaï succumbed to what he calls "my old demon" of drawing. Exhibited, they won him considerable acclaim; thirty were published in 1946. Dynamic and lusty, they are related to his sculptures, and like those little pebbles that fit into the palm of the hand, like his photographs, too, they have a magnitude far beyond their size. They could grow with ease to dominate a wall, a square or a mountainside.

Naturally Brassaï is now working in film, and the one surprising thing is that he didn't find himself involved in cinematography years ago. His first film, *"Tant qu'il y aura des bêtes,"* he describes as "entirely musical—musical also in its use of images—a kind of ballet that unrolls itself without a word, even of commentary." Eight hundred people attended its preview in one of the great

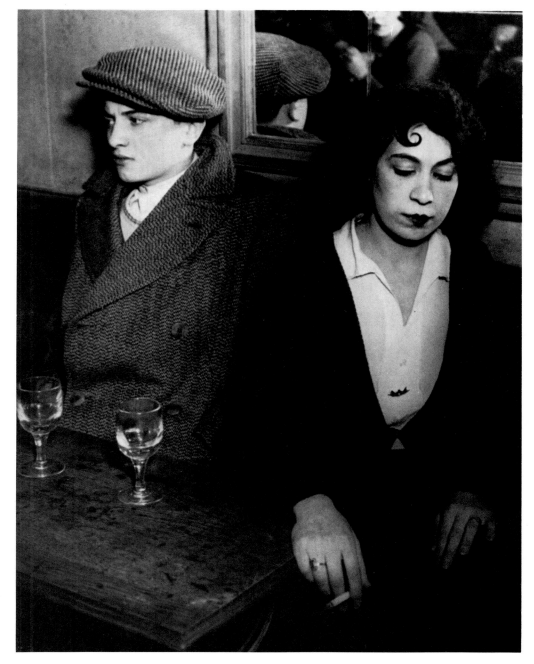

BRASSAÏ. *Dance Hall*. 1932. The Museum of Modern Art, New York.

movie houses on the Champs-Elysées: ". . . and I am very happy. . . . They laughed a great deal, and they were moved to tears." He is now at work on his second film.

It was dark and rainy when we emerged again into the street. A faint drizzle shone on the cobbles and haloed the lights of the fair. A rainy Monday night: the carnival people did not expect much business. Under their canopy of canvas, the little automobiles bumped crazily, incessantly. But the dove and the serpent were immobile. The proprietors of the shooting galleries shouted hoarsely as we approached: "Shoot the heads off the wedding party! —Try your luck with bow and arrow!—Hit the enemy bomber with a machine gun!" Here and there a solitary man picked a chained gun up from the counter. We walked towards the bright comfort of a café, Brassaï, in his flat black hat, holding over us an ineffectual but solicitous umbrella. We were walking through his Paris, through the obsessive images of the night.

BEAUMONT NEWHALL. *Portrait of Henri Cartier-Bresson.* 1946. The Museum of Modern Art, New York.

Vision Plus the Camera: Henri Cartier-Bresson

BEAUMONT NEWHALL
1946

During World War II, The Museum of Modern Art attempted to hold an exhibition of the work of the French photographer Henri Cartier-Bresson (born 1908). It was impossible to contact him for he was in the French army, address unknown. We later learned that he had been captured by the Germans, but happily had escaped on the third attempt. His friend, the photojournalist David Seymour ("Chim"), also in uniform, met him in Paris and extended the Museum's invitation, which he accepted. In 1946 he came to New York, on assignment for Harper's Bazaar. *At our first meeting I interviewed him for* Popular Photography *magazine. What he told me was a revelation. What my friends had considered "The Art of the Poetic Accident," the result of chance snapshooting, proved to be based on strict discipline in the mastering of instantaneous, intuitive recognition of "the decisive moment"—or, more accurately, the decisive split-second.*

We reproduce the photographs he selected to accompany the article.

Cartier, as he was called at that time, photographed me while I was writing the article. I photographed him at his apartment. He had just bought a new lens, and urged me to try it out on my Leica.

Henri Cartier-Bresson will tell you, if you press him, that photography is for him a kind of sketchbook, journal, or diary: a means to record what he sees. This over-simplification reminds one of the painter Cézanne's remark about his contemporary Monet: "He is only an eye—but good Lord what an eye!"

Cartier's eye has highly individual, penetrating and stimulating vision. A vision never superficial, not the mere physical act of perception; rather a vision directed by emotion. "One must photograph with the eye and heart," he often says, "one must be aware of the significance of what one photographs. Particularly in photo-graphing people, there must be a relationship between the subject and the photographer, and *I* and the *you,* if the result is to be more than a superficial resemblance or likeness."

To capture this extraordinary vision, Cartier has developed a technique which is swift, instant and sure. He has trained himself not only in the mechanics of the photographic process but also he has disciplined himself in the evanescent and often baffling problems of plastic organization. He paints, not for the public, but for his own education. His acquaintance with many of the masters of modern painting, particularly with Braque, Matisse and Rouault, gives him the opportunity of having frequent criticisms of his painting. He points out that in France most of the good photographers paint or draw if for no other reason than to develop within themselves the sense of what makes a picture. They have an interest in exhibitions of paintings and a lively appreciation of what can be learned from the old masters. As a result of this plastic interest, each of Cartier's pictures is not only a moment, rich with significance, arrested; it is also a moment seen in such a powerful way, with such a strong sense of the purely formal organization, that the transitory is made permanent.

He uses the miniature camera exclusively. He has a Contax, a Leica, and a battery of lenses. His favorite rig at the moment is a hybrid: a Contax $f/1.5$ lens mounted on a Leica body. He prefers the 35mm camera to the miniature reflex type because the optical eye-level finder is a more direct way of approaching the subject than the mirror ground glass image. His way of working demands that he be able to see the subject right up to the very instant of the exposure. When he finds a subject which arouses in him the emotion to make a photograph, he seeks a view point, dancing about like a boxer on tiptoe. When the proper combination of lighting, form, organization and emotion all work together, he makes the exposure. Cartier likes to speak of his way of working in metaphors: this split second peak of emotional tension culminating in the release of the shutter is "like a fencer making a lunge."

Reprinted from *Popular Photography* 20 (January 1947), pp. 56-57, 134, 136, 138. Copyright *Popular Photography*

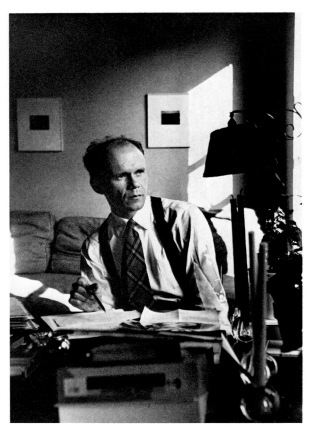

HENRI CARTIER-BRESSON. *Portrait of Beaumont Newhall.*
1946. Courtesy of the artist.

The picture is made at this moment of exposure; it is
then that the composition is determined. If, when en-
larging, Cartier finds it necessary to crop the print, or to
alter the image by trimming, he considers the picture as
only partly realized. Almost all of the photographs at his
forthcoming one-man exhibition at The Museum of
Modern Art are made from the full negative. Areas
which are essential to the composition extend to the very
extreme edge of the frame.

So strong is Cartier's sense of formal organization
that our eye is at once arrested by the force of the image.
It is remarkable that even 11 x 14 inch enlargements
from the 35mm frames do not seem to be grainy or to
lack definition. We do not have that feeling which is so
common when viewing enlargements of many diam-
eters: if only the photographer had used a larger camera!
Cartier does not ask the Leica or the Contax to be the
universal camera; he does not stretch the technique to
rival effects which can only be obtained by the view
camera. He limits his approach to what can be most
satisfactorily rendered by his medium.

The relationship between vision and technique is per-
haps the most critical aspect of the photographic process.
Cartier's technique has been created in order to realize

his vision. He does not discover through the camera;
on the contrary his camera records what his vision dis-
covers. Seeing comes before photographing. For this
reason he dislikes direct flashlight, which is largely un-
predictable: in those cases where he finds that photog-
raphy is possible only by playing auxiliary light upon the
subject, he prefers a photoflood, so that he can *see* what
he is doing. Recently he has begun to experiment with
the photoflash as a means of boosting the general illumi-
nation of an artificially-lighted interior to a level which
will permit him to work with the hand-held camera.
In this way he is able to maintain the natural quality of
the existing room lighting. For he never arranges a
scene, nor does he pose or direct the subjects. He is the
unobtrusive witness who recognizes pictorial possibilities
as they present themselves to his eye. His approach is
rooted in reality.

The work of Cartier-Bresson may be divided into three
periods. In the first, done during his years of wander-
ing in Africa, Spain, the Mediterranean, the United
States and Mexico, his concern was with the formal
recognition of plastic elements. Objects seem to com-
pose themselves as if by magic for him: the children
playing in a Spanish town seem to be puppets placed in
perfect relationship by an invisible pair of hands. Here
the sureness of composition is already evident. The sec-
ond period is one of satire, or caricature with the camera.
When he was sent by a French newspaper to photo-
graph the coronation procession of King George VI in
1937 he chose to photograph not the pomp and pageantry
of the parade, but the spectators and their reactions. The
third and most recent period is dominated by an interest
in portraiture, of an intimate and revealing type, with
the subjects informally seen in their usual surroundings.

During the war Cartier was a prisoner of the Germans
for thirty-five months. He had been captured at the time
of the Armistice, June, 1940, while he was serving as
a corporal in a French army film and photo unit. Two
times he escaped, only to be recaptured. On the third
attempt he gained his freedom, and came back to Paris
to work in his own surroundings. To the public eye he
was making photographs of artists for the publishing
house of Braun; to the initiated he was an active member
of the underground. Braun operated a post-office or
clearing house for the underground, one of the most
dangerous of all the secret activities because it involved
so many contacts. Cartier and his friends organized still
photographers to document the liberation of Paris and
the entry of the allied troops. He was so busy in this
work that, to our loss, he himself did not photograph
the stirring events of the liberation.

In speaking about his work and his particular point

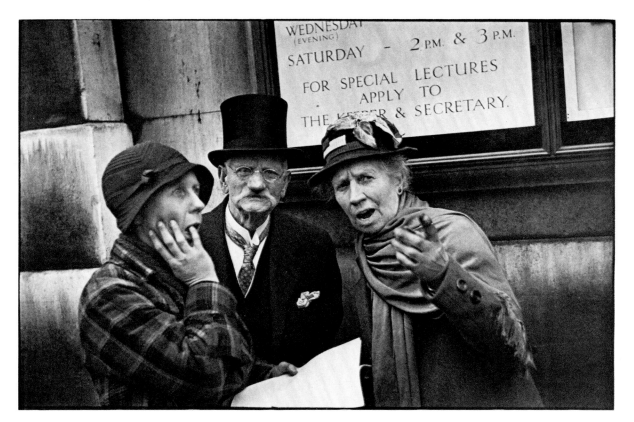

HENRI CARTIER-BRESSON. *The Coronation Procession, London.* 1937. Courtesy of the artist.

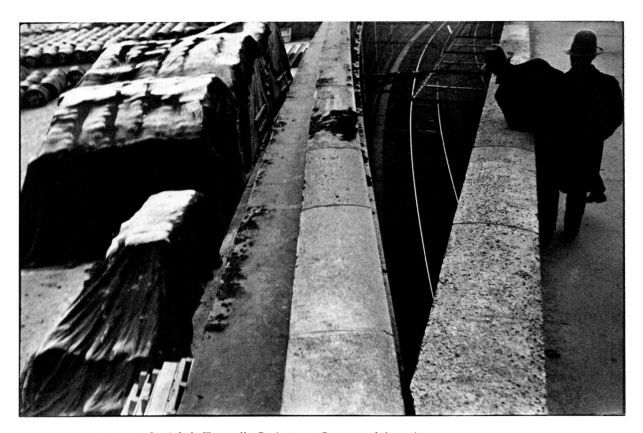

HENRI CARTIER-BRESSON. *Quai de la Tournelle, Paris.* 1933. Courtesy of the artist.

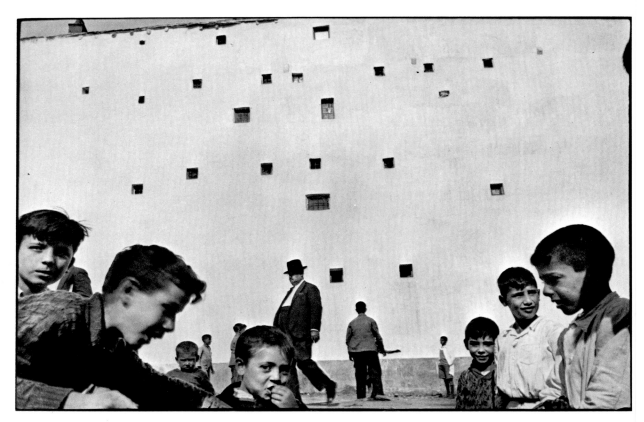

HENRI CARTIER-BRESSON. *Children in Madrid.* 1933. Courtesy of the artist.

of view, Cartier asked me specifically to point out that he has no dogma. He does not claim that his approach to photography is the only one. On the contrary, he feels that every photographer should seek out his own technique or rather *style*. We speak too much, he feels, of "technique." Photographers have overlooked style in their technical myopia. Style is the sum of emotion and visualization and technique. It is through style that a personal way of photographing can be developed. Cartier prefers photographs which are precise, sharp and *aigu,* or acute. Sharpness to him is not a matter of optical definition. Sharpness is a sureness and precision of approach. The ability of the camera to render parts of the field out of focus he recognizes as a functional control. He is much concerned with the problem of relating sharp with out-of-focus elements. Much experience is needed, particularly when a ground glass is not used, to judge this effect; a sixth sense is developed, so that one can predict how the background will be rendered when focusing on, say, ten feet at aperture $f/4$.

He has definite ideas about the tonal scale. He is fond of the rich gradation of middle greys which are rendered with such delicacy by the photographic emulsion. Grey tones prevail; black and white are used as accents. He avoids harsh contrasts and excessive low-key effects. He

likes semi-matt paper and rich full development of the image. But the print is for him largely a means to an end. He feels that photography's most important function is to serve as a means of communication, and that this end can best be accomplished through the publication of photographs in magazines, newspapers and books, where they will be seen by thousands of readers.

Photography means much more to him than passive picture-making of the passing scene. One must, he feels, approach the subject humbly but with an active and an open mind, prepared to evaluate and distill its meaning and its relationship to the problems and philosophy of the world today. The poetry of natural phenomena can be expressed with the camera, but only by continual contact with reality. To retire within an ivory tower, or to allow an esthetic approach to dominate over appreciation of human values, is to deny photography as a means of communication. One must have something to say, something concrete, definite and constructive to share with others. This is the driving force: technique and formal organization are the means by which to make this statement.

To the special problems of the picture story he has given much thought. He regrets that in recent years there has come into the picture story a detrimental shift of

emphasis from the photographer to the writer. He deplores a tendency to decide beforehand what and how a man is to see. The photographer, he quite rightly asserts, should be the one to discover the pictorial and emotional possibilities in a subject, and the editor should create from these pictures, by appropriate presentation and by necessary captions, the unified whole.

In addition to photography, Cartier-Bresson also makes films. He quite deliberately avoids operating the moving picture camera, concentrating on problems of direction and editing. He often describes the three fields of his most intense endeavor—painting, photography, and films—as the gearshift of an automobile. They are all interrelated, yet quite separate and distinct; one should avoid clashing gears; the three activities are kept in quite separate compartments in his philosophy of art production. He has worked as an assistant director with Jean Renoir, and lately he worked with a Franco-American film unit producing for the Office of War Information in Paris a film documenting the homecoming of the thousands of displaced persons who, in military prisons, concentration camps, or in labor batallions, had been ruthlessly torn from their homes by the Nazis. "Le Retour" was largely made by displaced personnel; Cartier himself was a prisoner of war, and the film has a rare emotional quality which is not frequently found in documentary productions.

At the moment Cartier is photographing in this country for *Harper's Bazaar*. He has found much material here which excites him: Coney Island and Louisiana, Brooklyn Bridge and the streets of New York. He is never to be found without his camera; he never knows when he will find a subject for his lens.

The rise and fall of the miniature camera has been a phenomenon of the past twenty years. Perhaps the fall of the miniature can be traced to the excessive demands which were placed upon it by those who expected to find in it the universal camera which could at once rival the all-over detail of the view camera and yet be operated in the hand under highly unfavorable lighting conditions. Perhaps the fall was due to its widespread and superficial use as a "candid camera." The "candid" shot is a gag: like all gags its life is of the moment and is not lasting. Cartier-Bresson's work is a vindication of the

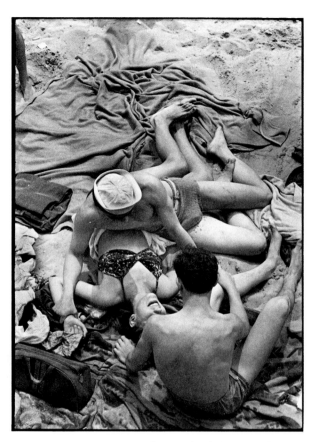

HENRY CARTIER-BRESSON. *Coney Island, New York.* 1946. Courtesy of the artist.

miniature camera. He has demonstrated that used knowingly it can produce results which no other camera can capture.

But to explain the magic beauty of the photographs of Henri Cartier-Bresson by mechanics, is an error. They move us because of his remarkable vision. They have lasting quality because they have been made by one who knows how to *see*. When Stieglitz was asked "How does a photographer learn?", he replied, "By looking." By looking at the world with a fine balance of emotion and intellect, by seeking to appraise the social background, by developing an awareness of what makes a picture lasting. To all of us who seek to use our cameras as instruments for something more than the production of pictorial records, Cartier's work is an object lesson.

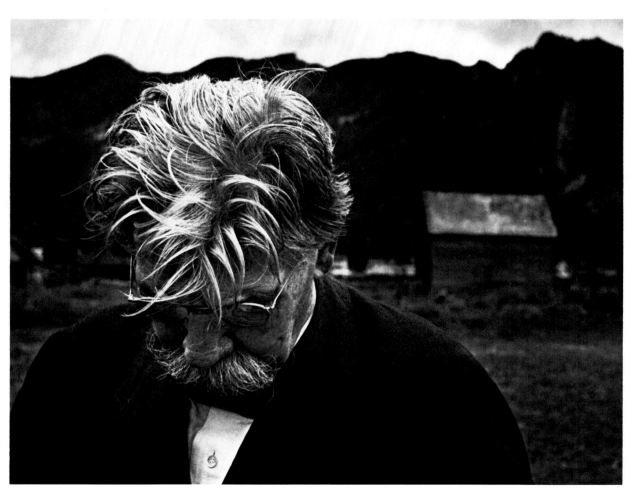

W. EUGENE SMITH. *Dr. Albert Schweitzer.* 1949. The Museum of Modern Art, New York. From *Life* Magazine, July 25, 1949.

W. Eugene Smith: A Great Photographer at Work
An Interview by Arthur Goldsmith

1956

In 1956 Arthur Goldsmith interviewed for the magazine Popular Photography *one of America's great photographers, W. Eugene Smith (1918–1978). The subject was, ostensibly, lighting. But Smith, with tactful determination, turned the discussion away from mechanics to the photographic process—the approach, not to the photojournalistic "assignment" but to the human problem it was his privilege to photograph.*

Q. *What is your attitude toward available-light photography?*
A. My attitude? It is quite friendly. However, let me give my definition of available light. This, to me, is simply any light which is available in any form—lighting that I can photographically take hold of and utilize, from an irregular nearly none at all, to a lighted match, to the headlights of a car, to flares, to anything. My attitude, first, is that the final picture must rise above the adequacies or inadequacies of light, overcoming and using light to state what its purpose is and what its characterization was intended to be. Secondly, I've never found I've been able to take pictures without light, no matter what is said in brag of the fast lenses and film speeds of today—excuse me, of tonight—and therefore, when I am in a situation where I cannot see my subject it is my simple-minded attitude that I must add light of some kind. In the midwife story, for example, there certainly was no light in those dark little cabins and I had to add light, so I used speedlight . . . I used oil lanterns, I used candles. Lighting, like any other singular

Reprinted from *Popular Photography* 39 (November 1956), pp. 48-49, 103-110, by permission of the Estate of W. Eugene Smith, Arthur Goldsmith, and Ziff Davis Publishing Co. In the interview Smith refers to the following picture essays that originally appeared in *Life* magazine: "Nurse Midwife," December 3, 1951; "Spanish Village," April 19, 1951; "Albert Schweitzer," July 25, 1949. "The Pittsburgh Project" appeared in *1959 Photography Annual* (New York: Ziff Davis Publishing Company, 1958), pp. 96-133.

of technique, is not *the* problem. The beginning and final problem is whether I eventually solve what I set out to do, with a sufficiency of command and depth not to demean my intent.

Q. *The argument advanced by the available-light purists usually is that any introduction of an artificial light source tends to destroy the mood or the appearance of the actual scene. How would you answer that?*
A. Silly little children talking in their narrow dark! I've heard them say, many times, that available light is the one, the only true approach to photography. These purists are soiled from their insufficiencies—that righteous blindness afflicting nearly all holders of the singular truth—seeing surface or less, yet unqualifying in their condemnations. What should we do? One day you go into a room to make a portrait of a man, and there's a 25-watt bulb hanging over his desk, so you use the available light. It's a small cell of a room, a dark room, and this one bulb actually is the only source of light. It's rather far over the subject's head, so the exposure has to be fairly long, the film very fast, and the souping-up considerable. Of course you end up with a picture that is probably dark and white block-ups, perhaps moody, and certainly grainy—a picture which may be completely contrary to this man's character and what you're trying to say about him—*if* you have something to say about him. Anyway, the next day, the same photographer goes back and finds they've just put up a large bank of fluorescent lights where that doggone little bitty bulb had been. This time you can shoot at 1/50 at *f*/8, have modulation, and no need for basketball grain. Who reformed the man, was it the light, or his neighbor's wife? Now, by light alone, which is the honest picture of the man?

Q. *Same man, same situation?*
A. But entirely different in visual effect.

Q. *Tell me, do you ever study the light as it exists before adding flash or flood and then try to duplicate the effect of the original source?*
A. Sometimes, yes. In one picture of mine that I set up

for color I used sixteen flashbulbs. You ran the picture [*Popular Photography,* November 1953]. Well, I calculated the effect of each bulb, and the final result looked like available light, with a needed depth of focus. But certainly in the midwife story I didn't try to duplicate the existing light. What with the dark skins and the white sheets and the oil lamp sitting behind them I could not possibly have seen the necessary details—the expressions and emotions and the relationships I was trying to relate.

Q. *Sometimes, then, you are forced to create your lighting entirely rather than to simulate what already exists?*
A. Certainly. Again, in the case of the midwife essay, I would have been considerably the liar and untrue to my essay-subject, and to my moral responsibilities, if I had passed up those pictures requiring the aid of additional lighting, and which often was contradictory to the lighting as found. And if—during and after the event, say of the birth of the child—if that birth was less a fact, less a truth, any different for my having added speedlight—I just don't believe it!

Q. *How about the psychological difficulty of introducing artificial light—don't you find this sometimes disturbs the atmosphere you've been trying not to disturb?*
A. Yes, this is a problem. It's a problem that is just one more phase of the difficulties a man always has when he intrudes himself with a camera. He has to be able to overcome these difficulties, to revert his subject from this added stimulation back into the flow of normal circumstances before taking pictures. I prefer, if possible, not to use flash because this is a continual tap-tap-tapping like the drip dropping of water. On the other hand, if you put a bounce floodlight into a room, after a few minutes it becomes a normal part of the environment. Actually, I've had people ask me to leave it on after the shooting was over because the return to normal light level was now an intrusion, and they wanted to finish what they were doing with the floodlight on. Again, all of this must go back, is charged to the man himself, the photographer. He has to be able to bring off a penetrative analysis of his subject, and lighting is but one of the useful tools of interpretation.

Q. *Speaking of lighting as one of the tools of interpretation, can you pin down concretely what you expect of it, or what it should actually do in a picture?*
A. The purpose of light, in the photographer's concern, is for a preciseness of clarity—to see, or not to see, as is chosen. Above all, light has to be functional, it has to underscore and intensify the characterization. A picture which has to work against its lighting, where the statement to prevail must overcome the inabilities or mis-

statements of its lighting, is not a complete picture. There are many pictures which survive—possibly some of these could be called very good—in spite of deficiencies in lighting, or in the particulars of the other techniques involved. Or, is it that the image compulsion of these photographs is beyond the knowingness of idea, or intent, of the photographer? Perhaps here enters the element of accident which gives some photographers one time glory. But these are never complete pictures; these, no matter how powerful, have failed to varying extents—do not say all that could be wished, or is possible.

But worse is, that so few, truly, fully try, in photography I mean—"try" is not necessarily of exposures made, of hours spent, of sweat expended, or weights carried; not of blood-blister complaints against editors and camera clubs. I think standards are too low, frighteningly low—conveniently low, and that many of the slovenlies are drummed as being virtues, or at least, as unavoidable necessities.

Q. *What do you mean?*
A. It is impossible, in this short time, to search fairly and give analysis of these ills of photography or of its few but sturdy attributes. Here, let me just touch upon this: photography is still young, it is not yet far enough away from its beginning. I believe that photographers—and this is not the full carcass—are intimidated by the very ease of photography, as well as by its difficulties. By its difficulties, until they have the feeling that, well, since there are so many things almost impossible to overcome, let's just sidle around them, daring nothing, and go ahead anyway, along the accepted paths—some of the biggest names do—and let us rely on its other nature, that quality of easiness. The lack can be explained, virtued, can be rationalized into a pardoning of ourselves from the trouble.

Lighting . . . A print also is of lighting, shaded in grays—a print is the summation. In much of the work I see—ignoring all else—considerable improvement could be gained by the sometimes not simple device of making a good print. By this, I don't mean trick printing to disguise the original, but I do mean a very careful printing and a reforcing of values back to the values present when the photograph was made, and with attention paid to an emphasizing of the important, the subduing of the irrelevant. I do not wish to be bothered with pretty, or densitometer negatives, I desire to see the print.

Q. *You don't insist on a straight print, then?*
A. No, when they get photographic emulsion to the point of adequacy, where it can handle the light which the world is equipped with, then I would say perhaps

straight prints conceivably could be made. But not today. You cannot make straight prints working under the conditions of light as you find it, or improve it, or have to put up with in awkward places. In the studio, of course, you can shade much nearer to easier fractions in value. But out in the world, far from lab tests, and theory's stale tower— am I not supposed to utilize the oft times magnificence of lighting's extremes and inconsistencies? Such as—such as even the bare sun, or its reflective children kicking sharp shafts from any variety of objects straight into my camera lens—these, giving wonderful muscle and command, but overpowering within the same photograph a delicate pattern of infinite counterpoint, no less important. Should I not attempt such as this, if it works for my photograph, even when the range is beyond all possibility of film for recording—and when I print am I supposed not to try to bring this back, forcing the scale back to the reality of vision as of my observations? And, am I never to attempt an intensification of reality, to a vision that lifts photography, as it does all other arts, beyond the mediocrity of dull tediums, and so called records? I doubt if I contradict those few accomplished photographers, master-printers, who advocate the straight approach—when I say that a straight print is a drug store print, or a player-piano interpretation. If so, I know damn well, my answer. For myself, at least.

Q. *Then you would say that the initial problem of lighting at the moment you take the picture can't be disassociated from what you are going to do when you print it?*
A. Certainly it is related. It has to be, and I usually see the print as I photograph. Rebalancing can be done— shadows lightened, or highlights darkened—but you can't remake the direction of a shadow or alter a dominant light which adversely cuts a face, forming painful light forms contrary to the good of the photograph . . . As a matter of fact, that is why, in doing many essays which are involvement with the intimate actions of people, I dislike using sunlight.

Q. *Direct sunlight, you mean?*
A. Yes, direct sunlight, but understand my qualifying of this within a purpose. Here, the reason is, quite simply, that when the light is softer—when there is not such strident contrast of light, the people can move about completely as they wish, and I follow, freed of the light; I can circle to the movement of the people, attentive in sense to the emotionally active compositions, the important statements that arise from the engaged in activity. And there are rich variables, in this less arrogant light. But with direct sunlight, in this situation, the sun is often quarrelsome to my content and composi-

tional desires, as motivated by these dramas before me— the sun is too brutal a destroyer of shadow areas, here. Again, I suffer the limitations of film against the freedom needed for my search—and I am resentful when the garish is without purpose, and overpowers the fragile, the beautiful, the quivering entrancement of inner living. However, as before indicated, I believe a lighting domination by the sun, intelligently used, can be magnificent. I probably care for it more as strong sidelighting, or as backlighting—but not necessarily. I might be just as pleased with it directly over one of my shoulders— I don't know which shoulder—like the instructions of photography simplified, say—or, I might like to use it directly overhead, or, in any other way—I am fluid to a situation. I think it was Alistair Cook who wrote an article about traveling across the country—and I think I remember one line in which he said that you should tour this country with the sun at your back. Other than it being harder to drive with the sun in your eyes, I don't agree with that at all. The beauties, and even the ugliness—the contours of the country, and of the man-made are so enriched, for me, by the late evening light or the early morning light as experienced when driving into it—there is luxury in those long sidelightings in dance upon the textured contours, with movement of shapes into shadows, and out again into fresh variation—all in a rhythmic play, that will give movement to the dullest lump.

Q. *If you were helping a serious beginner, how would you suggest ways by which he could increase his awareness of light?*
A. Not without seriousness—that he should drive the countryside, or walk a short block with the sun in his eyes. He can use a sunshade for his eyes, as long as he will continue to look—and to see. Two quite different things—to look, and to see. However, if someone were to ask, "How do I use one flash? . . . where do I put it?" . . . "How do I use two flashbulbs?" . . . the best thing I can think of suggesting that they do would be to take a floodlight and try the practical experiment of seeing. Get a bust, just a head bust—they are not yet ready for the kind that usually make the covers of magazines— one that is neither white not dark but is neutral in color, and then start with one floodlight. Move it around the room, see what happens, and remember that what they see can also be done with flash. Become aware of distance, become aware of direction, become aware of bounce, become aware of the absence of light, become aware of reflectiveness—by reflectiveness I mean where the main light sets up many counter reflections from around the room onto the subject. Then try two lights, and see how they can be played against each other, bring

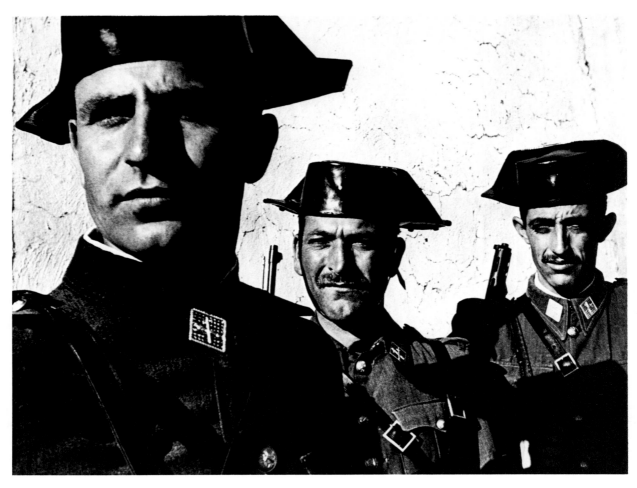

W. EUGENE SMITH. *Spanish Village.* 1951. The Museum of Modern Art, New York. From the photo-essay "Spanish Village," *Life* Magazine, April 9, 1951.

relationships of every degree in variation of—say, of the background, from white to black—say, of the bust, from white against black, or in silhouette against white. The variations are infinite. After this rather practical experiment, they should do this same kind of analyzing in moving through their daily existence. To see, as they were doing when giving themselves the straightforward lesson. Now it should become a straightforward part of their existence. This studying of light is something—one of the things I do constantly—wherever I am. Not necessarily as a discipline, either, but as a sensory pleasure that later I will be able to use. When I was the user of many flashbulbs, I knew precisely how I intended each light to come in, and it was mainly a question of practice, practice, and practice. This does not mean I claim always to have used intelligent lightings . . . I'm not a natural technician, nor a lighting expert. As a matter of fact, I'm rather like the Kentucky mountaineer measuring a distance by sight: he may not know whether it's twelve feet or fifteen feet, or if there is such a thing

as a yardstick, but he can look at a cabin he's building and look at a tree and cut it within a fraction of an inch by the measure of his eye—and that is knowledge, not information. It's the same way with light. I know no technical terms of light—I don't know what others call a Rembrandt lighting, and I doubt if he did—or this and such lighting, and although this named kind of knowledge might help you—I am not ridiculing it— the important thing in gaining this usable knowledge is simply to be aware, aware, aware. Let it be made a constant sideplay of practice, just for the sake of light. And this being aware should not be a burden, for it is a wonderful way to pass the time of day, the time of night, or any other time—it interferes with nothing, and it leads to far more than the experience of light.

Q. I wonder if you could illustrate that. If you were taking my picture now, sitting here behind this desk, with the light coming in through the window, what sort of running commentary goes through your mind as you're looking at the light?

292

A. The subtleties my mind is aware of—I doubt if I can so quickly conjour them into meaningful words. Well, I feel each slight shift that you make, and with each there is always a ripple of changing values . . . when you lean to that side—too heavy, in highlight on the left cheekbone, on the temple—the eye had lost its catchlight—the balance is wrong, gaining nothing from its wrongness. Now, in leaning forward turning your head, the light has become too flat, has lost its modulations—the catchlight has come back to the eyes—there is little separation with the background . . . I would begin this way, it would be nearly subconscious—subordinate, for I would be concentrating upon you, as individual, as the subject. All now must be made to work simultaneously, for there is but one exposure to each picture. I would be walking about, searching you out, feeling the play of light—talking, and walking, seeing with two visions—one focused sharply to your face, and one that is softly aware of everything behind you. By leaning to this side I see heavy conflicting highlights on that vase increase . . . but I could throw it against the dark turn of that wall. However, the other side of your face—the opposite side from the highlight—would be dark, nearly the darkness of the wall and with little separation between your head and it. I'd have to bring one or the other up a little, in printing—to get a decent separation, to make these elements work together . . . Now, I have become aware that you are slowly rocking back and forth—as you rock back there is a little jut of white behind your shoulder—that's an immediate annoyance. Well, it would either have to be thrown out of focus to the extent that it is soft in pattern in the background, or hidden, or I'd have to continue juggling these elements, or search from a new direction . . . But, these are so few of the things that must be correlated instantly . . .

Q. *Do you ever have occasions where the quality of the light itself suggests a picture, where the illumination is so strong or evokes such a definite emotion that the idea for the picture comes out of the lighting itself?*
A. It often happens—in reward for being aware. One of my better pictures from the Pittsburgh project happened that way. Crossing a bridge I was caught by the light of the late sun striking strong patterns out of a maze of railroad tracks. I stopped, and I played with it, but I wasn't satisfied so I marked the time and place and came back at a later date to have a longer time to work the place with that lighting. Actually, the picture was made weeks later, because the daily weather was not suitable to give me light of the right kind. There were many times, on the Pittsburgh project, when I would mark certain places or themes that I wished to return to when atmosphere and light were working with me

. . . say, with just a faint touch of fog in the air to give me separation between a church on the crown of a hill and the factories, the homes behind it. Sometimes the need may be pouring rain, or perhaps a smoke handling wind from the northeast. Sometimes I have seen the place, setting the scene in my mind, and then anticipating the various lightings with the aid of map or compass—returning then, at the time of my projected imagining . . . sometimes, tracing the path of the moon between two branches . . .

Q. *With the new fast films like Tri-X and improved developing techniques and faster lenses making available-light photography so easy that anybody can do it, do you think this in the long run will help raise the overall standards of photography?*
A. No, I don't think it will. Let's say that for the most part they can now make bad pictures even worse under a broader range of conditions by utilizing the "new" techniques. These are wild horses to ride, and the same chance in potential—I know I haven't tamed them yet to my complete comfort. If we are ever going to raise the quality of photography it's going to be by instilling a desire and a philosophy and a discipline into the minds of photographers, rather than from having placed faster films and faster lenses, and developers, in their hands and darkrooms. Very few photographers will take the time or the energy to use say an $f/1.1$ lens, with the delicate care within the specifics of purpose, and limitations that these lenses require. Although these lenses are marvelous they, like all photographic equipment, are unequipped with brain. No—often they're only going to make worse pictures, where they might ordinarily have made fairly adequate ones.

Q. *I wonder if you'd talk about some specific pictures of yours, in terms of lighting. Take the Spanish village set—nearly everybody has seen these pictures, in the museum shows or the magazines . . .*
A. And I'm delighted when they frequently argue with me that they were photographed in color—it lends support to my present dislike of color in photography.

Q. *You get that argument?*
A. Yes—very heavy argument from people insisting it was in color. In fact, the same thing came up the other day when some color of Pittsburgh was brought into a magazine, and the art director—I was not there—turned and said, "You know, there is more color in Gene Smith's black-and-whites of Pittsburgh that you have here." By that he didn't mean glaring, garish colors—these pictures showed brightness and flames enough—but something else. I've noticed quite often that if you use a richness of light and tone—and of course this is a use

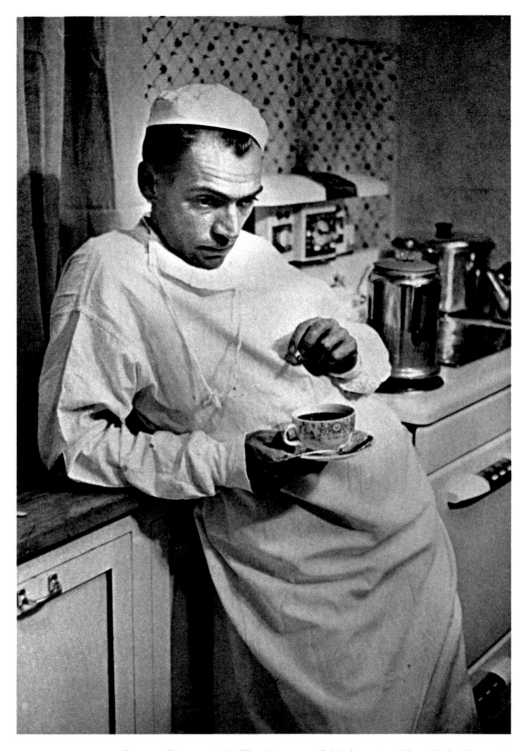

W. EUGENE SMITH. *Country Doctor*. 1948. The Museum of Modern Art, New York. From the photo-essay "Country Doctor," *Life* Magazine, September 20, 1948.

of light—you achieve the psychological feeling of color without the vulgarization that frequently results from the color materials we have today.

Q. *Take the death-bed scene from the Spanish village story—how was it lighted?*
A. Well, there was one candle, burning in a completely dark room. How to solve it? If I exposed for three seconds at $f/1.2$, I still would have been under, and I couldn't have held—I would have lost the emotional clarity. I very quietly took the reflector off the flash—I think I used flash on but three occasions, during the whole essay—and looking at the light the candle was throwing, feeling the mood of the light, I brought the bare bulb right to the point in front of the candle, and made the photograph—which I knew was going to be a horribly difficult negative to print. It was, too—but is that important? There was a somewhat similar situation with the Schweitzer pictures by the oil lamp. Except here, the oil lamp dominated—was the main light source. I gave a quarter of a second exposure, it may have been a half—hand held, to photograph with its light. In this situation I could have managed with just the oil lamp, because of it being just the one man. But by bouncing my handkerchief-covered Mighty Lite* off the dark stained floor, I managed just enough additional light to retain the detail and the soft roundness my eyes saw but which I knew would be lost by the film.

Q. *Would you say this was a case where the addition of an artificial light gave you a print that was closer to actuality than a straight available-light picture?*
A. Closer to the seeing—closer to the psychological situation of the moment as well.

Q. *Do you have any preference between conventional flash and speedlight?*
A. Well, I think the great value—other than its special uses—of speedlight over conventional flash is simply that if you must intrude with the popping of a flash, at least you don't have to clamber over and around people to change bulbs, and this is a great improvement. For it is desirable to have the least possible belaboring of subjects, and the least possible amount of photographer-caused confusion. I think photographers too frequently make themselves obnoxious—shamefully, unnecessarily so, as if unthinking, uncaring for the decent rights, the dignity of those who have fallen subject. Perhaps I am

*Trade name of an electronic flash unit.

shy, but I am frequently—by amateurs, and professionals —embarrassed for photography, and for human dignity, when I see a calloused, noisy, roughshod, trampling, raking over of the subject's feelings. I think of many news stories, public occasions from the past—however, I am again reminded of this having just watched—and photographed—during a two-day session on the piers where the survivors of the Andrea Doria were being landed, in all the chaotic conflicts of that ruptured world. I would rather mingle quietly, letting the world happen, in its honest complexity—photographing as the nearly unobserved observer, or, as in several of my essays, to become an intimately accepted participant. But there, the way it was on those piers—though it be news, fast breaking, I void this as excuse. No editor's call or threat, nor could my needs coerce me to do such as throw body blocks to hold harrowed mothers with their tiny children, or to physically harass children lost from parents, or to harass any others of the distressed, the grief stricken —to grab, to shove, to hold them as bewildered subject prisoners; shouting, shoving for this fake situation, for that cliché, demeaning the tragic, defiling the dignity and feelings—photographer-reporter teams wearing unwarranted arm bands of mercy, masquerading in this lie, to gain access to the heart core of the working areas of the officialdom of aid—a final working area rightfully barricaded to the press. No constructive purpose is served for news is not necessarily constructive—remember, such as the Weinberger kidnaping, Grace Kelly?—clobbering the tragic, the pictures often without semblance of honesty, without merits as pictures; what purpose, what value these pictures, are they no more than sucklings from human tragedy, for passing on for the consumption of the morbid feasters? I accept the reporting of tragedy, I admire truly great news photography—the kind almost never picked by the Pulitzer committee—but I wish the press would not abuse their power, or needlessly bruise the already bruised. In such a situation, I could not bring myself to use flash, or strobe, or the flying tackle—in such a situation, where the popping of lights in the eyes of the dazed, the shocked, the near hysterical is an aggravation to serious problems—here, then, I will say, if there must be photographs, here, in decency, is the one irrevocably right time and place to use discretion in a broad sense and available light in the narrow sense—in that if there is not sufficient light already present, and if the whole level can not be gently raised, then put away the cameras, for neither humanity nor photography is thus served.

PAUL STRAND. *Open Door.* 1945. The Museum of Modern Art, New York.

TIME IN NEW ENGLAND *in the Making:*
Excerpts from Correspondence between
Paul Strand and Nancy Newhall

1945-50

In 1945 Paul Strand and Nancy Newhall began to work together to produce a book of photographs and words expressing the spirit of New England, from the founding of the colony in 1620 to the present. The now-classic book appeared in 1950 under the title Time in New England. *Strand made three photographic excursions in New England, while Nancy Newhall collected documents, eyewitness accounts, poems, and other writing covering three centuries. Their concept was boldly experimental at the time: to put photographs with words not as illustrations but as symbols—or as Stieglitz might have put it, equivalents—of the spirit of the place, the time and the beliefs of many voices speaking from the past.*

The following note on the genesis of the book was written by Nancy at the request of some now-forgotten reviewer.

Time in New England *began with some beautiful photographs—and an unwary remark. Paul Strand and I, during his retrospective exhibition at The Museum of Modern Art in 1945, which I had directed, were having lunch in the Museum garden and discussing a proposal that he do a book on New England. What about the text and who should do it? "Why, the New Englanders themselves," said I. "Melville and Hawthorne and Thoreau and Emily Dickinson—who better? And it shouldn't be hard," said I rashly, "to find what you need."

At once an appalling vista of library stacks rose to haunt me and for several weeks I tried to shunt the job off on some New England scholar long since embedded in a library. But I was already hooked by the challenge of the idea: could a letter or journal three centuries old, or a poem, or the eyewitness account of an event, really expand and clarify the condensed meaning of these photographs? And also, here was an opportunity to do what I had long postponed—examine for myself, undistracted by champions or critics, what other Americans and Europeans seemed to regard as the "enigma" of New England.

That warning vista of library stacks, like a mirror reflecting another mirror, vista within vista, to infinity, proved less than the actuality. I cherished a blithe notion that by hard work and good luck I might emerge from the libraries in six weeks with some fifty short pieces to serve as hyphens for the photographs. But the material, as usual, took over. Voice after voice began speaking, until a kind of dramatic autobiography of New England throughout all three centuries took shape. And I stayed in the libraries a year!

Now and then Paul returned from New England with a new batch of photographs and I handed him a new section of rough text. The final sequence we made together, synchronizing our independent searches for the New England spirit. Neither of us sought for illustrations; we avoided apt or literal juxtapositions in favor of less obvious but more lasting inner relationships. The press and the public have been very kind!

The following excerpts from the lively correspondence between Nancy and Paul, written while he was photographing in Maine and Vermont, vividly document the close collaboration between two creative artists.

Paul Strand, c/o John Marin, Cape Split, Addison, Maine, to Nancy Newhall, September 27, 1945.

I know I have been pretty bad about letters—but almost every day has been a work day. That means, chopping wood, hauling water, cooking, ensuing dishes to wash—and photography. All these we share (except the photography—one photographer around a house is bad enough) and it has been swell. . . .

Well you will be wondering what I have been doing here with the camera. I wonder too, since developing is difficult, and I have done none of it since I left Vermont. For one thing, I find myself going back to things I tackled in Maine years ago. I guess every artist does that. Anyway this one does. Then too, there are some newish things, a few. The sea itself stumps me so far around here, it is so big. I have an idea that around Gloucester or the Cape I may be able to do more about it. Present plans are to leave here next week sometime

and go down the coast at least as far as Newburyport, and home about the middle of Oct. If you should hear of anyone who would have a darkroom to share, I would be very interested. Will have much to do. Would pay rent of course. . . .

Paul Strand, Waterbury, Vermont, to Nancy and Beaumont Newhall, undated.

Have moved up North to this town which is near Stowe, Montpelier and Burlington. There has been much snow—but no really exciting days yet, either grey-grey or blank/brilliant—patience! Very little photography as yet.

I wonder what you thought of the stuff I sent you, Nancy? Some of it I thought was interesting and useful. And it was a way of not just sitting around. I hope you don't mind, and hope you yourself will soon be into the material. It is quite a job but I think you will find it fascinating and incredibly time consuming. For instance just the copying to be done, unless you use photostats at 50¢ per page. I found some interesting stuff but too long for typing cost. The Hemenway Gazetteer is rich and I hope it can be found in N.Y. Also the book by Increase (wonderful name) Mather.

I think what is needed is to build a pattern of text, very variegated, with humour and seriousness that will give the flavor of the times and the country—around the developing struggle for freedom 1776 and again later anti-slavery 1861. Fun? ! ! ! Will you be able to start soon?

Nancy Newhall, New York, to Paul Strand, March 6, 1946.

Hail to the wanderer! How are the snows and thaws and lights? What price frozen thumbs and kerosene lamps or am I referring to the antiquities of my childhood? Meant to write you weeks ago; suffered or rather gloried in a complete letdown during which my mind was much like a meadow full of grasshoppers; was deluged by hordes of visitors all charming, and am now back at work again, forging through Parrington* and compiling a bibliography and beginning to see the shape of the book.

The stuff you found is swell! I liked particularly the old parson and ye howling of ye wolves, and the local history, such as the flood. You're wonderful to wade through the Mathers and so on for me, though I have no doubt that between the [NY] Society [Library] and NY Public and NY Historical Libraries all the famous

*Vernon L. Parrington, *Main Currents in American Thought*, 2 vols., 1928.

298

things can be found here. Local histories, news items, graveyard epitaphs, songs and chanteys and folklore may be more difficult, and I'm delighted you're hunting them out. I agree with you absolutely—the flavor, humor and character woven around the great struggle and growth. It IS exciting and Lord knows how much time it takes.

But the photographs are the most important thing—the catalyst, the new poetry, the vivid line which controls all the rest. The text is all extant and needs merely time to dig up, polish, and present.

Nancy Newhall, New York, to Paul Strand, March 18, 1946.

Am getting very excited about OUR BOOK! As you remarked, it takes a hell of a lot of time to find the really alive things, but I've already found some genuine possibilities. The Society Library is a treasure house, and the privilege of wandering through the stacks at will cuts down all that waiting time. Also, they reserve my stack of books—what tomes!—between times, and promise me a cubicle to work in. Am already working on a tentative list of the earliest people, and beginning to dream of the layout, the type, etc. As soon as I get this first outline worked out I'll send you a copy. I plan to spend, roughly, two weeks in each of the major sections—Founding to Revolution, Revolution to Civil War, Civil War to now. Then refine, reread, plan. When you come back, would it be possible to rough out prints for me to work with of the stuff we love best of what you've done so far? They shouldn't be good prints, because I want to work with them—copies or even reproductions, if full size, would do. But proofs are too impermanent. The book begins to sing in my head; I can see it.

How goes the photographing? Can't wait to see the new proofs. I never believe you any more when you say you don't think much of your latest endeavors—that is, I may believe you but I also believe that I shall find them more beautiful and potent than ever.

Paul Strand, Prospect Harbor, Maine, to Nancy and Beaumont Newhall, May 28, 1946

I am still followed by the most rotten weather—rain and still more rain. What is that lovely business about June and "then if ever come perfect days"? The poet covered himself nicely with that 'if ever'—

I do hope to hear from you in more detail what you feel is still needed for the book.

Nancy Newhall, New York, to Paul Strand, June 1, 1946.

Made a rough cut of the material so far. Good in some

places; tenuous in others. I suppose any cut will remain vague until all text and photographs are in, but I wanted to see how we are coming. Beau's feeling was that the connection was most successful where the text was lyrical rather than historical. Tried out some of it on the family; allowing for natural prejudice in favor of anything we do, they seemed to find parts very exciting—particularly the glimpses of the Revolution through letters and Tyler's* journal. My own feeling is as follows: A. If we follow our original idea—which I will at the moment attempt roughly to define as follows: a portrait shown through the great underlying themes of social and cultural development—we need many more images with concrete associations: the sea, the country, the people. As: an image not unlike our beloved little Gaspé town, to go with the Spectral ship symbol of isolation and hope and faith and fear. An image of peace and established loveliness, to go with the feeling Old Sam Sewall has about Newburyport, and which appears again and again. Might be a common with elms, or rolling countryside with glimpse of town in summer. An image of vast prospects—clouds, horizons—like the Mt. Washington sequence in *Native Land*†, or that first lovely glimpse of Maine islands under clouds in our beginning sequence, for Nathaniel Ames and the Revolution boys on the future. An image—very difficult—to accompany the love of books and excitement of scholarship, so beautifully expressed by Bradford, and Van Wyck Brooks. Nearest I can come to it at present is the closeup of the window with puttied panes, teapot, tomatoes, books beyond, which conveys a quiet and busy life. More than these even, we need the power and vastness of the sea—a violent storm or ragged, clearing sunset, without contemporary boats in it, unless they are schooners à la Marin. What about some keen young men's faces and the sea? Or boys with boats and nautical gear? The two little figureheads in the Peabody‡ have the spirit, and with nature images may carry it. The bowsprit of an old schooner or Friendship sloop, if you can find one still alive, would help. Maybe we can cheat and borrow again from Gaspé—the picket fences and gabled houses of a seaside town? And what about a head of one of the beautiful young girls? If potent, could come early on; if with pathos, later, with the sugarhouse view.

The trouble with the semi-historical approach is that its connections with the photographs must be quite close. Concrete connotations are needed; the more abstract emotions, such as driftwood, can be used only as peak of a sequence. So far, I've been feeling for the key images and putting them into the text where they give an added dimension. The TEXT, you see, is arbitrary in this approach, no matter how pruned. (I've been pruning like mad, keeping all discards of course) nor how combined.

B. Suppose we change the approach, as we have often thought we might do. Begin with the PHOTOGRAPHS, making a great sequence, and then using the text for the third dimension. We would then be freed from the necessity of "fair" "historical" representation of all sides in these many most complex situations, which I fear may lead to an overburdening of the books with text, even if we can find the perfect example in every facet. The subject-outline of the book might not be so difficult, but the concept would be much more free.

Of course, we are still going to need many of the photographs conveying the emotions listed above.

I'll try to rough out outlines of both proposals and send them to you for mulling over. Should we adopt the second, nothing is lost—we have gained a far clearer vision of New England and the text sources, which should help us project a greater conception.

Must pop this into the mail pronto, in hopes you get it Monday.

Cartier§ called you first of anyone—sorry you will not be here for his party next Tuesday. An exciting and sensitive person, with ideas so different from ours that they are a refreshing challenge.

Paul Strand, Prospect Harbor, Maine, to Nancy Newhall, June 5, 1946.

. . . It is difficult at this distance to understand quite the problems you have run into in the rough cut. I am sure there cannot be a too close relationship between the photographs and text for it would be impossible to in any real sense illustrate the text. The question is, how loose can it be? I shall be very interested in a more detailed account of the alternative approaches you mention. Don't quite "get" them yet.

The needed material I do understand and will do my best. I plan to make as many portraits of people as possible. The sea remains a tough problem. You really have to live with it and be ready for the dramatic moments when and if they come—none so far. The apple blossoms are just out up here, a month later than Mass. and I have been trying to do something about them—before they fly away in the almost constant breeze.

*Moses Coit Tyler (1835-1900), literary historian specializing in pre-Revolutionary American ideas.
†A motion picture directed and photographed by Strand in 1942 for Frontier Films.
‡The Peabody Museum, Salem, Massachusetts.

§Henri Cartier-Bresson, who had just arrived from Paris to photograph for *Harper's Bazaar* and to prepare for his upcoming exhibition at The Museum of Modern Art.

Nancy Newhall, New York, to Paul Strand, June 10, 1946.

Have been making sequences along the grey couches—fine, except that cats insist on regarding them as a new gambit or even fine nesting material! Several parts shaping beautifully; it helps a lot to disregard the text and just look at what YOU are saying. Then the text falls into the right perspective.

We seem to need—in addition to those in my last letter—

Spirit—soaring, dazzling images; the idealism that dominates the whole history. Not well-grounded in the earth, yet potent in influence. The church yearning for heaven needs supporting images, and one at least that mates well with it. Angel wings of driftwood the best so far.

Strength—wild mountains, maybe. Ethan Allen, early pioneers. Abolitionists, etc. Mount Desert? Or back to Vermont?

Youth, adventure—the young America, stretching west, sailing into the unknown, building a dream of a new world.

Sea, young people, peace and loveliness (what about lilacs?) wide horizons, learning, still very much needed.

God, you're a good photographer. Even in these rough prints, the pictures are like magnets.

PAUL STRAND. *Toadstool and Grasses, Georgetown, Maine.* 1928. The Museum of Modern Art, New York.

Hope you're having luck with the weather. Some brilliant days here—and hot, hot! I think you're wise to stay in one place. One functions much better with roots.

Paul Strand, Prospect Harbor, Maine, to Nancy Newhall, June 13, 1946.

Thanks for your good letter. What you say about the prints and most particularly the interest and help you are getting from Euripides and Chiquita. Cats have infallible taste.

You give me large orders—some of them should go to the person whom my landlady refers to as "the Old Man up there," pointing in a general way towards the sky.

The sea for instance only has its moments and you have to be around. Once since I have been here it was remarkable for 5 minutes for the Graflex—no storms off the ocean—and the days alternate bright and cloudy.

However I have exposed about 60 with the Deardorff and a number of 5 x 6's.* Will be working mostly now on people before I leave. Mountains really mean New Hampshire and I may drive back that way. But it is all chance whether they are as they were in "Native Land" or are washed out by summer haze.

I found another ship's figure up here, a lady about the size of the gent in Peabody, and photographed her outdoors against the sky. Also maybe we have an apple tree in bloom and some other growing things. The other day I spent an afternoon with beach grass which is endlessly fascinating.

Paul Strand, Prospect Harbor, Maine, to Nancy and Beaumont Newhall, June 19, 1946.

I can say only that I have worked hard, and done as much quantitatively speaking as I did last Fall. I have tried to get an apple tree in bloom, working on a number of trees here and at Cape Split. I am sure I could do good things of the sea, if I were around it long enough. There has been no storm during my stay, but there have been some miraculous moments when it cleared after rain. They last just about 10 minutes and one has to be ready on the spot. This means first to know the spots and then get there when you see the possibility of fireworks as I used to do with Ranchos de Taos Church. You don't wait for "years" but you wait. So there may be a few sea pictures—what a lot of work lies ahead.

*Strand used two cameras: a Deardorff view camera for 8 x 10-inch sheet film and a Graflex single-lens reflex camera for 5 x 7-inch sheet film, fitted with a permanent mask to record an image 5 x 6 inches—a proportion he favored over that of the whole negative.

PAUL STRAND. *Susan Thompson, Cape Split, Maine.* 1945. The Museum of Modern Art, New York.

Paul Strand, Prospect Harbor, Maine, to Nancy Newhall, October 18, 1946.

Well here I am in Maine. Arrived at Prospect on Wednesday, having driven just about 1000 miles (hard to believe) since we left N.Y. Of course I took some indirect routes and did a few things on the way. But the days were on the whole not very good photographically. It turned warm and that brought out autumnal haze. Today it rains.

My eye is watchful for material for the Hill & Down section and of course I hope for a storm up here. They had a beauty about two weeks ago—the tail of a hurricane.

Paul Strand, Prospect Harbor, Maine, to Nancy Newhall, October 22, 1946.

Well it is good to hear that Charles* is that pleased and I hope he stays so to the bitter end—which I think

*Charles Duell of Duell, Sloane & Pearce, who planned to publish *Time in New England,* but later transferred the contract to the Oxford University Press.

PAUL STRAND. *Church.* 1944. The Museum of Modern Art, New York.

we ourselves must have encompassed by January 1st, don't you?

Do you mean he feels that the images in the first part are not concrete enough and the text too full? I cannot say I agree with that. I keep wishing Paul Revere's ride was back in, but I don't see more coming out of 17th and 18th centuries.

Probably we do have to struggle with a better title. Did he have any suggestions or do you? It is one of the finest indoor or outdoor sports, thinking of titles for movies, film companies or books. Usually the session ends up with everyone becoming as absurd as possible out of sheer frustration relieved by loud guffaws of laughter. "Frontier Films" and "Native Land" came out of such excruciating sessions. So hold on fast, here we go.

I never saw such short days ever as they have in Prospect Harbor; by 5 PM it is night. Up here the Republicans blame this on the Democrats and no doubt they are right. Then the days have been virtually cloudless, the sea utterly calm—same reason—All of which I have to put up with. I suppose the day after I leave, and the Democrats not on their toes, there will be a hell of a storm. Such is politics in New England. Cheerio. We will fool them all with something really abstract entitled "rough sea." I shall look for but do not promise to find one of those uncommon commons for which you crave, et al.

Best to you both and here's to a rough sea and a smooth title.

Paul Strand left New York for permanent residence in France in 1950. He wrote from Paris.

It was good to get your letter before we left last Saturday. Arrived here next day very weary, for though the flight was smooth it is somehow exhausting.

Your new foreword is as you say greatly improved. Thus do we push each other along—and I am glad the dedication is acceptable to you—for now we are moving ahead and the rest is up to Oxford.

I had several conferences with Mr. Begg,* all very fine, the last one on Friday.

All things considered we decided unanimously not to take a chance on the new reticulated screen process as too experimental in its present stage, and stick to 150 screen conventional halftone. By now, you should have a proof of the fern, large size, which we felt was a pretty good plate. Also we felt that the slightly warmer stock was more satisfying than the original colder which we first picked out.

Also convinced Begg that the ornaments should be omitted altogether, because if used only occasionally they will appear to emphasize one piece of text over another, which of course is not the intention. Personally I think the page has greater dignity and simplicity without them (ornaments and brackets and page numbers). Do you agree?

I think there is no doubt that they plan to move full steam ahead, as Philip† said they would be "sunk" if they did not have the book ready for September. The main problem of the plates is going to be one of maintaining brilliancy of whites, not to let the usual flattening out into an overall greyness of letterpress take place. I think Begg understands this need and also is *not* cropping the edges.

Nancy Newhall, Carmel, California, to Paul Strand, October 27, 1950.

Have you got it? Do you hold it in your hand, at last? You said, during some of those dark days, that by God it would be published. And it IS . . . So now it's up to the public and may they adore it and get from it something of what we did and of what we put in!

Early reports are heart-warming, of course—all from prejudiced sources. May the reviewers join the happy throng!

Paul Strand, Paris, to Beaumont Newhall, November 26, 1950.

Thanks for your letter which I was happy to get— so full of good word from you. Yes, I think we can all be content with "Time in New England" as something really accomplished, that reflects the spirit of the way we worked and the result of the work itself. Philip wrote me that 3,500 copies were sold in what appeared to be the first three weeks—and I would judge that to be quite good—with many reviews just beginning to appear.

Of the many reviews, that written by Samuel T. Williamson in The New York Times Book Review *pleased Paul and Nancy most.*

"The New England spirit is an enigma. If completely revealed, it would no longer be an enigma. It must be experienced and felt. Paul Strand and Nancy Newhall recreate that feeling and experience in pictures and text. . . . Their creative collaboration is an exciting new form of bookmaking which I fear will have many imitators who won't realize that successful execution depends upon imagination. . . . Should I be deprived of all but one book on New England, I'd ask . . . for this one."

*Art director, Oxford University Press, New York.

†Philip Vaudrin, editor, Oxford University Press.

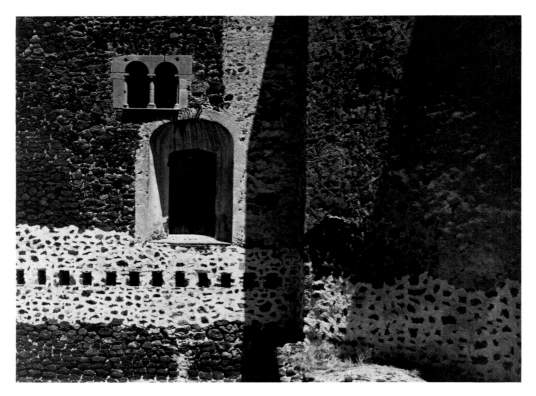

AARON SISKIND. *Acolman 5, Mexico.* 1955. The Museum of Modern Art, New York.

AARON SISKIND. *Chicago.* 1952. The Museum of Modern Art. New York.

In 1943 and 1944 A Great Change Took Place

AARON SISKIND
1963

In the life of every creative artist there comes a time when a truly personal style is found. This magic moment, this unfolding of the unconscious, is seldom recognized by the artist. Aaron Siskind (born 1903) is one of the few artists who pinpoints the moment when he found his personal style. He felt that "documentary" photography was a fetter, that a less doctrinaire approach was a release.

In 1943 and 1944 a great change took place. This great change was not the result of any intellectual decision—and this is very important—it was the result of a picture experience which almost surprised me as to its meaning. That is what changed my course from documentary photography to something new. During one of the years I was on Martha's Vineyard, I think it was '43, I did a whole batch of pictures without knowing why I was doing them. When I examined them it was revealed to me that I had made pictures that had a meaning basic to my life. The fact that you could take a picture in a pleasant way, without thinking too much, and then find out that it could reveal terrific meaning to *you*, and also that these pictures have a *consistency* of meaning, showed that I had gotten at something very fundamental. So I decided to continue to work in that way.

In working from the documentary approach, I had always tried to find what kind of meaning you could get in a picture of that kind, and was beginning to feel that I wasn't getting it. I felt that I wasn't hitting anything really personal, really powerful and special. I also found, upon examining it, that I wasn't really made for it, because my documentary pictures were very quiet and very formal.

I noticed that I was photographing objects in a setting. I noticed that in all the pictures I did that the total effect of the picture was such that it was a picture on a flat plane—I wiped out deep space and had objects which were organic in a geometrical setting. I was getting away from naturalistic space. The objects themselves no longer functioned as objects; instead of a piece of wood I felt the wood as a shape. It became transformed from object to force. The setting was no longer naturalistic. I was operating on a plane of ideas. The shift was from description to idea and meaning.

Another thing that struck me was the similarity of the pictures. They all contained a formal element and an organic element. These things surprised me, because they were symbolic of the essential duality of our nature—which was something that I was very much concerned about in the poetry which I used to write.

So I had struck something which I felt was fundamental. I decided to continue in this vein, but not by preparing a program, but simply by putting myself in a place and looking, and making pictures as they came. I did that in Gloucester because of physical reasons—it was during the war and I couldn't get any gasoline. So I chose Gloucester because I could get around on a bus—which was all very fortunate because Gloucester is rich in material.

I worked very systematically: every morning I would take twelve sheets of film and shoot six pictures. I found a very interesting thing: it was an exhausting way of working. I would take those six pictures in perhaps two to three hours. I moved very, very little, and sometimes would take all six pictures within the area of a block. And it was fantastic—when I got through I was worn out. And I did nothing!

Something was going on. The important thing was that although these were pictures about objects, these were pictures with terrific emotional involvement. What evidence did I have of that? I had the evidence of being tired. Of being glad I was through. I have comical evidences of terrific absorption. I smoke all the time, and I remember once a guy tapped me on the shoulder and said, "Hey Bud, you're burning up"—I was under the cloth with my cigarette. I was unconscious of anything but the picture taking. Those were good conditions that everyone should work under.

From an interview with Jeremy Stephany, 1963, edited by Peter Thompson. *Quarterly of the Friends of Photography* 7/8 (July-August 1974), pp. 32-33.

I found that it was impossible for me to change the object which I found in any way. I remember once kicking something out of the way on a wharf and then turning around to see if anyone had seen me doing it. I had that kind of belief in the thing itself. In spite of the fact that these pictures were abstracted from the setting, there was real emotional contact with the thing itself and a belief in the thing itself. I wasn't really using these things as something else. It wasn't an intellectual exercise.

The early rock pictures came out of an experience of photographing pre-Columbian sculpture during the previous winter. The effect of that was so strong that when I went back to Gloucester I saw images which I hadn't seen the previous summer, although I had walked all over those rocks. And suddenly, they were there. This is very important, because it reminds me that every artist is influenced by art. Art begets art. But I have still remained true to my documentary training, because although these rocks are definitely images with heads and figures, they are also *rocks.* The rock is never destroyed.

This also points out another important quality in all my work. My early pictures revealed to me the basic duality that I felt in regard to the geometric and the organic together. They pointed at the essential ambiguity of all my pictures. In them you have the object, but you have in the object—or superimposed on it—what I call the *image,* which contains my idea. These two things are present at one and the same time. There is, therefore, a conflict, a tension. The meaning is partly the object's meaning, but mostly *my* meaning. Sometimes the nature of the image is apparent, sometimes it is not. Sometimes the object is not recognizable as the object. It may be distorted tonally, but it is not un-recognizable as an object because of that, but because it is out of context, or because the experience of the viewer is limited—he's never seen anything like that before. I think recognition often depends on the viewer's life experience.

The last rock pictures represent a resolution of feelings about life. I was concerned with Contiguity. The realization of how people feel in relation to one another; the nearness, the touch, the difference between a mother and her children, how she touches them and hovers near them, and how a father does; how two people feel sitting next to each other in a train. As I worked on that, images began to arise in my mind of certain people I knew, and especially of one family. So I began to feel the importance of how these rocks touched each other, hovered over each other, pushed against each other— what I call Contiguity. Then I felt that I had gotten something that was unique. It *was* documentary, a projection of my philosophy. I was able to do it without distorting the rocks too much. I had to wipe out, to some extent, their physical reality. They had to become darker so that the detail, to some extent, was lost. But I've never worried about things having a disagreeable one.

I remember doing a study in 1935 of the Civic Repertory—a kind of pseudo-classical building on 14th Street. I made a very methodical study of it. Since it was a study of destruction, I found elements of destruction, I printed them and showed them at the Photo League, and because I had the theme of destruction, I printed them very dark. Technically, I was very unskilled. A man who later became a *Life* photographer objected very strongly, saying "why in the hell did you print them so dark?" I said "because that's what I want to say!" But they were ridiculous—they were too dark and I was destroying the picture itself. I made it impossible for him to get the dark mood. But it was a good thing that I did it, because I was concerned with relating the print quality to the idea, the tones to the idea, rather than getting a full range of tones, always getting a beautiful surface with fine toning—which is very nice but sometimes terribly irrelevant. I think that is a kind of dead end, making everything look "beautiful."

I feel the anthropomorphic qualities of shapes very strongly at times. I don't feel them as animals or because they resemble something, but as force or energy. When you feel a picture in that way, when you get it *right,* when you take it and examine it later, you find that there is a terrific amount of internal stuff which supports the original feeling you had about it. That *matters.*

Found Photographs

MINOR WHITE
1957

Minor White (1908–1976) brought a very special qual-
ity to photography: a spiritual, nonsectarian yet deeply
religious, mystical sensibility. A brilliant technician, he
produced photographs of great intrinsic beauty—that,
for him, had hidden meanings. The question of whether
his metamorphoses stand as such without his explanations
can never detract from their beauty. The following entry
in his unpublished diary, Memorable Fancies, *for April*
11, 1957, analyzes his thoughts from the event to the
photograph.

Only a small crash in the kitchen, but enough to shatter my calm and a bowl. One careless glance caught the pieces—white porcelain still quivering on the floor—a rice bowl, pleasant in subtle curve, from Japan, delicate to balance, was no more. He who dropped it fingered the pieces. He was silent and I suppose, sad. I turned back to preceding thoughts. Then he was jubilant. One fragment, he exclaimed "has a form!" And truly he pointed to one that was haunting to see.

The swift drop to the floor signalled eager forces into play: gravity was the trigger, clay and shape the material, the loving hand that shaped the bowl—had unconsciously stored an unguessed form in it. With the crash transmutation worked, metamorphosis took a deep breath and an object found itself. The death of the bowl was the birth of an object.

We might wish that birth and death were always as close. Actually they are, birth always explodes from death as fast as the splinter from the bowl—only those of us who feel the need of sleep close our eyes too long.

The splinter of china was more loving than the bowl had been, as if in this form all the love of the craftsman had crystalized. Furthermore metamorphosis did not stop when an object had found itself. From a radiation of a man's love for his work the splinter turned into the symbol of the female principle, and then into the thumb print of a goddess. And since I make photographs it

seemed natural to transmute yet again and make a photograph of it; to train my camera on the splinter seemed obviously the next step. But a thought stopped me. What is the status of a photograph of an object that has just found its own form? A copy? Or a photograph that in turn would find a form peculiar to itself?

There wasn't time to think through such questions in the chain reaction of thoughts that followed the explosion. In the "fallout" however, I found a name for some of my own photographs. I always photograph found objects; excepting portraits, all of my photographs are of found objects. And now, thinking of the best of them, I hear little crashes tinkling back twenty years, for the best of them have always been photographs that found themselves.

By photographs that found themselves do I mean the "lucky or happy accident"? That is one name for it. "Happy accident" is a name that I ought not to mention because many an extraordinary snapshot is passed off lightly with this appellation instead of being explained. I do mention it because it is a term of helplessness in the face of a photograph that is a freak, a sport in a man's work—unexplainable, so unsought for, so unaccountable that it is almost embarrassing. I have heard Edward Weston say that he strove to eliminate all accidents from his work and I copied his striving. I submitted to that discipline by which one earns the elimination of all accidents. I have made enough pictures so that now I see like a lens focused on a piece of film, act like a negative projected on a piece of sensitized paper, talk like a picture on a wall. I have even been so presumptuous as to try to tell others how to see, act, and talk likewise. I know fairly well how to eliminate accidents from my photographing, and, paradoxically, in so doing I have also learned that the happy accident can be cultivated!

I must admit to many accidents in my own work before I undertook the practice of learning to avoid them—and to many more since. Such accidents when they happen now, however, are not isolated incidents, unexplainable events, as infrequent as stumbling on mountain peaks in

From an unpublished manuscript, Minor White archives.

MINOR WHITE. *Burned Mirror.* 1959. The Museum of Modern Art, New York.

MINOR WHITE. *Windowsill and Daydreaming, Rochester, New York.* 1958. The Museum of Modern Art, New York.

a fog. After learning to eliminate accidents I can now sometimes trace the hawser marks between cause and effect—between chance and photograph. Why? Or how? In acquiring a discipline of seeing, and a technique of communication, I put myself into the position of the reckless driver of whom it is said, there goes a maniac in search of an accident.

And while I put myself in the path of accidents, the term "accident" is a misnomer here. Hence I am pleased at the crash in the kitchen because it was not a crash but an explosion. As one porcelain bowl died a thousand thoughts were born; a score of unexplained photographs were seen to be, not accident, but photographs that found themselves. By my discipline of seeing I put myself where photographs can find themselves.

The German publication *Photomagazin* printed a brief and sprightly piece by Roman Frietag in 1955. He said that each camera had a subconscious. He further made the astounding observation that this subconscious is responsible for the extraordinary snapshot—and that it does so while the photographer thinks he is looking. Frietag may have been sprightly instead of serious, because, if serious, no one would have listened to him. So with tongue in cheek (apparently) he traced down the cause of these unexplained photographs to a machine's subconscious. And what a powerful subconscious it is. This personality inadvertantly built into cameras at the drafting board can on occasion steer the unsuspecting and probably quite innocent owner. He is not alone in allocating minds to machines; long before our highly touted electronic brains took over, people in many places observed the phenomena. Ships are "she" for instance.

I can remember a mechanical pencil sharpener that plagued my youth: and all my cameras, whenever their will opposes mine, I consider devices of mechanical tyranny or pitchforks of the devil. Upon reflection, however, the devilishness appears to be mine; for against the hours of anguish or truce with cameras, there have been moments of rapport between myself and machine.

And so Mr. Frietag's identification of the liveliness of tools is as good as any other to explain the one photograph in thousands that seems to have character. In fact his term, for our time, is better than most because "subconscious" is as popular today as it is misunderstood. Call this liveliness of tools by some other name, the "still, small voice" for instance, and we can readily understand that it really makes no difference how one hears it, so long as one does. Hence no matter whether we call them "photographs that found themselves," "happy accidents," or the "subconscious of the camera" so long as such photographs are cultivated. How are they cultivated? Toss flowers in a pool and follow them as they

trace the slow undercurrents of the water and the twisting breath of the wind. Then, as they move at seemingly random, photograph precisely.

I would like to carry some of this story of the broken bowl a little further. Photography is peculiar in that when a photograph is born, the found object does not necessarily die. Photographing does not change the object—though no one has measured how much a photograph of a tree shortens that tree's life; or what it has taken away from a dried lentil found on a doorpost. Death does happen, of course; the layer of light-sensitive silver is broken. Ever so slightly broken at exposure, and broken with a crash that, while simultaneous with the roar of a shutter, is not to be confined with that. In the conventional processes the breaking itself is broken into exposure and subsequent development. In the newer Polaroid Land process the immediate image is back in photography (after a lapse of about three-quarters of a century) and exposure explodes into picture so fast the crack is practically audible. So while I can see nothing to indicate that the found object dies when a picture is born, and the idea of the silver emulsion dying at exposure may be a conceit or playful image, something does die in me when a picture is born. When I look at pictures I have made, I have forgotten what I saw in front of the camera and respond only to what I am seeing in the photographs. With the Polaroid system, it is true that I can compare photograph with scene; but this only serves to make me realize with lightning clarity what a tremendous transformation has taken place. A forceful change is present with any ordinary photograph: when the result is a photograph that has found itself, the transformation is truly remarkable.

"For what I am seeing is not what I saw" is the context of every photograph I make. This forgetfulness is not carelessness because I have worked to reach essences of place with photographs, and struggled to get character of persons somehow on film. This reaction is forced on me by the facts with every photograph I make. I can remember looking into a space between two buildings and saying to myself that there is a picture here, and then digging it out. Having to dig I remember many details, down to the texture of a piece of wood and just where the fly rested. On the contrary I have looked down a small gully that storms had cut into a rock beach and seen something in the light concentrated there that literally beckoned to me. The child who says "Take my picher Mr." is not more demanding. Here again the lapse occurs. The photograph is neither crevice nor child, neither essence of tree or character of person—it is only photograph. Or to say this another way: when the illusion of the reality of appearances is high, the photograph, for me, fails—when it is a splinter of the broken bowl, it succeeds.

If by chance someone is looking at some picture that seems to be a "found photograph," it makes no difference that he understand what I was trying to do, because I was not trying to do anything.

As was said, I have a technique that is well developed for my purposes. It is sturdy enough that I can photograph without thought, and without communicating. But why develop a technique of craftsmanship, or one of communication, if not to communicate? Again as was said, in order to put myself in the path of accidents. But more than that, to put my act of photographing at the service of an outside power. So that when I photograph an outside (or inside) power may leave its thumbprint.

And I need only enough technique to remember to use my camera without bungling when I am transfixed by light.

WALKER EVANS. *Corrugated Tin Facade.* 1936. The Museum of Modern Art, New York.

Walker Evans, Visiting Artist:
A Transcript of his Discussion with the Students of the University of Michigan

1971

In 1971 Walker Evans (1903–1975) was invited by the University of Michigan to visit Ann Arbor while his retrospective exhibition, first held at The Museum of Modern Art, was on display there. Charles Sawyer, director of the University Art Museum, had expected that Walker would give a lecture, but this invitation he declined. So Charles asked me to lecture on the work of my old friend. The three of us met at the airport and then had lunch. Charles asked which of us should be introduced first? I answered, "The honored guest, of course." To our surprise and to the delight of the students, Walker answered their questions for an hour, in an informal, perspective, sympathetic way that was both witty and profound. Happily, a tape recording was made of this conversation. The following transcription was made by Amy Conger. "The act of transcribing it," she writes, "emphasized the immense differences between a spontaneous conversation and a premeditated and prepared lecture. For the sake of written transmission, it was necessary frequently to make shorter sentences out of longer ones which flowed on with anarchic disregard for punctuation and pauses. Unfortunately, his emotion, his enthusiasm when he spoke could not be translated into the written word, nor could the gentle concern with which he answered 'Oh, my yes; I should say so' to a student wondering if he too had undergone hard times. Nor could the delight and enthusiasm of the students be captured on the printed page. As in much of Evans' photography, his thoughts flowed quickly, occasionally to be compressed or stopped in a reflective and translucent statement."

Walker Evans was introduced by Phil Davis, Professor of Photography. After outlining the visiting artist's career he concluded: "In a world where might makes right, where arrogance and aggression and

Transcription of a tape recording made at the University of Michigan on October 29, 1971. Published by permission of the University of Michigan and the Estate of Walker Evans.

simple bad manners are considered virtues, and the measure of a man's success is the number of snowmobiles he owns, Walker Evans stands apart: introspective, aware, compassionate, unpretentious, an exceptional human being. His forty-year career in photography has been one of intense involvement, concentration, and dedication in a style that is almost totally personal. He seems to have grown almost without help and without much encouragement from other photographers, apparently confident that his own direction and his own vision were right. Time has proved that they were, and he is now recognized as one of photography's great men.

"I met him for the first time today at lunch and I can testify that he is also a delightful person to be with. Incidentally, he has requested that after his talk, the meeting be conducted very informally, and he would like to answer questions and have conversation with the audience. We are honored to have him here today. It is with great pleasure that I introduce to you Mr. Walker Evans."

Walker Evans: Can I be heard? The chief point upon which he misled you was that I am not going to give you a lecture and you were probably led to believe that I was. You've been lectured at enough, and it could be a bore, and I can assure you that if I gave a lecture, I could be a *deadly* bore, so I won't do it. But I would like to talk a little bit and maybe read a couple [of] things I've tried to write, and, what I really want, if I can persuade you people, is to visit you, visit with you, be, in a sense, for an hour or so a kind of visiting artist, really. I want you to make use of me; interview *me;* ask me things. Most of you, I believe, have seen some of these pictures; if anything has come into your mind—even adverse criticism—whatever you would like to say, do talk to me. Just bear that in mind.

Now, I think I will read you something which I wrote in a great hurry for *The Boston Globe* when I was having *this* show in Boston. A young man telephoned me at home in Connecticut. He said, *The Boston Globe* would like to give you a little space. I thought fine; it's a little job; and I said "what do they pay?" and he said "nothing." In a perverse way that's been my story all my life.

311

Anyway, I wrote him a couple of paragraphs and I'm going to read them to you because it has to do with this show—the way I'd like it to be *taken*. Mind you, this is not a piece of prose. It was done in a hurry, the way newspaper things are. I called this "A Placard for a Museum Gallery Wall":

A good art exhibition is a lesson in seeing to those who need or want one, and a session of visual pleasure and excitement to those who don't need anything—I mean, to the rich in spirit—that's you. Grunts, sighs, shouts, laughter and implications ought to be heard in a museum room, precisely the place where these are usually suppressed. So, some of the values of pictures may be suppressed too—or plain lost in formal exhibitions. I'd like to address the eyes of people who know how to take the values straight through and beyond the inhibitions of public decorum. I suggest that religious feeling is sometimes to be had even at church, and, perhaps, with luck, art can be seen and felt on a museum wall. Those of us who are living by our eyes—painters, designers, photographers, girl-watchers—are both amused and appalled by the following half-truth: "What we see, we are;" and by its corollary: "Our collected work is, in part, shameless, joyous autobiography, *cum* confession, wrapped in the embarrassment of the unspeakable." For those who can read the language, that is—I mean, I never know just who is in the audience—when the seeing eye man does turn up to survey our work and does perceive our metaphors, we are just caught in the act, that's all. Should we apologize?

That's the end of the little piece that goes to *The Boston Globe*. It does convey, I hope, the idea that art museums are rather tight and suppressing places. They are to me. I feel that I've gotten a lot of education out of museums, and yet after a while a young man stops, a young woman stops looking at art and goes to life. I find now that my museum is the street and the little things I see that I relate to life and not to art. I am implying that to go into a museum and never feel that these things are anything but something I really ought to see in the museum—that spoils it a little bit. And I hope you students are not all feeling that, because here I am on the museum walls, much to my horror.

The gentleman that introduced me here made me sound like a great member of the establishment. But don't forget that I am simply the product of the establishment. And you're going to be too, most of you; and some of you already are. You can't help it. You may not like the establishment, but the University of Michigan

312

is the establishment and you're *here*. You're being shaped by it. I've been shaped. I've also been told, and I hope this is true, that my work doesn't look like establishment work, and I don't believe it does. I don't feel that it is.

I did, with some luck, speaking of establishment, appear in an antiestablishment place by chance. Lo and behold, I am quoted in *The Last Whole Earth Catalog*. I think that the *Whole Earth Catalog* is one of the finest things that the younger generation has produced, and so I'm very pleased to be in it. If I may, I will read you, if I can find it here, what was quoted. It's from an interview which I cooked up with a friend of mine called Leslie Katz because we felt that taped interviews were usually quite a failure. They turned out to be phony, pretentious and wrong. We decided to make a *true* one since we're good friends. I feel that we've brought it off and this is what the *Whole Earth Catalog* picked up. It is not a piece of written prose; it's terrible style, but it has a voice of speech. Katz and I did do this interview by sitting in my own living room because I had to be where I've got my books and things, and relaxing and turning the machine on and talking—having it agreed beforehand that a couple of silly questions would be asked. Well, the interview did appear in a little known magazine called *Art in America,* which you all probably know because it's in your field. May I have your permission to read just a little here?

The question is "Millions of people feel that they are performing an instinctual act when they take a snapshot. What distinguishes what they do from a photograph of yours?" This is Katz speaking to me.

Now my answer is as follows:

I don't know. As a matter of fact, I hope you will have gathered, sooner or later, that this thing is absolutely spontaneous. We weren't drunk, and we weren't high on anything but we were pleased with each other, and with ourselves, and it was a nice day, so we tried it.

It's logical to say that what I do is an act of faith. Other people might call it conceit, but I have faith and conviction. It came to me. And I worked it out. I used to suffer from a lack of it, and now that I've got it I suppose it seems self-centered to say so. I have to have faith or I can't act. I think what I am doing is valid and worth doing, and I use the word *transcendent*. [But, of course, I'm talking about photography now. When I say faith, I don't mean religious faith. I mean faith in myself as an artist, which you don't get until you're over 50, by the way, and none of you are anywhere near that, which is quite a subject you've got nailed on me.] That's very pretentious, but if I'm satisfied that something tran-

scendent shows in a photograph I've done, that's it. It's there, I've done it. Without being able to explain, I know it absolutely, that it happens sometimes, and I know by the way I feel in the action that it goes like magic—this is it. It's as though there's a wonderful secret in a certain place and I can capture it. Only I, at this moment, can capture it, and only this moment and only me. That's a hell of a thing to believe, but I believe it or I couldn't act. It's a very exciting and it's a heady thing. It happens more when you're younger, but it still happens later on or I wouldn't continue. I think there is a period of esthetic discovery that happens to a man and he can do all sorts of things at white heat. [Mind you, this is terrible language, but it's spoken so you just have to take it on the flight.] Yeats went through three periods. T. S. Eliot was strongest in his early period, I think. E. E. Cummings seemed to go on without losing much all his life. After all, poetry is art and these fields are related [poetry and photography]. It's there and it's a mystery and it's even partly mystical and that's why it's hard to talk about in a rational, pragmatic society. [You see why the *Whole Earth* people like this sort of thing.] But art goes on. You can defend it in spite of the fact that the time is full of false art. Art schools are fostering all sorts of junk, but that's another matter. There are always a few instances of the real thing that emerge in unexpected places and you can't stop it; there it is. Even in a puritan, materialistic, middle-class, bourgeois society like America. Because the country is like that, the artist in America is commonly regarded as a sick, neurotic man. (And tends to regard himself that way sometimes.) Until recently, true art in America was sick from being neglected. Now of course it's sick the other way: too much is being made of it. The period that's just finishing, of fame and fortune for a few artists, is outrageous. It's outrageous for a few to make hundreds of thousands of dollars while a number of very good artists cannot even make a living. It makes you sick to think about it. The art world is part of our very sick society. Think of what a man of letters is in Paris or in England and what he is here. Here he's either outrageously famous and rich, or treated as less than nothing, never understood, never honestly appreciated. In those countries everyone understands that there are many excellent poor, almost starving artists, and they are very much respected, just as old age is respected. The unappreciated artist is at once very humble and very arrogant too. He collects and edits the world about him. This is especially important in

the psychology of camera work. This is why a man who has faith, intelligence and cultivation will show that in his work. Fine photography is literature, and it should be. It does reflect cultivation if there *is* cultivation. This is also why, until recently, photography had no status, because it's usually practiced by uncultivated people. I always remember telling my classes that students should seek to have a cultivated life and an education: they'd make better photographs. On the other hand, Eugène Atget was an uneducated man, I think, he was a kind of medium, really. He was like Blake. His work sang like lightning through him. He could infuse the street with his poetry, and I don't think he even was aware of it or could articulate it. What I've just been saying is not entirely true. Since I'm a half-educated and self-educated man, I believe in education. I do note that photography, a despised medium to work in, is full of empty phonies and worthless commercial people. That presents quite a challenge to the man who can take delight in being in a very difficult and disdained medium.*

Well, as you can see this is chatter, but it has a certain spontaneity and life, but I wanted to read it to you. In view of the fact that it's pretty poor English, it's got a few ideas there.

Now, I feel that I've taken enough time plus reading and giving out some of my ideas. I wish now, if I may, to place myself at your disposal. Will anyone be prompted to ask me anything that they want about these photographs, or about anything else. If it isn't too devastating, I'll try to answer anything. Now, please, do speak to me, if you will, anybody?

STUDENT 1: What started you off in the medium? When did you begin and why?
W.E.: You'll forgive my sitting down and answering it. Even you, sir. I like to sit down too.

I don't think I can, but I'd like to try. I feel that I was drawn really for love, and by love, to this medium, and instinctively. I really didn't think very much. I've thought that I was some kind of artist. I was standing aside at the beginning of my life, standing aside from the world I found myself in—which was a New York life. I couldn't bear to enter the only life around me, which was commercial, and I couldn't bear to immerse myself in the problem of earning a living and getting a job. I felt that I would soon be stuck with that. I instinctively kept

*Leslie Katz, "Interview with Walker Evans," *Art in America* 59 (April 1971), pp. 87-88. Evans's asides to the audience are enclosed in brackets.

away from it and I wanted to work with the camera so I did have jobs. I had to earn a living. I took jobs at night. In those days, of course, I was young enough to have the energy to work in the daytime. So, I just went around with my camera, and taught myself, and excited myself. I now find, a very interesting thing to me, that is that I was doing things that I wasn't aware of. This is what I meant when I said, in referring to Atget, that sometimes an artist is a kind of medium. I really think that things would happen through me. For example, I can now see some work that amounts to prediction. Well, I *didn't predict* anything, but the work of mine *does*. What told me to do it, I don't know . . . what instincts . . . I was interested, for example, in 1928 in an abandoned motor car as the subject of camera art. Well, that is prophetic work, but just done by instinct.

Now, to try to sum up, to give you an answer, sir. This attraction of mine to the camera and its graphic product was a blind but passionate response to something I could not really analyze or describe. I knew I had to do it. Every young man has it, or woman too, has a knowledge that there is a path he must get on and follow. It's agony, of course, finding it and getting on it. Lots of us think we'll never find it, but we do. . . . Thank heavens. Otherwise we'd go out of our minds and refuse to live. Don't you think? I hope that made some sense to you.

STUDENT 2: What do you express making a picture. I can't quite tell. Do you think of it, when you get a picture that works, that you've captured something out of the world, or created something in the picture?
W.E.: You're not putting that so I exactly understand how to answer it.

STUDENT 2: Is it a lucky accident? And are you happy to be very lucky? You've got those instincts. . . .
W.E.: Well, it's both. I'll tell you what I think it is. I think you have a little of both. You have luck *and* you build on that luck. It's pyramided. You know instinctively, but not why, but that you're on a certain track, or that you've got something. Let's say, in a particular instance you've got something right. The more you develop that, the more you take advantage of those moments, the more they'll come to you. Your eye is a collector. It runs down this and that byway, some of them false and some of them very fruitful. You don't often know whether you're on the right track or not, but you do get on it and follow it. As I say, get on it by luck, and follow it by instinct. I hope that answers it a little bit.

STUDENT 3: You said that the street is your museum. Would you suggest any means of reaching the people in

the street who will never come into a museum?
W.E.: Gosh, that's quite a problem, isn't it? This gentleman asked me if I would suggest how to reach people in the street with art. Well, let me make a parenthesis first. When I said the street is my museum, I meant not what you think at all. I meant that *I* go to the street for the education of my eye and for the sustenance that the eye needs—the hungry eye, and my eye is hungry. I did not mean that I wanted to make use of the street to reach anyone, but my own work. But that raises a very interesting question because right now everybody feels the inadequacy of the *forms* through which the artist is speaking. Easel painting is something *disdained* by the young today. Naturally—you walk into Knoedler's Gallery in New York and if you haven't got $10,000, a painting doesn't mean anything to you. This is an absolutely infuriating and self-defeating problem, I mean matter. It raises this problem: what are we going to do to make art exist. It's a word I won't stop to define. You all know what it is. It's at an impasse or crossroads right now. What about it? So I mention the street and you, immediately, hook on to that, thinking there is a use for art. Well, of course, it *is* being used, you know. You see recently empty sides of buildings are being covered every once in a while by "flash art," I would call it. Also there are many street exhibitions of art, more than usual, since you're raising that question. This is not for me. As a matter of fact, I don't know that I think very much about the function of what I'm trying to do. I'm sort of doing it. I feel that things do reach a target, that the great point is the doing of the things, the making of a work of art. How it reaches anybody doesn't matter because if it's any good, it will reach them.

Now, does that in any sense answer your question? We have a misunderstanding, but have I cleared it up?

STUDENT 3: Well, I understood the other was. . . .
W.E.: Well, that wasn't what I was talking about. Now, would you like . . . ?

STUDENT 4: I wonder if you'd talk about why you went to Paris in 1926, and what you found there, and why you came home.
W.E.: Oh yes. This gentleman wants to know why I went to Paris in 1926, what I found there, and why I came home. I hope you all have a couple of hours of patience for me to answer that question. It is a big one. I'll try to do it in two minutes instead of two hours.

I went there because I had an intelligent and forebearing father who said if you want to leave college, which I did want to do, and go to Paris instead, and study there, go ahead and I'll pay for it. Of course, it was

WALKER EVANS. *Phillipsburg, New Jersey.* 1936. The Museum of Modern Art, New York.

damned cheap, cheaper than going to college here; the exchange was so much in our favor. But in any event, that answers the question. I went there because it was economically possible, because I wanted to. Any man of my age who was sensitive to the arts was drawn as by a magnet to Paris because that was the incandescent center, the place to be. It isn't now. It was then. Figure what was going on, who was alive: Proust was just dead; Gide was alive; Picasso was in midcareer; there was all the School of Paris art, which seemed revolutionary at the time. It was terribly exciting. The place, as I say, was incandescent. You had to go there.

Now, there were two parts to your question. The other one was . . . what did I do there?

STUDENT 4: What did you find there?
W.E.: I found the incandescence. One lived in a sort of fiery cloud of excitement. You're excited when you're young anyway, but this was super excitement. Every day it took the top of your head off. And I came home because I had to. So the question's been answered.

STUDENT 5: I'm very much interested in how you regard the work you did in the FSA and how you felt, and to what degree Roy Stryker influenced your work and vice versa?
W.E.: Oh. Hmmm. That's quite embarrassing, but it's an interesting question to me. What was the first part of your question? What I was doing there?

STUDENT 5: How you felt about your work aesthetically during that period?
W.E.: Well, I felt this great opportunity to go around quite freely—at the expense of the federal government, which supplied materials and travel expenses and lodging—and photograph what I saw in this country. Who could want a better career or thing to do? I was unattached, free, and devoted to what I was doing. I was able to go around, but I wasn't *supposed* to do that. I was cheating, in a way. I was looking upon this as a great opportunity for myself and I was exploiting the United States government, rather than having them exploit me. Therefore, I got in Dutch all the time. If I was asked to

315

WALKER EVANS. *Bedroom Dresser, Shrimp Fisherman's House, Biloxi, Mississippi.* 1945. The Museum of Modern Art, New York.

do some bureaucratic, stupid thing, I just wouldn't do it. So I misbehaved. I became a rather open anarchist, as far as all laws are anyway. They are out for themselves anyway. They believe they are justified in that. I just photographed like mad whatever I wanted to. I paid no attention to Washington bureaucracy. I'm sorry to say that Mr. Stryker was representing the government of bureaucracy and, therefore, naturally I antagonized him, poor fellow. I gave him a hard time, and he was very nice about it.

STUDENT 6: One always thinks of the dichotomy between the artist who creates things and the collector who collects them. Do you as an artist collect anything?
W.E.: Yes, now that brings up a subject that interests me very much. I think that artists are collectors figuratively. I've noticed that my eye collects. The rare collector does. The man who's interested in nineteenth-century French first editions, he gets his mind on that, and instinctively goes around. My eye is interested in streets that have just rows of wooden houses in them. I find them and do them. I collect them. Now, what is that great intellectual word "dichotomy" of yours? That really marks you as an intellectual student. How did you use that? Excuse me for being so personal. It amuses me to spot these words. How did you use it? Dichotomy of what? Collecting and creating, you say?

STUDENT 6: Right. Yes.
W.E.: Well, they do go together, but obviously they're not the same thing. One starts the other. Don't you see?

STUDENT 7: I think she wants to know whether you collect artifacts as well as impressions.
W.E.: Do you want to know that?

STUDENT 6: Sure.
W.E.: Yes, I'm an incurable and inveterate collector. Right now I'm collecting trash, literally. I've gotten interested in the forms of trash, and I have bins of it, and also discarded ephemera, particularly in printing. Some day I expect to be infirm and quaking and unable to speak. Rainy days will follow, and I'll sit in my chair, and I'll fool with all this stuff.

BEAUMONT NEWHALL: This morning as we were leaving the airport, suddenly there he was on his hands and knees. I thought he'd slipped or something. "I'm collecting printing," and he puts it into his pocket.
W.E.: Well, there was a beautiful magenta and black piece of lettering that came out of the airport ticket someone had cast aside. It belongs—I suppose it's going to sound pretentious and out of date to you—in some

kind of collage. That's what I'll do with it eventually.

STUDENT 8: Can you think of any place today that is like Paris was when you went there, as far as a center of. . . .
W.E.: I've thought of that too. This gentleman wants to know if there's any place that's playing the role that Paris played in the twenties. I don't think so. There are several places for different tastes. Paris was the place for all the tastes at the time. Now, of course, you see it's changed a little bit. Rome did succeed in attracting the young aesthete. Well, that isn't the only type that there is. But as I say, now it's multiple, I believe. Many types must find themselves in Moscow at the moment, or I suppose the "in country" for a couple of years is Yugoslavia. No, I don't think there's *any one* place. Do you? What would you suggest?

STUDENT 8: I wouldn't know.
W.E.: No. Well, I find that I am now *stuck* on the three centers of world cosmopolitanism. I'm at home in New York, Paris, and London—and in love with all three of them. I feel when I'm in any one of these places, that I am in the center of the world. You don't find that in regard to, say, Chicago. You just don't. That's not the place for me to be, I think.

Would anybody name a place that is the incandescent place? Maybe it's Ann Arbor, I don't know. You know, in the university world, and the young world today, Ann Arbor is supposed to be a kind of an "in place." I don't know whether you know that or not.

STUDENT 9: When you photograph your billboards, do you do it out of a sense of disdain or derision for them? Are you deriding them or do you consider them beautiful objects?
W.E.: Well, I love them, and I'm entertained by them. I feel they're stimulating and exciting and endearing.

STUDENT 9: Is there a social comment there?
W.E.: Not in the least. But you can put one in there if you want to. I don't think there's a social comment. I photograph what's in front of me and what attracts me. Half the time I can't say why. I have been politicized by other people, not by myself.

STUDENT 10: It seems to me there is a paradox between the majority of the prints that are in the show and what you just said about feeling at home both in New York, London, and Paris.
W.E.: I don't wonder. I'm not surprised that you feel that. I do too. I have a part-time but very preoccupying love of Americana and America. I'm really spiritually at

home in this country. I'm a deep-dyed Yankee from way back and it comes out emotionally. For example, I don't work very well in London or Paris. I just play a part—gentleman of leisure—I don't know what. In London I think I'm a millionaire, and I'm not. But, here this does speak to me—this is the essence of what's gone to make me. I respond to it. So I can answer you by saying that when I'm in these other places I may feel I'm at the center of the world—but I'm also on vacation. Does that answer you? Good. You're quite right to ask that question.

STUDENT 11: Are there any classic exemplars for *Let Us Now Praise Famous Men* for relating text and photographs?

W.E.: In the making of that book, was there? Well, now it interests me to try to answer that. I had an agreement with Jim Agee that we would go our own ways. He knew me well. I knew him well and we paid no attention to each other. We talked a lot about what we were doing, but he was very busy, and so was I. I hardly saw him on that job, so there wasn't a conscious coworkmanship in that job—but it was understood that things would go together. I now perceive, and other people do too, they've told me, that there are different methods and approaches in those two projects, the writing and the photographic project. Well, what more can I say? I'm not quite through with that. Ask it again. What was your question?

STUDENT 11: Are there any others in that genre which perhaps predated it in the collaborative effort of photographs and prose? Were there any other books of its type that you....

W.E.: Any other work that I knew about, that had been done? I didn't have any in mind. No. As a matter of fact, you must remember that the inception of this work was a journalistic assignment. So, that alters the approach to the answer to that question. No, no models in my mind, because as I say, that was going to appear in *Fortune* magazine. It never did. Now, I believe that does answer it, doesn't it?

STUDENT 12: Have you had times in life when your work was not appreciated by your friends, or something, but you knew that you liked it—but other people weren't catching it so well? Did that upset you or somehow influence you?

W.E.: *Oh, my yes.* I should say so. That's a problem with anybody. For years anybody I've talked to has felt that for the first years of any artist's life, he's very discouraged at moments at being out on a limb and not being understood. Usually there are a couple of friends, maybe

sometimes more, but public recognition is wanted and craved and not had for a long time. It's withheld. It usually comes too late—after a man is either sick and tired or dead or through. Yes, I've had great discouragement, and I can do things to this day that are misunderstood or considered not worth doing. I can be very cast down by that, sure. But, in general, I've had the luck to have been appreciated by more than I've ever expected to be.

STUDENT 12: Does it get to a point where people will trust you because they've liked your work in the past and they'll accept whatever you did as extremely valid and...?

W.E.: That's inevitable. Some do. But there's always some very sharp kind of fellow that says, rightly so, that this was good; now you're off the track here. This is not good. I ought to choose people I can follow and trust to do that.

STUDENT 12: Who are they? Who are some of those people?

W.E.: Oh gosh. I don't think I could mention anybody that would make any sense to our audience. I'm just talking about a close friend here and there, or a chance person that I've been talking to. It might be you. You might say something. You could, if you wanted to bother to go pick out something done in 1970 and it's weak compared to something you did in 1936.

STUDENT 13: Could you give us just a short account of your personal reaction to that project with the three sharecroppers' families that's documented in *Let Us Now Praise Famous Men?* How did you feel about that personally, while you were working on it?

W.E.: Well, I felt very stimulated, excited, and I felt it was a very valid thing to do. I felt the way we all want to feel in our work every once in a while. This is the right place and time, for me, at the moment. This is the right action. Oh, I felt perfect about that. But that has a lot to do with the validity of Agee, my respect and interest in him and his mind. I knew that he was doing something. By that time Agee had established himself, in my mind, as a great man really. He was only 27 years old but, I perceived, and I turned out to be right, that this man had a touch of genius anyway. You don't see that very often. Here I was, down there, with somebody that I really felt had genius. Well, that answers your question. That's the great thing. It doesn't happen very often.

STUDENT 13: His own personal feelings are pretty well expressed in the book verbally....

318

WALKER EVANS. *Storefront and Signs, Beaufort, South Carolina.* 1936. The Library of Congress, Washington, D.C.

W.E.: Oh gosh! All too much so expressed.

STUDENT 13: I wondered if you got involved to the extent that it either interfered with your work or. . . .
W.E.: Oh no, no. We were leaving ourselves, each other, alone. Agee was a man that you couldn't afford to be involved with. He was so rich and so stimulating and so powerful that you couldn't work when he was around. You couldn't even go to sleep. He'd keep you up all night talking, and beautifully—but you'd soon have enough of that. Nobody's strong enough to hear that.

STUDENT 14: Could you say a little something about the subway portraits?
W.E.: Yes, I'd like to try. The gentleman wants to know whether I have anything to say about the portraits I made in the New York subway. Well, this appeared to me,

again, to go back to this idea of collecting. I began to collect people in my eyes in the subway. Well, I thought, see, you recognize that. I'd better follow that out. It was a challenge, because in those days the lighting was poor, the equipment wasn't up to handling a difficult situation like that either, from the point of view of the lens sensitivity or film sensitivity. So, it was just something that attracted me more and more and more. I just got doing it and was delighted with it until I really sort of went crazy with the subject. I had to make myself stop—or I'd be doing it to this day. You know you get momentum. You never know when you're through. So, I just had to stop. I guess those remarks are about all I can think of. They do feed you a little bit in your curiosity about that? Good.

STUDENT 15: What was the sharecroppers' reaction to you, as a photographer? I mean, because you were, like

319

knocking their thing, sort of like. . . .

W.E.: Oh. Well, this was up to us to handle. The young lady would like to know what the sharecroppers—I really don't like that word—the farmers we were living with thought of what we were doing. It was largely due to Agee's tact and psychological gift that he made them understand and they felt all right about what we were doing. They began to like us and they *loved* him. He's a very lovable man and they took me along as his friend. I was really able to trail along and take advantage of an atmosphere that James Agee created with these people. They were made to feel by both of us, I think, that they were participating in an interesting operation. We were also paying guests in their house and we were getting them out of a financial hole they were in. We didn't want to exploit them so we gave them money. We told them exactly what we were doing. We told them the truth— the truth at the time. They didn't know it was going to be a book, because we didn't know it. We said this was going to be published in a magazine and it's about your lives. Now, if you'll accept us, then we want you to help us and to take part. They loved it. They had a very good time with us.

STUDENT 16: Two questions. Did you know Flaherty* at all, and were you at all interested in his kind of experiments? Then, secondly, for every one of the photographs that's a success, how many failures do you have? W.E.: Did I know Flaherty and how many failures do I have for every success?

There are some failures on the wall, I'd like to add, undoubtedly.

Yes, I knew Flaherty and was very impressed with *Nanook*. That was the first film of his I saw and probably his first film, which as you know was a documentary financed by the fur company. *Any true* documentary style of photography attracted me instinctively because that's really what I am—that's my kind of thing. So the answer is, I knew Flaherty. I'll come back to that in a minute.

The other part is: do I have a whole lot of failures? Well . . . yes, of course. Probably mountains of them, but, incidentally as a footnote to that remark, I would say that when a photographer of my ripe age looks at work that's thirty or thirty-five years old, he discovers that he has discarded some things that *were* good, and I have made some finds. There are pictures on these walls that have never been printed before, that are that old, that I now think are of some value.

*Robert Flaherty (1884-1951), American documentary filmmaker. He made *Nanook of the North* in 1922.

Now, I believe, I want to go back for a minute and say that the word "documentary" is a little misleading. It should be accompanied by the word "style," because a documentary photograph could be a police photograph of an accident, literally; but documentary style is what we're interested in. I think right now that among the young in America there is a mass interest in this kind of work because that spells honesty. What your generation is interested in is honesty, much to your credit. You've been lied to so much that you're damned well going to have something honest for a change. This style does seem honest. It isn't always so, but it seems so. It is possible to express yourself practically, honestly, with a camera, more so than perhaps other media.

STUDENT 17: Do you think that if the technical quality of 35mm or projection printing enlargement had been more advanced forty years ago, would you still have chosen to use the 8 x 10 contact print, or large-format contact print? W.E.: The question is, assuming that the technical proficiency of 35mm camera work were as great thirty-five years ago as it is today, would I still do 8 x 10 work. Is that the question? Well, the answer is, gosh, I don't know. Yes, I think I would. There's such a fascination in, for example, seeing your image although it may be upside down and in reverse on a ground glass. It's an entirely different kind of action. You don't do that with a 35mm, even though there is such a thing as a reflex housing on a 35mm now. It isn't big enough to excite you the way it does even on a 4 x 5, certainly on an 8 x 10. It's quite an exciting thing to see. So, I would do all those things. I would underline that they are quite different photographic activities, 35mm and 8 x 10.

STUDENT 18: [inaudible]
W.E.: How do I go about composing and taking a picture? Well again, more or less instinctively. That's a self-taught procedure. I don't do it very consciously. In fact, I don't think you should be very conscious in photography of classic rules of graphic composition. You should have a subject, instinctive taste in that matter, and proceed. So, I believe I've answered your question.

I think that I've given enough time, not only given, but also *taken* enough time, particularly since Mr. Beaumont Newhall has a whole lot of *really* scholarly and knowledgeable things to say. You will now get some *meaty* knowledge out of him.

At this point, Walter Evans borrowed my camera and photographed the students while I gave my lecture.

Index

Page numbers in italic refer to illustrations.

Abbott, Berenice, 235
Abbott, Yarnall, 186
Abney, Sir William de Wiveleslie, 161
Abraham Lincoln (Brady), *48*
"An Account of a Method of Copying Paintings upon Glass, and of Making Profiles by the Agency of Light upon Nitrate of Silver" (Wedgwood), 15 *ff.*
Achromatic lenses, 89
Acolman 5, Mexico (Siskind), *304*
Adams, Ansel, 251, 255–61, 277, 278
 work of, *253, 256, 257, 258, 261, 276*
Adams, John Quincy, 48, 49
Allston, Washington, 39
Adamson, Robert, 87, 91 *n.*, 220 *n.*
 work of, *82*
Aerial photography, 73–74
Aftermath of Flood, Mount Vernon, Indiana (Lee), *269*
Agee, James, 318, 319, 320
Albert Sands Southworth (Southworth, Hawes), *36*
Albright Art Gallery, Buffalo, photosecessionist show (1910), 189
Albumen prints, 50, 63, 66–67, 87, *128, 130, 131, 132,* 145
Alland, Alexander, Sr., 155
Amateur Photo Exhibition, London (1866), 161
"The Amateur Photographer" (Black), 149 *ff.*
Amateur Photographic Association of Great Britain, 152 *n.*
Amateur photography, 149–53, 163
America, 214, 215, 220
 West, 121 *ff.*
American Academy of Arts and Sciences, 74
American Amateur Photographer, The, 161, 185 *n.*
American Archives, 49 *n.*
"American School" of photography, 173, 174
Anderson Galleries, New York, 209, 215
Andrea Doria (ship), 295
Animals, in motion, 141–42

Annals of My Glass House (Cameron), 135 *ff.*
Annan, J. Craig, work of, *191*
Annie, My First Success (Cameron), *134*
Annual of Scientific Discovery, 74
Ansel Adams (Brassaï), 277, 278
Anthony, E. and H. T., 63, 64, 74
Anthony's Photographic Bulletin, 105 *n.*
Approaching Storm, The (Stieglitz), *168*
Arago, François, 17, 19, 20, 86, 94
Archer, Frederick Scott, 33, 51, 87
 work of, *50*
Architectural photography, 28, 80, 84, 115, 177–79, 181, 182
Argent corné, 19
Armco Steel, Ohio (Weston), *226*
Art, (in relation to photography), 79–80, 91–94, 112–13, 159–62, 163–65, 181, 201–03, 205, 223–27, 253, 254, 314
Art Center School, Los Angeles, 255
Art in America, 312, 313 *n.*
"The Art of Photography" (Frith), 115 *ff.*
Arthur and Guinevere (Eugene), *192*
"Artistic Photography in France" (Demachy), 173
"The Assignment I'll Never Forget," (Lange), 263 *ff.*
Astronomy, 74
Atget, Eugène, 235–37, 260, 280, 313
 work of, *234, 236, 237*
Atlas executé d'apres nature au microdaguerreotype (Donné), 74 *n.*
Attic (Weston), *222*
Autochrome process, 203 *n.*
Autotype, 137
Avenue de l'observatoire (Brassaï), *279*
Avenue des Gobelins (Atget), *237*

Balcon, 17 rue de Petit Pont (Atget), *234*
Ballet mécanique, 231
Balzac, Honoré de, 278
Barn (Holmes), *62*
Barthélemy, Victor, 278
Baudelaire, Charles, *111,* 112, 280
Bauhaus, 239
Baumann, Hans. *See* Man, Felix
Bausch & Lomb Lens Souvenir, The, 167

Bausch & Lomb Optical Company, 167
Baxter Street Alley in Mulberry Bend, New York (Riis), *155,* 156
Bayer, Herbert, work of, *247*
Beard, Mr., 83
Bedford, Francis, work of, *102*
Bedroom Dresser, Shrimp Fisherman's House, Biloxi, Mississippi (W. Evans), *316*
Benito Mussolini in His Office in the Palazzo Venezia, Rome (Man), *273*
Bennett, James Gordon, 46
Bergheim, John S., 184 *and n.*
Berliner Illustrierte, 274
Binocular camera, 147
Binocular lenses, 89
Binocular vision, 53, 162
Biot, Jean Baptiste, 17, 22
Birmingham Photographic Society, 105
Black, Alexander, 149
Black, James Wallace, 64 and *n.,* 76
 work of, *73*
Black Vase, The (Steichen), *174,* 176
"Block Notes" camera, *146*
Boards and Thistles (Adams), *253*
Böcklin, Arnold, 212
Böckmann, Mr. 15 *n.*
Booth, Edwin Thomas, 48
Booth, John Wilkes, 48
Booth, Junius Brutus, Sr., 45, 48
Born Free and Equal (Adams), 255
Boston, from the Balloon "Queen of Air," 1860 (Black), *73*
Boston Globe, The, 311, 312
Bowdoin College, 38
Bradley, Henry W., 128
 work of, *128*
Brady, Mathew B., 44, 45–49, 71, 72, 260
 work, of, *48*
"Brady, the Grand Old Man of American Photography," 45 *ff.*
Brancusi, Constantin, 210
Braque, Georges, 279, 283
Brassaï, 276, 277–81
 work of, *278, 279, 281*
"Brassaï: 'I Invent Nothing. I Imagine Everything.'" (B. Newhall), 277 *ff.*

Brassaï, Yosemite National Park, California (Adams), 276, 277
Braun (publishing house), 286
Breakfast Table, The (Talbot), 26
Breton, André, 279
Brewster, Sir David, 39, 40
British Journal of Photography, 37 *and n.*, 144
Bromoil, 251
Brownie camera, 207
Buckle, Mr., 119
Bull Run, Battle of, 49, 121
Bullock, John G., 187
Burned Mirror (White), 308
Burnham Beeches (Newton), 78
Burty, Philippe, 109

Cadett, Mr., 182
Cadiz (Coburn), *190*
Calhoun, John Caldwell, 46
California Spirit of the Times, 142
Calotype process, 33-35, 51, 80, 87, 119
 prints, *32, 35, 82, 102*
Camera Club, The, London, 105, 106, 159
Camera Club of New York, 163
Camera Notes, 171
Camera obscura, 16, 17, 20, 28, 55
 invention of, 19
Camera Work, 181, 209, 219, 254
Cameras, 38, *146-47*, 148-51, 251, 283, 287
Cameron, Julia Margaret, 135-38, 193, 214, 260
 work of, *134, 138, 139*
Candid shots, 287
Carbon prints, *170, 174*, 191
Card portraits, 69
Carlyle, Thomas, 135
Carson Sink, New Mexico, *124, 127*
Cartier-Bresson, Henri, 275, 279, 282, 283-87, 299 *and n.*
 work of, *284-87*
Cavaignac, Louis Eugène, 47
Cazotte, Jacques, 112
Celestial photography, 74 *and n.*
Central Pacific Railroad, 121, 123
Century Magazine, The, 148, 150, 151
Cézanne, Paul, 210, 283
Champney, J. Wells, work of, *148*
Chandler, Professor, 153
Charcoal Effect, A (Devens), *186*
Charles Baudelaire (Nadar), *111*
Charles Sumner (Southworth & Hawes), *38*
Chemistry of Light and Photography, The (Vogel), 68
Cheney, John, 39
Chesterton, Gilbert K., 200
Chiaroscuro, 37, 90
Chicago (Siskind), *304*
Chiffonier, The (White), *199*
Children in Madrid (Cartier-Bresson), *286*
Chilton, James R., 47 *n.*
Church (Strand), *303*

Cinema. See Film
Citrate paper, 230 *and n.*
Civil War, 45, 48, 49, 121
Clark, Rose, 187
Claude glasses, 162 *and n.*
Claudet, Antoine François Jean, 81, 83 *and n.*, 86, 90, 92, 95
Clay, Henry, 46, 47
Clearing Winter Storm, Yosemite Valley, California (Adams), *258*
Club of Amateur Photographers of Vienna, 173
Coburn, Alvin Langdon, 187, 200-205
 work of, *190, 200, 204, 205*
Cocotte, The (Höch), *248*
Collodion process (wet-plate), 33, 45, 46, 50-52, 53, 55, 56, 63-68, 79-80, 87, 144, 149, 260
 prints, *96-103*
Collotype, *168*
Color-etching, 219
Color filters, 182 *and n.*, 252
Color photography, 152, 203 *and n.*, 240
Coloring of photographs, 133
Colour Photography and other recent Developments of the Art of the Camera, 203 *n.*
Colour-screens, 182 *and n.*
Columbia College Amateur Photographic Society, 153
Combination printing, 105, 106
Composites, 152
Composition, 166
Composition no. 76 (Henri), *249*
Concealed Vest Camera, *147, 150*
Coney Island, New York (Cartier-Bresson), *287*
Confederate Dead by a Fence on the Hagerston Road, Antietam, September 17, 1862 (Gardner), *72*
Constable, John, 160
Contax camera, 283
Convent of Mar-Saba, near Jerusalem (Frith), *114*
Cook, Alistair, 291
Cooper, James Fenimore, 47, *47*
Corot, Camille, 109 *and n.*, 160
Coronation Procession, London, The (Cartier-Bresson), *285*
Corrugated Tin Facade (Evans), *310*
Country Doctor (Smith), *294*
Cropping, 284
Cubism, 205, 227
Cubists and Post-impressionism (Eddy), 227 *and n.*
Cundell, George S., 81, 87
Cunningham, Imogen, 251, 254
 work of, *254*
Custer, General George Armstrong, *132*
Cwerey, F. W., work of, *99*
Cypress, Point Lobos (Weston), *252*

Dadaists, 241

Daguerre, Louis Jacques Mandé, 15, 17-21, 37 *and n.*, 46 *and n.*, 54-56, 81, 85, 86, 89, 119
 work of, *19, 20*
Daguerreotype, 17-20, 33, 37-39, 51, 53, 56, 74, 86, 119
 works, *18, 19, 20, 36, 38, 39, 42, 75*
Dallmeyer, T. R., 184 *and n.*
Dallmeyer-Bergheim lens, 184 *and n.*
Dance Hall (Brassaï), *281*
"The Dark Blue Sea." Breakers on the Coast, North Devon (Pollock), *101*
Darkroom, 65, 151
Darktent, portable, 68
Darwin, Charles, 107
Daumier, Honoré, *108*, 109 *and n.*, 278
Da Vinci, Leonardo, 160
Davis, Jefferson, 48
Davy, Sir Humphry, 23-24, 27 *n.*, 30, 81, 86 *and n.*
Day, F. Holland, 187
Day in the Life of Mussolini, The (Man), 274
Daybook (Weston), 223
Daybooks of Edward Weston, The (N. Newhall, ed.), 223 *n.*
Dead Poplar in the Owens Valley, California (Adams), *257*
Dean, John, 74
Deardorff camera, 300 *and n.*
Debrie Parvo motion picture camera, *242*
Degas, Edgar, 212
Delaroche, Hippolyte, 86
De la Rue, Warren, 74 *and n.*
Demachy, Robert, 173, 174
De Meyer, Baron A., work of, *191*
Demonstration of Portraiture, A (Stieglitz), 209
Depression, Great, 263
"Design" (show), 205
Desnos, Robert, 228
"Detective" cameras, *147, 150*
Deutsche Werkbund, 242, 243
Devens, Mary, *186*, 187
Dial, The, 209, 224
Diamond, Hugh W., work of, *97*
Dickinson, Mr., 95
Did She? (Rejlander), *107*
Diorama paintings, 46 *n.*
Diver, The (Stettinus), *151*
Documentary photography, 255, 257, 267, 269, 270, 305, 306, 320
Dodging, *186, 187*, 260
"Doings of the Sunbeam" (Holmes), 83 ff.
Donaldson, Douglas, 224
Donné, Alfred, 74 *and n.*
Double camera, *146*
Dr. Albert Schweitzer (Smith), *288*
Draper, Henry, 74 *and n.*
Draper, John W., 46
Dresden China Fan, The (Meyer), *191*
Drop-shutter, 152
Dry mounting, 252

Dry-plate process, 144–45, 146, 149, 151
Duchamp, Marcel, 228
Duell, Charles, 301 and n.
Dumas, Alexandre, 109 and n., 112
Dumont, Mr., 187
Dyer, William B., 187

"Early History of Photography in the United States" (Southworth), 37 ff.
Eastlake Sir Charles, 81, 83, 146
Eastlake, Lady Elizabeth, 81, 82, 82, 97, 146
Eastman (George) House collection, 121, 271
Eddy, Arthur Jerome, 227 and n.
"Eduard J. Steichen" (Juhl), 173 ff.
Edwards, John Paul, 251
Eickemeyer, Mr., 186, 187
Electro process, 89
Electroplating, 54, 56
Electrotyping, 39
Elliot, Charles, 47
Ellis, Joseph, 81
Ellsler, Fanny, 48
Eluard, Paul, 279
Emerson, Peter Henry, 159, 163–65, 260
work of, 158, 161
England, early history of photography in, 15–16, 23–35
Engravings, 28–30, 85
Enlarging, 76
Entrance to the Great Temple, Luxor (Frith), 114
Epstein, Philip G., 109
Ermanox camera, 271, 272, 274
Essays on Art (Weber), 205
Eugene, Frank, 185–87, 220
work of, 192
"Eugene Atget" (Abbott), 235 ff.
Eugenè Delacroix (Nadar), 109
Evans, Frederick H., 177–84
work of, 178, 180, 181, 183
Evans, Walker, 311–20
work of, 266, 268, 310, 315, 316, 317
"An Experiment with Gelatino Bromide" (Maddox), 144 ff.
Exposition des Beaux Art, 84
"Expression of the Emotions in Man and Animals" (Darwin), 107
Ezra Pound (Coburn), 205

f.64 (group of photographers), 251–54
Family of Man, The, 267
Farm Security Administration. See FSA
Feilding, Horatia, 35
Film (cinema), 231–33, 239, 240, 241, 280, 281, 287
"Film und Foto" (Stuttgart 1929), 242 ff.
Films, types of, 251, 252, 293
Filters, 182 and n., 252

Fizeau, Armand Hippolyte Louis, 86
Flaherty, Robert, 320 and n.
Flashlighting, 284, 289–90, 291, 292, 295
"Flashes from the Slums: Pictures Taken in Dark Places by the Lightning Process," 155 ff.
Flood Refugees. Forrest City, Arkansas, February 1937 (Evans), 266
Floodlighting, 284, 289, 290, 291
Flourens, Pierre J. M., 70 and n.
Focus, 79–80, 251, 253, 286
Force, Peter, 49 and n.
Ford, Thomas, 161
Fort Sumter, 121
Fox Talbot, William Henry. See Talbot, William Henry Fox
France, 84, 173
French, Herbert S., 187
French Academy of Sciences, 17, 22, 23
French Chambers, 17, 18, 85, 86
French Underground, 286
French Society of Photography, 109
Frietag, Roman, 308
Frith, Francis, 65 and n., 115
work of, 114, 118
From the Transporter Bridge, Marseilles (Moholy-Nagy), 241
FSA (Farm Security Administration) photographers, 263–64, 267–70, 315–17
"The FSA Photographers" (Steichen), 267 ff.
"The Function of the Camera" (Scott), 201 ff.
Furman, Henry, 48
"The Future of Pictorial Photography" (Coburn), 205 ff.
"The Future of the Photographic Process" (Moholy-Nagy), 239 ff.

Gallatin, Albert, 48
Garden of Dreams (Keiley), 194
Gardner, Alexander, work of, 72
Gathered for Burial at Antietam after the Battle of September 17, 1862 (Gardner), 72
Gaucheraud, H., 17, 18
Gautier, Théophile, 110
Gay-Lussac, Joseph Louis, 86
Gazette de France, La, 17
Gazette des Beaux-Arts, La, 109
Gelatin bromide dry plate, 144–45, 149, 151
General George Armstrong Custer (Scholten), 132
George IV, King of Great Britain, 85
George VI, King of Great Britain, 284
Georgia O'Keeffe (Stieglitz), 211
German-Austrian school of photography, 173, 195
Ghost photography. See Spirit photography
Gibson, John, 69 and n.
Giphantie (Tiphaigne de la Roche), 13

Glass negatives, 55, 63, 67, 68, 149
Glycerine process, 187, 188, 194
Gold Medal Prize Picture, The (Bradley, Rulofson), 128
Goldsmith, Arthur, 289
Gould and Curry Mill, Virginia City, Nevada, The (O'Sullivan), 120
Gouraud, François, 37 and n.
Grafitti (Brassaï), 279
Graflex camera, 251, 264, 300 and n.
Grandmother's Present (Pollock), 103
Grant, Ulysses S., 48, 49
Graveyard Houses and Steel Mill, Bethlehem, Pennsylvania, November 1935 (Evans), 268
Great Exhibition of the Works of All Nations, 46 and n., 47
"A Great Photographer at Work" (Smith), 289 ff.
Greeley, Horace, 47
Grief (Rejlander), 107
"Group f.64" (Edwards), 251 ff.
Guizot, François, 109 and n.
Gum bichromate process, 163–65, 172, 173, 175, 177, 179–82, 187, 188, 190, 195, 197
Gurney, Benjamin, 130
work of, 130
Gurney, Jeremiah, 130
work of, 130

Hagemeyer, Johan, 223
Halász, Gyula. See Brassaï
Hall, H. B., work of, 47
Hamilton, Mrs. Alexander, 45, 48
Hand and Ear (Weston), 232
Hand of Man, The (Stieglitz), 186
Hands and Thimble-Georgia O'Keeffe (Stieglitz), 216
Harper's Bazaar, 283, 287
Harrison's globe lens, 76
Hartmann, Sadakichi, 185, 189 and n.
Hausner, Edward, 272
Hawes, Josiah Johnson, 37, 39
work of, 36, 38, 39, 42
Height and Light in Bourges Cathedral (F. Evans), 181
Heliar 4.5 lens, 278
Heliography, 23, 85, 87
Helmholtz, Hermann von, 159, 160, 162
Hennenberg, Hugo, 176, 195
Henri, Florence, work of, 249
Henry Clay (Jackman), 47
Herschel, Sir John F. W., 15 n., 23, 40, 86, 87, 88, 135, 137, 138
Herring, John Frederick, 142 and n.
Hill, David Octavius, 87, 91 n., 214, 220 and n., 260
work of, 82
Hinton, A. Horsley, 173
History and Handbook of Photography, A (Tissandier), 65
Höch, Hannah, work of, 248
Hogg, Jabez, 50

Holmes, Oliver Wendell, 53, 63
work of, 62
Honoré Daumier (Nadar), 108
Horse in Motion, The (Muybridge), 140–43 *and illus.*
Houston, Samuel, 46
How the Other Half Lives (Riis), 155
Hughes, C. Jabez, 115 *and n.*
Hull, S. Wager, 76, 77
Humboldt, Alexander von, 17
Humboldt Valley and Sink, Nevada, 124
Humphrey's Journal of Photography, 47 *n.,* 48 *n.*
Hunt, Robert, 87, 88, 90

Igor Stravinsky Conducting a Rehearsal (Man), 274
Impressionism, 210
"In 1943 and 1944 A Great Change Took Place" (Siskind), 305 *ff.*
International Magazine, 47
International Photographic Exhibition, New York, 268
Interiors, 151
Inverted in the Tide Stand the Grey Rocks (Watkins), 69
Iris Facing the Winter, Orgeval (Strand), 220
Irving, Washington, 47–48
Isabey, Jean Baptiste, 64 *and n.*
Ives, Frederic Eugene, 152

Jackman, W. G., work of, 47
Jackson, Andrew, 45, 46
James, Henry, 181
James Fenimore Cooper (Hall), 47
"*Jane Tudor,*" The (Johnson), 100
Japanese-American war relocation, 255
Jeffries, John, 73
John Marin (Stieglitz), 206
Johnson, David, work of, 100
Johnson, Mr., 38
Jones, Chapman, 177
Journal of the Photographic Society, The, 79 *n.,* 81, 87, 136
Journals of the Royal Institution, 23
Journal of the Royal Society, The, 84
Journet, Jean, 109 *and n.*
Juhl, Ernst, 173, 189 *and n.*

Käsebier, Gertrude, 167, 176, 187, 220
work of, 193
Katz, Leslie, 312, 313 *n.*
Kaufmann, Mikhail, 242
Keiley, Joseph T., 185, 187
work of, 194
Kelmscott Manor: Attics (F. Evans), 180
Kennedy, John P., 48
Kennerly, Mitchell, 215
Kertész, André, 278
Key, Philip Barton, 48
Kilburn, Mr., 95
Kinegraphe camera, 146

King, Clarence, 121
King, Samuel Archer, 73 *and n.*
Kodak camera, 147
Kölner, 274
Kuehn, Heinrich, 176
work of, 195

Lady at the Harp (Talbot), 35
Lamartine, Alphonse de, 47
Lamon, Marshal, 48
Landscapes, 15, 27–28, 84, 92–93, 121, 174, 223, 227
Lane, Harriet, 48
Lange, Dorothea, 251, 255, 259, 263–64
work of, 262, 264, 265, 266, 270
Lantern Slide Club, Chicago, 152
Lantern slides, 152, 155, 168, 169
Laurent, Marie, 109 *and n.*
Lauvrik, J. Nilsen, 224 *and n.,* 227
Lawrence, Richard Hoe, 156
Leaves, Glacier National Park, Montana (Adams), 256
Lee, Robert E., 48, 49
Lee, Russell, work of, 269
Léger, Fernand, 231
Leica camera, 283
Leicester Buildings (Archer), 50
Lenbach (Steichen), 186
Lenses, 38 39, 76, 116–17, 151, 184 *and n.,* 251, 283, 293
Let Us Now Praise Famous Men, 318
Levitt, Helen, 261
Lewis, Wyndham, 205
Library, The (Talbot), 32
Library of Congress, 49 *n.,* 264
Liebermann, Max, 274
Life and Landscape on the Norfolk Broads (Emerson), 158
Life magazine, 274
"Light Pictures," 176
Light rays. *See* Solar rays
Lighting, 284, 289–90, 291
Lincoln, Abraham, 48, 48
Lincoln, Mary Todd, 48
Lincoln Cathedral: A Turret Stairway (F. Evans), 178
Lind, Jenny, 48 *n.*
Linked Ring, The, 205
Linton, Sir James, 161
Lismore Castle, Ireland (Cwerey), 99
Lissitzky, El, work of, 243
Literary Gazette, The, 18, 26, 30 *n.*
Liverpool Amateur Photographic Association, 201
Liverpool Courier, 201
Lombardy Ploughing Team (Annan), 191
London, England, 317, 318
London Bridge (Coburn), 200
London Globe, 19
London Institution, 87
London Stereoscopic Company, 68, 69
Lorant, Stefan, 271–75 *and illus.*
Lorrain, Claude, 162 *n.*
Love Thy Neighbor (Moholy-Nagy), 238

Luc-Olivier-Merson, 236
Lucretius, 53

McAlpin, David H., 255
Machines, 212–15
Maddox, Richard Leach, 144
Madison, Dolley, 45
Maeterlinck, Maurice, 224
Major, Rev. J. R., 81
Malbone, Edward Greene, 64 *and n.*
Malignano, Battle of, 71
Man, Felix H., 271–75 *and illus.*
work of, 272–74
Man with a Movie Camera, 242
Manchester Art Treasures Exhibition, 105
Manger, The (Käsebier), 193
Marin, John, 206, 297
Marina, Bellagio (Stieglitz), 168
Martin, Paul, 198
Matisse, Henri, 279, 283
Mayall, Mr., 95
Melchior, Laurenz, 274
Memorable Fancies (White), 307
Mental Distress (Rejlander), 107
Mexican War, 46
Michelangelo, 160
Microphotography, 74
Microscope, solar, 26, 27, 28
Mighty Lite, 295 *and n.*
Migrant Mother (Lange), 262, 263–64, 264, 265
Miller, Henry, 277 *and n.,* 278, 279
Millet, Jean François, 159
Miniature cameras, 283, 287
Miraculous Mirror, The, 12
"The Modern Public and Photography" (Baudelaire), 112 *ff.*
Moholy-Nagy, László, 239–41
work of, 238, 240, 241, 245
Monet, Claude, 283
Moon, The (Whipple), 75
Moonlight Impression from the Orangerie, Versailles Series (Steichen), 197
Moonrise (Steichen), 185
Morphotype, 57
Morris, William, 180
Morse, Samuel F. B., 37 *and n.,* 38, 40, 46 *and n.,* 49
Motion photography, 17, 140–43 *and illus.,* 205, 239
Motion Picture Camera (Strand), 220
Motion picture (movies), 149, 242
Mountain Nymph, Sweet Liberty, The (Cameron), 138, 138
Mounting, 252, 260
Mrs. Anne Rigby and her daughter Elizabeth (Hill, Adamson), 82
Mulberry Bend, New York, 155
Müller, Johannes, 56
Mumford, Lewis, 254
Munich Illustrated Press, 271
Museum of Modern Art, The, New York, 235, 267, 305
Evans retrospective (1971), 311
Strand show (1945), 283

Museum of the City of New York, 155
Muybridge, Eadweard J., 141, 150
 work of, *140–43*

Nadar, 109, 112, 235
 work of, *108–11*
"Nadar's Portraits" (Burty), 109 *ff.*
Nagle, John T., 156
Nanook of the North, 320 *and n.*
Napoleon, Louis, 47 *and n.*
National Photographic Association,
 37, 43, 129
Natural Magic (della Porta), 19 *n.*
*Natural Photography for Students of
 the Art* (Emerson), 159
"Naturalistic Photography" (Emerson), 163
Near Los Angeles, California (Lange),
 270
Negatives, 33, 34, 51, 52, 55, 66, 119,
 180, 181, 201
 etching of, *192*
Net Mender, The (Stieglitz), 186
New England, 297–303
New Realism, 231
"A New Realism—The Object; Its
 Plastic and Cinematic Value" (Léger), 231 *ff.*
New York Academy of Fine Arts, 37
New York City, 155–57, 215, 216
New York from Its Pinnacles (Coburn), 205
New York Observer, 46 *n.*
New York Sun, 155, 156
New York Times, 303
Newhall, Beaumont, 271, 272, 283,
 284, 317, 320
 work of, *282*
Newhall, Nancy, 277, 297–303
Newton, Sir William J., 79–80, 91
 and n.
 work of, *78*
Niépce, Joseph Nicéphore de, 15, 17,
 18 *and n.,* 19, 21, 46, 84–85, 86, 88
Niépce de St. Victor, Mr., 87, 88
Night in London (Rejlander), 107
Night photography, 198
Niles' National Register, 19
Noskowiak, Sonya, 251
Notman, William, 131
 work of, *131*

Oakland Salon of Photography, 227
Oats (Talbot), *22*
Office of War Information (U.S.),
 255, 287
O'Keeffe, Georgia, 209, *211,* 216, *216*
Old Oak, An (Percy), 98
"On Art Photography" (Hughes),
 115 *n.*
On the Way from School (Schmid),
 150
Open Door (Strand), *296*
Optics, 40, 41
"Oscar Gustav Rejlander" (Robinson), 105 *ff.*

Oskar Schlemmer (Moholy-Nagy),
 245
O'Sullivan, Timothy H., 121, 260
 work of, *120, 123, 125, 126*
Ould, Robert, 48

Page, William, 46
Painter, The (Seeley), *196*
Painting, 160–66, 205, 223, 227, 239,
 240
Painting, Photography, Film (Moholy-Nagy), 239
Paintings on glass, 15–16, 26
Panatomic film, 252
Panchromatic film, 251
Panthéon (Nadar), 109 *and n.*
Paper, photographic, 145, 252, 253,
 260
Parcel Detective Camera, 147
Paris, France, 280, 281, 317, 318
Paris de Nuit (Brassaï), 278
Paunceforte family, 45
Payne, John Howard, 46
Peale, Charles Wilson, 49
Pennell, Joseph, 38, 39
Percy, John, work of, 98
"A Personal Credo" (Adams), 255 *ff.*
Perspective, 205
Peterhans, Walter, work of, *244*
Philadelphia Photographer, The 30 *n.,*
 128, 129, 130, 131
Phillipsburg, New Jersey (Evans),
 315
Philosophical Transactions, 87
Photo-Club de Paris, 174
Photo Cravatte camera, *147*
Photo-etching, 187
Photo-galvanic engraving, 88-89
Photo Jumelle camera, *147*
"The Photo-Secession" (Stieglitz),
 167 *ff.*
Photo-Secession, 187
Photo-Secessionists, 165, 167, 185–88,
 201, 205, 209, 251
 Albright exhibit (1910), 189
Photogenic drawings, 23–31, 33–35
 examples of, *22, 26, 29*
Photograms, 173, 180, 205, 240
Photograms of the Year 1900, 180
Photograms of the Year 1916, 205
Photographic Art Journal, The, 75,
 173 *and n.*
Photographic drawing, 84
Photographic Exchange Club, album
 of, 82
Photographic Journal, 92, 177 *n.*
Photographic News, 105, 106, 107
Photographic Notes, 81
Photographic Salon of London, 251
Photographic societies, 83–84
Photographic Society of Bombay, India, 83
Photographic Society of London, 79,
 81, 83, 91, 105, 136, 146
Photographic World, The, 132
Photographische Rundschau, Die, 168,
 173, 175

"Photographs from the High Rockies"
 121 *ff.*
"Photography" (Eastlake), 81 *ff.*
Photography (periodical), 174, 175
Photography (Strand), 219 *ff.*
Photography (Weston), 252
"Photography: A Pictorial Art" (Emerson), 159 *ff.*
Photogravure, 159, *161, 162,* 178,
 198, *198*
Photojournalism, 289
Photojournalism in the 1920's (Germany), 271–75
Photomagazin, 308
Photomicrography, 144
Photomontage, *238, 243*
Picasso, Pablo, 278, 279, 280, 315
Picasso, rue de la Boétie (Brassaï), 278
Pictorial photography, 79–80, 91–92,
 115–19, 159–62, 163–66, 167,
 183–89, 205–07, 223, 225
"Pictorial Photography" (Stieglitz),
 163 *ff.*
Pictures of East Anglian Life (Emerson), *161*
"Picture Plays," 149
Piffard, Henry G., 156
Platinotype, 163, 179, 181, 182, 191
 examples of, *158, 171, 180, 183,
 192, 193, 194, 196, 222, 224,
 226*
Platinum prints, 159, 164, 165 *and n.,*
 177, 198
 examples of, *181, 199*
"A Plea for Straight Photography"
 (Hartmann), 185 *ff.*
Poe, Edgar Allan, 45, 46
Polaroid Land process, 309
Polk, James K., 45
Pollock, A. I., work of, *103*
Pollock, Sir Frederick, 83
Pollock, George Frederick, 146
Pollock, Henry, work of, *96, 101*
Polytechnik, Berlin, 214
Popular Photography, 263, 283, 289,
 290
Porta, Giovanni Battista della, 20 *n.*
Porteuse de Pain (Atget), *237*
Portrait of a Baby (Stieglitz), *171*
Portrait of a Young Man (Steichen),
 185
Portrait of Beaumont Newhall (Cartier-Bresson), *284*
Portrait of Frits Thaulow (Steichen),
 175, 176
Portrait of Gilbert K. Chesterton (Coburn), *200*
Portrait of Henri Cartier-Bresson (B.
 Newhall), *282*
Portrait of Miss Jones (Eugene), 186
Portraiture, 45, 69–71, 92, 95, 116,
 119, 129–33, 166, 174, 216, 223,
 225
Post-impressionism, 227
Pound, Ezra, 204, 205, *205*
Pretsch, Mr., 88
Prévert, Jacques, 279, 280

Previsualization, 223
Pritchard, H. Baden, 106, 107
"Progress of Photography-Collodion the Stereoscope" (Ellis), 81
Propaganda, photography as, 269
Prosch, G. W., 46 n.
Pure photography, 251–60
Pyramid Lake, Nev.-Calif., 122–23 and illus.
Pyramid Lake (O'Sullivan), 123

Quai de la Tournelle, Paris (Cartier-Bresson), 285
Quitman, John Anthony, 46

"Random Notes on Photography" (Weston), 223 ff.
Ray, Man, 228–30, 235
work of, 272–74
Rayographs, 228
Reade, Rev. J. B., 87
Rear of Church, Cordova, New Mexico (Adams), 261
Redeveloping, 66
Reflected Sunlight on Torso (Weston), 224
Rejlander, Oscar Gustave, 105–07
work of, 104, 106
Rejlander the Artist Introducing Rejlander the Volunteer (Rejlander), 106
Rendez-Vous, Le (Prevert), 280
Renoir, Jean, 287
Retouching, 165, 166, 186, 187
Rigby, Anne, 82
Right Eye of My Daughter Sigrid, The (Sander), 232
Riis, Jacob A., 155–57
work of, 155, 157
Ritter, Mr., 15 n., 84
Rivaulx Abbey, Yorkshire (Bedford), 102
Robinson, Henry Peach, 105
Roche, Charles François Tiphaigne de la, 13
Rodin, Auguste, 176
Roerich, Nikolay, 227 and n.
Rolleiflex, camera, 280
Rood, Ogden Nicholas, 74 and n.
Roosevelt, Theodore, 155
Rose, The (Steichen), 176
Rosenfeld, Paul, 209, 224
Rosling, Mr., 119
Rouault, Georges, 279, 283
Rousseau, Pierre E. T., 160
Royal Photographic Society of Great Britain, 46, 81, 177, 205
Royal Society of Great Britain, 23, 30, 33, 34, 56, 85, 86
Ruby Range, Rocky Mts., 125, 127
Rulofson, William Herman, 128
work of, 128
Rushy Shore, A (Emerson), 158
Russel, Mary M., 187
Russian official photography, 269
Rutherford, Lewis Morris, 74 and n.

Sabattier effect, 228
Saint-Victor, Paul de, 109 and n.
St. Cloud (Atget), 236
Salomon, Erich, 271
San Francisco Call, 141
San Francisco Museum of Art, 224 n., 227
Sander, August, work of, 232
Santa Anna, Antonio López de, 46
Santorini Giovanni Domenica, 70 and n.
Sardou, Victorien, 236 and n.
Scheele, Mr., 15 n, 84
Schiller, Johann Christoph, 89 and n.
Schmid, William, 150
Scholten, John A., 132
work of, 132
Schutze, H., 187
Schweitzer, Albert, 288
Scott, John Dixon, 201, 203 n., 219
Scott, Winfield, 46, 48–49
Scovill (silver plate manufacturers), 37
Scribner's Magazine, 163
Scurrying Homewards (Stieglitz), 186
Seeley, George H., work of, 196
Self-Portrait (Lissitzky), 243
Self-portrait (Southworth), 36
Self-Portrait with Brush and Palette (Steichen), 172
Sellers, Coleman, 76 and n.
Senebier sur la Lumière, 15 n.
"Sensitive paper," 27, 28
Serner, Albert, 224
Seven Arts, 219
Seymour, David ("Chim"), 283
Shadowgraphs, 15, 228
Sharecroppers, Eutaw, Alabama (Lange), 266
Sharpshooter—Manuel Hernandez Galvan, The (Weston), 246
Shaw, George Bernard, 200, 201, 202, 224
She is looking at me, the dear creature (Rejlander), 107
Shells and Fossils (Daguerre), 19
Shifting Sand Dunes (O'Sullivan), 125
Short Tail Gang, under Pier at Foot of Jackson Street, Later Corlears Hook Park (Riis), 157, 157
Shoshone Falls (O'Sullivan), 126
Simpson, William, 251
Sir John F. W. Herschel (Cameron), 138
Siskind, Aaron, work of, 304
Sketch, The (Steichen), 176
Skies, photographing of, 74 and n.
Smith, W. Eugene, 275, 289–95
work of, 288, 292, 294
Society of Amateur Photographers of New York, 153, 155
Soft focus, 251
Solar microscope, 26, 27, 28
Solar rays, 15 and n., 16, 89, 90
Solitude (Steichen), 186
"Some Account of the Art of Photogenic Drawing" (Talbot), 23 ff.

Song of the Lily (Eugene), 185
South London Photographic Society, 115
Southern California Camera Club, 223
Southworth, Albert Sands, 36, 37–43, works of, 36, 38, 39, 42
Spanish Village (Smith), 292
Spectrum. See Solar rays
Speedlight, 295
Spiral Staircase, Marseille (Bayer), 247
Spirit photography, 76, 207
Spotting, 260
Stackpole, Peter, 251
Stanford, Leland, 141
Stannotypes, 64
Steichen, Edward, 167, 173–76, 185–88, 220, 267
work of, 172, 174, 175, 197
Steiner, Ralph, work of, 233
Stereographs, 57, 58, 59, 60, 61, 68, 69
Stereoscope, 39, 53–61, 63, 68, 88, 89, 112, 119
"The Stereoscope and the Stereograph" (Holmes), 5 ff.
Stereoscopic photography, 63, 68, 74. See also Stereoscope
Stereoscopic vision, 56, 57, 58
Stettinus, John L., work of, 151
Stewart, Mr., 79
Stieglitz, Alfred, 163, 167, 185–89 and n., 209–24, 254, 259, 260, 277, 287, 297
work of, 167–71, 198, 206, 211, 213, 216
"Stieglitz" (Rosenfeld), 209 ff., 224
Stiff Pull, A (Emerson), 161
Still Life (Diamond), 97
Still Life (Kuehn), 195
Stirling, Edmund, 187
Storefront and Signs, Beaufort, South Carolina (W. Evans), 317
Story, William Wetmore, 69 and n.
Story of Marie, The (Brassaï), 280
Strand, Paul, 219
and Time in New England, 297–303
work of, 220, 221, 296, 300, 301, 303
Stravinsky, Igor, 274, 274
Street, Fifth Avenue, The (Stieglitz), 198
Street Arabs in Sleeping Quarters at Night (Riis), 156, 157
Street Band, A (Champney), 148
Street—Winter, The (Stieglitz), 167
Stryker, Roy E., 263, 267, 315, 317
Sully, Thomas, 49
Summer Days (Cameron), 139
Sumner, Charles, 38
Sun-pictures, 55-56
Sunlight and Shadow, Mont St. Michel (F. Evans), 183
Surrealist movement, 228
Susan Thompson, Cape Split, Maine (Strand), 301

Swift, Henry, 251

Talbot, William Henry Fox, 15, 40, 56, 86, 87, 88, 119
 on calotype photogenic drawing, 33-35
 on photogenic drawing, 23-31
 work of, *22, 26, 29, 32, 35*
Talbotype. *See* Calotype
Tant qu'il y aura des bêtes (Brassaï), 281
Taylor, Henry, *136, 137,* 138
Taylor, Paul, 263
Taylor, Zachary, 45, 46
Tennyson, Alfred Lord, 135, 138
Terminal, The (Stieglitz), *169*
Thaulow, Frits, *175, 176*
Theobald Chartran (Steichen), *186*
Théophile Gautier (Nadar), *110*
35 mm, *320*
Thompson, Susan, *301*
Thompson, Warren, 47 *n.*
Time in New England (Strand, Newhall), 297-303
"Tin-types," 64
Tinting, 133. *See also* Toning
'Tis Light Within—Dark Without! (Rejlander), *107*
Tissandier, Gaston, 65
To My Patrons, 129-33
Toadstool and Grasses, Georgetown, Maine (Strand), *300*
Tonal quality, 286, 293
Toning, 67, 80
Torso (Stieglitz), *213*
Toscanini, Arturo, 274
Toulouse-Lautrec, Henri de, 278, 280
Tournachon, Gaspard Félix. *See* Nadar
Townsend, George Alfred, 49
Traité encyclopedique de la photographie, 146
Transition, 239
Transparencies, 152
Tri-X film, 293
Tschichold, Jan, work of, *248*
Tuileries and the Seine from the Quai d'Orsay, The (Daguerre), *20*
Turner, Joseph Mallord William, *116, 117*
Twain, Mark, 49
Twin-lens camera, 53, *146*
Two Callas (Cunningham), *254*
291 (periodical), 209

291 Fifth Avenue (Photo-Secession gallery), 209, 210, 216
Two Ways of Life, The (Rejlander), *104, 105-06*
Typewriter (Steiner), *233*
Typophotos, 240

United States, early history of photography in, 37-43
United States Geological Exploration of the 40th Parallel, 121
"Upon Photography in an Artistic View, and Its Relation to the Arts" (Newton), 79 *ff.*
U. S. Camera, 269
"The Use of Collodion in Photography" (Archer), 51 *ff.*

Van Dyke, Willard, 251, 253
 work of, *253*
Vance, Robert H., 128
Vanity Fair, 229
Vertov, Dziga, 242
Viaduct on the South Eastern Railway, A (Pollock), *96*
View camera, 251
Vigier, Viscount, 119
Vision, 56, 57, 58
"Vision Plus the Camera: Henri Cartier-Bresson" (B. Newhall), 283 *ff.*
Vogel, Hermann Wilhelm, 68
Voigtländer camera, 278
Von Schneidau, Polycarpus, 48 *n.*
Vorticist group, 205
Vortograph (Coburn), *204*
Vortographs, 204
Vortoscope, 205

Waldweben (Abbott), *186*
"Walker Evans: Visiting Artist," 311 *ff.*
Wallace, William Ross, 46
War Relocation Authority, 255
Watermelon Party, 53
Watkins, Carleton Emmons, 68 *and n.*
 work of, *69*
Watson, Eva, 187
Watzek, Hans, 176, 195
Weber, Max, 205
Wedgwood, Josiah, 84 *and n.*
Wedgwood, Thomas, 15, 23, 30, 84, *and n.,* 85, 86

Weston, Brett, work of, *232*
Weston, Edward, 223-27, 251, 252-53, 259, 260, 261, 277, 307
 work of, *222, 224, 226, 246, 252*
Wet Day on the Boulevard, Paris, The (Stieglitz), *170*
Wet plate process. *See* Collodion process
Whalebone and Sky (Van Dyke), *253*
"What is Modern Photography" (Siskind), 305
Wheatstone, Charles, 39, 53
Whipple, John Adams, 46 *n.,* 54, 56, 74 *and n.*
 work of, *75*
Whistler, James Abbott McNeill, 212, 224
White, Clarence H., 167, 176, 187, 220
 work of, *199*
White, Minor, 307-09
 work of, *308*
White Horse, Ranchos de Taos, New Mexico (Strand), *221*
Whitman, Walt, 214, 215
Willard, S. L., 187
Williamson, Samuel T., 303
Wilson, Cyllene Margaret, *138*
Wilson, Edward L., 129, 130, 132
Windowsill and Daydreaming, Rochester, New York (White), *308*
Windsor from the Railway (Frith), *118*
Winter on Fifth Avenue (Stieglitz), *186*
Wiseman, Cardinal Nicholas, 47
Wolcott, Alexander S., 38
Wolf, Mr., 46, 49
Wollaston, William Hyde, 15 *n.,* 84, 85
Woman [One Portrait], A (Stieglitz), *209*
"The Work of Man Ray" (Desnos), 228, *ff.*
World War II, 243, 255, 280, 283
Wykoff, Chevalier, 48

Yosemite National Park, 255, *258,* 276, 277

Zone system of exposure control, 255
Zoogyroscope, 141-42